Image and Imagination

McDONALD INSTITUTE MONOGRAPHS

Image and Imagination

a global prehistory of figurative representation

Edited by Colin Renfrew & Iain Morley

This volume is published as part of the 'Roots of Spirituality' project, funded by the John Templeton Foundation at the McDonald Institute for Archaeological Research.

Published by:

McDonald Institute for Archaeological Research
University of Cambridge
Downing Street
Cambridge, UK
CB2 3ER
(0)(1223) 339336
(0)(1223) 333538 (General Office)
(0)(1223) 333536 (FAX)
dak12@cam.ac.uk
www.mcdonald.cam.ac.uk

Distributed by Oxbow Books
 United Kingdom: Oxbow Books, 10 Hythe Bridge St, Oxford, OX1 2EW, UK.
 Tel: (0)(1865) 241249; Fax: (0)(1865) 794449; www.oxbowbooks.com
 USA: The David Brown Book Company, P.O. Box 511, Oakville, CT 06779, USA.
 Tel: 860-945-9329; Fax: 860-945-9468

ISBN: 978-1-902937-48-9
ISSN: 1363-1349 (McDonald Institute)

© 2007 McDonald Institute for Archaeological Research

All rights reserved. No parts of this publication may be reproduced, stored in a retrieval system, or transmitted, in any form or by any means, electronic, mechanical, photocopying, recording or otherwise, without the prior permission of the McDonald Institute for Archaeological Research.

Edited for the Institute by Graeme Barker (*Series Editor*), Dora A. Kemp (*Production Editor*) and Nick Jakins.

Cover image: *Figure at the quarry of Ranu Raraku, Easter Island.*
(*Digital art: Nick Jakins; photograph: Colin Renfrew.*)

Printed and bound by Short Run Press, Bittern Rd, Sowton Industrial Estate, Exeter, EX2 7LW, UK.

Contents

Conference participants	vii
Figures	ix
Tables	xiii
Acknowledgements	xiv
Prologue COLIN RENFREW	xv
Material Beginnings: an Introduction to *Image and Imagination* IAIN MORLEY	xvii

Section A Representing the Global Record

Chapter 1	The Earliest Imagery Around the Globe PAUL G. BAHN	3
Chapter 2	Monuments and Miniatures: Representing Humans in Neolithic Europe 5000–2000 BC CHRIS SCARRE	17
Chapter 3	Modes of Explanation for Prehistoric Imagery: Juggling Universalist, Historicist, and Contextualist Approaches in the Study of Early Figurines RICHARD G. LESURE	31

Section B Avenues of Interpretation

Chapter 4	Art, Language and the Evolution of Spirituality ROBERT LAYTON	49
Chapter 5	Upper Palaeolithic Anthropomorph Images of Northern Eurasia JIŘÍ SVOBODA	57
Chapter 6	New Questions of Old Hands: Outlines of Human Representation in the Palaeolithic IAIN MORLEY	69
Chapter 7	Images of Animality: Hybrid Bodies and Mimesis in Early Prehistoric Art DUŠAN BORIĆ	83
Chapter 8	Figurines, Meaning and Meaning-Making in Early Mesoamerica ROSEMARY A. JOYCE	101
Chapter 9	The Anti-rhetorical Power of Representational Absence: Incomplete Figurines from the Balkan Neolithic DOUGLASS W. BAILEY	111
Chapter 10	Monumentality and Presence COLIN RENFREW	121

Section C Figurines, Social Context and Process

Chapter 11	Refiguring the Corpus at Çatalhöyük LYNN MESKELL	137
Chapter 12	The Splendour of Women: Late Neolithic Images from Central Anatolia MARY M. VOIGT	151

Chapter 13	The *Chaîne Opératoire* Approach to Prehistoric Figurines: an Example from Dolnoslav, Bulgaria BISSERKA GAYDARSKA, JOHN CHAPMAN, ANA RADUNCHEVA & BISTRA KOLEVA	171
Chapter 14	The Emergence of Anthropomorphic Representation in the Japanese Archipelago: a Social Systemic Perspective KOJI MIZOGUCHI	185

Section D Representation, Regions and Power

Chapter 15	Abstract and Figurative Representation and the Politics of Display in Neolithic Southeast Italy ROBIN SKEATES	199
Chapter 16	Imagery and Social Relationships: Shifting Identity and Ambiguity in the Neolithic IAN KUIJT & MEREDITH S. CHESSON	211
Chapter 17	Bodies of Evidence: the Case Against the 'Harappan' Mother Goddess SHARRI R. CLARK	227
Chapter 18	The Emergence of Figuration in Prehistoric Peru RICHARD L. BURGER	241
Chapter 19	Early Figuration in Northwest Argentina: Materiality, Iconography, and the Uses of Imagery ELIZABETH DEMARRAIS	255
Chapter 20	Early Figurations in China: Ideological, Social and Ecological Implications LI LIU	271

Section E Refiguring Perceptions of Perception

Chapter 21	Before and Beyond Representation: Towards an Enactive Conception of the Palaeolithic Image LAMBROS MALAFOURIS	287
Chapter 22	A Note on Representations and Archaeology: Evolution and Interpretation EVANGELOS KYRIAKIDIS	301
Chapter 23	Neuroarchaeology and the Origins of Representation in the Grotte de Chauvet JOHN ONIANS	307

Section F Relating Representation and Religion

Chapter 24	The Worship and Destruction of Images ROBERT A. HINDE	323
Chapter 25	Images and the Biological Origins of Religion DONALD M. BROOM	333
Chapter 26	Incorporating Figuration and Spirituality F. LERON SHULTS	337

Topographical Index	341

Contributors

Paul G. Bahn
Independent Prehistorian, Hull.
428 Anlaby Road, Hull, HU3 6QP, UK.
Email: pgbahn@anlabyrd.karoo.co.uk

Douglass W. Bailey
School of History and Archaeology, Cardiff University, Humanities Building, Colum Drive, Cardiff, CF10 3EU, Wales.
Email: baileydw@cardiff.ac.uk

Dušan Borić
Department of Archaeology, University of Cambridge, Downing Street, Cambridge, CB2 3DZ, UK.
Email: db231@cam.ac.uk

Donald M. Broom
Department of Clinical Veterinary Medicine, University of Cambridge, Madingley Road, Cambridge, CB3 0ES, UK.
Email: dmb16@cam.ac.uk

Richard L. Burger
Department of Anthropology, Yale University, PO Box 208277, New Haven, CT 06520-8277, USA.
Email: richard.burger@yale.edu

Meredith S. Chesson
Department of Anthropology, 615 Flanner Hall, University of Notre Dame, Notre Dame, IN 46556, USA.
Email: mchesson@nd.edu

John Chapman
Department of Archaeology, University of Durham, South Road, Durham, DH1 3LE, UK.
Email: j.c.chapman@durham.ac.uk

Sharri R. Clark
Department of Anthropology, Harvard University, Peabody Museum, 11 Divinity Avenue, Cambridge, MA 02138, USA.
Email: srclark@fas.harvard.edu

Elizabeth DeMarrais
Department of Archaeology, University of Cambridge, Downing Street, Cambridge, CB2 3DZ, UK.
Email: ed226@cam.ac.uk

Bisserka Gaydarska
Department of Archaeology, University of Durham, South Road, Durham, DH1 3LE, UK.
Email: b_gaydarska@yahoo.co.uk

Robert A. Hinde
St John's College, University of Cambridge, St Johns Street, Cambridge, CB2 4RA, UK.
Email: rah15@cam.ac.uk

Rosemary A. Joyce
Anthropology Department, University of California, 232 Kroeber Hall, Berkeley, CA 94720-3710, USA.
Email: rajoyce@berkeley.edu

Bistra Koleva
Archaeological Museum, pl. Suedinenie, 1, Plovdiv, Bulgaria.
Email: b_ralinova@abv.bg

Ian Kuijt
Department of Anthropology, Notre Dame University, 611 Flanner Hall, Notre Dame, IN 46556-5611, USA.
Email: ikuijt@nd.edu

Evangelos Kyriakidis
School of European Culture and Languages, University of Kent at Canterbury, Cornwallis Building, Canterbury, CT2 7NF, UK.
Email: E.Kyriakidis@kent.ac.uk

Robert Layton
Department of Anthropology, University of Durham, 43 Old Elvet, Durham, DH1 3HN, UK.
Email: R.H.Layton@durham.ac.uk

Richard G. Lesure
Department of Anthropology, University of California, 341 Haines Hall, PO Box 951553, Los Angeles, CA 90095-1553, USA.
Email: lesure@anthro.ucla.edu

Li Liu
Faculty of Humanities and Social Sciences, La Trobe University, Victoria 3086, Australia.
Email: L.Liu@latrobe.edu.au

Lambros Malafouris
McDonald Institute for Archaeological Research, University of Cambridge, Downing Street, Cambridge, CB2 3DZ, UK.
Email: lm243@cam.ac.uk

Lynn Meskell
Department of Anthropology, Stanford University,
Main Quad, Building 50, 450 Serra Mall
Stanford, CA 94305-2034, USA.
Email: lmeskell@stanford.edu

Koji Mizoguchi
Kyushu University, Graduate School of Social and
Cultural Studies, 4-2-1, Ropponmatsu, Chuo-ku,
Fukuoka City, Fukuoka 810-8560, Japan.
Email: mizog@rc.kyushu-u.ac.jp

Iain Morley
McDonald Institute for Archaeological Research,
University of Cambridge, Downing Street,
Cambridge, CB2 3DZ, UK.
Email: irm28@cam.ac.uk

John Onians
School of World Art Studies and Museology,
University of East Anglia, Norwich, NR4 7TJ, UK.
Email: J.Onians@uea.ac.uk

Ana Raduncheva
Krasna Polyana, blok, 342, entr. A, fl. 5, app. 12,
Sofia 1330, Bulgaria.
Email: a_raduncheva@abv.bg

Colin Renfrew
McDonald Institute for Archaeological Research,
University of Cambridge, Downing Street,
Cambridge, CB2 3DZ, UK.
Email: acr10@cam.ac.uk

Chris Scarre
Department of Archaeology, University of Durham,
South Road, Durham, DH1 3LE, UK.
Email: chris.scarre@durham.ac.uk

F. LeRon Shults
Bethel Theological Seminary, Bethel University, 3900
Bethel Drive, St Paul, MN 55112-6999, USA.
Email: leron.shults@hia.no

Robin Skeates
Department of Archaeology, University of Durham,
South Road, Durham, DH1 3LE, UK.
Email: robin.skeates@durham.ac.uk

Jiří A. Svoboda
Institute of Archaeology, Academy of Sciences of
the Czech Republic, Královopolská 147 612 00 Brno,
Czech Republic, UK.
Email: svoboda@iabrno.cz

Mary M. Voigt
Department of Anthropology, College of William
and Mary, PO Box 8795, Williamsburg, VA 23187-
8795, USA.
Email: mmvoig@wm.edu

Figures

1.1.	*Petroglyph of stag, Wyoming, USA.*	4
1.2.	*Geometric paintings, Inca Cueva 4, Argentina.*	4
1.3.	*Handstencils, Los Toldos, Argentina.*	5
1.4.	*Paintings of guanacos unearthed during excavations, El Ceibo, Argentina.*	5
1.5.	*Sandstone spall from layer XII, Pedra Furada, Brazil, showing red stick figure.*	5
1.6.	*Petroglyphs in Early Man Shelter, Queensland, Australia.*	10
1.7.	*Shell necklace from Mandu Mandu Creek, western Australia.*	11
2.1.	*Locations of groups of fired clay figurines and statue-menhirs discussed in the paper.*	18
2.2.	*Anthropomorphic vessels in central and eastern Europe.*	19
2.3.	*Paris basin figurines from Fort-Harrouard (Eure) and Maizy (Aisne).*	20
2.4.	*Fired clay figurine from Noyen-sur-Seine (Seine-et-Marne) with plan of the site.*	21
2.5.	*Statue-menhir of Saint-Sernin-sur-Rance (Aveyron).*	22
2.6.	*Decorated stele (stele 25) from monument M XI at Petit-Chasseur (Sion, Switzerland).*	23
2.7.	*The Folkton drums.*	25
3.1.	*Cases of independent emergence of agriculture and/or pottery to be considered in the evaluation of Morss's model.*	35
3.2.	*The halo of anthropomorphic figurine-making around the Fertile Crescent (in gray) with sketches of figurines.*	36
3.3.	*Anthropomorphic figurine-making in the Middle American macro-region before 500 BC.*	37
3.4.	*Figurines from Paso de la Amada on the coast of Chiapas, Mexico, 1500–1400 BC.*	38
3.5.	*Stylized attention to the head and face on figurines from Amomoloc, central Tlaxcala, Mexico, 800–600 BC.*	40
3.6.	*Depiction of elaborate hairdos on Valdivia figurines from Real Alto, coastal Ecuador, 3000–2600 BC.*	41
4.1.	*The figure plots the distribution of particular animal motifs in several rock-art traditions.*	51
5.1.	*Map of Early Gravettian (Pavlovian) sites in northern Eurasia.*	57
5.2.	*Map of Upper Gravettian (Willendorf-Kostenkian) and Siberian Upper Palaeolithic sites.*	58
5.3.	*Map of Epigravettian (Mezinian) and later Siberian Upper Palaeolithic sites.*	58
5.4.	*Female carving in ivory. Czech Republic, Pavlovian.*	60
5.5.	*Female carving in hematite. Petřkovice, Czech Republic, Willendorf-Kostenkian.*	60
5.6.	*Female plastics in burnt clay. Pavlov, Czech Republic, Pavlovian.*	61
5.7.	*Globular human head of burnt clay. Pavlov, Czech Republic, Pavlovian.*	62
5.8.	*Double readings: the structure of anthropomorph symbols at Dolní Věstonice.*	63
5.9.	*Female figurine in ivory. Moravany, Slovakia.*	64
5.10.	*Female figurine in ivory, Gagarino, Russia.*	64
5.11.	*Female figurine in ivory, Gagarino, Russia.*	64
5.12.	*Female figurine in ivory, Kostenki, Russia.*	64
5.13.	*Female figurine in marlstone, Kostenki, Russia. Kostenkian.*	65
5.14.	*Female figurine in marlstone, Kostenki, Russia. Kostenkian.*	65
5.15.	*Female figurine in ivory, Malta, Russia. Siberian Upper Paleolithic.*	65
5.16.	*Female figurine in ivory, Malta, Russia. Siberian Upper Paleolithic.*	65
5.17.	*Symbols in action: experiments and play with female figurines.*	66
6.1.	*Hand prints, Chauvet cave.*	72
6.2.	*Palm prints, Chauvet cave.*	73
6.3.	*Hand stencil, Chauvet cave.*	74
6.4.	*Known locations of hand stencils.*	74
6.5.	*Hand stencils with shortened fingers, Cosquer.*	75
6.6.	*Hand stencils with shortened fingers, Gargas.*	76
7.1.	*(a) Apollo and Centaur, The Temple of Zeus at Olympia, c. 460 BC.*	84
7.1.	*(b) Dionysius on panther's back, Pellas, Macedonia, coloured pebbles, c. 300 BC.*	84
7.2.	*The Shaft scene, Lascaux, Upper Palaeolithic.*	88
7.3.	*Theriokephalic being engraved on a pebble, La Madeleine, Dordogne, Upper Palaeolithic.*	89
7.4.	*Human–animal hybrid male body engraved on a bone, Mas-d'Azil (Ariége), 11,000–9000 BC.*	92
7.5.	*Theriokephalic being (shaman?), Les Trois Frères, Upper Palaeolithic.*	92
7.6.	*Hybrid human–fish boulder artworks*	93
7.7.	*Incised human-like form on a stone boulder, Dwelling 2a, Vlasac, c. 7300–6500 BC.*	93

Figures

7.8.	Sculpted boulder showing a human–fish hybrid being, House XLIV/57, Lepenski Vir, c. 6200–5900 BC.	94
7.9.	(a) Child Burial 61 in House 40.	94
7.9.	(b) sculpted boulder depicting human–fish hybrid face, Lepenski Vir, c. 6200–5900 BC.	94
7.10.	Sculpted boulder depicting human–fish hybrid (beluga?), House XLIV/57, Lepenski Vir, c. 6200–5900 BC.	95
7.11.	Vultures with human legs depicted on the wall of Mellaart's 'Shrine VII.8', Çatalhöyük.	95
7.12.	Detail of painted leopard relief at Çatalhöyük.	96
7.13.	Stamp seal representing a hybrid deity.	97
7.14.	Relief of two splayed figures at Çatalhöyük.	97
8.1.	Playa de los Muertos figurine.	104
8.2.	Back of the head of Playa de los Muertos figurine.	104
8.3.	Back of the head of Playa de los Muertos figurine.	105
8.4.	Playa de los Muertos figurine.	105
9.1.	Figurines from Grave no. 626 of the Hamangia cemetery at Durankulak.	112
9.2.	Faceless figurines from Cucuten/Tripolye site of Dumeşti.	113
9.3.	Doll used in police interviews of child victims of sexual abuse.	115
10.1.	The Lady of Alexandrovac, the Vinca culture, Kosovo, c. 4500 BC.	122
10.2.	Large Amorgos figure, c. 2500 BC.	123
10.3.	Louvre head from Keros, c. 2500 BC.	124
10.4.	Athens head from Amorgos, c. 2500 BC.	124
10.5.	Plastered human skull from Jericho. c. 8000 BC, life size.	125
10.6.	Sculpture from Ain Ghazal, c. 8000 BC.	125
10.7.	The Warka head.	126
10.8.	Statue (now headless) of King Gudea of Lagash, c. 2300 BC.	126
10.9.	Life-sized bronze portrait head, possibly of Sargon of Agade, c. 2400 BC.	127
10.10.	Statue of Djoser.	127
10.11.	Statue of Kephren.	127
10.12.	Seated scribe, Egypt, c. 2600 BC.	127
10.13.	Drawing of the Ashmolean colossus from Coptos, c. 3100 BC.	128
10.14.	Stone figure (headless) from the temple at Hagar Qim.	128
10.15.	Lower part of monumental figure from the temple at Tarxien.	128
10.16.	Soldier of the First Qin Emperor.	128
10.17.	Bronze figure from Sanxingdui, Sezchuan, China, c. 1200 BC.	129
10.18.	Ahu Akivi, Easter Island.	130
10.19.	Figure at the quarry of Ranu Raraku, Easter Island.	130
10.20.	Olmec head from San Lorenzo Tenochtitlan, Veracruz, Mexico.	131
10.21.	Chacmool figure, Chichen Itza.	131
10.22.	The 'Atlantides' of Tula.	131
11.1.	Phallus from Çatalhöyük excavations 1996.	138
11.2.	Female marble figurine from a mixed fill deposit, Çatalhöyük.	139
11.3.	Zoomorphic clay figurines from Mellaart's Level VI, Çatalhöyük.	139
11.4.	Phallic pillar-like figurines from Çatalhöyük.	140
11.5.	Reconstruction of a figurine decorated with feathers, grasses and beads.	143
11.6.	Stone figurine from midden at Çatalhöyük with grooved 'waist', from 2005.	144
11.7.	Clay head with dowel hole, found in fill during the 1996 excavation.	144
11.8.	Figurines from Çatalhöyük showing holes.	145
11.9.	Drawing showing possible uses of organic material in body and figurine decoration at Çatalhöyük.	146
11.10.	Clay figurine showing skeletal features.	147
12.1.	Images associated with Hacılar Level VI House P.1.	155
12.2.	Hacılar Level VI House P.2.	156
12.3.	Hacılar Level VI House P.3.	157
12.4.	Hacılar Level VI House Q.2.	158
12.5.	Hacılar Level VI House Q.3.	159
12.6.	Hacılar Level VI House Q.4.	160
12.7.	Images from Hacılar VI House Q.3 & Hacılar VI House Q.5.	161

Figures

12.8.	*Statuettes from Hacılar VI House Q.5.*	162
12.9.	*Statuettes depicting standing women from Hacılar VI House Q.5.*	163
12.10.	*Statuettes from Hacılar Level VI House Q.5.*	164
12.11.	*Hacılar Level VI House Q.6.*	165
13.1.	*Plan and aerial view of the Late Eneolithic occupation layer of Dolnoslav.*	172
13.2.	*Pie chart showing distribution of simplified types of figurines, Dolnoslav tell.*	174
13.3.	*Right buttock and leg showing incised motifs with white incrustation and red crusting.*	175
13.4.	*Re-fitted upper torso and TOLE with secondary burning on left side.*	175
13.5.	*Hermaphrodite figurine with re-fitted leg and TOLE, with secondary burning on axis break of left leg.*	175
13.6.	*Right foot and lower leg with incised motifs and white & red crusting on axis break.*	175
13.7.	*Re-fitted figurine with wear on all breaks.*	177
13.8.	*Figurine re-fitted from four parts on site.*	178
13.9.	*Figurine re-fitted from two parts.*	179
13.10.	*Re-fitted left and right hollow feet and lower legs, fragmented at uneven heights.*	179
13.11.	*Pie chart showing the distribution of sidedness.*	181
13.12.	*Pie chart showing distribution of sidedness by context type.*	182
14.1.	*Graph depicting the closed self-referential reproduction of psychic systems and communication.*	186
14.2.	*Earliest figurines from the Kanto region.*	188
14.3.	*Middle Jomon 'standing' figurines.*	189
14.4.	*A typical example of the 'circular settlements': the site of Nishida, Iwate Prefecture (northeastern Japan).*	190
14.5.	*Early Late Jomon figurines.*	192
14.6.	*Middle Late Jomon figurines.*	193
14.7.	*Final Jomon figurines.*	194
15.1.	*Later Neolithic decorated pottery vessels.*	201
15.2.	*Ceramic stamps from the open site in front of Grotta Santa Croce & Cave Mastrodonato.*	201
15.3.	*Rock-cut tomb with stone idol at Arnesano.*	203
15.4.	*Ceramic figurines from Passo di Corvo, Canne & Grotta Pacelli.*	204
15.5.	*Painted motifs in the Grotta di Porto Badisco.*	205
15.6.	*Human burial in an enclosure ditch at Masseria Valente.*	205
16.1.	*Map of Pre-Pottery Neolithic sites of the southern Levant.*	212
16.2.	*Shifting material systems of Neolithic imagery.*	214
16.3.	*Pre-Pottery Neolithic A period figurines.*	215
16.4.	*Middle Pre-Pottery Neolithic B period anthropomorphic busts and statues.*	215
16.5.	*Middle and Late Pre-Pottery Neolithic B period anthropomorphic figurines and plastered skulls.*	216
16.6.	*Middle Pre-Pottery Neolithic B period zoomorphic figurines and facial representations.*	216
16.7.	*Comparison of anthropomorphic and zoomorphic imagery for the PPNA and MPPNB.*	217
16.8.	*Pottery Neolithic figurines.*	218
17.1.	*Two outdoor shrines in Gujarat, India, with aniconic representations and terracotta figurine offerings.*	228
17.2.	*Examples of the many types of female figurines from Harappa.*	229
17.3.	*Examples of the different types of male and other figurines from Harappa.*	230
17.4.	*A figurine from Harappa with body shape and attributes typical of Indus female figurines.*	231
17.5.	*Some globular figurines and figurines with children from Harappa.*	232
17.6.	*Some examples of figurines with panniers from Harappa.*	232
17.7.	*A male figurine from Harappa with panniers.*	233
17.8.	*One of the female figurines from Harappa with black residue in the panniers.*	233
17.9.	*One side of a moulded terracotta tablet from Harappa.*	234
17.10.	*A group of terracotta artefacts from Harappa.*	234
17.11.	*Some terracotta artefacts that suggest Indus belief in myth and magic.*	235
17.12.	*Some male figurines from Harappa with animal attributes.*	235
18.1.	*Cave painting from Toquepala, Peru.*	242
18.2.	*Unbaked clay figurines from Aspero, Supe Valley.*	243
18.3.	*El Paraiso unbaked clay figurine head.*	245
18.4.	*Clay sculpture of crossed hands from the Templo de los Manos Cruzados, Kotosh.*	246
18.5.	*Clay sculpture from Buena Vista, Chillon Valley.*	247

18.6.	*Incised clay frieze of a mythical fish from Cerro Sechin, Casma Valley.*	247
18.7.	*Cotton textile with the bird and serpent image from Huaca Prieta, Chicama Valley.*	248
18.8.	*Painted clay figure from Kuntur Wasi, Idolo Phase, Jequetepeque Valley.*	250
18.9.	*Drawing of giant clay frieze of a fanged mouth decorating the Middle Atrium at Cardal, Lurin Valley.*	251
18.10.	*Supernatural effigy of perishable materials recovered from the summit of Mina Perdida, Lurin Valley.*	252
18.11.	*The sculpted stone cult object from the Old Temple of Chavin de Huantar, Mosna Valley.*	252
19.1.	*Map of southern South America.*	256
19.2.	*Chronology chart for northwest Argentina.*	257
19.3.	*Petroglyph from the northern Calchaquí Valley.*	257
19.4.	*A stone mask from the Tafí culture.*	258
19.5.	*Menhir displayed in the Museo Arqueológico de Cachi.*	258
19.6.	*Zoomorphic pipe fragment, San Francisco culture..*	259
19.7.	*Condorhuasi vessel depicting a crawling (part-feline?) figure.*	259
19.8.	*Zoomorphic stone mortar.*	259
19.9.	*'Supplicant' sculpture in stone from the Alamito culture.*	259
19.10.	*(a) Figure with Two Sceptres (red and black on cream) on an Aguada vessel.*	260
19.10.	*(b) The Sacrificer, image from an incised vessel (Hualfín Grey Incised).*	260
19.11.	*Severed head vessel.*	261
19.12.	*Aguada bronze plaque showing a central personage flanked by two animals.*	261
19.13.	*Aguada bronze plaque showing three figures wearing elaborate tunics.*	262
19.14.	*Aguada figurines.*	263
19.15.	*Infant funerary urn from the Calchaquí Valley.*	264
19.16.	*Bronze plaque from Santa María Valley.*	264
19.17.	*The 'El Diablo' petroglyph.*	265
19.18.	*Cave-painting 'Dance of the Suris'.*	266
20.1.	*Location of archaeological cultures and major sites discussed in the text.*	272
20.2.	*Figurations from the Liao River region.*	273
20.3.	*Figurations from the Lower Yangtze River region.*	275
20.4.	*Figurations from the middle and upper Yellow River valley.*	278
20.5.	*Distribution of phalluses and female figurines in Neolithic China.*	279
21.1.	*Rhinoceroses, the panel of the horses, Chauvet Cave.*	287
21.2.	*Ceci n'est pas: the illusion of 'seeing'.*	288
21.3.	*Major perceptual features of Palaeolithic imagery. The panel of the horses, Chauvet Cave, France.*	294
21.4.	*Canonical perspective.*	295
21.5.	*The principle of proximity.*	296
21.6.	*Major perceptual Gestalts. The panel of the horses, Chauvet Cave, France.*	297
22.1.	*The 'Anatomically Correct Oscar'.*	304
23.1.	*Man and dolphin.*	308
23.2.	*Rhinoceros, Grotte de Chauvet.*	311
23.3.	*Lion, Grotte de Chauvet.*	311
23.4.	*Bear, Grotte de Chauvet.*	311
23.5.	*Reconstruction of bear activity, Grotte de Chauvet.*	312
23.6.	*Reconstruction of superimposed human and bear activity, Grotte de Chauvet.*	312
23.7.	*Human marking superimposed on bear claw marks, Galerie du Combel, Grotte de Peche-Merle.*	313
23.8.	*Hand stencilled with blown paint, Grotte de Chauvet.*	313
23.9.	*Chamber of the bear hollows, Grotte de Chauvet.*	314
23.10.	*Rock arch near Grotte de Chauvet.*	314
23.11.	*Animals painted around rock niche in End Chamber, Grotte de Chauvet.*	315
23.12.	*Mammoth climbing beside rock niche, Grotte de Chauvet.*	315
23.13.	*Reindeer moving in opposite directions, Grotte de Chauvet.*	316
23.14.	*Repeated lions and rhinoceros, Grotte de Chauvet.*	317

Tables

13.1a. *Fragments with secondary burning on axis break.* 177
13.1b. *Fragment with secondary burning on arm or neck break.* 177
13.2. *Descriptions of illustrated figurines by gender type and number of breaks.* 180

Acknowledgements

The symposium 'Image and Imagination: Material Beginnings' was held under the aegis of the 'Roots of Spirituality' project, funded by the John Templeton Foundation. The John Templeton Foundation also contributed the greatest part of the costs of the production of this volume. The conference received additional support from the British Academy, and the publication was partly subsidized by the McDonald Institute for Archaeological Research. The editors are very grateful to all of these sources for their support of this endeavour.

Early stages of the conceptualization of the symposium were greatly assisted by Chris Scarre, Richard Lesure, Lynn Meskell and Koji Mizoguchi who together constituted an organizing committee and made essential suggestions as to potential subject matter and contributors. Dr Paul Wason of the John Templeton Foundation made important contributions to the symposium itself, both practically as our principal contact, with many valuable suggestions, and intellectually, as one of the concluding discussants. The conference's smooth running was also greatly facilitated by the voluntary assistance of Sam Benghiat, Pamela De Condappa, Sarah Ralph and Isabelle Vella Gregory, to whom we are grateful.

Finally, and very importantly, our sincere thanks to both Dora Kemp and Nick Jakins for their excellent work on the production of this volume.

Prologue

Colin Renfrew

Becoming human

Archaeology today has developed great descriptive powers. We can observe the traces of significant episodes in human development and link these into a narrative which, while subjective in our choice of what to emphasize, can nonetheless be documented with hard evidence. What is much more difficult is to understand or explain the developments observed. Why did they take place when they did? What factors facilitated or discouraged sedentism in different parts of the world, or the development of new social formations, technical innovations, or religious institutions, to name but a few? Climatic change and population increase have frequently been invoked as relevant factors. But in themselves they are hardly a sufficient explanation for the emergence of new kinds of behaviour.

One approach to these questions is to exploit the variety of the archaeological record. Our knowledge of patterns of human dispersal now makes it possible to see the succeeding cultural developments in different areas as in some respects independent, at any rate until the development of effective technologies of travel. This implies that we can discern different trajectories of development in a number of different regions of the world. It may be that the similarities and differences among these trajectories can be informative, since the human story after the initial 'out of Africa' dispersals is not one story but several. It becomes one story again only after the completed exploration of the world in the eighteenth century AD, and then again with the reduction of travel time through air transport, and of information-flow time through radio and the internet. The paths of these different trajectories of behaviour must contain information relevant to our understanding of the capacity of human society to change and develop in ways not matched by any other species.

The underlying reality seems to be that, in genetic terms, each of us is born into the world in much the same condition as our ancestors and as that of other humans of 30,000 years ago. In that sense the hardware is the same. What has changed is the cultural context into which we are born, which might in aggregate be described as the software, of which the specific languages we speak constitute an important component. Each of us, as we reach adulthood, has had to learn in 15 or so years, what it has taken the society into which we are born millennia to develop. The ontogeny (of the individual) clearly represents one generation or part of it. The phylogeny (of the culture or society) took place over some 2000 generations since those early dispersals. We still do not understand very much about the nature of those processes.

The beginnings of figuration: a comparative approach

The underlying motivation for the present volume is to develop an approach which might allow us to address some of these issues. It is based upon the observation that figuration, that is to say the representation of the world by means of images (whether in two or three dimensions), does not seem to be a human universal. That this is so is made clear, for instance, by the patchy representation of figuration across the world prior to 10,000 BP and the onset of the Holocene. The suggestion that the 'Human Revolution' in the sense of the emergence of modern *Homo sapiens* from the antecedent hominins (including the appearance of 'modern' behavioural traits seen, for instance in the Upper Palaeolithic of Europe), involved a general propensity to produce cave art, is simply an error, although one that is frequently committed. As I believe this Symposium reminded us, cave painting and rock art have a relatively limited distribution during the Pleistocene. The same would certainly seem to be true for three-dimensional representations of the human figure or of animals, which are rare in the Pleistocene outside the distribution in Europe and limited parts of Asia, specifically of the Aurignacian and Gravettian cultures. Why should this be?

What we see instead is the emergence of figuration in different parts of the world, each region (as noted above) having its own trajectory of development. Various generalizations may perhaps be attempted. It would seem, for instance, that the production of baked clay figurines is often associated with the appearance of sedentism, or at least of settled life of a kind. That is true for many early agricultural communities, for instance in western Asia or Mesoamerica. It may also be true for sedentary but non-food-producing communities, like the Jomon of Japan, or for near-sedentary

communities seen in the hunter-gatherer communities of the Gravettian or Magdalenian. We may note also that the inception of figuration of a monumental nature sometimes takes place in association with the development of hierarchical societies and of the iconography of power. Imagery also has a powerful role in facilitating the development of religious thought, through a process of material engagement. Here the products of the human imagination, given material form, can initiate or enhance the experience of awe and of the numinous which are often an important component of religious experience.

Figuration, cognitive archaeology and spirituality

The subject of early figuration, especially of the human figure, on a worldwide basis, has been chosen for discussion precisely because it opens the way for a discussion of these larger issues. Similar arguments could be advanced for the merits of a cross-cultural analysis of the development of writing systems, which have indeed proved greatly influential through the process of what Merlin Donald has termed external symbolic storage. But writing develops comparatively late in the human story, whereas figuration is widely seen very much earlier — several millennia before the development of writing in most developmental trajectories. Evidence for symbolic behaviour may go back rather earlier than figuration, but it often remains difficult to analyse. Figuration at least guarantees the opportunity to consider cognitive aspects, since any figuration is, by definition, symbolic. It involves a representation and thus, usually, the prior existence of the thing represented. But that over-simplification should not obscure the power, in the hands of the creator of images, of calling new things into existence.

Figuration has traditionally been one of the principal component fields of cognitive archaeology. But the implications of figuration have not yet been sufficiently analysed. One area of interest is the emergence of spirituality, of the perception of values which lie beyond the scope of the single individual, and which are shared by the community. Within that area lies the whole field of religion, and of the representation of religious beliefs. Naturally figuration can involve the representation of a belief system, or of elements of that belief system — a materialization of belief. But it can be more than this. In some cases the very act of creating images opens the way to more explicit formulations of belief and of faith. In such cases the engagement with the material world which is implied in the creative process of figuration may also involve the development of new concepts, or new forms of concepts, which could with difficulty have taken place in the absence of such figuration.

Aspirations

In a certain sense members of our species have 'become human' not once but many times, since each developmental trajectory represents a different process of becoming. Of course, from the ontogenetic perspective, each of us becomes human once, at birth and in the learning process which follows, and that is a single, ongoing process, terminated by death. There are thus as many 'becomings' as there are individuals who come to maturity. It seems likely, as noted earlier, that from the phylogenetic standpoint, there may have been a single, shared process which in Africa led to the emergence of *Homo sapiens*. And we shall not deny the effective humanity of all members of our species, even back before the early dispersals out of Africa. But the story clearly does not stop at that point. And from then on there are several, perhaps many, trajectories of development.

The present volume and the symposium which gave rise to it, form part of the 'Roots of Spirituality' Project, generously funded at the McDonald Institute by the John Templeton Foundation. The aims of the Project were indeed to investigate the early origins of human spirituality, using the evidence from the prehistoric and early historical periods to gain deeper insights into the process of 'becoming human'. The intention, then, has been to use the material evidence from the archaeological record as a basis for the development of a cognitive archaeology, and so to give systematic consideration to the processes at work.

The creative field of figuration seems a good area in which to study and think about these processes, which at the same time were evidently taking place in other fields also, beyond figuration, with the development of new technologies and of new social formations. Figuration, however, gives us something concrete to study, which is open to examination and to debate, in a manner which might be described as scientific. But the implications of what we are studying here go very much further, impinging upon fields where objectivity is a goal difficult to formulate, let alone achieve.

In particular the study of figuration permits us to contemplate the diversity of human experience and achievement. That I see as one goal of the present volume.

Material Beginnings: an Introduction to *Image and Imagination*

Iain Morley

As discussed in the *Prologue* it is our aim that this volume presents a world view on early figuration, i.e. the representation in two or three dimensions of aspects of the visible world, considering the earliest and then subsequent occurrences in different regions. The intention is to consider the uses and functions of figuration across the full range of behaviours associated with imagery in different locales, economies and times. Imagery has the potential to be used to create, reflect and enforce power relations, and in many societies figuration is often associated with spirituality and the practice of religious ritual. Yet clearly the functions of figuration vary greatly, and many societies share a culture which is essentially non-figurative — there may be no universals at work. The volume also considers aspects of perception and cognition at the neurophysiological level, and explores ethnographic and iconographic approaches towards the interpretation of early imagery.

The development of figurative representation (anthropomorphic imagery, as well as zoomorphic and therianthropic — combined — imagery) may play important roles in the emergence and perpetuation of religious iconicity as well as of notions of ancestors, which is a different dimension of spirituality. Some may relate to the formation of new ideas of personal identity, constituting portraits of living individuals. This is a rich area for research, strongly rooted in the archaeological record, which leads directly to many questions in the archaeology of social structure, identity, interaction, cosmology, ritual and religion. It is hoped that this volume will present a starting point or catalyst for further considerations of figurative representation, in relation to a diversity of areas, themes and novel directions.

The chapters in this volume have their ultimate origins in papers delivered at a symposium at the McDonald Institute for Archaeological Research in Cambridge, 13–17 September 2005. The symposium, entitled 'Image and Imagination: Material Beginnings', was convened as part of the 'Roots of Spirituality' project, which is funded by the John Templeton Foundation. The papers were each read by every participant in advance, discussed communally at the symposium, and subsequently revised by the authors in light of the discussions.

The participants were invited on the basis of their being able to contribute information and expertise on the uses and effects of figuration in a wide range of contexts, periods and places from around the world. Areas covered include Europe, Mesoamerica, South America, Africa, India, China, the Near East and Australia, and periods encompassed range from the Middle Palaeolithic through to the present day, although the focus is primarily on prehistory.

The papers in this volume reflect a diverse set of approaches to interpreting a varied array of evidence related to figuration, and are organized into six main sections:
A. Representing the Global Record;
B. Avenues of Interpretation;
C. Figurines, Social Context and Process;
D. Representation, Regions and Power;
E. Refiguring Perceptions of Perception; and
F. Relating Representation and Religion.

It should be noted that there would have been many possible ways of arranging the contributions to this volume, and many of the papers contain considerations relevant to more than one of the above sections; the inclusion of a given paper in a particular section should not be taken to indicate an absence of content related to other sections of the book, it is only indicative of what we have identified as a prominent theme.

Overview

Section A: Representing the Global Record
This section contains papers that deal with the archaeological record at a larger scale, setting the scene for geographical and interpretive foci in the latter parts of the volume.

Paul Bahn opens the volume by providing a detailed and up-to-date survey of the earliest-known evidence for representation amongst Pleistocene hunter-gatherers, focusing in particular on the emerging record from outside Europe. He highlights

the fact that whilst many examples of representation have been difficult to confidently attribute to the Pleistocene there are nevertheless several examples from each continent (with the exclusion of Antarctica) which are securely dated to this period.

Chris Scarre carries out a valuable large-scale examination of the record for human representation from later European prehistory, associated with Neolithic farming communities. This includes both portable and monumental human representation as well as, in many areas, purely abstract representation with no anthropomorphic imagery at all. Scarre preludes many of the themes of this volume by exploring possible reasons for these differences, asking how these images represent humans, and what this means in terms of understanding the visualization, display and use of human bodies in European Neolithic communities. In particular he contrasts the differences between the form, perception and use of miniature and monumental figurative representation in Neolithic France.

Examining a selection of global case-studies of early figuration, Richard Lesure elaborates the potentials, and critiques the misapplication of historicist, universalist and contextualist explanations for the advent of figurative representations. Leading into the following section, he explores the possibilities for creating an effective interpretive strategy based on combined explanatory frameworks derived from the above approaches, each being used as a specialized tool for addressing particular issues.

Section B: Avenues of Interpretation
This section explores new ways of interpreting the record of figurative representation, the identification of levels of meaning, in relation to context, process and perception.

With reference to a number of ethnographic case studies, Robert Layton discusses shortcomings of shamamist explanations and modularity models for addressing the origins of Palaeolithic art. He links hunting and food-sharing strategies to the emergence of specialized forms of communication, proposing that different characteristic strategies differentiated the language requirements, social organization and contact amongst Neanderthals and modern humans. He goes on to explore the relationship between representation, narratives, communication and language, with regard to Neanderthal and modern human behaviours, and asks how we can try to identify spirituality in rock art.

Persistence and change in meaning forms a central theme of Jiří Svoboda's contribution, which examines the record of figurative representation left by the modern humans populating central and eastern Europe in the period associated with the Gravettian techno-complex. He explores the significance of the long-term use of representations made out of durable materials for the presence of temporal frameworks within the mental and social structures of the peoples present. This 'long-term art' is juxtaposed by the 'short-term art' which in some cases was evidently made and destroyed in a single act. Not only does this record include fragmented representations but also complete partial representations, with combinations of realism and abstraction (cf. Bailey, this volume). Svoboda goes on to discuss issues of anonymity and identity in the figures and contemporaneous burials, and figurative representations which, whilst seemingly stylized, form deliberate visual puns on aspects of the human body and gender.

The chapter by Morley highlights some issues of interpretation of Palaeolithic imagery, before going on to examine in detail anthropomorphic imagery in the form of hand prints and stencils. The paper advocates a critical assessment of our own interpretive biases (towards 'realism' and 'schematism') when dealing with animal and human imagery, and consideration of the extent to which our perceptual mechanisms shape the ways in which we are required to represent certain subject matter in order to communicate certain information. The main part of the paper considers the unique place of hand representations in the record of anthropomorphic imagery, in terms of their properties as (Peircean) indices, icons and symbols, and suggests some new considerations in the interpretation of their creation and meaning. Much of the meaning or value of the images may have been derived from (the experience of) the process of their creation, and numerous examples require reassessment in this light.

Dušan Borić argues that functionalist interpretations of meaning in imagery are not adequate as they neglect the 'Dionysian' aspects of meaning derived from human thought; recent shamanistic interpretations have greater explanatory power, in his opinion, but often homogenize explanations. Borić advocates an approach based in *animality*, which incorporates shamanism into a wider explanatory framework of daily life, mediating the human dichotomies between the animal corporeality, which is the basis of human existence, and the world of thought and reason. Such definitions of humanity are broad, and may include animals and spirits. He discusses the importance of the body as a focal point for agency, intentionality and differentiation between animal and human, and the significance of hybrid images for such concerns in early prehistoric representation.

Rosemary Joyce's contribution explores not *what* figurines mean, but *how* they come to mean things.

How is meaning *made* by figurative representation? She explores the strengths of a Peircean semiotic approach as opposed to a Saussurean one. The interrelation between indexical, iconic and symbolic properties of representational objects, and their effects on the interpretant (in the Peircean sense) have great explanatory power for exploring the way in which figurative meaning *works* — how it affects the individual and networks of individuals over space and time. Joyce examines this potential through Mesoamerican examples from Honduras, discussing the connections between figurations and other signs, and how their relations over time elucidate the processes of generation and interpretation of signs.

Many figurative representations are stylized and abstracted, and often represent or emphasize parts of the human body very selectively. Douglass Bailey addresses the meaning of *absence* of representation of body parts in figuration, with particular reference to Balkan Neolithic figurines. Drawing on examples from police investigative tools, modern pornography and Freudian psychoanalysis, he explores the role of abstraction, disembodiment and the subjective effects of incomplete stimuli in stimulating the formation of individual and group identity, through the subversion of expectation and meaning.

The majority of the contributions to this volume deal with relatively small, or even miniature, representations. Renfrew's paper, in contrast, examines the record for life-size and larger-than-life anthropomorphic representations from five areas of the world, before considering the contexts of use and interpretive impacts of such imagery. He discusses the evoking of vitality, aggrandizement and power and their representation of leaders and possible deities.

Section C: Figurines, Social Context and Process
Each of the papers in this section could have fitted easily into the preceding section, dealing as they do with levels of meaning, context and process, but they are united here by a focus on the *social* context and process of use.

Via an examination of recent finds and research at Çatalhöyük Lynn Meskell explores the function and meaning of figurines not as representations *per se* but as objects in their own right within a social sphere — not simply as *things* but as parts of *processes* — their construction, use, movement and disposal all having significance for an understanding of their role within a given lifeway.

Through a careful re-analysis of the Late Neolithic figures from Hacilar, Anatolia, and the data from the original site reports, Mary Voigt is able to identify new patterns in the distributions of types of figures, and proposes novel interpretations of their uses. She goes on to discuss how the identity of the users and the context of use of the figurines must be the first consideration, and how these can considerably illuminate the nature of the social and narrative use of the figurines.

Bisserka Gaydarska, John Chapman, Ana Raduntcheva and Bistra Koleva examine the evidence for deliberate breakage of figurines and their uses during and after such breakage, through a detailed study of the different contexts of deposition of fragmentary remains of figurines at the tell site of Dolnoslav in Bulgaria. They explore how the breaking of a figurative representation may be part of the process of its use and relate directly to its symbolic content, and the ways in which its symbolic life may continue long after its apparent destruction.

Within the context of the development of Jomon figurative objects, Koji Mizoguchi highlights the social aspect of the spiritual — the necessity for beliefs to be shared, or perceived as shared, with others. He discusses how figurative artefacts involved in such rationalization, through their use and transformation, can mediate the social formulation and sharing of the beliefs. Mizoguchi goes on to illustrate the ways in which the Jomon objects allow us to reconstruct social structures and the contingencies of concern to the populations.

Section D: Representation, Regions and Power
Figurative representation often occurs in association with the development of regional, social and individual identity, as well as to legitimate the human use of power. The papers in this section are united by a focus on developmental trajectories at a regional level, relating the changing forms and uses of figurative representation to changes in society.

Robin Skeates considers the potential effects and roles of 'figurative' and 'abstract' representation, especially in combination, through several case-studies from Neolithic southeast Italy. This record is dominated by abstract motifs interpretable across a variety of contexts, but also features rarer, explicit figurative representations, and imagery that falls on the continuum between abstract and figurative. He examines how the production and use of explicit figurative representation was controlled and restricted, and its roles in creating intra-group social cohesion and emphasizing social differentiation within groups.

Ian Kuijt and Meredith Chesson explore how we can understand the ways in which the use of figurines was related to changing social and economic behaviour in the Pre-Pottery Neolithic of the Near

East. They argue that previous studies have overemphasized the presence of female figurines, neglecting the co-existence of male, female and zoomorphic figures, thus failing to explore the significance of the relationships represented. They go on to identify longitudinal trends in the focus of representation, the nature of representation of sex and gender, and mortuary practice, and relate these to changing systems of social organization, personhood and identity.

Moving further east, Sharri Clark undertakes a re-interpretation of the terracotta figures from the Indus Valley centre of Harappa. Her own analyses of the corpus belie the traditional but still pervasive interpretations of the figurines from the Indus Valley as representing evidence of a matriarchal 'Mother Goddess' social and spiritual system, the prevalence of which has discouraged the development of more challenging and holistic interpretations of the full corpus of evidence from the sites. Clark reconsiders the attribution of gender and deity properties to the corpus of figurines, and examines the spatial distribution of one type in particular to test the viability of cultic interpretations of them; she proposes alternative, broader interpretative approaches which will ultimately yield more meaningful understandings of Indus society and beliefs than many that have been offered to date.

Richard Burger reviews the evidence for the emergence and roles of early figuration in the central Andes of Peru. Figurative representation appears to be linked to religious practice and belief from the earliest times. The very selective use of figurative representation in early phases leads Burger to consider the significance of the absence of representation before moving on to explore the emergence of figurines and monumental architecture. He explores the relationship between changing economic and social organization and the changes in the prevalence, forms and roles of representation, including its role in civic events, its relation to the power of ritual practitioners, and its portrayal of creatures and events outside of the quotidian world.

Continuing the focus on South America, Elizabeth DeMarrais presents what is probably the first synthesis in English of the figurative archaeological record of Argentina, considering the uses of figures throughout the Archaic, Early, Middle and Late periods. The relative presence of figurative representation varies over this time, as do the numbers of fantastical beings and situations represented. DeMarrais discusses how these trends might reflect the uses of the objects, and their possible meanings — both of the images themselves and of the larger social trends that they may reflect.

In a detailed synthesis, Li Liu considers the earliest evidence for figuration in the Liao River Region, the Lower Yangzi River Region and the Middle and Upper Yellow River region of China. Whilst the traditions in these regions developed independently, Liu suggests they initially grew out of similar social and environmental circumstances, and appear to have ultimately come to share several key representational themes. Liu takes a socio-ecological approach to exploring the reasons for these changes, in terms of the emergence and development of cosmologies, elite practices and social contacts and their associated symbolic systems.

Section E: Refiguring Perceptions of Perception
The contributions to this section, whilst very different in approach and argument, share a focus on ways in which perceptual and cognitive processes influence the experience of the production and perception of imagery.

Lambros Malafouris asks How is it that we perceive an image as an image, and how can it have meaning? Using the perspective of Material Engagement Theory, Malafouris argues that imagery is part of the relationship between cognition, perception and action; it should be understood as an active part of the world represented, and an active part of the creator's and perceiver's cognition. He discusses how, within such a system, imagery constitutes part of a two-way process of symbolizing and cognizing — as a process of acting within the world rather than simply representing it — facilitating the exploration of the significance lying within the symbolic plane beyond the basic representation and bringing forth new ways of thinking about and interacting with the world.

Evangelos Kyriakidis critically examines features of representational behaviour in relation to the capabilities of other animals, and goes on to explore the extent to which symbolizing requires conscious thought and propositional content. He argues that the creation and perception of representation need not necessarily rely on high-level thinking, with much of the interpretation being of indexical or iconic properties — capabilities that are shared with many other creatures. Consequently he argues that early representational behaviours may have constituted increased or different use of an existing capacity, rather than a new capacity. In light of this he goes on to discuss how the study of imagery can alert us to many different possible perspectives of authors and perceivers, and thus shed light on past human experience.

Writing from an art-historical standpoint, Onians discusses potential ways in which human

and primate neurological and ecological factors could have played formative roles in the emergence of representation. He argues that, assuming that modern humans had more sophisticated mirror neuron systems than their predecessors, these may have conferred a selective advantage in many spheres of existence, and also allowed the emergence of representation behaviours without conscious volition, via imitation instigated by their stimulation. He goes on to propose a novel explanation for why Chauvet might not only represent the earliest currently *known* Palaeolithic representation, but the earliest *per se*. Finally, he discusses the implications of these ideas for the emergence of language, and its relationship with representation.

Section F: Relating Representation and Religion
Whilst many of the papers in the preceding sections have related figurative representation to ritual and religious practice the papers in this section explicitly explore relationships between representation and religion, in terms of potential roles of representation for the conceptualization of the spiritual, and of ways in which theoretical approaches applicable to religious and archaeological studies might complement each other.

Robert Hinde opens his paper with an exploration of the nature of religious belief systems, spirituality, and reasons why peoples believe in gods — and the implications of these for possible interpretations of figurative representation. Importantly, he discusses the ways in which material representations can permit the development of more explicit and precise concepts about the spiritual, and be seen to be directly connected with supernatural entities. This is followed by a discussion of the nature of, and reasons for, iconoclasm in some contemporary and historical religious contexts, with a view to such examples illuminating further possible interpretations of the archaeological record. The discussion of the Reformation and the tensions between religious practices advocating and disavowing the religious power of images raises many points regarding the potential roles of figures in belief systems, the relationships between representation and conceptions of the supernatural, and of possible meanings of their destruction.

For Donald Broom one of the fundamental components of religious systems is a moral code, advocating helping others and not harming them. Such belief systems can be argued to have their basis in the selective advantages associated with cooperative and altruistic behaviours in many species. Broom discusses roles that figurative representation might have in the creation and perpetuation of moral codes, thus highlighting possible links between figuration and religious behaviours. He outlines some implications of these roles for the interpretation of figuration in the archaeological record.

Closing the volume, LeRon Shults has taken the important role of incorporating with each other aspects of figurative representation and spirituality, and exploring the ways in which archaeologists', anthropologists' and theologians' interests in the relationships between figurative representation, ritual and religion might progress each other. He highlights the advantages of a dialectic between our interest in the contextually specific and more general concepts, and discusses how the recent pursuit and emphasis on relationality rather than dichotomies of substance, is well-suited to the investigation of relationships between artefacts, culture and spirituality. He goes on to discuss how 'spirituality' can be conceived of as a way of mediating relations between the finite and infinite, and that figurative representation — when it is related to the religious aspects of a culture — can take an integral role in this process, in that it is an attempt to configure the transcendent, and 'to "figure out" that which cannot be controlled'.

Manifesting the transcendent

The volume showcases a wide diversity of approaches to interpreting the record of figurative representation, at many different levels, from the local and site specific, to regional and larger, and from the temporal scale of isolated events to long-term trajectories. Some contributions deal with figurative representation in the wider sense, of 'representation in two or three dimensions of aspects of the visible world', others specifically with figurines.

Nevertheless, there are key common threads that emerge between the papers. Rather than replicating here the conclusions of the individual chapters, without the carefully-written arguments of the papers themselves, the following editorial draws out some of those common threads, in the hope that the volume as a whole can ultimately provide a lead-point for future research in this area.

How images mean things

A critical issue in considering how representation comes to emerge, increase in importance, and to have particular roles in society, must be of *how* images mean things to people. This is a central theme of several of the papers — *how* do figurines mean things, and *how* do images represent humans (Scarre, Joyce, Malafouris)? An emergent theme of several of the papers

is the usefulness of considering how imagery means things in semiotic terms (Joyce, Morley, Kyriakidis), as *icons* as *indices* as well as the more commonly debated symbols.

Perceptual and cognitive influences on the power, form and effects of images

Several of the papers highlight the value of understanding our perceptual and cognitive tendencies as creators and perceivers of images (Borić, Morley, Bailey, Hinde, Malafouris, Kyriakidis, Onians). One such area concerns the significance of *absence* in representation — absence of parts of representations (Bailey, Svoboda) and absence of representation itself (Burger, Skeates). Deliberate decisions are often made on the part of the creators of images to *not* represent certain features, or to make them abstract or ambiguous. The decisions made as to what to absent, abstract and ambiguate, and the particular combinations of realism and abstraction, anonymity and identity, can have important implications for the power and potential use of the imagery (Scarre, Svoboda, Bailey, Renfrew, Skeates, Morley).

Image production and life-cycle as process

The meanings of figurative representation are derived from far more than merely the form of the representation itself. The manufacture, use, modification and discard of representations in different temporal, social and geographical contexts all confer meaning. We need to analyse the life-history of individual representations and the life-history of image systems in order to address questions of the relationships between figurative representation and changing social organizations, economic practices and public and private ritual (Kuijt & Chesson, also Clark). Such processes can begin when creation of the representation begins, and continue through its destruction to its deposition (and possibly exhumation and redeposition) (Meskell, Gaydarska *et al.*, Voigt).

The short-term creation and destruction of some images versus the long-term curation of others has important implications for the ways in which they were experienced and the social and thought processes underlying that experience (Svoboda). Part of this process that we should seek to understand is the *experience* of the creation of the image, and the by-products of this process (Morley, Meskell). The interaction of individuals with objects is an important part of the objects' *process* (Svoboda, Meskell, Voigt) — objects have meaning not simply as representational ends in themselves but as part of *processes* of social interaction and individual cognitive and experiential interaction with the objects (Meskell, Gaydarska *et al.*, Morley, Voigt, Kuijt & Chesson, Malafouris).

Imagery, narrative and exploration of relations between individuals, and between the quotidian and supernatural realms

The above observations may also hold true for other, non-representational, objects, but one characteristic by which figurative representations can be particularly well-suited to such roles in process and interaction is via their relationship with narrative. There is a fundamental relationship between representation and narrative (Layton, Voigt) — and between narrative and concepts relating to the supernatural and spiritual. As structures for supporting and elaborating narrative, figurative representations facilitate the *exploration* of self-identity and relations with others (Bailey, Meskell, Malafouris, Voigt), including cultural and individual understanding of (cultural and individual) identity (Svoboda, Scarre, Borić, Bailey, Kuijt & Chesson).

Importantly, one such explorative area facilitated is of relations between the quotidian material and supernatural worlds (Borić, Meskell, Malafouris, Hinde, Shults), as part of explanatory frameworks for understanding the world (Mizoguchi, Voigt). These include complex frameworks of time-awareness and considerations of life and death (Svoboda). They can mediate the boundary between the ritual communication system and its environment. These roles in the facilitation of the creation of shared beliefs (Mizoguchi), and formulation of community and self identity are also, in fact, key roles of what we recognize today as religious systems.

As well as having roles supporting the systems that in turn support ritual and religious beliefs (namely, religious systems and systems of power), through reinforcing power and forming foci for visualization of supernatural entities and concepts, figurative representations can actually take an active role in facilitating many of the human cognitive and social processes involved in the realization of the roles fulfilled by religion, for both individuals and societies (Hinde). They can aid in conceptualization of the otherwordly and negotiation of relations between earthly events and the forces we invoke to explain them, and capitalize on innate tendencies to anthropomorphize; they can thus form a focus or even conduit for human interaction with the supernatural.

Section A

Representing the Global Record

Chapter 1

The Earliest Imagery Around the Globe

Paul G. Bahn

The author presents a brief overview of the evidence for and against the existence of 'art' that is attributed, rightly or wrongly, to the Late Pleistocene, primarily outside the continent of Europe. Various sites in Asia, Africa, Australia and the New World are examined, bearing in mind the uncertainties that surround some dates that have been put forward.

For a long time after the discovery of Palaeolithic art in Europe — that is, the discovery of portable art after 1860 and that of parietal art between 1879 and 1902 — it was believed that, with the exception of a few sites in Siberia, Ice Age art did not exist elsewhere in the world, and thus represented an exclusively European phenomenon — indeed, until the discovery of the Spanish cave of Altamira, a number of (mostly French) scholars had claimed that art had been invented in France! But gradually, and especially over the past few decades, it has become clear that towards the end of the Pleistocene artistic activity was underway on all inhabited continents — mostly in the form of portable art, or parietal art in shallow rock-shelters, or even in the open air. In the years since my last surveys of this topic (Bahn 1991; 2002; Bahn & Vertut 1997), a range of new and varied evidence has come to light in many parts of the world. The technical, naturalistic and aesthetic qualities of European Palaeolithic images remain almost unique for the moment, but it is nevertheless true that, at this period (and sometimes earlier), in other parts of the world, one can see traces of the same phenomenon.

Europe

There are indications in Europe of a very early aesthetic sense, for example, the careful preservation of fossils within handaxes and other stone tools (Bahn 1998; Lorblanchet 1999; Odin *et al.* 2006); the apparently arranged incisions on bones from the Lower Palaeolithic of Bilzingsleben, and some sporadic examples of Mousterian art from Neanderthal times such as the 'mask' of La Roche-Cotard, and the jewellery from Arcy-sur-Cure and elsewhere (Bahn & Vertut 1997; Lorblanchet 1999; Marquet & Lorblanchet 2003; d'Errico *et al.* 1998). Where the art of the last Ice Age is concerned, among the earliest securely dated specimens are figurative ivory carvings from southwest Germany (Vogelherd, Geissenklösterle, Hohlenstein-Stadel, Hohle Fels), as well as a stone carving of a woman from Krems-Galgenberg, Austria, all of which date to rather more than 30,000 years ago. There is evidence for sporadic examples of parietal art from the Aurignacian period onward — for example in the Dordogne — but the much-touted early figures dated to the Aurignacian at Chauvet Cave, France (e.g. Clottes 2003), are still the subject of much controversy owing to their extreme sophistication, and the problem of their age remains unresolved at present (Pettitt & Bahn 2003). Subsequently, tens of thousands of images were produced, both as portable objects and on open-air rocks as well as on the walls of shelters and caves. Particularly rich and abundant in the final phases of the Upper Palaeolithic (Solutrean, Magdalenian), Ice Age art in Europe is one of the best — and longest — studied of all art corpora (Bahn & Vertut 1997).

The New World

The first clue to Pleistocene art outside Europe was found as long ago as 1870, only a few years after Edouard Lartet's and Henry Christy's discoveries in southern France were authenticated. Unfortunately, the object in question was badly published, and disappeared from 1895 until its rediscovery in 1956, and consequently very few works on Pleistocene art mention it. This mineralized sacrum of an extinct fossil camelid was found at Tequixquiac in the northern part

Figure 1.1. *Petroglyph of stag, Wyoming, USA.*

Figure 1.2. *Geometric paintings, Inca Cueva 4, Argentina.*

of the central basin of Mexico. The bone has perhaps been carved, and is definitely engraved — two nostrils have been cut into the end — to represent the head of a pig-like or dog-like animal. The circumstances of its discovery are unclear, but it is thought to be from a Late Pleistocene bone bed, and to be at least 11,000 or 12,000 years old (Aveleyra 1965; Messmacher 1981, 94; Schobinger 1997, 30).

Other examples of portable art in the New World are equally vague as to date or authenticity. For example, a bone with an apparent engraving of an animal (a rhinoceros to some eyes) from Jacob's Cave, Missouri, is thought by some to be of Pleistocene date (Messmacher 1981, 84; Schobinger 1997, 32). It has been claimed that an implement made of mammoth ivory, which was found in Florida's Aucilla River, and which bears an incised zigzag design, may be the oldest decorated object yet known from the western hemisphere, more than 10,000 years old (Purdy 1996b, 10; Purdy 1996a, 4–5). More recently, a buffalo kill-site in northwest Oklahoma has produced a bison skull, dated to 10,900–10,200 BC, with a red zigzag design painted on it (DK 1999).

As for parietal art, this is far more difficult to date. The New World has an abundance of decorated rocks, caves and shelters in many areas, and early dates for rock art have now been obtained in a number of different countries. In North America, accelerator mass spectrometry and cation-ratio ages have been obtained from organic material trapped in the rock varnish covering petroglyphs, some of which are in the Late Pleistocene (Whitley & Dorn 1987; 1993; Dorn 1998, 79). For example, the varnish on a geometric pattern in Arizona gave results around 18,000 years ago, while that on a bighorn sheep petroglyph from California's Coso Range was dated to more than 14,000 years ago — several other petroglyphs in the Coso Range have given cation-ratio ages of between 12,600 and 19,000. Moreover, petroglyphs in Wyoming (Fig. 1.1) have also produced radiocarbon results of 10,660 and 11,650 years ago (Whitley *et al.* 1996).

However, all of these results remain highly controversial, not only because they conflict with the orthodox but rapidly-disappearing North American

view that people were not yet in the New World before about 11,000 or 12,000 years ago, but primarily because of questions of methodology. Even if the dating of the organic material in the varnish is accurate, its source, and therefore its chronological relationship with the petroglyphs beneath, is far from certain, and therefore even the researchers who produced the dates advise extreme caution and scepticism (Dorn 1998).

Where paintings are concerned, some fairly direct dates have been obtained for pictographs in several widely separated parts of Brazil and Argentina. In the latter's northwestern province of Jujuy, the deep sandstone rock-shelter of Inca Cueva 4 contains some geometric motifs on the heavily exfoliated back wall (Fig 1.2). They were painted on a preparation of gypsum, and analysis by X-ray diffraction has revealed that exactly the same mineralogical composition of pigments and support is found on fallen, stratified fragments of paint, as well as on artefacts, in an occupation level that has been radiocarbon-dated to 10,620 years ago. In other words, the paintings must predate that time (Aschero & Podestá 1986, 40–43; Schobinger 1997).

At the other end of the country, in Santa Cruz province (Patagonia), two sites have yielded similar evidence. At Los Toldos, excavations in cave 3 recovered fallen fragments of ceiling bearing red paint, thought to be perhaps from ancient hand stencils (Fig. 1.3), in layer 10 (early Toldense) which indicates an age of around 11,000 years (Cardich 1987, 110; Schobinger 1997). Farther south, at the site of El Ceibo, as occupation layers were dug away, two dark red paintings of guanacos (wild llamas) appeared on the newly exposed rock wall (Fig. 1.4). Judging by their depth and the age of the layer (Casapedrense) masking them, they must be of similar age to the paintings of Los Toldos, around 11,000 years BP (Cardich 1987, 112).

Some simple linear petroglyphs covering about 16 sq. m of the bedrock floor of Epullán Grande Cave, in Argentina's Neuquén province (northern Patagonia), are thought to date back to at least 10,000 years ago (Crivelli Montero & Fernández 1996; Schobinger 1997).

Figure 1.3. *Hand stencils, Los Toldos, Argentina.*

Figure 1.4. *Paintings of guanacos unearthed during excavations, El Ceibo, Argentina. (Photo: A. Cardich.)*

Figure 1.5. *Sandstone spall from layer XII, Pedra Furada, Brazil, showing red stick figure.*

In Brazil, samples of pigment from red paintings in the sandstone Caverna da Pedra Pintada at Monte Alegre on the Lower Amazon have, through scanning electron microscopy, been found to be similar to samples from the hundreds of lumps and drops of red pigment — as well as two small fragments of painted wall — which were stratified in Palaeoindian levels radiocarbon-dated to a period from 11,200 to 10,500 years ago (Roosevelt *et al.* 1996, 378–80; Roosevelt 1999).

In the arid Piauí region of southeast Brazil, rock paintings at the huge sandstone rock shelter of Boqueirão da Pedra Furada have been dated to the same period (Fig. 1.5). One fallen fragment, bearing a clear red human stick-figure, has been found in occupation layer XII; from its position in relation to layers above and below, dated by charcoal, this level has been assigned to about 10,000 or 12,000 years ago, while another bearing two red lines, very probably the legs of a human or animal, came from a layer dating to around 17,000 years ago. These are therefore minimum ages for the fallen art (Guidon & Delibrias 1986; Pessis 1999; 2003). Another spall from a layer of *c.* 32,000 years BC bears a vague red patch, but it cannot be assumed to be humanly made and might be natural.

At the nearby rock-shelter of Toca do Baixão do Perna I, direct dating of organic carbon in a pigment ball fashioned by humans and apparently worn as an ornament gave a result of 15,250 years ago (Chaffee *et al.* 1993). Likewise at Perna — as at El Ceibo — a panel of small red figures was exposed by excavation of the layers which had covered it, and though faded, the images survived burial amazingly well. One fragment of charcoal still adhering to the panel gave a radiocarbon date of 9650 years ago, while charcoal from the layer touching the bottom of the panel has been dated to 10,530 years ago — hence, unless one envisages artists painting at nose level while lying on the floor, the panel must be somewhat older than this date (Bahn 1991, 92; Bahn & Vertut 1997, 29–30). Its figures correspond perfectly in size and type to that of similar age at Pedra Furada. Together with art of many other sites in this region, they have been attributed to the 'Serra da Capibara' style, which is thus thought to date back to at least 12,000 and probably at least 17,000 years ago (Pessis 1999; 2003).

Microscopic analyses of natural local ochres as well as of 28 pigment samples found in the layers of Pedra Furada and Perna I have proved that the pigments used in the paintings underwent a preparation — in other words, that they were clearly humanly made rather than natural — and hence that some paintings were made more than 20,000 and doubtless even 30,000 years ago (Meneses Lage 1999).

Africa

It is likely that some of Africa's rich abundance of rock art is of Late Pleistocene age. Mori (e.g. 1974), like Frobenius before him, proposed that the oldest rock engravings in the Sahara may date back to this period, but other specialists (e.g. Muzzolini 1986, 312–14) point out that this reasoning is based on a few isolated and possibly anomalous radiocarbon dates from occupations at the foot of decorated rocks, and which may have no association with the engravings. However, new research is suggesting that some large naturalistic engravings in the Sahara could well date to the end of the Pleistocene (Hachid 1998, 167–9), although proof is still lacking (Le Quellec 1998, 239, 249).

In Zimbabwe, what seems to be a paint palette has been excavated from a layer dating back more than 40,000 years at Nswatugi Cave. In addition, at Pomongwe Cave fragments of painted stone are known from layers dating to between 13,000 and 35,000 years old, and the same site has yielded granite spalls from the walls, bearing traces of paint, in deposits dating back at least 10,000 years and perhaps even to the twelfth millennium BC (Walker 1987, 142; 1996, 11–13).

At some decorated sites in Tanzania, levels have been excavated containing ochre fragments, ochre pencils and stained 'palettes' from about 29,000 years ago onward (Leakey 1983, 21–2). Moreover, pieces of pigment have been recovered from Zimbabwean shelter deposits of more than 125,000 years ago, while a Stone Age site at Nooitgedacht near Kimberley has yielded a ground ochre fragment with an estimated date of over 200,000 years, and pieces of haematite or ochre even appear to have been carried into sites in South Africa up to 800,000 or 900,000 years ago.

The most abundant and recent evidence of this kind has emerged from excavations by Barham (1998; 2002) in Zambia, where the Middle Pleistocene site of Twin Rivers has yielded 306 pieces of ochre, weighing dozens of kilos, from layers between 400,000 and 200,000 years old. Three per cent of the pieces display signs of rubbing or grinding, and Barham believes that the pigments — from a wide range of local sources (within 2 km) and with a variety of colours — were used for body painting and possibly rock painting.

Africa is also producing increasing quantities of Pleistocene portable art. One must, however, treat with enormous scepticism the claims for three fragments of Acheulian shell beads from the Libyan site of El Greifa (Bednarik 1997), and the equally dubious Acheulian quartzite anthropomorphous 'figurine' from Tan-Tan, Morocco (Bednarik 2001; 2003). The latter came from a fluvial terrace deposit; its shape is accepted to be entirely the result of natural weathering processes.

Bednarik claims to have observed some signs of human modification on it, but S. Ambrose (quoted in BBC News Online) sees no evidence whatsoever for toolmarks, and believes that the 'figurine' is most probably the result of fortuitous natural weathering.

Some of the earliest authenticated pieces of portable art from Africa have been unearthed in recent years at Blombos Cave, South Africa, from levels at least 70,000 years old: first, a bone fragment engraved with a set of subparallel incisions by a stone tool (d'Errico *et al.* 2001); then hundreds of pieces of ochre, including at least two fragments bearing engraved abstract patterns (Henshilwood *et al.* 2002); and finally a series of 41 beads of *Nassarius kraussianus* shells which are unquestionably of human manufacture and have very worn perforations (Henshilwood *et al.* 2004; d'Errico *et al.* 2005). These are all playing a major role in forcing a reassessment of the chronology and location of early human artistic development.

Even older beads have been identified at sites in the Middle East (see below), while, in North Africa, 13 perforated shell beads of *Nassarius gibbosulus* — the same genus as at Blombos — have been unearthed at the Grotte des Pigeons (Taforalt, Morocco), and date to about 82,000 years ago (Bouzouggar *et al.* 2007). Wear patterns show that they were suspended, and at both sites the beads were covered in red ochre.

Early beads made from ostrich eggshell have also come to light in many sites — most notably two small decorated examples from the Loiyangalani valley in Tanzania which may be between 110,000 and 45,000 years old (Holden 2004). The shelter of Enkapuna Ya Muto, Kenya, has given ostrich eggshell beads dating to *c.* 41,000 years ago (Ambrose 1998); and similarly, at Diepkloof Cave, South Africa, decorated fragments of ostrich eggshell are clearly associated with Middle Stone Age tools and charcoal: one fragment of shell has been dated by accelerator mass spectrometry to more than 40,000 years ago, while the sediment around it has given a luminescence date of 63,000 (Parkington 1999, 27–8).

Portable Palaeolithic art has also been well authenticated in Namibia, where seven fragments of stone found by Eric Wendt (1974; 1976) in the Apollo 11 Cave have paint on them, including four or five recognizable animal figures such as a black rhino and two possible zebras; they display a use of two colours, and were associated with charcoal which has provided a radiocarbon date of at least 19,000 and perhaps even 26,000 years ago. The site also yielded some notched bones of similar or greater age, as well as ostrich eggshell beads.

Engraved pieces of wood and bone (including a baboon fibula with 29 parallel incised notches) have been recovered from Border Cave, Kwazulu, and dated to between 35,000 and 37,500 years ago — the baboon fibula has been compared with similar calendar sticks of wood which are still in use by some Bushman clans in southwest Africa (Butzer *et al.* 1979, 1212; Beaumont 1973, 44). Later, this site also yielded several bone fragments 'decorated' with multiple incised parallel lines in levels dating to more than 100,000 years ago (Beaumont 1973). Similarly, a Middle Stone Age layer at the Klasies River Mouth Caves, South Africa, has yielded some notched and grooved bones dating to more than 100,000 years ago (Singer & Wymer 1982, 116, 149). A notched bone, dated to 28,880 BP, has been recovered along with other such objects from Sibudu Cave, in KwaZulu-Natal (Cain 2004; 2006).

A bored stone decorated with incisions was found in a layer of Matupi Cave, Zaire, dating to about 20,000 years ago (Van Noten 1977, 38). One should also mention the ceramic fragment with incised decoration, dating to about 20,000 years ago, from Tamar Hat Cave, Algeria (Saxon 1976), especially as the Upper Palaeolithic levels (between 18,000 and 11,000 years ago) of the site of Afalou-Bou Rhummel, in eastern Algeria, have more recently yielded about 50 fragments of small terracotta figurines, mostly of horned animal heads, made of a red clayey paste (Hachi 1997; 2003; Hachi & Roubet 2003). Tests have shown that they were fired at temperatures of between 800 and 850°C (Hachi *et al.* 2002).

The Middle East, central Asia and India

Anatolia (Turkey) contains a few pieces of Pleistocene portable art (Otte *et al.* 1995), but no definite parietal art as yet — figures in Kara'in Cave, near Antalya, have been attributed by some to the Palaeolithic, but they remain undated (Kökten 1955). Most recently, shell beads from Üçağızlı Cave in Turkey have been published, which date to between 41,000 and 39,000 BP uncalibrated (43,000–41,000 calibrated), while similar beads from Ksar 'Akil in Lebanon may be even older (Kuhn *et al.* 2001).

Even older shell beads have been identified at the Israeli sites of Qafzeh and Skhul — at the former site, four *Glycimeris* shells with natural perforations could be beads or pigment containers, while three perforated shells from Skhul and Oued Djebbana (Algeria) are of *Nassarius gibbosulus* (the same species as at the Grotte des Pigeons in Morocco). All these beads seem to date to around 100,000 BP or more (Vanhaeren *et al.* 2006).

Israel has also begun to produce a few pieces of art from the Pleistocene. Among the youngest is the limestone pebble from the Epi-Palaeolithic (*c.* 19,000–14,500 BP) site of Urkan e-Rub which has engravings

of 'ladder' motifs and parallel lines on it (Hovers 1990), and a number of figurines from the Natufian of El-Wad Cave, dating to 12,800–10,300 years ago (Weinstein-Evron & Belfer-Cohen 1993). There is also a rude engraving of a possible animal on a limestone slab from the Aurignacian of Hayonim Cave (Belfer-Cohen & Bar-Yosef 1981, 35), and this same site has yielded incised bone and limestone objects from its Natufian occupation (Bar-Yosef & Belfer-Cohen 1999). In addition there is a faint possibility that some linear rock engravings in a number of caves at Mount Carmel are Palaeolithic (Ronen & Barton 1981). Where paint is concerned, 84 pieces of ochre, ranging from red to pink and yellow/brown, and dating to *c.* 92,000 years ago, have been unearthed at Qafzeh Cave; some bear grooves in patterns, like those of Blombos (see p. 7). It has been claimed that practical hypotheses for ochre use, such as tanning hides, hafting, or medicinal purposes, do not account for the focus on red, or the spatio-temporal patterning of the finds at Qafzeh, and hence there is some evidence here for an early symbolic system using colour (Hovers *et al.* 2003).

The Mousterian site of Quneitra has yielded a flint plaque, dating to *c.* 54,000 years ago, whose rounded beddings have been carefully incised with four semi-circles and other lines (Goren-Inbar 1990; Marshack 1996); while, at the Acheulian site of Berekhat Ram, in the Golan Heights, a small, shaped piece of volcanic tuff was unearthed that dates to somewhere between 233,000 and 800,000 years ago (Goren-Inbar 1986). The fragment bears a natural resemblance to a female figurine, and seems to have grooves around its 'neck' and along its 'arms'. Much rested on the question of whether these grooves were natural or humanly made; but Marshack's microscopic analysis (1997) made it quite clear that humans were responsible. In other words, this was an intentionally enhanced image, and indisputably an 'art object'. A more recent analysis, using the scanning electron microscope, confirmed this diagnosis (d'Errico & Nowell 2000).

In India, the hundreds of caves and rock-shelters around Bhimbetka, near Bhopal, contain parietal paintings spanning a long period. Claims have been put forward that the earliest are Upper Palaeolithic in age (e.g. Wakankar 1984; 1985), especially since engraved ostrich eggshells from excavated layers here are said to have been dated to between 25,000 and 40,000 years ago (Kumar *et al.* 1988). One particularly fine fragment from Patne has a criss-cross pattern engraved between two parallel lines.

Bednarik has often claimed (e.g. 1993) that the oldest petroglyphs known in the world are at Bhimbetka — a large circular cupule and a pecked meandering line — in Auditorium Cave; they were covered by an Acheulian occupation layer. However, Lorblanchet, who has carefully studied this site, subsequently showed that in fact these 'petroglyphs' are natural or — even if they are indeed man-made — their age remains totally unknown (Lorblanchet 1999, 195–202).

Recently, Daraki-Chattan ('fractured rock'), a deep cavity between two sandstone rocks at Indragarh in India's Chambal valley, has been found to contain 498 cupmarks of very ancient appearance, which have been linked with Lower and Middle Palaeolithic artefacts on the cave floor (Kumar 1996). But here again, their true age remains unknown, though excavations may bring some concrete proof of great antiquity (Kumar 2002; Bednarik *et al.* 2005). One should also mention the small ochre pebble from Hunsgi, a site in southern India dating to between 200,000 and 300,000 years ago, which yielded abundant pieces of ochre; it seems to have been used as a crayon on rock.

In Afghanistan, excavations by Louis Dupree and his associates in the early 1960s at Aq Kupruk produced two small engraved or carved stone artefacts which comprise the only known examples of intentionally worked art objects from the Upper Palaeolithic or pre-Neolithic of that country. The date of the artefacts is the subject of some confusion, early reports claiming *c.* 20,000 BC and later reports *c.* 8000 BC. According to the analysis by Marshack, 'one of the artefacts is an apparently humanoid head carved and engraved on a small, soft limestone pebble, 2.5 inches high and 1.75 inches wide' (1972, 66), and so badly deteriorated that it powders to the touch. The eyes are engraved as circles, but the 'nose' forms a depression rather than a prominence, while the 'mouth' is equally bizarrely rendered. The top of the head has some kind of marking, interpreted as a coiffure or hat. What may be an ear is engraved at one side. Unfortunately, this intriguing object disappeared through the repeated looting of Kabul Museum in recent years. The other object is a flat fragment of much harder stone, 6 cm by 7 cm, containing four series of engraved notches along two of its very straight, right-angled edges. A more delicate linear marking on the faces of the plaque is, however, much deteriorated.

The Far East and Siberia

In Korea, a number of claims have been made (Sohn 1981) for portable art in the Middle Palaeolithic: these take the form of bones supposedly modified to depict animals, but serious doubts exist about all of them. Similarly, primitive pecked rock carvings in a number of sites are claimed to be Palaeolithic, in part because

they are thought to depict extinct reindeer and grey deer, and partly because they display 'Palaeolithic mentality' (Sohn 1974, 11), but once again proof is lacking.

In Japan, on the other hand, there are some extremely interesting engraved pebbles from the cave of Kamikuroiwa. Layer IX (Initial Jomon) has been dated to 12,165 BP, and contained several little pebbles with engravings on them, some of which seem to represent breasts and 'skirts' (Aikens & Higuchi 1982, 107). It should also be noted that pottery vessels in Japan — the oldest known in the world — currently date back to around 13,800 years ago uncalibrated (16,000 years calibrated) (Yasuda 2002; Keally *et al.* 2003; Kaner 2003) — for example, at the Odai Yamamoto site at the northern end of the country.

China's Palaeolithic art was limited for many years to the 120 beads and other decorative objects from the upper cave at Zhoukoudian. More recently, some hand stencils found in caves have been claimed to be of Palaeolithic age through simple analogy with those dated to the Pleistocene in France and Tasmania, but proof is still lacking for the moment. However, one definite piece of Palaeolithic art was found some years ago — an engraved 14 cm piece of antler from Longgu Cave (Hebei province) radiocarbon-dated to 13,065 years ago (Bednarik & You 1991). The site of Shiyu (Shanxi province) has yielded half of a perforated stone disc, 8 cm in diameter, which is about 28,000 years old. Recent excavations have also begun to yield pottery fragments which are almost as old as those of Japan — around 16,000 years old (Wu & Zhao 2003; Cohen 2003; Yasuda 2002).

Very early potsherds, often decorated, have for some years also been recovered from sites in eastern Siberia — for example at the site of Gasja, on the lower Amur river, associated with charcoal dated to 12,960 years ago (Okladnikov & Myedvyedyev 1983; Derevianko & Medvedev 1995). Further finds of similar date were reported at nearby Khummi (Lapshina 1995; 1999, 97); and now the whole region of the Lower Amur Basin and Transbaikal is seen by some scholars as an independent centre of the invention of pottery around 13,000 years ago (Kuzmin *et al.* 2001; Kuzmin & Orlova 2000; Yasuda 2002; Keally *et al.* 2003; Kuzmin & Shewkomud 2003), some of it decorated with indentations or cords.

Southern Siberia does, of course, have an abundance of Palaeolithic portable art objects, such as the famous figurines from Mal'ta and Buret (e.g. see Abramova 1995), as well as the remarkable bear-like animal head carved on the vertebra of a woolly rhino from Tolbaga, dating to about 35,000 years ago (Konstantinov *et al.* 1983; Avdeev 1986).

I have explained elsewhere (Bahn 2001; 2002) why the three open-air rock-art figures at Shishkino, on the Lena River, which Okladnikov (1959; Okladnikov & Zaporozhskaya 1959) attributed to the Upper Palaeolithic are certainly not as ancient as he thought — not only for geological and climatic reasons, but also because the arguments which he put forward are not valid. Firstly, although the bovid figure is quite far away from the two horses, he considered them a separate group, the oldest figures in the site, because of their size, technique and style, and the design of the forelegs (Okladnikov & Zaporozhskaya 1959, 89). He also based his rationale on the fact that European Upper Palaeolithic art is dominated by horses and bovids, and that Palaeolithic sites exist in this region. He declared that wild horses and bovids had disappeared from the region at the end of the Palaeolithic, and he considered the style of these figures to be of that period. In particular, the little oval beneath the belly of the big horse was compared with the so called 'vulva signs' of French Palaeolithic art, and the existence of this sign next to an erect stallion suggested some link with hunting magic (since he was not yet familiar with the theories of Leroi-Gourhan), whereas the zigzag sign under the big horse's tail represented water (Okladnikov & Zaporozhskaya 1959, 90).

Obviously, none of these arguments holds water. The presence of Palaeolithic sites in the area does not provide a date for these images. The bovid does not resemble those of the Palaeolithic art known in western Europe. The horses do have some features that could be Palaeolithic, although the big horse's head is more similar to that of an elk. The problem is that, unlike in Europe, the Pleistocene portable art of Siberia mostly comprises human figures, so that one barely knows the animal art of the period, and one has nothing with which to compare the Shishkino figures. The big horse, is troubling, being by far the biggest rock-art figure in Siberia — but the most important fact is that the rocks at Shishkino are very friable sandstone, in a permanent state of deterioration, and so none of these surfaces could have survived ten thousand Siberian winters intact.

Nevertheless, other scholars have begun to make similar declarations of great age for rock-art in other parts of Russia (see Bahn & Vertut 1997, 215, n. 90), even including open-air paintings in Yakutia! For the most part, the arguments put forward have been the great size of a few figures, or unusual features, or the species in question (rhinoceros, bovid, horse), or the fact that the figures have an 'archaic appearance'. Since the 1970s, other figures which could well be Palaeolithic have been found in other regions, and some Russian specialists think — very cautiously — that

Figure 1.6. *Petroglyphs in Early Man Shelter, Queensland, Australia. (Photo: N. Franklin.)*

what has been called the naturalistic 'Minusinsk' style in the open-air petroglyphs of the Yenisei region and the Altai, could date back to the end of the Ice Age. There is no hard evidence for this at present, but the discoveries of open-air Palaeolithic art in southwest Europe have made this a more plausible scenario.

A cave in the Mongolian Altai, Khoist-Tsenker-Agui or Chojt-Cencherijn-aguj cave (Cave of the Blue River), contains paintings of animals in niches. Their subject matter — horses, goats, bulls, ostrich-like birds, camels and elephants or mammoths — has led to their being ascribed to the Palaeolithic, especially as there are no human figures and no recognizable compositions. However, there is absolutely no proof of their age, and it has been pointed out that the site's gypsum rock is probably too unstable to preserve pictures from that period (Okladnikov 1972, 75; Novgorodova 1980, 38–51; Formozov 1983). However, some petroglyphs in the open-air in northwest Mongolia seem to represent mammoths, and have therefore been attributed to the Late Pleistocene (Tseevendorj 1999, 255; Jacobson *et al.* 2001, 22 & pls. 120, 296).

Australasia

In Borneo, cave paintings, including hundreds of hand stencils, often arranged in panels, have been discovered since 1994; calcite covering some of them has been dated to more than 10,000 to 14,000 years ago (Chazine 2000; Crançon 2000; Plagnes *et al.* 2003).

It is in Australia, with its incredible wealth of rock art, that one finds most of the non-European examples of Pleistocene parietal art (see Rosenfeld 1993). The first site where its existence was authenticated was Koonalda Cave, in southern Australia, which was found to contain abundant 'digital flutings' on the ceiling and walls, in total darkness, hundreds of metres inside. They seemed to be associated with the extraction of flint (Wright 1971). The site's archaeology showed that the mining activity took place at least 15,000 to 30,000 years ago, and so the marks are probably of similar age. These finger flutings are identical to those known in several of the European Palaeolithic caves.

Like those of Koonalda, finger flutings in the Snowy River Cave, Victoria, can be dated only by assuming that they are contemporaneous with archaeological deposits at the cave entrance, which are about 20,000 years old.

The first direct proof of the antiquity of Australian art came from the Early Man shelter in Queensland, where very weathered and patinated engravings (circles, grids and intertwined lines) covered the back wall (Fig. 1.6) and disappeared into the archaeological layer. As this layer yielded a radiocarbon date of about 13,200 years ago (Rosenfeld *et al.* 1981), it is clear that the engravings must be at least this old. It was precisely this sort of proof which also clinched the authenticity of Palaeolithic parietal art in Europe. A similar case of a *'terminus post quem'* date for rock art has recently emerged at Puritjarra rock-shelter in the Cleland hills, where the pecked circles must be at least 13,570 years old; this site also has painting or stencilling activity starting around 13,000 years ago, while ochre is present from 32,000 to 18,000 years ago (Rosenfeld & Smith 2002).

Since 1986, 26 red hand stencils have been found 20 m from daylight inside Ballawinne Cave in the Maxwell valley, southwest Tasmania. They are undated, but from a comparison of the cave's archaeological material with that of similar sites in the region, it has been estimated that they may be at least 14,000 years old (McGowan *et al.* 1993). Since 1987, another 23 hand stencils, a roughly drawn circle and extensive areas of wall smeared with deep red pigment have been found in another large limestone cave in southwest Tasmania, Wargata Mina (Judds Cavern), mostly in a high alcove about 35 m from the entrance, at the limit of light penetration (Cosgrove & Jones 1989; McGowan *et al.* 1993). The red pigment has been found to contain human blood, and AMS radiocarbon dating of samples of it from the cave has produced results of 9240 and 10,730 years ago (Loy *et al.* 1990; but see Watch-

man 2001). In 1988, a third cave in southwest Tasmania, TASI 3614, was also found to contain three red hand stencils, situated 10 m and 50 m from the entrance.

There is evidence of even older rock paintings in other parts of the country. What may be a painting on the wall of Sandy Creek 2 rock-shelter in Queensland has produced a date of 24,600 years ago (Watchman 1993), while excavations in Sandy Creek 1 produced two striated fragments of red pigment dating to around 32,000 and two yellow fragments dating to 28,000 and 25,900 (this site also yielded a fragment of sandstone, with part of a deeply pecked motif, in a layer dating to 14,400 years ago: Cole et al. 1995). On a boulder at Walkunder Arch Cave in the Chillagoe region of Queensland, a crust sample containing layers of paint from three different painting episodes has produced AMS radiocarbon estimates of 16,100, 25,800 and 28,100 years ago (Watchman & Hatte 1996).

In the Kimberley, some 'Bradshaw' figures have recently been dated in two different ways: some quartz grains in a wasp nest overlying one of these paintings yielded a luminescence date of 17,500 years, thus suggesting a Pleistocene age for this art corpus (Roberts *et al.* 1997); but radiocarbon dating of thin laminations of paint on two figures has yielded results of only 3900 and 1450 years (Watchman *et al.* 1997).

At Carpenter's Gap rock-shelter in the Kimberley, what seems to be a fallen fragment of painted wall was found in a layer containing charcoal dated to more than 39,000 years ago, suggesting a minimum age for the painting (O'Connor 1995; O'Connor & Fankhauser 2001), while in Arnhem Land, northern Australia, used blocks of red and yellow ochre and ground haematite have been found in occupation layers at the shelters of Malakunanja II and Nauwalabila I, dating to around 60,000 years ago (Chaloupka 1993). Most notable, in the former site, is a piece of high-quality haematite, weighing a kilogram, which was brought in from some distance and whose facets and striations are clear signs of use. Many ochre 'pencils' with traces of wear have also been found in this region's shelters throughout the Pleistocene layers. Although much of this colouring material may have been used for body-painting or some other purpose, it is likely that at least some of it was used to produce wall art. Some of the oldest paintings in the region are covered by a thin siliceous film, which is deposited only in very arid conditions, and the last such period here occurred 18,000 years ago.

Figure 1.7. *Shell necklace from Mandu Mandu Creek, western Australia.*

Moreover, among these apparently ancient figures are animals which some researchers interpret as species extinct in Australia for at least that length of time (e.g. the marsupial tapir Palorchestes) (Chaloupka 1984; Murray & Chaloupka 1983/4). Other scholars disagree with these interpretations and the proposed chronology (Lewis 1988), but everyone agrees that some of the art (the Boomerang/Dynamic/early Mimi period style) is 'pre-estuarine', and thus perhaps thousands of years earlier than 9000 BP (Lewis 1988, 85).

Samples of weathered dark pigment taken from sandstone rock-shelters along Laurie Creek in the Northern Territory have been claimed to contain human blood, and radiocarbon dating produced a date of 20,320 from them, but serious doubts have since been expressed as to whether the detection of blood was accurate and, therefore, whether the pigment was indeed humanly made at all (Loy *et al.* 1990; Nelson 1993; Loy 1994).

Australia has produced little portable art from the Pleistocene so far (Brumm & Moore 2005). In the cave of Devil's Lair, western Australia, three perforated bone beads have been found in a layer that is 12,000 to 15,000 years old, together with a possible stone pendant and some slabs of stone with possible engraved lines on them, although it is by no means certain that the lines are artificial (Dortch 1979; 1984). More recently, the upper incisor of a Diprotodon from a megafaunal assemblage at Spring Creek, Victoria, dating to the eighteenth millennium BC, has been found to bear a series of 28 incisions or grooves which observation and experimentation suggest strongly were made by humans (Vanderwal & Fullagar 1989). Finally, a necklace of 22 small *Conus* shells, deliberately modified as beads (Fig. 1.7), dating to about 32,000 years ago, has been discovered at Mandu Mandu

Creek rock-shelter, western Australia (Morse 1993). Most recently, a perforated tiger-shark tooth ornament from the cave of Buang Merabak in New Ireland (New Guinea) has been recovered, which dates to between 39,500 and 28,000 years ago (Leavesly 2007).

In northwest Australia, in the Pilbara, there are thousands of petroglyphs in the open-air, and many researchers are beginning to think that the patina on some proves that they are extremely ancient, probably some 10,000 to 15,000 years old. At Gum Tree Valley, on the Burrup Peninsula (western Australia), some visibly very old engravings are closely associated with seashells that have been dated to 18,510 years ago (Lorblanchet 1988, 286). At Sturts Meadows, in New South Wales, a compact carbonate overlying a desert varnish on petroglyphs has given AMS results of 10,250 and 10,410 years ago, suggesting that most of this huge site's figures are probably of at least that age (Dragovich 1986).

As in the USA (see pp. 3–7), the dating of desert varnish covering petroglyphs remains highly controversial and of uncertain validity, but has produced the earliest direct dates for rock art in the world so far: in the Olary region of South Australia, the cation ratio technique first produced a date of over 30,000 years (Nobbs & Dorn 1988; Dorn *et al.* 1988), while subsequently dating of varnish by both AMS radiocarbon and cation ratio has produced results of more than 42,000 years for an oval motif at Wharton Hill, and 43,140 years for a curvilinear motif at Panaramitee North (Nobbs & Dorn 1993).

Recently, some researchers declared that pecked cupmarks on some enormous sandstone boulders at Jinmium, in the Northern Territory, dated back at least 75,000 years (Fullagar *et al.* 1996) because of thermoluminescence dating of sediments. Unfortunately, more accurate dating by optical luminescence revealed that these results were contaminated, and that the cupmarks were no more than 20,000, and in fact probably only around 2000 years old (Spooner 1998; Roberts *et al.* 1998).

A whole series of decorated caves (e.g. Karliengoinpool, Paroong) in South Australia, near Mount Gambier, contain non-figurative marks made by humans on the walls and ceilings. They seem to represent three distinct traditions of petroglyphs, which are sometimes superimposed on the same wall, separated by thin layers of carbonate (Bahn & Vertut 1997, 38–41). The earliest phase comprises the digital flutings — more than 35 caves contain some, always beneath the engraved lines. Their age is unknown, but it is possible that — like those of Koonalda (see p. 10) — they may be at least 20,000 years old. The second phase, called 'Karake', is characterized by deeply engraved and weathered circles — simple, concentric or divided up by gouged lines — which resemble the archaic petroglyphs of Early Man shelter (see p. 10); finally the terminal phase, comprising shallow engravings, is probably much more recent, dating to the Holocene period.

Conclusion

This cursory survey of the major sites around the world confirms that the distribution of Pleistocene art is becoming increasingly dense, and that every continent — and especially Australia, South America and Africa — has yielded some very well-dated examples. It is highly probable that innumerable similar surprises await us in the next few years, all around the globe. However, with regard to the theme of this conference, it is noteworthy that — on present evidence — it is Eurasia which has yielded the earliest recognizably figurative art (apart from the proto-figurine from Berekhat Ram, Israel). Figurative art seems to arise somewhat later on other continents, primarily towards the end of the Ice Age. Before that, images tend to be 'simple', geometric and apparently non-figurative, though of course they may nevertheless incorporate extremely complex thinking which escapes us entirely.

References

Abramova, Z., 1995. *L'Art Paléolithique d'Europe orientale et de Sibérie.* Jérôme Millon: Grenoble.

Aikens, C.M. & T. Higuchi, 1982. *Prehistory of Japan.* London & New York (NY): Academic Press.

Ambrose, S.H., 1998. Chronology of the Later Stone Age and food production in East Africa. *Journal of Archaeological Science* 25, 377–92.

Aschero, C.A. & M.M. Podestá, 1986. El arte rupestre en asentamientos precerámicos de la Puna argentina. *Runa (Buenos Aires)* 16, 29–57.

Avdeev, S., 1986. The Tolbaga Sculpture as an Example of Prehistoric Art, in Abstracts of papers Part II: Quaternary Geology & Prehistoric Archaeology of South Siberia. Ulan-Uda, 80–83. [In Russian.]

Aveleyra Arroyo de Anda, L., 1965. The Pleistocene carved bone from Tequixquiac, Mexico: a reappraisal. *American Antiquity* 30, 261–77.

Bahn, P.G., 1991. Pleistocene images outside Europe. *Proceedings of the Prehistoric Society* 57(1), 91–102.

Bahn, P.G., 1998. *The Cambridge Illustrated History of Prehistoric Art.* Cambridge: Cambridge University Press.

Bahn, P.G., 2001. Palaeolithic open-air art: the impact and implications of a 'new phenomenon', in *Actes du Colloque de la Commission VIII de l'UISPP 1998*, eds. J. Zilhão, T. Aubry & A. Faustino Carvalho. (Trabalhos de Arqueologia 17.) Lisbon: Instituto Português de Arqueologia, 155–60.

Bahn, P.G., 2002. L'art paléolithique de plein air dans le monde extra-européen, in *L'art Paléolithique à l'air libre: le paysage modifié par l'image*, ed. D. Sacchi. (Tautavel-Campôme, 7–9 Octobre 1999.) Carcassonne: GAEP & GEOPRE, 209–15.

Bahn, P.G. & J. Vertut, 1997. *Journey Through the Ice Age*. London: Weidenfeld & Nicolson/Berkley (CA): University of California Press.

Bar-Yosef, O. & A. Belfer-Cohen, 1999. Encoding information: unique Natufian objects from Hayonim Cave, western Galilee, Israel. *Antiquity* 73, 402–10.

Barham, L.S., 1998. Possible early pigment use in south-central Africa. *Current Anthropology* 39(5), 703–10.

Barham, L.S., 2002. Systematic pigment use in the Middle Pleistocene of south-central Africa. *Current Anthropology* 43(1), 181–90.

Beaumont, P.B., 1973. Border Cave — a progress report. *South African Journal of Science* 69, 41–6.

Bednarik, R.G., 1993. Palaeolithic art in India. *Man and Environment* 18(2), 33–40.

Bednarik, R.G., 1997. The role of Pleistocene beads in documenting hominid cognition. *Rock Art Research* 14(1), 27–41.

Bednarik, R.G., 2001. An Acheulian figurine from Morocco. *Rock Art Research* 18(2), 115–16.

Bednarik, R.G., 2003. A figurine from the African Acheulian. *Current Anthropology* 44(3), 405–13.

Bednarik, R.G. & Y. You, 1991. Palaeolithic art from China. *Rock Art Research* 8, 119–23.

Bednarik, R.G., G. Kumar, A. Watchman & R.G. Roberts, 2005. Preliminary results of the EIP Project. *Rock Art Research* 22(2), 147–97.

Belfer-Cohen, A. & O. Bar-Yosef, 1981. The Aurignacian at Hayonim Cave. *Paléorient* 7(2), 19–42.

Bouzouggar, A., N. Barton, M. Vanhaeren *et al.*, 2007. 82,000-year old shell beads from North Africa and implications for the origins of modern human behavior. *Proceedings of the National Academy of Sciences of the USA* 104(24), 9964–9.

Brumm, A. & M.W. Moore, 2005. Symbolic revolutions and the Australian archaeological record. *Cambridge Archaeological Journal* 15(2), 157–75.

Butzer, K.W., G.J. Fock, L. Scott & R. Stuckenrath, 1979. Dating and context of rock engravings in southern Africa. *Science* 203, 1201–14.

Cain, C.R., 2004. Notched, flaked, and ground bone artifacts from Middle Stone Age and Iron Age layers of Sibudu Cave, KwaZulu-Natal, South Africa. *South African Journal of Science* 100, 195–7.

Cain, C.R., 2006. Implications of the marked artifacts of the Middle Stone Age of Africa. *Current Anthropology* 47(4), 675–81.

Cardich, A., 1987. Arqueología de Los Toldos y El Ceibo (Provincia de Santa Cruz, Argentina). *Estudios Atacameños (San Pedro de Atacama, Chile)* 8(No. especial), 98–117.

Chaffee, S. D., M. Hyman & M. Rowe, 1993. AMS 14C dating of rock paintings, in *Time and Space. Dating and Spatial Considerations in Rock Art Research*, eds. J. Steinbring, A. Watchman, P. Faulstich & P.C.S. Taçon. (AURA Publication 8.) Melbourne: AURA, 67–73.

Chaloupka, G., 1984. *From Palaeoart to Casual Paintings*. (Monograph 1.) Darwin: Northern Territory Museum of Arts and Sciences.

Chaloupka, G., 1993. *Journey in Time: the World's Longest Continuing Art Tradition. The 50,000-Year Story of the Australian Aboriginal Rock Art of Arnhem Land*. Chatswood, NSW: Reed.

Chazine, J.-M., 2000. Découverte de peintures rupestres à Bornéo. *L'Anthropologie* 104(3), 459–71.

Clottes, J. (ed.), 2003. *Chauvet Cave: the Art of Earliest Times*. Salt Lake City (UT): University of Utah Press.

Cohen, D.J., 2003. Microblades, pottery, and the nature and chronology of the Palaeolithic–Neolithic transition in China. *The Review of Archaeology* Fall, 21–36.

Cole, N.A., A. Watchman & M.J. Morwood, 1995. Chronology of Laura rock art, in *Quinkan Prehistory: the Archaeology of Aboriginal Art in S.E. Cape York Peninsula, Australia*, eds. M.J. Morwood & D.R. Hobbs. (Tempus vol. 3.) St Lucia: University of Queensland, 147–60.

Cosgrove, R. & R. Jones, 1989. Judds Cavern: a subterranean aboriginal painting site, Southern Tasmania. *Rock Art Research* 6, 96–104.

Crançon, S., 2000. Bornéo: des peintures du Pléistocène. *Archéologia* 372, 4–5.

Crivelli Montero, E.A. & M.M. Fernández, 1996. Palaeoindian bedrock petroglyphs at Epullán Grande Cave, northern Patagonia, Argentina. *Rock Art Research* 13(2), 124–8.

Derevianko, A.P. & V.E. Medvedev, 1995. The Amur River Basin as one of the earliest centers of ceramics in the Far East, in *The Origin of Ceramics in East Asia and the Far East*. Sendai: Tohoku Fukushi University, 11–25.

d'Errico, F. & A. Nowell, 2000. A new look at the Berekhat Ram figurine: implications for the origins of symbolism. *Cambridge Archaeological Journal* 10(1), 123–67.

d'Errico, F., J. Zilhão, M. Julien, D. Baffier & J. Pelegrin, 1998. Neanderthal acculturation in western Europe? A critical reveiew of the evidence and its interpretation. *Current Anthropology* 39, s1–s44.

d'Errico, F., C. Henshilwood & P. Nilssen, 2001. An engraved bone fragment from c. 70,000-year old Middle Stone Age levels at Blombos Cave, South Africa: implications for the origins of symbolism and language. *Antiquity* 75, 309–18.

d'Errico, F., C. Henshilwood, M. Vanhaeren & K. van Niekerk, 2005. Nassarius Kraussianus shell beads from Blombos Cave: evidence for symbolic behaviour in the Middle Stone Age. *Journal of Human Evolution* 48, 3–24.

DK, 1999. Ancient painting. *Discovering Archaeology* 1(6), Nov/Dec, 18.

Dorn, R.I., 1998. Age determination of the Coso rock art, in *Coso Rock Art: a New Perspective*, ed. E. Younkin. Ridgecrest: Maturango Museum, 69–96.

Dorn, R.I., M. Nobbs & T. A. Cahill, 1988. Cation-ratio dating of rock engravings from the Olary Province of arid South Australia. *Antiquity* 62, 681–9.

Dortch, C., 1979. Australia's oldest known ornaments. *Antiquity* 53, 39–43.

Dortch, C., 1984. *Devil's Lair: a Study in Prehistory*. Perth: Western Australia Museum.

Dragovich, D., 1986. Minimum age of some desert varnish near Broken Hill, New South Wales. *Search* 17, 149–51.

Formozov, A.A., 1983. On the problem of 'centres of primitive art'. *Sovetskaya Arkheologia* 3, 5–13. [In Russian.]

Fullagar, R.L.K., D.M. Price & L.M. Head, 1996. Early human occupation of northern Australia: archaeology and thermoluminescence dating of Jinmium rock shelter, Northern Territory. *Antiquity* 70, 751–73.

Goren-Inbar, N., 1986. A figurine from the Acheulian Site of Berekhat Ram. *Mi'Tekufat Ha'Even* 19, 7–12.

Goren-Inbar, N. (ed.), 1990. *Quneitra: a Mousterian Site on the Golan Heights*. (Monograph 31.) Jerusalem: Institute of Archaeology.

Guidon, N. & G. Delibrias, 1986. Carbon-14 dates point to man in the Americas 32,000 years ago. *Nature* 321, 769–71.

Hachi, S., 1997. Résultats des fouilles récentes d'Afalou Bou Rmel (Bédjaïa, Algérie), in *El Món Mediterrani després del Pleniglacial (18.000–12.000 BP)*, eds. J.M. Fullola & N. Soler. (Série Monográfica 17.) Girona: Museu d'Arqueologia de Catalunya-Girona, 77–92.

Hachi, S., 2003. *Aux Origines des Arts Premiers en Afrique du Nord*. (Mémoires du Centre National de Recherches Préhistoriques, Anthropologiques et Historiques, Alger, Nlle série No. 6.) Alger: CNRS.

Hachi, S. & C. Roubet, 2003. Les premières manifestations de l'art: les figurines en terre cuite d'Afalou (Babors, Algérie), in Préhistoire de l'Algérie. *Dossiers d'Archéologie* 282, 22–5.

Hachi, S., F. Fröhlich, A. Gendron-Badou, H. de Lumley, C. Roubet & S. Abdessadok, 2002. Figurines du Paléolithique supérieur en matière minérale plastique cuite d'Afalou Bou Rhummel (Babors, Algérie): premières analyses par spectroscopie d'absorption infrarouge. *L'Anthropologie* 106(1), 57–97.

Hachid, M., 1998. *Le Tassili des Ajjer. Aux sources de l'Afrique 50 siècles avant les pyramides*. Paris: Editions Paris-Méditerranée.

Henshilwood, C.S., F. d'Errico, R. Yates *et al.*, 2002. Emergence of modern human behavior: Middle Stone Age engravings from South Africa. *Science* 295, 1278–80.

Henshilwood, C.S., F. d'Errico, M. Vanhaeren, K. van Niekerk & Z. Jacobs, 2004. Middle Stone Age shell beads from South Africa. *Science* 304, 404.

Holden, C., 2004. Oldest beads suggest early symbolic behavior. *Science* 304, 369 (see also *New Scientist* 10 April, 8).

Hovers, E., 1990. Art in the Levantine Epi-Palaeolithic: an engraved pebble from a Kebaran site in the lower Jordan Valley. *Current Anthropology* 31, 317–22.

Hovers, E., S. Ilani, O. Bar-Yosef & B. Vandermeersch, 2003. An early case of color symbolism. *Current Anthropology* 44(4), 491–522.

Jacobson, E., V. Kubarev & D. Tseevendorj, 2001. *Répertoire des Pétroglyphes d'Asie Centrale*, Fasc. 6: *Mongolie du Nord-Ouest*. Paris: De Boccard.

Kaner, S., 2003. The oldest pottery in the world. *Current World Archaeology* 1(1), 44–9.

Keally, C.T., Y. Taniguchi & Y.V. Kuzmin, 2003. Understanding the beginnings of pottery technology in Japan and neighbouring East Asia. *The Review of Archaeology* Fall, 3–14.

Kökten, K., 1955. Ein allgemeiner Uberblick über die prähistorischen Forschungen im Karain-Höhle bei Antolya. *Belleten* 19, 271–93.

Konstantinov, M.V., V. Sumarokov, A. Filippov & H. Ermolova, 1983. *The Most Ancient Sculpture of Siberia*. Moscow: Kratkie Soobshcheniya Instituta Archeologia, 78–81. [In Russian.]

Kuhn, S.L., M.C. Stiner, D.S. Reese & E. Güleç, 2001. Ornaments of the earliest Upper Paleolithic: new insights from the Levant. *Proceedings of the National Academy of Sciences of the USA* (June 19) 98(13), 7641–6.

Kumar, G., 1996. Daraki-Chattan: a Palaeolithic cupule site in India. *Rock Art Research* 13, 38–46.

Kumar, G., 2002. Archaeological excavation and explorations at Daraki-Chattan 2002: a preliminary report. *Purakala* 13(1–2), 5–20.

Kumar, G., G. Narvare & R. Pancholi, 1988. Engraved ostrich eggshell objects: new evidence of Upper Palaeolithic art in India. *Rock Art Research* 5(1), 43–53.

Kuzmin, Y.V. & L.A. Orlova, 2000. The Neolithization of Siberia and the Russian Far East: radiocarbon evidence. *Antiquity* 74, 356–64.

Kuzmin, Y.V. & I.Y. Shewkomud, 2003. The Palaeolithic–Neolithic transition in the Russian Far East. *The Review of Archaeology* Fall, 37–45.

Kuzmin, Y.V., S. Hall, M.S. Tite, R. Bailey, J.M. O'Malley & V.E. Medvedev, 2001. Radiocarbon and thermoluminescence dating of the pottery from the Early Neolithic site of Gasya (Russian Far East): initial results. *Quaternary Science Reviews* 20, 945–8.

Lapshina, Z.S., 1995. The early pottery from the Khummi site (Lower Amur river basin), Bull. *Far East Branch of the Russian Academy of Sciences* 6, 104–6. [In Russian.]

Lapshina, Z.S., 1999. *Antiquities of Lake Khummi*. Khabarovsk: Amur Region Geography Society. [In Russian.]

Leakey, M., 1983. *Africa's Vanishing Art*. New York (NY): Doubleday.

Le Quellec, J.-L., 1998. *Art Rupestre et Préhistoire du Sahara*. Paris: Payot & Rivages.

Leavesly, M.G., 2007. A shark-tooth ornament from Pleistocene Sahul. *Antiquity* 81, 308–15.

Lewis, D., 1988. *The Rock Paintings of Arnhem Land, Australia: Social, Ecological and Material Culture Change in the Post-glacial Period*. (British Archaeological Reports International Series 415.) Oxford: BAR.

Lorblanchet, M., 1988. De l'art pariétal des chasseurs de rennes à l'art rupestre des chasseurs de kangourous. *L'Anthropologie* 92, 271–316.

Lorblanchet, M., 1999. *La naissance de l'art. Genèse de l'art préhistorique*. Paris: Editions Errance.

Loy, T.H., R. Jones, D.E. Nelson, *et al.*, 1990. Accelerator radiocarbon dating of human blood protein pigment from Late Pleistocene art sites in Australia. *Antiquity* 64, 110–16.

Loy, T.H., 1994. Direct dating of rock art at Laurie Creek (NT), Australia: a reply to Nelson. *Antiquity* 68, 147–8.

McGowan, A., B. Shreeve, H. Brolsma & C. Hughes, 1993. Photogrammetric recording of Pleistocene cave paintings in southwest Tasmania, in *Sahul in Review*, eds. M.A. Smith, M. Spriggs & B. Fankhauser. (Occasional Papers in Prehistory 24.) Canberra: The Australian National University, 225–32.

Marquet, J.-C. & M. Lorblanchet, 2003. A Neanderthal face? The proto-figurine from La Roche-Cotard, Langeais (Indre-et-Loire, France). *Antiquity* 77, 661–70.

Marshack, A., 1972. 'Aq Kupruk: art and symbol', in Prehistoric research in Afghanistan (1959–66), eds. L. Dupree, D. Perkins, A. Marshack, R.H. Brill & C.C. Kolb. *Transactions of the American Philosophical Society* 62(4), 66–72.

Marshack, A., 1996. A Middle Palaeolithic symbolic composition from the Golan Heights: the earliest known depictive image. *Current Anthropology* 37, 357–65.

Marshack, A., 1997. The Berekhat Ram figurine: a late Acheulian carving from the Middle East. *Antiquity* 71, 327–37.

Meneses Lage, M.C.S., 1999. Dating of the prehistoric paintings of the archaeological area of the Serra da Capivara National Park, in *Dating and the Earliest Known Rock Art*, eds. M. Strecker & P. Bahn. Oxford: Oxbow Books, 49–52.

Messmacher, M., 1981. El arte paleolítico en México, in *Arte Paleolítico*. Mexico City: Comisión XI, Xth Congress UISPP, 82–110.

Mori, F., 1974. The earliest Saharan rock-engravings. *Antiquity* 48, 87–92.

Morse, K., 1993. Shell beads from Mandu Mandu Creek rockshelter, Cape Range peninsula, western Australia, dated before 30,000 BP. *Antiquity* 67, 877–83.

Murray, P. & G. Chaloupka, 1983/4. The Dreamtime animals: extinct megafauna in Arnhem Land rock art. *Archaeology in Oceania* 18/19, 105–16.

Muzzolini, A., 1986. *L'Art Rupestre Préhistorique des Massifs Centraux Sahariens.* (British Archaeological Reports International Series 318.) Oxford: BAR.

Nelson, D.E., 1993. Second thoughts on a rock-art date. *Antiquity* 67, 8935.

Nobbs, M. & R.I. Dorn, 1988. Age determinations for rock varnish formation within petroglyphs: cation-ratio dating of 24 motifs from the Olary region, South Australia. *Rock Art Research* 5(2), 108–46.

Nobbs, M. & R. Dorn, 1993. New surface exposure ages for petroglyphs from the Olary province, South Australia. *Archaeology in Oceania* 28, 18–39.

Novgorodova, E., 1980. *Alte Kunst des Mongolia.* Leipzig: E.A. Seemann Verlag.

O'Connor, S., 1995. Carpenter's Gap Rockshelter 1: 40,000 years of Aboriginal occupation in the Napier Ranges, Kimberley, WA. *Australian Archaeology* 40, 58–9.

O'Connor, S. & B. Fankhauser, 2001. Art at 40,000 BP? One step closer: an ochre covered rock from Carpenter's Gap Shelter I, Kimberley region, western Australia, in *Histories of Old Ages: Essays in Honour of Rhys Jones*, eds. A. Anderson, I. Lilley & S. O'Connor. Canberra: Pandanus Books, Australian National University, 287–300.

Odin, G.S., J. Pelegrin & D. Nérudeau, 2006. Présence d'un fossile d'oursin préservé sur un nucléus paléolithique (site de plein-air de Tercis, Landes, France). *Comptes Rendus Palévol* 280, 743–8.

Okladnikov, A.P., 1959. *Shishkinskie Pisanitsy.* Irkutsk.

Okladnikov, A.P., 1972. *Centre of Primitive Art in Central Asia.* Novosibirsk. [In Russian.]

Okladnikov, A.P. & V.Y. Myedvyedyev, 1983. Investigation of the stratified settlement of Gasja on the lower Amur. *Izwestiya Sibirskogo otdyelyeniya Akad. Nauk USSR, Novosibirsk* 1(1), 93–7. [In Russian.]

Okladnikov, A.P. & V.D. Zaporozhskaya, 1959. *Lenskie Pisanitsy.* Moscow-Leningrad: Nauka.

Otte, M., I. Yalcinkaya, J.-M. Leotard *et al.*, 1995. The Epi-Palaeolithic of Öküzini Cave (SW Anatolia) and its mobiliary art. *Antiquity* 69, 931–44.

Parkington, J., 1999. Western Cape landscapes, in *World Prehistory: Studies in Memory of Grahame Clark*, eds. J. Coles, R. Bewley & P. Mellars. London: British Academy/Oxford: Oxford University Press, 25–35.

Pessis, A.-M., 1999. The chronology and evolution of the prehistoric rock paintings in the Serra da Capivara National Park, Piauí, Brazil, in *Dating the Earliest Known Rock Art*, eds. M. Strecker & P. Bahn. Oxford: Oxbow Books, 41–7.

Pessis, A.-M., 2003. *Imagens da Pré-História. Parque Nacional Serra da Capivara.* São Paulo: Fumdham.

Pettitt, P. & P.G. Bahn, 2003. Current problems in dating palaeolithic cave art: Candamo and Chauvet. *Antiquity* 77(295), 134–41.

Plagnes, V., C. Causse, M. Fontugne, H. Valladas, J.-M. Chazine & L.-H. Fage, 2003. Cross dating (Th/U - 14C) of calcite covering prehistoric paintings in Borneo. *Quaternary Research* 60, 172–9.

Purdy, B.A., 1996a. *How to do Archaeology the Right Way.* Gainesville (FL): University Press of Florida.

Purdy, B.A., 1996b. *Indian Art of Ancient Florida.* Gainesville (FL): University Press of Florida.

Roberts, R.G., G. Walsh, A. Murray, *et al.*, 1997. Luminescence dating of rock art and past environments using mud-wasp nests in Northern Australia. *Nature* 387, 696–9.

Roberts, R.G., M. Bird, J. Olley, *et al.*, 1998. Optical and radiocarbon dating at Jinmium rock shelter in Australia. *Nature* 393, 358–62.

Ronen, A. & G.M. Barton, 1981. Rock engravings on western Mount Carmel, Israel. *Quartär* 31/32, 121–37.

Roosevelt, A.C., 1999. Dating the rock art at Monte Alegre, Brazil, in *Dating and the Earliest Known Rock Art*, eds. M. Strecker & P. Bahn. Oxford: Oxbow Books, 35–40.

Roosevelt, A.C., M. Lima da Costa, C. Lopes Machado *et al.*, 1996. Paleoindian cave dwellers in the Amazon: the peopling of the Americas. *Science* 272, 373–84.

Rosenfeld, A., 1993. A review of the evidence for the emergence of rock art in Australia, in *Sahul in Review*, eds. M.A. Smith, M. Spriggs & B. Fankhauser. (Occasional Papers in Prehistory 24.) Canberra: Australian National University, 71–80.

Rosenfeld, A., D. Horton & J. Winter, 1981. *Early Man in North Queensland.* (Terra Australis 6.) Canberra: Australian National University.

Rosenfeld, A. & M.A. Smith, 2002. Rock art and the history of Puritjarra rock shelter, Cleland Hills, Australia. *Proceedings of the Prehistoric Society* 68, 103–24.

Saxon, E.C., 1976. Pre-Neolithic pottery: new evidence from North Africa. *Proceedings of the Prehistoric Society* 42, 327–9.

Schobinger, J., 1997. *Arte Prehistórico de América*. Milan: Jaca Books.

Singer, R. & J. Wymer, 1982. *The Middle Stone Age at Klasies River Mouth in South Africa*. Chicago (IL): Chicago University Press.

Sohn, P.-K., 1974. Palaeolithic culture of Korea. *Korea Journal* April, 4–11.

Sohn P.-K., 1981. Inception of art mobilier in the Middle Palaeolithic period at Chommal Cave, Korea, in *Resumenes de Comunicaciones, Paleolítico Medio*. Mexico City: Xth Congress UISPP, 31–2.

Spooner, N., 1998. Human occupation at Jinmium, northern Australia, 116,000 years ago or much less? *Antiquity* 72, 173–7.

Tseevendorj, D., 1999. *History of Early Mongolian Art*. Ulaanbatar: Institute of History, Mongolian Academy of Sciences. [In Mongolian.]

Van Noten, F., 1977. Excavations at Matupi Cave. *Antiquity* 51, 35–40.

Vanderwal, R. & R. Fullagar, 1989. Engraved Diprotodon tooth from the Spring Creek locality, Victoria. *Archaeology in Oceania* 24, 13–16.

Vanhaeren, M., F. d'Errico, C. Stringer, S.L. James, J.A. Todd & H.K. Mienis, 2006. Middle Paleolithic shell beads in Israel and Algeria. *Science* 312, 1785–8.

Wakankar, V.S., 1984. Bhimbetka and dating of Indian rock paintings, in *Rock Art of India*, ed. K.K. Chakravarti. New Delhi: Arnold-Heinemann, 44–5.

Wakankar, V.S., 1985. Bhimbetka: the stone tool industries and rock paintings, in *Recent Advances in Indo-Pacific Prehistory*, eds. V.N. Misra & P. Bellwood. New Delhi: Oxford and IBH Publishing Co, 175–6.

Walker, N.J., 1987. The dating of Zimbabwean rock art. *Rock Art Research* 4, 137–49.

Walker, N.J., 1996. *The Painted Hills: Rock Art of the Matopos*. Gweru, Zimbabwe: Mambo Press.

Watchman, A., 1993. Evidence of a 25,000-year-old pictograph in northern Australia. *Geoarchaeology* 8, 465–73.

Watchman, A., 2001. Wargata Mina to Gunbilmurrung: the direct dating of Australian rock art, in *Histories of Old Ages: Essays in Honour of Rhys Jones*, eds. A. Anderson, I. Lilley & S. O'Connor. Canberra: Pandanus Books, Australian National University, 313–25.

Watchman, A. & E. Hatte, 1996. A nano approach to the study of rock art: 'The Walkunders', Chillagoe, north Queensland, Australia. *Rock Art Research* 13(2), 85–92.

Watchman, A., G.H. Walsh, M.J. Morwood & C. Tuniz, 1997. AMS radiocarbon age estimates for early rock paintings in the Kimberley, north-western Australia: preliminary results. *Rock Art Research* 14, 18–25.

Weinstein-Evron, M. & A. Belfer-Cohen, 1993. Natufian figurines from the new excavations of the El-Wad Cave, Mt Carmel, Israel. *Rock Art Research* 10, 102–6.

Wendt, W.E., 1974. 'Art mobilier' aus der Apollo 11-Grotte in Südwest-Afrika. *Acta Praehistorica et Archaeologica* 5, 1–42.

Wendt, W.E. 1976. 'Art mobilier' from the Apollo 11 cave, south west Africa: Africa's oldest dated works of art. *South African Archaeological Bulletin* 31, 5–11.

Whitley, D.S. & R.I. Dorn, 1987. Rock art chronology in eastern California. *World Archaeology* 19(2), 150–64.

Whitley, D.S. & R.I. Dorn, 1993. New perspectives on the Clovis vs pre-Clovis controversy. *American Antiquity* 58, 626–47.

Whitley, D.S., R.J. Dorn, J. Francis *et al.*, 1996. Recent advances in petroglyph dating and their implications for the pre-Clovis occupation of North America. *Proceedings of the Society for California Archaeology* 9, 92–103.

Wright, R.S.V. (ed.), 1971. *Archaeology of the Gallus Site, Koonalda Cave*. Canberra: Australian Institute of Aboriginal Studies.

Wu, X. & C. Zhao, 2003. Chronology of the transition from Palaeolithic to Neolithic in China. *The Review of Archaeology* Fall, 15–20.

Yasuda, Y. (ed.), 2002. *The Origins of Pottery and Agriculture*. New Delhi: Lustre Press/Roli Books.

Chapter 2

Monuments and Miniatures: Representing Humans in Neolithic Europe 5000–2000 BC

Chris Scarre

The production of anthropomorphic images among the early farming communities of Europe was highly variable. In some regions, notably the Balkans, such images seem to have been relatively common, and fired clay figurines are regularly discovered both in graves and settlements (Bailey 2005; Chapman this volume). In many other regions of Europe, by contrast, Neolithic human representations are exceedingly scarce. Such is the case in Britain and Ireland, where despite the well-known carvings on exposed rock surfaces and megalithic blocks, the motifs employed are apparently non-figurative, consisting mainly of spirals, cup marks and geometric forms. Was there, as some have suggested, a taboo on representations of the human form in certain areas of western Europe?

Human imagery during the Neolithic period falls into distinct categories. In first place are the fired-clay figurines, familiar from the Balkans but found also through central Europe westwards. Whether these figurines were all in some way part of a single tradition, or are manifestations of convergent trends among unconnected societies, is open to debate. A second category of human imagery is the series of monolithic (often megalithic) representations found mainly in south-central and southwestern Europe in the form of carved stone stelae or statue-menhirs. These too form a broad family of related images, some perhaps drawing upon each other, others independent in origin. Finally there are the human depictions in the rock art of the Alpine zone, southern France, Iberia and Scandinavia. They include the 'hunter's art' of northern Scandinavia, although the majority of the famous south Scandinavian examples belong to the second millennium BC or later, as do many of those in the Alps.

The variable distribution of human representations across Neolithic Europe must hold considerable significance. Why are there so many fired clay figurines in southeast Europe, and so few of them in other areas? A scatter of broadly similar figurines, generally belonging to the earlier stages of the Neolithic (sixth/fifth millennium BC), extends across central Europe and into eastern and southern France. In the Rhineland, they made a brief appearance during the late sixth millennium and then disappeared. In the Paris basin, they were produced during the late fifth millennium and then abandoned. Such figurines are altogether absent from the greater part of northwest Europe, and that contrast poses intriguing questions about the role of figurative traditions in these different societies. Is it possible that human representations were made in perishable materials that have not survived the passage of time?

Figurines are of course only one of the kinds of human representation that were produced by Neolithic societies, and while northwest Europe lacks figurines it does have depictions of the human body in other media. These include the rock engravings of the Alps and Scandinavia, and the rock-shelter paintings of Levantine Spain. Furthermore, along the Atlantic façade and around the west Mediterranean, standing stones carry anthropomorphic carvings or are shaped in human form. The most elaborate are those carved in the round, such as the south French statue-menhirs of the Rouergat group. It is important to recognize also that even standing stones that are unshaped and undecorated may represent humans, as analogies from Madagascan ethnography suggest (Parker Pearson & Ramilisonina 1999). Thus the many thousands of standing stones in Atlantic Europe might each have stood for an individual person.

The iconographic distance that separates the unshaped menhirs of western Europe from the fired clay figurines of the southeast renders hazardous any attempt to treat these human representations together as parts of a single unified belief system. Yet that was the approach favoured by Marija Gimbutas. In *The Gods and Goddesses of Old Europe* (Gimbutas 1974) she

Figure 2.1. *Groups of fired clay figurines and statue-menhirs discussed in this paper: A) Southeast Europe; B) Bandkeramik figurines; C) Paris basin figurines; D) stelae and statue-menhirs of southern France and the western Alps.*

argued that the figurines of southeast Europe and southern Italy (the area she designated 'Old Europe') were evidence of a prehistoric religion concerned with fertility in which goddesses played the primary roles. It was these goddesses and their acolytes (together with occasional male consorts) that the figurines were intended to depict. In her later writings, Gimbutas extended this theory to encompass western and northern Europe also, where designs in rock art and megalithic art were interpreted as symbols of goddess-worshipping matriarchal societies. Even such seemingly inscrutable objects as the backstone of the Table des Marchand passage grave in southern Brittany were interpreted by Gimbutas as depictions of the Goddess (Gimbutas 1989, 289).

This ambitious scheme demands many interpretative leaps from its adherents and the diversity of the evidence on which Gimbutas selectively draws is itself a strong argument against her approach. Her approach assumes that early European farming societies had developed from the outset the concept of deities whom they visualized and portrayed in human form. The figurines would accordingly represent the materialization of those concepts. This assumption overlooks the varied contexts in which images have been produced and deployed within better-documented societies. It also draws attention away from the anthropomorphs themselves, and the manner in which they depict the human body. Images of bodies make us see our own bodies in particular ways, either through likeness or contrast (Bailey 2005, 141). Thus rather than manifestations of belief systems, it may be more rewarding to ask of them what they can tell us about the attitudes to the body of those societies that produced them. Furthermore, rather than shoe-horn the entire European corpus of Neolithic figurative and non-figurative motifs into a single overarching religious scheme we should perhaps seek to learn from the diversity. How were human images used in particular communities or contexts, and why, in many places, were they absent?

The approach proposed by Marija Gimbutas may itself be flawed but it allows us to highlight the problems associated with a series of key issues surrounding the significance of figurines and human representations. Why are they found where they are found, and why are they so much more common in some regions or periods than in others? Do they represent a unified phenomenon? Finally, what does the mode of representation convey? The aim of this paper will be to explore these three questions through two separate sets of material: the fired clay figurines of central and western Europe, and the statue-menhirs and related stelae of Mediterranean France and the western Alps. The objective is not so much to ask *what* they represent as *how* they represent. The two categories of representation are so different in style, scale and medium that there need have been no connection between them. They constitute very different ways of depicting the human body and must have been produced and deployed within very different social and cultural contexts. Nor need either of the two categories have been internally coherent within itself: these are not monothetic visual traditions. Yet consideration of the contrasting materializations may help us to explore the ways that human bodies were visualized, displayed and exploited in their respective societies.

Figurines: people of clay

In central Europe, the earliest human representations are the fired clay figurines of the Bandkeramik complex, a series of early farming communities that spread relatively rapidly from an origin in eastern Austria or western Hungary *c.* 5650 BC, reaching the Rhineland some three centuries later, and subsequently appearing further west in the Paris basin around 5100 BC (Gronenborn 1999, 153–6; Dubouloz 2003; Fig. 2.1). This may represent a colonization phenomenon involving groups of pioneer farmers moving west and north along the major river valleys, but a measure of regional diversity in material culture and burial practices suggests the absorption or recruitment of

indigenous local communities. In the Paris basin, for example, the flint arrowhead types are derived from indigenous Mesolithic forms (Allard 2005, 233–9). The contention that the Bandkeramik absorbed local communities has gained support from recent dietary isotope studies that have shown that individuals in several Bandkeramik cemeteries had passed the earlier parts of their lives in neighbouring upland areas (Price *et al.* 2001; Bentley *et al.* 2002; 2003). There are, however, no figurines or other human representations within the indigenous Mesolithic tradition of this region; the obvious parallels for the Bandkeramik figurines lie instead in the Early Neolithic of southeast Europe.

Studies of the Bandkeramik material have focused on the morphology of the figurines and have paid little attention to the contexts of discovery, though few appear to have come from graves and most are settlement finds. Some are clearly marked as female by the presence of breasts, and a few are clearly male, but many are fragmentary or ambiguous as to the sex represented. The surface decoration of incised lines might represent clothing or body paint, but while necklaces and belts are sometimes shown the position and nature of many of the motifs may have little to do with the appearance of living individuals. The schematic rendering of the faces argues against any suggestion that the figurines functioned as recognizable depictions of real people, but that does not preclude the possibility that they stood (for example) for deceased ancestors or indeed for living people. Like many of the Balkans figurines, they may have been produced and used within domestic settings. In the Bandkeramik case this would have meant the longhouses and associated buildings. There may have been shrines, but it is perhaps more plausible to envisage the figurines operating within a domestic context, in the new private world of house and household created by early farming communities (Wilson 1988). It is in this novel setting that the human miniatures of fired clay seem to have been displayed and used.

One of the puzzling features of the Bandkeramik figurines is their relative scarcity. Höckmann has questioned how the tradition of producing figurines could have been maintained given the vast area occupied by the Bandkeramik, and a time span of half a millennium or more. If the fired clay examples that have been discovered are any indication of their original frequency, most inhabitants of Bandkeramik settlements are likely never to have seen one. Höckmann suggested that the tradition of representation may in fact have been complemented in other materials that have not survived, notably wood, though he also mysteriously notes that we cannot rule out representations in bread (Höckmann 1988, n.4).

Figure 2.2. *Anthropomorphic vessels in central and eastern Europe: Banderkamik vessel from Erfurt, Germany (above); Late Neolithic vessel from Hódmezővásárhely-Kökénydomb, Hungary (below). (From Höckmann 1965.)*

The earliest Bandkeramik developed in the Hungarian Plain at the margins of the Starčevo-Körös-Criş complex. This Early Neolithic complex shares with the rest of the southeast the distinction of a relative abundance of fired clay figurines. In the Bandkeramik, by contrast, human representations are rare: they occur at few sites and generally in small numbers, save only in Lower Austria, Moravia and western Hungary which are the Bandkeramik areas closest to southeast Europe. Are the Bandkeramik figurines, then, to be seen merely as a westward extension of the southeast European figurine area?

That argument finds support in the similarity of figurine forms. The Bandkeramik examples are usually preserved in only a fragmentary state, with arms, legs and other anatomical features modelled in the round, and in some cases with surface decoration of incised lines. The hollow cylindrical bodies and triangular flattened heads are features shared with figurines from Körös sites in the Balkans (Höckmann 1965). Others have preferred to draw parallels between these features and the figurines of the early Vinca cul-

Figure 2.3. *Paris basin figurines from Fort-Harrouard (Eure) (above) and (below) Maizy (Aisne). Inset shows figurine findspots: 1 = Fort-Harrouard; 7 = Maizy. (From Mohen 1986; Lebolloch et al. 1986)*

ture (Bánffy 2003). On either reading there appears to have been a close link between the Bandkeramik figurines and those of Early and Middle Neolithic groups in the Balkans. The link is reinforced by the geography of the distribution: they are much more numerous at Bandkeramik sites in eastern areas nearest to the Hungarian Plain. Morphological parallels extend beyond figurines to include anthropomorphic vessels, such as the hollow seated figure from the Bandkeramik site of Erfurt in central Germany (Höckmann 1965, Abb. 6). The Erfurt vessel finds a remarkably close parallel in the seated figure from the settlement of Hódmezővásárhely-Kökénydomb in Hungary (Fig. 2.2). This Hungarian example is attributed to the Late Neolithic Tisza culture (Kalicz & Raczky 1987). Such close parallels emphasize the general family resemblance between the Bandkeramik figurines and those of Neolithic southeast Europe.

Thus the Bandkeramik figurines may represent the permeation of Balkan cultic practices and beliefs among the early farming communities of central Europe. The discovery of a clay figurine, clay 'altar' and bone spatulae from a site of the earliest Bandkeramik phase at Eilsleben in central Germany was regarded by Kaufman as evidence of the direct import of religious beliefs from the Carpathian basin (Gronenborn 1999, 179–80). In western Hungary, Bánffy has identified a number of sites with mixed assemblages of late Starčevo and early Bandkeramik type. One of these sites, Szentgyörgyvölgy-Pityerdomb, had head and foot fragments of a fired clay human figurine and an almost complete bovid figurine (Bánffy 2003). There were also two fragments of a clay altar. Bánffy interprets these mixed assemblages as evidence of interaction between late Starčevo and early Bandkeramik groups in western Hungary, with influences passing in both directions. As far as the figurines are concerned, however, the direction of influence seems to have been only one way — from the Balkans to the Bandkeramik, rather than the reverse.

Hence geographical distribution and morphological resemblance together argue that the Bandkeramik figurines form part of a unified tradition with those of southeast Europe. Those of the latter region are more numerous and more diverse both in their forms and in their contexts of discovery, but the Bandkeramik examples might easily be considered a subset within that broader tradition. That is not to deny the specificity of figurine production and use at particular times and places, but merely to argue that Bandkeramik figurines were probably not produced in complete ignorance of those being manufactured in adjacent regions. Their much smaller numbers indicate, however, that they did not occupy the same symbolic or ritual context and that they may not have been used in the same way.

The question of a unified tradition becomes more problematic when we cross the Rhine into eastern France. A small number of human figurines are known from the Paris basin in late fifth-millennium (Middle Neolithic) contexts (Fig. 2.3). These are a millennium later than the Bandkeramik examples and occur in areas where no Bandkeramik figurines have yet been found. The argument that there was a connection between the two traditions remains hypothetical, not to say hazardous. It is true that the French figurines occur in eastern France, in the area that had earlier lain on the margins of the Bandkeramik zone, but against this is the fact that figurines ceased to be pro-

duced by post-Bandkeramik groups in the Rhineland: the thin scatter of Bandkeramik figurines is followed by a figurative void, in contrast to the continued production of figurines by post-Bandkeramik groups (notably Lengyel) further to the east in Austria and Moravia.

One of the most striking of the Paris basin figurines was excavated at the promontory fort of Fort-Harrouard in 1920 (Fig. 2.3). The breasts and swelling hips mark it as female, but the portrayal as a whole is essentially two-dimensional, with short peg-like legs and vestigial arms (the head is missing). Fragments of ten further figurines were discovered at this site (Mohen 1986). A similar figure, almost complete, was discovered at the lowland enclosure of Noyen-sur-Seine (Fig. 2.4). Though broken at the legs and lacking its head (which had been separately modelled and fitted into a groove in the upper torso), the breasts modelled in relief indicate that it is a female representation. The two upper fragments were found among the pits and bedding trenches of a settlement, the lowest part in a shallow pit 100 m away on the eastern margins of the site. The separate disposal of the figurine fragments may have been intentional, an attempt perhaps to neutralize a special or sacred object (Mordant & Mordant 1986). Similar figurine fragments are known from the Loire valley and Burgundy, and from the southern part of the Massif Central in the Auvergne. These broadly resemble the Paris basin pieces; the torso fragment from Clermont-Ferrand is particularly close in style to the Noyen-sur-Seine figure (Daugas *et al.* 1984). As at Noyen (and in other examples) the head had been modelled separately; an isolated head was found at Espaly-Saint-Marcel in the Auvergne.

At two Paris basin sites, figurines were associated with another category of 'special' artefact, known as the 'vase-support'. These are hollow ceramic cylinders or cubes with a dished upper surface. Many of them are decorated and they are often the only decorated vessels in an otherwise plain ceramic assemblage.

Figure 2.4. *Fired clay figurine from Noyen-sur-Seine (Seine-et-Marne) (above) with (below) plan of the site. Figurine fragments (triangles) were scattered across the area of occupation (hatched) within the two enclosures: A & B) palisade lines; C) marshy hollow. (From Mordant & Mordant 1986.)*

The traditional appellation 'vase-support' is misleading and it is now generally accepted that they were used as small braziers for the burning of aromatic or intoxicating substances. In western France they are frequently found in burial chambers but in the Paris basin they occur at enclosure sites in association with figurines. At Jonquières, fragments of three figurines and a decorated vase-support were found together in a part of the site where they had been intentionally

broken (Blanchet 1986). Figurines and vase-supports may both have been used in specific practices, perhaps concerned with commemoration of the dead or communication with the spirit world.

The Middle Neolithic fired clay figurines from France share many features with those of the Bandkeramik. The emphasis on bodies rather than faces gives them an anonymous character, and the find circumstances suggest that they may have functioned in a domestic context. They were for private use rather than public display. The occasional association with cultic equipment does not negate this reading: at Noyen-sur-Seine, the figurine fragments were scattered across the whole of the occupation area (Mordant & Mordant 1986), and there is nothing to indicate a central cult place or shrine (Fig. 2.4). The size of the figurines (10–15 cm tall) would have made them easy to handle. One feature of particular interest is the presence of a socket for a removable head on the supposedly masculine figurine from Jonquières and the supposedly female example from Noyen. This may indicate that the heads were modelled in other materials but also that there may have been a practice of mounting alternative heads on the same bodies. That should perhaps be seen alongside the absence of decoration or any indication of clothing on the French Neolithic figurines. They may essentially have been armatures, with heads and clothing added as occasion demanded, and capable of representing different individuals as required. If so, these figurines must be interpreted as generalized body images, representing them as categories rather than individuals. Furthermore, if they were indeed intended to be clothed, their nakedness takes on a special significance. The modelling of breasts and hips indicates the desire to sexualize the images, but in ways that would not ordinarily have been visible. Breasts and hips were perhaps considered so intrinsic a facet of human identity that they could not be excluded when modelling an image. The representation of hidden features of the body may also indicate a fundamental tension between private life and public display, between the naked and the clothed, in these societies.

In several respects, the French Middle Neolithic figurines compare closely with those of the Bandkeramik, raising again the issue of whether there may have been a direct connection between the two traditions. Did Bandkeramik figurines directly inspire the Paris basin examples? If so, how was the continuity of tradition maintained across the gap of a millennium or so that separated them? We may posit representations in other non-durable media. It is also possible, however, that these figurines arose independently from convergent practices in societies that though separated nonetheless possessed similar conceptions of the human body.

What may those practices have been? The presence of other 'cultic' equipment ('altars' and 'vase-supports') could be evidence for small domestic shrines. Given their scarcity, however, it is difficult to argue that each Bandkeramik household or settlement had such a shrine. The occurrence of cultic equipment and figurines is much more consistent at the Paris basin sites. Morphologically, too, the Paris basin figurines are different. One significant difference is the absence of the seated forms found within the Bandkeramik corpus. Yet they and the Bandkeramik figurines are united in their general conception — that of producing a miniaturized fired clay human — and in their association with domestic settlement contexts. They do not seem to have been items of public display, and their small size would have made them easy to handle. They invite the intimate encounter of being held in the hand and scrutinized at close quarters. Rather than the manifestation of an underlying cult or religion, however, as Gimbutas proposed, the figurines constitute a particular mode of representation, a miniaturized materialization of the human form which may have been deployed against the background of a range of different beliefs. Above all, however, they indicate a specific and widely-shared characterization of the human body, one that was appropriate only perhaps to be seen in private domestic settings.

Figure 2.5. *Statue-menhir of Saint-Sernin-sur-Rance (Aveyron). The figure is carved in a block of red sandstone probably taken from a source 5 km to the northwest. Height of figure: 1.2 m. (Drawing by A. D'Anna, from D'Anna 1977.)*

Statue menhirs: the body as monolith

The fired clay figurines of eastern and southern France are objects to be held in the hand, manipulated and observed at close quarters. They are not only anthro-

pomorphic, but miniaturized versions of the human form, and that miniaturization may in itself have particular effects upon the person who is viewing or handling them (Bailey 2005, 33–3). They are intimate models, which might well have been created for the domestic context; for display within the setting of the household. Very different are the statue-menhirs of western and southern France and the Alpine zone. These were public monumentalized displays of the human form. They were in no way intimate, and even the three-dimensionality of the human form is sometimes lost in its inscription on the block of stone.

Statue-menhirs do not feature in Gimbutas's accounts of the goddess cults of the earlier Neolithic, since they post-date the fourth-millennium watershed of 'aggressive infiltration and settlement of semi-nomadic pastoralists' (Gimbutas 1974, 18). According to Gimbutas, the latter replaced matriarchy with patriarchy and male deities henceforth became dominant. Once again, however, the images are difficult to read if we seek to know what they mean. It is more productive to ask what the mode of representation conveys.

The most striking of the south French statue-menhirs are those of the Rouergat, on the limestone uplands of the Causses (D'Anna 1977; Serres 1997; Philippon 2002). They are unambiguously anthropomorphic, and carefully worked to give parallel sides and a rounded top. The face (eyes, nose, and more rarely the mouth) is carved in the middle of the rounded top, below the apex of the curve. In some cases the face is omitted altogether. On many of the 110 members of this group, arms and legs are also depicted, the latter in schematic fashion as two orthogonal bands descending from the belt, sometimes ending in toes. The shortness of the legs suggests that some of these may be figures in sitting position. The arms, however, are also shown much shorter than they would be in real life, and are held across the chest or stomach. Breasts identify some of the statue-menhirs as female; others, which lack these features, are thought to be male. Many of the female statues are also identified by the portrayal of a multi-stranded necklace below the face. Male figures wear a diagonal shoulder belt supporting an enigmatic 'object'. Some also carry an axe, a bow and arrow, or both. Judged on this basis there are some 26 female statues, 40 male, and 10 which have suffered a sex-change: 9 where reworking has changed the sex from masculine to feminine by the erasure of the shoulder belt and the addition of breasts and necklace; and 1 where a female statue has been transformed into a male (Serres 1997, 62).

The most striking of the Rouergat statue-menhirs is the female figure from Saint-Sernin-sur-Rance, deeply carved in a block of red sandstone (Fig. 2.5).

Figure 2.6. *Decorated stele (stele 25) from monument M XI at Petit-Chasseur (Sion, Switzerland) representing individual dressed in elaborate clothing (including a belt and a possible necklace) and carrying a bow and arrow. The detailed depiction of the clothing and accoutrements is in striking contrast to the summary nature of the face. Height of stele 15.8 cm. (From Gallay & Chaix 1985.)*

The face is shown schematically, though parallel lines either side of the nose probably represent facial paint or tattoos. Below the face a five-strand necklace is shown, and below that again a Y-shaped object which is a pendant of which antler examples are known from third-millennium sites in this region. Arms and legs, ending in fingers and toes, are depicted schematically and short; the shortness of the legs gives the impression that the figure is seated. The rear surface of the stone is carved with a series of deep vertical grooves which pass beneath the belt and continue around the sides. They are probably the representation of a full-length pleated cloak, hanging from the shoulders. In the middle of the rear surface a single long strand of

hair descends, merging eventually with the folds of the garment (D'Anna 1977; Serres 1997).

Like many of the statue-menhirs of southern France the Saint-Sernin example was found by accident in the nineteenth century in the course of farm work. The farmer dragged the stone to the side of his field and abandoned it there (D'Anna 1977, 41). The precise context in which these images were carved and erected remains unknown. Careful study of the findspots and their surroundings does not suggest that the Rouergat statue-menhirs were raised to mark burials, nor that there were settlements in the immediate proximity. To the west of the Rouergat, by contrast, undecorated stelae appear to have been set up within settlements. At Montaïon in Languedoc, a group of stones including a large anthropomorphic slab had stood at the centre of a large Late Neolithic settlement. At Cambous a few centuries later, stelae were reused in the foundations of houses (D'Anna *et al.* 1997). To the east of the Rhône in Provence the rectangular stelae of the Trets basin appear to have functioned as grave markers, as recent excavations at Château-Blanc have shown (Hasler 1998). Traces of red paint have been detected on some of the Trets stelae, but the colouring appears to have been used to pick out features of the decorative frame rather than to add details of the otherwise blank faces (Walter *et al.* 1997).

These stelae and statue-menhirs of southern France date mainly to the third millennium BC, but their origins may lie at least 1000 years earlier. The carved and sculpted statue-menhirs have been interpreted as a late manifestation of a tradition which began with anthropomorphic slabs, chosen for their form and little altered from the natural state. This was followed by a period in which menhirs were shaped but not carved, and finally by the carving or sculpting of the surfaces (Rodriguez 1998). It is difficult to believe, however, that the statue-menhirs were merely the product of better stone-working techniques. It was not simply a question of freeing the human form from a natural block of stone. The social context was all-important. This is borne out by the symbols of power depicted on these stones, by their frequent destruction and redeployment, and by their original contexts, sometimes associated with funerary monuments, occasionally with settlements. They mark a specific social or cultural phenomenon and show much more than just the gradual improvement in sculptural techniques. Above all, they may indicate a new understanding of the decorated human body as a powerful political individual.

In the Alpine region, human representations appear in the Late Neolithic or Chalcolithic and occur both as statue-menhirs and in rock art. In the western Alps the most famous statue-menhirs are those discovered at Petit-Chasseur at Sion (Valais). Excavations at this complex of ten megalithic tombs and cist graves led to the discovery of 29 statue-menhirs. They are held to be masculine on the basis of the weapons that they carry. Incision and pecking were used to represent ornate clothing, and most of the figures are depicted wearing a belt. In contrast to the elaborate representation of clothing and weapons, the faces are shown only in summary fashion. Stele 25, for example, has a rounded top with raised outer margin representing hair or eyebrows, from which descends a simple oblong to indicate the nose (Fig. 2.6; Gallay & Chaix 1985). Eyes, ears and mouth are absent.

Gallay has divided the Petit-Chasseur stelae into two groups, spanning the greater part of the third millennium BC (type A: 2700–2450 BC; type B: 2450–2150 BC) (Gallay 1995). A few were simply lying on the ground where presumably they had been intentionally toppled. 24 of the 29, however, were discovered reused in the stone cists and cairns. No fewer than eight of the stelae had been reused in monument M XI, four of them forming the sides of the burial chamber, two in the blocking of the entrance, one in a cist grave and one incorporated into the southeastern horn of the cairn. Initially these stones stood in front of the monuments, their finely carved motifs visible to all; subsequently they were dismantled and reused. The fact that one of the stelae had been reused three times testifies to the power held by these images even after they had been removed from public view. A few had been recarved, and many had been intentionally damaged (often by decapitation) before they were reused (Bradley 2002, 47). The symbols of status that these figures hold — the weapons, the elaborate belts, the carefully represented clothing — suggest that they may be representations of important individuals. The erection, destruction and recycling of the stones may indeed have shadowed that of the individuals they represented: carved and displayed during their lifetime, removed and hidden away upon their death (De Saulieu 2004, 54–5).

Petit-Chasseur is one of a small number of sites in the western Alps with statue-menhirs datable to the third millennium BC. Human representations are not restricted to menhirs or statue-menhirs, however, but occur also in rock art, notably in the major concentrations of Valcamonica and Mont Bégo. Among the earliest are those of the Fontanalba region of Mont Bégo, where 169 human figures have been recorded, associated with halberds, axes and plough teams. These may belong to the beginning of the third millennium BC, and are followed by carvings in the Vallée des Merveilles sector of Mont Bégo which appear to show schematic human figurines,

together with a smaller number of more complex representations such as the famous 'Chef de Tribu' which some have interpreted as gods (De Lumley *et al*. 1990). These figures are dated through the co-occurrence on the same rock surfaces of carvings of triangular copper daggers of Remedello type. Similar daggers occur 250 km to the north on some of the Petit-Chasseur stelae (e.g. stele 7: Bocksberger 1976). Thus it is clear that rock carvings and decorated stelae formed part of the same broad world of symbols, although the location of the two groups is strikingly different: the Mont Bégo rock art in relatively inaccessible upland locations far removed from the zone of everyday life; the decorated stelae in valley and lake basins. The purpose and meaning of the two groups was also probably quite unlike. The upland carvings were the work of visitors from the settled lowland areas, perhaps even of pilgrims drawn to sacred locations, or young men engaged in initiation rituals (Barfield & Chippindale 1997). The human forms are mainly schematic, and sometimes occur in large numbers on the same rock surface, associated with other motifs, though it is difficult to identify specific scenes. The stelae, by contrast, may have been representations of living or dead individuals, and at Petit-Chasseur, were associated with (and later incorporated into) funerary monuments.

Figure 2.7. *The Folkton drums: carved chalk cylinders discovered by Canon Greenwell in 1889 accompanying the burial of an adolescent beneath a round barrow in eastern Yorkshire. (From Kinnes & Longworth 1995.)*

The invisible body: Britain and Ireland

In contrast to these well-known figurative traditions, human representations are almost entirely absent from Mesolithic and Neolithic contexts in Britain and Ireland. The famous megalithic art of the Boyne Valley passage graves is abstract or geometrical in character, consisting of chevrons, spirals, zigzags and lozenges. These might represent beings of some kind, but if so they are not portrayed in recognizably human form. Unambiguously human representations are very scarce. The carved chalk figure from the Grimes Graves flint mine is now widely dismissed as modern (Russell 2000, 42–6). More interesting is the wooden figure from the Somerset Levels (the Somerset God-Dolly), dated by its association with timber trackways to the middle of the third millennium BC. Carved out of ash, it portrays the head and torso of a hermaphrodite figure with breasts and a large erect penis; the legs may have been broken away. The surviving portion measures only 16 cm in height. It was found resting upside down beneath the Bell B trackway where it had been deposited presumably as an intentional act (Coles & Coles 1986; Coles 1990; 1998). The wooden figure discovered at Dagenham on the north bank of the Thames in 1922 is both larger (49.5 cm tall) and slightly later in date than the Somerset Levels figure. The Dagenham figure has a well-defined circular head with eyes, nose and mouth, vestigial arms, but clearly shaped buttocks and legs. There is a socket for the attachment of a penis. The figure is carved out of a single piece of pine and has been AMS dated to 2351–

2139 BC (Coles 1990). These wooden figures recovered from wetland contexts recall the practice of deposition in watery locations that appears to have been widespread in northern Europe throughout the later prehistoric period. Votive deposits include polished stone axes, food offerings in pottery vessels, metalwork, and the famous 'bog bodies' (Torbrügge 1971; Bradley 1990; Koch 1998; Van der Sanden 1996). Cultic objects may have been returned to the earth when they went out of use or were broken; the Somerset Levels figure has lost its legs and the Dagenham figure has ancient damage to the left side of the face.

Altogether more enigmatic are the objects known as the Folkton drums (Fig. 2.7). These three cylinders carved from solid chalk were discovered by Canon William Greenwell in 1889 in a burial mound on Folkton Wold. They accompanied an adolescent burial in a grave towards the edge of the mound (Kinnes & Longworth 1985, 115–16). They are graded in size, measuring from 8.7 cm high and 10.4 cm in diameter (drum 1) to 10.7 m high and 14.6 cm diameter (drum 3). They are decorated in similar fashion, with a face on one side, flanked by geometrical decoration extending around the back of the drum and further geometrical decoration on the slightly domed top. The faces on drums 1 and 3 depict eyebrows, eyes and mouth, with flaring triangles expanding either side above the mouth perhaps to represent a moustache. The geometric motifs on the sides, back and top of the drums find parallels in motifs carved on Grooved Ware pottery and confirm the third-millennium date of the Folkton drums, but they remain for the present without parallel in Britain and Ireland (Longworth 1999). They may be translations into stone of objects more usually made in another material such as wood. The shape of the drums is indeed strongly suggestive of a circular wooden box with a lid.

The Grooved Ware associations of the Folkton drums have been recalled by the recent discovery of a fragmentary sandstone plaque carved with a design resembling part of a human face from Rothley Lodge Farm in Leicestershire. It was found in a pit together with Grooved Ware sherds beneath the sunken floor of an abandoned house (Pitts 2005).

The scarcity of human representations in the British and Irish Neolithic stands in sharp contrast to other areas of Europe. The wooden figures from Britain, however, have a special significance, leading us to suspect that many more may once have existed. The durability of the various media used for human representations has obviously played a distorting role in the formation of the archaeological record. Yet the absence of human representations in rock carvings, despite the abundance of abstract motifs, argues that human images may well have been consciously avoided in Neolithic Britain and Ireland. Rather than constituting the tip of a vanished iceberg, the Somerset Levels God-Dolly, the Folkton drums and the Rothley Lodge plaque may be just what they appear: rare exceptions in an otherwise non-iconic world.

Conclusion: scale, intimacy and power

Such generalized observations are easy enough to make. The challenge, however, is to go beyond the recognition of difference in an attempt to interpret human representations both as culturally constrained systems of meaning and as material artefacts that functioned in specific ways in their social and cultural contexts. Let us in these concluding remarks return to the two main bodies of French Neolithic representations and consider why they are so different and what those differences may mean. The objective is to deconstruct human representations as a category.

The two main bodies of human representation are the fired clay figurines and the carved statue-menhirs. They contrast in size, material, posture and find context. The fired clay figurines are small: although most survive only in an incomplete condition, the largest appear to have measured around 15 cm tall (examples complete save for missing heads from Fort Harrouard and Maizy c. 13.8 cm; nearly complete but headless figurine from Noyen-sur-Seine 12.6 cm: Mohen 1986; Mordant & Mordant 1986). They are examples of miniaturism, and the reduction in scale would have provoked conditions of intimacy in handling these objects: the viewer would have needed to hold them close up in order to inspect them. This intimate nature of the encounter provides the viewer with a new way of seeing and a new way of understanding the object and, by extension, the human body that it represents (Bailey 2005, 38).

The fact that these objects are portable and could be handled is itself significant. They might have been displayed and manipulated in household contexts, and it should be noted that the majority come from sites that could be interpreted as settlements, although the presence of ditches and palisades may indicate that they also had ceremonial or defensive functions. There is no specific evidence that the contexts from which they came should be interpreted as shrines. The fragments of decorated incense-burners (the misleadingly termed 'vase-supports') from the same sites may also very well have functioned within a domestic context rather than a public building. A further feature shared by all the figurines is that they appear to be shown unclothed. Despite their small size the possibility cannot be excluded that they were originally dressed in some

way, and that the baked clay objects that survive are in fact the armatures of figurines that were more elaborate, more colourful, and altogether more striking in their original appearance. This need not imply that they were intended for public display, however, and the fact that at Noyen-sur-Seine (the site for which the best information exists) the figurines fragments were scattered across the area of the settlement is consistent with a domestic context of use. They are perhaps to be considered private, intimate, household objects.

The statue-menhirs of southern France and the western Alps represent an altogether different category of the person that must have functioned in a very different social context. Some, as we have observed, were set up as grave markers; others may have stood within settlements; for yet others, including the famous Rouergat group, the original context is unclear. Yet while they are internally diverse in their morphology and in their original settings, they represent a clear contrast to the fired clay figurines. In the first place, all the evidence suggests that they were intended for public display. Even the stelae found in settlement contexts appear to have stood not in houses or buildings but in an open space within the settlement.

Together with their public outdoor placement goes their size, the durability of the materials from which they were carved, and the elaborate surface decoration that many of them display. Few of them approach life-size — few of even the largest Rouergat statue-menhirs measure over 1.2 m tall — yet they are far different in character from the miniaturized fired clay figurines. They are too large and heavy to be handled and were clearly fixed in position. Unlike the fired clay figurines, where the size of the viewer places him or her in a relationship of dominance *vis-à-vis* the figurines, the statue-menhirs might be considered the dominant partners in the exchange of gaze with the human viewer. This relationship of dominance is reinforced by the elaborate decoration or dress, originally given even greater impact through the application of colour, and by the symbols of power or authority that many of these figures seem to grasp. If the Rouergat group does indeed include individuals portrayed in a sitting position (D'Anna 1977, 171), these may be representations of 'enthroned' individuals.

Thus the human representations from Neolithic France fall into opposing categories of monumentalism and miniaturism: into images that were hidden away in the domestic context, and that provided the opportunity for private, intimate encounters, and those that were on public display. Within such an analysis, it becomes less important to establish whom it is (living individual, ancestor, divinity) that is being represented (Bailey 2005, 23), though that question can never be far from our thoughts. What is more important is to recontextualize the representations, to consider them just one among many expressions of materiality. In eastern and central Europe, from the sixth millennium BC, this included the radical new medium of fired clay, which offered new opportunities for expressing identity both in the shapes and decoration of the ubiquitous pottery containers and in the fired clay figurines that made use of the same materials and technology to create miniature human forms. Further west, at a slightly later date, another new medium was created through the shaping of large stone blocks to create another kind of human image. If intimacy and the domestic were hallmarks of the fired clay figurines, the large stone images worked very differently to convey public messages of power. It would be easy to read this contrast in terms of emerging leadership and social hierarchy. These are not small naked figurines, hidden from the view of all save those allowed entry into the private domestic context. The body is no longer secluded and intimate. The human body of the statue-menhirs is a public declaration, elaborately clothed, fixed in position and challenging the viewer. This is not the domestic body but the body as a political instrument, part of a changing world of social relations in which status was becoming symbolized in increasingly permanent form.

These interpretations are, however, contextually constrained, and cannot easily be read as a diachronic narrative of changing body symbolism or personhood. The fired clay figurines were fashioned, handled and displayed in the specific social circumstances of the late fifth millennium BC. The statue menhirs were in turn the product of their own time and context. Furthermore, the relative scarcity of the fired clay figurine fragments suggests that they were not ubiquitous in eastern and southern France in the way that they were in the Balkans. It is difficult to argue that fired clay figurines were in any significant sense the inspiration for the statue-menhirs, especially since, as we have observed, an alternative origin for the statue menhir tradition can be found in the selection and erection of unshaped naturally anthropomorphic blocks (Rodriguez 1998). These stood, presumably, for people, but it was only during the third millennium BC that the shaping and carving of stone blocks developed to the point of producing elaborate human representations. Many of these were essentially two-dimensional — stelae rather than statue-menhirs in strict archaeological terminology — which connects them perhaps more strongly with the contemporary rock carvings of Mont Bégo than with the fired clay figurines of an earlier period.

The anthropomorphic representations of Neolithic western Europe are too patchy in their distribution

across time and space, and too varied in their material and social context, to be considered as manifestations of a single tradition. They relate to changing social practices, and very likely to changing conceptions of the body, but cannot in themselves provide a coherent narrative. The extreme scarcity of human representations in certain regions, such as Britain and Ireland, is further testimony to the variability of representational practices. Individuals — living or dead — may have been represented through other media such as standing stones or timber posts, and it may be relevant to note that folklore frequently interprets standing stones as petrified people, punished for sacrilegious acts (e.g. Hunt 1865). Yet the aniconic standing stone is a far cry from the human figurine, and we must distinguish between objects that may have 'stood for' people and those which were intentionally 'shaped as' people. It is the explicit anthropomorphism of the latter which instantly captures our attention as human observers. Through its contrasting portrayal of intimate bodies and public bodies this materialization provides insight into some of the ways in which the human body may have been seen and imagined by West European Neolithic communities. What is perhaps most striking, however, is the sense of incompleteness, that what we are viewing are scattered manifestations of a much larger set of concepts and traditions in which the explicit representation of the human form was never more than an occasional and regionally specific practice.

Acknowledgements

I am grateful to John Robb for his comments on an earlier version of this paper, and to Katie Boyle for assistance with the illustrations.

References

Allard, P., 2005. *L'industrie lithique des populations rubanées du Nord-Est de la France et de la Belgique.* (Internationales Archäologie 86.) Rahden: Verlag Marie Leidorf.

Bailey, D.W., 2005. *Prehistoric Figurines: Representation and Corporeality in the Neolithic.* London: Routledge.

Bánffy, E., 2003. Die balkanischen und lokalen (?) Wurzeln der Glaubenswelt des mitteleuropäischen Linearbandkeramik-Gruppen. *Acta Archaeologica Academiae Scientiarum Hungaricae* 54, 1–25.

Barfield, L. & C. Chippindale, 1997. Meaning in the later prehistoric rock-engravings of Mont Bégo, Alpes-Maritimes, France. *Proceedings of the Prehistoric Society* 63, 103–28.

Bentley, R.A., T.D. Price, J. Lüning, D. Gronenborn, J. Wahl & P.D. Fullagar, 2002. Prehistoric migration in Europe: strontium isotope analysis of Early Neolithic skeletons. *Current Anthropology* 43, 799–804.

Bentley, R.A., R. Krause, T.D. Price & B. Kaufmann, 2003. Human mobility at the Early Neolithic settlement of Vaihingen, Germany: evidence from strontium isotope analysis. *Archaeometry* 45, 471–86.

Blanchet, J.-C., 1986. Les figurines en céramique du camp chasséen de Jonquières (Oise). *Antiquités Nationales* 18/19, 177–9.

Bocksberger, O.J., 1976. *Le site préhistorique du Petit-Chasseur, Sion, Valais, 1–2: Le dolmen MVI.* Lausanne: Université de Genève.

Bradley, R., 1990. *The Passage of Arms: an Archaeological Analysis of Prehistoric Hoards and Votive Deposits.* Cambridge: Cambridge University Press.

Bradley, R., 2002. *The Past in Prehistoric Societies.* London: Routledge.

Coles, B., 1990. Anthropomorphic wooden figures from Britain and Ireland. *Proceedings of the Prehistoric Society* 56, 315–33.

Coles, B., 1998. Wood species for wooden figures: a glimpse of a pattern, in *Prehistoric Ritual and Religion*, eds. A. Gibson & D. Simpson. Stroud: Sutton, 163–73.

Coles, B. & J. Coles, 1986. *Sweet Track to Glastonbury: the Somerset Levels in Prehistory.* London: Thames & Hudson.

D'Anna, A., 1977. *Les statues-menhirs et stèles anthropomorphes du midi Méditerranéen.* Paris: Editions du CNRS.

D'Anna, A., X. Gutherz & L. Jallot, 1997. L'art mégalithique dans le Midi de la France: les steles anthropomorphes et les statues-menhirs néolithiques in *Art et symboles du mégalithisme Européen: Actes du 2ème Colloque International sur l'art mégalithique, Nantes 1995*, eds. J. L'Helgouach, C-T. Le Roux & J. Lecornec. *Revue Archéologique de l'Ouest,* supplément no. 8, 179–93.

Daugas, J.-P., J.-M. Roger & G. Vernet, 1984. Les statuettes chasséennes en céramique du Massif Central (Puy-de-Dôme, Haute-Loire, Gard), in *Influences méridionales dans l'est et le centre-est de la France au Néolithique: le rôle du Massif-Central.* Clermont-Ferrand: CREPA, 185–96.

De Lumley, H., J. Begin-Ducornet, A. Echassoux, N. Gisuto-Magnardi & O. Romain, 1990. La stèle gravée dite du 'Chef de Tribu' dans la région du Mont Bego, Vallée des Merveilles, Tende, Alpes-Maritimes. *L'Anthropologie* 94, 3–62.

De Saulieu, G., 2004. *Art rupestre et statues-menhirs dans les Alpes. Des pierres et des pouvoirs 3000–2000 av. J-C.* Paris: Errance.

Dubouloz, J., 2003. Datation absolue du premier Néolithique du Bassin parisien: complément et relecture des données RRBP et VSG. *Bulletin de la Société Préhistorique Française* 100, 671–89.

Gallay, A., 1995. Les stèles anthropomorphes du site mégalithique du Petit-Chasseur à Sion (Valais, Suisse). *Notizie Archeologische Bergomensi* 3, 167–94.

Gallay, A. & L. Chaix, 1985. *Le site préhistorique du Petit-Chasseur (Sion, Valais), 5–6: Le dolmen M XI.* Lausanne: Bibliothèque Historique Vaudoise.

Gimbutas, M., 1974. *The Gods and Goddesses of Old Europe.* London: Thames & Hudson.

Gimbutas, M., 1989. *The Language of the Goddess.* London: Thames & Hudson.

Gronenborn, D., 1999. A variation on a basic theme: the transi-

tion to farming in southern–central Europe. *Journal of World Prehistory* 13, 123–210.

Hasler, A., 1998. Les steles de la nécropole tumulaire néolithique de Château-Blanc (Ventabren, Bouches-du-Rhône), in *Actes du 2ème Colloque International sur la Statuaire Néolithique,* ed. J Guilaine. *Archéologie en Languedoc* 22, 105–12.

Höckmann, O., 1965. Menschliche Darstellungen in der bandkeramischen Kultur. *Jahrbuch des Römisch-Germanischen Zentralmuseums Mainz* 12, 1–26.

Höckmann, O., 1988. Ein Statuettenteil aus der ältesten Linienbandkeramik von Goddelau, Stadt Riedstadt, Kr. Gross-Gerau. *Archäologisches Korrespondenzblatt* 18, 15–24.

Hunt, R., 1865. *Popular Romances in the West of England*. London: J.C. Hotten.

Kalicz, N. & P. Raczky, 1987. The Late Neolithic of the Tisza region: a survey of recent archaeological research, in *The Late Neolithic of the Tisza Region*, ed. P. Raczky. Budapest: Szolnok, 11–30.

Kinnes, I.A. & I.H. Longworth, 1985. *Catalogue of the Excavated Prehistoric and Romano-British Material in the Greenwell Collection*. London: British Museum.

Koch, E., 1998. *Neolithic Bog Pots from Zealand, Møn, Lo land and Falster*. Copenhagen: Kongelige Nordiske Oldskriftselskab.

Lebolloch, M., J. Dubouloz & M. Plateaux, 1986. Sauvetage archéologique à Maizy (Aisne): les sépultures rubanées et l'enceinte de la fin du Ve millénaire. *Revue Archéologique de Picardie* 1–2, 3–12.

Longworth, I.H., 1999. The Folkton drums unpicked, in *Grooved Ware in Britain and Ireland*, eds. R. Cleal & A. MacSween. Oxford: Oxbow Books, 83–8.

Meaden, T., 1999. *The Secrets of the Avebury Stones*. London: Souvenir Press.

Mohen, J.-P., 1986. Les statuettes néolithiques du Fort-Harrouard et le groupe parisien des 'Vénus'. *Antiquités Nationales* 18/19, 155–62.

Mordant, C. & D. Mordant, 1986. Noyen-sur-Seine: autour d'une figurine feminine. *Antiquités Nationales* 18/19, 163–9.

Parker Pearson, M. & Ramilisonina, 1998. Stonehenge for the ancestors: the stones pass on the message. *Antiquity* 72, 308–26.

Philippon, A. (ed.), 2002. *Statues-Menhirs: des énigmes de pierre venues du fond des âges*. Rodez: Editions du Rouergue.

Pitts, M., 2005. Stone plaque is first Neolithic face in over a century. *British Archaeology* 84, 9.

Price, T.D., R.A. Bentley, J. Lüning, D. Gronenborn & J. Wahl, 2001. Prehistoric human migration in the Linearbandkeramik of central Europe. *Antiquity* 75, 593–603.

Rodriguez, G., 1998. L'évolution de la statuaire mégalithique en Haut-Languedoc et ses différences avec la Rouergate, in *Actes du 2ème Colloque International sur la Statuaire Néolithique*, ed. J Guilaine. *Archéologie en Languedoc* 22, 167–81.

Russell, M., 2000. *Flint Mines in Neolithic Britain*. Stroud: Tempus.

Serres, J.-P., 1997. *Les statues-menhirs du groupe rouergat*. Rodez: Musée du Rouergue.

Shee Twohig, E., 1981. *The Megalithic Art of Western Europe*. Oxford: Clarendon Press.

Torbrügge, W., 1971. Vor-und frühgeschichtliche Flussfunde. *Bericht der Römisch-Germanishen Kommission* 51–2, 1–146.

Van der Sanden, W., 1996. *Through Nature to Eternity: the Bog Bodies of Northwest Europe*. Amsterdam: Batavian Lion International.

Walter, P., C. Louboutin & A. Hasler, 1997. Les stèles anthropomorphes de la Bastidonne: Trets (Bouches-du-Rhône) et l'usage de la couleur sur les stèles provençales de la fin du Néolithique. *Antiquités Nationales* 29, 27–33.

Wilson, P.J., 1988. *The Domestication of the Human Species*. New Haven (CT) & London: Yale University Press.

Chapter 3

Modes of Explanation for Prehistoric Imagery: Juggling Universalist, Historicist, and Contextualist Approaches in the Study of Early Figurines

Richard G. Lesure

To extract meaning from prehistoric imagery, archaeologists have experimented with several modes of explanation. Up through the mid-twentieth century, ambitious interpretations generally emphasized what I will call *grand historicism*: the tracing of historically particular peoples, practices, or beliefs across vast swathes of space and time. One thinks of the Mediterranean goddesses of James Mellaart (1967) or Marija Gimbutas's (1989; 1991) matrifocal Old Europe threatened by the patriarchal hordes. In the New World there was the Chavin-Olmec link propounded by Donald Lathrap (1974) or James Ford's (1969) title question about Formative cultures generally: diffusion or the psychic unity of man? That explanatory orientation came under attack in the later twentieth century with the flourishing of self-conscious theorization in processual and then postprocessual archaeology. Each of these championed a different explanatory mode. That of processualism I refer to as *universalist* since explanation involved constructs transcending particular cultures. Postprocessual approaches adopted instead a narrow historicism that I refer to as *contextualist* since it raised up particulars of individual contexts against both universalist and grand-historicist modes of explanation. By the end of the century, archaeology's kaleidoscope of interpretive practices had shifted once again, witnessing the re-emergence of grand historicism, in several guises (e.g. Sherratt 1995). In one prominent manifestation, it is framed as a scientific history that traces the movements of peoples and innovations through a conjunction of linguistic, genetic, and archaeological evidence (e.g. Bellwood 2005).

While the contextualist mode of explanation today reigns supreme in studies of early imagery, universalist argument has slipped only so far as the cracks beneath the surface. Focusing on the interpretation of early prehistoric ceramic figurines from different parts of the world, I draw a strand of universalism out into the open and subject it to the appropriate procedures of evaluation. I choose Earl Morss's (1954, 61) hoary but modestly elegant explanation for the 'parallel appearance of abundant clay gynecomorphs in the earliest agricultural and ceramic stages of culture'. Morss's model can be convincingly falsified. The results of that effort do not, however, support what I regard as the standard response, elevation of contextualism as the only legitimate explanatory mode. Instead, they demand that we reconsider the possibilities of a grand-historicist vision.

Explanation and rhetoric

In the 1980s and 90s, different modes of explanation were ascribed to mutually antagonistic approaches to knowledge. Today we are more inclusive. We all turn out to be simultaneously traditional, processual, and postprocessual, with a shared goal of exploring the human past. In a theoretical climate friendly towards multiple perspectives, we combine universalist, grand-historicist, and contextualist strands. But such interpretive promiscuity threatens to undermine the apparatus of empirical justification associated with each mode of explanation.

The universalist framework forged by processualists involves the deliberate creation of explanatory theory transcending any particular context. Propositions are evaluated through procedures of falsification in which individual cultures become test cases. In historicist approaches, explanation is specific to an individual case and the analytical goal is to show how a particular state of affairs emerges understandably from antecedent conditions. While grand-historicism and contextualism are both 'historicist' in this sense,

they operate at different spatial scales. As a result, they employ distinct constellations of analytical procedures. The narrow historicism of the contextualist mode emphasizes the conjoining of multiple lines of evidence from a single context to show how all point towards a particular interpretation. As the scale of historicist inquiry expands, this kind of total synthesis runs into information overload. Total syntheses at a grand-historicist scale tend to require the intuitive leaps of faith that led interpreters such as Gimbutas so far astray. Sound empirical justification in grand-historicist mode selects a manageable range of motifs or objects and examines in great detail their appearance across space and time (e.g. Nicholson 1976).

Each mode of explanation employed by those studying ancient figurines thus comes with its own procedures for justifying arguments. But if our arguments are actually a patchwork of explanatory modes, how do we justify them empirically? I propose embracing multiple frameworks of justification as tools of thought in building and assessing arguments. Each framework becomes a research tool applicable to those strands of argumentation for which it is designed (universalist, historicist, contextualist) without being put forward as the sole legitimate means of justification for all strands. We extract a strand from its place within a larger argument, subject it to the appropriate evaluative procedures, then return it — in modified form — to its place within the whole. Such procedures help open choice of explanatory mode to a healthy empirical scrutiny.

Identifying universalism

Interpretations of early imagery are not at first glance universalist. Most make no claims extending beyond a single context. But we cannot end our search there. Some time ago, Renfrew (1982, 20–22) pointed out that while archaeological writings are full of universalist language, explanations themselves are usually only quasi-universalist. Archaeologists formulate interpretations for application in a specific context, and they rarely go on to systematically evaluate universalist claims by testing them in other contexts. We might say that they take advantage of the plausibility of universalist rhetoric — its ability to convince — without fully assessing its validity. The charge seems as apt today as in 1982, particularly in domains such as the study of ancient imagery, where contextualism reigns supreme. What this rhetorical analysis suggests is that we need to look beyond overt cross-cultural analysis to consider logic that is universalist by *implication*.

At that point, the relevance of focusing on a seemingly arbitrary class of evidence like figurines becomes clear. From the contextualist standpoint, such a move reifies archaeological categories; 'figurines', can properly be understood only in relation to all other sources of evidence within a particular context. However, early figurines from different parts of the world are often simple. They tend to look vaguely alike, and their contexts of discovery can be quite similar as well. As a result, an explanation tailored to one context but weak in parameters unique to that context can be applied elsewhere. For instance, Marcus (1998, 311) argues that Formative figurines from the Valley of Oaxaca, Mexico 'were made by women' to provide 'a venue to which spirits of recent ancestors could return during ancestor rituals'. Figurines were female because 'it was the role of women to invoke their recent female ancestors' (Marcus 1998, 312). In a remarkably similar vein, Mabry (2003, 105) argues that Neolithic figurines from the Near East were related to the 'development of the female-domestic ritual sphere in which ancestor images were used to help remember genealogies and propitiate and communicate with recent female ancestors'.

Mabry has taken an implicitly universalist argument in Marcus's study and transported it to a new context. He frames his conclusions in explicitly universalist terms: 'in neolithic/formative communities around the world' a 'new importance of households and property inheritance encouraged the construction of ancestry' and a 'need to keep track of lineages,' leading to the propitiation of female ancestors, by women, in domestic settings, often using small figurines (Mabry 2003, 105). Whether Mabry is right or not, his rhetorical move exemplifies a widespread pattern. 'Transportable' strands of argument cannot be allowed to hide behind a contextualist façade. They are implicitly universalist and need to be evaluated as such.

Analysts often propose that figurines were ritual in purpose or, more specifically, that these were objects of household ritual in communities organized largely on the basis of kinship. Either way, more figurines means more ritual. Building on this line of thought, one explanation for the appearance of figurines is that they were a response to stress (Bolger 1996, 368; Talalay 1993, 48). Another possibility is that figurines were caught up in the negotiation of social relationships or struggles for power (Bailey 1996; Gopher & Orrelle 1996; Lesure 1997; Ikawa-Smith 2002, 351–2). Figurine-making is widely linked to the character of 'Neolithic' societies — to the appearance of agriculture, the investment of labour in fixed resources, or a broadly egalitarian ethos (a Campo 1994; Haaland & Haaland 1995; Mabry 2003). Finally, early figurines from many areas are regularly identified as female and their femaleness explained in universalist terms (as a reflection of the social importance of female

productive/reproductive labour; as an effort to ward off threats to the health of women or their progeny; or as a sign that the bodies, labour, or offspring of women were the subject of ideological struggle). The purported femaleness of figurines has come under attack (Ucko 1968), with particular intensity in the last decade (Hamilton 2000; Knapp & Meskell 1997). While identification of figurines as female is a theme in my discussion, I am less concerned with its validity than with making some general points concerning interpretation.

Evaluating universalist strands: Why Earl Morss?

Having identified universalist arguments lurking in the cracks of contextualist studies, my proposal is to pluck them out and subject them to evaluation as if they were full-blown universalist models. I am not ready to do this for today's most popular universalisms — that figurines were deployed in struggles for power or to propitiate ancestors. Instead, I focus on two themes that, if theoretically passé, are nevertheless still pervasive in the literature: 1) the idea that, in most cases, early figurines are mainly female; and 2) the suggestion that something about the early agricultural setting of these traditions explains the emphasis on femaleness.

To convert the themes of femaleness and early agriculture into a universalist model, we need go no further than Earl Morss (1954, 61), who wondered why there was a 'parallel appearance of abundant clay gynecomorphs in the earliest agricultural and ceramic stages of culture'. His explanation was two-pronged. First, people who mould clay into pots are likely to invent further ceramic arts to meet their other needs. Second, in small-scale agricultural societies, reproduction of the labour force is a pervasive concern and therefore fertility is a focus of cultic activity. To complete the logic of his argument, Morss assumed that femaleness stands universally for fertility. In sum, then, early agriculturalists made female figurines of clay because they were already making other things out of ceramic, they were worried enough about fertility to make it a focus of ritual, and femaleness provided a natural symbol for their object of concern. The thesis actually has a kind of elegance rare in functionalist arguments, since it addresses itself to something specific to the objects — that they are made of clay. This is the model I subject to evaluation as universalist argument.

Testing Morss's model

To evaluate Morss's thesis, we need to look for an association of early agriculture, early pottery, and female figurines across the globe. It is straightforward to operationalize agriculture and pottery for cross-cultural analysis. The third term of interest (figurines) is more difficult; I follow the spirit of Morss's formulation without agonizing over categories. 'Figurines' I take to be small clay sculptures typically under 20 cm in height. To identify 'femaleness' in imagery I have looked to the opinions of investigators from each region, taking note of ranges of opinion.

Of course, Morss's 'easy' link between fertility and images of femaleness seems unacceptable today (Conkey & Tringham 1995; Cyphers 1993; Ikawa-Smith 2002). The link, though, is necessary to the logic of the model. My solution is to treat it as an argument in need of empirical justification. Thus, other evidence of fecundity as a symbolic theme (besides 'femaleness') must also be present in the imagery for Morss's model to be supported. I consider: artistic emphasis on genitals; rounded bellies plausibly interpretable as pregnant; depictions of the act of birth; and depictions of adults holding children.

Agriculture, pottery, 'female' figurines, and plausible fertility symbolism thus constitute my primary set of observations. Nevertheless, two other points from Morss help round out the analytical agenda. First, clay gynecomorphs are not simply present; they are, he claims, 'abundant'. I return to that point below. Second, female figurines are not simply associated with agriculture and pottery but with *early stages* of agricultural economies and pottery production. Stage concepts refer to events that unfold independent of historical connections. The centrality of this notion of independence has helped make stages popular in universalist explanation. To evaluate them, independent occurrences need to be sorted from similarities derived from contact or shared histories. This sets an agenda for the evaluation of Morss's model. To resist the danger of basing universalist conclusions on an examination of historically linked cases, we should look to the earliest, truly independent occurrences of pottery and agriculture across the globe.

We immediately run into problems. The appearance of pottery and agriculture were far from perfectly coordinated. Japan had a long ceramic tradition in a social stage more 'Mesolithic' than Neolithic. In the Near East, an embarrassing 'Pre-Pottery' Neolithic lasted for thousands of years. In Middle America, plants were domesticated by mobile peoples in a ('Mesolithic') Archaic; the appearance of pottery corresponds more closely to the settled village life of the Formative. Such observations are clearly deeply problematic for Morss's thesis, but if we are deterred so early we will miss out on the potential insights. I decouple Morss's two criteria, looking for independent inventions of either pottery or agriculture.

Further notes on method

Morss's claim that gynecomorphs were 'abundant' in early agricultural/ceramic stages provides a basis for some clarifications of method. Clearly, a mere handful of figurines will not impress. We are not looking for isolated cases, but recurring patterns. That principle of recurrence can be applied not simply to numbers of figurines but also to *representational themes*. Our model suggests that if we assess iconographic/stylistic complexes for their most salient themes, femaleness and fertility should emerge as central. Thus, cases of plausible fertility symbolism should, like figurines themselves, be 'abundant'. I have therefore looked for figurine traditions in which numerous pieces display a coherent stylistic/iconographic complex. I have then identified the most salient stylistic or iconographic themes in that complex, with a particular eye to whether femaleness and fertility might be among them.

Agriculture, pottery, and gynecomorphs

There remains the critical step of selecting 'independent' cases to compare. Most cases present at least some interpretive dilemmas. Middle and South America, where a gap of thousands of years separates domestication of crop plants and emergence of agricultural village life, are a particular problem. I have decided to treat the Peruvian Andes, northern South America, Central America, and Mesoamerica as a single case of agricultural emergence, dubbed the Middle American macro-region. My final choice of cases shown in Figure 3.1 draws on Barnett & Hoopes (1995), Piperno & Pearsall (1998), Richerson *et al.* (2001), Smith (1995), and Bellwood (2005).

Four areas in which pottery technology emerged independently and before agriculture can be identified: the southern Sahara of Africa, parts of my Middle American macro-region, Japan, and parts of the North American Southeast. Of these, I consider the first three. Six areas in which agriculture emerged independently are: the Fertile Crescent of the Near East, the Yellow and Yangzi Rivers in China, the southern Sahara of Africa, the Middle American macro-region, eastern North America, and Highland New Guinea. Some would split the Chinese cases since crops are different in the north and south, but Bellwood (2005) lumps them and I follow suit for parallelism with my treatment of the Middle American macro-region. Of the six cases, I consider the first four.

Southern Sahara
During the Early Holocene, surface water in the Sahara, much of it in lakes, promoted sedentism among hunting and gathering groups, who fished and collected wild grains (Phillipson 1993, 107–29; Smith 1995, 106–10). Pottery first appeared here by the end of the eighth millennium BC, apparently a local invention (Close 1995). Over the following several millennia, indigenous plants (including millet and sorghum) were domesticated in a long belt across the continent. Cattle may well have been domesticated here from African stock, though sheep and goats were introduced from the Near East.

Figurines in this region are rare. Where they do appear, they are overwhelmingly zoomorphic (Gouletquer & Grébénart 1979; Smith 1980). Cattle are the predominant subject matter. The few anthropomorphic figurines are highly schematic and apparently unsexed; Gouletquer & Grébénart (1979, fig. 2) report 13 possible cases from two sites, Oroub and Eghazer, both in Niger. At Daima near Lake Chad, figurines of cattle appear in the lower levels, but anthropomorphic figurines appear later in the sequence (Connah 1981, 135–6). There are sporadic exceptions to these patterns in the Nile Valley, along the easternmost edge of this zone, where we might expect more contacts with the Near East.

Japan
Towards the close of the Pleistocene, hunter-gatherers in Japan became increasingly sedentary and invented pottery, creating an adaptation that persisted from 12,500 to 400 BC. It is referred to with a single label, Jomon. A definitive shift to rice agriculture occurred only with the Yayoi period (400 BC–AD 250).

Jomon is famous for its anthropomorphic clay figurines. Although two fragments are now known from the earliest subdivision of the period, placing their origins in the same time range as pottery, figurines are rare before 3500 BC (Ikawa-Smith 2002; Mitsukazu 1986). Thousands are known from the last three subdivisions of Jomon, but they are far from being evenly distributed in space. Many may be female based on the depiction of breasts. Still, one systematic assessment of 655 published illustrations found that 31 per cent lacked breasts (Ikawa-Smith 2002, 348).

Looking for evidence of fertility symbolism, we find some bulging bellies that might depict pregnancy. Occasionally, figurines hold babies. One piece is variously interpreted as a man with a penis or a woman in the act of giving birth (Ikawa-Smith 2002, 344). But the case for fertility beyond femaleness is slender. Instead, a spectacular degree of variation in body form and decorative elaboration of torsos is the predominant pattern. Jomon figurine artists were most concerned with stylizing the human form in dramatically different ways.

The long-term fate of the Jomon figural tradition is a surprise: it ended with the transition to an agri-

Figure 3.1. *Cases of independent emergence of agriculture and/or pottery to be considered in the evaluation of Morss's model.*

cultural economy in the Yayoi period. That outcome is obviously directly contrary to the Morss thesis. But even more striking here is the incredible span of time over which this tradition of making small clay images was transmitted. While there is plenty of internal variation across space and time, the tradition of image-making has coherence as a practice transmitted over 10,000 years (see also Mizoguchi this volume).

The Fertile Crescent
Domestication in the Levant was underway by the earliest Holocene, in the Pre-Pottery Neolithic A, or PPNA (10,000–8700 BC). Agricultural life based on an array of plants and animals (wheat and barley; sheep, goats, pigs, and cattle) was established throughout the Fertile Crescent during the following PPNB (8700–6800 BC). Pottery appeared later, during the seventh millennium BC.

Small anthropomorphic figurines appear in the earliest Neolithic villages, though animal imagery is sometimes numerically predominant (Cauvín 2000; Kuijt & Chesson 2004; Mabry 2003; Kuijt & Chesson this volume). Some of the Neolithic figurines are stone, but they are usually made of unfired or somewhat fire-hardened clay. They are fragile and often schematic. Frequency varies considerably.

The literature on early Near Eastern figurines refers to them over and over as female even when they are only vaguely human in form and not overtly sexed. Indisputably male figures (with phallus or beard) are rare. Schematic anthropomorphs are most numerous, but figurines sexed female by the depiction of breasts are regular finds across much of the Fertile Crescent. Female breasts are actually one of a set of recurring traits that also includes fleshy buttocks and thighs, a seated posture, a lack of artistic attention to the head, and an emphasis on overall bodily form rather than naturalistic detail. It is possible that schematic figures with just one of these traits (say, fleshy thighs) might have originally been identifiable as 'female'.

Hints of a fertility theme can be ferreted out. Some are singular, well-known pieces, such as the image of an 'enthroned' woman from Çatalhöyük said to be shown giving birth. In the Levant, there is a persistent occurrence of clay or stone phalli, and some apparently female figurines are claimed to have, overall, a phallic shape (e.g. McAdam 1997; Stekelis 1972). But claims of fertility symbolism are clumped in space and/or time. There is a high concentration from the Levant, but few in the Zagros Mountains. It seems plausible that fertility was *a* theme sometimes associated with figurines in the Neolithic of the Near East, but that it was not *the main* theme. Search for a more widespread stylistic/iconographic complex yields the set of traits (fleshy thighs, etc.) mentioned above. Those very attributes, which arguably include femaleness, have often been enlisted as support for fertility as a theme. The claim, however, is no more

Chapter 3

Figure 3.2. *The halo of anthropomorphic figurine-making around the Fertile Crescent (in gray) with sketches of figurines bearing some or all of the following traits: fleshy buttocks and thighs, a seated posture, female breasts, schematic heads, and an emphasis on overall bodily form over naturalistic detail. Figurines are rare in some of the areas included (Egypt, peninsular Italy) and in some places post-date the beginning of the Neolithic (Turkmenistan, Egypt, Sardinia). Although the thematic complex suggested by the sketches is widespread in time and space, its prominence fluctuates; in some places it is most clear late rather than early in the Neolithic sequence (e.g. central Anatolia). In some areas it is overwhelmed by other themes, such as stylistic variation and body decoration in the Balkans. (Dates are rough estimates in calendar years.)*

plausible than a variety of others that have been suggested — abundance, authority, or womanhood in general (Broman Morales 1990, 19; Voigt 2000, 288).

There is a final striking pattern here: Neolithic cultures surrounding the Fertile Crescent in most directions developed traditions of small anthropomorphic images in clay (or sometimes stone). In many of these cases, a complex of traits appears which is similar to that of the Fertile Crescent (Fig. 3.2). We find cases that fit this characterization to varying degrees to the east, along the Indus Valley (Jarrige 1991); to the north, in the Transcaucasus (Chataigner 1995, 185–7); to the west through Anatolia, on various Mediterranean islands, and across much of the Balkans (e.g. Gimbutas 1982; Talalay 1993); and, finally to the southwest along the Nile Valley (Midant-Reynes 2000, 155–8; Tristant 2004, 63). It is as if there was a halo of Neolithic traditions of figurine-making surrounding the Fertile Crescent. Within the halo the probability of occurrence of figurines is high; outside the halo, the probability drops off rapidly. The halo of figurine-making includes all the immediate areas to

which Near Eastern domesticates spread beginning in the PPNB, though figurines do not occur in the earliest Neolithic in all those areas (see Fig. 3.2).

Yellow and Yangtze rivers of China
Villages with subsistence based on millet emerged along the Yellow River by the late seventh millennium BC, while rice agriculture appeared on a similar horizon along the Middle Yangzi (Crawford & Shen 1998; Underhill 1997). Pottery appeared quite early in both agricultural cores (Underhill 1997). Despite a coincidence of Morss's two conditions, figural imagery is rare and the expected gynecomorphs are largely absent (Komoto & Imamura 1998; Yang 1988). Small ceramic or stone figurines, generally zoomorphic, are occasional finds. When people are represented they may be unsexed, or sexed male or female. Occasionally, there is phallic imagery. Each find, though, is virtually unique. Across much of China, there are no well-defined stylistic/iconographic complexes with abundant exemplars until the Late Neolithic.

A possible early exception is the Liao River region of northeast China, where there is anthropomorphic imagery in various scales throughout the Neolithic (Chang 1986; Komoto & Imamura 1998; Yang 1988). Even there, small figurines are hardly 'abundant'. Towards the end of the Neolithic, other well-defined complexes appear, including Shijiahe in the Middle Yangtze Valley (Komoto & Imamura 1998, fig. 1; Yang 1988, pls. 8–11) and Anban in Shanxi province (Komoto & Imamura 1998, fig. 10:14–23). Still, in early agricultural/ceramic settings in China, it is the general *absence* of figurine traditions that is striking.

Middle American macro-region
Evaluation of Morss's scheme in my Middle American macro-region — which includes Mesoamerica at its northern extreme and the Andes to the south — is complicated by the necessity of examining several plausible points in the Holocene sequence, each with different geographic foci. First is the appearance of pottery (before agriculture) on the lower Amazon during the sixth millennium BC (Roosevelt 1995) and its subsequent appearance across northern South America to Mexico. Second, there is the emergence of what Piperno & Pearsall (1998, 312–15) consider effective food production by still-mobile swidden farmers in lowland areas of northern South America and Central America (between the sixth and third millennia BC). Finally, there is the mosaic appearance of 'Formative' village life, typically involving sedentism, ceramics, and agriculture, beginning in the late fourth millennium with the Valdivia complex of coastal Ecuador (Piperno & Pearsall 1998, 313).

Figure 3.3. *Anthropomorphic figurine-making in the Middle American macro-region before 500 BC (in gray) with the locations of sites mentioned in the text. Figurines are abundant in Mesoamerica and coastal Ecuador. In Peru they are rare and appear to be primarily ceremonial in function (Burger this volume). Crude anthropomorphic figurines appear at Milagro and other sites in the Tucson Basin of Arizona in pre-ceramic contexts together with the earliest introduction of maize agriculture.*

The first two cases do not provide any support for Morss's model. Early pots in the Amazon and northern South America were occasionally adorned with zoomorphic effigies. The same pattern holds for early lowland swidden systems in Columbia, Panama, and Costa Rica. A single fire-hardened anthropomorphic figurine is known from a pre-ceramic context at Tlapacoya-Zohapilco in the Basin of Mexico (Niederberger 1976), raising the possibility that we are missing early traditions in unfired clay.

Anthropomorphic figurines do appear in Formative contexts, though the distribution of figurines is far from uniform (Fig. 3.3). Two areas stand out: coastal Ecuador, where abundant figurines are associated with the Valdivia complex, and Mesoamerica, where figurines are common across a large region for much of

Chapter 3

Figure 3.4. *Naturalistic attention to the head and face (sometimes verging on caricature) on figurines from Paso de la Amada on the coast of Chiapas, Mexico, 1500–1400 BC. (Photograph: Lesure.)*

the Formative. In both cases, figurines with modelled breasts are routinely identified as mainly female. Male figurines are rare but present. There are sometimes significant numbers of figures not obviously sexed; in Mesoamerica, the importance of this category varies by area and time period.

Evidence of fertility as a theme is scant. In the case of Valdivia, there is a debate over whether figurines depict females at several life stages from pre-pubescence to adulthood (DiCapua 1994) or, instead, a chaotic interplay of primary and secondary sexual attributes both female and male (Marcos & García 1988). Either way, 'fertility' does not capture the central themes ('sexuality' might do better). Among Formative figurines of Mesoamerica, depiction of genitals is rare, as is depiction of people holding babies. Possible depictions of pregnancy are more common (Cyphers 1993). Still, 'fertility' has not been a theme in interpretations for decades. In the widely separated cases of Chalcatzingo, San José Mogote, and Playa de las Muertos, depiction of females at multiple life stages has been suggested (Cyphers 1993; Marcus 1998; Joyce 2003, respectively). Youthfulness and beauty are identified as themes in both traditional (Coe 1965) and recent (Joyce 2000; 2003; Lesure 1997) interpretations.

As in the Near East, a widespread suite of stylistic/iconographic attributes can be identified. Though female breasts can be included, the suite in Mesoamerica is otherwise distinct from that of the Near East (Lesure 2002). It includes standing posture, a tendency towards naturalism rather than schematization in overall bodily form, and elaborate attention to the head and face that can yield either naturalism or strong stylization but not schematization (Figs. 3.4 & 3.5). Intriguingly, Valdivia figurines have certain affinities with this Mesoamerican suite. While faces are schematic, elaborate hairdos are important. As in Mesoamerica, figurines stand and the head is the centre of attention (Fig. 3.6). Certainly, interpretations of Valdivia figurines have followed paths similar to those trod by Mesoamericanists (there was a 'pretty lady' phase and more recently a multiple-life-stages trend). There are also some very specific similarities, such as two-headed female figurines in both Valdivia and central Mexico.

A second closing point can be made about the northern part of the Middle American macro-region.

The figurine-making traditions of Formative Mesoamerica have neighbors to the north, including a scattering of traditions in the American Southwest. Among the Southwestern traditions are the Hohokam figures that one grand-historicist found to be 'obviously crude imitations of the Mesoamerican Formative examples' (Ford 1969, 81; see also Haury 1976). Hohokam figurines are preceded by crude anthropomorphic figures in the earliest agricultural settlements of southern Arizona around 1100 BC (Huckell 1995, 13; Mabry 1999). Still, the occurrence of figurines in the Southwest is highly variable. The area seems to form a northern boundary for traditions of making abundant, plausibly female figurines in an 'early agricultural stage'.

Results

As I pointed out at the outset, a conjunction between agriculture and pottery, a central tenet of Morss's model, cannot be preserved. If we nevertheless disarticulate those two supposed causes, we do find cases in which anthropomorphic figurines, often plausibly female, were associated with independent appearances of pottery (Jomon Japan) or of agriculture (PPN Near East) or both (Formative coastal Ecuador and Mesoamerica). In the southern Sahara and along the Yangtze and Yellow Rivers, results were negative. In the former case, figurines are zoomorphic while in the latter, early figurine traditions are basically absent. Anthropomorphic figurines are also absent in the earliest pottery-making traditions of the Middle American macro-region. The identification of 'independent' cases is somewhat complicated by the diffuse pattern of Formative transitions in the Americas, and one might be tempted to let Morss have fifty per cent positives. From the standpoint of agriculture, however, the putative positive of Jomon Japan becomes distressingly negative, since figurines disappeared with the introduction of rice farming. When we look at independent cases across the globe, traditions of 'female' figurines are *not* reliably associated with early agriculture and/or pottery.

Further, evidence for fertility as a symbolic theme is present only in very low frequency or spottily distributed in space or time. Other sorts of themes are more prominent — schematization, obesity and a seated posture in the Near East; stylistic variation in Japan; emphasis on the head in Mesoamerica and Ecuador. Fertility was no more than a localized, intermittent, or secondary theme among whatever messages were conveyed by figurines. That finding deals a third blow to the agriculture-pottery-gynecomorph thesis.

The apparatus of falsification developed in the universalist explanatory tradition, applied to early figurines, prompts us to conclude that Morss was wrong. In only a few independent cases were traditions of 'female' figurines associated with early agriculture and/or the manipulation of clay for practical purposes. Further, in those cases where figurines do appear, the only way to argue for 'fertility' as a central theme is to accept the essentialist argument that 'femaleness' always equals 'fecundity'.

Grand historicism — with trepidation

A universalist model explaining figurines as a functional correlate of agricultural village life has little prospect for success. Though few interpretations are so ambitious today, evaluation of Morss's model was not an end in itself but one step in a rhetorical analysis that also implicated strands of universalist logic as brief as mere sentences. The results cast suspicion on all generic appeals to the 'condition' of early agricultural societies in interpretations of figurines, even when those are embedded in overtly contextualist accounts. Clearly, we need to draw on universalist logic with care, lest it sink to the level of 'mere rhetoric'.

Still, it would be inappropriate to conclude that contextualism is the sole legitimate mode for explanation of figurines. Such a conclusion might have been supported if there had been no observed patterning across world areas — for example, if figurine-making traditions had appeared and disappeared seemingly at random. But those were not the results. While the proposed universalist model was not supported, strong patterning was in fact observed, signalled by those findings flagged as 'startling': the longevity of figurine-making in Jomon Japan, the vast halo of figurine-making around the Fertile Crescent, similarities between central themes in Valdivia and Mesoamerica, the extension of figurines from Mexico to the American Southwest, even the absence of Neolithic figurines along the Yangtze and Yellow Rivers. Where figurines appear, the tradition tends to persist — however shifting or intermittent in the details — for thousands of years. Where figurines do not appear, this absence is equally persistent. What we gain from the falsification of Morss's thesis is thus the recognition that figurine-making is highly clumped into macro-units of space and time.

From the world-wide perspective, it is that grand-historicist observation rather than universalism that seems the most promising line of inquiry for explanatory strands extending beyond individual contexts. We can even glimpse fragments of specific grand-historicist storylines. We find figurines in the Early Neolithic of the Near East, including schematic, fleshy, seated anthropomorphs. We then find a strong

Chapter 3

Figure 3.5. *Stylized attention to the head and face on figurines from Amomoloc, central Tlaxcala, Mexico, 800–600 BC. (Drawings: a,d,e - Jeremy Bloom; b - Amy Carroll; c - Laura Baker.)*

Figure 3.6. *Depiction of elaborate hairdos on Valdivia figurines from Real Alto, coastal Ecuador, 3000–2600 BC. (Drawings by Lesure of figurines at the Complejo Cultural Real Alto, Ecuador.)*

tendency towards the manufacture of anthropomorphic figurines — often with a similar specific thematic suite — in many of the immediate areas to which Near Eastern domesticates were disseminated (though see Fig. 3.2 caption). Was figurine-making at least sometimes disbursed with cultigens, either through the movement of people or ideas? The suggestion echoes recent grand-historicist interest in the expansion of agricultural peoples from the Fertile Crescent. That grand-historicist narrative is itself a strand in a more ambitious 'scientific history' that harnesses grand-historicism to a universalist agenda by tracing demic expansions of early agriculturalists worldwide (Bellwood 2005). Are we on the verge of another universalist scheme for figurines? No. There are elements of similarity between the Middle American macro-region and what I suggest for the Near East, particularly the possible transfer of figurine-making with maize agriculture from Mesoamerica to the American Southwest (Huckell 1995, 13). Still, the situation from Mesoamerica south is murkier. Similarities between Mexico and Valdivia are offset by intervening areas 'empty' of anthropomorphic figurines and anthropomorphic imagery in Peru appears to have different roots altogether (see Burger this volume). Agriculture and figurine-making have their own complex histories across the Middle American macro-region. The Jomon case further reinforces the fundamentally historicist dimensions of the problem. There, figurine-making (see Mizoguchi this volume)

was replaced, upon the introduction of agriculture, with a new practice: the not-making of figurines. Association of agriculture and figurines turns out to be fortuitous, a particular of individual sequences. What unites these three cases is that, in each, figurine-making was part of a larger tradition of beliefs and practices, the fate of which was determined by historically specific factors.

I make these suggestions with the same 'trepidation' with which Miller (2002, 232) identifies the subject matter of Yarmukian figurines (Levant, Pottery Neolithic) as 'the Matron of the Yarmukian people'. When I embarked on this work, I anticipated reaching some sort of nuanced interplay between contextualism and universalism. But it is to historicism, with all its problematic baggage, that the evidence points. I am certainly not advocating a return to Gimbutas, Mediterranean Goddesses, and the like. I am also not suggesting that contextualism be displaced from its position as a primary explanatory reference point. I am suggesting that the grand-historicist dimensions of our subject demand attention. The Mediterranean Goddess has been persistent in figurine studies because the evidence coheres at that scale (Fig. 3.2). She cannot be done away with by an embrace of pure contextualism. Instead, She needs to be replaced by new grand-historicist syntheses.

What would such syntheses look like? I suspect that the notion of shared *belief* — so central to Goddess formulations — will not be particularly useful. Disjunctions between belief and form — including radical transformation of belief associated with constant form — are well known. Homogeneity of belief — correspondences between historical deities in different Near Eastern and Mediterranean societies, for instance — may often have been a late rather than early development, a result of ongoing contacts. I suspect that it is more productive to locate historical links in transmitted *practices*. Such a formulation obviously does not explain the longevity or distribution of figurine-making as a practice, but I leave that problem to another occasion.

Conclusions

Most studies of early imagery are overtly contextualist, claiming that it is properly explained by parameters unique to one spatiotemporal context. Much of the discussion in such studies is in fact contextualist. Still, careful inspection reveals that other modes of explanation are regularly woven into contextualist tapestries. In particular, universalist argument continues to be important. While few studies set out explicitly to build and test universalist explanations for early imagery, interpreters regularly resort to arguments that are universalist by implication. For instance, one might claim that 'the very experiences, anxieties, and wishes of everyday life would have inspired the themes and aesthetics of Neolithic idoloplastic' or that 'in early farming communities, reproduction and maternity could be metaphorically parallel to agriculture, both phenomena consisting in the dramatic transformation of natural elements into life by human ... interference' (Kokkinidou & Nikolaidou 1997, 93–6). My impression, based on a perusal of numerous studies from different world areas, is that such universalist strands often have some importance to the overall logical coherence of any given contextualist argument.

In other words, interpreters of figurines regularly draw on multiple modes of explanation. I see nothing inherently wrong with such a practice. Still, it creates challenges for empirical justification, especially when scholars rely on a single framework of evaluation, such as the contextualist approach of conjoining all evidence from a single context. That framework is effective in producing empirically grounded interpretive statements in contextualist mode, but it is of no help in assessing implicit universalisms. As a result, universalist strands are perpetuated if they 'sound good' and plausibly conform to evidence in a given context; their universalist dimensions are not assessed.

One solution to this dilemma would be to explicitly identify the multiple explanatory modes that make up interpretations of prehistoric figurines. We could then isolate strands of argumentation in each mode and evaluate those strands according to procedures appropriate to that mode. The present paper constitutes a kind of experiment with such an approach. I have considered a universalist claim that is rarely stated ambitiously or explicitly these days but which is easy to identify as an implicit logical strand in the interpretation of prehistoric imagery from all over the globe: the idea that it was a functional response to the conditions of early agricultural life. Empirical patterns do not support such a formulation when it is subjected to appropriate procedures of evaluation; my results would recommend vigilance against it even as an implicit universalism. Although the universalist model was falsified, that effort yielded a challenge to unadulterated contextualism from what these days, in the aftermath of the processual/postprocessual squabbles, seems an unexpected direction. To the distress of the contextualist, there is patterning to early traditions of image-making at very large scales of space and time — but to the embarrassment of the universalist, that patterning appears most amenable to explanation in the grand-historicist mode. While grand-historicism should not replace the primacy of contextualism, we

might experiment with redirecting some of our universalist rhetoric ('the anxieties of everyday life would have inspired Neolithic figurine-making') towards historicism at scales beyond the particular. We should also, though, be prepared to evaluate such claims in explicitly historicist terms, with an analytical framework appropriate to that interpretive mode.

Acknowledgements

I would like to thank the participants at the Image and Imagination symposium as well as all the many people who advised me about different areas of the globe. The latter included Elizabeth Carter, Paola Demattè, Ernestine Elster, Rowan Flad, Steven LeBlanc, Monica Smith, and Willeke Wendrich. My gross errors of fact and interpretation obviously remain my own responsibility. I gratefully knowledge Jorge Marcos, Mariella García, and the Complejo Cultural Real Alto (CEAA, Escuela Politécnica del Litoral, Guayaquil) for permission to examine Valdivia figurines from Real Alto.

References

a Campo, A.L., 1994. *Anthropomorphic Representations in Prehistoric Cyprus: a Formal and Symbolic Analysis of Figurines, c. 3500–1800 BC.* Jonsered: Paul Åströms Förlag.

Bailey, D., 1996. The interpretation of figurines: the emergence of illusion and new ways of seeing. *Cambridge Archaeological Journal* 6(2), 291–5.

Barnett, W.K. & J.W. Hoopes (eds.), 1995. *The Emergence of Pottery: Technology and Innovation in Ancient Societies.* Washington (DC): Smithsonian University Press.

Bellwood, P., 2005. *First Farmers: the Origins of Agricultural Societies.* Oxford: Blackwell.

Bolger, D., 1996. Figurines, fertility, and the emergence of complex society in prehistoric Cyprus. *Current Anthropology* 37(2), 365–73.

Broman Morales, V., 1990. *Figurines and Other Clay Objects from Sarab and Çayönü.* (Oriental Institute Communications 25.) Chicago (IL): The Oriental Institute of the University of Chicago.

Cauvín, J., 2000. *The Birth of the Gods and the Origins of Agriculture,* trans. T. Watkins. Cambridge: Cambridge University Press.

Chang, K., 1986. *The Archaeology at Ancient China.* 4th edition. New Haven (CT): Yale University Press.

Chataigner, C., 1995. *La Transcaucasie au Néolithique et au Chalcolithique.* (British Archaeological Reports International Series 624.) Oxford: BAR.

Close, A.E., 1995. Few and far between: early ceramics in North Africa, in *The Emergence of Pottery: Technology and Innovation in Ancient Societies,* eds. W.K. Barnett & J.W. Hoopes. Washington (DC): Smithsonian University Press, 23–37.

Coe, M.D., 1965. *The Jaguar's Children.* New York (NY): Museum of Primitive Art.

Conkey, M.W. & R.E. Tringham, 1995. Archaeology and the Goddess: exploring the contours of feminist archaeology, in *Feminisms in the Academy,* eds. D.C. Stanton & A.J. Stewart. Ann Arbor (MI): The University of Michigan Press, 199–247.

Connah, G., 1981. *Three Thousand Years in Africa: Man and His Environments in the Lake Chad Region of Nigeria.* Cambridge: Cambridge University Press.

Crawford, G.W. & C. Shen, 1998. The origins of rice agriculture: recent progress in East Asia. *Antiquity* 72, 858–66.

Cyphers, G.A., 1993. Women, rituals, and social dynamics at ancient Chalcatzingo. *Latin American Antiquity* 4(3), 209–24.

DiCapua, C., 1994. Valdivia figurines and puberty rituals. *Andean Past* 4, 229–79.

Ford, J.A., 1969. *A Comparison of Formative Cultures in the Americas: Diffusion or the Psychic Unity of Man.* (Smithsonian Contributions to Anthropology 11.) Washington (DC): Smithsonian Institution Press.

Gimbutas, M., 1982. *The Goddesses and Gods of Old Europe, 6500–3500 BC: Myths and Cult Images.* New and updated edition. London: Thames and Hudson.

Gimbutas, M., 1989. Women and culture in goddess-oriented Old Europe, in *Weaving the Visions: New Patterns in Feminist Spirituality,* eds. J. Plaskow & C.P. Christ. San Francisco (CA): Harper and Row, 63–71.

Gimbutas, M., 1991. *The Civilization of the Goddess: the World of Old Europe.* San Francisco (CA): Harper San Francisco.

Gopher, A. & E. Orrelle, 1996. An alternative interpretation for the material imagery of the Yarmukian, a Neolithic culture of the sixth millennium BC in the southern Levant. *Cambridge Archaeological Journal* 6(2), 255–79.

Gouletquer, P. & D. Grébénart, 1979. Figurines en terre cuite du Néolithique de la région d'Agadez (République du Niger). *Bulletin de la Société Préhistorique Française* 76(3), 91–6.

Haaland, G. & R. Haaland, 1995. Who speaks the goddess's language? Imagination and method in archaeological research. *Norwegian Archaeological Review* 28, 105–21.

Hamilton, N., 2000. Ungendering archaeology: concepts of sex and gender in figurine studies in prehistory, in *Representations of Gender from Prehistory to the Present,* eds. M. Donald & L. Hurcombe. New York (NY): St Martin's Press, 17–30.

Haury, E.W., 1976. Figurines and miscellaneous clay objects, in *The Hohokam: Desert Farmers and Craftsmen.* Tucson (AZ): University of Arizona Press, 255–72.

Huckell, B.B., 1995. *Of Marshes and Maize: Preceramic Agricultural Settlements in the Cienega Valley, Southeastern Arizona.* (Anthropological Papers, University of Arizona 59.) Tucson (AZ): University of Arizona Press.

Ikawa-Smith, F., 2002. Gender in Japanese prehistory, in *In Pursuit of Gender: Worldwide Archaeological Approaches,* eds. S.M. Nelson & M. Rosen-Ayalon. Walnut Creek (CA): Altamira Press, 323–54.

Jarrige, C., 1991. The terracotta figurines from Mehrgarh, in *Forgotten Cities on the Indus: Early Civilization in*

Pakistan from the 8th to the 2nd Millennium BC, eds. M. Jansen, M. Mulloy & G. Urban. Mainz: Verlag Philipp von Zabern, 87–93.

Joyce, R.A., 2000. *Gender and Power in Prehispanic Mesoamerica*. Austin (TX): University of Texas Press.

Joyce, R.A., 2003. Making something of herself: embodiment in life and death at Playa de los Muertos, Honduras. *Cambridge Archaeological Journal* 13(2), 248–61.

Kidder, J.E. Jr, 1957. *The Jomon Pottery of Japan*. (Artibus Asiae Supplementum 17.) Ascona (Switzerland): Artibus Asiae.

Knapp, A.B. & L. Meskell, 1997. Bodies of evidence on prehistoric Cyprus. *Cambridge Archaeological Journal* 7(2), 183–204.

Kokkinidou, D. & M. Nikolaidou, 1997. Body imagery in the Aegean Neolithic: ideological implications of anthropomorphic figurines, in *Invisible People and Processes: Writing Gender and Childhood into European Archaeology*, eds. J. Moore & E. Scott. New York (NY): Leicester University Press, 88–111.

Komoto, M. & Y. Imamura, 1998. Corpus of the stone and earthen figurines in prehistoric East Asia, in *Prehistoric Cultures of the Circum East China Sea Area*, ed. M. Komoto.

Kuijt, I. & M.S. Chesson, 2004. Lumps of clay and pieces of stone: ambiguity, bodies, and identity as portrayed in Neolithic figurines, in *Archaeologies of the Middle East: Critical Perspectives*, eds. S. Pollock & R. Bernbeck. Oxford: Blackwell, 152–83.

Lathrap, D.W., 1974. The moist tropics, the arid lands, and the appearance of great art styles in the New World, in *Art and Environment in Native America*, eds. M.E. King & I.R. Traylor, Jr. (Special Publications of the Museum.) Lubbock (TX): Texas Tech University, 115–58.

Lesure, R.G., 1997. Figurines and social identities in early sedentary societies of coastal Chiapas, Mexico, 1550–800 BC, in *Women in Prehistory: North America and Mesoamerica*, eds. C. Claassen & R.A. Joyce. Philadelphia (PA): University of Pennsylvania Press, 225–48.

Lesure, R.G., 2002. The Goddess diffracted: thinking about the figurines of early villages. *Current Anthropology* 43(4), 587–610.

Mabry, J.B., 1999. Changing concepts of the first period of agriculture in the southern Southwest. *Archaeology Southwest* 13(1), 3.

Mabry, J.B., 2003. The birth of the ancestors: the meaning of human figurines in the Near Eastern Neolithic villages, in *The Near East in the Southwest: Essays in Honor of William G. Dever*, ed. B.A. Nakhai. (The Annual of the American School of Oriental Research 58.) Boston (MA): American School of Oriental Research, 85–116.

Marcos, J.G. & M. García [de Manrique], 1988. De la dualidad fertilidad-virilidad a lo explicitamente femenino o masculino: la relación de las figurinas con los cambios en la organización social Valdivia, Real Alto, Ecuador, in *The Role of Gender in Precolumbian Art and Architecture*, ed. V. Miller. Lanham (MD): University Press of America, 35–51.

Marcus, J., 1998. *Women's Ritual in Formative Oaxaca: Figurine-Making, Divination, Death, and the Ancestors*. (Prehistory and Human Ecology of the Valley of Oaxaca 11.) Ann Arbor (MI): University of Michigan Museum of Anthropology.

McAdam, E., 1997. The figurines from the 1982–5 seasons of excavations at Ain Ghazal. *Levant* 29, 115–45.

Mellaart, J., 1967. *Çatal Hüyük: a Neolithic Town in Anatolia*. London: Thames and Hudson.

Midant-Reynes, B., 2000. *The Prehistory of Egypt: from the First Egyptians to the First Pharoahs*. Oxford: Blackwell.

Miller, M.A., 2002. The function of the anthropomorphic figurines: a preliminary analysis, in *Sha'ar Hagolan*, vol. 1: *Neolithic Art in Context*, eds. Y. Garfinkel & M.A. Miller. Oxford: Oxbow Books, 221–33.

Mitsukazu, N., 1986. Clay figurines and Jomon society, in *Windows on the Japanese Past: Studies in Archaeology and Prehistory*, eds. R.J. Pearson, G.L. Barnes & K.L. Hutterer. Ann Arbor (MI): University of Michigan Center for Japanese Studies, 255–65.

Morss, N., 1954. *Clay Figurines of the American Southwest*. (Papers of the Peabody Museum of American Archaeology and Ethnology 49(1).) Cambridge (MA): Harvard University.

Nicholson, H.P., 1976. Preclassic Mesoamerican iconography from the perspective of the postclassic: problems in interpretational analysis, in *Origins of Religious Art and Iconography in Preclassic Mesoamerica*, ed. H.B. Nicholson. Los Angeles: UCLA Latin American Center Publications, 158–75.

Niederberger, C., 1976. *Zohapilco: Cinco Milenios de Ocupación Humana en un Sitio Lacustre de la Cuenca de México*. Mexico City: Instituto Nacional de Antropología e Historia.

Phillipson, D.W., 1993. *African Archaeology*. 2nd edition. Cambridge: Cambridge University Press.

Piperno, D.R. & D.M. Pearsall, 1998. *The Origins of Agriculture in the Lowland Neotropics*. San Diego (CA): Academic Press.

Renfrew, C., 1982. Explanation revisited, in *Theory and Explanation in Archaeology: the Southampton Conference*, eds. C. Renfrew, M.J. Rowlands & B.A. Segraves. New York (NY): Academic Press, 5–23.

Richerson, P.J., R. Boyd & R.L. Bettinger, 2001. Was agriculture impossible during the Pleistocene but mandatory during the Holocene? A climate change hypothesis. *American Antiquity* 66(3), 387–412.

Roosevelt, A.C., 1995. Early pottery in the Amazon: twenty years of scholarly obscurity, in *The Emergence of Pottery: Technology and Innovation in Ancient Societies*, eds. W.K. Barnett & J.W. Hoopes. Washington (DC): Smithsonian University Press, 115–31.

Sherratt, A., 1995. Reviving the grand narrative: archaeology and long-term change. *Journal of European Archaeology* 3(1), 1–32.

Smith, A.B., 1980. Domesticated cattle in the Sahara and their introduction into West Africa, in *The Sahara and the Nile: Quaternary Environments and Prehistoric Occupation in Northern Africa*, eds. M.A.J. Williams & H. Faure. Rotterdam: Balkema, 489–501.

Smith, B.D., 1995. *The Emergence of Agriculture*. New York

(NY): Scientific American Library.

Stekelis, M., 1972. *The Yarmukian Culture of the Neolithic Period*. Jerusalem: Magnes Press, Hebrew University.

Talalay, L.E., 1993. *Deities, Dolls, and Devices: Neolithic Figurines from Franchthi Cave, Greece*. Bloomington (IN): Indiana University Press.

Tristant, Y., 2004. *L'habitat prédynastique de la Vallée du Nil: Vivre sur les rives du Nil aux Ve et IVe millénaires*. (British Archaeological Reports International Series 1287.) Oxford: BAR.

Ucko, P.J., 1968. *Anthropomorphic Figurines of Predynastic Egypt and Neolithic Crete with Comparative Material from the Prehistoric Near East and Mainland Greece*. (Royal Anthropological Institute Occasional Papers 24.) London: Andrew Szmidla.

Underhill, A.P., 1997. Current issues in Chinese Neolithic archaeology. *Journal of World Prehistory* 11(2), 103–60.

Voigt, M.M., 2000. Çatal Höyük in context: ritual at early Neolithic sites in central and eastern Turkey, in *Life in Neolithic Farming Communities: Social Organization, Identity, and Differentiation*, ed. I. Kuijt. New York (NY): Plenum, 253–93.

Yang, X., 1988. *Sculpture of Prehistoric China*. Hong Kong: Tai Dao Publishing.

Section B

Avenues of Interpretation

Chapter 4

Art, Language and the Evolution of Spirituality

Robert Layton

Spirituality is a sophisticated phenomenon, and anthropologists have long struggled to do justice to the religions and beliefs of exotic cultures (classic examples include Tylor 1871 [1958]; Durkheim 1915 and Evans-Pritchard 1937). The problem of translating discourse in the idiom of other cultures has been well explored by the 'Writing Culture' school of anthropology in the U.S. (Clifford & Marcus 1986). I have argued elsewhere (Layton 1995b; 1997; 2001) that the Hermeneutic and Pragmatist traditions in philosophy provide some guidelines as to how the problems of translating culture may be minimized (see Puttnam 1995; Quine 1960; Schutz 1972). By living with members of what is to us an exotic community we can enter into dialogue, and make some attempt to understand the world in their terms. In a living tradition mistakes can be corrected and we can to some extent identify what people are talking about by means of the references their discourse makes to shared experience. Among the language universals identified by Wierzbicka (1996) are words equivalent to 'the same', 'other/else', 'like' (i.e. similar to) and 'because'; all modern human cultures recognize figures of speech such as simile and metaphor, and all recognize relationships of cause and effect, even if a relationship that one culture regards as cause and effect ('because') may be regarded by another as a figure of speech ('like'). As the anthropologist and his instructor stand in a desert landscape, the indigenous instructor's explanations of cause and effect and similitude between referents such as rocks, people and animals that they can both see give the anthropologist some insight into possible, but unfamiliar worlds. 'That rock right there is my father.' 'When I rub that rock I make plenty of pythons' (see Layton 1995a). The greatest difficulty, as Evans-Pritchard noted in his 1937 study of Azande witchcraft, lies in trying to match experiences in the exotic culture with those in our own after fieldwork is over, so as to translate our field experiences into a comprehensible ethnography. Terms such as *magic* and *animism* have associations peculiar to our own culture and do not seem to do justice to field experience. Despite such problems of translation, language is indispensable in conveying spiritual beliefs.

Even within a single community, however, meaning is constantly negotiated. Anthropologists now appreciate that 'culture' is not a monolithic collective consciousness in which every member of the community is equally immersed. The French Structuralist Durkheim (1915) advocated the concept of the collective consciousness. Bourdieu (1977) objected that structural analysis in the Durkheimian tradition tends to render variation in individual performances as deviations from an unwritten score (culture) that is, in fact, an artificial construct built by the analyst. Bourdieu devised the concept of *habitus* to bridge structure and action. Each individual internalizes what they understand to be the way that meanings and values are organized in their community, and then express that understanding through their own actions. *Habitus* is the individual's reconstruction of rules and tactics deduced from others' actions. Each person's *habitus* can be seen as a structural variant of those learned by other members of the community. Artists learn how to read the style and iconography of existing performances and use that knowledge to create new performances within the cultural idiom. These new works are in turn 'read' by an audience, whose expectations are shaped by their experiences. Where artist and audience share a similar habitus, readings will be more or less consistent, but we cannot assume this. The degree of consistency of readings needs to be verified and explained through fieldwork. Fieldwork shows the relationship between art, language and spirituality to be a complex one, and this needs to be kept in mind when assessing potential archaeological evidence.

For communication to succeed, however, each participant must share similar, if not identical, understandings of each other's intended meanings.

Studies from Australia show that when, for example, native people are confronted with a rock painting produced within their own cultural tradition by artists of previous generations, they typically rely on their knowledge of iconography, style and placement in the landscape to deduce probable or best-guess interpretations of the painting's significance. Iconography and placement in the landscape make reference to objects such as animals and places but people may debate whether a painting depicts a kangaroo or a cockatoo, and whether it is painted at a sacred site or a traditional camp site. Style typically makes reference to alternative, but familiar discourses: paintings of ancestral beings will be painted in a different style to sorcery paintings or records of everyday life (e.g. Merlan 1989; Mulvaney 1996; Layton 1995b).

Mulvaney's (1996) case study comes from the Keep River region, in the monsoon zone of northern Australia. His paper documents the recollections of elderly Aboriginal people concerning rock art produced by members of their parents' generation between the 1920s and 1940s. The paper describes paintings in seven shelters and deals only with paintings attributed to named people who were witnessed painting by Mulvaney's instructors.

Several categories of rock painting were recognized, of which the first was sorcery painting. The father of one instructor had produced two sorcery paintings to kill his first wife and the man she had run off with. The choice of site and materials was important but based on restricted knowledge (see Mulvaney 1996, 9 and addendum). The second category consists of ancestral and legendary beings. Ancestral figures are usually larger than other paintings. Records of quotidian/everyday events were also identified. In one shelter containing an ancestral figure a large number of smaller and rather crude figures of goannas were painted to record a very successful hunt; they were cooked and eaten in that very rock-shelter. Mulvaney provides some information on the kind of contextual clues that help to reduce potential uncertainty. Most importantly, painting was only ever practised within one's own clan territory. Coupled with the tendency to depict ancestral beings at sites they created during their journeys, this circumscribes potential interpretation.

Similar inferences were drawn by Merlan's Wardaman instructors at sites that they had been prevented from visiting for many years by local cattle ranchers. Clan totemism is a territorial system, and paintings of totemic ancestors are an assertion of control over the land of the clan estate. Wardaman interpretation of rock art rests fundamentally on the distinction between *buwarraja* (Dreaming) and man-made *bulawula* (drawings) or engravings (Merlan 1989, 16). The central part of Merlan's paper describes a disagreement that arose over the interpretation of engravings at sites near Yingalarri (Ingaladdi). The little-known sites were discussed in terms of certain conventions, especially relationship to known Dreaming sites nearby and the patriclan affiliation of the surrounding country, which both limit the number of possible interpretations and identify particular people as best authorised to make an interpretation.

The Australian case studies show that not all north Australian rock art is totemic, and that indigenous people rely on cues such as subject, size and style to discriminate between secular and totemic art. Even in regions where rock art is demonstrably associated with shamanism, not all rock art is necessarily shamanic. Records of the significance of rock art in the Stein River Valley of British Columbia, in the territory of the 'Nlaka'pamux, were obtained in the late nineteenth and early twentieth century by Harlan Smith and Teit. Harlan Smith was a member of the American Museum of Natural History's Jesup North Pacific expedition, led by Franz Boas.

In the early twentieth century Teit interviewed native people in British Columbia, including two 'Nlaka'pamux elders from the Stein River district, about rock art (Teit 1918). Some artists were still alive at that time (Teit 1918, 4). Teit recorded several motives for rock painting. He learned that,

> at the expiration of the training (or sometimes also during the same if they had any vision or experience considered extraordinary or especially important) the novice painted pictures on cliffs or boulders … By writing these things on the rocks the novice hoped to facilitate the acquisition of power and make it stronger and more permanent: people usually made their paintings in secret and alone (Teit 1918, 1–2).

Harlan Smith was shown the rock-shelter at 'Nzikzak'wxn by his 'Nlaka'pamux guide, who said it was a place where boys and girls went to fast during the puberty rituals. Harlan Smith was told that Ts'ets'ékw, a second site, is a place where girls washed with fir branches during their puberty ceremonies.

Teit and Harlan Smith's information is supported by what we were told, during a September 2002 conference organized by Jim Keyser, about paintings on an island in the Columbia River made by adolescents during their spirit quest (Layton 2006). Yet Teit also recorded other reasons for painting. Paintings were occasionally made to ward off disaster foreseen in a dream. Paintings of guardian spirits were painted near camps or overlooking walking routes, to deflect enemies or evil. Some paintings were historical records, for example, at sites of battles. The largest and oldest paintings were 'pictures made and shown by the mys-

teries, or powers, or spirits of the places where they are to be seen' (Teit 1918, 4). Sooner or later all adults achieved the spirit quest, but few went on to become professional shamans. It may seem trivial to insist that the initiation of children is not shamanism but, while guides showed early researchers two rock-art sites in the Stein Valley where young people trained, they did not show them the largest rock-art site in the valley, nearby, which oral tradition today says was 'associated with the activities of Indian doctors' (York *et al.* 1993, 114). The distinction was evidently important to them. It takes four years to train to become a shaman in the area of the Stein Valley. The Chinook people who elucidated Columbia River rock art for us insisted that a professional shaman would paint or engrave his art in a secret location for fear that a rival shaman might destroy it and thus deprive the first of his power.

In recent reconstructions of the prehistory of spirituality, shamanism has been advocated as the first religion (Clottes & Lewis-Williams 1996; Ouzman 1998). As argued in previous papers (e.g. Layton 2000), I consider it simplistic to suppose that the prehistoric cave art of Europe can simply be characterized as 'totemic' or 'shamanic'. Rather, the art should be analysed for the kind of variability that is pertinent in ethnographic traditions. One feature of French and Spanish cave art that stands out is the presence of two styles: those of the animal art and the geometric signs. While the same animals (horse, bison, deer) typically occur in relatively constant frequencies in many caves some 'signs', such as members of the class of large, rectangular tectiforms, appear to be specific to particular sites while others, such as claviforms, are more ubiquitous. Do we here see the shadow of two or more discourses in Upper Palaeolithic culture? Do signs make reference to place in a different fashion to the animal art? Ethnographic cases suggest that shamanic and totemic art, and records of everyday foraging, are characterized by different frequencies of animal species within and between sites (Layton 2000). I do not, personally, find the case for either totemism or shamanism in the Upper Palaeolithic completely convincing, but I do believe that we will only approach possible readings of the art by detecting a repeated structure in the outward expression of ideas, and seeking to match the possible world of the Upper Palaeolithic with other possible worlds that have existed among similar societies in the recent past. Such parallels will, however, always be inexact.

Spirituality

What can we learn from this review of the interpretation of rock art about exploring the origins of spiritu-

Figure 4.1. *The figure plots the distribution of particular animal motifs in several rock-art traditions; the number of sites at which that species appears in the region covered by the sample is indicated on the vertical axis; the frequency with which each species appears in the whole region is plotted on the horizontal axis. The rationale for the analysis, and the data on which the analysis is based, are presented in Layton (2000, 179–83). The figure shows that the pattern characteristic of the Upper Palaeolithic does not correspond to any of the ethnographic cases, although it encompasses the quotidian case from Australia. For a development and critique of this method, see Sauvet* et al. *(2006).*

ality? There are two commonly used anthropological approaches to spirituality: to define religion as a belief in spiritual beings, proposed by Tylor (1871 [1958], 8), and to interpret religion as a form of cognitive or explanatory model based on parallels between the social and the natural world. The latter was formulated, in reaction to Tylor's approach, by the French sociologist Durkheim (1915) who argued that if religion is so pervasive in human societies, it must have a rational basis and cannot simply be naive superstition. Durkheim's approach was elegantly re-expressed by Horton (1960, 211), who defined religion as an explanatory system that uses social life as the source of models to explain the operation of less familiar areas of experience. Horton argued that, in small-scale communities, society provided 'the most markedly ordered and regular area of experience, whereas their biological

and inanimate environment is by and large less tidily predictable'. Horton contended that the various types of non-human agency recognized by the Kalabari of the Niger Delta corresponded to different aspects of social experience: the lineage ancestors, the village heroes and the water spirits. The ancestors protected their descendants, the village heroes taught people the valuable institutions that unite the lineages living in a village into a single community, while the water spirits caused anti-social and innovative behaviour. However, the animal world also (as Lévi-Strauss (1966) long ago pointed out) frequently provides models in spiritual thought. In both native North America and Australia, animals whose unusual behaviour attracts attention identify themselves as vehicles for spirits: personal guardians, totemic ancestors or malevolent forces. One function of religion is to model human social interaction, particularly to represent its basis in morality. Mithen (1996) has recently argued that the evolution of modern human cognition is signalled by the ability to draw analogies between different cognitive domains such as is seen in religious explanatory models, but I find Mithen's specific explanation for the evolution of such cognitive skills unsatisfactory and return to the adaptive aspects of human cognition and communication below.

Religious explanatory models are clearly cognitively complex, but so too is belief in spirits. In the language of the Anangu (Pitjantjatara/Yankunytjatjara) people whom I worked with in central Australia, *kurunpa* means spirit, self or will (Goddard 1987). An individual gains their spirit from the sacred site nearest to which they lost the stub of their umbilical cord as an infant; as if an entry to the person's inner body had been uncorked. Each sacred site is the physical embodiment of one of the simultaneously human/animal ancestors of the creation period; each ancestor creates a number of sites along his or her journey. The individual whose inspiration comes from a site incarnates the ancestor and is likely to display the same character traits. At death people return to the landscape, becoming a place once more. That is why it is possible to say 'that rock is my grandfather'. The Anangu theory of being embodies a theory of relativity in which matter and energy or, specifically, agency, are interchangeable. Where an ancestor enters the landscape, their agency becomes a rock, waiting to be liberated by rubbing or reincarnation in a newborn child (see Layton 1995a). This is how rubbing the transformed body of the python ancestor creates lots of pythons.

What kind of archaeological evidence would be symptomatic of spiritual beliefs? The 30,000-year-old lion-headed human figurine from Hohlenstein-Stadel, Germany (Hahn 1993), and the *c*. 10,000 BP marsupial-headed humans from the Dynamic rock art of Arnhem Land, northern Australia (Lewis 1988, 105, 178) provide convincing evidence for cognitive parallels drawn between human and animal. Deliberate burials such as those at Lake Mungo in southeast Australia dating to between 45,000 and 25,000 years ago (O'Connell & Allen 2004), seem plausible evidence of belief in a spiritual life. While rock art is unique to modern humans, the possible occurrence of Neanderthal burials has been hotly debated (Gargett 1989).

The role of art

The role of verbal exegesis in appreciating the rock-art traditions outlined above is clearly important, but it is conducted with reference to the material patterning in the art. Mulvaney cited Macintosh's (1977) argument that one would need to talk to the artist to discover the original meaning of rock art. Merlan (echoing Bourdieu) objects: 'if taken to an extreme, (that) would deny the significant social dimension of the art' (Merlan 1989, 22; cf. Layton 2001). Stylistic analysis, she argues, may allow us to go some way toward recovering, or at least suggesting, some of the constitutive conventions of the iconography, such as the species represented by animal figures and whether the paintings are secular or totemic. But, she continues,

> anything we would want to call the 'meaning' of the art lies in the relationship between images and their understood interpretation or sense within the terms of the '*contemporary narrative tradition*' (Merlan 1989, 14 [my italics]).

In itself, all rock art is highly ambiguous. To the informed viewer, there are some clues that help to reduce ambiguity in the art: iconography, size and style, location in the landscape and materials used. In all three case studies outlined above, however, verbal narratives (stories) are important. They provide a parallel discourse that further removes ambiguity and unpacks ideas concerning causality and parallelisms that inspire the art.

To what extent, if at all, can rock art therefore be treated as a medium of communication? Art has the advantage over spoken language of leaving a lasting record but, in his posthumous book *Art and Agency*, Alfred Gell argues provocatively against art as visual communication. He asserts that nothing except language itself has 'meaning' (Gell 1998, 6). The need for verbal exegesis partly supports Gell's argument that art is not like language. Mulvaney's comment that paintings are memory triggers for stories applies equally to the Stein River. During the 1980s, further interpretations of the Stein River paintings were ob-

tained by Daly and Arnett from Annie (Zex'tko) York, who was born in 1904 and learnt the traditional stories of the 'Nlaka'pamux as a child. Annie never visited the Stein River paintings herself; they lie some 50 miles up-river from her home town of Spuzzum. Instead, she worked with detailed drawings made by Arnett. The guide 'Jimmy' showed Harlan Smith a painting of deer or mountain goats connected by two lines to a three-metre vertical line marked by short diagonal dashes. He explained that the line represented a trail over the hill where the animal goes (York *et al.* 1993, 81). Teit showed two of Smith's drawings of this site to his 'Nlaka'pamux instructors who told him a large bulbous human figure with antlers represented a vision. The pair of horizontal lines behind the figures were trails, and the two circles connected by a single line were lakes connected by a river. The game animals were mountain goats (York *et al.* 1993, 82). When Annie was shown a drawing of this panel, she construed the two circles joined by a line as a snare, with a mountain goat standing below it. The small animals at the lower right corner are a doe, a buck and a fawn. The line running off above the buck (Harlan Smith's trail over the hill) is, in Annie's reading, the stick to cook it on. The bulbous figure with horns is 'a man, yet he has a deer horn on his head. He's a deer in the time of that legend life.'

Although Annie uses personal anecdotes to elucidate her interpretations, much is based on her reasonable assumption that she and the makers of the paintings share a body of knowledge about legendary beings. Daly concludes Annie's readings and those obtained by Teit and Harlan Smith are equally plausible. Everyone was familiar with trail talk and sign language, recording of historical events (and marking time), but only the individual dreamer would know of their specific revelation. The dreams of one initiate, or seasoned healer or hunter, are unique and cannot be conveyed in their entirety to others (especially, as Teit (1918, 4) pointed out, the painter was alone at the time). The gestural sign language, iconography of artefacts, and exposure to psychic training would have enabled the art to be read 'in a meaningful way' (York *et al.* 1993, 230). However, 'in such a system … no two readers will arrive at exactly the same interpretation of the writings, even though the general theme and iconography may be known to both' (York *et al.* 1993, 229). While Daly treats Stein River art as a proto-language which is 'read' by those literate enough to appreciate it, Schmidt's objection (quoted by Daly) seems valid. Schmidt argued 'I think it is more useful to see your rock "writings" as rock "art" with a specific set of literary functions: to act as a prompt for oral performance, interpretation or creation' (York *et al.* 1993, 225). Merlan writes that the dependence of Wardaman art on spoken tradition probably existed from the moment the art was created. What we call meaning lies in the relationship between figures and the narrative frame (Merlan 1989, 21).

The material remains of art thus constitute one side of the dialogue within and across generations that Bourdieu termed 'habitus'. The structuring of material culture predisposes members of the cultural tradition inwardly to interpret its significance in certain ways that inform their own subsequent performances.

The role of language

World views as complex as those of the Kalabari, Chinook and Anangu could only be created through the medium of language. Language is a social phenomenon. Language is only adaptive in a social context — there must be other people to talk with (cf. Croft 2000, 87) — and it is likely that language's prehistory entailed a co-evolutionary process in which the adaptive, social functions of language and the cognitive capacity to use language each influenced the other. It is possible to trace the appearance of recent world views in Aboriginal Australia with a reasonable degree of probability through the emergence of their distinctive material patterning in rock art (Layton 1992). To trace the origins of spirituality, however, probably demands an investigation of the more intangible evidence for the evolution of language.

Language is a multi-layered phenomenon, and the elements were no doubt added at different times: the arbitrary association of sound and meaning; the non-random ordering of morphemes in phrases, so that each conditions the sense of the others; the 'double articulation' of phoneme and morpheme through which a limited range of sounds are combined to produce a large vocabulary; the use of tense and mood to talk about things separated in time and space from the speaker. It is tempting to arrange hominin species in an ascending rank order and attach the appearance of the various layers in language to each species, from the call system of chimpanzees to the fully-modern languages of *Homo sapiens*. Hypothetical early stages are often described as 'proto-languages'. Mithen (1996, 192–3) takes this approach, resorting cautiously to the notion that the child's cognitive development recapitulates the course of hominin evolution. He concludes that the adaptive pressure for the evolution of fully modern languages came largely from the use of food in the negotiation of relations between the sexes, and that it was facilitated by the increasing length of childhood development. Yet each type of language must surely have been adaptive (and not deficient) in its social context.

The modern human foraging adaptation is very different to that of our nearest living relatives, the chimpanzees. Studies in East Africa (Goodall 1986; Nishida *et al.* 1985) report that male chimpanzees defend the boundaries of their community territory and hardly ever leave the group they are born into. Male chimpanzees hunt collectively and tolerate juveniles or females taking part of the kill. The chimpanzee community rarely if ever all assembles in one place and each individual sleeps where he or she happens to be at nightfall.

Chimpanzees manage without language, and language must therefore only be adaptive in specific social environments: hunting or scavenging, camping where night falls or returning to a base camp, tolerated theft or deliberate sharing. Robin Dunbar (1993) points out that the major increase in brain size does not take place until relatively late in hominin evolution (the appearance of *Homo heidelbergensis*, about 500,000 years ago). This suggests that many of the most cognitively demanding strategies did not take place until quite late in human evolution. Two alternative lines of adaptation can be traced from *Homo heidelbergensis*:
- Neanderthals adapt to a continental European environment.
- Modern humans probably adapted initially to a semi-arid environment in southern Africa, but perhaps shifted to a coastal environment as they spread along the southern coasts of Asia, reaching Australia (at *c.* 45,000 BP?) before their arrival in Europe around 40,000 BP.

The characteristic modern human practice among hunter-gatherers is for men to hunt independently rather than co-operatively, and to bring the meat back to an overnight base camp where the whole band assembles. This is a strategy for reducing risk when hunting success is uncertain. Ethnographic studies show that a distinction is commonly made between plants and small game, which are not expected to be shared between households, and large game, which is distributed through the camp (see review in Layton 2005). Kaplan & Hill calculate that all observed food sharing among the Ache increases nutritional status by 80 per cent (Kaplan & Hill 1985, 233). This strategy is, however, cognitively more demanding than the chimpanzee one, and demands the tracking of free-riders who may not be present at all times (Will X bring his game back to camp?). It also lays the grounds for the evolution of a second strategy distinctive of modern humans: flexible territoriality. Modern humans living in low latitude semi-desert and forest environments allow members of neighbouring bands to forage on each others' territories providing permission is first obtained, and adults of both sexes can freely change band membership. This strategy allows people to escape local shortages caused by drought, etc., by staying with friends or relatives in distant camps, but its success demands tracking relations of debt and credit over a period of months or years and depends on trust between people who may not see each other for long periods. Other terms universal to modern human language include 'now', 'before', 'after', 'here' and 'far' (Wierzbicka 1996). I agree with Mellars's (1998) contention that language embodying tense and the subjunctive would be necessary to talk about social relationships with people displaced in time and space ('If this drought continues I may visit Y, whom we allowed to camp with us three years ago').

Neanderthals?

So what was the Neanderthal strategy? The paper by Berger & Trinkaus (1995) that compared Neanderthal injuries to those sustained by rodeo riders suggests Neanderthals engaged in a close-encounter, confrontational hunting strategy, whereas recent hunter-gatherers such as the Kalahari San and Australian Aborigines hunt by stealth, approaching until the prey is within range of a spear thrower or arrow. I therefore tentatively suggest the strategy of independent hunting combined with subsequent meat-sharing is distinctive of modern humans, and evolved in low latitudes. Kuhn & Stiner (2001, 124) note that Mousterian foraging groups may have been even smaller than the 25 people often cited as minimum band size for modern humans. Given the probable hunting technique — spears — and evidence of regular injuries implying close encounters, I suggest that Neanderthal meat distribution was, on the balance of probabilities, also based on co-operation. If, however, all hunters were present at the kill, distribution could be carried out on the spot, posing less demanding constraints on the temptation to act selfishly and escape detection.

A risky strategy depending on close co-operation would demand a high degree of mutual trust and support, consistent with the recovery of Neanderthals from injuries and, perhaps, the scattered evidence for deliberate burials. The kind of social context evoked here recalls Bernstein's work on elaborated and restricted linguistic codes. A restricted language code is functional in such a context of high co-operation:

> The most general condition for the emergence of [a restricted] code is a social relationship based on shared identifications and expectations ... which reduces the need to verbalise intent ... the structure of the speech is simplified, and the lexicon will be drawn from a narrow range (Bernstein 1971, 118–19).

Rather than postulate that Neanderthals possessed a proto-language, we can hypothesize that a simple form of language would actually have been most adaptive in the context of their society. If Neanderthals did indeed sometimes bury their dead, that may be the consequence of a strong sense of mutual indebtedness engendered by co-operation in risky circumstances, and not a symptom of spirituality. A restricted code may not allow the complex kind of reasoning embodied in the religious world views described by Durkheim and Horton.

Mithen (1996) has proposed that modern humans experienced a cognitive revolution in which the mental modules that dealt with different areas of human experience became linked, enabling analogical thinking and figures of speech. While an interesting idea, the causes of such a development are not, in my opinion, adequately explained. The model suggested here provides a tentative functional explanation for a similar development. Art is a relatively late product of human cognitive evolution and is unlikely to throw light on its origins. The best way to test the model proposed here would probably be to compare the behaviour of the animal species hunted by modern humans in low latitudes with that of the herd animals characteristic of Europe in the Middle Palaeolithic, and establish whether the dispersal of single hunters provides a higher probability of success that the co-operative hunting apparently characteristic of Neanderthals in Europe — but that is a project for the future.

References

Berger, T.D. & E. Trinkhaus, 1995. Patterns of trauma among the Neanderthals. *Journal of Archaeological Science* 22, 841–52.

Bernstein, B., 1971. *Class, Codes and Control*. London: Routledge.

Bourdieu, P., 1977. *Outline of a Theory of Practice*, trans. A. Morton. Cambridge: Cambridge University Press.

Clifford, J. & G.E. Marcus (eds.), 1986. *Writing Culture: the Poetics and Politics of Ethnography*. Berkeley (CA): University of California Press.

Clottes, J. & D. Lewis-Williams, 1996. *Les chamanes de la préhistoire: transe et magie dans les grottes ornées*. Paris: Seuil.

Croft, W., 2000. *Explaining Language Change: an Evolutionary Perspective*. Harlow: Longman/Pearson.

Dunbar, R., 1993. Co-evolution of neocortical size, group size and language in humans. *Behavioural and Brain Sciences Evolution* 16, 681–735.

Durkheim, E., 1915. *The Elementary Forms of the Religious Life*, trans. J.W. Swain. London: Unwin.

Evans-Pritchard, E., 1937. *Witchcraft, Oracles and Magic Among the Azande*. Oxford: Clarendon.

Gargett, R., 1989. Grave shortcomings: the evidence for Neanderthal burial. *Current Anthropology* 30, 157–90.

Gell, A., 1998. *Art and Agency: an Anthropological Theory*. Oxford: Oxford University Press.

Goddard, C., 1987. *A Basic Pitjantjatjara/Yunkunytjatjara to English Dictionary*. Alice Springs: Institute of Aboriginal Development.

Goodall, J., 1986. *The Chimpanzees of Gombe: Principles of Behaviour*. Cambridge (MA): Harvard/Bellknap.

Hahn, J., 1993. Aurignacian art in central Europe, in *Before Lascaux: the Complex Record of the Early Upper Palaeolithic*, eds. H. Knecht, A. Pike-Tay & R. White. Boca Raton (FL): CRC Press, 229–41.

Horton, R., 1960. A definition of religion and its uses. *Journal of the Royal Anthropological Institute* 90, 201–26.

Kaplan, H. & K. Hill, 1985. Food sharing among Ache foragers: tests of explanatory hypotheses. *Current Anthropology* 26, 223–46.

Kuhn, S. & M. Stiner, 2001. The antiquity of hunter-gatherers, in *Hunter-Gatherers: an Interdisciplinary Perspective*, eds. C. Panter-Brick, R. Layton & P. Rowley-Conwy. Cambridge: Cambridge University Press, 99–142.

Layton, R., 1992. *Australian Rock Art: a New Synthesis*. Cambridge: Cambridge University Press.

Layton, R., 1995a. Relating to the country in the western desert, in *The Anthropology of Landscape: Perspectives on Place and Space*, eds. E. Hirsch & M. O'Hanlon. Oxford: Clarendon, 210–31.

Layton, R., 1995b. Rereading rock art: text and discourse, in *Perceiving Rock Art: Social and Political Perspectives*, eds. K. Helskog & B. Olsen. Oslo: Novus forlag, 217–27.

Layton, R., 1997. Representing and translating people's place in the landscape of northern Australia, in *After Writing Culture*, eds. A. James, J. Hockey & A. Dawson. London: Routledge, 122–43.

Layton, R., 2000. Review feature: shamanism, totemism and rock art: *Les chamanes de la préhistoire* in the context of rock art research. *Cambridge Archaeological Journal* 10(1), 169–86.

Layton, R., 2001. Intersubjectivity and understanding rock art, in *The Archaeology of Cult and Religion*, eds. P. Biehl & F. Bertemes with H. Meller. Budapest: Archaeolingua, 27–36.

Layton, R., 2005. Are immediate return strategies adaptive?, in *Property and Equality: Ritualisation, Sharing, Egalitarianism*, eds. T. Widlok & W. Tadesse. Oxford: Berghahn, 130–50.

Layton, R., 2006. *Habitus* and narratives of rock art, in *Talking with the Past: the Ethnography of Rock Art*, eds. J.D. Keyser, G. Poetschat & M. Taylor. Portland (OR): The Oregon Archaeological Society, 73–99.

Lévi-Strauss, C., 1966. *The Savage Mind*. London: Weidenfeld and Nicolson. [French edition 1962.]

Lewis, D., 1988. *The Rock Paintings of Arnhem Land, Australia: Social, Ecological and Material Culture Change in the Post-Glacial Period*. (British Archaeological Reports International Series 415.) Oxford: BAR.

Lewis-Williams, D. & T. Dowson, 1988. The signs of all times: entoptic phenomena in Upper Palaeolithic rock art. *Current Anthropology* 29(2), 201–45.

Macintosh, N.W.G., 1977. Beswick Creek cave two decades

later: a reappraisal, in *Form in Indigenous Art*, ed. P. Ucko. Canberra: Australian Institute of Aboriginal Studies Press, 191–7.

Mellars, P., 1998. Neanderthals, modern humans and the archaeological evidence for language, in *The Origin and Diversification of Language,* eds. N.G. Jablonski & L. Aiello. San Francisco (CA): Memoirs of the California Academy of Science, 89–115.

Merlan, F., 1989. The interpretive framework of Wardaman rock art: a preliminary framework. *Australian Aboriginal Studies* 1989(2), 14–24.

Mithen, S.J., 1996. *The Prehistory of the Mind: a Search for the Origins of Art, Religion and Science.* London: Thames and Hudson.

Mulvaney, K., 1996. What to do on a rainy day: reminiscences of Mirriuwung and Gadjerong artists. *Rock Art Research* 13, 3–20.

Nishida, T., M. Haraiwa-Hasegawa & Y. Takahata, 1985. Group extinction and female transfer in wild chimpanzees in the Mahale National Park, Tanzania. *Zeitschrift für Tierpsychologie* 67, 284–301.

O'Connell, J. & J. Allen, 2004. Dating the colonization of Sahul (Pleistocene Australia–New Guinea): a review of recent research. *Journal of Archaeological Science* 31, 835–53.

Ouzman, S., 1998. Towards a mindscape of landscape: rock art as expression of world-understanding, in *The Archaeology of Rock Art*, eds. C. Chippindale & P. Taçon. Cambridge: Cambridge University Press, 30–41.

Puttnam, H., 1995. *Pragmatism, an Open Question.* Oxford: Blackwell.

Quine, W.V.O., 1960. *Word and Object.* Cambridge (MA): M.I.T. Press.

Sauvet, G., R. Layton, T. Lenssen-Erz, P. Taçon & A. Wlodarczyk, 2006. La structure iconographique d'un art rupestre est-elle une clef pour son interprétation? *Zephyrus* 59, 195–208.

Schutz, A., 1972. *The Phenomenology of the Social World*, trans. G. Walsh & F. Lehnert. London: Heinemann.

Teit, J.A., 1918. Notes on Rock Painting in General by J.A. Teit, Spences Bridge, 1918. Unpublished typescript on file at the National Archives of Canada.

Tylor, E.B., 1871 [1958]. *Primitive Culture: Researches into the Development of Mythology, Philosophy, Religion, Art and Custom,* vol. 2. London: Murray.

Wierzbicka, A., 1996. *Semantics: Primes and Universals.* Oxford: Oxford University Press.

York, A., R. Daly & C. Arnett, 1993. *They Write Their Dreams on the Rock Forever: Rock Writings in the Stein River Valley of British Columbia.* Vancouver: Talonbooks.

Chapter 5

Upper Palaeolithic Anthropomorph Images of Northern Eurasia

Jiří A. Svoboda

Temporal frameworks and symbolism: the origins of modernity

Whereas the origins of modernity are being sought in Africa and the Near East between 200–100 kya (McBrearty & Brooks 2000), a modern human revolution took place considerably later (between 40–20 kya) in the vast areas of Eurasia (Mellars & Stringer 1989). In other words, art and symbolism flourished in the newly settled areas in regions where modern humans were in touch with indigenous populations, namely the Neanderthals.

Additional behavioural changes are more or less clearly readable in the Upper Palaeolithic record, but a debate is being raised about what lies behind them. Materialist answers stressing changes in diet, hunting strategies, lithic raw materials and technologies, storage and sedentism, compete with explanations focusing on cognition and structural changes in the human mind (Davidson & Noble 1989; Chase & Dibble 1992; Mithen 1996; Noble & Davidson 1996; Lewis-Williams 2002).

One of the crucial components of the modern human mind is time-awareness, structured along various culturally determined rules (Yates 1966; Adam 1990; Gell 1992). This paper is based on the simple presumptions that: 1) an image includes information; and 2) time-awareness provides the dimension in which this information may be transmitted over shorter or longer time-spans (Svoboda 1997; 2004). Information storage and transmission bring with them memory and epics, self-awareness, and life and death concepts. In this sense, the hypothetical establishment of a hunter-gatherer temporal framework, structured along the sequences in nature and in human life, is considered an important part of the Upper Palaeolithic adaptation system in Eurasia.

In contrast to the still scarce MSA/Middle Palaeolithic evidence of ochre and beads, the Upper Palaeolithic archaeological evidence of Eurasia comprises symbolic images, items of decoration, ochre, and ritual burials. Further, whereas the earliest Upper Palaeolithic centres of either parietal or mobile art (before 30 kya) are related to the Aurignacian of western and southern Europe, the Gravettian and chronologically comparable sites of northern Eurasia (30–15 kya) provide a context where the various mentioned elements appear together. This paper focuses on anthropomorph images of this time period, which is further subdivided

Figure 5.1. *Map of Early Gravettian (Pavlovian) sites in northern Eurasia. West European sites are not included in maps 5.1–5.3.*

Chapter 5

Figure 5.2. *Map of Upper Gravettian (Willendorf-Kostenkian) and Siberian Upper Palaeolithic sites.*

Figure 5.3. *Map of Epigravettian (Mezinian) and later Siberian Upper Palaeolithic sites.*

into three chronological horizons: the early Gravettian (Pavlovian: Fig. 5.1), the later Gravettian (Willendorf-Kostenkian: Fig. 5.2), and Epigravettian (Mezinian: Fig. 5.3). For comparative reasons, images from the Siberian Upper Palaeolithic are included as well, although it should be emphasized that the Siberian industries are typologically not Gravettian.

Anthropomorph figurines: past interpretations

Over more than a century of research, studies of Upper Palaeolithic anthropomorphs have undergone a long intellectual development, emphasizing a variety of approaches and methods (Abramova 1963; Leroi-Gourhan 1965; Marshack 1972; 1991; Delporte 1993; McDermott 1996; Soffer *et al.* 2000). The Gravettian female figurines have been interpreted either as realist depictions of individual females, artist's self-portraits, priestesses, ancestors, or mythological goddesses. On another level, the same figurines may be interpreted as abstract symbols of life, home, beauty, fertility, sexuality and eroticism. One-site focus on sites like Brassempouy, Grimaldi, Dolní Věstonice-Pavlov, Kostenki, Gagarino, Avdeevo, Mal'ta and others, which yielded female figurines in larger groups and in a context of additional images and symbols, reveals in greater detail the patterns of local variability (Delporte 1993; Klíma 1983; 1989; Verpoorte 2001; Svoboda 2005; Efimenko 1958; Praslov & Rogachev 1982; Gvozdover 1995; Tarasov 1979; Gerasimov 1931). In contrast, trans-continental comparisons on the Eurasian scale documented a surprising similarity of their form and design, which may reflect long-distance interaction, alliance networks, or migrations (Gamble 1982; Mussi *et al.* 2000). The most striking similarities over distances of more than 1500 km are documented during the Upper Gravettian between sites like Willendorf-Gagarino or Moravany-Kostenki.

The contextual approach: images in time and space

As a result of large-scale excavations by Zamiatnine, Gerasimov, Efimenko and Praslov in Russia, Absolon and Klíma in former Czechoslovakia, Leroi-Gourhan in France, and Bosinski in Germany, a contextual or 'topographic' approach to symbols and images pre-

dominated in Eurasian archaeology. This approach may be realized on several levels, starting with topographic analysis of northern Eurasia (Figs. 5.1–5.3), through settlement analysis of individual Upper Palaeolithic landscapes, to mapping the interior of the large and complex settlements, and ending with internal analysis of individual settlement units ('huts').

It is evident that this mosaic of Gravettian occupations was not a static one, but displays a dynamic pattern of changes. Moravia, where the settlement density and complexity culminates during the earlier Gravettian (Pavlovian, 30–25 kya), provides a reverse picture of that of eastern-central Europe, eastern Europe and Siberia, where the majority of dates ranges between 25–20 kya (Willendorfian, Kostenkian, Siberian Upper Palaeolithic) and some between 20–15 kya (Epigravettian, or Mezinian). Given the strong formal resemblances in form and style among art objects found in long distances, it has been argued that this dynamic reflects certain population shifts from central to eastern Europe, and possibly further east. The likely impulse for such migration was the important expansion of the Fennoscandinavian ice-sheet, causing climatic deterioration around 20 kya (LGM); this event terminated the Gravettian occupation in most of central Europe, but had less effect on settlement and cultural continuity further east.

The geographic frame is the north Eurasian steppe. Large Gravettian sites and site complexes that provided anthropomorph images are clustered in several areas, usually attached to larger rivers such as the Danube and its affluents Dyje, Morava and Váh (Willendorf, Dolní Věstonice-Pavlov, Předmostí, Moravany), Dniepr and Desna (Mezin), Don and Sejm (Kostenki-Borshevo, Gagarino, Avdeevo) and Angara (Mal'ta, Bureť). The Gravettian site-location strategies in the landscape follow certain common patterns, such as a preference for the slopes of river valleys, lower altitudes, and regular distances between the site-clusters; but they also exhibit patterns of difference. In addition, the landscape was probably structured by places of symbolic meaning, such as the remarkable mountain chain rising from the plains above Dolní Věstonice-Pavlov, with a clearly zoomorphic shape. It has been hypothesized that some of the landscapes and sites were even manifested as objects of two-dimensional graphic representation: the so-called 'maps', which are complex geometric patterns engraved on surfaces of mammoth tusks (Pavlov, Předmostí, Kiev-Kirillevskaya, Mezhirich, Eliseevichi).

Within the settlements and settlement clusters, the majority of the figurines are found in the central and densely (or, repeatedly) settled zones. Some are clustered around hearths and some are deposited (or, redeposited) in holes and other depressions. In one case (Brno 2), a male figurine was directly associated with a burial of an older male.

Anthropomorph images: the inventory

Czech Republic
- *Dolní Věstonice I*: carvings in ivory (a female face, stylized females, and a series of anthropomorph pendants) and clay figurines (bodies, legs, a head, a vulva). — Pavlovian. Age: 25–27 kya.
- *Pavlov I*: carvings in ivory (a complete female figurine, a stylized head) and clay figurines (female and possibly male bodies, fragments of bodies, numerous legs and 'boots', stylized heads). — Pavlovian. Age: 25–27 kya.
- *Předmostí Ia*: female engraving in mammoth tusk, and a series of rough problematic 'anthropomorphs' of mammoth phalanges. — Pavlovian. Age: 25–27 kya.
- *Spytihněv*: an 'anthropomorph' of mammoth phalanx, as at Předmostí.
- *Brno 2*: a male figure, carved of ivory. — Willendorf-Kostenkian. Age: 23–25 kya.
- *Petřkovice*: a female torso, carved of haematite. — Willendorf-Kostenkian. Age: 21–23 kya.

Austria
- Willendorf II, layer 9: a female figure of soft stone. — Willendorf-Kostenkian. Age: 23–25 kya.

Slovakia
- Moravany: a female torso, carved of ivory. Willendorf-Kostenkian.

Ukraine
- Mezin: carvings in ivory (series of females with exaggerated buttocks, also interpreted as birds). — Similar carvings from Mezhirich are less clear with regard to their anthropomorph interpretation. — Epigravettian (Mezinian). Age: 14–18 kya.
- *Molodova V, layer 7*: anthropomorphic engraving on pierced antler. — Willendorf-Kostenkian. Age: 23–24 kya.
- *Molodova V, layer 3*: an anhropomorphic carving in soft stone. — Epigravettian. Age: c. 13.5 kya.

Russia
- *Kostenki 1*: carvings in ivory (female bodies, a large series of fragments), carvings in marlstone (female bodies and a series of fragments and partial representations: heads, bodies, legs, vulvas), unclear 'anthropomorphs'. — Kostenkian. Age: 21–24 kya.

Figure 5.4. *Female carving in ivory. Pavlov, Czech Republic, Pavlovian. (Photo: Martin Frouz.)*

Figure 5.5. *Female carving in hematite. Petřkovice, Czech Republic, Willendorf-Kostenkian. (Photo: Martin Frouz.)*

- *Kostenki 13*: a female figure, carved of soft stone; an ivory fragment of head. — Kostenkian. Age: as site 1 (21–24 kya).
- *Khotylevo II*: carvings in ivory (female figurines, fragments, a series of unclear 'anthropomorphs'). — Kostenkian. Age: 23.5–25 kya.
- *Avdeevo*: carvings in ivory (complete female figurines), carvings in marlstone (series of female figurines and fragments), problematic 'anthropomorphs' of ivory and bone. — Kostenkian. Age: 21–22.5 kya.
- *Gagarino*: carvings in ivory (complete female figurines, double statue, unclear anthropomorphs). — Kostenkian. Age: *c.* 22 kya.
- *Eliseevitchi*: a female statue, carved of ivory. — Epigravettian. Age: *c.* 17 kya.
- *Maininskaja*: a plastic clay figure of clay. — Siberian Upper Palaeolithic. Age: 16–17 kya.
- *Mal'ta*: carvings in ivory (complete slim female figures, unfinished pieces, fragments). — Siberian Upper Palaeolithic. Age: *c.* 21 kya.
- *Bureť*: carvings in ivory (complete slim female figures, fragments). — Siberian Upper Palaeolithic. Age: *c.* 21 kya.

Time, symbols and memory

This paper is based on the simple statement that symbols, if made in durable material, conserve their meanings through time and, therefore, creating a temporal framework must have been an integral part of early modern human mental constructs. In addition, concepts of time are linked to the memory and prognosis.

Selection of materials of various resistance (ivory and hard stone versus clay and soft stone) suggest that there was a variability in duration of their usage. Carvings in bone, ivory and hard stones (Figs. 5.4 & 5.5) communicated their meaning for a longer time, some were possibly carried around, some exhibit traces of polish and wear, and some could have been attached to clothing. Figurines of clay (Dolní Věstonice-Pavlov:

Fig. 5.6) or of soft stones (Kostenki) were created and destroyed during a single act. We must assume a shorter duration of meaning for symbolic objects modelled in clay or carved in soft stones, most probably limited to one event (ritual), and a more permanent one in the case of carvings in ivory or hard stones. This dichotomy of 'short-term art' versus 'long-term art' (Svoboda 1995; 1997) is also valid for anthropomorph images and the meanings these objects transmitted.

The individual symbols may be ordered into sequences, like those of Leroi-Gourhan (1964–65), to create a 'language of forms'. By convention, forms repeatedly used in this language may be formally reduced into 'metaphors' and 'synecdochs' (Hodder 1993). Upper Palaeolithic examples show that a body — anthropomorph or zoomorph — may be reduced or stylized, but also substituted by its individual parts, such as head, legs and sexual organs.

Self-awareness and identity

One of the questions in analysing anthropomorphic images concerns the social structure and hierarchy expected in the society under study (Wobst 1977). Archaeologically, some information may be provided by items of body decoration. Compared to the Initial and Upper Palaeolithic (White 1989; Vanhaeren & d´Errico 2002), Gravettian items of decoration reveal a larger diversity of shapes, and a standardization of some of them, starting with pierced natural objects such as carnivore teeth and mollusc shells, through simple geometric forms (rings, cylinders, beads) to abstractions derived from zoomorphic and anthropomorphic shapes.

Such items of body decoration are also found in Gravettian burial contexts, directly associated with bodies, especially in Italy where marine shells were predominantly represented. Within the north Eurasian zone, the most typical adornments are beads carved from ivory or bone, or perforated carnivore teeth. The richest burials, with bodies completely adorned, occur at Sungir; otherwise the burials such as those at Dolní Věstonice-Pavlov or Kostenki only provide a few decorative objects, mostly placed on the skulls.

In addition, geometric patterns occupy space on objects of various types such as bones, bone tools, items of decoration, and sometimes (as at Mezin) directly on the figurines (Marshack 1972; Chollot-Varagnac 1980; Shovkoplyas 1965). For the Gravettian, the most typical are geometric parallel and cross-cut patterns (linear, 'zigzag', 'herring-bone', 'textile' and others). Several questions surround these patterns: we usually do not understand their meaning (or metaphors), sometimes we do not even know the

Figure 5.6. *Female plastics in burnt clay. Pavlov, Czech Republic, Pavlovian. (Photo: Martin Frouz.)*

function of the decorated objects themselves, and evidently, we do not know the acts in which the objects were used or the status of their manipulators. Nevertheless, these patterns were visibly located on the bodies. Therefore, one may assume that this decorative system provided information, and if associated with an individual, this information may have concerned their personal identity, social identity, and awareness of such identities.

Anthropomorphs: anonymity versus identity

The definition of identity, however, is hardly reflected by the anonymous anthropomorphic images that predominate at the same sites. Clearly, the majority are females and, in addition, mostly naked females. Even if these representations might possess multiple meanings — and individual authors have suggested various alternatives — the basic one is as a symbol of a woman itself, with the basic information derived from human anatomy and physiology.

Figure 5.7. *Globular human head of burnt clay. Pavlov, Czech Republic, Pavlovian. (Photo: Martin Frouz.)*

Even though the skulls are the most richly decorated areas in the human burials, in figurines the head and face are strictly reduced, following several schemes derived from geometry. A globular head dotted by points or strokes is largely distributed at sites like Pavlov, Willendorf, Gagarino or Avdeevo (Fig. 5.7); a biconical or 'mushroom' shape is typical at Pavlov; a simple protrusion, with or without eyes and in two cases with four holes on the top, is recorded at Dolní Věstonice (the Black Venus); and a triangle is exhibited on the engraved female from Předmostí.

Of the human heads found separately, not all must necessarily be fragments of complete figurines (likewise not all of the headless Venuses must necessarily have had heads, originally). The vulvas, made in clay at Dolní Věstonice and in soft stone at Kostenki, are complete objects bearing a complete meaning. At least partly, this may also be true for some of the human and animal legs, which constitute one of the most frequently-found ceramic objects at Dolní Věstonice.

On some of the anthropomorphic figurines from Pavlov and Kostenki we observe 'belts', 'cordages', and possibly some more complex patterns of partial clothing or decoration. Soffer *et al.* (2000), who described and analysed such patterns, suggests symbolic and informative meanings of the female clothing. These adornments may certainly add a meaning to the images (as an 'adjective'), but hardly refer to individuality. In addition, not all the patterns visible on the bodies are descriptive in terms of observed reality, and some of the geometric lines may instead be symbolic (cf. discussion of Soffer *et al.* 2000).

There are nevertheless a few cases where an image may refer to a concrete individual. Firstly, the relatively realistic female head of ivory from Dolní Věstonice I, which Absolon (1945), upon discovering it, described as 'breaking tribal rules'. After Klíma (1983) later added a rough 'mask' with a similar pattern of mouth asymmetry from the same site, this feeling could be supported by analogy with the female skull DV 3, which was found nearby, and shows a comparable pattern of facial pathology, but, as noted by Trinkaus (pers. comm. 2007), as a mirror image. Naturally, the famous 'portrait' head from Brassempouy was cited as a direct analogy to Dolní Věstonice, from the time of the discovery. It may be added that at both sites, the 'portraits' represent just one case within a larger assemblage of otherwise 'anonymous' anthropomorphs.

Another case of individuality is the carving of a male, composed of head, trunk, and an arm (the other extremities are missing), and found in the context of a male burial, Brno 2 (Makowsky 1892). In this case, it was suggested that the image depicts either the buried man directly (possibly a shaman), or his symbolic 'double being'.

Double usage: anthropomorphs or utilitary objects?

Since late nineteenth century, archaeologists have discovered, at various sites, a number of ambiguous ivory and bone objects, with features allowing them to be attached or suspended, either a perforated ear (as at Předmostí), or, more frequently, a globular 'head'. Obviously, the utility of such artefacts lies in their weight and in the attachment of fibrous cordage; in fact, a similar principle has been recorded, amongst much debate, in the Lower Palaeolithic (cf. Berekhat Ram: d'Errico & Nowell 2000). A comparative study shows that between 30–15 kya, analogical objects appear repeatedly in various Gravettian phases, as well as in the Late Aurignacian (e.g. Předmostí, Pavlov, Willendorf, Spytihněv, Alberndorf, Kostenki, Avdeevo, Mezin: Svoboda 2001). In earlier literature, almost all of them were interpreted as primitive anthropomorphic figurines (as is the case with Berekhat Ram), and some also as phalluses. The simplicity of their form has been explained either by the presumed 'undeveloped' stage of art during the Palaeolithic, or by the unfinished state of their production. Even if our approach is preferentially functional and techno-

Figure 5.8. *Double readings: the structure of anthropomorph symbols at Dolní Věstonice.*

logical, an additional symbolic meaning of some of these objects, evoked by the anthropomorphic 'heads', should not be neglected: the objects probably had a function (weights, etc.), but their producers, who are renowned for a sensitivity to meanings of natural shapes (rocks, stalactites etc.), may have been well aware of their anthropomorphism.

Double readings: male and female

The Western structuralist approach (Leroi-Gourhan 1965) stressed the bipolar division of symbols into male and female groups on the basis of their morphology. The eastern Russian view, however — traditionally more closely related to the Eurasian ethnographic record — is ready to accept a dual meaning of certain symbolic objects, such as the 'transitional' bird-female or phallic-female carvings from the Mezinian (Shovkoplyas 1965; Iakovleva 1992). The Gravettian anthropomorphic symbolism has traditionally been explained as predominantly female, centred on stylizations of breasts and vulvas. The fact that both symbols may be combined on the same object led researchers to conflicting determinations rather than to a more synthetizing, or metaphoric, view of their meaning as a whole. If the double reading is applied,

breasts may change to testicles and a stylized female body to a phallus (Kehoe 1991) without negating, however, the primary female meaning of the object.

One example is provided by the images of Dolní Věstonice I. Anthropomorphic symbols from this site may be ordered along the bipolar reading (Fig. 5.8; Svoboda 1997; 2004): above, the breast-or-penis symbols, and below, the typical triangular symbols of vulva. In the light of this reading, the image of the famous Black Venus of Věstonice becomes, in fact, a sophisticated cryptogram, a synthesis of the female organ below with a male organ above, all in the shape of a female figure. The meaning may be a universal unity of the two opposed symbols, but it may also be just a joke, a visual pun.

The images in action

Archaeology may potentially reveal situations where the individual symbols are ordered in groups, and possibly in epic sequences. In the deep-cave sites of western Europe, painted and engraved symbols are spatially ordered in 'sacred' areas, far from the settlements. In the eastern Gravettian settlements 'sacred' and 'profane' zones were evidently not separated. In Moravia, the occurrence of ceramic figurines and

Chapter 5

Figure 5.9. *Female figurine in ivory, Moravany, Slovakia. Willendorf-Kostenkian. (Photo: Martin Frouz.)*

Figure 5.10. *Female figurine in ivory, Gagarino, Russia. Kostenkian. (Photo: Martin Frouz.)*

Figure 5.11. *Female figurine in ivory, Gagarino, Russia. Kostenkian. (Photo: Martin Frouz.)*

Figure 5.12. *Female figurine in ivory, Kostenki, Russia. Kostenkian. (Photo: Martin Frouz.)*

fragments, as the most typical example, correlates with the central settled areas, around hearths, and, presumably, inside the hypothetical dwellings (Absolon 1945; Klíma 1978; 1989; Soffer *et al.* 1993; Svoboda 2005). There are fragmented heads, extremities, and bodies of mammoths, other larger herbivores, carnivores, and humans and anthropomorphic fragments (heads, legs, vulvas). Some of them display intentional incisions, made while the clay was wet, or deformations caused by thermal shock during and after heating, as well as other types of fragmentation. In Russia, a parallel role could have been played by the carvings in soft stone (Efimenko 1958; Iakovleva 2000).

There is a sort of story in these actions, and earlier literature supposed a simple hunting magic scenario. However, similarly to other areas of European hunters' art, the subjects depict important and imposing animals (carnivores — mainly felines, mammoths, and other larger herbivores) as well as humans (mainly females), rather than the smaller animals that formed the real subsistence base. Therefore, we agree that these symbols were involved in ritual actions, but

Upper Palaeolithic Anthropomorph Images of Northern Eurasia

Figure 5.13. *Female figurine in marlstone, Kostenki, Russia. Kostenkian. (Photo: Martin Frouz.)*

Figure 5.14. *Female figurine in marlstone, Kostenki, Russia. Kostenkian. (Photo: Martin Frouz.)*

Figure 5.15. *Female figurine in ivory, Malta, Russia. Siberian Upper Paleolithic. (Photo: Martin Frouz.)*

Figure 5.16. *Female figurine in ivory, Malta, Russia. Siberian Upper Paleolithic. (Photo: Martin Frouz.)*

the story behind these rituals was more complex, narrative, and 'mythological'. One of the interpretations is of a deliberate process of formation and destruction of images, a process which evidently had a ritual character and a symbolic meaning.

Once the act was finished, the objects were left *in situ*. It appears that the meaning of the story (and the value of the objects) was directly connected to the act of their production–destruction, and thus time-limited.

An additional observation was recently added by dermatoglyphic studies of the surface of the ceramics (including the famous Black Venus of Věstonice: Králík *et al.* 2002). The finger imprints suggest that young people and children were present — and active — around the ceramic-production processes. This coincides well with some of the western European data from painted caves, where the presence of children has also been documented (Sharpe & van Gelder 2004). We

65

Figure 5.17. *Symbols in action: experiments and play with female figurines.* (Photo: Martin Frouz.)

do not wish to suggest that children were the producers of this art — either of the 'big' parietal art of the west or of the miniatures of Moravia — but it should be taken into account that symbolic art production was a complex process assisted by the whole community. And — as today — children were probably anxious to touch everything directly.

What about the 'long-term art' in this context? None of the finely carved female figurines of northern Eurasia (Figs. 5.9–5.16) could stand independently (in contrast to some Neolithic figurines, which have seats or stands). Rather, their forward-inclined globular heads, exaggerated breasts, buttocks, and belts are suitable for attachment. Once hanging, the body weight was well balanced (Fig. 5.17). I suggest that the ivory figurines also entered into an action, movement, rhythm, and play of shadows, attached to the human body (as recorded on Siberian shamans: Svoboda 2007), trees, or elements of dwelling constructions.

Our approach in this paper is not to observe the anthropomorph images as static objects, but as components of a type of social event taking place in the context of the steppic landscape, a particular dwelling, with adults and children, dance and music, lights and shadows.

Conclusion

The origin of symbolism is in fact a technological process involving a higher level of communication and information transmission. Compared to words and gestures, an image, with its capacity to express and conserve meanings in (or on) a durable material, imparts a more permanent character to any type of information.

The Gravettian sites offer a context where anthropomorphic images are found in association with images of animals, items of decoration, profane and ritual areas, and human burials. In their material, form, and context, these images exhibit a high level of variability. Formally, they occur as fragments of ceramics and soft stones which may be evidence of a time-limited ritual action, as well as ivory and hard stone carvings, possibly used and carried around for a longer time-period. They are either realistic or abstract, with emphasis on certain parts of the body (heads, legs, breasts, vulvas). Some allow double usage, as tools and as symbolic objects, and some allow double readings, as female and male, for example. In addition, anthropomorphs are associated with zoomorphs in order to represent past realities, stories, or mythologies. Occurrence of these symbols at a single site or in one cultural context does not seem to be accidental. It is suggested that time-awareness, communal identity, self-identity, epics and life and death concepts lay behind these objects and ritual actions. These phenomena make an important contribution to the Upper Palaeolithic adaptation system, 'modernity', and the 'Human Revolution' in general.

Acknowledgments

For access to north Eurasian anthropomorph figurines I cordially thank colleagues from the Slovak National Museum, Bratislava, Institute of Archaeology of the Slovak Academy of Sciences, Institute of History of the Material Culture of the Russian Academy of Sciences, the Kunstkamera and the State Hermitage at St Petersburg. All photos are courtesy of Martin Frouz. The documentation was realized as a part of the Czech Grant Agency project 404/06/0055.

References

Abramova, Z., 1963. *Izobrazheniya cheloveka v paleoliticheskom iskusstve Evraziyi*. Moscow & Leningrad: Nauka.
Abramova, Z., 1995. *L'art paléolithique d'Europe orientale et de Sibérie*. Grenoble: Jerome Millon.
Absolon, K., 1945. *Výzkum diluviální stanice lovců mamutů v Dolních Věstonicích na Pavlovských kopcích na Moravě. Pracovní zpráva za třetí rok 1926*. Brno: Polygrafia.
Adam, B.E., 1990. *Time and Social Theory*. Cambridge: Polity Press.

Chase, P.G. & H. Dibble, 1992. Scientific archeology and the origins of symbolism. *Cambridge Archaeological Journal* 2(1), 43–50.

Chollot-Varagnac, M., 1980. *Les origines du graphisme symbolique. Essai d'analyse des écritures primitives en préhistoire.* Paris: CNRS.

Davidson, I. & W. Noble, 1989. The archeology of perception: traces of depiction and language. *Current Anthropology* 30, 125–55.

Delporte, H., 1993. *L'image de la femme dans l'art préhistorique.* Paris: Picard.

d'Errico, F. & A. Nowell, 2000. A new look at the Berekhat Ram figurine: implications for the origins of symbolism. *Cambridge Archaeological Journal* 10(1), 123–67.

Efimenko, P.P., 1958. *Kostenki I.* Moscow: Izdatel'stvo AN SSSR.

Gamble, C., 1982. Interaction and alliance in Palaeolithic society. *Man* 17, 92–107.

Gell, A., 1992. *The Antropology of Time: Cultural Constructions of Temporal Maps and Images.* Oxford: Berg.

Gerasimov, M., 1931. *Mal'ta. Paleoliticheskaia stoianka.* Irkutsk: Izdanie Kraevogo muzeia.

Gvozdover, M., 1995. *Art of the Mammoth Hunters: the Finds from Avdeevo.* (Oxbow Monographs 49.) Oxford: Oxbow Books.

Hodder, I., 1993. The narrative and rhetoric of material culture sequences. *World Archaeology* 25, 268–82.

Iakovleva, L., 1992. Les statuettes féminines en ivoire du mézinien de Meziritche. *Bulletin de la Société Préhistorique Française* 89, 68–71.

Iakovleva, L., 2000. The Gravettian art of eastern Europe as exemplified in the figurative art of Kostenki 1, in *Hunters of the Golden Age*, eds. W. Roebroeks, M. Mussi, J. Svoboda & K. Fennema. Leiden: University of Leiden, 125–33.

Kehoe, A., 1991. No possible, probable shadow of doubt. *Antiquity* 46, 129–31.

Klíma, B., 1978. Les représentations animales du Paléolithique supérieur de Dolní Věstonice, in *La contribution de la zoologie et de l'ethnologie á l'interprétation de l'art des peuples chasseurs préhistoriques.* Fribourg: Université de Fribourg, 323–32.

Klíma, B., 1983. *Dolní Věstonice, tábořiště lovců mamutů.* Prague: Academia.

Klíma, B., 1989. Figürliche Plastiken aus der paläolithischen Siedlung von Pavlov (ČSSR), in *Religion und Kult.* Berlin: DVW, 81–90.

Králík, M., V. Novotný & M. Oliva, 2002. Fingerprints on the Venus of Dolní Věstonice I. *Anthropologie* 40, 107–13.

Leroi-Gourhan, A., 1964–65. *La geste et la parole.* Paris: A. Michel.

Leroi-Gourhan, A., 1965. *Préhistoire de l'art occidental.* Paris: Mazenod.

Lewis-Williams, D., 2002. *The Mind in the Cave: Consciousness and the Origin of Art.* London: Thames and Hudson.

Makowsky, A., 1892. Der diluviale Mensch im Löss von Brünn. *Mitteilungen der Anthropologischen Gesellschaft Wien* 22, 73–84.

Marshack, A., 1972. *The Roots of Civilization.* New York (NY): McGraw-Hill.

Marshack, A., 1991. The female image: a 'time-factored' symbol: a study in style and aspects of image use in the Upper Palaeolithic. *Proceedings of the Prehistoric Society* 57, 17–31.

McBrearty, S. & A.S. Brooks, 2000. The revolution that wasn't: a new interpretation of the origin of modern human behavior. *Journal of Human Evolution* 39, 453–563.

McDermott, L.R., 1996. Self-representation in Upper Palaeolithic female figurines. *Current Anthropology* 37, 227–75.

Mellars, P. & C. Stringer, 1989. *The Human Revolution.* Edinburgh: Edinburgh University Press.

Mithen, S., 1996. *Prehistory of the Mind.* London: Thames and Hudson.

Mussi, M., J. Cinq-Mars & P. Bolduc, 2000. Echoes from the mammoth steppe: the case of the Balzi Rossi, in *Hunters of the Golden Age*, eds. W. Roebroeks, M. Mussi, J. Svoboda & K. Fennema. Leiden: University of Leiden, 105–24.

Noble, W. & I. Davidson, 1996. *Human Evolution, Language, and Mind: a Psychological and Archaeological Inquiry.* Cambridge, Cambridge University Press.

Praslov, N.D. & A.N. Rogachev (eds.), 1982. *Paleolit kostenkovsko-borshchevskogo raiona na Donu, 1879–1979.* Leningrad: Nauka.

Sharpe, K. & L. van Gelder, 2004. Children and Paleolithic 'art': indications from Rouffignac Cave, France. *International Newsletter on Rock-Art* 38, 9–17.

Shovkoplyas, I.G., 1965. *Mezinskaya stoyanka.* Kiev: Naukova dumka.

Soffer, O., P. Vandiver, B. Klíma & J. Svoboda, 1993. The pyrotechnology of performance art: Moravian Venuses and wolverines, in *Before Lascaux*, eds. H. Knecht, A. Pike-Tya, R. White. Boca Raton (FL): CRC Press, 259–75.

Soffer, O., J.M. Adovasio & D.C. Hyland, 2000. The 'Venus' figurines: textiles, basketry, gender, and status in the Upper Palaeolithic. *Current Anthropology* 41, 511–37.

Svoboda, J., 1995. L'art gravettien en Moravie: contexte, dates et styles. *L'Anthropologie* 100, 254–67.

Svoboda, J., 1997. Symbolisme gravettien en Moravie: espace, temps et formes. *Bulletin Société Préhistorique Ariege-Pyrenées Préhistoire Ariégoise* 52, 87–104.

Svoboda, J., 2001. Ivory weights from Předmostí and Pavlov, in *Ve službách archeologie*, vol. 3. Brno: Muzejní a vlastivendá spolecnost, 184–9.

Svoboda, J., 2004. The hunter's time, in *La spiritualité*, ed. M. Otte. Liege: ERAUL 106, 27–35.

Svoboda, J.A. (ed.), 2005. *Pavlov I — Southeast. a Window into the Gravettian Lifestyles.* (The Dolní Věstonice Studies 14.) Brno: Institute of Archaeology.

Svoboda, J.A., 2007. Upper Pleistocene steppe of north Eurasia: implication for the shamanic hypothesis, in *Rock-Art in the Frame of the Cultural Heritage of Humankind, XXII Valcamonica Symposium.* Darfo Boario Terme: UNESCO, Centro camuno di studi preistorichi, 473–8.

Tarasov, L.M., 1979. *Gagarinskaia stoianka i ee mesto v paleolite Evropy.* Leningrad: Nauka.

Vanhaeren, M. & F. d'Errico, 2002. The body ornaments associated with the burial, in *Portrait of an Artist as a*

Child, eds. J. Zilhão & E. Trinkaus. Lisboa: Instituto Portugués de Arquelogia, 154–86.

Verpoorte, A., 2001. *Places of Art, Traces of Fire.* (Archaeological Studies Leiden University 8/Dol. Věst. Stud. 6.) Leiden: University of Leiden.

White, R., 1989. Production complexity and standardization in early Aurignacian bead and pendant manufacture: Evolutionary implications, in *The Human Revolution*, eds. P. Mellars & C. Stringer. Edinburgh: Edinburgh University Press, 360–99.

Wobst, H.M., 1977. Stylistic behavior and information exchange, in *For the Director: Research Essays in Honor of James B. Griffin*, ed. C.E. Cleland. Ann Arbor (MI): Museum of Anthropology, 317–42.

Yates, F., 1966. *The Art of Memory*. Oxford, Clarendon Press.

Chapter 6

New Questions of Old Hands: Outlines of Human Representation in the Palaeolithic

Iain Morley

Investigating aspects of interpretation of figurative representation from the Upper Palaeolithic of western Europe is a task that can be approached with both relish and a certain amount of trepidation. On the one hand it is a rich and dynamic body of evidence, spanning up to 30,000 years (*c.* 40,000–10,000 years BP), with regular new and highly significant discoveries (e.g. Cosquer and Chauvet caves in France and Creswell Crags caves in Britain) which can dramatically affect our interpretations and chronologies. On the other hand it is a field with a heritage of 150 years of investigation, a diverse body of experts and at least as many competing interpretations and controversies.

Southwestern European Palaeolithic imagery has undoubtedly received a greater level of attention than that of any other single region. For many years it was seen as the most significant, if not the only body worthy of attention. As more examples of Pleistocene imagery have been, and continue to be, found elsewhere, not just in Europe, but in Russia, Africa and Australia, it has become clear that the evidence from southwestern Europe can no longer be viewed in isolation. It represents part of a record with a vast temporal and geographic span, whilst at the same time probably representing a myriad of temporally and regionally limited traditions.

As noted, the study and interpretation of Palaeolithic imagery has a long history of its own. This has been usefully summarized and critiqued by several authors (e.g. Bahn & Vertut 1997; Conkey 1999; Lewis-Williams 2002; White 2003), and the reader is directed to these for a more detailed coverage than is appropriate here. The present brief account must inevitably risk caricaturing interpretive positions which were the product of protracted debate and years of investigation; certainly without that heritage of interpretation we would be considerably impoverished today.

Palaeolithic imagery has been divided into two main categories, *parietal* (or 'wall art') and *mobiliary* (or 'portable art'). Note that this does not simply equate to paintings for the former and sculpture for the latter, although these are the predominant manifestations; parietal images may also be carved or pecked into the surface, even to the extent of constituting bas-relief, and mobiliary images may be painted or engraved on portable plaquettes or bone and antler objects. These two 'types' of representation have each been the recipients of greater or lesser attention and attributed value at various times in the history of scholarship on Palaeolithic representation, although it seems unlikely that they should be considered in isolation from each other.

The interpretation of Palaeolithic imagery has been through a number of phases of predominating theories. An 'art for art's sake' explanation, that these were the images made by peoples simply appreciating and wishing to represent the world around them — the product of abundant resources and a concomitant leisured lifestyle — predominated initially but was largely usurped by ideas concerning 'sympathetic magic' and the need to ensure successful provision of (meat) resources (a model influentially extolled for many years by Abbé Breuil). In general such interpretations had the ambition of explaining the entire available corpus of the time. A structuralist division of imagery into categories on the basis of style and location was subsequently applied by Leroi-Gourhan (e.g. 1964), ultimately seeking to divide the material on the basis of its 'maleness' or 'femaleness'. This detailed analytical approach went some way to supplanting holistic hunting-magic models; however, despite being based on unprecedented levels of detail in analysis and divisions of the material, it still sought to provide a single explanatory framework for the diverse phenomena in question. As with many paradigms in other disciplines it is clear with hindsight that dominant theories are very often heavily influenced by the concerns of their time, including predominant models in other disciplines, such as social evolutionism, psychoanalysis and linguistics, for example. This is,

perhaps, inevitable, but in the latter two decades of the twentieth century the increase in the quantity of material discovered, the number of researchers involved in the field (including of 'rock-art' studies more generally), and the subsequent volume of writing on the subject have resulted in a greater diversity of theories and a more pluralistic approach. For example, more recent theories as to 'meaning' or 'purpose' in Palaeolithic imagery have been concerned with information storage and transmission, initiation rites, reinforcing group boundaries, breaking down group boundaries and promoting cooperation, and extra-sensory *entopic* experiences derived from hallucination and sensory deprivation (see, for example, Bahn & Vertut 1997; Conkey 1999; Lewis-Williams 2002; White 2003).

Human subject and subjectivity in Upper Palaeolithic representation: consideration of some issues of interpretation

Continuity, discontinuity and duration
To ask 'what is the meaning of Palaeolithic art?' may be no more meaningful, or useful, than to ask 'what is the meaning of Holocene art' — and, in fact, we are dealing with a duration at least three times that of the Holocene. The chances of there being a single correct explanation for the phenomenon (or, perhaps more accurately, phenomena) seems exceedingly unlikely. Notwithstanding semiotic issues of authorial intent, and of objectivity and subjectivity in interpretation, both on the part of modern and the 'original' audiences (and it is worth bearing in mind the possibility that many of these images were only ever perceived by an 'audience' thousands of years after they were created), the geographical, material, temporal, contextual and morphological diversity that is so often subsumed under the umbrella term 'Palaeolithic art' mitigates against a single explanation.

It could be argued that the consistency of the subsistence strategy over this period lends weight to suggestions of 'functional' or 'interpretative' continuity over the period (cf. 'hunting magic' explanations). Such suggestions, whilst intuitively reasonable, can be countered by pointing to the diversity of modern cultures (and thus the diversity of forms of symbolic expression) that share a 'supermarket subsistence' strategy today or, if that seems too far removed, by observing the cultural *dis*continuities between the various modern hunter-gatherer societies (e.g. Lee & Daly 1999), all of which (definitively) share broadly the same subsistence strategy. Subsistence can obviously have a great influence on cultural products, but need not dictate them, and it is not justifiable to assume continuity in material expression on that basis alone.

It should, however, be pointed out that continuity over vast time scales is not without precedent. Whilst it is extremely important to maintain an awareness of the durations in question, and not to default to conflating thousands of years of human activity into catch-all descriptive or interpretive categories, we exist today in an era of such rapid technological and social change that we can easily find ourselves inclined to treat change as more representative of the norm than is continuity. In fact continuity of material form over long spans certainly can occur, as is evidenced by various tool-making traditions, for example. This would seem especially to be the case when form is shaped by function, through fundamental physical or Gestalt principles, and a perennial, but critical, question is of the extent to which such fundamental principles might underlie behaviours which otherwise appear culturally and contextually determined. In looking at the record of representation in the Upper Palaeolithic of Europe we should not treat it as a single, unique, isolated phenomenon, but as a series of unique, but related phenomena occurring under particular circumstances over the course of at least 25,000 years. The really interesting questions to be asked must concern how and why *different* cultures over a large area and huge durations came to carry out behaviours which to our eyes appear part of a continuity.

Attributions of 'realism' to zoomorphic vs anthropomorphic images
Although much of the past discussion regarding this archaeological record of representation has referred to its subject matter as 'Palaeolithic art' or 'cave art', throughout this paper the term 'art' will be avoided. The term carries a large collection of presuppositions of aesthetic values and functions which not only impose upon the material implicit criteria for interpretation, but which may also limit the bounds of interpretation. This is not to say that it is inappropriate to appreciate the aesthetics of Palaeolithic imagery, or to view it as 'art' or as 'artistic', but that that is a different and narrower set of concerns than those with which archaeology is concerned. The terms 'images' and 'imagery' will be preferred instead, under which title I include both three-dimensional and two-dimensional representations.

It is often claimed that Palaeolithic zoomorphic images tend to be lifelike, dynamic and accurate, whilst anthropomorphic representations tend to be stylized, schematic and caricatured. This perspective, whilst perhaps representative of the clearest examples of the (more numerous) zoomorphic representations, is not a distinction that can be applied much more widely than that. As Bahn points out (Bahn & Vertut

1997), many of the animal representations from the Palaeolithic are incomplete, sketchy and ambiguous. Naturally, the zoomorphic images that feature most prominently and frequently in the literature are those that are considered to be the 'finest' examples, so the perspective that we have of the overall corpus is dominated somewhat by this relatively small percentage. Nevertheless, it does seem, to modern eyes, that there is no representation of humans comparable to these more celebrated zoomorphic images in terms of 'realism' or 'accuracy'. One possible factor underlying this perception relates to deliberate decisions that may have been made on the part of the creators of such images, as well as to the ways in which they have been viewed by modern commentators.

Humans are extremely sensitive to the recognition of faces — the attribution of individual identity to a particular combination of facial characteristics, as well as the attribution of facial characteristics to non-human objects and phenomena (for example, the 'man in the moon') (Guthrie 1993; Hinde 1999; Hinde this volume). Because of this, if the desire is to represent a *generic* specimen of our species, or a species ideal, it may be felt *necessary* to represent such characteristic features ambiguously or schematically. This is the only way of avoiding an image of a human seeming to constitute a portrait of a single individual. This is in contrast to our representation of other animal species, in which an absolutely accurate reproduction of anatomical features will not jeopardize an endeavour to represent a generic specimen or ideal, because we do not default to attributing an individual identity to each individual of a non-human species.

Observations by modern commentators, that fauna are represented in an 'extremely realistic' way (e.g. Robert-Lamblin 2003, 201) whereas humans are always stylized and abstract, may in fact be a product of the same disposition to recognize individual human features but not to do so with animals. We are inclined to treat individual animals as generic, and disinclined to treat individual humans as generic. Consequently in looking at the Palaeolithic imagery we often over-attribute abstraction to images of humans, and under-attribute abstraction to images of fauna. Each may contain elements that are very accurately represented, and others that are abstracted. For example, an accurate representation of an ibex's ears, antlers and hooves on a silhouette body makes for a 'remarkably lifelike' and 'anatomically accurate' representation of an ibex; an accurate representation of a human's ears, hair and feet on a silhouette body makes for an 'abstract' and 'stylized' representation of a human.

This is not to say that human representations are necessarily more 'realistic' than is acknowledged; only that we should be aware that the criteria that we apply to judge 'realism' are often different for different subjects. We expect the ibex simply to be *an ibex*, whilst we expect the human to be *a person*. These perceptual expectations are not simply a matter of aesthetics, but seem at least in part to be a consequence of cognitive-perceptual mechanisms. Before we can ever achieve an understanding of the meanings of and motivations for the creation of Palaeolithic imagery we must have some understanding of how these mechanisms are likely to have shaped, if not dictated, that process, and concomitantly, how they are likely to have shaped our own critical interpretations.

This volume is concerned with the archaeology and interpretation of *figurative representation*, which has the potential to be a broad category, encompassing anthropomorphs, zoomorphs and combined therianthropes, in three dimensions, two dimensions, and bas-relief, painted, engraved or sculpted. All of these forms are represented in the Upper Palaeolithic of Europe. Nevertheless, it is intended that, whilst avoiding making unnecessary or unjustified exclusions, the focus of the volume within this broader theme should lie with anthropomorphic representations. The remainder of this paper is concerned principally with an appraisal of the evidence for and interpretation of two particular types of Palaeolithic anthropomorphic imagery: human hand prints and hand stencils. These are not subject to the issues of interpretation highlighted above (individual attribution via face perception, and differential interpretation of zoomorphic and anthropomorphic imagery), in that there is no directly comparable form of zoomorphic representation, and their form, as a direct (indexical) representation of part of the body, is not subject to the same issues of realism versus abstraction. As such they highlight a number of further issues of interpretation of their own.

Hand print and stencil anthropomorphic representation

Often 'anthropomorphic representation' is taken to refer only to iconic representations of humanoid figures which are, in comparison to zoomorphic representations, relatively rare in the Upper Palaeolithic of Europe. However, there is another form of anthropomorphic representation which occurs quite prolifically (Fig. 6.4) — representations of hands. Hand images are also well-known in ethnographic examples from around the world, including much of Australia, Indonesia, and parts of Africa (Lorblanchet 1980), including Tunisia, where they often decorate the doors and walls inside houses (Pradel 1975). The hand may have been seen as the focus or embodiment of skill, intelligence,

Figure 6.1. *Hand prints, Chauvet cave. (From Clottes 2003, 82.)*

and its environs in Mediterranean France, at La Baume-Latrone, Bayol and Grotte aux Points (Baffier & Feruglio 2003). These can be themselves divided into two types — prints of the whole hand, including the digits (Fig. 6.1), and palm-prints, where the palm is used to make a large 'dot' of pigment (Fig. 6.2). The latter are thus far only known from Chauvet cave, and were not originally recognized as being prints caused by the application of the hand to the wall, until they received close scrutiny (Lewis-Williams 2002).

In the area of Chauvet cave known as 'The Red Panels Gallery' there are, amongst others, two panels, known as 'The Panel of Hand Prints' and 'The Panel of Hand Stencils'. The former consists of a 12-m-long rock surface at the right-hand end of which is a collection of zoomorphic images, representing seven feline heads and one complete feline, plus a horse, mammoth and rhinoceros. In the centre of this collection of zoomorphs are five full hand prints, as well as two hand stencils (Aujoulat 2003). The stencils were created by spraying red pigment onto the wall; of the prints, two of the five are left hands, three right, and these were made by applying red ochre to the hand, and then the hand to the wall (Baffier & Feruglio 2003).

The latter, 'The Panel of Hand Stencils' is a surface 4 m long and 90 cm high, and features two clusters of (sprayed) red dots, two unidentifiable weathered drawings and two zoomorphic representations, a horse and a mammoth, in black. In addition there are three red hand stencils, one of which is within the outline of the horse, and another within the mammoth-outline. In at least the latter case the hand stencil can be seen to postdate the zoomorph, as it partially overlays the outline of the mammoth (Aujoulat 2003).

In addition to these few full prints and stencils, in the Brunel Chamber there is one further full hand print, plus the aforementioned large dots of red ochre made by applying the palm of the hand to the wall (Baffier & Feruglio 2003). In this instance the principal intention appears not to have been to create the impression of a hand on the wall of the cave, but to use the palm of the hand as a tool for the creation of a large dot of paint, which in turn formed part of a larger image. It appears that pigment was placed in the palm and then slapped against the wall. This was repeated over a very large area, with the dots numbering almost 500. In one area 92 of them form the shape

tool-making and hunting, activities and traits essential to hunter-gatherer subsistence; as Robert-Lamblin puts it, it is 'the human attribute *par excellence*' (Robert-Lamblin 2003, 203). It is perhaps no coincidence that the demographic of right and left hands represented in Palaeolithic cave imagery closely accords with the demographic of dominant hands in modern human populations (i.e. approximately one in ten).

Hand prints, and stencils of hands, are a particularly interesting form of anthropomorphic representation in that, within Palaeolithic imagery, they are uniquely *indexical* of the presence of a human. Whatever other belief systems form part of their interpretation, a hand print or outline is instantly indexical of a human. Any symbolic interpretations (such as the presence of an anthropomorphic spiritual entity who might make such signs, or a code) build upon that basic indexical property of the hand representation. This is in contrast to other forms of anthropomorphic representations and zoomorphic representations in general, which are *iconic*, and whose *cause* is less self-evident.[1]

Hand images in Palaeolithic contexts take two forms: hand prints, and hand stencils (silhouettes). Whilst they may intuitively seem likely to have been equivalent in their symbolic value they are in fact very different in terms of the techniques, time and pigment required to make them. In terms of the conceptual associations to which they might lend themselves therefore, they may also be very different.

Hand prints
Positive hand prints, in contrast to negative stencils, are relatively rare in Upper Palaeolithic Europe, and are concentrated mainly around the Rhône valley

of a large herbivore (Robert-Lamblin 2003). Occasionally the lower phalanx of a digit is visible where the pigment has 'bled' under the finger upon application, but this appears to be an unintentional by-product. This is not to say that the fact that the hand was being used was not significant, but that these 'prints' should not be seen as equivalent with those where the primary intention appears to have been to represent the hand.

How important this direct contact between body and 'canvas' was to the creator, and to the intended perceiver, is an interesting issue which does bear upon the interpretation of hand prints, and may be one aspect in which the full hand prints and palm prints differ. In the case of the latter, is it likely that a perceiver would know that this 'dot' represents the physical contact of an individual with the wall (cf. White 2003; Clottes & Courtin 1996)? As noted, these were not initially recognized by modern observers as having been made with the hand, until they received close scrutiny. It might nevertheless be the case that as far as the creator is concerned the dot, or pattern created, might gain significance as a consequence of its direct application by a human hand.

Hand stencils
By far the more common of the two types of hand representations are hand stencils (Fig. 6.3). Hundreds of examples are known from caves in France and Spain, including Gargas, Cosquer, Chauvet, Tibiran, Fuente del Trucho and Fuente del Salín, for example (Bahn & Vertut 1997; Clottes & Courtin 1996; Clottes 2003). In total hand stencils are currently known from 22 caves (Fig. 6.4).

There would appear to be two main ways of making a stencil of a hand, having applied it to the rock surface; one would be to daub paint onto and around the hand using a large brush or wad, the other would be to spray pigment over the hand and surrounding area of the rock surface. The effects of these two techniques are quite different — the former creates an even spread of paint with a clear edge, whereas the latter creates a more 'hazy' effect with a softer

Figure 6.2. *Palm prints, Chauvet cave. (From Clottes 2003, 165.) Bottom photograph has been digitally altered to show hand positions.*

edge. Daubing appears to have been used only rarely, with the vast majority of known stencils having been achieved through spraying of pigment using either a pipe (of bone or reed for example) or directly from the mouth (Lorblanchet 1980; Wildgoose *et al.* 1982; Bahn & Vertut 1997).

Cosquer cave has been particularly significant for the study of hand representations, as until its discovery only hand *prints* were known from Mediterranean France. In contrast, Cosquer contains no positive prints, only negative hand stencils, created either with a red clay-based or a black charcoal-based pigment; of the 46 stencils at Cosquer, 34 are black and

Chapter 6

Figure 6.3. *Hand stencil, Chauvet cave. (From Clottes 2003, 84.)*

Figure 6.4. *Known locations of hand stencils: 1) Gargas/Tibiran; 2) Erberua; 3) Les Trois-Frères; 4) Cosquer; 5) Pech-Merle; 6) Les Fieux; 7) Les Merveilles at Rocamadour; 8) Roucadour; 9) Moulin-de-Laguenay; 10) Les Combarelles; 11) Font-de-Gaume; 12) Le Poisson shelter; 13) Bernifal; 14) Grotte du Bison; 15) Labattut shelter; 16) Roc-de-Vézac; 17) Grande Grotte at Arcy-sur-Cure; 18) Altamira; 19) El Castillo; 20) La Fuente del Salín; 21) Maltravieso; 22) La Fuente del Trucho. (From Clottes & Courtin 1996, 66.)*

12 are red. Those hand stencils that have been made using charcoal have been radiocarbon dated to around 27,000 years ago. Where there is any overlap between the hand stencils and the painted or engraved animals in Cosquer, the hand stencils without exception pre-date the zoomorphic images; indeed, the zoomorphs that have been directly dated are approximately 7000 years younger than the hand images (Clottes & Courtin 1996).

Whilst hand prints and hand stencils may superficially appear to be equivalent (and they are often considered synonymously), there are several considerations and issues of interpretation that relate particularly to stencils, which illustrate that, in fact, the two types of representation are far from equivalent. There is clearly more to the activity of creating a hand stencil than simply creating a representation of a hand. There are far quicker, and easier, ways of doing this — a hand print, created by painting the palm-side of the hand and applying it to the surface in question, need only take a minute, whereas the process of stencilling has been demonstrated by experimental reproduction to take around 15 minutes with dry powder pigment, and between 30 and 45 minutes with liquid pigment (Lorblanchet 1980). This is no small undertaking, and there is clearly something about the particular product of this process, the process itself, or both, that is significant. Furthermore, whilst it is sometimes possible to identify a single individual creating several silhouettes on the basis of similarities in size or morphology of representations, there is far less personally identifiable information available from a silhouette than from a hand print. Explanations on the basis of the marking of human presence, individual presence, or personal 'graffiti' (cf. Clottes & Courtin 1996) would thus not, in view of the above considerations, appear to be adequate to explain the phenomenon of hand silhouettes.

Another feature that distinguishes stencils from prints, in terms of the ways in which they may be 'experienced' subsequently, is that a stencil leaves a 'space' into which a hand can subsequently be fitted. Definitively, a hand stencil is an outline, an index with the significant feature 'missing'. Of course the hand that will fit there best is that of the individual who made the stencil, but another individual who places their hand into the outline is 'taking the place' of the creator of the image. If this process also involves folding some or all of the fingers (see below), the individual is in fact also having to 'transform' themselves

to become more like the creator of the image. A subsequent visitor, in doing this, will recreate some of the sensory experiences of the creator of the image — the form of their hand, their location in the cave environment and their posture must obviously be very similar, as is the tactile sense through the hand. Only future research closely examining the unpainted rock surface in the centre of hand stencils may be able to determine whether such subsequent activities have taken place, in which case there may be polishing to the rock surface, or the paint at the edges of the hand outline may be more worn than elsewhere.

The process, as well as the product, may be equally important in considering hand silhouettes. If one is stencilling a hand by blowing or daubing paint around it, or making a print by applying paint directly to the hand, another product of the activity will be to end up with a painted hand. Was this a significant goal of the process, a by-product that was nevertheless significant, or an incidental outcome? With hand prints the role of the hand in the process is to *transfer* paint to the surface. Once this has been achieved, a large proportion of the pigment applied to the hand has been transferred to the wall. In the case of stencilling, however, the hand is not a vehicle for the pigment, but *prevents* the paint from reaching the surface, by receiving it itself. The hand receives as much pigment as the surrounding area. Lewis-Williams (2002) suggests that the fact that the hand and the wall are both simultaneously painted may be significant, the hand becoming 'sealed into' the wall, to use his phrase, by pigment which was probably seen as a potent substance, rather than simply a colouring agent.

As noted earlier, the process of creating a hand silhouette requires that one of two processes be used: pigment may be sprayed either through a pipe or directly from the mouth. These two different techniques have their own implications for the circumstances under which a stencil was produced, when one considers that an individual making a hand silhouette immediately has one hand out of use, pressed up against the rock surface. This leaves them with only one other hand for holding the pigment, a pipe through which the pigment is to be applied, or a lamp to illuminate the area of work. Assuming that the images were not made in total darkness (and this seems exceedingly unlikely given the relatively accurate aim required,

Figure 6.5. *Hand stencils with shortened fingers, Cosquer. (From Clottes & Courtin 1996, 70.)*

consistency of form of silhouettes, not to mention the precarious positions that sometimes must have been required), the spraying of a hand silhouette could be achieved by a *single* individual only if there was a convenient nearby surface where a source of illumination could be placed, or if the process of blowing pigment from the mouth was used, thus freeing the other hand to hold a lamp or torch. Alternatively, two individuals at least would have to be present.

A curious feature of hand silhouettes in several sites is that the hand representations frequently have one or more fingers shortened (Fig. 6.5). In some sites such images actually outnumber 'complete' hands by some considerable amount (Bahn & Vertut 1997), and Cosquer falls into this category. In fact 25 of the 46 hand stencils (66 per cent) in Cosquer represent shortened fingers. This phenomenon occurs in four of the 22 caves that are known to feature hand stencils, most prolifically by far at Gargas (Hautes-Pyrenees) (see Fig. 6.6), where only ten of the 124 best-preserved silhouettes show all fingers completely, but also at Maltravieso in Estramadura, and with a single example at the Grande Grotte of Arcy-sur-Cure.

Gargas features 16 different combinations of shortened fingers, in terms of which fingers are shortened and which hand is represented (Clottes & Courtin 1996; or 20 according to Pradel 1975), although the differences between some are so subtle that it seems they could easily have been caused by distorting effects of variations in the rock surface, which can result in artificial foreshortening or apparent

complete, but are deliberately represented shorter by folding them, as part of a symbolic system.

The first of these positions was that preferred by Breuil (and disciples). Ritual and punitive mutilation is well-known from several ethnographic cases, when, for example, the end of a digit is removed (e.g. in certain coastal tribes of tropical Australia: Lorblanchet 1980). Breuil suggested, in line with his other 'hunting magic' interpretations of cave representation, that the incomplete silhouettes may represent the record of ritual activities to ensure hunting success or of initiation rites, for example. This perspective was prevalent for many years, and the term '*mains mutilées*' is still in frequent use in the literature, even in the context of discussing alternative explanations. Approximately 40 years after Breuil's writings (and approximately 40 years before the present), two alternative explanations were advocated.

Sahly (1969), a medical doctor, and later Barriere (1976) suggested that the hands that were stencilled at Gargas were in fact incomplete as a consequence of physical pathologies, such as frostbite, Reynaud's disease or leprosy. These conditions all result ultimately in tissue death at the extremities of the digits culminating in loss or amputation of the distal phalanges. It has been argued that in the harsh conditions of glacial Europe, especially the Last Glacial Maximum at the start of the Magdalenian period, loss of digits to frostbite may have been a prevalent condition. Reynaud's disease, a circulatory disorder caused by neural spasming in the digital extremities (especially in cold conditions), (Tardos 1993), is a condition to which there could be genetic susceptibility within a population, and leprosy could also affect a large proportion of a given population. The hand stencils sometimes feature spatulate ends to the shortened digits, and this has been taken as a confirmation that these are the stumps of amputated/lost phalanges.

At around the same time, Leroi-Gourhan (1967) was also re-assessing the prevalent 'deliberate mutilations' explanation. To him the idea that a population would voluntarily handicap a large proportion of their members, when the hand was critical to so many survival-related activities, was an anathema. Ritually removing the distal phalanx of a little finger is one thing; removing more than that, and of two, three or even four fingers, is another. As he put it,

> that hunters would amputate all the fingers of the hand in order to have greater luck with the hunt, and by the same token, that they would amputate those of future hunters, who were also their children, doesn't correspond to an economically defensible practice (Leroi-Gourhan 1964, 102, trans. IM, quoted in Delluc & Delluc 1993)

Figure 6.6. *Hand stencils with shortened fingers, Gargas. (From Clottes & Courtin 1996, 67.)*

stretching of individual digits (cf. Lorblanchet 1980). At Cosquer, there are five different combinations: little finger shortened (left hand) (2), little finger and ring finger shortened (left hand) (15), little, ring and middle fingers shortened (left hand) (6), all four fingers shortened (left hand) (1), and all four fingers shortened (right hand) (1) (Clottes & Courtin 1996).

Those from Gargas and Maltravieso have been the topic of much comment and investigation and the examples from Cosquer add considerably to the corpus known, further fuelling the debate as to what these shortened fingers represent. Theories fall into three main categories — those holding that the hand stencils with shortened digits show hands that are actually missing phalanges as a consequence of deliberate mutilation, those that hold that the hands represented are missing phalanges through pathology, and those that hold that the fingers are in fact

Leroi-Gourhan conceded that the possibility that the Palaeolithic people 'had lost their fingers for pathological reasons is not, after all, impossible, but accords badly with the structure of the ensemble (of representations)' (Leroi-Gourham 1967, 122, trans. IM, quoted in Delluc & Delluc 1993). In contrast, he cites the fact that amongst modern hunters 'finger games' to signal the presence of prey etc. are well-known (Leroi-Gourhan 1967, 122) and, in fact, Norwood (1979) (cited by Lorblanchet 1980), demonstrated a correspondence between the finger signals of Aborigines of the central plateaux of Queensland and the apparently 'mutilated' hand stencils of that region (Lorblanchet 1980). The possibility that the shortened fingers represented signals had been proposed at an early date by Capitan (1911); Leroi-Gourhan favoured this type of explanation, and went on to attempt to directly relate the incidence of the various finger combinations to the prevalence of faunal types represented in parietal art. Like the pathological explanation, the finger-folding explanation has continued to be advocated strongly in the subsequent years, and it is this explanation that, ultimately, Clottes & Courtin favour for Cosquer, in their initial publication at least (1996).

Each of these three explanations has had its ascendancy, but there is currently little or no consensus regarding which is the most likely, if, indeed, one of them is, and there are several problems associated with each of the explanations.

Some objections to ritual mutilation
1. As Leroi-Gourhan (1964; 1967) pointed out, some of the 'mutilations' are so extreme as to severely handicap the capabilities of individuals to carry out day-to-day survival activities. This would possibly be an acceptable situation if they were punitive mutilations as opposed to those associated with 'hunting magic' or rites of passage, although we might expect some standardization if they are punitive acts, and must ask why individuals who had been vilified in this way would have access to such apparently important spaces and activities as those involved in cave decorating. One might also ask whether such a broad cross-section of the population as is represented at Gargas (which includes adults, adolescents and children, males and females) would be included in such activities (punitive or ritual).
2. One would perhaps expect to also see hand *prints* with missing fingers (though it could be argued that prints and stencils were created by different cultural groups with different traditions).
3. The appearance of broader ends to shortened digits, cited as an indicator that the distal phalanges must have been amputated leaving stumps, is an effect that is also caused by folding the digit.
4. The collection of 55 hand stencils at Maltravieso, which all show a shortened little finger, and have been taken as making a good case for consistent ritual mutilation, are in fact stencils of complete hands which have had the little finger painted out subsequently (Ripoll *et al.* 1997; Bahn & Vertut 1997).

Some objections to pathological damage
1. Logically, we have no reason to believe that the 'other' hand (usually the right) was not equally afflicted by the purported pathologies (be they Reynaud's disease, gangrene, leprosy or frostbite). In the case of Gargas especially, this leaves us with an extremely detrimentally afflicted set of individuals who would be severely limited in their capabilities for many day-to-day survival-related activities. It is conceivable that a single population group was thus (terminally) afflicted with disease and decided to mark their presence at Gargas; the fact that such similar stencils exist at Cosquer over 250 miles away suggests that this was not the case.
2. Reynaud's disease and frostbite both tend to affect all the fingers simultaneously, rather than different digits selectively as would be suggested by the Gargas and Cosquer silhouettes. The same applies to leprosy which, furthermore, results in equivalent lesions on the thumb (Tardos 1993); in contrast, the thumb is always complete in the hand silhouettes known (with the single exception of the white hand at Gargas — this silhouette is also exceptional in its colour, and the technique of pigment application, which is by pad or brush rather than spraying).
3. One would perhaps expect also to see hand *prints* with missing fingers (though it could be argued that prints and stencils were made by two different population groups, one of whom was more susceptible to circulatory disease — although this seems rather like special pleading).
4. The appearance of broader ends to shortened digits, cited as an indicator that the distal phalanges must have been amputated leaving stumps, or swollen due to pathology, is an effect that is also caused by folding the digit.

Some objections to folding of the fingers
1. Some hand positions that would be required are very difficult to achieve. Barriere & Sueres (1993) maintain that it is impossible to fold only the distal phalanx, and that if one is folding the fingers one must fold at the first knuckle.
2. The thumb is never missing (with the single exception of the white hand at Gargas). Why not make

use of folding the thumb in signalling language?
3. If the shortened fingers are part of a signalling system why are there so many cave sites with only complete hands represented (Barriere & Sueres 1993)?
4. Barriere & Sueres (1993) (with reference to Gargas) and Clottes & Courtin (1996) (with reference to Cosquer) point out that some of the hand stencils would have been impossible to execute with the palm up, so must have been carried out with the palm to the wall; this has been taken (by Barriere & Sueres 1993) to indicate that palm-up positions were not used at all, thus reducing the number of ways of achieving given combinations of shortened digits through folding of the fingers.

There are, however, various counters that can be made to several of these objections to folded fingers; in order:
1. Lorblanchet (1980) and Groenen (1990) demonstrated that all of the stencil outlines present at Gargas are replicable with 'healthy' hands by folding the fingers (but see also Wildgoose *et al*. 1982, who had problems doing so), although Lorblanchet makes the point that some hand positions would be arduous to maintain for the extended period required to make them. It is possible, of course, that difficulty associated with the creation of the image may in fact add some significance to it. With regard specifically to the folding of the distal phalanx, Lorblanchet (1980) and Groenen (cited in Clottes & Courtin 1996) have both demonstrated that in fact it was perfectly possible to create the effect of a finger shortened by one phalanx by arching it, and this need not result in any 'bleeding' of the pigment under the arched finger. In addition, Lorblanchet cites the fact that in two caves with hand stencils (Gargas and Pech-Merle) there is imprinted evidence of fingers in profile where the distal phalanx is folded, demonstrating that Palaeolithic people *could* effectively fold their phalanges, if desired (Lorblanchet 1980)
2. This is a valid issue; however, it does nothing to help us to choose between the posited explanations, as the same question applies to practices of ritual mutilation, and it is an even more significant problem with pathological explanations, as the thumb should not be spared by these pathologies.
3. This is also a somewhat dubious criticism of this particular theory, as both of the other models are only really seeking to explain the incomplete hands too. It does, however, remain an important point that there must be some *other* motivation for making complete hand stencils, or an underlying motivation for making hand stencils, whether complete or otherwise, even if there is additional significance to the variations that are created by shortening the digits.
4. That some stencils would have been impossible to execute palm-up does not mean that none were executed in this way.

There are also some factors which count in favour of a finger-folding explanation.

Some factors in favour of finger-folding
1. Whilst Lorblanchet (1980) demonstrated that a partially-folded finger raised slightly from the rock surface need not result in 'bleeding' of the pigment under the raised area of the hand, there are instances in Gargas illustrated in Barriere (1976) where this has in fact apparently occurred, suggesting that the hand being stencilled was not flat against the rock surface, and perhaps that fingers were folded underneath the palm.
2. The diversity of different combinations of extended and shortened digits at Gargas and Cosquer accords better with a repertoire of signs than systematic mutilation or pathological effects.
3. As mentioned, the hand stencils from Maltravieso, all 55 of which appear to represent shortened little fingers, are in fact complete hands of which the little finger has been subsequently painted out (Ripoll *et al*. 1997). This demonstrates not only that they were executed by a population with healthy hands, but that there was a particular symbolic significance to illustrating them with a shortened finger (whether or not the action of painting-out the finger was carried out by the original makers of the stencil, or subsequent visitors).
4. Both Gargas and Pech-Merle each feature a row of folded thumbs (or possibly fingers), stencilled in the same way as the hands. The creation of novel signs by folding the digits was clearly a technique familiar to the people responsible for the hand stencils.

As Clot *et al*. (1995) point out, past theories have tended to aim for a single universal explanation for all incomplete hand representations, regardless of their location or period, be they red, black, yellow or white. Arguments for and against one or other of the aforementioned techniques tend to rely on very particular examples. It is possible that each of the three explanations may be correct for *some* examples in some locations, but there are substantial objections to be raised at a more general level to the pathological and ritual mutilation explanations. The objections that have been raised against folded fingers are, in turn, less convincing, and it is this explanation which appears to fit best with the greater proportion of the evidence. This is not necessarily to suggest a single

universal explanation for all hand stencilling; after all, the above debate relates to only the incomplete hands, and these only occur at 4 of the 22 currently-known sites with hand stencils. Secondly, even if finger-folding turned out to be the correct explanation for the *creation* of all of these, this would not imply a single symbolic system — the meanings associated with such images could be very different in different locations (within, as well as between sites, even), and possibly times — simple in some locations and very complex in others. Finally, until more dating evidence is available illustrating how temporally close the various examples are (within a given site as well as between sites) we could not hope to critically assess the likelihood of them representing a single social tradition.

Summary and conclusions

Despite over a hundred years of observation, analysis, theorizing and argument about the nature and meaning of Palaeolithic hand representations, there is still clearly much that can be said, and much that may still be found out.

The arguments that have been made seem often to be perfectly applicable to one or a few individual examples, but rarely to the whole corpus. Whether or not it is correct to speak of a 'corpus' of hand stencils (and it is probably not), the models and arguments often have been made at a more generic than specific level, whilst using very specific examples to illustrate them. The exception to this has been the finger-folding explanation, which does appear to *have the potential to be* more widely applicable as an explanatory framework.

Several practical reconstructive experiments have been carried out demonstrating the potential of the hand for creating the various representations seen, and the pigments and techniques that are most likely to have been used; these have been extremely valuable in helping to rule out certain possibilities, and highlighting some of the technicalities of producing the stencils at a general level. However, there seems to have been little written which applies this knowledge to the question of the nature of the *experience* of making individual images: the practicalities in terms of physical exertion, the lighting required, the number of people who must have been present at the time, and the after-effects of the activity (not least, a painted hand). These are significant factors for all hand images, but especially stencils, which take considerable time and effort to produce. They may each vary for every hand stencil image, but if that is the case, then it is just as important to know this as whether the experience of creating them was the same for each.

There is still much scope for attempting to determine whether the same individuals were responsible for numerous stencils within a site. This has been attempted for some of the stencils in Gargas, but often on the basis of identifying an individual with a particular combination of 'mutilated fingers', which, as we have seen, may very well not be an identifying feature of a single individual. If it is possible to identify particular individuals making particular stencils within a site, then we can start to ask whether there is any spatial patterning to where particular people of particular ages and genders made the stencils, and only then start to gain some insight into their social significance. These factors, as well as those of the practicalities of production, may be especially important in terms of identifying any patterns which may exist in the stencils with shortened fingers.

To date the only hand stencils with shortened fingers that have been directly dated are those made with charcoal at Cosquer. The others are dated only by relative dating or by association with directly dated features, and until a more concrete chronology can be established for the different sites it will be impossible to know how generally applicable different explanations may be.

Overall, in interpreting Palaeolithic imagery we need to be careful not to make categorical statements about individual pieces until we are confident of how they relate to those around them, in the same site, and that site in relation to others, chronologically if possible, and spatially. We must also be very careful to be consistent in our application of interpretive criteria, and understand the ways in which we, as humans, are predisposed to experience and interpret such visual phenomena. These predispositions, as well as the processes of production themselves, are likely to have been highly significant in shaping the meaning and 'spiritual' content or significance of the imagery. Before we can hope to understand the meaning of this varied imagery to the people who created it, and to those who observed it, we must have some understanding of the experience of creating the image, and the by-products of the process too.

The experimental reconstructive work of Lorblanchet and others, and the development of new chemical and photographic analytical techniques (e.g. Clot *et al.* 1995; Ripoll *et al.* 1997) are opening up many new avenues of investigation of such questions; there are doubtless many still to be asked.

Acknowledgements

Many thanks to Jean Clottes for his permission to reproduce the images for this paper.

Note

1. **Peirce's semiotics of signs** — symbols, indices and icons — may provide a useful framework in which to consider the different types of representation, and whether they rely upon different cognitive-perceptual capabilities for their creation and interpretation (see also Joyce this volume).

 Icon: A sign which refers to the object that it denotes merely by virtue of characters of its own — relationship by *similarity*.

 Index: A sign which refers to the object that it denotes by virtue of being really affected by that object — *causal* relationship.

 Symbol: A sign which is constituted a sign merely or mainly by the fact that it is used and understood as such — *conventional* relationship.

 (Summarized in White 1978).

 Painted or engraved anthropomorphs may be *icons* or *indices*, in that they may be images of humans, or handprints, fingerprints, or hand silhouettes, for example. Anthropomorphic three-dimensional images ('in the round') or bas-relief images **must** be *icons* in that in order to be anthropomorphic they must represent a human.

 Hand prints or silhouettes are *indices* of human presence — i.e. they are anthropomorphic indices rather than anthropomorphic *icons*, which an illustration would be. It is important to remember, however, that whilst they are *indices* of a human they can be *icons* of a hand.

 So we can instantly say that anthropomorphs **must** be *indices* or *icons* (though they **may** also have *symbolic* meanings). Therianthropes **must** have *symbolic* meanings, and cannot be simply *indexical* or *iconic*, as they have no real-life referent. However, in the sense that they combine *iconic* traits of different creatures into a whole they could be thought of as the sum of iconic components. As a consequence of the fact that we can perceive this sum of components as a whole we are able to represent iconically something which in fact has no single referent.

 Note that all of the above (including three-dimensional and bas-relief) may have *symbolic* meanings too, in that they may stand for something else in addition.

 There is not the potential here to do more than superficially outline a few direct implications of the viewing of Palaeolithic representations in the context of Peirce's system of signs, but it can at least be seen that different types of Palaeolithic imagery are by no means equivalent in the way in which they may transmit information.

References

Aujoulat, N., 2003. Drawing in the cave: the Red Panels Gallery, in *Return to Chauvet Cave: Excavating the Birthplace of Art, the First Full Report*, ed. J. Clottes. London: Thames and Hudson.

Baffier, D. & V. Feruglio, 2003. The dots and hands, in *Return to Chauvet Cave: Excavating the Birthplace of Art, the First Full Report*, ed. J. Clottes. London: Thames & Hudson, 164–5.

Bahn, P.G. & J. Vertut, 1997. *Journey Through the Ice Age*. London: Seven Dials.

Barriere, C., 1976. *L'art pariétal de la grotte de Gargas*. (British Archaeological Reports International Series 14, 2 vols.) Oxford: BAR.

Barriere, C. & C. Sueres, 1993. Les mains de Gargas. *Les Dossiers d'Archéologie* 178, 46–54.

Capitan, L., 1911. Les impreintes de mains sur les parois de la grotte de Gargas. *Bulletin Anthropologique* 1911, 87–8.

Clot, A., M. Menu & P. Walter, 1995. Manières de piendre des mains à Gargas et Tibiran (Hautes-Pyrénées). *L'Anthropologie* 99, 221–35.

Clottes, J. (ed.), 2003. *Return to Chauvet Cave: Excavating the Birthplace of Art, the First Full Report*, trans. P.G. Bahn. London: Thames & Hudson.

Clottes, J. & J. Courtin, 1996. *The Cave Beneath the Sea: Palaeolithic Images at Cosquer*, trans. M. Garner. New York (NY): Abrams.

Conkey, M., 1999. A history of the interpretation of European 'palaeolithic art': magic, mythogram and metaphors for modernity, in *Handbook of Human Symbolic Evolution*, eds. A. Lock & C.R. Peters. Oxford: Blackwells, 288–349.

Delluc, B. & G. Delluc, 1993. Images de la main dans notre prehistoire. *Les Dossiers d'Archéologie* 178, 32–45.

Groenen, M., 1990. Quelques problèmes à propos des mains negatives dans les grottes paléolithiques: approche épistémologique. *Annales d'Histoire de l'Art et d'Archéologie* 12, 7–29.

Guthrie, S., 1993. *Faces in the Clouds: a New Theory of Religion*. Oxford: Oxford University Press.

Hinde, R., 1999. *Why Gods Persist*. London: Routledge.

Lee, R.B. & R. Daly (eds.), 1999. *The Cambridge Encyclopedia of Hunters and Gatherers*. Cambridge: Cambridge University Press.

Leroi-Gourhan, A., 1964. *Les religions de la préhistoire*. Paris: Presses Universitaires de France.

Leroi-Gourhan, A., 1967. Les mains de Gargas: essai pour une étude d'ensemble. *Bulletin de la Société Préhistorique Française* 64(1), 107–22.

Lewis-Williams, D., 2002. *The Mind in the Cave*. London: Thames and Hudson.

Lorblanchet, M., 1980. Piendre sur les parois de grottes. *Les Dossiers d'Archéologie* 46, 33–7.

Norwood, M., 1979. Art and Stone. Unpublished PhD thesis, Canberra. Cited by P. Lorblanchet 1980.

Pradel, L., 1975. Les mains incompletes de Gargas, Tibiran et Maltravieso. *Quartär* 26, 159–66.

Ripoll Lopez, S., E. Ripolli Perello, H. Collado & S. Ripoli, 1997. Cueva de Maltravieso. *Revista de Arqueologia* 193, 6–15.

Robert-Lamblin, J., 2003. An anthropological view, in *Return to Chauvet Cave: Excavating the Birthplace of Art, the First Full Report*, ed. J. Clottes. London: Thames and Hudson, 200–207.

Sahly, A., 1969. Le problem des mains mutilées dans l'art prehistorique. Unpublished doctoral thesis, Toulouse-Tunis.

Tardos, R., 1993. Les mains mutilées: etude critique des hypotheses pathalogiques. *Les Dossiers d'Archéologie* 178, 55.
White, R., 2003. *Prehistoric Art: the Symbolic Journey of Humankind*. New York (NY): Abrams.
White, H., 1978. *Tropics of Discourse: Essays in Cultural Criticism*. London: Johns Hopkins University Press.
Wildgoose, M., E. Hadingham & A. Hooper, 1982. The prehistoric hand pictures at Gargas: attempts at simulation. *Medical History* 26, 205–7.

Chapter 7

Images of Animality:
Hybrid Bodies and Mimesis in Early Prehistoric Art

Dušan Borić

We will assume for the moment that we know nothing of theories of matter and theories of spirit, nothing of the discussions as to the reality or ideality of the external world. Here I am in the presence of images ... Yet there is *one* of them which is distinct from all the others, in that I do not know it only from without by perceptions, but from within by affections: it is my body. (Bergson 1981, 17)

... the possibility of metamorphosis expresses the ... fear of no longer being able to differentiate between the human and the animal, and, in particular, the fear of seeing the human who lurks within the body of the animal one eats ... (Viveiros de Castro 1998, 481)

Can one consider early prehistoric art to be of Apollonian nature (Fig. 7.1a), an advance of reason, maddeningly reproducing and resembling the natural order as a mimetic device and a medium for 'external memory storage', or should it be better understood as an expression of the Dionysian aspects of human nature (Fig. 7.1b), relating to 'dark' and subconscious corners of the human mind and to uncontrollable forces from 'within'? These quite different understandings of prehistoric and traditional societies' artworks (not that long ago called 'primitive' art) reflect two general groups of interpretations offered today in attempts to understand such art. The first group of interpretations (functionalist) emphasizes the ecological and cultural situatedness of early examples of image-making. For instance, Palaeolithic cave art paintings as well as *art mobilier* depict a wide range of Pleistocene animal species, which inhabited the same ecological space as human groups. This approach focuses on the functional issues of the origin of image-making, such as exchange of information, group alliances, etc. (see Mithen 1988; 1989; 1991; Gamble 1982; 1991), rather than considering the multiplicity of possible meanings that such depictions might have had. On the other hand, the other group of interpretations (shamanistic) asserts that early examples of artistic expression can be understood by envisioning a shamanistic religious context for their making. This argument relies, for the most part, on the neurological commensality of the modern human mind when experiencing hallucinations in altered states of consciousness, primarily by powerful individuals like shamans. Subsequently, images perceived during such states became rendered in art (Lewis-Williams 2002; 2004; Lewis-Williams & Pearce 2005).

Various critiques of functionalist interpretations have already been raised (e.g. Dowson 1998; Lewis-Williams 2002). Some of these critiques have focused on a tendency towards a teleological argument in functionalist interpretations that primarily recognizes the practical and everyday nature of the image-making — it is seen as a representationalist medium for transmitting information about the availability of potential resources. In contrast to this type of interpretation, in this paper I will argue that, at the current state of research, shamanistic interpretations have more explanatory potential than functionalist interpretations. In shamanistic interpretations, importantly, Dionysian aspects of art are explored. Yet these interpretations remain preoccupied with shamanistic practice and altered states of consciousness in an overly simplified and uniform way by reducing all types of ritual practices and image-making to shamanism. In shamanistic interpretations, art-making by hunter-gatherer and early agriculturalist societies is reduced to an ideological resource of a few powerful shamans, being imposed on the ordinary folks. I will argue that shamanistic interpretations of image-making can usefully be extended by incorporating them under a wider theoretical framework of *animality* as discussed in the field of anthropological philosophy (e.g. Bataille 1989; 2005). I will also suggest amending certain aspects of such notions of animality on the basis of more recent anthropological discussions of Amerindian perspectivism and the role of body as

Chapter 7

Figure 7.1. *(a) Apollo and Centaur, The Temple of Zeus at Olympia, c. 460 BC.*

Figure 7.1. *(b) Dionysius on panther's back, Pellas, Macedonia, coloured pebbles, c. 300 BC.*

the site of ontological differentiation between different kinds of beings.

Building around the idea of the Dionysian nature of early prehistoric art, I develop the notion of animality in relation to such art, primarily related to the representation of hybrid human-animal (therianthropic) images. The suggestion is made that animality can encompass the shamanistic interpretation as one of its media while offering a wider framework for the examination of traditional and early prehistoric art. I proceed by focusing on the notions of body form and its mutability with a particular reference to Amazonian ethnography (e.g. Viveiros de Castro 1998; 2004). Image-making and the ontological status of images are further discussed using the Platonic theory of *eikōn*, or mimetic image (likeness). Two examples of early prehistoric image-making are offered with the emphasis on the depiction of human–animal hybrids.

Altered states of consciousness and shamanism

David Lewis-Williams is the main propagator of the inextricable link between shamanistic practices and altered states of consciousness and the range of images and symbols depicted in the art of hunter-gatherer societies (e.g. 2002). More recently, he extended this argument to a range of early agriculturalist communities (Lewis-Williams 2004; Lewis-Williams & Pearce 2005). Here, shamanism is understood to be a religious system that numerous societies around the world practised throughout human history (cf. Eliade 1972). In a shamanistic religious system the world is seen as a tiered cosmos where shamans are exceptional individuals who possess the power to travel and communicate between different levels. There are three main levels: the subterranean (chthonic) and upper levels occupied by a variety of spirits, spirit-animals and other creatures, and the intermediate level occupied by human beings. Shamans are believed to use special powers to transcend these different levels by performing 'such tasks as healing, divination, control of animals, control of weather and extracorporeal travel' (Lewis-Williams 2004, 30). Lewis-Williams connects a shamanistic organization of the cosmos to the neuropsychological properties of the human mind, emphasizing 'wired' experiences in altered states of consciousness that 'include sensations of passing through a vortex or tunnel and flight' (Lewis-Williams 2004, 30). His all-encompassing and universal interpretation of cave art (as well as other similar art, around the world and throughout human history) proposes that it is intimately tied to shamanistic religious practices. In this context, shamanistic

visions (visual hallucinations perceived in altered states of consciousness that are induced by sensory deprivation or sensual stimulations, including psychotropic substances, etc.) are resources that become socially appropriated and manipulated.

Lewis-Williams emphasizes the importance of particular animals and hybrid beings with mixed attributes of animal and human bodies, so-called therianthropic images, in art. Such depictions, according to the shamanistic interpretation, are spirit-animals, i.e. spiritual counterparts of wild animals who may act as powerful spirit guides and helpers for hunter-gatherers and farmers. In his detailed analysis of Upper Palaeolithic cave art, Lewis-Williams asserts that the depictions of spirit-animals on cave walls (either painted or created by utilizing natural protrusions of rock or natural staining on cave walls), released the beings from the underworld that they inhabited (2002). Cave walls acted as a 'living membrane' between this world and the nether world, akin to the way sculpted materials were created whereby 'the carver of the image merely released what was already inside the material' (Lewis-Williams 2002, 199–200; cf. Ingold 2000b, 126). Similarly, at the Early Neolithic site of Çatalhöyük in Turkey, according to Lewis-Williams, houses may have served as constructions of a tiered cosmos, where 'each replastering and repainting may have been a new celebration and enactment of the emergence of spirit-animals and "goddesses"' (2004, 38).

This interpretation of early prehistoric art importantly overcomes 'functionalist approaches to Palaeolithic cave art [that] have relied solely on a Western, post-enlightenment appreciation of art' (Dowson 1998, 71), that is frequently understood as a passive record of observed natural phenomena. Yet, this argument still begs the question: Why are animals so pervasive in these early artistic expressions? Lewis-Williams argues that 'the mental imagery we experience in altered states is overwhelmingly ... derived from memory and is hence culturally specific' (2002, 126), hinting at the proximity of hunter-gatherers and farmers to animals. However, such an explanation for the abundant references to the animal realm in art is not completely satisfactory. This explanation is based on a psycho-cognitive argument that assumes the universality of visions seen in altered states of consciousness as 'hard-wired' in the neurological functioning of modern human brain. All prehistoric art can then be read easily as the reflection of various stages of hallucination. Yet, there is something deeply unsatisfactory with this kind of argument.

Lewis-Williams's argument is based on an unexamined assumption that such commensality of human neurology during altered states of consciousness could have arisen independently in any social and cultural context, being subsequently appropriated as a religious resource. In this way, he leaves unquestioned and unexamined (a) the origins of various traditions of shamanism and their possible diachronic and spatial diffusions and/or conversions; and (b) neglects the context-specific historically and regionally situated cosmologies and mythologies of traditional societies in the past and the present. Furthermore, one must question whether the altered state of consciousness of a shaman is the only type of experience that prompts such image-making, or might it also derive from other forms of liminal experiences during various stages of ordinary life?

The theoretical background for Lewis-Williams's understanding of the shamanistic practice during the Upper Palaeolithic and even more so during the Neolithic is the view of ideology in a Marxian sense, i.e. as false consciousness. Especially during the Pre-Pottery Neolithic in the Near East, according to Lewis-Williams and Pearce, shamans are seen as powerful individuals that structure the lifeways of the ordinary folk based on the exclusivity of their visions during altered states of consciousness. In his opinion, this elite of shamans must have relied on human and animal sacrifices in order to impose a specific worldview. During the Pre-Pottery Neolithic period in the Near East they,

> controlled the transition to spirit realms by means of sacrifice: they had the power to send people, whether sacrificed children, specially selected individuals or captives, in to the other world ... (Lewis-Williams & Pearce 2005, 81–2; also 126–8).

To support their claims, among other examples, Lewis-Williams & Pearce quote Amerindian shamanism, and especially 'vertical shamanism' with the emphasis on 'esoteric knowledge that is revealed and transmitted within a small elite' (Lewis-Williams & Pearce 2005, 86–7).

However, it is precisely amongst Amerindian anthropologists that a critique has been raised with regard to those anthropological accounts that primarily focus on the shamanistic practice as a more exciting research venue at the expense of domestic and ordinary life (e.g. Fausto 2000; Overing & Passes 2000; Vilaça 2002). These authors indicate that various aspects of domestic and everyday life, such as filiation and affinity in the making of kinship ties (e.g. even the production of the child's body) are analogous to shamanistic practice of dialoguing with the non-human (animal/spirit and other) entities. The act of birth is not assurance that the new-born will become human and children at this age are particularly prone to the influ-

ence of 'exterior' forces (Vilaça 2002; cf. Astuti 1998). In other words, in everyday life across Amazonia people are concerned about how to maintain a 'properly human identity' that can be in danger not only in the post-natal period during infancy, when the child is at a particularly vulnerable stage, but also throughout 'various periods of adult life (especially initiation, first menstruation, warfare reclusion, and illness)' (Vilaça 2002, 349). Hence, mundane life in Amazonia, and not only shamanistic practice, is focused on the alterity and difference in continuous attempts to maintain life within the terms of what is considered 'humanity'.

Moreover, Amerindian perspectivism (see below) makes it clear that 'humanity is not restricted to what we consider as human beings: animals and spirits may also be human, which means that humanity is above all the position to be continually defined' (Vilaça 2005, 448). The shamans and their knowledge are certainly important for their explicit negotiation between different 'perspectives' (between spirit-animals and an ill human being, for instance). In fact, the shaman can be considered to be 'chronically ill' (Vilaça 2002, 361) as he remains in a continuous dialogue with the 'exterior', i.e. as a translator between humans, animals and other non-human subjectivities. But an indigenous everyday understanding revealed by Amazonian ethnography holds that the world is constituted of unstable bodies that may undergo the process of transformation from one type of being to another not necessarily connected to shamanistic practice *per se* (see also Ingold 2000 on the importance of metamorphosis for Ojibwa). This metamorphic capacity is a central feature of all humanity (Vilaça 2005, 452).

Such understanding significantly damages Lewis-Williams's position, who implicitly or explicitly argues that all early prehistoric imagery can be interpreted as the outcome of shamanistic visions during altered states of consciousness. If we accept the possibility that social reality in the past could have been understood in terms different from our own, i.e. as a processual universe of relationships between different kinds of beings that possess an inherent capacity for metamorphosis, then visions of powerful shamans during altered states of consciousness may not after all be the exclusive resource from which the varied range of images were drawn in the early prehistoric art, including the depictions of hybrid beings.

I argue that in the discussions of Upper Palaeolithic and Neolithic hybrids, it is most useful to focus on contextual details in reconstructing possible specificities of relational cosmologies that included humans, animals and other-than human beings for each regional sequence where such images appear (see two case studies below). Although the representations of hybrid beings could derive from shamanistic visions, I would argue that, first, on a general level it remains important to understand social realities of prehistory in terms of differing ideologies that are a constitutive part of a particular everyday reality (cf. Althusser 1971) rather than to understand ideology as false consciousness imposed 'from above' by an elite of shamans. Wherein lies a potential for understanding the ontological grounding of shamanistic practice in everyday reality and not restricting it to visions deriving from altered states of consciousness. Second, in order to examine archaeological evidence for the signs of specific ontologies, different from our own, here I discuss the case of Amazonian ontology of relatedness. The main goal of this exercise is to highlight the possibility that among various societies of Old World prehistory where one encounters hybrid body imagery, their mythological vocabulary rendered in art may indicate specific ontologies, where corporeality was understood as the main source of agency/intentionality. My first goal is to situate the shamanistic explanation of hybrid beings under the rubric of animality, referring to the field of anthropological philosophy opened up by French philosopher Georges Bataille.

Rein of animality: Georges Bataille's tour of Lascaux

Georges Bataille (1897–1962) occupies a unique place in the tradition of French philosophical thought. As he gladly admitted, he was not an academic philosopher, and he refused to be attached to any of the philosophical movements of his day, such as existentialism, as he opposed such thinkers as Sartre (Bataille 2005, 47–8). As a journal editor, he published early works of Barthes, Foucault and Derrida and influenced numerous thinkers of the poststructuralist philosophical provenience. Troubled by ill health, his philosophical thought focused on phenomena such as death, sex, eroticism, sickness, expenditure and transgression. His thought denies ontological and religious transcendence. Influenced by the Gnostic conception of matter, Bataille envisioned the continuity of 'base' matter 'as an active principle having its own eternal autonomous existence as darkness […] and as evil' (Bataille 1970, 302). Such a conception of 'base' matter as active, dark, evil, formless (*informe*) and overwhelmed by silence, goes beyond philosophical traditions of idealism and materialism and evokes 'the immense deathscapes of a universe without images' (Gargett 2002, 13). Human existence and the birth of the subject and being, according to Bataille, represent

a violent and tragic separation from the 'base' matter or 'continuity' (1989). It is the world of consciousness and the human world of work, prohibitions and taboos that Bataille contrasts against the world of animality and transgression. His analysis builds on animality and its antithesis: work/understanding. Bataille believed that in searching for ecstasy the subject desires to experience loss of being.

> The actions of religious sacrifice and of erotic fusion, in which the subject seeks to be 'loosed from its relatedness to the I' and to make room for a reestablished 'continuity of Being,' are exemplary for him. Bataille, too, pursues the traces of a primordial force that could heal the discontinuity or rift between the rationally disciplined world of work and outlawed other of reason. He imagines this overpowering return to a lost continuity as the eruption of elements opposed to reason, as a breath-taking act of self-de-limiting. In this process of dissolution, the monadically closed-off subjectivity of self-assertive and mutually objectifying individuals is dispossessed and cast down into the abyss (Habermas 1987, 99–100).

While the mentioned aspects of Bataille's philosophical thought are well-known and frequently evoked in such diverse fields as anthropological (e.g. Taussig 1993; 1999) and architectural theory (e.g. Kwinter 2001; Bois & Krauss 1997), Bataille's fascination with prehistoric art is rarely discussed (but see Taussig 1993, 85; Borić 2005, 52–3). Bataille's interest, as an educated general reader, in tracing the historical trajectory of some of his philosophical concepts in the field of prehistoric research has recently been brought to light with the publication of his essays and lectures on the topic of prehistoric art (Bataille 2005). Upper Palaeolithic parietal art particularly fascinated Bataille. The central theme of his text in the lavishly illustrated monograph, *Lascaux or the Birth of Art* (1955), is the passage from animal to man, i.e. the birth of the subject. While closely following and acknowledging the authority of specialist prehistorians, particularly his contemporaries such as Abbé Breuil, Bataille 'find[s] something missing in the greater part of the writings that deal with the prehistoric times' (1955, 30). As a result, he developed a theory that incorporates the archaeological evidence of early prehistory, with special references to visual art, into a wider framework of philosophical anthropology.

Bataille sees the existence of prohibitions as characteristically human behaviour and the main difference between humans and other animals. The earliest prohibitions are related to death (including prohibition against murder) and sexual reproduction (including prohibitions related to incest). As 'the enduring animality in us forever introduces raw life and nature into community, ... prohibitions exist to quell these uprisings and spread oil on the sea of insurgent animal passion and unruliness' (Bataille 1955, 37). Moreover, such surges of animality become channelled through acts of intentional expenditure and excessive waste at the time of holidays and feasts, the phenomenon that Bataille refers to as *transgression*. It is through transgression that one finds 'the source of ecstasy and the core of religion' (Bataille 1955, 37), i.e. the sacred world. Here Bataille points to shamanistic religious practice as a medium of transgression.

Bataille suggests that animal images found in Lascaux and other caves are evidence 'of the animality that they [humans] were shedding' (1955, 115). Palaeolithic humans chose to 'flee their humanity; these men refuse the destiny that determines them: they overflow into savagery, the night of animality…' (2005, 65). These eruptions of animality are radically different from the later tendency to reduce animals to things, which emphasized a discontinuity, a fundamental difference between humans and animals:

> [a]s soon as human beings give rein to animal nature, in some way we enter the world of transgression forming the synthesis between animal nature and humanity… we enter a sacred world, a world of holy things (Bataille 1986).

Bataille's explanation for the origin of religious thought differs from the common distinction between animality and humanity-divinity. For Bataille, animality *is* the entry point to the sacred.

Bataille also discusses the naturalist, precise execution of animal images in the Upper Palaeolithic. Such naturalism sharply contrasts with the way humans are represented — frequently as schematic forms ('stick'-like style), sometimes with an animal mask and usually as representations of therianthropic hybrids. This phenomenon is best exemplified by the widely-cited shaft scene (also known as the well or pit scene) from Lascaux. A beautifully rendered dying bison is apparently pierced with a spear, 'the life inside him pouring forth from the belly' (Kendall 2005, 27), while in front of it is a bird-faced representation of a man with bird-like hands, who falls backwards in a stiff (dying?) ithyphallic posture with open arms and his sex erect (Fig. 7.2). The inclusion of a bird on a staff suggests a continuous avian theme. Whether the nearby naturalistic representation of a rhinoceros leaving the scene is contemporaneous and meaningfully connected to the described set is debated. This scene is the most widely discussed image of the Upper Palaeolithic parietal art and various interpretations have been offered. The initial interpretation of Abbé Breuil, that the scene represents a hunting accident with a

Figure 7.2. *The Shaft scene, Lascaux, Upper Palaeolithic.*

dying hunter in front of a wounded bison, has been rejected as naïve by most authors. As early as 1952, H. Kirchner wrote that the scene represents a shaman or medicine-man who assumes some characteristics of a bird during trance in order to achieve extracorporeal (aerial) travel. A shamanistic interpretation of the scene is further elaborated in more recent discussions by Davenport & Jochim (1988) and Lewis-Williams (2002, 262–6).

Bataille accepts that the scene represents a shaman, but his explanation is different: '[the] shaman [is] expiating, through his own death, the murder of the bison' (Bataille 1955, 75). Here, Bataille insists that murder is considered taboo and a primeval sin.

> … [B]y painting the animals that they killed, they envisioned something other than their earthly desires: what they wanted to resolve was the haunting question of death. Certainly death did not cease terrifying them, but they overcame it through identification, through a *religious* sympathy with their victims. This sympathy was in a sense absurd, since they did kill them. But it was profound in this particular sense: that by killing them, they made them divine. And in its essence, the divine is that which exceeds death (Bataille 2005, 169).

The death of the shaman is frequently not a 'real' death, but a death necessary to make a journey to another world (Lewis-Williams 2002, 265) or to become a new person through the process of body metamorphosis (e.g. Ingold 2000a,b). A hunter may face great danger when killing an animal, since beneath the skin of a hunted animal one may encounter a dangerous spirit. The hunted animal must be in complicity with its own murder if the hunter is to avoid misfortune, sickness or even death (e.g. Ingold 2000b, 121–3; Vilaça 2005). Ethnographic evidence may support Bataille's notion of expiation, of asking the murdered animal for forgiveness by offering a symbolic death of a shaman who metamorphosed into an animal. The liminality of shaman's existence in-between worlds is most aptly characterized on the basis of Amazonian ethnography in the following way: 'The soul of shamans, the only people to have an ever-present soul, is simply an animal body' (Vilaça 2002, 361). The animals are represented in their naturalistic beauty, while the man is represented in a grotesque style, as a childlike caricature. There are a number of similar therianthropic, frequently formless, figures that are found in Upper Palaeolithic parietal art (see Bataille 1955, 133–6) (Fig. 7.3).

The dichotomy between animal world (as nature) and human world (as culture) has been, for better or worse, present in anthropological accounts too. For instance, in Amazonian ethnography, among the Barasana, a Tukano-speaking group, it has been argued that this passage from animality to humanity is implicit in beliefs held by this group in relation to children and the possibility of their transformation into an animal:

> That an unborn soul is part of a world that includes animals is evidenced by the fact that tapirs and other Taking-in People … try to suck the child into their anus — a reversal of birth — as they are jealous of the loss of one of their number … Birth is thus like a passage from the animal world (nature, He) to the human world (culture) (Hugh-Jones 1979, 141 quoted by Vilaça 2002, 358–9)

This case and other similar ethnographic accounts (e.g. Da Matta 1976, 90–91 quoted by Vilaça 2002, 359) would accord with the main animality thesis in the work of Georges Bataille when discussing prehistoric cave art as a visual rendering of this process of negotiation between animality and humanity. Pervasive as this narrative may be, there has been a growing body of relevant anthropological literature that highlights difficulties with this opposition between animality and humanity in a critical way. The main critique launched by several authors whose work falls under the rubric of Amerindian perspectivism warns that

these types of accounts remain confined to the too familiar Western conceptual dichotomy of 'Nature' versus 'Culture'. This critique provides a specific reading of the Amazonian ethnography with regard to the classic anthropological issue of kinship and relatedness by emphasizing the importance of the body as the privileged dimension in differentiating among kinds of beings. The theoretical relevance of such a reading goes beyond the regional confines of an ethnography as it may help in displacing the complacence of our commonsense understandings when interpreting prehistoric art.

Body and its metamorphosis: the site of ontological differentiation

The theoretical position in current anthropological thought known as Amerindian perspectivism can be described, on the one hand, 'as a label for a set of ideas and practices found throughout indigenous America' (Viveiros de Castro 2004, 5), and, on the other hand, as an ethnographically grounded extension of specific theoretical concepts touched upon by various thinkers of the Western episteme, such as Gilles Deleuze and Bruno Latour among others. The main thesis of Amerindian perspectivism is that the ethnographic evidence of indigenous Amazonia indicates a very specific ontology, fundamentally different from our Western ontology that dominates the anthropological discourses, such as the embodiment paradigm (e.g. Csordas 1999). The ontology to which the most widespread anthropological discourses subscribe could be described as multiculturalist — single reality (nature) and many cultural expressions of this same unity. Such a common understanding assumes that the body is a universal given, while subjects have particular spirits in the world of many meanings. In contrast, for various indigenous people in Amazonia (and this thinking is not confined only to Amazonia: cf. Ingold 2000b; Leenhardt 1979 quoted by Vilaça 2005, 448), all beings, human and non-human, are endowed with the same spirit (animism), but the site of main differentiation between different kinds of beings is the body. Instead of Western multiculturalism, the Amazonian thought is founded on the logic of 'multinaturalism' — many natures and one culture. Subsequently, the way people see the world depends on the perspective they occupy, which is determined by the kind of body they have: '... the set of habits and processes that constitute bodies is precisely the location from which the identity and difference emerge' (Viveiros de Castro 1998, 480). Commensality (for instance, being able to share food or residing in the same location) is the affirmation of

Figure 7.3. *Theriokephalic being engraved on a pebble, La Madeleine, Dordogne, Upper Palaeolithic. (Photo: Musée des Antiquités Nationales, Saint-Germain-en-Laye.)*

sharing the same perspective that is constantly fabricated by constructing bodily grounded memories (Vilaça 2002; 2005, 454).

In this ontology, humanity characterizes all beings in their interaction with their own species:

> ... individuals of the same species see each other (and each other only) as humans see themselves, that is as being endowed with human figure and habits, seeing their bodily and behavioural aspects in the form of human culture. ... Where we see a muddy salt-lick on a river bank, tapirs see their big ceremonial house ... Such difference of perspective — not a plurality of views of a single world, but a single view of different

worlds—cannot derive from the soul, since the latter is the common original ground of being. Rather such difference is located in the bodily differences between species, for the body and its affections (in Spinoza's sense, the body's capacity to affect and be affected by other bodies) is the site and instrument of ontological differentiation and referential disjunction (Viveiros de Castro 2004, 6).

Such cosmology holds that humanity rather than animality is the meta-condition of all beings, both humans and animals. Animals lost their humanity according to Amerindian myths and the humans are struggling to preserve their own humanity in the face of threatening exterior powers. In Amazonian thought, death is never caused by natural causes but is always the outcome of the influence of malignant agency (e.g. Taylor 1996, 202; Vilaça 2005, 453). Moreover, what characterizes the relationality between human and various figures of alterity (for instance, wild animals or enemies) is the continually shifting predator/prey relationship (e.g. Vilaça 2005, 455).

This thought holds that bodies are characterized by a significant transformability. Illness and death are the most typical types of transformation where a human agent becomes the prey of a particular predator in the form of enemy, animal or spirit. Hence there is a widespread fear of metamorphosis in Amazonia (Viveiros de Castro 1998). The only humans capable of interacting with different classes of beings are shamans. They can assume different perspectives, i.e. metamorphize into different bodies.

> ... Amerindian perspectivism has an essential relation with shamanism and with the valorization of the hunt ... the animal is the extra-human protoype of the Other, maintaining privileged relations with other prototypical figures of alterity, such as affines ... This hunting ideology is also above all an ideology of shamans, in so far as it is shamans who administer the relations between humans and the spiritual component of the extra-humans, since they alone are capable of assuming the point of view of such beings and, in particular, are capable of returning to tell the tale (Viveiros de Castro 1998, 472)

This understanding puts an important emphasis on the shamanistic practice as both a practical and esoteric ideology. Shamanistic visions and altered states of consciousness are an important practical resource in maintaining daily life in Amazonia (e.g. shamanistic healing or visions searches: cf. Taylor 1996, 207–9). Such a view supports the importance placed upon shamanism as argued by Lewis-Williams (see above), and may indeed suggest that some of those hybrids found in prehistoric art depict powerful shamans whose bodies change in order to see the world from a different perspective in their encounters with the 'exterior'. At the same time, this claim is made without assuming that shamanistic ideology was experienced as false consciousness but as a truth of the everyday reality structured by long and complex mythical genealogies. Furthermore, this explanation does not need to rely on 'hard-wired' experiences of the human brain during altered states of consciousness as claimed by Lewis-Williams. Moreover, as the Amazonian case shows, the everyday experience and not only shamanistic practice can be characterized by a constant struggle in the fabrication of the human body, which at the swirl of a malignant influence may slip into the realm of animality understood as exteriority, which in practical terms translates as illness or death.

As suggested on the basis of the Amerindian perspectivism, one needs to theoretically contextualize and dissect Bataille's notion of animality. Too often, the notion of animality is put in a sharp opposition to the notion of humanity, and this dichotomy re-enacts the Western conceptual schemata of 'Nature' versus 'Culture' in which the culture is fabricated and nature is given. In such accounts, to use Bataille's vocabulary, it is the 'passage from animality to humanity' that becomes underlined. Conversely, the Amerindian thought makes a claim that it is nature that is fabricated and culture (seen as 'humanity' that shares the common vital force/spirit among different kinds of beings) is given, universal and innate. In such a conceptual universe, which also might have characterized various conceptual universes in the past, the reliance on our own ontological postulates is of little help. Amerinidian perspectivism may, thus, be used as a theoretical proxy case to challenge our conceptual schemes against the archaeological data.

On the other hand, the examples from Amazonian ethnography may indicate the importance of some points put forth by Bataille in interpreting the Upper Palaeolithic artistic depictions. In particular, differing stylistic depictions of human and animal bodies in the situation of contact between different kinds of beings (see the Lascaux Shaft scene, Fig. 7.2) seem to indicate an understanding by which the main locus of differentiation between different kinds of beings is exactly the bodily appearance that became rendered in this art.

While not doing full justice in this summary to the complexity of arguments presented in recent discussions of Amerindian perspectivism, it is instructive to close this discussion by focusing on the question of reproducing an image in indigenous Amazonia. The image here is related to the concept of soul as a representation of the body or the 'other of the body' in another realm.

> ... the soul as an actualization of the body in another world (which means within another set of relations) is evident in the association the Wari' make between soul, shadow, reflection, and traces left by the body, all named in an identical manner: *jam-* ... This association is not restricted to the Wari' and is, in fact, widespread. ... among the Araweté, Viveiros de Castro ... reports that *î* is the term for shadow, image, reproductions (such as recording of a voice, for example), as well as being the term for vital principle. (Vilaça 2005, 453)

From such an understanding stems an important implication that depictions of a range of images in prehistoric art, including therianthropic images, might have been related to the understanding by which a spiritual agency from another world is itself depicted or is purely being released by the act of depiction. In this way, rendered images might have been reifications of powerful forces that come out of non-persons, i.e. physical substances (cave walls, replastered walls of buildings, stone boulders, etc.; see below) that are endowed by a relational agency (Gell 1998; Ingold 2000a). In order to explore this thesis further, I consider the concept of mimesis.

Eikōn and mimesis

Here I discuss the nature of mimetic activity, i.e. the way 'reality' becomes reproduced through images on the basis of the Platonic theory of *eikōn* and its subsequent philosophical refigurings. When considering images and mimetic reproduction of 'reality', this philosophical tradition distinguishes between simple mirroring of semblances and image-making that exposes the true being of what becomes represented. Artistic (mimetic) practice may act as a medium that exposes a more profound reality than that encountered in the world of everyday human experience.

The theory of mnemic presence that explains the persistence of images in the mind is found in texts by both Plato and Aristotle. In Plato's *Theaetetus* we find the first discussion of memory in the Greek philosophical tradition, using the metaphor of a slab of wax with imprints (*typoi*) to describe the persistence of images in the mind. Here one encounters one of the greatest aporias of memory: an image that stands for an absent thing (cf. Krell 1990; Ricoeur 2004). Closely related to the question of memory and images that are retained in the mind is the question of the reliability of the images that remain, or that become memorized. Hence the theme of likeness (*eikōn*) is found in a number of Plato's dialogues. In *Sophist*, the discussion of idol-making distinguishes between sculpture and paintings that maintain the exact proportions and colours of the represented person, and semblances in which proportions are distorted in order to make, for instance, a colossal work appear well-proportioned according to human geometry. In the tenth book of Plato's *Republic* Socrates and Glaucon discuss the sophistic art of mirroring:

> ... do you not perceive that you yourself would be able to make all these things in a way?
>
> ... You could do it most quickly if you should choose to take a mirror and carry it about everywhere. You would speedily produce the sun and all the things in the sky, and speedily the earth and yourself and the other animals and implements and plants and all the objects of which we just now spoke.
>
> Yes, he said, the appearance of them, but not, of course, *the beings in their true self-showing* [my emphasis]. (*Sophist* 233e–4e cited by Krell 1990, 34)

This dialogue distinguishes the 'appearance' of beings from their 'self-showing' and brings to mind Heidegger's discussion of the three kinds of production: the god producing the idea, the craftsman producing the thing and the painter producing the image. The image is produced by 'leading forward into radiant outward appearance or profile, a bringing out of concealment and into presence' (Krell 1990, 34). The mimetic representation of an image exposes the fundamental being of a god-like *idea* executed as a thing.

> What is decisive for the Greek-Platonic concept of *mimēsis* or imitation is not reproduction or portraiture, not the fact that the painter provides us with the same thing once again; what is decisive is that this is precisely what he cannot do, that he is even less capable than the craftsman of duplicating the same thing. It is therefore wrongheaded to apply to *mimēsis* notions of 'naturalistic' or 'primitivistic' copying and reproducing. Imitation is subordinate production. The *mimētēs* is defined in essence by his position of distance; such distance results from the hierarchy established with regard to ways of production and in the light of pure outward appearance, being. (Heidegger 1979, 185).

This way of understanding images can also be found in the Orthodox Christian tradition of icon-making. *Icons* are painted pictures of saints that acquire numinous qualities in a very material way. Similarly, we can think of images found on the walls of Palaeolithic caves as having a very material effect on those Palaeolithic humans who descended into those secluded spaces. I would claim that one could make a useful connection here between the philosophical discussion of *eikōn* and the meaning and function of a range of images found in early prehistoric art. The mimetic process of image-making should not be considered a naturalistic representation or copy of the mundane reality of early prehistory, but can more appropriately

Chapter 7

Figure 7.4. *Human–animal hybrid male body engraved on a bone, Mas-d'Azil (Ariége), 11,000–9000 BC. (Photo Musée des Antiquités Nationales, Saint-Germain-en-Laye.)*

Figure 7.5. *Theriokephalic being (shaman?), Les Trois Frères, Upper Palaeolithic. (Reproduced after Breuil 1979, fig. 130.)*

The Platonic theory of *eikōn* points to the ontological problem of making-present and self-showing, which is at the core of a mimetic act. Human forms represented as therianthropic images (Fig. 7.4) on the cave walls along with more 'naturalistic' representations of a wide range of animals in the Upper Palaeolithic parietal art suggest not a copied reality of the everyday, but rather the world of exposed animality encountered in dreams or indeed while experiencing altered states of consciousness. In this other reality, an animal mask always accompanies humanoid form (Fig. 7.5). The presence of an animal mask indicates that similarly to various ethnographic instances, some of which have been described here, it is the body metamorphosis (i.e. the change of perspective by acquiring a new body form) that enables the communication and cross-over between different kinds of beings. In what follows, I provide two examples of human–animal hybrid depictions related to the beginnings of the Early Neolithic, in an attempt to explore specific regional and contextual meanings attached to this practice.

Therianthropic images in the Neolithic

Apart from the previously mentioned images representing human–animal hybrids found in the European Upper Palaeolithic art, such images are also frequently found among Pre-Neolithic and Early Neolithic societies in the eastern Mediterranean. Here, I will briefly illustrate my previous discussion on the basis of two case studies from this wider region: Lepenski Vir and Çatalhöyük.

Danubian hybrids: Lepenski Vir
An obvious example of therianthropic images, not mentioned in the recent work *Inside the Neolithic Mind* by Lewis-Williams & Pearce (2005), which treats other such imagery for the given period, is found at the Mesolithic–Early Neolithic site of Lepenski Vir in southeast Europe (*c.* 9300–5700 cal. BC: Borić & Dimitrijević 2007). Here sculpted boulders, depicting human–fish hybrid beings (Figs. 7.6 & 7.10), were found in trapezoidal buildings, frequently around rectangular stone-lined hearths (Borić 2005; Srejović 1969; 1972; Srejović & Babović 1983). This regional tradition has roots in the local Mesolithic sequence and is confined to settlements found on both banks of the Danube in the area known as the Danube Gorges (Borić 2002a,b; Borić & Miracle 2004; Radovanović 1997). The appearance of art in the trapezoidal buildings at Lepenski Vir from around 6300–5900 cal. BC is chronologically contemporaneous with the appearance of the first Early Neolithic communities in the wider region of the central Balkans.

be connected to the desire to expose the true structure of being, or, in terms of Amerindian perspectivism (see p. 90), the soul counterpart of the body in another world. If understood in this way, images that appear in the course of the Upper Palaeolithic and the Neolithic were a medium through which a 'true' reality (animality or immanence according to Bataille) became exposed.

An early example of anthropomorphic representation in this region comes from the Late Mesolithic site of Vlasac, which is situated in the immediate vicinity of Lepenski Vir (Srejović & Letica 1978). Here we find a schematic representation of a human body incised on a stone boulder (Fig. 7.7), which could also be related to similar 'formless' images frequently found during the Upper Palaeolithic period (see above). Around 6300 cal. BC, a number of 'representationalist', geometric and aniconic sculpted boulders became an important medium of social/ideological/religious expression that at least in part must have been related to the appearance of the first Neolithic communities in the wider region. Although boulders appear at several sites during this period, they are by far most abundant at Lepenski Vir, which is also the only site where the representations of hybrid faces are found (Figs. 7.8 & 7.10). Apart from a number of explicitly 'representationalist' images with the clearest depiction of heads bearing mixed human and animal features, other boulders were frequently carved by applying only geometric motifs over their surfaces. Yet, their round or sometimes elongated shape and carved motifs indicate that these apparently non-representational boulders could also stand for bodies of fish-like beings, possibly indicating a particular state of body metamorphosis (Borić 2005).

Palaeodietary data from the region indicate a strong reliance on fish throughout the Mesolithic period (Bonsall *et al.* 1997; Borić *et al.* 2004; Borić & Dimitrijević 2005). One of the specialties in relation to fishing in this region is the presence of sturgeon remains (Borić 2002b). Although various species of fish remained an important source of protein in the diet after 6300 cal. BC and during the Early Neolithic period, on the basis of stable isotope data it seems that at least a part of the population during this period, and particularly those buried at the central site of Lepenski Vir, abandoned a high reliance on fish that had characterized the Mesolithic diet. Since this change largely coincides with the appearance of the boulder tradition and fish/human hybrids' depictions, one is tempted to interpret this dietary change, although not entirely, as a consequence of specific prohibitions, including taboos against eating at least certain types of fish (Radovanović 1997).

This suggestion could be reinforced on the basis of the available contextual data. Both representationalist as well as geometric boulders from Lepenski Vir in several instances commemorated deceased individuals, hence connecting the realm of the dead and the living (Borić 2005). Representations of human–fish hybrids and their associations with at least several buried individuals at Lepenski Vir, strongly indicate

Figure 7.6. *Hybrid human–fish boulder artworks found* in situ *around a stone rectangular hearth in the centre of trapezoidal building House XLIV/57, Lepenski Vir.*

Figure 7.7. *Incised human-like form on a stone boulder, Dwelling 2a, Vlasac, c. 7300–6500 BC. (After Srejović & Letica 1978, T. LXIX.)*

a belief in the possibility of human metamorphosis into a certain kind of fish being. Such a belief might have become a dominant view in the period after 6300 BC, which matches the pattern of the stable isotope data. For instance, in the Amazonian ethnography the fear of metamorphosis into a certain kind of animal

Figure 7.8. *Sculpted boulder showing a human–fish hybrid being, House XLIV/57, Lepenski Vir, c. 6200–5900 BC.*

closely related to humans comes out of the horror of eating the human (one's kin) who 'lurks' in the animal skin (Viveiros de Castro 1998, 481). The dead are here not understood as humans but as spirits that are intimately related to animals: '[t]he dead are logically attracted to the bodies of animals; this is why to die is to transform into an animal … as it is to transform into other figures of bodily alterity, such as affines and enemies' (Viveiros de Castro 1998, 482).

Only two instances of representationalist boulders associated with the deceased were reported at Lepenski Vir and in both cases the deceased were children (Fig. 7.9; cf. Borić & Stefanović 2004). These examples of boulders commemorating the deceased, along with other types of representationalist boulders not found in association with the deceased, likely point to a specific iconography of depicting the face (and eyes in particular) that is related to prescribed stages of embodiment connected to particular age and gender characterization of the deceased (Borić 2005). However, one is also tempted to think of the narrative value of these examples in objectifying the metamorphosis of these two children who perhaps died in a particularly ominous way. By placing these boulders in association with the burials, the living might have acted in order to assure the prescribed way of metamorphizing into the totemic animal. These images seem to objectify a particular idea of (at least certain individuals') mutation in death. Here, the hybridity

Figure 7.9. *(a) Child Burial 61 in House 40 and (b) sculpted boulder depicting human–fish hybrid face found above the head of the child, Lepenski Vir, c. 6200–5900 BC.*

of the represented boulder body associated with a particular deceased warns of the liminal zone that the deceased has entered. It is the body that is affected by the change of topological orders as the main site of ontological differentiation: the image of the body retains the elements of humanity and acquires a new element of animality in its depiction (Figs. 7.8 & 7.10). The death in this way does represent a major shift of one's perspective and the change of that perspective is underlined with the mutation of the body form.

Where does the tradition of the boulder artworks from Lepenski Vir leave the shamanistic interpretation of Lewis-Williams with regard to other similar theriantropic and geometric imagery found in the Neolithic? For instance, a range of geometric images found on

Lepenski Vir boulders (Fig. 7.8), according to the type of analysis made by Lewis-Williams & Pearce in other case studies (Lewis-Williams 2002; Lewis-Williams & Pearce 2005), could easily be related to visions during altered states of consciousness. Contrarily, I prefer to see these motifs as an expression of context-specific patterns of a particular being-in-the-world to a universal interpretation that sees these motifs as an expression of 'hard-wired' experiences in altered states of consciousness. Be that as it may, what seems possible is that the evidence from Lepenski Vir and other sites in this region indicates that the idea (fear?) of human metamorphosis into hybrid fish beings depicted on some of the boulders might have become a predominant belief after 6300 cal. BC, which in turn might have triggered taboos toward the intake of certain species of fish. Such beliefs might have been connected to shamanistic practice, as shamans must have been those individuals who were able to 'see' these different perspectives that different bodies occupied, i.e. different types of beings in the realm of animality. However, since the sculpted boulders were practically found in every building at Lepenski Vir and since it is unlikely that solely shamans inhabited buildings at this site, it seems more likely that the understanding of the obsession with the possibility of human metamorphosis was shared across the social matrix at this and perhaps other neighbouring sites. Among other things, this idea of metamorphosis and change of perspective might have related to the possible influx of new people and new practices around this time in the wider region, requiring negotiation of different figures of alterity, be it animal or foreign human bodies.

Anatolian hybrids: Çatalhöyük
Çatalhöyük is a large mound situated in south-central Anatolia with a continuous occupation between *c.* 7400 and 6200 cal. BC (Hodder & Cessford 2004, fig. 1). The organization of building activities and daily life at this site followed a strictly prescribed set of rules that applied to every building at the site when it came to the arrangement of building space or the prescribed life cycle of each of these spaces (Hodder & Cessford 2004). The best-known aspect of this site is the abundance and the range of painted imagery found on the walls of a number of buildings (Mellaart 1967; Hodder 1990; 2006). Large plastered bucrania were also part of buildings' interiors. The renewed work at Çatalhöyük indicates that there were no major differences between buildings in terms of the possible distinction into shrines and domestic areas on the basis of the accumulation of particularly charged aspects of symbolism (e.g. presence of burials, elaborate paintings, building size, etc.). A suggestion was made that such a

Figure 7.10. *Sculpted boulder depicting human–fish hybrid (beluga?), House XLIV/57, Lepenski Vir, c. 6200–5900 BC.*

Figure 7.11. *Vultures with human legs depicted on the wall of Mellaart's 'Shrine VII.8', Çatalhöyük. (Photo: James Mellaart.)*

situation indicates that houses were loci of social relations with no central office of priests or other figures of authority (Hodder & Cessford 2004).

With regard to therianthropic images of humans, the original excavator of the site, James Mellaart, noticed that the legs of some vultures found painted in Shrine VII.8 appear as human legs (1967, 82, figs. 14–15) (Fig. 7.11). And on the inner walls of houses, vultures are frequently associated with headless human figures. Just as in the Upper Palaeolithic parietal art, human figures at this site appear as elaborated silhouettes, in contrast to a more 'naturalistic' rendering of animals (Fig. 7.12); the implication of this being the

Chapter 7

Figure 7.12. *Detail of painted leopard relief at Çatalhöyük. (Photo: James Mellaart.)*

need to underline the difference between human and animal realms by a different style of depicting body forms, and possibly the non-mundane character of the depicted world. Although humans do not assume an animal mask, they are shown with leopard skins around their waists (see Hodder 2006), which might have held some protective power in the nether world, which these scenes might have represented. Here, too, it seems that the artistic representation of the world reveals a more profound reality than a simple reproduction of everyday routine.

One recent discovery from this site is of particular relevance to my discussion of therianthropic images. It relates to a stamp seal of a hybrid deity with its humanoid body and front and hind legs raised upwards and with an animal (bear?) head (11652. X1, Summit) (2005 Stamp Seal Archive Report, http://www.catalhoyuk.com/) (Fig. 7.13). This is a unique find and it finally solves the mystery of the iconic role of a humanoid form found moulded on numerous buildings at this site with its front and hind legs raised upwards in the same way as on this seal stamp (cf. Mellaart 1967). Such sculpted images coming out of the northern walls of buildings at Çatalhöyük occupied the dominant position in buildings (Fig. 7.14). This hybrid being must have had an important place in the mythology of the Çatalhöyük occupants. The prevailing interpretation of these images was that they indicate the 'mother goddesses' giving birth to a bull, and a lot of ink was spilled in elaborating

the significance of these finds in the construction of rather familiar Neolithic narratives of domestication and fertility (e.g. Cauvín 2000). The problem that obstructed the adequate interpretation of these finds has been the fact that these images were always found with the heads and hands cut off as intentional acts of building abandonment. However, it is likely now that in all these instances it is a hybrid being with a human body and an animal head that was depicted. The suggestion has been made that the head of the stamp seal depicts a bear (S. Farid, pers. comm.). The significance of bear for the Çatalhöyük mythological universe could also be reinforced by the find of a bear's paw in one of the buildings in the South Area of the site during the renewed excavations (cf. 1998 Archive Report, http://www.catalhoyuk.com/).

Possible interpretation could be that the bear might have represented a totemic animal from a distant past, and that this community turned it into an important ancestral and possibly protective figure that oversaw the daily life within buildings at the site. The destruction of the paws and the head on the moulded images of this ancestral being, as found on the walls of Çatalhöyük buildings, is significant here. It is through the destruction of animal elements on the body of the hybrid being that the prescribed closure of the building's lifecycle is assured. One should note that it was the head that was also frequently removed from the buried deceased found beneath building floors. While it would be hard to penetrate into the specific

meanings of this practice, it is likely that such acts of beheading for the community at Çatalhöyük marked the change of topological orders by altering the body. At Çatalhöyük, the head of either this hybrid being or the deceased held importance. In numerous contexts, the head and face are particularly expressive elements of one's identity. The fact that both the heads of the deceased and the ancestral being were removed, and also that headless human figures were associated with sometimes therianthropic vultures, may indicate that the head and face but perhaps also feet and hands in particular were the elements of the body through which the metamorphosis from one kind of being into another was revealed.

The abundance of imagery found painted on the walls of buildings at this site (Mellaart 1967) has recently been interpreted by Lewis-Williams as images perceived by shamans during altered states of consciousness (2004; Lewis-Williams & Pearce 2005). I will not here repeat my previous critique of such an exclusive connection of image-making and shamanistic practice (see above). It is more important to emphasize here Lewis-Williams's idea about the materiality of images found on the walls of buildings at Çatalhöyük. He suggests that through the acts of re-plastering (sometimes up to 80–100 layers) and rendering of the variety of images, this community exposed the presence of the parallel nether world from the very walls they inhabited (2004). This is a powerful idea and it may be reinforced by the existence of an obsessive and repetitive practice of rebuilding walls at this site as well as by the practice of placing animal remains, such as horns or teeth of wild animals, into the walls of buildings at this site (cf. Hodder 1990). Especially large predators, such as bears or leopards, another animal that was in numerous instances found as a part of the mythological universe at this site (Hodder 2006), were the focus of attention. This constant negotiation with the animal realm that came out of the building walls (as if these building efforts went beyond the practical utility) and the structuring of the daily routines in the domestic areas at Çatalhöyük might have been interconnected processes of maintaining a proper human identity threatened by an inherent metamorphic capacity of all beings.

Conclusion

Functionalist approaches to the study of the 'prehistoric mind' insist on the understanding of prehistoric art (and religion) as a medium of 'information transmission' and are viewed as inadequate due to their primary reliance on evolving intelligence and rationality in explaining the impetus for image-making. Contrarily, shamanistic interpretations of early

Figure 7.13. *Stamp seal representing a hybrid deity with its front and hind legs raised upwards and with an animal (bear?) head (11652.X1, Summit), Çatalhöyük. (Photo: Jason Quinlan, (c) Çatalhöyük Research Project.)*

Figure 7.14. *Relief of two splayed figures at Çatalhöyük. (Photo: James Mellaart.)*

art have introduced an element of irrationality and 'esotericism' into the explanation of religious thought and the origins of image-making. Yet the shamanistic explanation reduces the abundant images of animals and human–animal hybrids in early art to a neurological

sensation that occurs in the state of altered consciousness as 'wired' in the brain of modern *Homo sapiens*.

In this paper, I have tried to argue for placing shamanistic explanations in the context of a more encompassing concept of animality. Animality as evoked by Georges Bataille relates to the animal existence (animal corporeality, body) that is at the basis of human existence. In this sense animality is opposed to the world of human consciousness and reason. Yet, this departure from the world of 'prehistory' (*sensu* Horkheimer & Adorno 2000), the 'passage from animal to man', persists in the dichotomies that characterize human thought: body and mind, nature and culture. Recent accounts of Amerindian perspectivism challenge this conceptual fixture. Here, the body is the main site of differentiation and the change of perspective implicates the change of one's body, i.e. a metamorphosis caused in the predator–prey interaction. The negotiation of animality and humanity in Amazonian ethnography is related to the everyday despite the importance of shamanism for transcending the confines of one's bodily perspective. Such an understanding that emphasizes a constant mundane dialogue with the 'exterior' and 'other' undermines universalistic shamanistic interpretations of image-making. The abundance of hybrid images in early prehistoric art seems to indicate that in these societies the corporeality of the body was considered the most important source of agency and intentionality.

Following Bataille and Ingold, I suggest that early prehistoric art, rather than naturalistically representing the observed natural world as an expression of the realm of the everyday, rationality and understanding, was an attempt to open up a nether world, or the reality that lies beyond and beneath the superficial world of appearances. This 'supernatural' reality is frequently understood as divine and sacred. Shamanistic religious practice is a tool of 'transgression' (*sensu* Bataille), used to approach this realm, while visual or other artistic creations might have been understood as entry points into this world of animality, immediacy and immanence.

Acknowledgements

I would like to thank conference organizers for the invitation to present this paper at the 'Image and Imagination: Material Beginnings' conference. It is necessary here to acknowledge the influence of Amerindian perspectivism on the final shape of this paper and to thank Aparecida Vilaça for her initial introduction to this specific anthropological perspective. I also thank the Çatalhöyük project and particularly Shahina Farid for the permission to reproduce the image of the new stamp seal discovery from this site. I would also like to thank Mary Kate Boughton for her editing. This paper was written during my postdoctoral fellowship as part of the Leverhulme Research Programme 'Changing Beliefs of the Human Body: a Comparative Social Perspective' at the Department of Archaeology, University of Cambridge.

References

Althusser, L., 1971. Ideology and ideological state apparatuses (notes towards and investigation), in *Lenin and Philosophy and Other Essays*, ed. L. Althusser. London: New Left Books, 121–73.

Astuti, R., 1998. 'It's a boy,' 'it's a girl!' Reflections on sex and gender in Madagascar and beyond, in *Bodies and Persons: Comparative Perspectives from Africa and Melanesia*, eds. M. Lambek & A. Strathern. Cambridge: Cambridge University Press, 29–52.

Bataille, G., 1955. *Lascaux or the Birth of Art*. Geneva: Skira.

Bataille, G., 1970. *Oeuvres Completes*. Paris: Gallimard.

Bataille, G., 1989. *Theory of Religion*. New York (NY): Zone Books.

Bataille, G., 2005. *The Cradle of Humanity: Prehistoric Art and Culture* (ed. Stuart Kendall). New York (NY): Zone Books.

Bergson, H., 1981. *Matter and Memory*. New York (NY): Zone Books.

Bois, Y.-A. & R. Krauss, 1997. *Formless: a User's Guide*. New York (NY): Zone Books.

Bonsall, C., R. Lennon, K. McSweeney *et al.*, 1997. Mesolithic and Early Neolithic in the Iron Gates: a palaeodietary perspective. *Journal of European Archaeology* 5(1), 50–92.

Borić, D., 2002a. Lepenski Vir conundrum: a reinterpretation of the Mesolithic and Neolithic sequence in the Danube Gorges. *Antiquity* 76, 1026–39.

Borić, D., 2002b. Seasons, Life Cycles and Memory in the Danube Gorges, c. 10000–5500 BC. Unpublished PhD Dissertation, University of Cambridge.

Borić, D., 2005. Body metamorphosis and animality: volatile bodies and boulder artworks from Lepenski Vir. *Cambridge Archaeological Journal* 15(1), 35–69.

Borić, D. & V. Dimitrijević, 2005. Continuity of foraging strategies in Mesolithic–Neolithic transformations: dating faunal patterns at Lepenski Vir (Serbia). *Atti della Società per la preistoria e protoistoria della regione Friuli-Venezia Giulia* XV, 2004–05, 33–80.

Borić, D. & V. Dimitrijević, 2007. When did the 'Neolithic package' arrive at Lepenski Vir? Radiometric and faunal evidence. *Documenta Praehistorica* XXXV.

Borić, D. & P. Miracle, 2004. Mesolithic and Neolithic (dis)continuities in the Danube Gorges: new AMS dates from Padina and Hajdučka Vodenica (Serbia). *Oxford Journal of Archaeology* 23(4), 341–71.

Borić, D. & S. Stefanović, 2004. Birth and death: infant burials from Vlasac and Lepenski Vir. *Antiquity* 78, 582–601.

Borić, D., G. Grupe, P. Joris & Ž. Mikić, 2004. Is the Mesolithic–Neolithic subsistence dichotomy real? New stable isotope evidence from the Danube Gorges. *European Journal of Archaeology* 7(3), 221–48.

Breuil, H., 1979. *Four Hundred Centuries of Cave Art*. New York (NY): Hacker Art Books.

Cauvín, J., 2000. *The Birth of the Gods and the Origins of Agriculture.* Cambridge: Cambridge University Press.

Csordas, T., 1999. The body's career in anthropology, in *Anthropological Theory Today*, ed. H. Moore. Cambridge: Polity, 172–205.

Da Matta, R., 1976. *Um mundo dividido: a estrutura social dos índios Apinayé.* Petrópolis: Vozes.

Davenport, D. & M.A. Jochim, 1988. The scene in the Shaft at Lascaux. *Antiquity* 62, 558–62.

Dowson, T.A., 1998. Rock art: handmaiden to studies of cognitive evolution, in *Cognition and Material Culture: the Archaeology of Symbolic Storage*, eds. C. Renfrew & C. Scarre. (McDonald Institute Monographs.) Cambridge: McDonald Institute for Archaeological Research, 67–76.

Eliade, M., 1972. *Shamanism: Archaic Techniques of Ecstasy.* New York (NY): Routledge.

Fausto, C., 2000. Of enemies and pets: warfare and shamanism in Amazonia. *American Ethnologist* 26, 933–56.

Gamble, C., 1982. Interpretation and alliance in Palaeolithic society. *Man* 17, 92–107.

Gamble, C., 1991. The social context for European Palaeolithic art. *Proceedings of the Prehistoric Society* 57(1), 3–15.

Gargett, A., 2002. Vampire: George Bataille and the philosophy of vampirism. *The Richmond Review*, www.richmondreview.co.uk

Gell, A., 1998. *Art and Agency: an Anthropological Theory.* Oxford: Clarendon Press.

Habermas, J., 1987. *The Philosophical Discourse of Modernity: Twelve Lectures.* Cambridge: Polity Press.

Heidegger, M., 1979. *Nietzsche*, vol. 1: *The Will to Power as Art.* San Francisco (CA): Harper & Row.

Hodder, I., 1990. *The Domestication of Europe: Structure and Contingency in Neolithic Societies.* Oxford: Blackwells.

Hodder, I., 2006. *Çatalhöyük, the Leopard's Tale: Revealing the Mysteries of Turkey's Ancient 'Town'.* London: Thames & Hudson.

Hodder, I. & C. Cessford, 2004. Daily practice and social memory at Çatalhöyük. *American Antiquity* 69(1), 17–40.

Horkheimer, M. & T.W. Adorno, 2000. *Dialectic of Enlightenment.* New York (NY): Continuum.

Hugh-Jones, S., 1979. *The Palm and the Pleiades: Initiation and Cosmology in Northwest Amazonia.* Cambridge: Cambridge University Press.

Ingold, T., 2000a. A circumpolar night's dream, in *The Perception of the Environment: Essays on Livelihood, Dwelling and Skill*, ed. T. Ingold. London & New York (NY): Routledge, 89–110.

Ingold, T., 2000b. Totemism, animism and the depiction of animals, in *The Perception of the Environment: Essays on Livelihood, Dwelling and Skill*, ed. T. Ingold. London & New York (NY): Routledge, 111–31.

Kendall, S., 2005. Editor's introduction: the sediment of the possible, in *The Cradle of Humanity: Prehistoric Art and Culture*, by G. Bataille. New York (NY): Zone Books, 9–31.

Kirchner, H., 1952. Ein archälogischer Beitrag zur Urgeschichte des Schamanismus. *Anthropos* 47, 244–86.

Krell, D.F., 1990. *Of Memory, Reminiscence, and Writing: On the Verge.* Bloomington & Indianapolis (IN): Indiana University Press.

Kwinter, S., 2001. *Architectures of Time: Toward a Theory of the Event in Modernist Culture.* Cambridge (MA): The MIT Press.

Lewis-Williams, D., 2002. *The Mind in the Cave: Consciousness and the Origins of Art.* London: Thames & Hudson.

Lewis-Williams, D., 2004. Constructing a cosmos: architecture, power and domestication at Çatalhöyük. *Journal of Social Archaeology* 4(1), 28–59.

Lewis-Williams, D. & D. Pearce, 2005. *Inside the Neolithic Mind.* London: Thames & Hudson.

Mellaart, J., 1967. *Çatal Hüyük: a Neolithic Town in Anatolia.* London: Thames & Hudson.

Mitthen, S.J., 1988. Looking and learning: Upper Palaeolithic art and information gathering. *World Archaeology* 19(3), 297–327.

Mitthen, S.J., 1989. To hunt or to paint: animals and art in the Upper Palaeolithic. *Man* 23, 671–95.

Mitthen, S.J., 1991. Ecological interpretations of Palaeolithic art. *Proceedings of the Prehistoric Society* 57(1), 103–14.

Overing, J. & A. Passes (eds.), 2000. *The Anthropology of Love and Anger: the Aesthetics of Conviviality in Native Amazonia.* London: Routledge.

Radovanović, I., 1997. The Lepenski Vir culture: a contribution to interpretation of its ideological aspects, in *Antidoron Dragoslavo Srejović completis LXV annis ab amicis, collegis, discipulis oblatum.* Beograd: Centar za archeoloska istraivanja, filozofski fakultet, 85–93.

Ricoeur, P., 2004. *Memory, History, Forgetting.* Chicago (IL) & London: The University of Chicago Press.

Srejović, D., 1969. *Lepenski Vir — Nova praistorijska kultura u Podunavlju.* Belgrade: Srpska književna zadruga.

Srejović, D., 1972. *Europe's First Monumental Sculpture: New Discoveries at Lepenski Vir.* London: Thames & Hudson.

Srejović, D. & L. Babović, 1983. *Umetnost Lepenskog Vira.* Belgrade: Jugoslavija.

Srejović, D. & Z. Letica, 1978. *Vlasac. Mezolitsko naselje u Đerdapu (I arheologija).* Belgrade: Srpska akademija nauka i umetnosti.

Taussig, M., 1993. *Mimesis and Alterity: a Particular History of the Senses.* London & New York (NY): Routledge.

Taussig, M., 1999. *Defacement: Public Secrecy and the Labor of the Negative.* Stanford (CA): Stanford University Press.

Taylor, A.C., 1996. The soul's body and its states: an Amazonian perspective on the nature of being human. *Journal of the Royal Anthropological Institute* (N.S.) 2, 201–15.

Vilaça, A., 2002. Making kin out of others in Amazonia. *Journal of the Anthropological Royal Institute* (N.S.) 8, 347–65.

Vilaça, A., 2005. Chronically unstable bodies: reflections on Amazonian corporalities. *Journal of the Anthropological Royal Institute* (N.S.) 11, 445–64.

Viveiros de Castro, E., 1998. Cosmological deixis and Amerindian perspectivism. *Journal of the Anthropological Royal Institute* (N.S.) 4, 469–88.

Viveiros de Castro, E., 2004. Perspectival anthropology and the method of controlled equivocation. *Tipití* 2(1), 3–22.

Chapter 8

Figurines, Meaning and Meaning-making in Early Mesoamerica

Rosemary A. Joyce

Small, hand-modelled fired clay figurines are the earliest widespread medium of human representation recognized in Mesoamerica. An early period of production of highly schematic figures was followed by production of effigies with a much higher degree of iconic specificity that have been interpreted as images of young women or men, and elders, or of supernatural beings, especially ancestors (Clark 2004; Cyphers 1993; Lesure 1999; 2000; Marcus 1998; Niederberger 1976; 1987; Reyna Robles 1971). Most studies of Mesoamerican figurines in recent decades have been concerned with the kinds of analyses (iconography, social analysis, symbolic studies, and uses) that Lesure (2002) suggests bear on ways to answer the question, 'What do figurines mean?'.

In my own analyses of Mesoamerican figurines (Joyce 1993; 1998; 2000; 2003), I have chosen to pursue instead the question, not of meaning, but of meaning-making: *How* do figurines mean? — not to the exclusion of questions of meaning, but as a necessary first step in approaching meaning across a vast gulf of change and cultural difference. In the present study, I want to explicitly sketch out the underlying logic of this approach. I approach meaning-making not in terms of the structural semiology of Saussure (and its specific structural anthropological descendants) long employed in archaeology, but from the semiotics of Charles Sanders Peirce (Deacon 1997; Preucel & Bauer 2001). Below, I first sketch out the key differences in these approaches and then re-examine my own analyses of early figurines from Honduras, making explicit the model of meaning-making on which I rely.

Semiology and semiotics: implications for archaeology

In their discussion of a Peircean semiotic approach to meaning in archaeology, Preucel & Bauer (2001, 87) describe characteristics of material signification that make the use of a Saussurean model of meaning problematic. The critical shift they outline is from the dyadic relation of signifier and signified in the Saussurean sign, to the triadic relation of Sign, Object, and Interpretant in the Peircean sign. This triadic relation requires explicit inclusion of ontological and epistemological propositions absent from, or deterministically given in, Saussurean semiology (Preucel & Bauer 2001, 88–9). The inclusion of the relation of pre-existing objects and an active interpreter shifts analysis from a more restricted model of meanings contained in vehicles (the Saussurean signifier–signified relation) to one of meaning-making, as the creation of relations among people and objects. Arguing that this pragmatic dimension of Peircean semiotics makes it preferable for archaeological analysis, Preucel & Bauer (2001, 89) cite ethnographer Milton Singer's much earlier critical assessment of these two approaches:

> [Saussurean semiology] cannot deal with the problems of how the different cultural 'languages' are related to empirical objects and egos, to individual actors and groups ... It is possible to deal with such extra-linguistic relations within the framework of semiotic theory, because *a semiotic anthropology is a pragmatic anthropology*. It contains a theory of how systems of signs are related to their meanings, as well as to the objects designated and to the experience and behavior of the sign users. (Singer 1978, 223–4; original emphasis)

A Peircean analysis of material meaning-making does not require that all forms of meaning be understood using a single model of the sign as arbitrary. Instead, a more complex spectrum of interacting indexical, iconic, and symbolic relations between signs and their objects is proposed (Knappett 2002, 102–3). Symbolic relations of the Peircean sign correspond most closely to the Saussurean model of the culturally specific (arbitrary) relation of signifier and signified, although even here there is a significant difference because

Peircean symbols are understood historically, not simply synchronically. As products of specific histories, Peircean symbols are far from arbitrary.

Peirce's indices and icons are by definition non-arbitrary, motivated by specific relations that are culturally and historically grounded. Indexical signs register 'an existential relation' between a sign and its referent (Preucel & Bauer 2001, 88). Hand prints are an example of early human imagery better understood using the concept of indexicality than that of the symbol. With examples dating to the Archaic period (*c.* 7000–2500 BC) at sites such as the El Gigante rock-shelter in Honduras (Scheffler 2000, 117; 2002), Loltun Cave in Yucatan (Velázquez Valadez 1999), and Santa Marta Ocozocoautla rock-shelter in Chiapas (Garcia-Barcena & Santamaria 1982), hand prints are among the earliest identified forms of human figuration in Mesoamerica (Garcia-Barcena 2001; Künne & Strecker 2003, 13; Stone 1995, 46). These graphic marks are indices of the people who applied pigment to rock surfaces using their bodies as instruments. They stand as signs of the presence at these places of the people who produced them at a particular time in the past (see also Morley this volume).

Iconicity, the third form of sign relationship explored by Peirce, establishes meaning by resemblance. The presence in Archaic sites like the El Gigante rock-shelter in Honduras and the Cueva del Espiritu Santo of El Salvador (Coladán & Amaroli 2003; Haberland 1972; 1991) of painted positive images that at first look like hand prints, but on closer inspection are paintings of hand prints, provides an example of the interplay of indexicality and iconicity. Both positive hand prints and paintings of hand prints are indexical signs of the presence of human subjects. Neither signifies the human presence merely arbitrarily, through a convention that calls for the human presence to be represented by a hand-shaped positive mark. Indeed, these signs may well have had different symbolic meaning, less accessible to us today than their iconic and indexical signification.

Preucel & Bauer (2001, 90) cite Richard Parmentier's discussion of a traditional archaeological analysis of a pottery style as another example of the relationship between indexicality and iconicity. Rather than view this as an arbitrary relation between style (signifier) and some form of identity (signified), Parmentier suggested we understand pottery styles as indexical signs incorporating iconic signs. Every pot recognizable as in a specific style indexes the set of repeated traits that make up the style. The legibility of different pots as of the same style is a product of their mutual resemblance, or iconicity. The identification of 'resemblance' that underpins iconicity clearly requires an act of interpretation.

Iconicity is central to every interpretation of a lump of modelled clay as an image of a human body. This is dramatically evident in the interpretive work required to see human figuration in the earliest examples of fired clay figurines in the region, from central Mexico (Niederberger 1976; 1987; Reyna Robles 1971) and the lower Pecos River region on the Texas–Mexico border (Shafer 1975). A unique figurine, notable for its limited iconicity, was recovered near a hearth at the central Mexican site of Zohapilco, associated with a radiocarbon date 2300±100 bc (*c.* 2920 BC). The main body is a shaft of clay, divided at one end into two 'legs' (one of which is broken). A raised protrusion with a single marked punctation for a navel is usually described as a pregnant belly. Drawings show slight modelling where breasts might be expected. No arms are indicated at all, nor is a neck. The end of the shaft has a central modelled ridge interpreted as a nose, flanked by two sets of three punctations, identified as eyes.

In the lower Pecos River region, Shafer (1975) described unfired clay figurines in Archaic caves and rock-shelters dating as early as 2000–1200 BC. Two examples were fired, Shafer argued most likely accidentally. Like the Zohapilco figurine, these lower Pecos figurines represent very simple schematic anthropomorphic forms, flattened rod-like forms tapering at both ends to a point. Some have no indication of a head, and most have no facial features; the most complete head is represented by a long ridge of clay for a nose, punctate eyes, and a small hole below the nose. Normally the torso is the focus of elaboration on these figurines, with some having applied conical 'breasts'; some of these have additional linear painted patterns. Shafer notes that only torsos with breasts (which he identifies as female) have additional patterning.

In these early, rod-like figurines, iconicity is reduced to a minimum: a body with a polarity established by the definition of a head end, a 'face' signified only by selected features. Yet owing to the presence of a few features in rough anatomical orientation, we can recognize a resemblance between these objects and a human form. The figurines I discuss in more detail below make greater use of iconic resemblance to define less-generalized human forms. Both the early, more schematic figurines, and the later ones that appear more like miniaturized human beings, are simultaneously iconic of a human body, and indexical of the activity of their makers and users. And no doubt, they were symbolic of concepts associated conventionally with the general and specific human forms represented. But to understand any of these kinds of meaning-making, we must include in our analysis an explicit specification of the meaning-maker.

A Peircean perspective, through the third term of the Interpretant, introduces the response of the interpreter into the sign. Preucel & Bauer (2001, 91–2) describe the Interpretant as the sign created by the interpreter observing the Object–Sign relationship. They note that Peirce identified three different forms of Interpretant: 1) a feeling in the mind of the interpreter; 2) an immediate response or habitual reaction by the interpreter; and 3) a considered response or action or change in habitual response by the interpreter. These states of the Interpretant provide a way to specify how we understand signification affecting the individual person and other persons connected in social networks in space and time. In the conclusion of this paper, I return to the question of the Interpretant and the changes its inclusion in our model of the sign allows in our answers to both the 'meaning-making' and the 'meaning' questions. The basis for that discussion must be a fuller consideration of such a semiotic approach to the production of human images in early Mesoamerica. In the following section, I provide an example of a semiotic approach to early figurines from Honduras.

Figurines in early Formative Honduras

The material for my analysis consists of fragments of hand-modelled figurines recovered from archaeological sites in northern Honduras dating from 1100–200 BC. My approach to these figurines has been concerned to foreground the recursive, experiential aspects of their production and use for the living human beings whose enduring material marks they are (Joyce 2000; 2003). This has involved subordinating purely iconographic discussions in favour of considering the material features of the making of figurines and the ways these interact with materialities for the production of particular disciplined forms of embodied life. This is essentially an exploration of meaning-making rather than of meaning *per se*. Of course, my analysis involves proposing potential propositional (iconographic and social) meanings that might have emerged from the process of producing and using these images and giving them cultural significance, providing a motivation for their reproduction and for innovations in production over time.

I have based my analyses of figural representation on an understanding of signification based on the more complex triadic model of the sign, especially employing the concepts of iconicity and indexicality (Joyce 1993; 1998). As Preucel & Bauer's (2001) discussion suggests, in order to advance my analysis, I have had to specify connections between figurines and other signs, and have had to treat their chains of connection over time as evidence of processes of interpretation and generation of signs. A review of the features I have identified as key will allow more detailed discussion of the ways I see indexicality, iconicity, and symbolicity as useful in discussing early traditions of human representation.

The earliest dated figurines in northern Honduras come from Chotepe phase (1100–900 BC) Puerto Escondido (Joyce & Henderson 2001). While these fragments are all from refuse, one complete example of a contemporary figurine was recovered archaeologically from a cave in the region used for human burial (Healy 1974; Henderson 1992). The contexts of recovery of other complete examples in museum collections are not known. At this period, there is no evidence for architectural contexts distinct from the houses and courtyards that made up early villages.

All the figurines of this period from Honduras that I have recorded are hollow effigies, averaging 13 cm tall and 9–10 cm wide. They make use of rather generalized iconicity, with limbs represented as cones with nubbin tips, or by rods of clay with slashes where digits would be expected, wrapped around the body and attached in the same way as handles on contemporary pottery vessels. In general, the production of figurines employs techniques of forming and finishing also seen on contemporary pottery vessels, and their pastes and slips are indistinguishable from those of vessels.

While the sample of early figurines is small, the represented human images are varied in facial features and treatment of hair and ornaments on or close to the head. Little detailing of the body is present, but at least two complete examples have a small frontal apron indicated by incised lines. One complete figurine explicitly depicts facial wrinkles and sagging breasts. In addition to seated humans, animal subjects are represented in the excavated collections by limbs and heads, apparently of deer. These early hollow effigies fall comfortably within the size range of the contemporary vessels with which they share technological features, and some fragments could have come from vessels with modelled anthropomorphic or zoomorphic features.

Later figurines (produced from 900–200 BC) are distinct, products of a technology developed specifically for the manufacture of images with more detail and more varied postures. Smaller than their predecessors, these Playa de los Muertos style figurines include full size standing (averaging 8.9 cm tall, 6.8 cm wide, by 3.9 cm front–back) and seated examples (6.6 cm tall, 6.3 cm wide, by 4 cm front–back), and smaller versions (averaging 5.1 cm tall by 3.3 cm wide, and 2.5 cm front–back). Named after a village site where

Figure 8.1. *Playa de los Muertos figurine with hair denoted by parallel lines, tied on top of head. (Computer graphic by Rosemary Joyce based on original in the Peabody Museum, Harvard University.)*

Figure 8.2. *Back of the head of Playa de los Muertos figurine with hair denoted by fingernail impressions. (Computer graphic by Rosemary Joyce based on original in the Peabody Museum, Harvard University.)*

two complete figurines were documented in one of a dozen burials excavated in the 1920s, all examples archaeologically recovered subsequently at Playa de los Muertos or contemporary Honduran sites have come from refuse and architectural fill. Complete examples in the smaller size range recorded have been recovered from refuse and fill. The presence in museum collections of complete examples of the full-size solid figurines, not recovered in refuse or fill in recent archaeological excavations, suggests that use in burials, while not routine or even common, may have been a repeated practice.

Contemporary with the new smaller solid figurines, larger hollow effigy vessels of both human and animal subjects continued to be made, using vessel pastes and slips and forming techniques. These effigy vessels share the manner of representing the human figure and face, and the proportions of head and body, that are employed by the makers of the smaller solid figurines. However, the small solid figurines were made using specially prepared materials and techniques adapted to the task of delineating varied postures and more detailed bodies. The Playa de los Muertos style solid figurines are thus an addition to a repertoire of human representation, not a replacement for the established practice of anthropomorphizing and zoomorphizing vessels.

The new technique of production typical of Playa de los Muertos solid figurines begins with rods of clay joined to form a rough armature for torsos in standing and seated postures. A blunt stub at one end served to anchor a separately modelled head. Both the roughly shaped body armature and the core of the head were covered with fine clay, free of nonplastics, and in at least some cases, mixed with a high proportion of calcium carbonate (Agurcia Fasquelle 1977). This clay plaster was used to sculpt smooth-surfaced limbs and torsos with musculature, folds of flesh, and raised facial features such as lips, nose, and eye sockets. The clay-plastered surface was carved away to recess the eye, with single punctations forming pupils. Where not otherwise altered, the fine clay was burnished, forming glossy uniform surfaces. In most examples, the underlying clay body fired a uniform light beige, and the superficial layers of finer clay were consistent in colour with this core. Variant clay mixtures that fired red were covered with a thicker layer of fine clay slip of a light cream colour, suggesting that the makers wished to produce light-coloured fired clay surfaces.

An additional layer of clay was applied on the head to represent hair. This applied layer was often cut away in geometric designs suggesting shaving of parts of the skull. The thin layers of clay that stood for hair were textured in three different ways. Incised

parallel slashed lines marked chin length or shorter hair of infants held in arms, and of other figurines that I suggest also depict younger subjects. Parallel lines can also mark longer hair, often shown drawn up and tied on top of the head (Fig. 8.1), in what I suggest are images of older but still youthful subjects. On the majority of figurines showing hair extending below the neck, often in tresses ornamented with beads, rows of fingernail impressions replace straight incised lines (Fig. 8.2). This second convention is employed even within the geometric areas left raised when other sections of the hair layer were cut away (Fig. 8.3). Finally, on all of the figurines with facial wrinkles or other apparent signs of age, the head was covered by zones of punctation, ending at the nape of the neck, sometimes combined with long tresses marked by fingernail impressions (Fig. 8.4). Punctated caps of hair are also found on figurine heads without obvious signs of age, suggesting that this convention marks a broader adult category including elderly subjects.

Clothing was rarely depicted, but when it was it was also normally modelled with separate layers of the fine clay plaster. Ornaments at ears, neck, wrists, and ankles, and interwoven in the represented hair, were either made of applied modelled pellets or, more commonly, indicated by punctations and cut slashes. Red, yellow, and white slips were sometimes applied to these represented body ornaments. All of this sculptural and pictorial detail was executed at a scale producing much smaller figurines, at most 70 per cent of the size of the earlier hollow effigies. The smaller figurines, with comparable detail are less than 40 per cent of the size of the older, large hollow effigies. These smallest figurines, which include all the known animal subjects, include many examples pierced at the neck, apparently for suspension. This difference in use may also account for the subtle difference in the proportions of smaller figurines, which are significantly shallower from front to back than the full-size, free-standing figurines.

By 200 BC, figurines in the smaller size range dominate assemblages. These late figurines include innovations in details of costume, in particular, an emphasis on aprons, including repeated depiction of an animal pelt as a frontal apron. They de-emphasize the diversity of features of hair and head and standardize postures of the human subjects depicted. Eyes on these latest Playa de los Muertos figurines are not created by the more careful technique of carving out a lower-relief oval field with a central punctation, but are made by placing three punctations next to each other.

In my symbolic analysis of these figurines, I argue that these images represent idealized human subjects of different age grades participating in ceremonies of life

Figure 8.3. *Back of the head of Playa de los Muertos figurine with hair denoted by fingernail impressions in raised areas outlining 'shaved' patterns. (Computer graphic by Rosemary Joyce based on original in the Peabody Museum, Harvard University.)*

Figure 8.4. *Playa de los Muertos figurine with punctations denoting closely cropped hair on head, and fingernail impressions denoting long tresses. (Computer graphic by Rosemary Joyce based on original in the Peabody Museum, Harvard University.)*

transition (Joyce 2000; 2003). But this set of interpretations is neither the beginning point of my analysis nor its end, which is less concerned with identifying specific meanings than with understanding meaning-making. A triadic concept of the sign is of particular help here. Indices, icons, and symbols should not be understood as different kinds of signs. Instead, they are forms of signifying relationships that we can examine independently but that are immanent in any sign. Because these signifying relationships are established differently — formally, through engagement with other signs in networks of signs, or through conventions (Knappet 2002, 104, citing Deacon 1997, 71) — they provide distinct approaches to meaning-making. This can be illustrated by re-examining the analysis of Honduran figurines in terms of the ways I understand signification.

Indexicality

As indices, figurines point toward the existence of active agents in the past making an enduring mark that we recognize as meaningful (Knappet 2002, 101). This provides a relatively firm beginning point for analysis, assuming neither a particular iconic mapping nor a specific symbolic interpretation. Thus in my work on Honduran figurines, I begin with the actions that establish these objects as indices of human labour. This leads me to an unexpected series of observations about the meaning-making of which these objects were media and products.

First, in the initial phase of production of fired clay effigies, while I am quite certain that I am dealing with iconicity since it is only through resemblance that I recognize the human and animal subjects, it is suddenly less clear that these effigies are actually symbols (representations) of persons. They are separated from the broader production of ceramic vessels only by my bracketing them off, because I already think I know that iconic signs that resemble human forms are different from other signs appearing on contemporary ceramic vessels. These other signs seem very far from iconic; carved into the exterior walls and upper surfaces of the rims of bowls, or the exterior bodies of small bottles, they consist of angular and curvilinear marks disposed in asymmetric fashion around vessel circumferences. Like the anthropomorphic and zoomorphic modelling and incising of fired clay that I recognize as figurines, these other marks on ceramic vessels are also indices of their makers, whose actual motor actions we can reconstruct with a fair degree of certainty. From an indexical perspective, the two sets of marks belong together, not apart.

These sets of less iconic marks can be interpreted as highly schematic versions of zoomorphic motifs distributed widely across Mesoamerica at the time (1100–900 BC), motifs which are held to symbolize a variety of supernatural zoomorphic creatures (Lesure 2000; Joyce 2001; Joyce *et al.* 1991). So rather than having a well-defined practice of production of figures that iconically denote human and animal subjects, with additional symbolic connotations established by convention, I am actually faced with evidence of practices of production of ceramic vessels whose surfaces are marked using a uniform set of techniques (compare Lesure 1999, 215). These elaborative marks are part of signs, varying systematically in their iconicity, whose objects are human and animal subjects and whose interpreters recognized them as signifying these objects as a consequence of culturally specific and historically contingent habituation. While Lesure (2000, 206–10) can demonstrate a chronological sequence at Paso de la Amada, Mexico from the production of modelled, iconically less ambiguous zoomorphic signs to the production of more conventionalized zoomorphic signs on vessels, at Puerto Escondido these are contemporary variants. Thus my understandings of the way meaning was being made through the human (and animal) effigies should be revised to incorporate the entire suite of products, not abstracting only those objects that work best together from my perspective.

I have to begin with these objects as vessels, containers for literal physical contents in some cases, and potentially for nonliteral metaphysical contents in others. The vessels are themselves, of course, indices of their contents (literally for us as modern interpreters conducting residue analyses). The less iconically marked vessels, appropriate for serving food and drink, index occasions on which food was shared among groups of people whose consubstantiality was made manifest through these meals (Joyce 1996; Henderson & Joyce 2006). Marked symbolically with signs of supernatural beings, these vessels incorporated their contents within the bodies of these beings. The more iconic human and animal subjects may have been understood also to contain substances integral to the beings of which they were signs. In cases where iconic modelled features were applied to morphologically functional serving vessels, equivalences were created between physical and metaphysical contents of vessels (Joyce 1998). For example, a stirrup-spouted bottle in the shape of a Playa de los Muertos-style reclining human figure is part of a group of vessels shown by residue analyses to have contained cacao; the represented person incorporated cacao drink within its interior in the same manner as the living persons who imbibed these drinks.

With this re-orientation to recognize the earliest human figures as containers, the innovations in pro-

duction techniques used in the development of solid Playa de los Muertos figurines seem to constitute a sharper break with preceding practices, since the new figurines lack the hollow interior spaces of vessels and effigies. The re-examination of the earlier figures helps draw attention to the way that construction of an armature around which a thinner, more mobile skin was shaped indexes the conception of bodies as skins containing concealed interior substances, in this case foregrounding the hard interior framework comparable to the bony skeleton of the living person.

The focus in Playa de los Muertos figurines shifts to the way the outer body, and especially its surface skin, is formed through practices of dress, body ornamentation, hair treatment, and even posture (resulting in the shaping in living bodies of the folds of flesh so scrupulously rendered by Playa de los Muertos artisans). These figurine makers experimented in this plastic medium with iconically capturing a diversity of fleeting bodily postures and gestures, recalling the experimentation with appearance by the makers of Locona phase solid figurines at Paso de la Amada (Lesure 1999, 213–14). The Honduran makers and users of these figurines also participated in analogous practices of modifying living bodies, indicated by the recovery of ornaments in burials at the same bodily sites, and inferred from the material culture of embodiment recovered in refuse (Joyce 2003).

Iconicity
The utility of a more complex semiotic model becomes evident when we turn to the interplay of indexical and iconic signs in interpretation of these figurines. Iconicity and indexicality are particularly intimately related. Indexicality is 'bidirectional':

> meaning is made possible not only by conventional relations between Sign and Object, but also by sign-activated connections that 'point to' other sign relations and contexts ... [so that] culture works by representing aspects of reality, and by linking together individuals, groups, and situations with objects (Preucel & Bauer 2001, 89).

The bidirectionality of indexical signs implies that as a ceramic figurine indexed a figurine maker's specific labor, the personhood of the maker also indexed the figurines he or she had made.

Here I am taking issue with Nelson Goodman's (1976, 4) critique of the concept of iconicity, in which he claims that 'while a painting may represent the Duke of Wellington, the Duke doesn't represent the painting'. Indeed, the Duke is not a representation denoting the painting by resemblance, as the painting is a representation denoting the Duke by some (culturally and historically conventional) resemblance. But 'the Duke of Wellington' as an object of discourse does point back to the entire spectrum of those things that index his existence at a particular point in time. The painting, created in particular social, cultural, and historical circumstances, is understood by later interpreters as an index of the historical person of whom it was constructed as an icon. The painting and the 'Duke' share a bidirectional existential relation.

The makers of Playa de los Muertos figurines and their products similarly shared an existential relation, or better, a history of existential relations, which I have suggested we can understand as reflexive connections between representational practices and embodied practices. This includes the practices indexed by the figurine (the labour and intentions of the figurine makers and users) as well as those practices iconically signified in the figurines (ways of standing, sitting, moving, and of dressing and modifying the body).

From this perspective, the selection of hair as the most elaborated site of iconic significance in Playa de los Muertos figurines is especially interesting. Knappett (2002, 105–6), commenting on the 'convergence of icon and index', suggests that the human person should be 'less diffuse in time and space' than other examples where indexicality and iconicity are hard to separate, so that the task of distinguishing iconic and indexical representation of the person might be expected to be clearer. He notes that clothing can be removed from the body and become indexical of the person, as I argue occurred with body ornaments in Mesoamerica (Joyce 2000). He argues that this is not normally the case with parts of the biological person, which cannot be removed without negatively affecting the living body. But hair, which grows continuously, can be cut off without harming the person, becoming a real index of that person. What Playa de los Muertos figurines represent iconically (among other things) is precisely the production of physical indices of persons through the modification of their hair.

I take these elaborate hair treatments as truly iconic, imaging what were actual visible variants in the living appearance of people in these early villages, as hair treatments did in later Mesoamerican societies (Joyce 2000; 2003). These early hair treatments apparently varied with age of the represented person, signified by such still-recognizable iconic features as wrinkled faces and sunken cheeks. Age difference could also be signified by other features that, while equally iconic for an interpreter who shared the social and cultural premises of figurine makers, elude us today, at least initially. Figurines with the punctated hair style, lacking depiction of obvious wrinkles or missing teeth, have no other bodily characteristics that suggest old age to me. But they do have distinctive iconic fea-

tures, shared with the obvious old figurines and rare in figurines without punctate hair. Most obvious is posture, with punctate hair figurines far more likely to be shown in a seated posture than standing.

This correlation leads me to understand posture in these Honduran figurines as iconic of age, a reading somewhat at odds with the interpretation by John Clark of seated postures of the figurines of Paso de la Amada as marking social authorities (Clark 2004; Clark & Pye 2000). These two different emphases can, of course, be reconciled by equating authority with age (Lesure 1999, 213). Most important, at this point our analyses clearly are not diverging owing to our iconic interpretive activity, since we agree on the iconic interpretation. One way of framing these differences is to recognize that our contemporary interpretive efforts are themselves active constructions of signs, as we understand these things as indexical, iconic, or symbolic of different social facts (Preucel & Bauer 2001, 91–2). It is in our ways of approaching the symbolic character of figurines as objects in sign relations that archaeologists encounter our greatest difficulties.

Symbolicity
With the separation of different kinds of meaning-making implicit in a Peircean analysis of signs, it becomes clear that reliance on a model of symbolic signs is actually a weakness when dealing with material culture (Preucel & Bauer 2001; Knappett 2002, 103–4). I share with Lesure (2002) a concern about how analyses of apparently similar material things from socially similar contexts in historically and culturally related societies can ultimately be so very different. For me, the points of divergence almost always can be tied to understandings of figurines, or features of figurines, as symbolic signs.

This can be illustrated by a comparison between my analysis of Honduran figurines and that of similar, contemporary hand-modelled figurines recovered from domestic refuse contexts at the highland Mexican site of Chalcatzingo, Morelos (Cyphers 1993). These figurines are also understood as representations of different age grades related to events in the female life course. In both collections, female sex is identified by the presence of secondary sexual characteristics, and the absence of depictions of male genitalia or of distinctive male items of costume. The modelling of breasts on the chests of figurines at both sites is actually quite variable, something that these assemblages share with many other Mesoamerican collections. Some Playa de los Muertos figurines, and some Playa-style effigy bottles, have carefully modelled vulvas and labiae (often on the bottom surface of the figurine, invisible to most viewers).

At Chalcatzingo, secondary sexual characteristics recognized included features identified as iconic of specific physical manifestations of pregnancy, not just fat abdomens, so often identified as evidence of pregnancy in figurine assemblages without consideration of the wider context of this physical characteristic in specific assemblages or living communities. While many Playa de los Muertos figurines have fat bellies, the graphic features taken as more precise denotation of stages of pregnancy at Chalcatzingo are not present.

So perhaps the fact that I argue for the figurines from Honduras symbolizing social ceremonies, and the Chalcatzingo figurines are said to be evidence of biophysical experiential states, could be reconciled simply on the basis of differences in iconicity. That solution, however attractive, cannot be accepted, because our analyses were incommensurable from the outset. While Cyphers (1993) identified all of her figurines as either male or female, I allowed a third possibility, that figurines may not have been intended to mark legible sex differences (Joyce 2003). Both analyses propose particular symbolic relations between the iconic features of figurines and systematic sexual differences within the source societies. But our ability to even proceed with a comparison is complicated by our different models of what ontologically prior social distinctions might have been relevant at the time.

Discussion

The most common strategies of analysis of figurines begin with iconicity, seeking to identify what is represented by an argument of resemblance. The main difference between these analyses and my own work is that I begin with indexicality. Analyses that begin with iconicity often proceed directly to symbolic inference, or make no distinction between these two kinds of signifying relations. For me, symbolic interpretation of image-making (whether in terms of symbolism of abstract concepts like ancestry, or of social relations such as hierarchy) must be a last step, always partly impeded by a lack of access to conventionalizations from the community of production and use.

Inevitably, my attempt to think about figurines from the perspective of meaning-making requires consideration both of interpretation and agency (Knappett 2002, 102). Preucel & Bauer (2001, 93) note that Peirce's concept of habit and Bourdieu's *habitus*:

> both refer to the way people engage with Signs in the world in a regularized way without reflecting on their ambiguity. To Peirce, the many possible meanings of a Sign are not cognized simultaneously, but

from one semiotic moment to the next, whether they be internal to one's mental processes ... or the engagements of different embodied 'knowers'. Meanings are not inherently ambiguous, but become so as the same, or different, 'knowers' (or, if you prefer, 'agents') engage with the Sign ... again and again in different contexts.

In my analyses of early figurines in Mesoamerica, I have primarily been concerned with the iconic and indexical rather than the symbolic aspects of meaning. My analyses have begun with production of signifying objects, something that would be open to criticism if no consideration were given to the 'consumption' or post-production engagements with these objects by others (Knappett 2002, 107; Clark 2004). To be clear about this, it is not solely, or even primarily, that objects are indexical for their makers. Rather, through objects people become linked by the indexical actions of signs in particular, often asymmetric, and always different relations of meaning:

> a person and a person's mind are not confined to particular spatio-temporal coordinates, but consist of a spread of biographical events and memories of events, and a dispersed category of material objects, traces, and leavings, which can be attributed to a person and which, in aggregate, testify to agency ... during a biographical career which may, indeed, prolong itself long after biological death. The person is thus understood as the sum total of the indexes which testify, in life and subsequently, to the biographical existence of this or that individual (Gell 1998, 222).

References

Agurcia Fasquelle, R., 1977. The Playa de los Muertos Figurines. Unpublished MA thesis, Tulane University.
Clark, J.E., 2004. The birth of Mesoamerican metaphysics: sedentism, engagement, and moral superiority, in *Rethinking Materiality: the Engagement of Mind with the Material World*, eds. E. DeMarrais, C. Gosden & C. Renfrew. (McDonald Institute Monographs.) Cambridge: McDonald Institute for Archaeological Research, 205–24.
Clark, J.E. & M.E. Pye, 2000. The Pacific coast and the Olmec question, in *Olmec Art and Archaeology in Mesoamerica*, eds. J.E. Clark & M.E. Pye. (Studies in the History of Art 58; Center for Advanced Study in the Visual Arts Symposium Papers XXXV.) Washington (DC): National Gallery of Art, 217–51.
Coladán, E. & P. Amaroli, 2003. Las representaciones rupestres de El Salvador, in *Arte Rupestre de Mexico Oriental y Centro America*, eds. M. Kunne & M. Strecker. (Indiana: Beiheft, vol. 16.) Berlin: Gebr, Mann Verlag, 143–61.
Cyphers, A., 1993. Women, rituals, and social dynamics at ancient Chalcatzingo. *Latin American Antiquity* 4, 209–24.
Deacon, T., 1997. *The Symbolic Species*. London: Penguin.
Garcia-Barcena, J., 2001. Cenolitico superior y Protoneolitico (7000–2500 A.C.). *Arqueologia Mexicana* IX(52), 52–7.
Garcia-Barcena, J. & D. Santamaria, 1982. *La cueva de Santa Marta Ocozocoautla, Chiapas: estratigrafia, cronologia y ceramica*. (Coleccion Cientifica: Prehistoria, vol. 111.) Mexico: Instituto Nacional de Antropologia e Historia, Departamento de Prehistoria.
Gell, A., 1998. *Art and Agency: Towards a New Anthropological Theory*. Oxford: Clarendon Press.
Goodman, N., 1976. *The Languages of Art*. Indianapolis (IN): Hackett.
Haberland, W., 1972. The Cave of the Holy Ghost: rare and important cave paintings are discovered in Central America. *Archaeology* 25(4), 286–91.
Haberland, W., 1991. Informe preliminar de investigaciones arqueologicas en la gruta de Corinto y sus alrededores. *Mesoamerica* 21, 95–104.
Healy, P., 1974. The Cuyamel caves: preclassic sites in northeast Honduras. *American Antiquity* 39, 433–7.
Henderson, J.S., 1992. Catalogue entry 9. Statuette, in *Die Welt Der Maya: Archäologisches Schätze aus drei Jahrtausenden*, eds. E. Eggebrecht, A. Eggebrecht & N. Grube. Hildesheim & Mainz am Rhein: Roemer-Pelizaeus-Museum & Verlag Phillipp von Zabern, 304.
Henderson, J.S. & R.A. Joyce, 2006. Brewing distinction: the development of cacao beverages in Formative Mesoamerica, in *Chocolate in Mesoamerica: a Cultural History of Cacao*, ed. C. McNeill. Gainesville (FL): University Press of Florida, 140–53.
Joyce, R.A., 1993. Women's work: images of production and reproduction in Pre-Hispanic southern Central America. *Current Anthropology* 34, 255–74.
Joyce, R.A., 1996. Social dynamics of exchange: changing patterns in the Honduran archaeological record, in *Chieftains, Power and Trade: Regional Interaction in the Intermediate Area of the Americas*, eds. C.H. Langebaek & F. Cardenas-Arroyo. Bogota: Departamento de Antropología, Universidad de los Andes, 31–46.
Joyce, R.A., 1998. Performing the body in Prehispanic Central America. *Res: Anthropology and Aesthetics* 33, 147–65.
Joyce, R.A., 2000. Girling the girl and boying the boy: the production of adulthood in ancient Mesoamerica. *World Archaeology* 31, 473–83.
Joyce, R.A., 2001. Crocodile, serpent, and shark: powerful animals in Olmec and Maya art, belief and ritual, in *Forests and Civilizations*, ed. Y. Yasuda. Kyoto: International Research Center for Japanese Studies, 71–84.
Joyce, R.A., 2003. Making something of herself: embodiment in life and death at Playa de los Muertos, Honduras. *Cambridge Archaeological Journal* 13(2), 248–61.
Joyce, R.A., 2005. Early Representation: Mesoamerica and its Neighbours. A paper presented at the conference 'Image and Imagination: Material Beginnings'. McDonald Institute for Archaeological Research, Cambridge University, September 2005.
Joyce, R.A. & J.S. Henderson, 2001. Beginnings of village life in eastern Mesoamerica. *Latin American Antiquity* 12, 5–24.

Joyce, R.A., R. Edging, K. Lorenz & S.D. Gillespie, 1991. Olmec bloodletting: an iconographic study, in *The Sixth Palenque Round Table, 1986*, vol. VIII, eds. M. G. Robertson & V. Fields. Norman (OK): University of Oklahoma Press, 143–50.

Knappett, C., 2002. Photographs, skeumorphs and marionettes: some thoughts on mind, agency and object. *Journal of Material Culture* 7, 97–117.

Künne, M. & M. Strecker, 2003. Introduccion, in *Arte Rupestre de Mexico Oriental y Centro America*, eds. M. Kunne & M. Strecker. (Indiana: Beiheft, vol. 16.) Berlin: Gebr, Mann Verlag, 9–28.

Lesure, R.G., 1999. Figurines as representations and products at Paso de la Amada, Mexico. *Cambridge Archaeological Journal* 9(2), 209–20.

Lesure, R.G., 2000. Animal imagery, cultural unities, and ideologies of inequality in Early Formative Mesoamerica, in *Olmec Art and Archaeology in Mesoamerica*, eds. J.E. Clark & M.E. Pye. (Studies in the History of Art 58; Center for Advanced Study in the Visual Arts Symposium Papers XXXV.) Washington (DC): National Gallery of Art, 193–215.

Lesure, R.G., 2002. The goddess diffracted: thinking about the figurines of early villages. *Current Anthropology* 43, 587–610.

Marcus, J., 1998. *Women's Ritual in Formative Oaxaca: Figurine-Making, Divination, Death and the Ancestors*. (Memoirs of the Museum of Anthropology, University of Michigan 33.) Ann Arbor (MI): Museum of Anthropology, University of Michigan.

Niederberger, C., 1976. *Zohapilco: cinco milenios de ocupacion humana en la Cuenca de Mexico*. (Coleccion Cientifica, Arqueologia 11.) Mexico: Instituto Nacional de Antropologia e Historia.

Niederberger, C., 1987. *Paleopaysages et archeologie pre-urbaine du Bassin de Mexico (Mexique)*. (Etudes mesoamericaines 11.) Mexico: Centre d'etudes mexicaines et centramericaines.

Preucel, R.W. & A.A. Bauer, 2001. Archaeological pragmatics. *Norwegian Archaeological Review* 34, 85–96.

Reyna Robles, R.M., 1971. Las figurillas preclasicas. Tesis professional, Escuela Nacional de Antropología, Instituto Nacional de Antropologia e Historia.

Scheffler, T.R., 2000. Research report on the proyecto Cueva El Gigante — 2000, La Paz, Honduras. *Mexicon* XXIII(5), 115–23.

Scheffler, T.R., 2002. *El Gigante Rock Shelter: Archaic Mesoamerica and Transitions to Settled Life*. Online report at www.famsi.org.

Shafer, H.J., 1975. Clay figurines from the Lower Pecos region, Texas. *American Antiquity* 40, 148–58.

Singer, M., 1978. For a semiotic anthropology, in *Sight, Sound and Sense*, ed. T.A. Sebeok. Bloomington (IN): Indiana University Press, 202–31.

Stone, A.J., 1995. *Images from the Underworld: Naj Tunich and the Tradition of Maya Cave Paintings*. Austin (TX): University of Texas Press.

Velázquez Valadez, R., 1999. Las grutas de Loltun, in *Cenotes y grutas de Yucatan*, ed. G. Gomez Chacon. Merida: Secretaria del Gobierno del Estado de Yucatan, 148–53.

Chapter 9

The Anti-rhetorical Power of Representational Absence: Incomplete Figurines from the Balkan Neolithic

Douglass W. Bailey

During the excavations of the Hamangia Culture cemetery at Durankulak on the Bulgarian Black Sea coast, Henrietta Todorova's team recovered a number of figurines; Grave no. 626, for example, contained four (Fig. 9.1). The figurines were buried with a 20- to 25-year-old woman whose body was accompanied by a large *Spondylus* bracelet, three strings of copper and malachite beads and three fragments of finger rings (Vajsov 1987; 1992; 2002; Todorova *et al.* 2002, 62, 109). As with other Hamangia figurines from settlement and funerary contexts, the Grave 626 figurines are striking for the simplicity of their form and their lack of surface treatment. Necks are long, thin, triangular and without faces or heads. On the body of one figurine, two horizontal and curving incised lines form a pubic triangle and a short vertical slit suggests that the figure is female. The other three have no sexually identifiable body parts, through two have small protuberances on their chests, which may be breasts, though they may just as easily be men's as women's; indeed the potential breasts sit rather high on the chest and are as much part of the shoulders or neck as they are of the chest. Only two of the figurines have arms preserved; one has short, thick, square-ended arms that extend straight out to the sides. On the other figurine, arms are thinner, bent at the elbows with hands resting on the top of the abdomen.

Like other Hamangia figurines, the examples from Durankulak are remarkable objects and there would be value in devoting all of the present paper to the role that any one of these four figurines, or any one of the many others like it from this or any other contemporary site, may have played in communities of the Neolithic in the Lower Danube region (6500–3500 cal. BC).[1] Here I wish to focus on one aspect of these figurines from Durankulak: the absence of any facial detail, indeed the absence of a head. While I have chosen to begin this discussion with an object from one particular region of southeastern Europe and a particular set of communities who shared similar ways of living, of making objects or burying their dead, it would have been just as feasible to use other figurines from other cultures in the region: from northeastern Romania, Moldova and the Ukraine (i.e. the Cucuteni/Tripolye cultures); from western Bulgaria, Serbia, southeastern Hungary, and Macedonia (i.e. the Starčevo and Vinča cultures); or from Thessalian Greece. In all of these places, it is not unusual to find figurines that have very little, if any, representation of faces or even heads (Fig. 9.2). Furthermore, I could have focused on the absence of body parts other than the head and face: on the absence of hands or feet, of arms or legs, of genitalia or buttocks. Indeed it is impossible to find a Neolithic figurine with all of its body parts represented. Why is this? Why were particular body parts not represented? What might be the significance of not representing the head or the face? This paper attacks these questions by investigating the representational importance of absence, by considering first the role that the process of abstraction plays in the creation of figurines, then by looking at the processes of cropping and disembodiment (especially in pornography), and finally by thinking about how psychoanalysis and experimental psychology have examined the ways that humans construct subjectivity and engage with incomplete or unsettling visual stimuli. Finally, I will turn back to the specifics of the Neolithic in southeastern Europe and examine how thinking about absence helps us to better understand Neolithic figurines and to understand better the ways in which Neolithic people lived in their world, thought about themselves and thought about each other.

Abstraction

To get to grips with Neolithic figurines from southeastern Europe requires getting to grips with a set of constitutive processes: 1) the making of something

are not shown everything nor are they shown the full detailing of those elements that are selected for representation. The fact that some elements are not included in a miniature object such as a figurine critically warps the relationship between the observer and the representation and, unavoidably, radically alters the observers' understanding and comprehension of the object. The brevity that comes with abstract representation forces the viewer beyond the information that is provided. The abstraction of a miniature demands that the spectator draws inferences. Thus, a person who gazes at a Neolithic figurine in its museum vitrine or as it is uncovered in an excavation trench, is drawn, almost without realizing it, to think of what is not there, of what has been left out. In the Hamangia example from Durankulak, described above, one is forced to ask: Where is the detail of human expression, the face, the head?

Through abstraction, representational objects are made active; abstraction forces the viewers to do something that otherwise they would not do.[2] Making the viewer draw inferences about what is not represented in a Neolithic figurine has important consequences for the understanding that the viewer develops about the miniature, abstracted object. The range of inferences that any one viewer can draw are almost limitless; the only constraints come from each individual viewer's particular beliefs, understandings, interests, backgrounds and desires. The potential for an abstracted representation to stimulate different inferences means that the responses and understandings of an abstracted representational object, such as a figurine, are many.

Elsewhere, I have drawn a distinction between a miniature object and a model and I have suggested that abstracted representations such as figurines do not present the exactitude, complete knowability or comprehensive meaning that is inherent in a model (Bailey 2005, 26–35). Models seek factual reproduction (for example, architects' models or model boats) while miniatures create a non-existent entity that is neither accurate nor faithfully representative. A model

Figure 9.1. *Figurines from Grave no. 626 of the Hamangia cemetery at Durankulak. (Redrawn by Howard Mason; after Vajsov 2002.)*

small; 2) of representing one object in another medium; and 3) of reproducing the human form. These are all processes of significant complexity and, having written about them in detail in a recent book (Bailey 2005), I will not devote space here to discussing them further. However, one of the constitutive processes, abstraction, warrants comment here because abstraction plays a fundamental role in the exclusion of particular features of the human body as represented in Neolithic figurines.

As part of the process of miniaturization, abstraction demands selection; it works through the inclusion of some features and exclusion of others. As a result, people looking at (or, just as significantly, holding) a miniature object such as a figurine are cheated. They

proposes a single meaning and limits the range of variation that a spectator's perception may experience. Via forced inferences, any one miniature (e.g. a figurine) can create many different meanings and the reactions, all of which, within reason, are equally valid. Absence is part of the power of miniaturism to provoke multiple interpretations. In their absences, missing body parts or facial details play a paradoxically strong role in stimulating the inferences forced upon a person looking at a figurine. In their absences the missing components release the viewer from the restrictions of a set meaning; the viewer is thus freed to imagine and provide his or her own feelings and emotions. These absences provide the real stimulus for thought (probably at an unconscious level), and, as I shall argue in the rest of this paper, it is in these absences that one finds the true meaning of miniature representations such as faceless figurines.

Cropping and disembodiment

Abstraction though miniaturization is one way in which absence comes into play in representational objects. Absence can also result from the processes of cropping, segmenting or disembodying the whole. In this section and the one that follows, I step away from the local Neolithic contexts in which this paper began and discuss representational mechanisms such as cropping and disembodiment, moving first to late nineteenth-century painting and then to debates concerning modern pornography before looking, in the following section, at the ways in which police interview victims of child-abuse.

 Linda Nochlin has drawn interpretive attention to the ways that the Impressionist painter Édouard Manet (1832–83) selectively cropped many of his paintings, intentionally cutting off parts from bodies (Nochlin 1994). By doing so, an arm or leg was left truncated at the painting's edge. The fragment of the whole body which Manet represented within the physical dimensions of the painting alluded not only to the rest of the body (often a female one) but also to other worlds that existed beyond the boundaries of the picture frame, worlds of sexualized bodies and body parts. Thus, Manet greatly increased the representational presence of a leering man in *Nana* (1877), a dancing girl in *The Beer Server* (1878–79), and a trapezist in *A Bar at the Folies-Bergère* (1882). While cropping alludes to what is absent (and thus titillates the viewer) it also urges the viewer to draw inferences about what is missing, to create other worlds based on the suggestions made in the partial representations. For Nochlin cropping is a way of playing with the normal borders of reality, a tool for questioning and for suggesting contemplation.

Figure 9.2. *Faceless figurines from Cucuten/Tripolye site of Dumeşti; height c. 20 cm. (Photo: George Dumitriu; after Mantu et al. 1997.)*

 The process of disembodiment has similar results. By working with fragments of the human body which have been removed from their normal contexts and expected scales of representation, it is possible to denaturalize the body and to allow it to be reconstructed in unusual and provocative ways (Pultz 1995, 162). Dismemberment invites redefinition outside of any commonly accepted understanding of the object in a way and to a degree that can never be possible when encountering the unfragmented whole/closed/finished object as it normally appears. With the collection, ordering and assembling of disembodied parts, the body can be built up from one piece into a reconstituted whole and may turn out to be very different from the original, pre-fragmented being. Many different whole bodies can be built from the same isolated parts and no single reconstructed body need be the correct whole. In this way, disembodiment of the body invites creation of the ungeneralizable, of the particular and discrete, and of series of differences rather than creations of completenesses (Nochlin 1994, 56).

Cropping and disembodying the human form focus the viewers' attention on particular body parts. In doing so these processes isolate those parts and invite a scopophilic consumption that often would not be permitted in more natural, complete, contexts. Importantly, cropping implies a control over the body via fragmentation; repetition and unnatural cropping produce decontextualized body fragments (Pultz 1995, 68). In this sense, cropping is a mechanism that, unintentionally, can create and exploit absence to create and exploit desire. Disturbingly, each part is invested with the power to evoke the whole with more perfection than any original, empirically unified, whole (Mercer 1999, 440). In many senses, cropping makes the fragment more exciting than the real thing.[3]

Pornography, disembodiment and absence

Cropping and the disembodiment are salient features and representational codes of pornography (Kuhn 1985, 36–8; Soble 1986, 56–67; Mercer 1996). In pornographic representation, the cropped image invites scopic interest onto areas of a body such as the breasts, buttocks and genitals in a fetishistic way (Coward 1982, 17). Disembodiment isolates one part (a breast) of something else (a body) and allows that part to be controlled and manipulated in a way that would not have been possible or permissible in the body's original location or context. By removing the part from its context, disembodiment strips it of any power or authority or association that it may have derived from its original context and position. By not showing the whole person, the pornographic code of dismembering the body depersonalizes the individual represented: the person (and their body) are decontextualized.[4] Understanding how some pornography works via the codes of cropping and disembodiment is important as it introduces us to the ways in which parts of the human body can be manipulated and repositioned in representation in ways that affect the authority or autonomy of the complete, whole body.

The absence of a body part from a representation is different from disembodiment as used in pornography, but the issues of authority of the body are of similar relevance. The important difference is that, with disembodiment, although the body is dissected into disconnected pieces, the parts remain visible, though they are out of context and out of order. Representational absence is different: particular body parts have been omitted from the representation altogether. Intriguingly, representational absence performs the inverse of disembodiment; the original contexts (with their associated power and authority) of the now absent part remain intact but the body part itself is missing. Critically, absence creates a gap in a place, and in a context, where something should be. It creates a representational vacuum that needs filling and which usually contains a high potential for the generation or contestation of meaning, thought and debate. The gap needs to be filled and whatever fills it will feed on the rhetorical power of the original representational context; in the example of the Hamangia figurines at Durankulak, the particular context is the human body and more specifically the face and head, both sites of extraordinary power within the constitution of meaning in definitions of identity, self and personhood.

Furthermore, in the vacancy created by absence, there rests the potential for the enrichment of the meaning and the values of the place left empty. Absence prompts intensification in the potential for thought and for the production of meaning, indeed for the production of multiple, conflicting and irresolvable meanings. Absence does not proscribe thought within the spectator (as disembodiment does with the pornographic voyeur), but invites, demands even, discussion and debate; in this sense, representational absence is a liberating process. Pornographic disembodiment of the body had the opposite effect; it offered a single, restricted meaning and weakened the potential for open thought and contemplation. If pornography runs with the code of disembodiment, then the Hamangian figurine from Durankulak runs with the code of absence.

Police interviews of child sex abuse victims

By thinking about what happens when bodies and body images are cropped and dismembered, when abstraction excludes some body parts and includes others, and when representation works through a code of absence, we are better able to recognize the power of these processes. But how might the results of these processes, especially the exclusion of particular body parts, affect people looking at or handling objects such as the figurine from Durankulak? Part of the answer is found in the practicalities of modern police-procedures and victim-interviewing technique.

As you will imagine, the procedures by which police, lawyers or judges interview children who may be victims of sexual abuse are complex. Problems of communication arise because children are reluctant to talk about abuse; reluctance comes from fear, embarrassment, the limits of children's vocabulary, or their span of attention (Morgan 1995, 12). Language differences between child and investigator also hamper communication (Morgan 1995, 40). Since the 1970s, law enforcement agencies have been using anatomical dolls during interviews (Morgan 1995, xiv) because the

dolls help remove the difficulty or embarrassment that children experience when describing abuse (Fig. 9.3). These dolls offer an efficient bridge of communication that links child and detective, judge or prosecutor (Morgan 1995, 2, 40). The dolls succeed because they create an environment in which the potentials for child trauma and emotional damage have been lowered (Morgan 1995, xiv, 2).

The dolls used in interviews and court questioning are specially made. They are less toy-like than play-dolls, most obviously as they are more sexually explicit. Normal, off-the-shelf, children's dolls are particularly unsuitable as they vary greatly in morphology and have inappropriately proportioned, or inadequately detailed, genitalia. Acceptable, purpose-made anatomical dolls are soft cloth figures that present a general replica of the human body, complete with sexual body parts such as a penis and testicles for male dolls, vaginal openings for female dolls, oral and anal openings, and pubic hair on adults. A set of dedicated interviewing dolls includes adult and child dolls and represents not only the abused child and the abuser but also the victim's siblings and other adults of the child's daily environment (e.g. grandparents).

Though these dolls are sometimes referred to as anatomically complete or anatomically correct, they are not biologically accurate as not all body parts are represented. The dolls provide only a basic map of the human body and, as such, are representations and not exact replicas or factual models (Morgan 1995, 3, 65). More importantly, where normal play-dolls have faces that bear precise expressions (smiling, frowning, laughing, crying) that represent particular emotions (happiness, displeasure, pleasure, fear, pain), anatomical dolls have faces intentionally left expressionless.

The relevance of interview dolls for our examination of the faceless figurines from Hamangia lies in understanding the rationale for the manufacturers' inclusion of certain body parts and their exclusion of others. The neutrality of the doll's facial expression is essential as it allows the child to communicate a full range of emotions and ensures that the doll cannot be blamed for suggesting to the child a particular reaction or feeling, suggestions that could jeopardize court prosecutions (Morgan 1995, 4). The expressionless face of the doll allows the child to demonstrate a variety of emotions depending on the child's experience and not on the toy designer's intention (Morgan 1995, 8). The inclusion of genitals and anus is as expected. Critically, these body parts must appear in a standardized form; they are not open to negotiation or interpretation by child, interviewer, prosecutor, judge or jury. They are the firm ground of the interview; they are the evidence. They must be unequivocal parts of the

Figure 9.3. *Doll used in police interviews of child victims of sexual abuse. (After Morgan 1995.)*

investigation and the subsequent court proceedings.

The absence of other body detail, however, is suggestive. On the one hand, their absence is a factor of the legal exercise in which the dolls play a part and are a product of law enforcers' and prosecutors' efforts to prevent objections made in court by defence lawyers: for example, that a particular part of a doll's appearance either led the child to think about sexual things that he or she would not have noticed otherwise or led a child to think of a particular person as the abuser (Morgan 1995, 6). Thus, the faces of anatomical dolls are intentionally left expressionless. The expression and emotion must be supplied by the child. These elements are not fixed or agreed; in their description lies the maximum variability. It is up to the child to fill in these details. The abstract, emptiness of the facial expression forces the child to come up with the answers, to fill in the blanks, to supply the evidence.

Therefore, the body parts that are represented (the genitalia) are fixed and not open to negotiation or alteration; the parts of the body (such as the face) that are left undefined invite consideration and imagination. This has direct bearing on our understanding of representational absence: what is left out determines the areas about which people must draw their inferences. Thus, the empty, undecorated or unmodelled parts of the Durankulak figurine and the body parts which are not depicted are the areas of the figurines that provoke thought and contemplation. Paradoxically, in their absence, they are the elements that invite maximum attention and consideration. The static and fixed parts that are represented offer no room for such contemplation.

Psychoanalysis and experimental psychology

Although thinking about abstraction, cropping, disembodiment and the inspiration to inference that the code of representational absence possesses helps us to start to get to grips with absence, we still have little idea of how absence works within the ways that people think and perceive. Two lines of approach are of value: the psychoanalytical theorizing of Lacan (and Freud) and the experimental psychology of Richard Gregory. The works of Freud and Lacan are complex and the literature of subsequent Lacanian and Freudian scholars is even less straightforward. While there is much of interest to be found in these works, for our study of absence it is the psychoanalytical attention to loss and desire as a means of constituting subjectivity which is of most relevance.

Drawing on the work of Freud (1899), Lacan (1966; 1973) and others, Patrick Fuery (1995) has written in detail about the role that absence plays in constructing meaning, about how absence is a constitutive process, about how it is deeply tied to the idea of self-consciousness and self-reflexivity, but also about how absence disrupts. Fuery argues for a dialectic of absence as developed from Lacan's 'Mirror Stage'[5] and from Freud's *The Interpretation of Dreams*: that there exists the idea of a site of subjectivity which is absent and which is desired precisely because of its absence. The desire is to rejoin and regain a seeming lost sense of wholeness. For Fuery, absence is a powerful and central constituent of being. Such an understanding of absence is a paradox: that which is not present is fundamental to understanding our existence, and, perhaps, is even more fundamental to our conceptions of reality than are those things which are present and which, one would otherwise assume, are the more important (indeed perhaps even the only) components of our existences.

Psychoanalytic work on absence and loss suggests that there is a deep subconscious link between our understandings of who and what we are and what we lack, how we are incomplete, and thus what we desire. Work by psychologists such as Richard Gregory provides another, equally provocative, understanding of what happens to the human brain when it confronts examples of incompleteness and missing parts. A useful strand of Gregory's work investigates illusions and particularly the ways that the brain deals with visual illusions (Gregory 1968; 1977; 1980; 1997; 1998; Gregory & Harris 1975; Gregory & Heard 1979).

Illusions are distortions, fictions, ambiguities, and paradoxes; they are discrepancies from truth which present the human brain with particular problems of comprehension: one of Gregory's examples of an illusion is a hollow mask of a human face with facial features painted on both the convex and the concave surfaces (Gregory 1998, fig. 1).[6] Because our brains hold a hypothesis of what a human face looks like, the spectator sees both sides of the mask as if they were convex (i.e. the facial features are sticking out) when in fact one side (the 'inside') is concave.

When a person encounters an illusion (such as the hollow face), the brain tries to understand it by using the limited information that it has accumulated from past experience. When encountering a situation (such as a human form) that is similar to a situation encountered in the past (such as another human form, living or ceramic), the brain will process the form as it has in previous situations. If in the new situation, however, there is information missing (i.e. things are absent) then the brain fills in what is missing by using information from previous experiences. In attempting to fill in the gaps, the brain tries out possible alternative solutions. In a merely ambiguous situation where little critical information is missing from the new experience, the brain will eventually find a solution. However, in a situation where critical information is absent, the brain has trouble and is prevented from finding a solution that is complete. Importantly, the brain is not content with a partial or slightly unsatisfactory solution; it continually looks for a better answer. The brain seeks closure. As the search for a better solution continues and as satisfactory answers are not found, the intensity of the interest in finding (and in the desire to find) the solution increases. The longer the search goes on, the greater the interest and the greater the desire.

The valuable thing to take from Gregory's work on illusion is, first, a recognition that absence may work in the same way as illusion does in presenting the brain with a problem and, second, a recognition of how the brain responds to the problem presented by representational absence and how the brain struggles to fill in the missing information. The problem presented to the human brain by its encounter with the faceless Hamangia figurine is that here is a clearly human form but one that is missing important features which the brain wants to see. The brain has to deal with this problem. What does it do? It searches for answers; that is its nature, to attempt to create a coherent perception, to supply missing information. The insurmountable problem is that the missing information is not to be found in the figurine; it must be supplied. The longer that the brain struggles in its quest to find the answer and to resolve the problem created by the absence of needed information, the greater becomes the significance of the search and the greater becomes the importance of the subject of the search (i.e. the features of the face).

Absence as anti-rhetoric

From these examinations of abstraction, cropping and disembodiment, psychoanalysis, and psychology, the following potential consequences of representational absence emerge:

1. In relation to the processes of abstraction, absence is a stimulus for thought and an inspiration for spectators to draw inferences.
2. Spectators will draw inferences about the parts that are missing.
3. The parts not represented become more important than those that are present.
4. As a process that is the inverse of disembodiment, absence creates a powerful representational vacuum that requires filling.
5. Although the human brain will try to fill this vacuum by calling on its accumulated perceptual experience, it will not succeed.
6. The continuing failure of the brain to fill the vacuum will fundamentally enrich the potential for meaning and significance of the absent features.

From these suggestions, a further point emerges: representational absence is anti-rhetorical. Though it stimulates thought and inference, absence does not persuade or convince. If anything, it invites questioning and uncertainty, promoting open-ended interpretations of representations and preventing the fixing of any closed, secure meaning or interpretation of the parts that are missing, or about what should fill the gap. Absence makes the human brain work and forces people to think on and on without resolution; it keeps things moving and in flux. As such, representational absence has tremendous potential to disrupt and subvert expectations about that which is accepted in a particular historical context.

The Neolithic figurines, and the corporeal politics of being

How does this examination of representational absence help us to better understand the local historical contexts of the face-less Hamangia figurine from Durankulak? The answer lies in understanding the dynamics of daily life in this region at this time (the fifth millennium cal. BC). Fundamental to the Neolithic was a way of arranging people, things and places (over specific durations and within particular boundaries), that was distinct from what had come before, in the Late Upper Palaeolithic, as well as what was to come after, in the Early Bronze Age.[7] Similarly distinct were peoples' particular capacities, desires and needs to understand who they were as individuals and who they were as members of household or village group.

Then, as now, to know oneself was to know one's relationship to others.

While there was nothing specific to the Neolithic in the human need to understand social relationships, there were specific material and political conditions that characterized Neolithic manifestations of human identities. Specifically, new conceptualizations of society were created in new media, including the built environment and the formal deposition of the deceased; however, Neolithic perspectives on society found their most powerful manifestations in the repeated, daily, visual experience of people seeing representations of the human body in the miniature, durable, three-dimensional form of anthropomorphic figurines. Far from being defined in terms of a new economy (i.e. Childe's original shift from food gathering to food producing: Childe 1936), the Neolithic is better understood in terms of a particular appearance of the human body and in the articulations of corporeality, identity, community and individuality. The Balkan Neolithic was a particular corporeal politics of being, and figurines were at the core (see Bailey 2005, 197–204).

In Neolithic communities, anthropomorphic figurines were potent manifestations of the body. Whether or not they represent conscious, intentional acts of doing so is irrelevant. I am not seeking to uncover original intended uses or meanings; I doubt that a search of that type would produce results of any interpretive value. In this sense, the figurine's importance rests in its frequent (perhaps continuous) circulation and visibility in people's daily lives. Figurines were important because they were the habitual presentation of the human body. Regardless of any superficial function they may have played (as goddesses, as votives, as portraits, or as objects to be broken and deposited) figurines saturated communities with specific images/senses of being human. The ever-presence of these senses of being human was fundamental to the Neolithic understanding of being.

Importantly, in most (but critically not all) respects, the Neolithic corporealization of the self and the person was a homogenizing process which rejected and suppressed diversity and differences between individuals as well as within and between communities. Across these Neolithic landscapes, within village boundaries, and between individual buildings, the corporealized individual (and its representation) became one of the cores of social community. In this sense, the actual physical diversity among the living, breathing, flesh and blood individuals should be seen as a significant threat to community cohesion. The existence and long-term success of specific, fundamentally similar and repeated forms of household

and village social aggregations (i.e. the 2500-year survival of a Neolithic way of living) depended on the continuous, unintentional, suppression of the risks that diversity among living bodies posed for social division and disintegration. This is one of the incredible paradoxes of the Neolithic: the individual body, through its repeated visual representation, was the essence of the communal.

Conflicting presentations of the Neolithic body

On the one hand, these Neolithic communities performed dramatic public ceremonies linked to burials, and possibly related to rituals of deposition (as suggested by Chapman 2000), as well as to events of house building and destruction (Tringham 2005). Communities shared the socially organizing facility of the built environment. The rituals of architecture (and, to a more limited extent, of burial[8]) had particular effects on how people understood their relationships to others, whether those relationships were defined by prestige, status or hierarchy (as could be contested via burial ritual) or whether they were defined in terms of what activities one carried out where and with whom (as facilitated by the boundaries of houses and villages). The built environment and the treatment of the deceased were loud and obvious ways in which social and political relationships were guided and fashioned; both treated the body in particular and highly visible ways either by decoration and deposition (or incineration) or by the choreography of movement into, across, and out of a site. The occasional public ceremonies which accompanied death, burial, house construction and destruction, explicitly proclaimed intra-group distinction and intra-community division.

At the same time, however, figurines were working in much subtler and, thus, much more powerful ways, and made people think more deeply (probably without conscious recognition that they were thinking at all) and absorb the ways in which each person fitted into the larger social groups. Figurines were saturating the visual worlds of these communities with particular images and arrangements of the human body. As such, figurines were the quieter rhythm of an unspoken corporeal reality. In this way, figurines did not actively proscribe systems of identities nor even did they represent preferred systems of identities; if anything, figurines were identity.

Figurines as subversions
As abstractions, figurines represented particular body parts and neglected others and, more importantly, forced viewers to draw inferences from what was represented and what was left out (i.e. the unbalancing provocation to inference). More provocatively, figurines generated a series of contradictions and paradoxes within Neolithic spectators and it is from these paradoxes that they may have had their greatest effects. As partial and unnatural combinations of body parts, figurines unbalanced viewers and put them on edge; as representations, they preferred the complex and convoluted to the straightforward and clear. Figurines provoked spectators to think around issues such as identity and being (most probably without their realizing that they were thinking about them at all) without offering a complete answer or solution to the enquiry. As representations of the human form from which particular body parts were absent, many figurines (such as the examples from Durankulak) drew on the power of the apparent contradiction that the most important areas of a figurine's surface may have been those without any decoration: figurines with little surface treatment were most open to thought and (Neolithic) interpretation. Similarly the cropping of figurine bodies (the frequent absence of heads and faces) provoked thought about what was not represented, of what could not be seen and, thus, what must be imagined.

By recognizing that Neolithic figurines worked in these ways, had the potential to stimulate thought, provoked inference, and facilitated entry into other worlds, we come closer to understanding their meaning. Figurines were philosophies in the politics of being in the Neolithic. Figurines do not mean any one thing, yet they meant everything. They questioned familiar and comfortable orientations and made people aware of their contact in the world. They altered the ways that people saw the world around them. Figurines were part of people's (possibly subconscious) definitions of the edges of their visible realities and of what made each person distinct (if they were distinct at all) from those other places, times and individuals. Figurines made people question who they were, where they were, what they were, and what their relationships were to others. In the Neolithic Balkans, figurines were at the core of a physicality of being that became visible in new conceptions of corporeality; the body became the key to understanding identities and relationships in the world. Therefore, if there is a meaning of figurines, if they had a function, then it is that they were philosophies of being human.

Return to the Hamangia figurine from Durankulak

One of the most striking elements of the material record from Durankulak and other Hamangia cemeteries (e.g. Cernavoda), and from other contemporary communities in southeastern Europe, is the effort di-

rected towards the adornment of the human body and, especially, of the face and head. At Durankulak, for example, Grave 626 contained not only four figurines but also a *Spondylus* bracelet, three strings of copper and malachite beads and fragments of finger rings. Other graves contained similar concentrations of similar items (especially shell jewellery) as well as copper and gold objects such as finger and arm-rings. *Spondylus* and hundreds of *Dentalium* beads were also used in elaborate belts, diadems, plaquettes, and stringed-capes. Deer teeth, stone and clay were also made into beads and pendants. It is clear that the ceremonies and places of death were significant foci for activities, material deposition and the performance of shared community beliefs. Though there does not appear to be evidence for disproportionate distribution of grave-goods when compared with the sex of the deceased, burials with adult bodies are better kitted out than are children's graves. The inclusion of particular materials such as *Spondylus*, copper and gold and their use to make body ornaments marks the beginning of widespread and increasingly dramatic attention to burial ritual and, especially, extraordinary deposition of large quantities of gold, copper and shell grave-goods in cemeteries dating to the subsequent cultural phases (e.g. the Varna culture phases at both Durankulak and at the type site, further to the south).

Hamangia practices, ceremonies and materials of living and of dying rest uneasily between two markedly different ways of being. On the one hand there are clear and deep links to traditions that can be traced into the local Early and Middle Neolithic and perhaps even to the Mesolithic (e.g. the continued presence of microliths in the flaked stone assemblages and the striking presence of animal bones — especially of deer and boar — in burials). On the other hand, the use of gold, copper and *Spondylus* in particular burials hints at patterns of activities and social belief systems that intensify in the succeeding centuries. If we think of Hamangia perceptions of identity and perceptions of social relationships among individuals, perhaps the facelessness of the figurines begins to make sense. Perhaps, these communities were run through with diverse and contesting conceptions of appropriate appearances of the human body and especially of how particular parts of the body were implicated in definitions of socially acceptable (or claimed) descriptions of reality. The codes of representation that worked via gold, copper and *Spondylus* may have followed (and promoted) a tightly constricted understanding of how particular individuals or members of a community should appear. The codes that worked through the representation of the body via figurines may well have moved in other directions, where a less-restricted understanding of human appearance and identity allowed more fluid interactions between people. Neither of these versions of reality precluded the other and it is most likely that these two must be seen in addition to others that we have yet to uncover within Hamangia society.

Notes

1. The interested reader will find such a discussion in Bailey (2005, 45–65).
2. Of course it is equally possible to argue that all material culture is active in this way (Hodder 1982); here, I am focusing on the physical and constitutive particularities of figurines that make them especially powerful as stimuli to inference.
3. Writing about the ways in which he tried to represent his live performance art into a static two-dimensional medium for a book on site specific art (i.e. Kaye 2000), the late Clifford McLucas suggested that the spectator of the cropped fragments may prefer to retain the charged erotics of incompletion by leaving things as they are — forever unfinished (McLucas n.d., in Kaye 2000, 125).
4. And it is for these and other reasons that conceits such as fragmentation and disembodiment are favourite devices within postmodern approaches to reality: the intention is to disturb and unsettle, to prevent existing, long-standing power relationships from continuing.
5. Lacan used the term 'Mirror Stage' to describe a stage in infant development occurring between the ages of approximately 6 and 18 months, when a child begins to react to its image in a mirror as a separate entity (see Lacan 1966).
6. The best representations of the Hollow Face illusion can be found on the world wide web. At the time of writing, the following websites had video clips of the illusion in action: http://www.michaelbach.de/ot/fcs_hollowface/index.htm.; http://www.grand-illusions.com/hollowface.htm.
7. For an extended discussion of this interpretation of the Neolithic in southeastern Europe, see Bailey (2000).
8. In other contemporary communities (e.g. Kodzhaderman-Gumelniţa-Karanovo VI) in which figurines were present in similar numbers, formal disposal of the dead focused on extra-mural cemeteries. The same distinction can be found there between occasional, loud, public ceremonies proposing differentiations within communities and the quieter, continuous presence of body imagery that was at the core of social cohesion.

References

Bailey, D.W., 2000. *Balkan Prehistory: Exclusion, Incorporation and Identity*. London: Routledge.
Bailey, D.W., 2005. *Prehistoric Figurines: Representation and Corporeality in the Neolithic*. London: Routledge.
Chapman, J., 2000. *Fragmentation in Archaeology: People, Places and Broken Objects in the Prehistory of South Eastern Europe*. London: Routledge.

Childe, V.G., 1936. *Man Makes Himself.* London: Watts.
Coward, R., 1982. Sexual violence and sexuality. *Feminist Review* 11, 9–22.
Freud, S., 1899. *The Interpretation of Dreams,* trans. J. Crick. Oxford: Oxford University Press.
Fuery, P., 1995. *The Theory of Absence: Subjectivity, Signification and Desire.* London: Greenwood Press.
Gregory, R., 1968. Perceptual illusions and brain models. *Proceedings of the Royal Society* 171, 279.
Gregory, R., 1977. *Eye and Brain.* 3rd edition. London: Weidenfeld & Nicolson.
Gregory, R., 1980. Perceptions as hypotheses. *Philosophical Transactions of the Royal Society B* 290, 181–97.
Gregory, R., 1997. Knowledge in perception and illusion. *Philosophical Transactions of the Royal Society of London B* 352(1), 121–8.
Gregory, R., 1998. Brainy mind. *British Medical Journal* 317, 1693–5.
Gregory, R. & J.P. Harris, 1975. Illusion–destruction by appropriate scaling. *Perception* 4, 203–20.
Gregory, R. & P. Heard, 1979. Border-locking and the café wall illusion. *Perception* 8, 365–80.
Hodder, I., 1982. *Symbols in Action.* Cambridge: Cambridge University Press.
Kaye, N., 2000. *Site-specific Art: Performance, Place and Documentation.* London: Routledge.
Kuhn, A., 1985. *The Power of the Image: Essays on Representation and Sexuality.* London: Routledge and Kegan Paul.
Lacan, J., 1966. *Écrits: a Selection,* trans. B. Fink. New York (NY): W.W. Norton.
Lacan, J., 1973. *The Four Fundamental Concepts of Psychoanalysis,* trans. A. Sheriden. New York (NY): W.W. Norton.
Mantu, C.-M., G. Dumitroaia & A. Tsaravopoulos (eds.), 1997. *Cucuteni: the Last Great Chalcolithic Civilization of Europe.* Thessaloniki: Athena.
McLucas, C., n.d. *Ten Feet and Three Quarters of an Inch of Theatre.* [Reproduced in Kaye, N., 2000. *Site-specific Art: Performance, Place and Documentation.* London: Routledge, 125–37.]
Mercer, K., 1996. Decolonization and disappointment: reading Fanon's sexual politics, in *The Fact of Blackness: Frantz Fanon and Visual Representation,* ed. A. Read. Seattle (WA): Bay Press, 114–31.
Mercer, K., 1999. Reading racial fetishism: the photographs of Robert Mapplethorpe, in *Visual Culture: the Reader,* eds. J. Evans & S. Hall. London: Sage, 435–47.
Morgan, M., 1995. *How to Interview Sexual Abuse Victims Including the Use of Anatomical Dolls.* London: Sage.
Nochlin, L., 1994. *The Body in Pieces: the Fragment as a Metaphor of Modernity.* London: Thames & Hudson.
Pultz, J., 1995. *Photography and the Body.* London: Weidenfeld & Nicholson.
Soble, A., 1986. *Pornography: Marxism, Feminism, and the Future of Sexuality.* New Haven (CT): Yale University Press.
Todorova, H., T. Dimov, Y. Boyadzhiev, K. Dimitrov & M. Avramova, 2002. Katalog der prähistorischen Gräber von Durankulak', in *Durankulak, Band II. Die Prähistorischen Gräberfelder von Durankulak, Teil 2 (Katalog),* ed. H. Todorova. Berlin & Sofia: Deutsches Archäologisches Institut, 31–125.
Tringham, R.E., 2005. Weaving house life and death into places: a blueprint for a hypermedia narrative, in *(un)settling the Neolithic,* eds. D.W. Bailey, A. Whittle & V. Cummings. Oxford: Oxbow, 98–111.
Vajsov, I., 1987. Pogrebeniya s idoli ot praistoricheskiya nekropol kraj s. Durankulak, Tolbukhinski okrug. *Dobrudzha* 4, 77–82.
Vajsov, I., 1992. Anthropomorphe Plastik aus dem prähistorischen Gräberfeld bei Durankulak. *Studia Praehistorica* 11(12), 95–113.
Vajsov, I., 2002. Die Idole aus den Gräberfeldern aus Durankulak, in *Durankulak, Band II: Die Prähistorischen Gräberfelder von Durankulak, Teil 1,Text,* ed. H. Todorova. Berlin & Sofia: Deutsches Archäologisches Institut, 257–66.

Chapter 10

Monumentality and Presence

Colin Renfrew

In this short paper I shall refer to one class of image which I have always myself found very impressive, and which I believe will have been even more impressive in those societies where it was first encountered, before the visual eclecticism of the modern era: the life-sized human figure, in three dimensions. Earlier papers have discussed the revolutionary significance of figuration: the representation of the world (and specifically the human figure) by means of images, whether in two or three dimensions. The small human figurines of the Gravettian culture must have been utterly fascinating to those who made or handled them — the first time that the human body had been modelled or figured, the first externalization of our corporeal existence. The same attraction will have held in those early farming communities in western Asia and in Mesoamerica where such figures, usually of baked clay, were produced. Usually they are all about the same size. They seem made to be held in the hand, or perhaps it is just that they are made by holding in the hand. The size may be a by-product of the manufacturing process rather than a matter of pre-formulated intentionality. It is not easy to be clear about their function or functions, but we can reasonably speculate about the manner of their reception. Such human figures will have been found intriguing and arresting. When they carry features of dress which signify difference, they will have promoted discussion and social observation — like toy soldiers in the early twentieth century. When they lack such specific attributes, they may nonetheless have promoted concentration — good to hold in the hand, like Yorick's skull in the hands of Hamlet.

Life-sized figures are very different. The labour involved in their construction or production makes them a more serious and substantial product. In many cases they are of stone, since figures of more than a metre in unbaked clay lack durability. And large figures in terracotta are difficult to fire without breaking. The Etruscans are one of the few cultures that seems to have produced life-sized figures in terracotta on a regular basis, to which the Chinese at the time of the first Qin Emperor should certainly be added.

For most of us, the experience of life-sized statues of stone, notably marble, is a common one. Most of us live in a culture which comes down to us from the Italian Renaissance which took up the conventions of sculpture in marble where the Ancient Greeks and Romans had left off. Bernini is a natural consequence or succession of Phidias. But it is different when one sees the first life-sized statues in the Greek tradition: the kouroi and the korai of the Archaic period. There one feels in the presence of something difficult, something fresh, something that is just beginning. These, however, are some two thousand years younger than the first life-sized statues of the Aegean, of the Early Cycladic period. These Early Cycladic sculptures seem an astonishing achievement, when one sets them in the perspective of the three or four millennia of miniature figurines which preceded them. As we shall see, they are about the same date as the first life-sized, three-dimensional figures of Egypt and Mesopotamia. It seems all the more remarkable, therefore, that they appear to have been anticipated by larger-than-life figuration in the Mediterranean island of Malta.

In Mesoamerica, as we shall see, the traditions are rather different. In general the human figure, in three dimensions and in isolation was not a major preoccupation. That, of course, makes the very early and very large Olmec heads all the more notable.

In the notes which follow a number of early occurrences are mentioned of life-sized or nearly life-sized sculptures. These are usually of stone, although both in Egypt and Mesopotamia, by about 2000 BC, life-sized statues were being cast in bronze. One of the surprises of recent Chinese archaeology has been the recognition of life-sized human representations in bronze from the time of the Shang Dynasty.

Perhaps the whole theme of statues which are larger than life-sized ('colossi') should be separately considered. Some of the very earliest Greek kouroi of the sixth century BC were larger-than-life, as were

Chapter 10

Figure 10.1. *The Lady of Alexandrovac, the Vinca culture, Kosovo, c. 4500 BC. Height c. 45 cm.*

some of their Egyptian precursors. As we shall see there are traditions of representation in stone in Mesoamerica that are larger than life. Large figures are known from Polynesia, notably from Easter Island. And of course the Buddhist tradition in central Asia (e.g. Bamiyan) and as far south as Sri Lanka, involves monumental representations. Gargantuan figures recur, in a more secular context, among the totalitarian regimes of the late twentieth century, with Stalin, Chairman Mao and Saddam Hussein among favourite subjects. Here, however, our interest lies primarily in early figuration and in the early emergence of monumental sculpture.

The first four cases quoted are apparently the earliest known instances of life-sized or monumental sculpture. Each of these dates back to 2500 BC or earlier. The Asian, Pacific and American cases are rather later.

Case I: Early Cycladic

I shall begin with the early sculptures of the Early Bronze Age Cycladic islands of Greece. There is a long tradition of Neolithic figurines in Greece, small in size, going back to the time of the first farmers around 6500 BC. Indeed it seems likely that the outlook which found the production of small-scale figurines of baked clay to be appropriate, came to Greece and indeed to the Balkans in general, from the earlier Neolithic of Anatolia, where such small representations are known. Typical of these would be the terracotta figure with 'coffee bean' eyes from Neolithic Nea Nikomedeia, in north Greece, from around 6500 BC.

The Neolithic tradition continues in the Aegean and in the Balkans. Indeed the terracotta figurines of the Vinča culture, especially in the Kosovo region, achieve an impressively large size, the head from Alexandrovac being *c.* 45 cm high (Fig. 10.1).

In the Aegean, however, such figures, sometimes seated, are rarely more than 20 cm in height, although there are some larger examples. Most are of terracotta, but some, already from the early neolithic, are of marble.

With the onset of the Early Bronze Age of the Cyclades, before 3000 BC, small marble figurines are quite commonly placed in the graves which are, at this time, arranged together in cemeteries. By 2500 BC the form has become standardized into the canonical 'folded arm figurine', which exists in several quite well-defined varieties.

For our purposes, however, it is the appearance at this time of a number of very large figures, conforming strictly to the 'folded arm figure' form which is notable. One famous example, 1.49 m in height, comes from Amorgos and is now in the National Museum in Athens. The other large figures, which are preserved entire, are more recent finds, obtained by collectors and museums from the illicit market, so that their authenticity may sometimes be called into question. However, two virtually life-sized heads, one from Keros in the Louvre and one from Amorgos in the National Museum in Athens (Figs. 10.2–10.4), are nineteenth-century finds, whose authenticity need not be doubted.

After about 2100 BC, marble sculpture in Greece seems to have been discontinued, apart from a few very small and very flat representations which were produced for a further couple of centuries. It was not resumed until the sixth century BC when the kouroi (young men) and korai (maidens) of Archaic Greek art made their appearance. The human form was a central focus of the art of Classical Greece, with the life-sized

122

statue its supreme expression. The conventions of representation which were established then became dominant also in the Roman world, and were accepted and elaborated during the Italian Renaissance, and hence in the Western culture which followed. The canons of the Greeks and Romans still set the norm for most representations of the human figure in the world today, challenged only by sculptors in the modernist tradition, from Brancusi onwards, who are nonetheless profoundly influenced by them.

Monumentality and presence

The effects upon the viewer of these works are very considerable, and very varied. The archaeologist (Wolters 1891) who first published the Amorgos head (Fig. 10.4) described it as 'dieser abstossend hässlich Kopf' ('this repulsively ugly head'). Today, after the impact of the early 'modern' painters and sculptors (who were themselves much influenced by 'primitive' art), we are inclined to look more favourably upon these wonderfully simple figures. Of course there is no means by which we today can reliably evaluate the effect of such works upon their contemporaries within the community concerned. But I think we can develop some ideas, and perhaps formulate some distinctions.

The white marble of these figures gives them naturally a very pale tone. There is clear evidence, moreover, that some of the detail, such as an indication of the eyes, which is otherwise notably lacking, and also of the hair, was supplied by the addition of some painted decoration. I should imagine that in a darkened room, such an image would have a very powerful presence — all the more so since those seeing it would almost certainly never have seen a life-sized representation of the human figure anywhere else.

The function of these figures is not well documented. Since the smaller ones have been found mainly in the Cycladic cemeteries, it has been suggested that they were made mainly for funerary use. However there are several indications which make this a rather unsatisfactory conclusion, and the alternative is possible: that they had a significant use-life before being buried in the grave with the deceased person. I have always imagined that one of these large figures would make a very impressive cult image within a sanctuary, but it should be admitted that there is as yet no evidence for such a use. It is difficult to doubt, however, that these sculptures will have had a very considerable impact upon the viewer, as indeed they do today.

In such life-sized figures, especially in a society that is not saturated with all manner of images, there must always, beneath the surface, be the possibility

Figure 10.2. *Large Amorgos figure, c. 2500 BC, height 1.49 m.*

that the figure is alive although motionless, and even that it might indicate vitality through speech, or even movement, or at the very least by influencing the course of events in some significant way. Such is of course the story of Pygmalion, the sculptor, as told by Ovid in *The Metamorphoses* (X, 243–97). He carved a

Figure 10.3. *Louvre head from Keros, c. 2500 BC.*

Figure 10.4. *Athens head from Amorgos, c. 2500 BC.*

statue in ivory, so beautiful and so life-like that he fell in love with it. So he petitioned the goddess Aphrodite at her great festival in Cyprus, that he should receive a wife like his ivory virgin. His wish was granted, and the statue came to life with a kiss.

Case II: western Asia

Most of the three-dimensional representations which emerge in western Asia already before the onset of farming (but at about the same time as the development of sedentism) are small, rarely more than 20 cm high. One notable exception, however, is offered by the plastered skulls of the Pre-Pottery Neolithic B culture of the Levant, around 8000 BC. The examples found by Garstang and then Kenyon at Jericho (Fig. 10.5), and others from the area, use the secure basis offered by the human skull to model the features of the face in plaster. The eyes are often denoted by cowrie shells. These images are arresting today, and must have been enormously so nine thousand years ago. But the head was isolated from the body by this treatment. From around the same period there is a group of remarkable plaster effigies from the site of 'Ain Ghazal in Jordan, but the largest is about 70 cm in height (Fig. 10.6). So that although these are much larger than the widely-found figurines at this time, they do not approach the life-sized category.

The earliest from Mesopotamia that can be so claimed is the celebrated, life-sized head in alabaster from Uruk, dating to *c.* 3500 BC (Fig. 10.7). I am not aware of equivalent works, even fragmentary ones, from the area at so early a date. But in the succeeding Early Dynastic phase of Sumerian civilization, life-size or nearly life-sized sculptures are found, often in polished black stone. There is a famous series portray-

124

Figure. 10.5. *Plastered human skull from Jericho. c. 8000 BC, life size.*

Figure 10.6. *Sculpture from Ain Ghazal, c. 8000 BC, height c. 70 cm.*

ing King Gudea of Lagash (Fig. 10.8). A few centuries later one sees the wonderful life-sized portrait head in bronze, often taken to be a representation of King Sargon of Agade (Fig. 10.9).

Remarkably enough, there does not seem to be a strong and continuous tradition in western Asia for the production of life-sized representations of the human (or divine) form, such as is indeed seen in Egypt. The palace reliefs of the Assyrians, much later in the eighth century BC, show large human figures in low relief, and the great and monumental winged lions date form the same time. But the later sculptures of Mesopotamia, like those of Hatra and of the Sassanians may be regarded as the inheritors of the Greek tradition initiated in those lands by Alexander the Great.

Case III: Egypt

Of all the cultures of the Old World, the ancient Egyptians used life-sized and monumental sculpture most consistently. Already from the early days of the Old Kingdom, from the days of the early Pyramids, sculptures of the pharaohs, often in granite, were produced. The statues of the early pharaohs Djoser (Fig. 10.10) and Kephren (Fig. 10.11), found near their pyramids, were funerary statues. They are larger than life-sized, and exceedingly impressive. At the foot of the pyramid, which was of course built to be the tomb of the pharaoh, are set several built constructions, each large enough to contain a seated statue of the pharaoh. This is one of the cases where the viewpoint of the viewer is very carefully controlled. Today one looks through a peephole at this impressive seated figure. The effect is solemn and perhaps a little unsettling, with the feeling of this calm presence whose gaze has been unwavering for some 4500 years.

From the early days of the Old Kingdom, however, there is a further series of statues, often in wood, of officials and servants of the pharaoh. The figure of the seated scribe is the most notable (Fig. 10.12),

Figure 10.7. *The Warka head.*

Figure 10.8. *Statue (now headless) of King Gudea of Lagash, c. 2300 BC.*

possessed of a vivid realism, enhanced by painted details, and with a degree of severity and simplicity which was later matched by early Roman portraiture and by Etruscan portrait sculpture.

Many of the statues of pharaohs are rather larger-than-life, but the great upsurge for the making of truly monumental statues began in the New Kingdom. The celebrated Colossi of Memnon at Luxor have never been buried, but washed by the floods of the Nile since shortly after their construction by Amenophis IV. Monumental sculpture flourished in Egypt from the early Old Kingdom around 2700 BC down to the time of the Ptolemies and then the Romans.

Interestingly, however, there is an antecedent to the Pharaonic statues of the Old Kingdom in late Predynastic Egypt, in the three colossi from the early shrine at Coptos (Kemp 2000) (Fig. 10.13). These fascinating, larger-than-life sculptures mark the beginning of monumental sculpture in Egypt. Although their precise date is open to discussion, there is consensus that they belong either to the Late Predynastic or the very beginning of the Early Dynastic period, around 3100 BC. They are identified as representing the god Min, by the traditional position of the deity whose left hand grasps the root of his erect penis. The three sculptures are flat and thin, resembling carved standing stones, with modelling achieved through carving down from the flat slab, at the front and the back, to show the legs and the left arm. The statues are now headless, but a fragmentary head remains, and the general form may be reconstructed with the aid of the numerous ivory statuettes from the Predynastic period.

Case IV: Malta

The prehistoric temples of Malta, long thought to be dependent in some sense upon the cultures of the east Mediterranean, were shown by the calibration of the radiocarbon time scale, to be considerably earlier

Figure 10.9. *Life-sized bronze portrait head, possibly of Sargon of Agade, c. 2400 BC.*

Figure 10.11. *Statue of Kephren.*

Figure 10.10. *Statue of Djoser.*

Figure 10.12. *Seated scribe, Egypt, c. 2600 BC.*

Chapter 10

Figure 10.13. *Drawing of the Ashmolean colossus from Coptos, c. 3100 BC, preserved height 1.68 m.*

Figure 10.15. *Lower part of monumental figure from the temple at Tarxien. Preserved height 1.11 m. Original height c. 2.5 m.*

Figure 10.14. *Stone figure (headless) from the temple at Hagar Qim. Height 38 c. 38 cm.*

Figure 10.16. *Soldier of the First Qin Emperor.*

than their supposed oriental predecessors. One of the features of this remarkable culture is the series of stone sculptures (Fig. 10.14), some up-to-40 cm high. At the temple of Tarxien, however, there is the lower half of what was once a larger-than-life-sized figure, of a form well known from those of smaller size (Fig. 10.15). The legs are characteristically plump, and the figure wears a skirted or kilted garment with a frill. Unfortunately the sculpture is missing above the waist. Most of the Maltese figures lack specific sexual attributes, and it is not clear whether this figure would be male or female: probably it lacked specific sexual diagnostic attributes.

What is interesting here is that the sculptors of Malta, operating apparently quite independently of those in Egypt or western Asia have produced one of the earliest monumental statues in the world. On the calibrated time scale (Renfrew 1972, 143) it should fall during the Tarxien phase and therefore somewhere before 2500 BC.

Since this figure is located prominently in the largest of the Maltese temples, at Tarxien, it is generally regarded as a cult figure. This seems likely, albeit uncertain.

Case V: China (with southeast Asia and Polynesia)

It seems a remarkable feature of the Neolithic of China that human representations, even in small form, are relatively rare, although some are found. It had been thought that the earliest life-sized representations were in the Han period (contemporary with Imperial Rome), and immediately before, during the time of the first Qin Emperor. His mausoleum near Xian was defended by a remarkable terracotta army of warriors and of horses (Fig. 10.16).

In the Yellow River valley, the heartland of Chinese civilization in the Shang and Chou periods, life-sized sculptures are not found. The recent find at Sanxingdui, further south in Sezchuan, of a series of very large, indeed monumental effigies in bronze is therefore all the more remarkable (Fig. 10.17). These figures are undoubtedly anthropomorphic. Yet they deviate much further from an anatomically valid rendition of the human body, even in schematic form, than any of the figures discussed earlier.

Large sculptures are widely found in south and southeast Asia, but the sculptural tradition, at least in India, seems to derive from the Greek sculptural style, imported to India at the time of Alexander. The remarkable sculptures of the Ghandara region of north Pakistan presumably stand at the head of the great sculptural traditions which develop later, for the representation of the Buddha and his disciple, and indeed for the representation of the deities of the Hindu pantheon.

Figure 10.17. *Bronze figure from Sanxingdui, Sezchuan, China, c. 1200 BC. Height 2.62 m.*

Chapter 10

Figure 10.18. *Ahu Akivi, Easter Island.*

Figure 10.19. *Figure at the quarry of Ranu Raraku, Easter Island.*

The tradition in the Pacific, which culminates in the great sculptures on the image ahu of Easter Island (Figs. 10.1 & 10.19) do, however, represent an autonomous line of development, which can be related with other smaller figuration elsewhere in Polynesia.

Case VI. New World traditions (including Mesoamerica)

There are no doubt many trajectories for the development of figuration in the Americas. As noted earlier, small figurines, usually of terracotta are a noted feature of the Early Formative period. Life-sized sculpture is uncommon, however, although the Huastec culture on the Gulf Coast can boast a series of impressive sculptures of stone. This makes all the more remarkable the colossal stone heads of the Olmec (Fig. 10.20).

Once again, it is the early appearance of large-scale human representation which interests us here. Later images among the Aztec, for instance at the Templo Major at Mexico City, or indeed rather earlier among the Toltecs, including the Chacmool figures beloved of Henry Moore (Fig. 10.21) and the 'Atlantides' of Tula (Fig. 10.22), are not here the primary focus.

Consideration

Several lines of development may be recognized in the foregoing, each leading to the creation of impressive life-sized images. The production of figures very much larger-than-life has a rather different effect upon the viewer, and it is in presence of the life-sized ones, I think, that the illusion of a living presence is most easily created.

The functions are no doubt very different for each case in turn, although in several instances, especially

130

Monumentality and Presence

Figure 10.20. *Olmec head from San Lorenzo Tenochtitlan, Veracruz, Mexico. Middle Formative period. Height 2.60 m.*

Figure 10.21. *Chacmool figure, Chichen Itza.*

Figure 10.22. *The 'Atlantides' of Tula.*

for the very large figures, it is often possible to think in terms of the exercise, aggrandizement and reinforcement of status, and of the 'iconography of power', to use Joyce Marcus's telling phrase. This applies to a number of the portrait heads seen on Maya stelae, often representations of the ruler of the local city. The same theme is certainly relevant for the 'royal' statues of western Asia (Gudea, Sargon etc.) and indeed for the statues of the pharaohs. Often, however, these royal sculptures had a funerary use. Indeed portraiture at life size often seems to be used within a funerary context, for instance among the Etruscans.

It may well be the case that the gigantic heads of the Olmec are portraits of rulers. And the great platforms of Easter Island with their rows of colossal statues, the image ahu, are generally regarded as focal burial places and ceremonial centres of chiefdom societies. But while the great figures may well represent deceased ancestors, as been suggested, they are scarcely portraits in the sense of representing specific features. The line of great figures at Ahu Akivi or Ahu Tahai speaks rather of redundancy and repetition.

Others on our list may well be the representations of divine figures. The colossi of Min of Coptos are very plausibly set at the head of a series of later sculptures

of that deity of Ancient Egypt. The same may apply for the large figures from Tarxien in Malta, and possibly also for the Sanxingdui figures of China.

The use of repeated very large figures in an architectural context is seen with the 'Atlantides' of the Toltec period at Tula and with related figurations at Chichen Itza in Yucatan at about the same period. And of course that terminology is taken from the Greek hero, Atlas, whose role is to support the world, a role much like that of the Caryatids, seen notably on the Acropolis of Athens.

The use of wood has been mentioned here only once (for the figures of Old Kingdom Egypt), but that must be a feature at least partly of preservation. Waterlogged sites also produce evidence for the use of timbers in anthropic representation. Indeed discussion of areas of special preservation can come up with a number of surprises. For instance wooden posts were used to produce roughly life-sized anthropomorphic forms in the Goumouguo culture in the Taklamakan desert of Xinjiang *c.* 2000 BC. And just a few hundred kilometres to the north and 1500 years later, in the frozen barrow of Pazyryk, splendid examples of tattooing were found on the frozen and buried bodies. This is body decoration rather than sculpture and was obviously undertaken during the life of the individual. But it could fall within the general category of 'body modification', where the plastered skulls of Jericho could also be placed.

A very broad category, but one scarcely touched upon in the preceding, is that of the standing stone, and the anthropic stela, which is often in effect simply a standing stone with a few modifications. These are however distinctly relevant to my theme, since they are often at life-size scale or slightly larger. The whole general theme of aniconic representations (if that is not too contradictory a term) is an interesting one. One is thinking here of upright stones or pillars, without any sculptural modification to give them human form, and without superficial decoration. In Europe, during the late Neolithic, there are some stelae in France which indicate breasts and sometimes eyes and a nose, although otherwise the stone is flat on each side (see Scarre this volume). But these superficial features convert it rapidly and convincingly into the human form. The same is true for a whole series of 'stelae' seen in Italy, and (perhaps in an independent series) in the Eurasian steppelands during the Bronze Age. There, facial features are sometimes indicated, and often there is a single dagger at the waist, which is generally taken to indicate that the human in question is male.

An earlier series of stone in Europe goes back to the earlier Neolithic and to the megalithic tradition — the 'megaliths' being in the first instance stone-built collective tombs. But associated with these, and with the henge monuments which succeed them, there are sometimes single standing stones. And in the later Neolithic and on into the Bronze Age, circles of standing stones are found which follow on, in a sense, from the circles of stones found accompanying some henge monuments, such as Avebury or the Ring of Brodgar. Although there is nothing to compel us to see these as anthropomorphic, they have traditionally often been so viewed. Indeed folk names for such monuments, such as 'Long Meg and her Daughters', sometimes evoke both human individuals, and the circular dances which such monuments may have encouraged.

The standing stone may indicate one approach towards real anthropomorphic figuration, for instance the colossi of Min of Coptos. These could be seen as an interesting mix of the very large tabular form (i.e. with the two flat faces of a stela) modified slightly to have some of the attributes of the small ivory figurines of the Predynastic period. On the other hand the Cycladic and Maltese figures have much more plastic qualities and can be seen rather as large-scale versions of the small figurines of the time, of baked clay as well as stone, which themselves have a long ancestry going back to the figurines of the early neolithic. The seated statues of the Early Dynastic period, both in Egypt and in Mesopotamia, may have a different genesis, and their form may in part be governed by the constraints of carving a block of very hard stone (with granite or diorite often the chosen material).

Envoi

I leave this short paper with the strong feeling that there is, somehow, more to be said. The impact of some of the life-sized figures, although inevitably experienced subjectively, seems to me so strong that more effective interpretive use might be made of it.

There are also intersecting themes which have not been explored here. One of great interest is certainly portraiture, which is often at its most effective when undertaken at or close to life-sized. It seems clear that some Maya heads must be close portraits, just as some Peruvian ceramics (generally at slightly less than life-sized) could be so considered. There is no doubt that some of the Egyptian sculptures are real portraits. And of course with the Greeks and Romans the tradition of portrait busts is initiated, which re-emerges in the Renaissance and survives today.

If there are valid cross-cultural generalizations to be made, they have certainly not been formulated here. Meaning has to be interpreted within its own contextual framework. Yet we may already discern some parallels. And certainly we come to see more

clearly how very exceptional are some outcomes — like the great stone heads of the Olmec (although even these could be compared with the very large heads at the Sanctuary of Nemrut Dag in Turkey). What seems to me indubitable is that each of the five early cases discussed here, all fully developed by 2500 BC, represents a formidable and impressive innovation.

References

Cilia, D. (ed.), 2004. *Malta Before History: the World's Oldest Free-Standing Stone Architecture*. Sliema: Miranda Publishers.

Evans, J.D., 1971. *The Prehistoric Antiquities of the Maltese Islands*. London: Athone Press.

Kemp, B., 2000. The Colossi from the early shrine at Coptos in Egypt. *Cambridge Archaeological Journal* 10(2), 211–42.

Marcus, J., 1974. The iconography of power among the Classic Maya. *World Archaeology* 6, 83–94.

Rawson, J., 1996. *Mysteries of Ancient China: New Discoveries from the Early Dynasties*. London: British Museum Press.

Renfrew, C., 1972. Malta and the calibrated radiocarbon chronology, *Antiquity* 46, 141–4.

Renfrew, C., 1991. *The Cycladic Spirit*. New York (NY) & London: Harry Abrams & Thames & Hudson.

Renfrew, C., 2003. *Figuring It Out*. London: Thames & Hudson.

Wolters, P., 1891. Marmorkopf aus Amorgos. *Athenische Mitteilungen* 16, 46–58.

Zervos, C., 1957. *L'art des Cyclades*. Athens: Editions Cahiers d'Art.

10.2 National Museum, Athens. Photo John Bigelow Taylor, NYC. 10.3 Musée de Louvre, Paris. Photo Christian Zervos. 10.4 National Museum, Athens. Photo John Bigelow Taylor, NYC. 10.6 Photo by Kathy Tubb. 10.7 Iraq Museum, Baghdad. 10.8 Musée du Louvre, Département des Antiquités Orientales, Paris AO 2. 10.9 Directorate General of Antiquities, Baghdad, Iraq. 10.10–10.12 Egyptian Museum, Cairo. 10.13 From Kemp 2000, fig. 1, 212. 10.14–10.15 Malta National Museum of Archaeology. 10.16 Museum of Qin Terracotta Warriors and Horses, China. Photo Colin Renfrew. 10.17 Sanxingdui Museum, Guanghan. 10.18–10.22 Photos Colin Renfrew.

Section C

Figurines, Social Context and Process

Chapter 11

Refiguring the Corpus at Çatalhöyük

Lynn Meskell

In this paper I have several aims and my discussion oscillates between a refiguring of the 1960s project materials at Çatalhöyük and the finds from the new excavations since the early 1990s. First, I want to present a more comprehensive and representative range of figurines from the site, balancing out the sensationalized finds of the so-called 'Mother Goddess' images. This includes forefronting the abbreviated human forms in clay, the ubiquitous animal figurines and the prominence of clay bucrania and horns produced possibly as metonyms. I then want to give a sense of the findings from preliminary spatial analysis conducted in the 2005 season, thus providing a framework for the context and circulation of figurine materials. This leads to a consideration of the constitution of figurine worlds at Çatalhöyük, to challenge the very special notion of the category of figurine, and to decentre it as art, perhaps even as religion in the conventional sense — or at least differentiate between types of figurines or between the image of the figurine and those in wall paintings and so on. Central to these challenges are the possibilities for revising assessments of the figurines by using various media such as video and experimental reconstruction (see Meskell & Nakamura 2005). These provide ways of viewing the materials that potentially offer new windows onto ancient constructions.

By developing these aims, the larger existential issues of self-reflection, of negotiating self and sexuality, of relations between human and animal worlds, might thus come into sharper analytical focus. Advocating evidence for 'spirituality' in a tightly focused religious sense may prove difficult, whereas an exploration of one's place in the world, a network of related sensuous experiences between other people, species and places may be more readily deduced from the materials. I would like to move away from the sterile attempts to deduce function and meaning from a visual reading — the, 'Is it a deity or not?' type of equation. Instead I want to work around the objects, weaving together patterns of figurine making, technology, use, mobility and discard, coupled with the traversing of categories from figures to plastered features to wall paintings. In this way I hope to build up more of a life-world for the Neolithic community, taking into account the inherent visuality and materiality of a figured corpus. It is not enough to say that these figurines are *representations* or visual proxies, they are *things* in themselves with their own spheres of interaction. By employing the notion of representation we infer that figurines stand in for something real and are a reflection of that reality, of someone or something. And yet these objects are not necessarily referents for something else tangible, but could be experienced as real and tangible things in themselves (Meskell 2004; 2005). They may not simply be emblematic or allegorical devices as the term figuration also implies. And while this is not tantamount to arguing for figurines as necessarily agentic beings, such possibilities should not be dismissed through an elision of language.

Given our knowledge of aesthetic spheres at Çatalhöyük, this prompts us to ask whether there was something special about settling down in tightly packed communities in the Neolithic that made its inhabitants more attentive to the contours of personhood and sexual identity; were they playing with classifications and categories that we might find unfamiliar? But first of all we have to balance the scales in terms of readily identifiable genders, as the numbers of male, androgynous, phallic and ambiguously sexed figures need to be recalculated. This is a task we have taken seriously over our first two seasons and we are close to achieving a fuller picture of the entire range of material. A notion of *becoming* at this site might then have encompassed experimental imagery that incorporates various sexual symbolism or combines innovative ways of viewing attributes depending on viewpoint, movement and circulation (Fig. 11.1).

At the outset I want to make clear that this is very new work conducted by Carolyn Nakamura and myself over two short seasons in 2004 and 2005. During

Chapter 11

Figure 11.1. *Phallus from Çatalhöyük excavations 1996 (1505.X1).*

that time we had to devise and construct an entirely new data base system for recording and analysing the materials from the 1960s, from our predecessor on the project during the 1990s and then from the new seasons. This has been a mammoth task in itself, representing recording over 1500 clay and stone objects (not all of which can be readily classified as figurines). The data base design process did not simply involve archiving the collections, but engaged a critical rethinking of analytical and interpretive categories orientated towards a more integrative approach to figurine studies. Refocusing figurine research towards such areas of overlap prompts a productive rethinking of our taxonomic framework in terms of processes of resource acquisition, technological and gendered production and use, rather than in terms of the end product. Basically, I want to reconsider the whole notion of the figurine-as-*thing* to one of the figurine-as-*process*.

Refiguring the archive

New excavations at Çatalhöyük under the directorship of Ian Hodder began in 1993 and have continued to the present, and while Mellaart's fieldwork might well be termed 'extensive' the current project would best be described as 'intensive' (Hodder 1996; 2000; 2005; 2006a). The site comprises a series of 'superimposed buildings (rather than rebuilds or alterations of existing buildings)' (Farid 2007, 42), and as a result of this particular building technique, has an accumulation of some 21 m of deposit in approximately 18 layers

of occupation (Hodder 2006b, 17). These layers were divided up and numbered by Mellaart in a system that remains in use by the current project. There are 15 superimposed building levels from 0 to XIII, the latter being the earliest. However, Level VI has two levels, VI-A and VI-B respectively. Çatalhöyük is currently dated from 7400–6200 cal. BC (dates now 7400–6000 cal. BC) and is considered late in the central Anatolian sequence (Cessford *et al.* 2006; Hodder 2006b, 15).

There are many reasons why Çatalhöyük remains distinctive, but one major factor is that the

> narrative character of the wall paintings remains unparalleled in Anatolia and the Near East at this date. And the sheer amount of the art — its concentration in so many houses in one site — remains particular. Indeed, the main mystery of Çatalhöyük remains the question of why all this art and symbolism, this flowering of imagery, should occur in this place at this time (Hodder 2006b, 16).

In this paper I focus on one important corpus within what Hodder and others (Last 1998) generally term 'art' — the figurines — and where appropriate link these objects to other visual forms whether wall paintings or plastered features (see also Nakamura & Meskell 2004; 2006; Meskell & Nakamura 2005).

At a fundamental level we need some dialogue between the two periods of excavation in terms of material culture — even if not the stated contexts, given the levels of specificity in recording during the 1960s (Todd 1976). The scale and speed of the early work uncovered a dazzling array of materials, yet lacked the benefit of Hodder's careful, contextual methodologies. This is evidenced very clearly with the figurine corpus. If one were to take the Mellaart finds at face value, specifically the published pieces, and thus ignore the wide variation in figurine types, then one might posit that two rather different sites had been excavated (see Mellaart 1962; 1964; 1965; 1966; 1967; 1975). Mellaart would have uncovered a large number of impressive stone and clay pieces, whereas conversely our project would have found more mundane clay examples of quadrupeds, bucrania (miniature clay models that resemble the plastered real remains in houses at Çatalhöyük), abbreviated human forms and so on. Though we have found impressive examples, the mundane dominates numerically. One way to challenge this picture is to re-excavate Mellaart, to literally work in his areas and through his spoil heaps. A training and educational excavation (TEMPER), under the aegis of the wider project, carried out the latter and we now have a very good idea of what Mellaart overlooked or even discarded. Our findings indicate that he missed significant numbers of figurines (anthropomorphic and zoomorphic) along with fragments of each; non-

Figure 11.2. *Female marble figurine from a mixed fill deposit, Çatalhöyük (10475.X2.)*

Figure 11.3. *Zoomorphic clay figurines from Mellaart's Level VI, Çatalhöyük: a) 318.1; b) 172.1; c) 305.1; d) 315.1; e) 331.1; f) 321.1).*

diagnostic pieces, shaped clay pieces and scrap that is probably ceramic debitage.

Of those clay examples that he did record that were of a less-than-spectacular nature (over 80 examples) most were very obvious quadrupeds with features such as heads and horns intact. He also collected conspicuous abbreviated human forms, though they are often less than 5 cm in height they are obvious to the eye. We do not have a range of horns or bucrania from Mellaart's sample and he did not pick up undiagnostic fragments of figurines, as we do. In sum, this skews significantly the numbers and types of figurines for which the early excavation is known with a bias in favour of the evocative carved stone examples or complete clay forms and an under-representation of everyday types.

In excavating in the Mellaart area (now called South Area) we have similarly uncovered the figurine forms we find in such rich abundance in the newly chosen excavation areas from the 1990s onwards. For example, we do find small clay abbreviated human figures, ceramic cattle horns and bucrania, geometric pieces and many indeterminate forms. If we take these *in toto*, those from the spoil and from the old excavations in Mellaart's area, we have some 355 figurines: 158 are anthropomorphic and 154 zoomorphic, which includes 61 abbreviated human forms and 23 horns. This starts to balance out the preponderance of formal stone pieces with the more ubiquitous clay varieties.

The new project is also uncovering more of the complex stone and clay examples for which the early excavation was famous. In 2004, in a mixed fill deposit, excavators retrieved a marble figurine that is reminiscent of the types that Mellaart publicized. The female figure (10475.X2: Fig. 11.2) holds its arms up to its breasts and incised lines indicate the breast divide, pubic triangle/stomach, and divided legs on the front; similarly incised marks delineate arms, divided legs, and a horizontal detail across the upper legs on the back. The head and face appear to have been worked, but possibly modified or defaced, suggesting either that no facial details were executed or that they were removed. There is a suggestion of hair or some form of detail around the head. Even despite the damage to the base of the figurine, it is unlikely that it ever had proportioned feet or that it was ever freestanding. The dimensions are 7.5 cm in height, 4.9 cm in width and 3.5 cm thick. The base material and detail of this example in terms of workmanship has tended to overshadow the clay examples in terms of scholarly emphasis. Other examples to be discussed later include two marble pieces and a clay example that combines skeletal elements (see below).

While the now famous examples in stone may seem compelling, they are greatly outweighed in number by their counterparts in clay and plaster. So diverging from a Western materialist perspective, those objects that are made of stone may not neces-

sarily have more symbolic weight *in toto* than the myriad clay forms that were constantly and repetitively made. What it says is that we perhaps need to turn this material hierarchy on its head and focus more on the density and ubiquity of these clay renderings: expedient, consistent, mundane and deeply ingrained in everyday practice. What perhaps mattered most on a daily level was the regular making of zoomorphic or anthropomorphic figurines in the available clays and plasters that were to be found locally and used in ceramics, wall preparation, and so on. We do not have an established industry of bone figurines (though personal adornment may also be linked to the category of figurine, see below). Plaster is an interesting material for figurines, one that again might speak to the everyday nature of manufacture. Plaster was used throughout all the domestic spaces and so repeatedly, probably on a seasonal basis, that the residents seem to be taking the plaster, mixing it with portions of marl, and shaping everything from phallic forms to abbreviated figurines to horns (Fig. 11.3).

Becoming bodies

The new figurine project at Çatalhöyük has also taken a new direction in terms of embodied imagery and the concomitant rethinking of gender and sexuality. While this represents new work, it is also in a preliminary stage. We might approach the archive through various modes of viewing, leading to other ways of interpreting, and different angles and viewpoints (literally and metaphorically). On a primary level what seems to have been most salient at Çatalhöyük was the presentation of personhood, not a specifically gendered person with discrete sexual markers, but an abridged version of the human form, reduced to an elongated torso or trunk seated on two stubby legs. The trunk is often fashioned into a head, nose or folded hair-like element. Despite their simplicity they are indicative of the human form, and there is some variability in detail to break the general uniformity of base shape. Many are bent forward and, as they have disproportionately long pillar forms, they begin to look rather phallic. This pillar can either end in a conical base or a divided pair of stumpy legs: the latter type also begins to resemble male genitalia when viewed from various angles. These are generally made in much finer, cleaner fabrics such as marl, than the zoomorphic figures. As a set they are unevenly fired and were probably 'passively fired' (Nurçan Yalman pers. comm.) near ovens or hearths during routine activity (Fig. 11.4).

Other figurine makers took this trunk or pillar-like style to another level, the phallic form of the cylindrical body and elongated neck may have been

Figure 11.4. *Phallic pillar-like figurines from Çatalhöyük: a) 324.1; b) 303; c) 8589X; d) 347.1; e) 162.1; f) 312.1; g) 343.1 (a, b, d–f from Mellaart's level VI; c from 2002 BACH excavations.)*

evocations of sexual ambiguity, the blurring of sexual features or sexual complementarity combining differently gendered bodies. We have seen similar but perhaps more striking examples from prehistoric Mediterranean (Knapp & Meskell 1997) and Near Eastern contexts (see Kuijt this volume). We also see similarities in the worked bone assemblages, specifically items of personal adornment (Russell 2005, 442–3), which show phallic forms, specifically the pillar shape ending in a knob or groove. Other examples have a pillar offset by two spheres, one either side, creating an image of male genitalia. In many of these instances we have discovered that using video to record the figurines as they are moved and handled provides a more embodied set of perspectives and we can begin to witness some of the visual punning that we think underlies many of the fabrications.

Many researchers at the site are beginning to ask why masculinity is so strongly demarcated across a

range of imagery (Hodder 2006b). For example, in wall paintings of people and animals, maleness is very evident. Animals being chased, teased or hunted seem to be usually male, with their sexual organs erect. As a consequence of sexual dimorphism, it is true that the male of each species is generally more obvious and with more highly elaborated features; one need only think of the horns of bulls, goats, antelope, the lion's mane, for example. Also their coats are often more patterned and they are almost always larger in size. Maleness could also represent aggression, the thrill of the kill, animals that are more difficult to bring down, with the act of doing so representing an act of bravery, skill and prowess. Such a feat may fortify the reputation of an individual, perhaps even indicate manhood or maturity, and such animals (or parts thereof) may have been retrieved and kept as pride and proof. This is not to say, however, that women were not also involved in the hunt, nor children for that matter — all sorts of human forms are shown in the famous murals. Perhaps such image making represents a wide cross-section of the community and maybe all needed to be involved at certain hunting events.

Our future research seeks to question whether the Neolithic was a sexual revolution, a period of 'self' exploration at a level not experienced before. Is the coming together of people in clustered communities a way of seeing the self differently, exploring the contours of a sexed self, of understanding self-fashioning in less than binary terms? Many of the contributions in this volume are also grappling with the issue of ambiguity and the blending of sexed elements. In this way too figurines could be part of a *process* rather than a finished and contained product. They might then be experimental media where potentials for manipulation (Bailey 2005) are executable in malleable materials that are not always possible in fleshed reality. What we would like to focus on in coming seasons is to explore the nature of personhood as a visual category. How did the visual presentation of the self mesh or diverge from other spheres of selfhood, like that presented in the household, through the processes of burial and re-circulation, and across a range of experiential settings?

Questions of context

As a general premise at Çatalhöyük the figurines and shaped clay objects as a collective are found in secondary contexts, they are primarily in room fill, fill between walls, middens, burial fill and rubbish areas. Occasionally they have been found on or near floors. In the new excavations we do not see the patterns that Mellaart's early work would suggest; that figurines (specifically anthropomorphic) are found in special or cultic area, associated with features such as platforms, shrines, grain bins and so on. For example, Mellaart (1964) described finding a 'goddess figurine' painted red in an associated shrine, we too have found red paint on clay figurines but none of those come from such grandiose contexts since the whole notion of what constituted a 'shrine' has been cogently deconstructed (Hodder 2006b). Mellaart often claimed that figurines (goddess figurines, specifically) were found only in shrines, whereas rigorous excavation over the past decade has shown them to be consistently in rubbish and fill deposits, alongside vast quantities of animal bone, plant remains, ground and chipped stone and other small finds. Interestingly, when we do excavate rooms with plastered bucrania and benches with protruding horns, as was done in the 2005 season, there were no figurines to be found, human or animal. This space would definitely have been categorized as a shrine area by Mellaart. One of the rare instances where we may have evidence of purposeful deposition comes from the 2004 season, space 227 in building 47, where a carved stone figurine seems to be placed on or close to the floor perhaps in association with a number of animal bones and worked bone, obsidian fragments, and worked stone. The excavator (Bogdan 2004) believes that this was not consistent with room fill but an assemblage purposefully left there after which the room was backfilled. This may be ultimately difficult to substantiate (Hodder pers. comm.); however, the finds uncovered may relate to the closing of the house or an associated event.

Figurines commonly evoke notions of a 'Mother Goddess', the female domestic sphere, and ritual or cultic activities, but such ideas alone do not account for the striking diversity of the Çatalhöyük assemblage which features objects spanning a spectrum of highly elaborated to abbreviated forms, human and animal depictions, and range from careful to quick disposal/depositional contexts. Although some of the objects likely derive from ritual activities, the majority is associated with contexts suggestive of more everyday practices. Furthermore, a strict division between the 'everyday' and the 'magical' or 'ritual' might not have been operative in the past; allowing for this possibility marks another example of our concerted attempt to challenge taxonomic structures or binaries in all levels of interpretation (Nakamura & Meskell 2004). Our recording and analysis attempts to unpack descriptive categories as much as possible and gives equal footing to a diversity of interpretive possibilities.

If we think of a range of uses or rationales for making figurines we arrive at the usual suite of suggestions: amulets, talismans, narrative devices, images of individuals or ancestors, tokens, training devices,

deities, gaming pieces, objects of magic or manipulation, initiation, contracts in clay, and so on (Talalay 1993). Does this really help us at Çatalhöyük? All of these possibilities have degrees of merit, yet since we lack the primary contexts, they can only be suggestive. However, we can potentially analyse across various media to try and ascertain a symbolic life-world — it is important to note that figurines did not exist in a vacuum for the people of the Neolithic, they must have worked in conjunction with other forms such as wall paintings and plastered features. They must have had symbolic resonances across these classes, perhaps even working cross-platform, literally.

This enables us to say certain things. For example, wall paintings of an anthropomorphic nature do not generally resemble those images from the figurine corpus. The wall paintings generally show humans in active positions with their arms and legs clearly delineated. In the plastered wall features we typically have splayed individuals, arms upraised with all the limbs clearly delineated, and with no sexual features. This is at variance with the many anthropomorphic figurines in their abbreviated and sometimes sexed forms. In addition, quantitatively there are more males shown in wall paintings than female, and many figures show no sex characteristics at all. The human forms in painting are much more realistic, and more detailed. This is at variance with the anthropomorphic figurine corpus.

There are a few examples that do resemble the larger, more detailed pieces from the figurine corpus. A white female with upraised arms from Level IV looks remarkably like a corpulent figurine type, with small, undistinguished feet (Mellaart 1962, pl. XIII). Another of the figures known as 'leopard dancer' (although we would not use such terms), has a painted area around his head comprised of dots. Interestingly there are several figurines of various types and shapes that have holes around or on the head indicating hair or a specific hairstyle or decoration. Looking at ethnographic groups is a useful reminder that we often forget about paint for the face and hair, coupled with other decorative elements (Fig. 11.5).

Moreover, if we look at the wall paintings from Mellaart's excavations, they feature both humans and animals, some of which may assume mythical proportions. Leopards clearly have captured the imagination in two dimensions (Hodder 2006b) but have little resonance in the ceramic figurine assemblage. However, the famous red bull is shown (undoubtedly dead) in a wall painting surrounded by humans, and the image of cattle and of metonymic bucrania is ubiquitous in the clay figurine assemblage as well as plastered house features. Yet there is only one little known wall painting that shows animals in a form we would recognize from the figurine assemblage.

Mellaart claimed correctly that animal figurines could be pierced or maimed after modelling, but was largely incorrect in his assumption that they were placed in pits after use. These animals look rather different again to the images in wall paintings. The majority of the figurines represent cattle and domesticates, and there is a notable absence of the exotic fauna evidenced in the wall plastering of leopards and the painting of animals such as stags and birds. Moreover, we have several examples of pierced anthropomorphic forms, as Nakamura has noted, which calls into question the notion that this action is simply about hunting magic. Previous interpretations somewhat narrowly posit that stab marks signify the killing of animals (and by association, people); if that was the case then why are so few individual animals 'ritually stabbed' within the corpus?

We do have tangible evidence that skeletal elements from boars, vultures, goats and bulls were all embedded into walls with plaster coatings and mouldings. These probably have a stronger connection to the types of zoomorphic figurines we find and I will have more to say about this below. One possible interpretation is that interactions with ancestors or sacred beings were perhaps mediated through the animals, as is the case with cattle for the Zulus today. In this case it is not that the specific animals are in any direct way the ancestors in question, but they are the medium through which they can be contacted — an embodiment of sorts. The plastered animal parts at Çatalhöyük may also relate to real or mythical events and encounters outside the confines of the settlement, within the wider landscape, with powerful animals and equally powerful human hunters. Interestingly Douglas Baird (2003) has found examples of plaster objects containing animal bones at his site at Pinarbaşı in a seventh-millennium context. Basically we should envisage other interpretations that move beyond simplistic notions of goddess and bull worship.

Off the pedestal

A central aim is to try and rethink the categories that Mellaart so successfully instantiated, to try and refigure the corpus: to take them out of the static position of religious statues, destined to spend their lifetimes sitting it out upon altars and pedestals. This interpretation was tacitly influenced by Mediterranean and Egyptian traditions of cultic statues, and Mellaart's vision of Çatalhöyük was heavily influenced by his knowledge of these Bronze Age civilizations (Meskell 1998). In fact, Mellaart used these compara-

tive data sets as analogous ethnohistory, his own type of ethnography through the vastly richer and more recent aesthetic and textual records. While we are not interested in identifying or using modern Turkish ethnographic traditions to understand the Neolithic, it is instructive to look at other cultural repertoires in order to, in a sense, defamiliarize and divorce ourselves from Mellaart's vision.

Today we also tend to present figurines in the same static and unmoving genres, diligently producing technical drawings that place figurines in their sitting, upright postures. By showing conventionalized views of these objects we may risk failing to acknowledge the possibilities that figurines were handled, moved and thus viewed in a variety of positions. Working with John Swogger we are currently attempting to re-imagine some of these clay figurines as being carried on the person, possibly within skin or textile bags, probably with a range of other portable items (organic and inorganic). There is evidence of wear on the small anthropomorphic and zoomorphic examples in clay. It is more difficult to determine wear on stone examples as the process of manufacture also includes various forms of abrasion. It is difficult not to reflect on Zuni fetishes (Fane *et al.* 1991) and the portability of those material beings, their need for food and sustenance and so on. Like the Zuni example, it is possible that some figurines may have been worn about the body by means of string or twine, attached in some way to other things. It should also be noted that the abbreviated anthropomorphic figures sit on bases for the most part, and some of the stone examples do. However, notable marble examples have no feet, never sit on stools or chairs nor do they have flat backs suggesting that they may have been positioned in reclining postures or circulated through the site and thus regularly handled. Here again the use of hand-held video provides another instructive layer of viewing as it challenges the static renderings we are familiar with and brings the figurines to life. It also allows us to recreate a process of handling, turning and circulating figurines, as was the case in antiquity.

There is the danger that we tacitly imagine that the pieces retrieved, whether in clay or stone, *are* as they *were* originally — devoid of not only paint, but also the possibilities for beading, clothing, the addition of cloth, skin, twine, grasses and so on. All of these materials occur frequently at the site (and are readily identified in other ethnographic contexts). A closer examination of the carving, abrasion, and surface patterning may reveal differences in wear around areas such as grooved 'waists' on some of the stone figures analysed in 2004 and 2005 (Fig. 11.6). The 2005 season also revealed tools, both obsidian and ground

Figure 11.5. *Reconstruction of a figurine decorated with feathers, grasses and beads. (Drawing: John Swogger.)*

stone, which may have been used for carving and working the stone figurines at the site (Karen Wright pers. comm.).

In the 4040 area during the 2005 excavation a further marble figurine (12102.X1) was excavated from another midden context. Similar to the example found in 2004, this piece combined a solid base with, most likely, a phallic neck. But in this recent case the long neck has been carefully cut off, probably with obsidian and other stone tools, perhaps even polished after removal (Fig. 11.6). Another example of a removed limestone head occurs with a figurine now in Ankara (79-8-65). It may be a speculative connection at this juncture, but the removal of heads also occurs in human burials, and the circulation of heads after death has been repeatedly identified at Çatalhöyük. Also we have several clay figurines that have dowel holes for what appear to be detachable heads as well as the small spherical heads which may have been used to complete some of the composites (Fig. 11.7). What might the transfer of heads tell us

Figure 11.6. *Stone figurine from midden at Çatalhöyük with grooved 'waist', from 2005. (12102.X1.)*

Figure 11.7. *Clay head with dowel hole, found in fill during the 1996 excavation (1056.H1.)*

to explore narrative and experience — the exploits of individuals, encounters with animals, mythic or historic. The ability of figurines to be malleable, to change identities through the transfer of heads, presents an interesting set of possibilities and leads us away from static forms into the notion of figurine as process.

When we experimented with re-creating these forms we all encountered various levels of difficulty. First of all, despite their inherent simplicity the figurines (zoomorphic and anthropomorphic) are of a particular cultural style and their forms were something that the inhabitants at Çatalhöyük could achieve through practice — however they remained very foreign to us even though we were constantly handling and examining them. At the outset I imagined that they would only take about five or six moves to recreate, whereas even the most experienced modeller among us took some 15 moves to make an abbreviated form initially, although quickly got it pared down to 6 moves. Of course there are differences between working with clay and working in oven-bake clay modelling paste. Another issue was size. Each person struggled to model the correct size for the copy, with everyone exceeding the size of the original. While we are witnessing certain routinized behaviours and gestural habits that appear to be all very generic — generic depictions of generic humans — within that general schema there is variation, and no two pieces are the same.

Figurines as process at Çatalhöyük

The notion of figurine as process can refer to almost every stage in the life of a figurine. From its inception the gathering of materials for making represents a social process of procurement, whether sourcing local stone, clays or combining the plaster from regular wall-plastering activities with marl to fashion figures of remarkably fine quality and light appearance. In all of these activities we could imagine a collective sphere where various individuals were present and where collaboration took place. In the case of ceramic examples, following on from retrieval were stages of preparation and cleaning of clays. Many but certainly not all of our examples are made from relatively clean clay with little chaff and small-grained inclusions. In the case of the stone examples it seems that most of the marble and calcite came from within a 15–20 km radius of the site. As stated above, the lithic and ground stone assemblages also include the tools with which figurines may have been carved, suggesting also that they were completed on site. The project's ground stone specialist, Karen Wright, believes she

about the social construction of belief, memory and identity? It is possible that the role of myth and storytelling may have been central and 'figurine worlds' may have proffered a rich vehicle via which

has identified an area of Mellaart's old excavation that functioned as a stone figurine workshop. While it is possible that figurine manufacture may have been a secretive skill, shared by a few, our evidence suggests that the making of such pieces occurred in or around houses, in a domestic context using materials readily at hand. The next stage in the process of making could be both formal, as in the case of carved stone, or more informal and everyday in the case of shaping anthropomorphic and zoomorphic images. In the case of the latter, the routinized making and individual variation suggest many people were fabricating figurines in and around the settlement much of the time. They would have had easy access to the materials, and given the short space of time it takes to shape abbreviated forms, people could have made them at regular intervals.

Albeit difficult to reconstruct, we might posit that everyday social lives may have incorporated much image making, from the repeated layers of wall painting, embedding and plastering parts of animals, to decorating with stamp seals on skin or fabrics, crafting items of personal adornment, and of course making figurines. Given the quantity of clay scrap and non-diagnostic pieces found in domestic contexts (over 500 at the last count), we might suggest that figurine making occurred in and around houses and did not explicitly occur off site. We have initiated a preliminary analysis of finger print size, and while it is too early for anything conclusive, we can conjecture now that these were not clay toys made by children as some have suggested (Hamilton 1996, 224; 2006). Since many are lightly fired, various team members have commented that they are 'passively fired' by hearths or ovens, again in domestic contexts. To date there is no evidence for specially built kilns at Çatalhöyük and, as with other clay objects, these were exposed to heat during other processes of cooking, burning, and heating or lighting houses. Again these were all public activities or at least household practices.

The notion of when figurines were finished *per se* is an interesting one. We only have to think of Cycladic examples, that we now know were painted, to recall that our aestheticized image of pristine, minimal and modernist bodies is a misconception. The Çatalhöyük figurines of all materials may have had secondary materials added, as outlined above; certainly many examples were painted, but more than that it is possible to imagine the addition of organic items: cloth, skin, fabric, grass, beads, feathers, string and so on (see above). These may have been removable and transferable, in a similar way to the heads, for various moments and contexts, whether events, seasons, ceremonies, rituals or narratives. We can thus posit moments of dressing, decorating or undressing, all of which require

Figure 11.8. *Figurines from Çatalhöyük showing holes possibly meant for decorations of feathers, grasses or other organic material (see Fig. 11.5).*

moving and handling — all of which are processes in themselves. Given that we have various examples of figurines pierced around the face, ears and hair, their makers could have attached organic materials or beads. Such possibilities are illustrated by the myriad African figures that have grasses, string, human hair or feathers attached (see Figs. 11.5, 11.8 & 11.9).

Organic matter such as wood, textiles, cloth, leather, basketry, string, marsh grass, fur, and so on does not generally survive, but in the place of these materials we do sometimes have phytoliths. Many of Mellaart's incredible finds of organic materials were as a consequence of his excavation of a particular area where firing acted as a type of preservation. The materials were burnt and thus preserved in carbonized form, which means that some imaginative reconstruction is required as part of the current excavations. Hans Haelbeck worked for a month on Mellaart's materials, consisting of a sack of wooden vessels, beads, pendants and fur, often with thread preserved, which then went to the Ankara Museum. In the 1960s excavations, knotted threads and fabric with selvedge fringe, apparently remains of a string skirt, were also found (Mellaart 1967; 1975). The new excavations have also found remains of string. All of these materials are suggestive in terms of extra-somatic details and decorations for the figurine corpus.

Given that the evocative imagery presented by Mellaart has resisted, or avoided, vigorous challenge in the time that has elapsed since his publications, we do need to call upon some radical ways of rethinking or refiguring the archive. Figures were probably moved about during their use-lives as well and it is unlikely that they were static; as outlined above, many cannot stand unaided. Though we can say little about

Chapter 11

Figure 11.9. *Reconstruction drawing showing possible uses of organic material in both body and figurine decoration at Çatalhöyük (see also Figs. 11.5 & 11.8). (Drawing: John Swogger.)*

or stones, objects of amuletic value, organics, bone objects, both decorative and functional, or other types of miniatures. Native American fetishes, for example, were often carried or worn on the person and treated like the animal spirit that it manifests, and were fed ground turquoise from miniature pots. Natural products like sage were imbued with sacred valences and were carried in what were considered sacred bundles. The significance of these objects is formed through action not in isolation or distanced contemplation. They are things to be *used*.

We might posit that the people who made the clay examples were probably different to the individuals who fashioned the stone pieces. Perhaps the large complex stone and clay pieces really belong to another category. Researchers tend to put these all together under the heading of figurines, but perhaps the informal clay examples are really a different sort of *thing* — not simply because some would say they are 'crude' but rather because of their expediency or frequency, as opposed to the larger-scale projects. A related point is that there are very few points of aesthetic overlap between such groups of objects; Which are significant? Certainly the contexts are related since they are all (almost without exception) found in building fills and midden areas. The clay example found in 2005 with skeletal features (see Fig. 11.10) was also found amongst collapsed building materials in decontextualized fill. While they are undoubtedly purposefully included in such deposits for the most part, we struggle to reconstruct the contexts of their primary use. It is difficult to imagine that being placed in fill should be their *raison d'être* for manufacture of course, which may not be wholly incorrect in all cases. One thing that mitigates against that possibility is the practice of movable heads, as mentioned above, and the general idea of transforming figurine identities by their appearance. They are things in process, in motion, and thus temporally situated. While this may seem an obvious statement, the various things we tend to call figurines may have had very different roles and

their original use-lives from the excavation and contextual data retrieved, we know from their use-wear, damaged state and their final deposition in fill, that they were not like 'cult statues' that were spatially and temporally separated from human affairs. These were incorporated into practice, a moving and mobile suite of embodied actions.

One suggestion we have is that the small clay human forms (and perhaps some of the animal figures) were collected together in small skin or woven bags, worn or carried, as evidenced in other ethnographic contexts. They could have been carried together with other evocative objects such as pebbles

purposes for people at Çatalhöyük and it may prove misleading to categorically lump them together.

Almost all of the clay figurines of this very general type have missing heads, although damaged we might posit that many also had dowel holes for detachable heads. One figurine that does retain the head is now in Ankara museum (79–803–65) though it has been restored (from the present state we cannot be sure, but this looked originally as if it were all one piece). The ears and nose are prominent, the eyes less so and there is little sign of a mouth. There is a head ring present and an incised line at the top of the forehead. Apart from this exception most clay figurines whether sexed or not are missing heads: stone heads remain intact in the main. However it is notable that we have several marble examples that have been intentionally decapitated, such as the example found this year in the 4040 region (12102.X1, see Fig. 11.6).

Figurine 11967.X7 found in the Istanbul area is a unique piece for which I have found no parallel examples across this site, for the Anatolian Neolithic or for the European Neolithic for that matter. It combines the typical corpulent female on one side with her hands resting on pendulous breasts, with a back view comprising an articulated skeleton (scapula, delineated vertebra, pelvis). The whole effect is heightened by the style and posture of the arms that are reduced to bones ending in detailed fingers that rest on the breasts (see Ankara 79-803-65 and 10475.X2 for parallels). The shoulder blades arch like wings and the bones protrude much higher than they normally would for a human body. The overall effect is chilling for some, reassuring and legible for others who have seen the figurine.

There are traces of red paint around the chest area in the form of concentric loops (see Ankara figurine 79-20-65 for parallel), on the wrists, around the pelvic region suggesting anklets on the folded feet below (all on the corpulent side of the figurine, see Ankara figurines 79-20-65; 79-656-65). There is no sign of red paint on the back of the figure. A prominent dowel hole indicates that originally the piece had a detachable head, almost certainly in ceramic material. The hole was made with the usual kind of stick we see in figurines with stab marks, punctures and perforations. A marked depression in the area of the head suggests it fits snugly into this curved

Figure 11.10. *Clay figurine (11967.X7) showing skeletal features.*

space. Yet examining the depth of the depression in contrast to the height of the shoulder bones shows that the exaggerated shoulders would have risen much higher than anatomically possible.

Thinking through the figurine with other materializations at Çatalhöyük, such as the plastered animal parts, I have begun to think more about the idea of embedding, particularly the hard forms of bodies, the skeletal or horn and claw elements of animals that survive after fleshy decay. We see so many instances where cattle horns, boar tusks, vulture beaks, weasel and fox skulls are embedded in walls, platforms and features — all of which are the distinctive, bony elements that both present the individual animal and successfully survive death. With the addition of plaster and shaping: some retain their life-like forms for perpetuity, others remain lumpy and hidden. So too with this figurine, the bony, skeletal part of the human body that survives death and burial is both embedded and revealed. The villagers regularly saw human skeletons as they dug down to retrieve skulls and objects from burials (Hodder 2006b). Just like the embedding of real animal parts, its materiality grapples with the embedding of real human parts within a shaped human living form. The notion of embedding real human bones in some manner like the animal parts may have been taboo; whilst unimaginable in many societies, it is not in all, as the Maya circulation of worked human bone makes apparent (Meskell & Joyce 2003). So we are perhaps witnessing an extension of the community's treatment of the animal world, more specifically the dangerous animal world, and an application of this treatment to the human body. The aesthetics of

fleshing out the skeleton can also be seen in the form of plastered skulls, the earliest Anatolian example of which for was found last year at Çatalhöyük. Carolyn Nakamura and myself (2005) have suggested that the heads of figurines, possibly even detachable ones, resemble the plastered skulls with their high foreheads and smoothed, minimal facial treatment, lacking in mouths and detailed features. Clays and plasters may have had a specific set of associations with bodily flesh as well, whether human or animal flesh, as numerous cases from the site may suggest.

Keeping the dead close by and rendered permanent (at least in living memory) was made possible through this process of embedding; whether burying them under platforms and plastering over them, plastering skulls and burying them with descendents, embedding the bony parts of animals as plastered protrusions, or perhaps even making clay images of the human form with protruding skeletal elements. Were these attempts to transform, display and render permanent the iconic and durable elements of human and animals: skulls, horns, beaks, claws and so on? Duration is a recurring theme in a great many human societies, both ancient and modern and, while being careful not to impose Egyptian notions of death and burial (something Mellaart was very keen to apply), it would not be inconceivable to envisage that the Çatalhöyük residents were concerned with their own sense of history and memory. That making of history applied equally to the embedding of specific animals as to people, to the rendering permanent of particular individuals, possibly even events such as the capture and killing of an aurochs or bear. The fabrication of history and memory might not have been focused solely upon human beings, but upon animal and spirit worlds as well. While these ideas are briefly sketched, my aim for future work is to link the figurine corpus more closely with these other materialities and to reconfigure the whole as *process* rather than inert objects of worship or contemplation. Here we are approaching a corpus of objects through which we can talk about spirituality and its embodied iterations.

Final thoughts

This paper has attempted to cover many aspects of a figured life-world at Neolithic Çatalhöyük. While it is too early for us to draw many definite conclusions it is hoped that the groundwork for analysis and interpretation in our upcoming seasons has been laid; what is described above is all part of our ongoing work. We plan to continue to experiment with ways of embodying figurines and their surrounding practices of making, circulation and deposition by using various new forms of media coupled with creative reconstructions. We also want to embed figurines themselves into wider visual and material worlds at Çatalhöyük and continue to rethink and refine the specific taxonomies that we readily construct and instantiate as archaeologists (Meskell 2004). We are already some way to rethinking certain material hierarchies and associations and sometimes inverting them.

We also have some very pedestrian tasks at hand, such as the balancing up of previous work with our own findings. This is particularly true in terms of species and gender categories where humans rather than animals, and similarly women rather than men, have been over-emphasized in the corpus. This leads to a further rethinking of sexuality and self, particularly in the context of the Neolithic, and in the light of the myriad tantalizing images of a specific brand of masculinity from other sites such as Göbekli (Schmidt 2002) or Nevali Çori. There is much more to be done on the notion of community at Çatalhöyük; the site is a very specific locality that may have visual and material links to other sites in central Anatolia, but retains a unique set of associations and practices. It may be that the experience of village life, and the choices of clustered housing and intramural burial tell us a great deal about social life at this time. The ubiquity of image making in general at the site suggests that what we would consider 'ritual' or 'religious' things and acts infused and comprised the everyday to such an extent that it might be impossible to parse out. Again the specificities of our categorical understandings are unlikely to mesh with the ancients'.

In terms of the themes that are most evocative at present, the notion of figurine as *process* rather than end *product* must be the first. It is inextricably linked to the idea of circulation and mobility; figurines are not static but mobile and potentially shifting things. Part of that malleability is their inherent range of possibilities for identity changes and narrative, evidenced at Çatalhöyük by the detachable heads and ceramic anthropomorphic bodies with dowel holes. In addition, we have the removal or severing of heads in the case of stone human figurines. The idea of storytelling, coupled with memory and identity are evocative. And finally this connects to the wider practice across media of embedding skeletal parts and plastering or covering them with cultural materials that replace impermanent natural ones. In doing so both animals and humans were preserved, they survived death and decay, and were incorporated into the very fabric of houses and spaces at the site. They served as ever-present reminders, fleshed out, of their former selves and former existence, redolent with memories, stories or myths that are steeped in their attendant materiality.

References

Bailey, D., 2005. *Prehistoric Figurines: Representation and Corporeality in the Neolithic*. London: Routledge.

Baird, D., 2003. Pinarbaşı. *Anatolian Archaeology* 9, 2–4.

Bogdan, D., 2004. Excavations of the 4040 area, in *Çatalhöyük 2004 Archive Report*. www.catalhoyuk.com/archive_reports/2004/ar04_09.html

Cessford, C., *with* M.W. Newton., P.I. Kuniholm, S.W. Manning *et al.*, 2006. Absolute dating at Çatalhoyuk, in *Changing Materialities at Çatalhoyuk: Reports from the 1995–99 Seasons*, ed. I. Hodder. (McDonald Institute Monographs/BIAA monograph 39.) Cambridge: McDonald Institute for Archaeological Research/London: British Institute at Ankara, 65–99.

Fane, D., I. Jacknis & L.M. Breen (eds.), 1991. *Objects of Myth and Memory: American Indian Art at the Brooklyn Museum*. New York (NY): the Brooklyn Museum.

Farid, S., 2007. Introduction to the South Area excavations, in *Excavating Çatalhöyük: South, North and KOPAL Area Reports from the 1995–99 Seasons*, ed. I. Hodder. (McDonald Institute Monographs/BIAA monograph 37.) Cambridge: McDonald Institute for Archaeological Research/London: British Institute at Ankara, 41–58.

Hamilton, N., 1996. Figurines, clay balls, small finds and burials, in *On the Surface: Çatalhöyük 1993-1995*, ed. I Hodder. (McDonald Institute Monographs.) Cambridge: McDonald Institute for Archaeological Research, 215–63.

Hamilton, N., 2006. The figurines, in *Changing Materialities at Çatalhöyük: Reports from the 1995-99 Seasons*, ed. I. Hodder. (McDonald Institute Monographs.) Cambridge: McDonald Institute for Archaeological Research, 187–213.

Hodder, I. (ed.), 1996. *On the Surface: Çatalhöyük 1993-1995*. (McDonald Institute Monographs/BIAA monograph 22.) Cambridge: McDonald Institute for Archaeological Research/London: British Institute at Ankara.

Hodder, I. (ed.), 2000. *Towards Reflexive Method in Archaeology: the Example at Çatalhöyük*. (McDonald Institute Monographs/BIAA monograph 28.) Cambridge: McDonald Institute for Archaeological Research/London: British Institute at Ankara.

Hodder, I. (ed.), 2005. *Inhabiting Çatalhöyük: Reports from the 1995–99 Seasons*. (McDonald Institute Monographs/BIAA monograph 38.) Cambridge: McDonald Institute for Archaeological Research/London: British Institute at Ankara.

Hodder, I., (ed.) 2006a. *Changing Materialities at Catalhoyuk: Reports from the 1995–99 Seasons*. (McDonald Institute Monographs/BIAA monograph 39.) Cambridge: McDonald Institute for Archaeological Research/London: British Institute at Ankara.

Hodder, I., 2006b. *The Leopard's Tale: Revealing the Mysteries of Çatalhöyük*. London: Thames & Hudson.

Knapp, A.B. & L.M. Meskell, 1997. Bodies of evidence in prehistoric Cyprus. *Cambridge Archaeological Journal* 7(2), 183–204.

Last, J., 1998. A design for life: interpreting the art of Çatalhöyük. *Journal of Material Culture* 3(3), 355–78.

Mellaart, J., 1962. Excavations at Çatal Hüyük: first preliminary report, 1961. *Anatolian Studies* 12, 41–65.

Mellaart, J., 1964. Excavations at Çatal Hüyük: third preliminary report, 1963. *Anatolian Studies* 14, 39–119.

Mellaart, J., 1965. *Earliest Civilizations of the Near East*. London: Thames & Hudson.

Mellaart, J., 1966. Excavations at Çatal Hüyük: fourth preliminary report, 1965. *Anatolian Studies* 16, 165–91.

Mellaart, J., 1967. *Çatal Hüyük: a Neolithic Town in Anatolia*. London: Thames & Hudson.

Mellaart, J., 1975. *The Neolithic of the Near East*. London: Thames & Hudson.

Meskell, L.M., 1998. Twin peaks: the archaeologies of Çatalhöyük, in *Ancient Goddesses: the Myths and Evidence*, eds. C. Morris & L. Goodison. London: British Museum Press, 46–62.

Meskell, L.M., 2004. *Object Worlds in Ancient Egypt: Material Biographies Past and Present*. London: Berg.

Meskell, L.M., 2005. Objects in the mirror appear closer than they are, in *Materiality*, ed. D. Miller. Durham (NC): Duke University Press, 51–71.

Meskell, L.M. & R.A. Joyce, 2003. *Embodied Lives: Figuring Ancient Maya and Egyptian Experience*. London: Routledge.

Meskell, L.M. & C. Nakamura, 2005. Çatalhöyük figurines, in *Archive Report on the Çatalhöyük Season 2005*. www.catalhoyuk.com.

Nakamura, C. & L.M. Meskell, 2004. Figurines and miniature clay objects, in *Archive Report on the Çatalhöyük Season 2004*. www.catalhoyuk.com.

Nakamura, C. & L.M. Meskell, 2006. Çatalhöyük figurines, in *Archive Report on the Çatalhöyük Season 2006*. www.catalhoyuk.com.

Russell, N., 2005. Çatalhöyük worked bone, in *Changing Materialities at Çatalhöyük: Reports from the 1995–99 Seasons*, ed. I. Hodder. (McDonald Institute Monographs/BIAA monograph 39.) Cambridge: McDonald Institute for Archaeological Research/London: British Institute at Ankara, 425–54.

Schmidt, K., 2002. Excavations at Göbekli Tepe (southeastern Turkey): impressions from an enigmatic site, in *Neo-Lithics: a Newsletter of Southwest Asian Lithics Research* 2, 8–13.

Talalay, L., 1993. *Deities, Dolls, and Devices: Neolithic Figurines from Franchthi Cave, Greece*. Bloomington (IN): Indiana University Press.

Todd, I., 1976. *Çatal Hüyük in Perspective*. Menlo Park (CA): Cummings Publishers.

Chapter 12

The Splendour of Women: Late Neolithic Images from Central Anatolia

Mary M. Voigt

Images of humans sculpted in stone and modelled in clay occur at most sites dating to the Neolithic and Early Chalcolithic periods in the Middle East. The great range of variation in image form and the quality of the workmanship documented at sites such as Çatalhöyük in Turkey and at Tell es-Sawwan in Iraq have been of considerable interest to Near Eastern prehistorians, and have also attracted the interest of archaeologists working in other regions, as well as scholars from other disciplines and the general public. Given the number of scholarly and popular publications that have discussed and utilized the figures and figurines excavated by James Mellaart at Çatalhöyük, it might be hard to see how anything new could be said about them. Nevertheless, in the mid-1990s I undertook a detailed analysis of those figures and figurines using a methodology that emphasized location/disposition, breakage and wear (Voigt 2000). This study not only provided evidence for different kinds of figure/figurine use, but also documented a significant break within the archaeological sequence. In the early Neolithic levels of Çatalhöyük (Level VI and below), both males and females were represented by stone images in approximately equal numbers. In the Upper Neolithic levels (Levels V–I), modelled images were usually made of clay and can be identified as females, while males (and a few females) are depicted in wall paintings (Voigt 2000). I concluded by suggesting that some of the early stone figures from Çatalhöyük (dated *c.* 7000–6500 BC) were stylistically and iconographically related to figures found at Nevali Çori (*c.* 8500–7000 BC) and Göbekli Tepe (*c.* ?9000–7000 BC) in southeastern Turkey. The later clay figures at Çatalhöyük (*c.* 6500–6000 BC) represent a new development in central Anatolia, which I linked to the increased prominence of a female deity who was also represented by contemporary figurines from the site of Hacılar. In this paper I will focus on the clay and stone images from Late Neolithic Hacılar (*c.* 6300–5700 BC). Based on the results from Hacılar, an alternative interpretation of the 'late' clay images from Çatalhöyük is suggested.

Late Neolithic Hacılar

During the early 1950s James Mellaart conducted surface surveys across southwest and south-central Turkey (Mellaart 1954). Although at the time his research interests lay primarily in the Bronze Age, he was intrigued by painted pottery with bold designs that he found on the surface of several mounds in the Lake District of southwestern Turkey. This type of pottery had not been found at Beycesultan, the single major excavated site in the area. In 1957 Mellaart began his own excavation at the site called Hacılar, which had produced complete painted pots looted by a local antiquities dealer (Mellaart 1958, 127). In an era when culture history dominated prehistoric archaeology in the Middle East, and when little was known about the prehistory of Anatolia, Mellaart sought to extend the archaeological sequence into the Chalcolithic and Neolithic periods and to document possible relationships between Anatolia and major geographical regions to both east and west (1970, xii).

Hacılar is a very low mound, described as *c.* 150 m in diameter, with a depth of deposit of less than 5 m. Mellaart dug for four seasons, from 1957 to 1960; the total time spent working at the site was 117 days (Mellaart 1970, xiii). During this short period, a total of 18 building levels were identified, ranging in date from the 'Aceramic Neolithic' to Early Chalcolithic. The size of the excavated area for any given building level is difficult to determine as a result of irregular trench outlines and discontinuous excavation units, but as expected for any mounded site, the area cleared was very small for the earliest levels (roughly estimated at a maximum of 120 m^2), and large for the latest levels (more than 2000 m^2 for I–II) (Mellaart 1970, fig. 1).

Chapter 12

Most of the anthropomorphic images recovered from Hacılar came from Level VI of the Late Neolithic settlement, now dated *c*. 6000 BC (Thissen 2002, 332–3). The houses within this architectural level were destroyed by fire, preserving architectural details and a wide range of artefacts that remained in the places where they had been stored or used. Among these artefacts were 76 images made of clay or stone. Application of the criteria that I have used to determine figurine use requires good descriptions of the artefacts and information on disposition, breakage and wear, all of which can be obtained from the site report, supplemented by examination of figurines on display in the Museum of Anatolian Studies in Ankara and a catalogue produced for that museum (Kulaçoğlu 1992).

Figurine morphology and manufacture

Mellaart divided the images into four categories based on morphology and raw material: [clay] 'statuettes', [clay] 'figurines', 'schematic clay figures' and 'stone slabs with incised features' (1970, 166–76). Each of these groups will be briefly described, reserving a more detailed description for the discussion of specific contexts.

Statuettes are carefully modelled figures that depict female bodies in some detail (Mellaart 1970, pls. CXXV–CLVIII, CLVIXb–d, figs. 192 & 194–229). Although I dislike the term 'statuette' (used by Mellaart because he saw these images as 'works of art': 1970, 166), it seems preferable to retain it rather than to introduce a new terminology and potential confusion. Many statuettes were made of unbaked clay that was hardened in the fire that destroyed their context, but others had been slipped, painted, and fired during the manufacturing process. Most of these images had been damaged (see below), providing information on techniques of manufacture: heads, bodies and legs were 'made separately and then pressed together', while heads are described as 'pegged into the body' (Mellaart 1970, 167). The statuettes vary greatly in size, with the largest complete example reaching a height of 24 cm, and the smallest measuring around 7 cm. They also exhibit a significant diversity in posture, hand position, leg position, fat patterns, hairstyles and costume (rarely shown). Some statuettes are accompanied by a second human or by animals. All of the statuettes have physical attributes that clearly mark them as female (breasts, vaginal slits, fat patterning on torso and legs).

Mellaart divided the statuettes into sub-groups based on posture/position:
1. *standing* (including some bent at the waist which I would argue are probably seated on a low stool based on more complete figurines from the contemporary and culturally related occupation at Höyücek: Duru 1995, pl. 42);
2. *seated* (with legs to one side or bent and drawn up in front of the body);
3. *resting* (lying upon one side or face down);
4. *enthroned* (seated on a chair made up of one or more animals).

He then created a large series of subtypes based on a list of attributes that are descriptive and interpretive rather than analytical. For example, standing figures include 'mature woman with pendulous breasts', 'young woman, slim, in briefs' and 'young woman with animal(s)'; resting figures include 'resting on elbows', 'resting with head turned' and 'pregnant, resting on side' (Mellaart 1970, 168–9). In my own initial attempts at constructing descriptive types for the Hacılar VI statuettes, I looked at the position of hands: standing figures may have their hands at their sides or beneath their breasts; seated and reclining figures often have their hands beneath their breasts, but may also have them extended or may be grasping a second figure. I also tried to record the relative size of breasts, stomachs, buttocks and thighs, information that proved far more useful than hand position, especially when combined with posture. In the end, however, I found that it was most productive to retain the four posture groups outlined by Mellaart, and to define the set of distinctive attributes characteristic of each group.

The second most common category of images defined by Mellaart is '*Figurine*', which is based on inferred function as 'ex voto substitutes' rather than on form (1970, 175). While I would not argue with Mellaart's intuitive functional assessment for many of the figures in this group, the category includes two distinct morphological types:
1. *Stub-armed figures* are easily recognized as crudely modelled humans with arms and legs and either a lumpy head or a hole in the neck where a head of wood or bone could be inserted (Mellaart 1970, pls. CLIXa, CLXg–k; figs. 231 & 232, nos. 2–4.)
2. *Quadrilateral figures* are highly schematic but are often carefully made (Mellaart 1970, pl. CLXa–f; figs. 232 [no. 1] & 233). These are tiny figures *c*. 2–3 cm tall with flat rectangular or trapezoidal fronts that tend to be elongated at the corners to indicate arms and legs. They have flat bases, and in some cases lumpy protrusions to the rear (buttocks?) which allow them to be freestanding. All quadrilateral figurines have a carefully made hole or slot at the neck for a detachable head, and Mellaart reports fragments of wood (charcoal?) in association with one group (1961, 47); bone heads, sometimes still in place on quadrilaterals, are documented at

Höyücek (Duru 1995, pl. 47). Within each of the two figurine groups at Hacılar there are images with clearly depicted breasts, but others have no indication of gender.

Schematic clay figures clay slab figures are rare, with only two examples recovered. These are made by cutting a thin slab of clay into an anthropomorphic silhouette and indicating facial and body features by incision (Mellaart 1970, pl. CLXI, fig. 235). Initially, these figures appear almost childlike, and the more complete figure has a flat chest with no indication of breasts. On the other hand, both schematic clay figures have incised rectangles on their heads that appear to represent the hairline characteristic of statuettes and both have large incised pubic triangles or briefs — both characteristic of the unambiguously female statuettes. The fragmentary schematic clay figure has incised zigzags on its cheek and an incised string skirt. These images are small (under 10 cm tall) and were slipped, burnished and fired. Closely related to schematic clay figures in form, but larger, are *Stone slabs with incised features* made of limestone and ranging from 8–19 cm in height (Mellaart 1970, pls. CLXII–III, figs. 236 & 237, no. 1). The four examples recovered have incised eyes and chins. Two have incised hairlines and one has a vertical incised line in the centre of the base, all attributes that characterize other Hacılar images that are explicitly female.

Context and depositional processes

The buildings of Level VI were heavily burned. Although the possibility that this fire was deliberately set as a closure ritual cannot be excluded, an accidental burning seems more likely given the range and number of artefacts that were preserved. Two clusters of rectangular rooms were exposed in Trenches P and Q (Mellaart 1970, fig. 7). Although domestic features and a few postholes were found in the area between P and Y (Trenches R and B), Mellaart's interpretation of this area as an open court seems reasonable (1970, 10–11).

For our examination of image use, the kinds of spaces in which the images were found (and in this case were stored or used) is critical. A minimal definition for the term 'house' is a roofed space used for activities that are a normal part of everyday life, including storing, cooking, eating, and sleeping. I would consider rooms that are connected by doorways to be part of the same domestic space, especially when there is only one exit to the outside from these rooms. Mellaart states that the houses of Hacılar VI 'consist of a single oblong room with a floor space of 40–45 sq. m on the average…' (1970, 11). We then learn that, apart from the large single room, each house was provided with a number of cubicles (sometimes only one) serving as kitchens or for other domestic purposes. These were attached on either side of the doorway leading into the building and were constructed of light materials (Mellaart 1970, 15).

While these descriptions fit the structures in Trench P, those in Trench Q are somewhat different, and this difference significantly affects our interpretation of image distributions. For example, House Q.VI.5 has a small room at the northern end of the building that has none of the features associated with a kitchen, and a wide doorway leading into a second space enclosed by reconstructed walls. House Q.VI.3 seems to have originally been an alley between Q.VI.5 and Q.VI.4 which was later enclosed with posts set into the floor to support a roof (Mellaart 1970, 19); this space extends off into the unexcavated area to the south. House Q.VI.2 has doorways leading into the area to the south where a large pit has disturbed most of the excavated area. Most perplexing is Mellaart's definition of Houses Q.VI.4 and Q.VI.1: these two rooms are linked by a doorway, and the only exit to the exterior leads out to the north from Q.VI.1. In fact, Q.VI.1 is very lightly built and is better interpreted as an example of an exterior kitchen, and I will consider these rooms to be a single dwelling unit designated as Q.VI.4/1.

Even more important for an understanding of distributional data is the fact that the Hacılar VI building plans tell us only about the first floor of two-storey structures. Mellaart describes walls preserved up to 6 ft in height, filled with debris (1961, 42). The source for much of this fill is a collapsed second storey:

> The presence of such upper floors (as distinct from roofs) is indicated by a number of features: in house P.1 part of an upper floor, with hearth of the usual raised type, pottery and objects had collapsed into the room just behind the doorway, covering the collection of pottery and stone bowls that lay *in situ* on the lower floor … [In some] rooms pottery occurred in two superimposed levels … (Mellaart 1970, 17).

Although Mellaart believed that the second floor above major rooms was lightly built of wood, reeds and plaster, he is puzzled by the thickness of the brick walls and the lines of postholes that run along the long axis of each completely excavated room and in some cases along the walls (1970, 16) — all features that would support a much heavier second floor. Whatever its structure, it is clear that the second storey was an important living space. It was also a space where the most interesting and spectacular collections of images were used or stored. For example, 'In House Q.5, the upper floor had collapsed into the room [below] dis-

charging deposits of carbonized grain and legumes and numerous statuettes, many of unbaked clay' (Mellaart 1970, 17).

We are also told that statuettes (i.e. carefully modelled clay figures) tended to be found near hearths, and that 'they are never found mixed up with other objects, such as pots, sickles or bone tools, all of which occur in these houses' (Mellaart 1970, 167). The association of statuettes with hearths is questionable for two reasons. First, in the case of House Q.VI.5 we know that the association with the hearth is spurious since the statuettes dropped down from the upper story when it collapsed. Second, it is hard to imagine that images would have been scattered across the ground floor of House Q.VI.3 (Mellaart 1970, fig. 191) under ordinary conditions. If the fire was indeed accidental, it seems far more likely that the Q.VI.3 images also dropped from a second storey, perhaps even from the second storey of the adjacent House Q.VI.5. The segregation of statuettes from all other types of artefacts is hard to evaluate in the absence of complete distributional data, but Mellaart does tell us that most tools, weapons and personal ornaments were found in areas that were separated from the main living area (where hearths were located) by a lightly built 'screen wall' (1970, 14). The careful storage of artefacts that would have been in regular use (presumably on the ground floor) is hard to reconcile with a careless scatter of statuettes. It seems more likely that most of the statuettes were embedded in a layer of collapse, and so were not associated with anything that lay on the ground floor. Mellaart also provides contextual information on one group of images. Within House Q.VI.2, a group of unbaked 'figurines' was found in a 'niche' or 'serving hatch' extending through a thick house wall (Mellaart 1961, 47; 1970, 14–15: fig. 7).

When the Hacılar VI images are sorted into groups based on location, clear patterns emerge (Figs. 12.1–12.11). This is gratifying given the small number of buildings and the fact that most of them have not been completely excavated. Basic information for establishing these patterns was provided by Mellaart (1970, 176), but his summary table contains numerical errors if one accepts the locational information given in photo and line drawing captions of 'figurines' and incised stone slabs. I therefore made my own data base derived from the images illustrated by Mellaart supplemented by images provided by a catalogue of figurines in the Museum of Anatolian Civilizations (Kulaçoğlu 1992). Note that the number of statuettes listed by Mellaart is greater than the number that he illustrated, but this difference does not affect distributional patterns.

We can make the following generalizations about figurine distribution using my data base, illustrated here by Figures 12.1–12.11:

1. Most buildings had an incised slab figure, either of clay or of stone. Houses P.VI.3, Q.VI.2 and Q.VI.5 do not have one of these images, but none of these buildings has been completely excavated. (Mellaart assigned one stone slab to House Q.VI.5, but this artefact comes from a stratum above the house: 1970, 176).
2. House Q.VI.2 produced a cluster with at least five illustrated quadrilaterals (out of 10 reported by Mellaart 1961, 47) and two more houses contain a single quadrilateral figure (P.VI.1 and Q.VI.5). If we include stub-armed figures within this distribution pattern we find that each of the houses with quadrilaterals also produced one or more stub-armed figures, as did House Q.VI.3. One of the images from Q.VI.3 provides a different kind of support for grouping quadrilaterals with stub-armed figures since it has the form of a quadrilateral but differs in that it has a clay head attached (Mellaart 1970, fig. 232.2). House Q.VI.4 had no illustrated figurine but Mellaart lists one example (1970, 176). The only buildings without any of these simple images are Houses P.VI.2 and Q.VI.6 (which did not contain a clay image of any sort) and House P.VI.3 (which was only partially excavated). The small size of the quadrilaterals make it highly likely that they were sometimes missed during excavation given the speed with which Mellaart proceeded. Thus quadrilaterals and stub-armed figures can be seen as an important if not essential artefact within each household's artefact assemblage.
3. Relatively large quantities of statuettes are found in Houses Q.VI.5, Q.VI.3 and Q.VI.4 as indicated by my own census, supported by Mellart's numbers which are slightly larger (170, 176). A single figure was found in House P.VI.3, and fragments were found in House P.VI.1. Even taking into account differences in the size of excavated areas, it is clear that statuettes were clustered, and I will argue later in this paper that only the largest clusters represent images in use at the time of the fire.

Interpretation

My charge for this volume was to discuss the roles and uses of images, a task that I had previously undertaken using material from my own excavation. Trying to make sense of the clay figures of humans and animals from Hajji Firuz Tepe in Iran (*c.* 6000–5500 BC), I began with the functional types defined by Peter Ucko (1968): cult images, vehicles of magic, initiation figures and toys. I then added information on patterns of disposition, breakage and wear gathered from Ucko as well as other sources (Voigt 1983, 186–93: tables 28–30).

Figure 12.1. *Images associated with Hacılar Level VI House P.1 include each of Mellaart's morphological categories. Reading rows from top to bottom, and left to right. Rows 1 and 2, clay statuettes: Mellaart number 587 (no measurement published), 456 (12.5 cm), and 568 (10.0 cm); Row 3 clay quadrilateral figurine 483 (2.2 cm); Row 4 schematic clay figure/clay slab 455 (8.7 cm) and stone slab with incised features 458 (12.0 cm).*

The Hajji Firuz figurines showed patterning in wear and disposal patterns, as did other Neolithic sites in Turkey (Voigt 2000).

One problem inherent in the names that Ucko gave his functional types needs to be considered before returning to the Hacılar figures. Implicit in his typology is a distinction between religion and magic: cult images represent 'deities' that are part of a formal religious system, while vehicles of magic represent informal practices — still associated with the supernatural, but not part of a formal cult or religion. I rejected this distinction (which arbitrarily segments

Chapter 12

Figure 12.2. *Hacılar Level VI House P.2 was only partially excavated and produced a single image, a stone slab with incised features: Mellaart number 449 (19.2 cm).*

a continuum of beliefs about the supernatural) and emphasized the difference between the symbolic value of images and the way that they were used. If we consider only symbolic value, we can group images into three classes: representations of animals; representations of humans, and representations of supernatural beings (Voigt 1983, 186 n. 1, 188–9). Although cult images and vehicles of magic do represent supernatural beings, this does not mean that initiation figures and toys do not. The distinction between 'cult images' and 'vehicles of magic' that matters most if we are looking at figurine function is not the kind of 'being' represented, but the context in which the images are used and who uses them. Put simply, the larger and more elaborate cult images are more likely to have been used by a group of people in a public context, while the small and usually schematic vehicles of magic could be used by individuals in attempts to manage the well-being of themselves and their families. Initiation figures, used in rituals designed to mark a transition to adulthood, and usually intended as a means of instilling values and ensuring proper behaviour, might well include images that symbolize animals, humans and supernatural beings, and the same is true (though

Figure 12.3. *Hacılar Level VI House P.3 was only partially excavated and produced only one image, the fragmentary clay statuette 485 (10.0 cm). Although Mellaart interpreted this as a standing figure, the posture makes more sense if interpreted as a figure that was once seated on a low stool.*

to a lesser extent) of toys which carry their own value as narrative devices.

Quadrilateral figures and stub-armed figures
The tiny quadrilateral figures are best represented in House Q.VI.2 where a group of at least 10 was found in association with stub-armed figures in a niche; accompanying the figurines were at least six bars of clay of unknown significance (Mellaart 1970, fig. 234). The only house with a large corpus of images that did not produce a quadrilateral is Q.VI.4/1. The quadrilateral figures from Hacılar do not show any evidence of damage or wear on the body, but material, size, morphology and the cluster in House Q.VI.2 are all consistent with vehicles of magic. The figures are also made so that heads can be inserted, and just as easily detached — an easy method of destroying the image or its power, again a common characteristic of vehicles of magic. Strong support for this interpretation comes from the site of Höyücek, where quadrilateral figures identical to those from Hacılar sometimes bear cut marks — again, the kind of damage characteristic of vehicles of magic (Duru 1994, pl. 27).

Because of the association of stub-armed figurines and quadrilaterals in the House Q.VI.2 niche, we might infer a similar function for at least some of these figures. The two variants also share the ability to gain or lose heads at will, but unlike the quadrilaterals, stub-armed figures have sometimes suffered fragmentation. The damage is severe (e.g. fig. no. 490 from House Q.VI.2; Mellaart 1970, fig. 231, no. 2) and does not seem to occur at points of structural

Chapter 12

Figure 12.4. *Hacılar Level VI House Q.2 was unusual within the excavated sample because of the absence of statuettes and schematic slab figures, and the large number of what Mellaart called 'figurines', all found within a niche in a house wall. The examples illustrated by Mellaart include five quadrilaterals and three stub-armed figures, one of the latter shown only in a photograph (Mellaart 1970, pl. CLXj). The quadrilaterals in the left column, reading top to bottom are Mellaart numbers 492a (1.9 cm), 492Bb (1.8 cm), 493 (1.8 cm); right column, top to bottom are Mellaart numbers 291 (2.2 cm) and 532 (3.3 cm). No dimensions were given for the stub-armed figures, and they may be smaller than is suggested here: top Mellaart number 490, bottom 589.*

158

Late Neolithic Images from Central Anatolia

Figure 12.5. *Hacılar Level VI House Q.3 produced examples of each of Mellaart's clay image types. Reading top to bottom left are statuettes 539 (body 9.2 cm, non-joining head 3.3 cm), 532 (8.5 cm) and 534 (5.0 cm with non-joining? head), and schematic clay figure/clay slab 554 (14.6 cm). To the right reading top to bottom are statuettes 531 (8.5 cm) and 487 (6.6 cm) and stub-armed figures 524 (5.1 cm) and 565 (3.1 cm). See also Figure 12.7 for statuettes found in House Q.3.*

Chapter 12

Figure 12.6. *Hacılar Level VI House Q.4 is anomalous in that it did not contain any quadrilaterals or slab images. The only stub-armed figure recovered was not illustrated by Mellaart. The statuettes from this room are also unusual in that all four had been fired and suffered battering or damage that is difficult to attribute to the fire that destroyed the building. Reading left column top to bottom, statuettes 507 (9.4 cm), 486 (6.2 cm) and stone slab 459 (8 cm). Right column top to bottom, statuettes 505 (8.0 cm) and 506 (10.2 cm).*

Late Neolithic Images from Central Anatolia

Figure 12.7. *This illustration includes images from two houses. Rows 1 and 2 illustrate statuettes from Hacılar VI House Q.3. Reading from left to right in Row 1 are statuettes 575 (8.3 cm), 535 (5.0 cm) and 536 (no measurements given); Row 2 illustrates statuette fragments 538a (5.0 cm), 538b (3.0 cm), 538c (3.0 cm) and 5.85 (no measurements given); Rows 3–5 illustrate images from Hacılar VI House Q.5, which produced examples of all figurine types. Row 3 depicts a fragment of stub-armed figure 566 (4.6 cm) and statuette 521 (7.8 cm); Row 4, quadrilateral 512 (2.3 cm); and Row 5, stone slab 450 (10.5 cm).*

weakness. It is, therefore, at least possible that these had been stored in a fragmentary state, and that the way in which they were used was somewhat different from that of quadrilaterals. Some difference in meaning or use is also suggested by the fact that the bodies of stub-armed figures show large hips, and buttocks that are proportionately even larger than those on statuettes (e.g. Mellaart 1970, 175, pl. CLXj, an

Figure 12.8. *The most elaborate statuettes (as well as the largest sample of images) comes from Hacılar VI House Q.5. Shown here are three large images, reading top to bottom Mellaart numbers 523 (9.4 cm), 518 (13.0 cm) and 525 (7.0 cm). The smaller fragment of a standing statuette to the far right is Mellaart number 577 (5.5 cm).*

un-numbered figure that was found near the figurine cache in House Q.VI.2).

Slab figures
Given that most houses have one of these clay or stone images, one can argue that they had some kind of symbolic value important for houses or household members, but we can say little more than this. They do not have any indication of wear, and were not found in discard contexts, so we have very little information that can be used to infer function. We can speculate that these images represent apotropaic beings or guardians, but whether they are spirits or ancestors or figures from mythology must remain unknown. On the other hand, the emphasis on women is maintained. Although Mellaart is uncharacteristically cautious about assigning gender to the slab figures, I would argue that four of the six published examples can be identified as female based on their distinctive hairline, and a fifth has a vertical/vaginal slit. Reinforcing the icon provided by hairline, the two clay slab images also have large pubic triangles, another characteristic of unambiguously female statuettes.

Figure 12.9. *Statuettes depicting standing women from Hacılar VI House Q.5. Row 1, Mellaart number 520 (24 cm); Row 2 Mellaart numbers 514 (11.7 cm) and 529 (9.8 cm).*

Statuettes
Because of their elaborate form and the skill required to model them, statuettes might be either cult images (as Mellaart thought), or initiation figures. Based solely on the great range of morphological diversity exhibited by this group, I consider use as initiation figures or teaching devices more likely, an interpretation that can be supported by a more specific consideration of statuette form and, to a lesser extent, by arguments based on curation. The largest numbers of statuettes come from Houses Q.VI.5 and 3, with smaller numbers from Houses Q.VI.4 and P.VI.1 and a single fragment

Chapter 12

Figure 12.10. *The statuettes from Hacılar Level VI House Q.5 are diverse in posture and style, and include depictions of human pairs. Reading top to bottom and left to right: Row 1, Mellaart numbers 571 (5.2 cm), 508 (7.7 cm) and 570 (9.2 cm); Row 2, Mellaart number 528 (12 cm); Row 3, Mellaart number 576 (11 cm); Row 4, Mellaart numbers 573 (6 cm without the non-joining head) and 515 (10.2 cm); and Row 5, Mellaart number 519 (6.6 cm).*

Late Neolithic Images from Central Anatolia

This is easily established by looking at the underside of the seated and reclining figures, but the most extraordinary example of this aspect of the Hacılar statuettes is the small image of a young girl with an unusual flat body (Fig. 12.8, no. 525; Mellaart 1970, pl. CXXIX, fig. 202). The figure is stable when placed on its stomach and breasts with shoulders and head jutting upward. The position of the head is awkward and the snake-like position of the legs as depicted from the top is anatomically impossible, but the figure makes sense when it is turned over, revealing a female with legs spread. Finally, the standing figures have small stubby feet that do not provide a stable base for the relatively heavy bodies; it seems far more likely that these images were viewed by someone holding them than that they were exhibited lying flat on a floor or other surface.

The ways in which females are represented by the statuettes can be analyzed through several themes, all but one appropriate for figures used in rituals related to the life course of women. First, the body types displayed by standing figures from House Q.VI.5 show how women's bodies develop with age. Slim young girls with small breasts and narrow hips wear a thong and dress their hair in a pigtail (Figs. 12.5, no. 539; 12.6, no. 486 & 12.10, no. 508). A torso with intact head that probably came from a standing figure shows the pigtailed headdress and small breasts of a young woman whose torso is painted to indicate a blouse or robe (Fig. 12.10, no. 571). Mature women have enlarged upper arms, medium to large breasts, pendulous stomachs, and huge hips and buttocks; they are certainly well-fed, whether or not any of them are meant to depict pregnancy (e.g. Fig. 12.6, nos. 507, 505 & 506). Their hair is pulled back from the face and neatly tucked into a bun at the back of the head. A third group of standing figures have very large and pendulous breasts, sagging bellies and relatively slim hips and thighs; the only figure with its head intact has painted eyes and a fringe (Figs. 12.5, no. 531, 12.9, no. 529 & 12.10, no. 570). Although other interpretations are possible, these look to me like women whose bodies are worn by work and childbirth, and have lost their muscle tone. All of the seated and reclining figures from House Q.VI.5 are mature women with heavy lower bodies; when heads are preserved, they usually show the same hairstyle as the mature standing figures (e.g. Fig. 12.10, nos. 528, 576, 573 & 519).

A second theme is the depiction of female sexuality. All of the figures from House Q.VI.5 proudly display their bodies; one of their most endearing aspects to those of us no longer young and slim. This characteristic is well-illustrated by a statuette from another context (House Q.VI.4), a woman whose 10-

Figure 12.11. *Hacılar Level VI House Q.6 is actually a small open area to the south of House Q.4. The only image recovered is a stone slab, Mellaart number 500 (12.3 cm).*

from P.VI.3. Thus the distributional evidence indicates that statuettes were meant to be used and viewed as a group. Since we have the best information on context from House Q.VI.5 I will use this assemblage to suggest patterns in the data (Fig. 12.7).

The form of the statuettes suggests that these images are made to be handled (a characteristic of Ucko's initiation figures) rather than displayed (a characteristic of cult images: see Voigt 2000, table 2). First, most of the images are hand-sized, a fact that is obscured by the way in which the statuettes were originally published (scaled to fit a large format page), and perhaps by qualities of the wonderful line drawings that were produced by a sculptor (Mrs Seton Lloyd). Thus clay images that appear monumental on the printed page are instead quite small and delicately modelled. Second, all of the figures are fully three-dimensional.

cm-long body is posed to emphasize her magnificent belly, hips and thighs (Fig. 12.6, no. 525; Mellaart 1970, pl. CXLIX top only, pl. CL, fig. 225). There are also more explicit expressions of sexuality that have been obscured by Mellaart, whose initial, quite reasonable interpretations (1961) were later rejected in favour of an emphasis on childbirth and maternity. The flat figure described above (Fig. 12.8, no. 525) was first described as 'a young girl resting' (Mellaart 1961, 56), but later became a 'young goddess in position of childbirth' (Mellaart 1970, 171). The second interpretation is hard to accept given that the figure is lying on her stomach, and that this stomach is flat as a pancake. The pigtail indicates that this is a young girl, and her position with hands on breasts and legs spread is better described as 'female displaying'. Interpreting this display as signalling a readiness for sexual activity does not have to rest on a modern reading of the piece, but can be linked to a wall painting from Çatalhöyük that is only slightly earlier than the statuette. The painting, from the south wall of Shrine F.V.1, shows a small figure with legs spread, one arm raised and the other resting on her knee; to her left is a standing male grasping his erect penis (Mellaart 1966, pl. LXIIb). A second Hacılar statuette shows a mature woman resting on her side or back with a second smaller figure grasping her hips and legs; the smaller figure is not preserved above the waist (Fig. 12.10, no. 528; Mellaart 1970, pls. CLII–IV, fig. 227). Mellaart initially saw 'the young goddess … in the embrace of the adolescent god' (1961, 56), but later explained that

> … this group does not show a "hieros gamos", but a mother playing with her child. For one thing the sexual act is not depicted, and closer inspection has shown that the goddess is dressed in a painted leopard skin garment … (1970, 170).

Given the position of the smaller figure, its hand shown grasping the hip of the woman, one leg pushed in between her knees and the second wound around her thigh, sexual activity seems to be indicated. There is, of course, no indication of the gender of the smaller figure unless one accepts its slim thighs and buttocks as diagnostic for males. Just who the larger figure might represent is another issue (see below), but the spots, which cover her back, cannot be interpreted as an encumbering garment.

If the life course of women is represented in this suite of images, what about pregnancy and childbirth? Many of the Hacılar statuettes have been described as pregnant, but assessing pregnancy on images depicting women with substantial fat deposits is not easy. To me, most of the figures look fat rather than pregnant, but I do not think that this is a very important distinction within a society in which most women were probably pregnant for most of their relatively brief adult lives. Nevertheless, there is one statuette from House Q.VI.5 that does appear to be pregnant, and her reclining posture may have something to do with childbirth (Fig. 12.10, no. 576; Mellaart 1970, pl. CLI, fig. 226). A second figure that shows a seated woman holding a small child to her side is also arguably pregnant (Fig. 12.10, no. 519; Mellaart 1970, pls. CXLII-III, CLIX bottom, fig. 218). This is also one of the rare depictions of maternity. The only other example comes from House Q.VI.3, a poorly preserved statuette that shows a relatively slim seated woman with two tiny legs resting on one thigh (Fig. 12.7, no. 575; Mellaart 1970, pl. CXLIV, fig. 219).

The last theme is illustrated by a minimum of three images from House Q.VI.5: a close relationship between females and small animals. Mellaart has identified these images as representations of a goddess. The two most complete examples from the Q.VI.5 assemblage show a female seated on a chair. One of these 'chairs' is unambiguously a quadruped (Fig. 12.8, no. 518; Mellaart 1970, pls. CLVI, CLVII left, fig. 228): the long slim tail of the larger animal curling over the female's hip and up her torso makes its identification as a cat reasonable. On the other hand, the small animal that she cradles in her arms has a very thick tail and could as easily be a fox or ferret as a cat. A second figure on a tall seat has slim rolls of clay on her back that have been used to reconstruct a double-cat chair (Fig. 12.8, no. 523; Mellaart 1970, pl. CLVIII, fig. 229). The reconstruction is reasonable if imaginative, but the most interesting thing about this figure is her unique hairstyle, a tiny roll of hair on the top of her head. A third statuette depicting a seated female with legs awkwardly splayed out below the knees is reconstructed with a child climbing up its back; however, the clay scars shown in the photographs make reconstruction of a climbing animal at least as likely (Fig. 12.10, no. 573; Mellaart 1970, 173, pl. CXLV [with erroneous context], fig. 220). All of these images depict mature women, but a fragment from Q.VI.5 shows a slimmer, standing female with a thick tail extending down between her buttocks, and a thin roll of clay running down her leg (Fig. 12.8, no. 577; Mellaart 1970, pl CLIXb [with ambiguous context label], fig. 197). By itself the reconstructed image of this figure would be unconvincing, but a second, more complete example from House Q.VI.3 clearly shows a young woman wearing a good approximation of a modern thong holding a long-tailed cat against her hip (Fig. 12.5, no. 539; Mellaart 1970, pl. CXXVII, fig. 196; note that the head restored on the line drawing does not match the neck of the body, nor does the form of the plait match, illustrating a consistent problem with the Mellaart reconstructions).

Interpretation of these images as depictions of a goddess with her iconic animal has been generally accepted, especially since the discovery of stone and clay images of women depicted controlling large cats at Çatalhöyük (e.g. Voigt 2000). Their presence within the group of statuettes that I consider to depict ordinary women does not invalidate an interpretation of the entire assemblage as a set of teaching devices or more specifically initiation figures. The purpose of initiation figures is to illustrate and reinforce a set of values and behavioural norms expressed as stories, sayings or fables. That some of the lessons might be associated with a supernatural being, especially a female supernatural being, seems more likely than not.

Disposition and wear are critical for arguments about figurine use, but in this case, the images were still in use and, as far as we can determine, carefully curated up to the time of the fire. Most of the House Q.VI.5 figures are badly damaged, a condition that is not hard to explain when fragile sun-dried artefacts were subjected to extreme temperatures and then tumbled down in a collapsing second storey. The conditions under which the images were recovered archaeologically were also difficult: the Level VI houses were all excavated in 1960, and the images from Houses Q.VI.3-5 were found in the last week of excavation (Mellaart 1961, 47). Given both the depositional processes and the haste with which they were removed from their archaeological context, the degree to which vulnerable body parts — and especially heads — are still intact is remarkable. A final consideration is the location of a group of initiation figures in a domestic context. In Ucko's ethnographic sample (drawn almost entirely from East Africa), initiation figures were rarely associated with houses (Ucko 1962; Voigt 2000, table 2). In the case of Hacılar, the figures came from a second-storey room where they were presumably in storage rather than active use, generally isolated from other kinds of artefacts but associated with a significant quantity of grain.

There is, however, some evidence that might indicate what happened to statuettes when they went out of use. Those images that were of sun-dried clay would be easily disposed of by simply putting them in water, but a few figurines were ceramic — slipped, burnished, sometimes painted and then fired — and it is these relatively indestructible images that provide a clue. Mellaart does not provide a catalogue with details of construction and surface finish, so this discussion is based only on those images specifically identified as being fired. Within the group from House Q.VI.5, the single statuette that seems to have been deliberately fired is also the largest, with a height of 24 cm, triple that of many of the other images (Fig. 12.9, no. 520; Mellaart 1970, pls. CXXXI-II, fig. 202). Set on its stubby feet, this figure would have dominated the rest of the images; given this dominance it is worth noting that this figure is also anomalous because of the small size of its breasts in comparison to its heavy lower body, giving an impression of androgyny from the front but still identified as female by its hairdo and profile. The other fired images in the Hacılar VI sample include two of the three statuettes from House P.VI.1, both small fragments (Fig. 12.1, nos. 456, 568; Mellaart 1970, fig. 203a–b); and all four of the statuettes found in House Q.VI.4 (Fig. 12.6; Mellaart 1970, 166). The latter group includes the standing figure of a young woman whose shoulders were partially broken away with her head (Fig. 12.6, no. 486; Mellaart 1970, pl. CXXV, fig. 192); a standing woman whose torso has been battered away (Fig. 12.6, no. 507; Mellaart 1970, pl CXXXVIII, fig. 208); a standing woman represented by a single leg (Fig. 12.6, no. 505; Mellaart 1970, fig. 209); and a reclining woman who is missing her lower legs as well as her head (Fig. 12.6, no. 506; Mellaart 1970, pls. CXIX, top only, CL, fig. 225). Although it is conceivable that all of these images from House Q.VI.4 were damaged in the fire, this stretches credibility given the pristine condition of the fired figure from House Q.VI.5 and the good condition of unfired images from that house. I would instead argue that the images in House Q.VI.4 had been deliberately damaged, presumably at the end of the ritual in which they were used. Support for the deliberate removal of body parts, and especially of heads, comes from House Q.VI.5, where Mellaart reports finding three heads inside a pot (Mellaart 1970, 167)! Mellaart speculates that these were 'perhaps ready for baking' but it is just as likely that the heads were removed as part of a discard process. Taking all of the evidence into account, it seems likely that statuettes were 'killed' as part of a disposal process, but that the pieces of such images retained some value even in their damaged state.

Conclusion

I have argued that three different functional classes of images can be identified for Late Neolithic Hacılar: stone and clay slabs that serve as vehicles of magic and that are specifically associated with dwellings or houses; small clay images that also served as vehicles of magic but perhaps protected or served the purposes of individuals; and larger more elaborate clay images that were used in initiation rituals associated with women. At least some of the initiation figures can also be identified with an iconic figure who may indeed be a goddess, but these are few in number and the majority of the Hacılar statuettes are better

identified as ordinary women, models for adult roles within the society.

As has been pointed out by Lesure (2002, 591), there is considerable overlap in the attributes that I have used to identify figurine use (Voigt 2000, table 4), and this is especially true for cult images and initiation figures. It is unreasonable to expect that the real world falls into neat categories, and especially unreasonable when the categories are based on cross-cultural comparisons. By showing the overlaps between functional types graphically, I deliberately emphasized the fact that we can only deal with increased or decreased probabilities when making inferences about the uses of images in deep prehistory. However uncertain, interpretations based on established patterns of human behaviour are far better than assertions rooted in modern (or even ancient) ideologies.

We can now return to a reconsideration of the clay images from the upper levels of Çatalhöyük. When looked at as part of a continuum that included early stone images, it seemed likely that the clay figures from Building A.II.1 were similar in function, images of supernatural beings used in religious rituals. But if these same images are placed within a context that includes the Hacılar VI clay statuettes, it seems even more likely that the Çatalhöyük clay images were also initiation figures, including young and mature (natural) women, and one spectacular supernatural female identified by her icons, her companion cats. Logically, life-course rituals for girls and women would be mirrored by rituals for boys and men. Hacılar provides no clues to these rituals, but they may be represented at Çatalhöyük in another medium: the wonderful paintings of men and animals found on the walls of the Late Neolithic houses. Ian Hodder has recently linked the hunting images at Çatalhöyük to initiation and feasting, leaving open the possibility that young women as well as men participated in these events (2006, 190, 200). We can never be certain of the meanings and use of prehistoric images, but one thing is clear: it is in the Late Neolithic period in Anatolia that we begin to see highly differentiated images of males and females. The challenge is to use archaeological data to delineate the meaning of these differences in the daily lives of men and women — a process that has already begun at Çatalhöyük.

Note on illustrations

The individual line drawings used to illustrate this chapter were taken from James Mellaart's final report on Hacılar (1970). The purpose of the illustrations is to reconstruct the groups of images associated with specific houses, and to show the approximate size of the different morphological types. Mellaart's drawings have been altered in two ways. First, reconstructions indicated by dashed lines on the original figures have been removed when they seemed dubious. Second, I have attempted to reproduce all line drawings at the same scale based on information culled from Mellaart (1970) and Kolaçoğlu (1992). Mellaart published the line drawings at many different scales, and often did not give his single basic measurement (length of artefact or preserved fragment), so that measurements had to be taken from the line drawings. The size of the images presented on my Figures have to be considered as approximations, since a figurine shown in several views in Mellaart's publication will vary in size from one view to the next (e.g. Fig. 12.10, Mellaart no. 576). Insofar as was possible, the illustrations for this chapter have been scaled consistently to show the relative size of the Hacılar images, but inevitably, there are inaccuracies. Where possible, I have given the length of each artefact as published by Mellaart. Ideally, new measurements for each figurine could be taken, but these data are not critical for the arguments made in this paper. Note that Mellaart did not provide line drawings or photographs for some of the figurines recovered, and that one complete statuette (Mellaart 1970, fig. 194, no. 513) was inadvertently omitted from my illustrations. The building plans come from Mellaart (1970, fig. 7).

Acknowledgements

Few archaeologists have produced the kind of descriptive reports needed to perform the kind of re-analysis on which this paper rests. My thanks go to James Mellaart who has left important legacies to those of us who followed him: detailed and comprehensive reports on his field work and interpretations that still inform the ideas that archaeologists develop about the past of Anatolia. For help in preparing the figures I thank Carrie Alblinger and Sarah Chesney. Christine Eslick copyedited the manuscript and provided comments gratefully received, as did Grey Gundaker, who developed a strong interest in the 'lumpy ladies' of Hacılar.

References

Duru, R., 1994. Höyücek excavations 1990. *Türk Tarih Kurumu Belleten* LVIII(221), 745–50.
Duru, R., 1995. Höyücek excavations 1991–92. *Türk Tarih Kurumu Belleten* LIX(224), 479–90.
Hodder, I., 2006. *The Leopard's Tale*. London: Thames & Hudson.
Kulaçoğlu, B., 1992. *Anadolu Medeniyetleri Müzesi Tanrılar ve Tanrıçalar*. Ankara: T.C. Kültür Bakanlığı, Anitlar ve Müzeler Genel Müdürlüğü.
Lesure, R.G., 2002. The goddess diffracted: thinking about the figurines of early villages. *Current Anthropology* 43(4), 587–607.
Mellaart, J., 1954. Preliminary report on a survey of pre-classical remains in southern Turkey. *Anatolian Studies* IV, 175–240.
Mellaart, J., 1958. Excavations at Hacılar, first preliminary report. *Anatolian Studies* VIII, 127–56.

Mellaart, J., 1961. Excavations at Hacılar, fourth preliminary report. *Anatolian Studies* XI, 39–75.

Mellaart, J., 1966. Excavations at Çatal Hüyük, 1965: fourth preliminary report. *Anatolian Studies* XVI, 165–91.

Mellaart, J., 1970. *Excavations at Hacılar.* (British Institute of Archaeology at Ankara Occasional Publications 9–10.) Endinburgh: Edinburgh University Press.

Thissen, L., 2002. Time trajectories for the Neolithic of central Anatolia, in *The Neolithic of Central Anatolia,* eds. F. Gérard & L. Thissen. Istanbul: Ege Yayınları, 13–26.

Ucko, P., 1962. The interpretation of prehistoric anthropomorphic figurines. *Journal of the Royal Anthropological Institute* 92, 38–54.

Ucko, P., 1968. *Anthropomorphic Figurines of Predynastic Egypt and Neolithic Crete with Comparative Material from the Prehistoric Near East and Mainland Greece.* (Royal Anthropological Institute Occasional Paper 24.) London: Andrew Szimidla.

Voigt, M.M., 1983. *Hajji Firuz Tepe, Iran: the Neolithic Settlement.* (University Museum Monograph 50.) Philadelphia (PA): University of Pennsylvania.

Voigt, M.M., 2000. Çatal Höyük in context: ritual at Early Neolithic sites in central and eastern Turkey, in *Life in Neolithic Farming Communities: Social Organization, Identity and Differentiation,* ed. I. Kuijt. New York (NY): Plenum, 253–94.

Chapter 13

The *Chaîne Opératoire* Approach to Prehistoric Figurines: an Example from Dolnoslav, Bulgaria

Bisserka Gaydarska, John Chapman, Ana Raduncheva & Bistra Koleva

Introduction

The study of Balkan prehistoric figurines continues to suffer from two major and inter-related problems — a superfluity of interpretation and a lack of dynamics. At a time when meaning is at a premium, researchers are prone to ask 'What does this figurine mean?' or 'What does this figurine group mean?' These are vital questions but often researchers assume that the form in which a figurine was made remained the same through use and eventual deposition, unless it was accidentally broken during use and deposited in fragments because it was broken. This leads to a static picture of figurines, whose symbolism and meaning are treated as unchanging — a view that ignores one of the basic material qualities of figurines as images — their fractality (e.g. Bailey 2005; Nanoglou 2005). This view hinders the understanding of the meanings of figurines by providing a fundamentally flawed view of their life-histories. The challenge is to link the fluidity of figurine form with the changing significances that figurines carry throughout their lives. In this short contribution, we hope to stimulate discussion about the utility of the *chaîne opératoire* approach to prehistoric figurines. In our view, this approach provides a theory and a methodology for overcoming both of the problems outlined above.

André Leroi-Gourhan (1964) introduced the term '*chaîne opératoire*' to lithic studies — at the time, as with figurine studies now, a field dominated by typological studies but with new approaches competing for attention. After numerous developments, not least by Geneste (1985), the approach is now the mainstream way of creating rigorous interpretations of Palaeolithic lithic assemblages. In its essence, the *chaîne opératoire* seeks to define stages in the fabrication of a product, each of which can be recognized by diagnostic débitage.

In the absence of a reductive production strategy for figurines, the main difference in the figurine's *chaîne opératoire* consists of the inscription of each stage in its life-history on the figurine itself or on its constituent parts. Once the figurine's parts have been assembled (for discussions of the making of figurines from multiple parts, see references in Chapman 2000; Gheorghiu 2005, etc.), the complete figurine goes through a series of modifications before its final deposition or discard. It is the aim of the *chaîne opératoire* approach to identify the complete sequence of modifications that, collectively, make up a figurine's life-history. Since what we excavate is the final stage of the life-history of a figurine — its discard — the only material evidence we have to fill in the mid-life stages of a personal biography is what is inscribed on the figurine itself.

Our view, which we seek to demonstrate here, is that figurines change in significance — i.e. at different stages of their life-history, they change in respect of the generative principles used to order their making (e.g. structuring principles such as gender, sidedness, verticality, etc.). It should not be surprising that, with changes in their very form and nature, figurines should emphasize new symbolic aspects in relation to the humans who changed them.

The excavation contexts of figurines rarely, if ever, allow us to form a 'reflection' of the life-history of the figurine. Even less probable is the notion that a site figurine assemblage 'reflects' a 'living' assemblage of figurines. But the discard context is vital, since it provides a contextually-rich picture of how figurines were 'killed'. When examined at the site level, but also more generically, figurine life-histories tend to conclude in one of three different ways: A) the discard of complete figurines; B) the discard of parts of figurines that re-fit with other fragments discarded in

Chapter 13

figurines tend to be represented, by photographs or by single-face line drawings, makes it very difficult, if not impossible, to disentangle the life-history of a figurine. We modestly claim that the representations of figurines from sites such as Dolnoslav (see Figs. 13.5–13.7 & 13.9–13.10), Sedlare and Omurtag (Gaydarska *et al.* 2005) set new standards for figurine illustration.

In this paper, we shall present an example of the life-history approach through the examination of a specific data set — a figurine assemblage from a single site in southern Bulgaria. We begin by setting the scene with a brief characterization of the site of Dolnoslav. We shall then turn to some more general questions that could benefit from a life-history approach:

1. How did people use the changes in principles embodied in figurines (gender, sidedness, verticality, etc.) throughout their life-times?
2. What can fragmentation studies contribute to the study of figurines?
3. What is the significance of right — left sidedness in figurine depositional practices?

The site of Dolnoslav

The prehistoric landscape of southern Bulgaria is dominated by settlement mounds (or 'tells') which stand out in the plains and lowland valleys as significant places, both for the coeval settlers and for their ancestors (Chapman 1997). Tell-formation implies the decision to return and live directly above where the ancestors had lived. There is an obvious bias in the recognition of tells as contrasted with flat settlements, which are much harder to find. Nonetheless, it is possible to identify phases in Bulgarian prehistory in which the decision to live on tells was more or less emphasized. While the Karanovo IV phase (the Late Neolithic) has few tell occupations, there is no doubt that the Karanovo VI phase (the Late Eneolithic) shows the highest density of tell occupation (Todorova 1979, karta 3). One of the tells occupied in two phases with a long intervening hiatus is the tell outside the modern village of Dolnoslav.

Figure 13.1. *Plan and aerial view of the Late Eneolithic occupation layer of Dolnoslav (Sources: upper — Raduntcheva 1996; lower — modified from Koleva 2002.)*

other parts of the same site; C) the discard of 'orphan' figurine fragments (*sensu* Schiffer 1987) — that do not re-fit with any other figurine fragment on the site but may re-fit with fragments discarded off-site (e.g. on another site). Each of these different end-results can be interpreted through the discussion of principles such as integration (the integration of the individual person, the household group, the lineage or the community) and enchainment (the creation of material links of exchange with other persons, either on site or between sites). But a richer body of data awaits careful examination of the figurines themselves in a study of their *chaînes opératoires*.

There is also an issue of representation that our research raises. The manner in which prehistoric

The Dolnoslav tell is located in the Maritsa valley, in the southern part of the Thracian plain. The tell measures 6.25 m in height and has an oval form, with basal dimensions of 105 m by 64 m. There are two main prehistoric horizons — the earlier, dating to the Early Neolithic, has not been investigated at all, while the Final Eneolithic horizon has been almost totally excavated by A. Raduntcheva and B. Koleva over nine seasons (1983–91) (Raduntcheva 1996; 2002; Koleva 2001; 2002).

The Final Eneolithic occupation (Fig. 13.1) was enclosed by a low dry-stone wall of river pebbles. Immediately inside the enclosing wall was an open area, partly explored, whose flat clay surface was coloured black through the admixture of manganese. This was separated from a second zone with clays of different colours in different phases by a narrow zone of fine river pebbles. Inside the open area was a zone of buildings, part of whose internal space was dug into the soil up to 0.30 m in depth. Within this zone was a group of buildings that were built upon the flat cleared surface of the tell. Finally, there were some structures in the centre of the site that were built upon an artificial platform 0.60 m in height. In this reading of the site plan, we can see a concentric pattern of structures, with an increase in the vertical dimension as people moved towards the centre of the site. This must have produced a very striking visual pattern of a relatively low mound in the plain with increasingly visible and dominant central structures.

When the Final Eneolithic group who re-settled Dolnoslav came to the site, they would have seen a low, ancestral mound that had not been occupied for about one millennium. The excavators recognized three phases within the overall Late Eneolithic occupation but the very first act of the new settlers was the construction of a platform measuring a maximum of 40 × 20 m in the centre of the mound. This operation could be termed the Pre-A Phase.

The platform acted as the foundation for seven structures built in the first phase of occupation (Phase A). A total of 21 other buildings were constructed on the flat surface of the mound. Only Buildings B1, B2, B3 and the central Shrine were fully investigated in their earliest phase (Phase A) of use. The plans of the buildings were generally rectangular or trapezoidal, with only one single circular structure (B18). The buildings were mostly one-roomed; only two are two-roomed.

In the second phase (phase B), all of the 28 structures in the site continued in use. A stone cobbled surface was laid down east of B10. The site was carefully planned to ensure easy access to each building, with an east–west running-path that divided the site into equal halves. The surface of the encircling open area was plastered with a black clay near the wall and a yellow clay towards the interior; it is believed that the dry-stone enclosure wall was by then in existence.

A major change in the arrangement of the structures took place in the third phase (Phase C). In the southeast part of the mound, three buildings (B14, B15 & B20) were dismantled and their remains, including their Phase B finds, were covered with a deposit of earth mixed with daub, much charred grain and including much other material culture. This deposit is the midden D3 ('middens' are referred to as 'depots' in the figures) and covered an area of $c.$ 15 × 15 m. The demolition and sealing of these three buildings created a large open area in the southeast part. This is thought to have resulted in the construction of a new entrance on the south side of the enclosure wall. Despite these changes, the majority of buildings (25 structures) in the inner area continued in use. In this phase, the inner open areas between the houses were plastered with a mixture of red ochre and clay to produce a striking red surface. The surfaces of the outer open areas near the enclosure wall were plastered with a grey-green clay with various other coloured nuances, that was shaped into various bas-relief shapes (Raduntcheva 1996), with the black manganese-rich clays still between this zone and the enclosure wall.

After some time had elapsed, all of the remaining 25 buildings were deliberately burnt down, together with their rich and varied contents. This could be termed the Post-C Phase. The mass of burnt building materials created a destruction deposit that was up to 1.5 m thick in some places. Part of this ritual closure of the site included the middening of large quantities of earth mixed with daub and containing much material culture in three parts of the inner area: middens D1 and D2 were deposited on the east–west path, while midden D4 was deposited south of B1 and B2. The excavators suggest that, after this act of closure, the building remains were covered with soil and the mound was plastered with white mineral. Much of the details recorded in the excavation therefore refer to the closure of the site — the destruction of the Phase C structures and internal features, as well as the destruction of three structures and their closure under midden D3.

In terms of the five phases of the sequence at Dolnoslav, the vast majority of artefacts was deposited in Phase C, with the destruction of the buildings transforming them into a series of more or less sealed 'death-of-building' assemblages. For example, from a total of over 500 figurines, none was placed in the initial platform, only four were deposited in the first phase, fewer than ten in the second phase and over

DISTRIBUTION OF SIMPLIFIED TYPES

Figure 13.2. *Distribution of simplified types of figurines, Dolnoslav tell.*

480 in the third phase. One major exception is the large quantity of pottery mixed with the earth to form the initial building platform in the Pre-A Phase.

As a final but vital introductory point, there are very few grounds for believing that the finds placed in the destroyed buildings of the second and third phases constitute in any sense a 'living assemblage' of artefacts that 'reflected' the social and economic activities of the inhabitants of the Dolnoslav mound. Most of the finds represent deliberate collection of objects for deposition in a wide variety of contexts. The time dimension of the collection of such assemblages should not be under-estimated.

The figurines from Dolnoslav

Fired clay figurines were the third most common artefacts on Dolnoslav tell, after antler tools and pottery. During the re-fitting study performed in the spring of 2004, 500 anthropomorphic figurines were analysed, omitting more than 200 clay zoomorphic, bone and marble figurines (for a more detailed presentation of the Dolnoslav figurines, see Chapman & Gaydarska 2006, ch. 6). They were divided into 24 'types' or body parts according to their morphological characteristics. The assemblage as a whole is typical for the Balkan Late Copper Age presenting some widespread types of figurines such as seated or standing figurines, as well as some less common types designed as single body parts, such as ear, bust or arm. The terms used to denote the types in the current study are based on the visual body part(s) and their position on each individual artefact, instead of attempting to link the figurines to any of the existing classification schemes. Thus, if a body and legs are present, the figurine is assigned as TOLE (i.e. torso and legs) rather than either as standing or as 'N 123 or class *fragment*, type *legs*' (Vajsov 1992, 41). The distribution of simplified types, in which the 13 types represented by less than 1 per cent are unified in the category 'Others', is given in Figure 13.2. The most common body part is the leg (Fig. 13.6), followed by hollow (SA) figurines, standing figurines (Fig. 13.8) and torsos with legs (Fig. 13.5). The majority of the figurines is medium-sized (61 per cent), followed by small figurines (34 per cent). Most of the fragments are proportional — medium-sized in length and small in width.

Five gender categories were identified on the basis of the gender traits present on the fragments. Female figurines were determined by the presence of breasts and/or incised pubic triangle (Fig. 13.4). For simplicity and because of the relatively low number of such examples, the ranking of the fragments by the number of traits — one or two — was avoided. Male figurines were determined by fragments with male members, while hermaphrodite fragments have both female and male attributes (Fig. 13.5). An interesting gender category is the unsexed group of figurines. They comprise figurines and body parts that might have been gendered but instead the makers chose to leave them unsexed. The last gender group is the group with fragments with no gender information, that consist of body parts that usually do not have gender traits — e.g. heads, arms, legs etc. (Fig. 13.6).

Of the three main contexts in which clay anthropomorphs were found — buildings, middens and open areas, the majority of the figurines is deposited in the middens (n = 208 or 41 per cent). There are fewer figurines from the buildings (n = 179 or 36 per cent) and significantly fewer examples from the open areas (n = 113 or 23 per cent). The number of figurines deposited in one building varies from 1 to 17 but the mode is 7, found in five buildings; the number of types deposited in one building varies from 1 to 9.

The life-histories of figurines

The study of artefact biographies seeks to identify the social implications of the multiple activities performed on certain objects after their production. Many figurines from Dolnoslav tell (n = 213 or 42 per cent) have features that are the result of either pre-fragmentation or post-fragmentation treatment or both. Our observations on the production of the 'raw' figurine bodies will be presented elsewhere (Gaydarska *et al.* in prep.). In this section, we summarize the evidence for modification of the raw bodies in the form of a *chaîne opératoire*.

The *Chaîne Opératoire* Approach to Prehistoric Figurines

Figure 13.3. *Right buttock and leg showing incised motifs with white incrustation and red crusting (Museum no. 2992 — H: 11.6 cm, W: 3.9 cm, TH: 2cm).*

Figure 13.4. *Re-fitted upper torso and TOLE with secondary burning on left side (Museum no. 4307 — H: 17 cm, W: 3 cm, TH: 4.6 cm & Museum no. 3681 — H: 5.6 cm, W: 5.3 cm, TH: 4.6cm)..*

Figure 13.5. *Hermaphrodite figurine with re-fitted leg and TOLE, with secondary burning on axis break of left leg (Museum no. 587 — H: 5.5 cm, W: 2.3 cm, TH: N/A & Museum no. 590 — H: 7.5, W: 3.5, TH: 1.3).*

Figure 13.6. *Right foot and lower leg with incised motifs and white & red crusting on axis break (Museum no. 2900 — H: 4.6 cm, W: 2.8 cm, TH: 2.2 cm).*

Pre-fragmentation activities

The first stages in the 'cooking' of the figurine body produce three sorts of contrasts between different parts of the figurine body: 1) matt/gloss contrasts; 2) colour contrasts (two types — different colours of firing and contrasts between the background figurine and the red and/white crusting) (Fig. 13.3); 3) burnt/unburnt contrasts (a few fragments were exposed to secondary burning before later fragmentation) (Fig. 13.4). The presence/absence of these stages can be related to the different forms of figurines, their different genders and the position of the modification(s) in terms of sidedness, verticality, front-and-back, etc. (cf. Biehl 2003).

Fragmentation

The next stage or — more often — series of stages — in the *chaîne opératoire* concerns the breaking of the figurine into two or more parts and, successively, into more parts still. As this discussion develops, it will become clear that *the only way* to explain the data is through deliberate acts of fragmentation.

The vast majority of figurines deposited on the tell were broken (96 per cent). More than half of the complete examples show a clustered deposition in just a few contexts. The ratio of 'complete:fragmented figurines' is equal or very similar for all types of context in relation to the whole assemblage. This proportional distribution of complete and broken objects suggests a common message about the relative importance of integral and fragmented images in all parts of the site: social integration is as important as diverse enchained relations. Each surface break showing a fracture or adjoining fractures (rarely two and even more rarely three) that could have been made by a single blow to the figurine was considered to represent a 'break'. Adjacent 'breaks' that could not have been produced by the same blow were designated as two 'breaks'.

More than half of the figurines have two (28 per cent) or three (31 per cent) breaks (Fig. 13.10). Fragments with one break are fewer (16 per cent), which may be an indicator for the potential of further fragmentation activities (Fig. 13.5, the leg). In contrast, figurines with 4 breaks (15 per cent) represent the late or even the final stages of the fragmentation chain (Fig. 13.7): around 10 per cent of the fragments have five or more breaks (Fig. 13.9, the torso).

The relationship between fragmentation and gender is often complex. Thus, if a figurine with a gendered body and four ungendered limbs has all four of the limbs broken off, creating a gendered body and four limbs, the body would be designated as having four breaks, and each limb be designated as having one break. Most figurines with no gender information have suffered two breaks. Most of the female fragments have three breaks (Fig. 13.4, the lower part), as do many unsexed figurine fragments (Fig. 13.3). Therefore, there is an equal possibility of a fragment either preserving or losing its gender after a third break. In that sense, any body fragment that has passed the third break point without loss of gender may be considered as a body part with targeted gender preservation. The unsexed figurines are dominated by fragments with three breaks; after three breaks, the message of a deliberate denial of engendering is still very clear. It is important to underline that the number of breaks does not affect the gender of the figurines. There are extreme examples of single fragments with up to seven to eight breaks, which preserve their gender even after such intensive fragmentation, while, at the same time, there are cases where a single break removes gender information from one new fragment. Therefore, it could be assumed that the changing of gender may have been one of many goals, but certainly not the only aim of fragmentation practices.

The principle of sidedness enshrines oppositional symmetry and mirror imagery from the outset. Whereas all complete and some broken figurines maintain the integration of opposites (Fig. 13.8), a broken figurine selects for neutrality as to sidedness or a deliberate preference for right- or left-sidedness. In terms of the social action that a figurine performs, a right-sided fragment puts into play the choice of a side with distinctive symbolic connotations for the society in question (Fig. 13.3). It would be unwise to generalize the results of Needham's (1973) global review of right and left in human societies, even in societies based upon the moiety principle of complementary opposition. We should recall that the perception of left and right is not only culturally specific but also relational (e.g. seasonal) and that, in addition, there are multiple examples of reverse associations (e.g. left is sometimes good!). We may re-phrase the effects of fragmentation thus: while a complete figurine maintains the sidedness principle as immanent, fragmenting the figurine brings the principle into social action.

The same is not exactly so for verticality, since this principle is based upon oppositional asymmetry *ab initio*. Thus, the contrast between the head and the rest of the body, and especially the legs, can only be heightened by fragmentation of the figurine — most dramatically in the case of Hamangia figurines, that change gender when the phallic, masculine neck is detached from the female lower parts of the body (Chapman 1999; Chapman & Gaydarska 2006, ch. 3). Here, the principle of verticality differs dramatically from that of sidedness — a contrast with much potential in advanced stages of a figurine's life-history.

Post-fragmentation activities
Post-fragmentation activities are of potentially major significance, since they can demonstrate unequivocally the continued use of figurine parts after their fragmentation. Secondary burning and decoration on breaks occur frequently at Dolnoslav, as do traces of wear, often heavy, on breaks after prior fragmentation.

The most common post-fragmentation activity is the secondary burning traceable on 30 fragments (Fig. 13.5). They were found in all contexts — buildings, middens and open areas — and very few examples can be explained by burning during the last destructive fire. The majority of the breaks are on the left/right axis and leg or bottom (Table 13.1a). There are only three fragments with secondary burning on torso breaks — one has additional burning on the lower torso, the other — over the incised and encrusted decoration, the third over the breast break. A similar number of fragments have burning on arm and neck breaks (Table 13.1b).

Fourteen fragments were crusted with different paint over a variety of different breaks — mostly using white paint but occasionally red paint and a combination of red and white (Fig. 13.6).

Wear over figurine breaks can be demonstrated to have occurred in several cases, indicating long and/or intensive usage after the break. In the illustrated example (Fig. 13.7), there are five breaks, four of which feature subsequent wear. However, most traces of heavy wear cannot be related to the fragmentation sequence. They are found on body parts that may have symbolized a specific activity — e.g. foot, heel or sole (walking), bottom (sitting), back of head (lying). In such cases, heavy wear may symbolize multiple performances of these activities, and hence the long life and experience of the figurine.

Despite the general uncertainty of the time of burning with regard to the fragmentation practice, there are some figurines on which secondary burning was applied before or after decoration, indicating different phases of the figurine's biography, each marked by a separate trace.

The re-fitting exercise
A fundamental aspect of understanding the processes of enchainment through fragmentation was a series

Figure 13.7. *Re-fitted figurine with wear on all breaks (Museum no. 4688 — H: 4.6 cm, W: 4.5 cm, TH: 3.3 cm & Museum no. 5335 — H: 8 cm, W: 8.7 cm, TH: 3.9 cm).*

Table 13.1a. *Fragments with secondary burning on axis break.*

Type of break	No. of examples
Axis break	3
Axis break and top front leg	1
Axis break and back of leg	1
Axis break and right leg	1
Axis break and right side of leg and leg	1
Axis break and leg and bottom	1
Axis break and bottom	7

Table 13.1b. *Fragment with secondary burning on arm or neck break.*

Type of break	No. of examples
Arm break and left side of torso	1
Arm break and bottom	1
Arm break and bottom and back	1
Arm break and on front after incised decoration	1
Arm break and on front below face	1
Neck break and right arm	1
Neck break and right arm and back	1
Neck break and right ear and right neck	1
Neck break and right ear and face	1

Chapter 13

Figure 13.8. *Figurine re-fitted from four parts on site; the four parts were arranged symmetrically around a brown coarse ware storage jar (Museum no. 540 — H: 17.5 cm, W: 8.7 cm, TH: 2 cm).*

of re-fitting studies completed on various materials at different sites. One re-fitting experiment involved the Dolnoslav figurines (for gender and number of breaks of illustrated figurines, see Table 13.2). A few figurines were re-fitted during the excavation from fragments that were found in adjacent contexts (Fig. 13.8). During the new refitting study, another 25 joins between fragments were identified. From a total of 474 fragments, 52 form 25 conjoint examples (Figs. 13.4, 13.5, 13.7, 13.9 & 13.10). This is a relatively high percentage (11 per cent). None of the joins makes a complete figurine; there are three that form 95 per cent completeness with a head or an arm or both still missing. Thus, parts of even these re-fitted figurines were deposited somewhere off the tell.

Most of the joins are between fragments found in buildings and middens (*n* = 8), six of which are between fragments deposited during the last phase C. Only three joins are found between fragments found in different buildings, while there are four joins between fragments found in the buildings and the open areas — one between a phase B and a phase C fragment. There are three joins between fragments found in middens and open areas but only two joins have both matching parts deposited in different open areas. Two joins occur between fragments deposited in phase A and fragments deposited in phase C. It is important to note that re-fitting is documented for *both spatial and diachronic links* of deposition.

The conjoint figurines were coded as female in 15 cases, with six intentionally unsexed, one hermaphrodite and three with no gender information. Seven figurine fragments maintained their gendered identities through the act of fragmentation (five females and two unsexed) while three fragments continued to lack gender information. All the others suffered partial loss of gender information in four ways:

1. Three of the female fragments were each transformed into one female fragment and one unsexed fragment.
2. Seven of the female fragments were each transformed into one female fragment and one or two fragments lacking gender information.
3. One hermaphrodite was transformed into one hermaphrodite fragment and one fragment with no gender information.
4. Four unsexed fragments were each transformed into one unsexed fragment and one lacking gender information. This result reinforces the frequency of the unsexed figurines and stands in contrast to the pattern of Hamangia figurines' gender changes through breakage.

More than a third (*n* = 20) of the conjoint body parts had two breaks, followed by fragments with three breaks (30 per cent) (*n* = 16); relatively few fragments had only one (*n* = 5) or more than three (*n* = 13) breaks. In general, however, there are more parts of joins that revealed a developed or final stage of fragmentation. It is very important to underline that a relatively high percentage of the refitted parts was deposited after one or two breaks — at a relatively early stage of their potential biographies. The majority of breaks have suffered little pre-depositional wear, suggesting that the period between the breakage, the 'use' and the final deposition of figurines was not very long. Alternatively, between the initial stage — the fragmentation — and the final stage — the deposition, the already broken parts were not treated in a way that leaves any traces of wear. However,

six refitted fragments do have traces of wear on their breaks (as on Fig. 13.7). Two of them are worn in more than one place, suggesting a complex life-history.

The most important single conclusion from the re-fitting study is that it provides strong support for the premise of deliberate figurine fragmentation. It is inconceivable that accidental breakage produced this spatial pattern of deposition in two or even three contexts and across two phases of site use.

The life-history of a single re-fitting
Some of the re-fitting figurine fragments also provide valuable insights into the *chaîne opératoire* of the Dolnoslav figurines. A single example will serve to illustrate the potential of this approach to prehistoric figurines in general.

Join 6 consists of two fragments — a head with a top knot found in D1 and upper torso found in building 24 (Fig. 13.9). The head has incised eyes and a mouth and the front of the neck is decorated with incised motif 108. The torso also has incised decoration on front and back — motif 174 (for catalogue of motifs, see the website: http://ads.ahds.ac.uk/catalogue/resources.html?partwhole_ba_2006). The head has no gender information, while the presence of breasts on the torso indicates a female figurine. The head has only one irregular break at the neck in contrast to the seven breaks on the torso. Three of them are irregular — on the neck and on both arms, and three are just flakes detached from the back and both breasts. The seventh break, which is at the point of detachment from the lower torso (the waist), is complex and worn.

Additional features on the fragments are graphite on the front of the neck, traces of wear on the back of the head, the burnished front of the torso and the smoothed back of the torso. Therefore at least four different activities were performed on the fragments from join 6 — graphite application, wear, burnishing and smoothing. There are visual

Figure 13.9. *Figurine re-fitted from two parts: A) graphite linear decoration; B) worn part of head; C) burnishing on front of torso; D) smoothed back of torso (Museum no. 3902 — H: 5.4 cm, W: 8 cm, TH: 4.8 cm & Museum no. 3357 — H: 5.6 cm, W: 5.6 cm, TH: 4 cm).*

Figure 13.10. *Re-fitted left and right hollow feet and lower legs, fragmented at uneven heights (Museum no. 2206 — H: 5.4 cm, W: 5.6 cm, TH: 4 cm & Museum no. 2207 — H: 3.4 cm, W: 5.6 cm, TH: 3.5 cm).*

overlaps between two of the treatments — the application of graphite and the burnishing both result in black shining surfaces. The fact that two techniques were applied to achieve similar effect suggests the possibility that these operations were executed after the head was detached from the body. Otherwise, it

Table 13.2. *Descriptions of illustrated figurines by gender type and number of breaks.*

Fig. no.	Museum no.	Gender type	No. of breaks
13.3	2992	unsexed	3
13.4	4307	female	4
13.4	3681	female	3
13.5	587	no information	1
13.5	590	hermaphrodite	4
13.6	2900	no information	2
13.7	4688	no information	3
13.7	5335	female	5
13.9	3902	female	7
13.9	3357	no information	1
13.10	2206	no information	2
13.10	2207	no information	3
13.13	2302	no information	2
13.13	2835	unsexed	3

would be difficult (but not impossible) to perform either manipulations on one part (e.g. burnishing of the torso) without leaving any traces on the other. We cannot exclude the possibility that different body parts *had* to be treated differently, in which case these techniques were performed on a more or less complete figurine. In any case, it is clear that the front of the figurine was deliberately treated to present one part in colour and matt/gloss contrasts. The other part consists of the relatively rough back (a worn head and smoothed but not burnished back with detached flake) in opposition to the carefully treated front. Even if the body parts were treated as fragments (head and torso) rather than as a whole, the front/back opposition remains significant.

From the moment of its creation to the moment of its final deposition, the head has passed through three major manipulations — detachment from the body, application of graphite and wear. Much more varied was the life-history of the upper body part. It has been transformed at least nine times — four major detachments from the head, lower torso and both arms, four minor detachments from the back and both breasts, burnishing, smoothing and wear. The only secure sequence of activities is that burnishing and smoothing took place before the detachment of the flakes — otherwise, the polishing activities would cover the places of detachment. It is important to point out that the removal of the breasts does not change the gender of the figurine; although the breasts are absent, their traces are indicative of female affiliation. This is in contrast to the Hamangia figurines where breakage can erase any traces of previous gender. The question of why the breasts were removed can be approached by putting the answer in the perspective of de-gendering by breakage — the most famous

of which is the case of Hamangia figurines. Since the body morphology of the vast majority of Dolnoslav figurines does not imply androgyny, single or indeed series of breaks cannot readily erase the initial gender. There are, however, some activities like smoothing and burnishing that may have aided the full de-gendering of the figurine. The fact that they were not undertaken suggests that full de-gendering was not sought before the final deposition of the upper body part in building 24, 5–7 m from the head, deposited in D1. There are at least three remaining body parts that were not deposited on the site.

Implications

There are important implications of the fragmentation and re-fitting study:
A. their relevance to deliberate fragmentation;
B. their significance for enchainment;
C. their implications for movement of figurines between sites and off-site to on-site.

Sceptics of deliberate figurine fragmentation are obliged to answer the question 'Where are the missing fragments?' — a question few have tried to tackle yet, let alone answer convincingly. It is clear that, on a site excavated without sieving, full recovery of microliths and small copper objects is improbable. But our Balkan colleagues have a strong interest in figurine fragments, most of which are more than 1 cm in width and often several cm in length. It would be unwise to seek a solution to the question of the missing fragments by blaming poor recovery techniques. Moreover, a tiny proportion of vessels in the Balkan Chalcolithic have grog temper (temper made from fragments of broken ceramics) and there is scanty evidence for manuring scatters involving ceramic being spread onto fields. If we eliminate these three possible explanations of the disappearance of figurine fragments, we are left with very few — possibly no — alternatives to the core principal premise of fragmentation studies — that people broke figurines into two or more parts and used the parts (standing for the wholes) in further social practices.

There are also a number of figurines whose manner of breakage is virtually impossible unless it was deliberately conceived. This notion is particularly applicable to hollow figurines, such as the joined hollow legs broken at different heights (Fig. 13.10). Other cases include figurines broken axially to provide a back half and a front half. The idea of specialist figurine-knappers has been proposed to account for such skilled practice (Chapman 2000).

The fragmentation premise is supported by at least two further observations presented here — the

post-fragmentation treatment of the fragments and their deposition in different parts of the site. Either observation demonstrates the continuing use of fragmentary figurines. It is manifestly absurd to believe that red and/or white crusting could have occurred accidentally on figurine fragments. Heavy wear is equally difficult to reproduce accidentally. The location of burning on many fragments makes it impossible for it to have occurred during the final burning of the buildings; in any case, secondary burning on fragment breaks occur on figurines deposited in the middens, that were not burnt *in situ* but which incorporated ash, as well as in open areas that were not burnt at all.

How could fragments from the same figurine have been discarded in different parts of the site? Schiffer, O'Sullivan, Skibo and many collaborators in the USA have worked long and hard on this question and they have documented many means whereby materials move around a site after initial discard (Schiffer 1987; Skibo *et al.* 1989; Sullivan *et al.* 1991). Children are a potent source of fragment re-location but all residents (human and animal) may be responsible. While this argument may explain the movement of figurine fragments into open areas of the site, it is unlikely to be relevant to the deliberate filling of middens and buildings-to-be-burnt. Moreover, the use of figurines in key social practices may have placed a prohibition on random or accidental displacement. Most of the American research related to discarded sherds and lithics, whereas ritual objects do not play a part in this research. The random/accidental relocation idea also cannot explain the re-fitting of fragments across occupation phases; here, we are dealing with deliberate curation of fragments to reinforce trans-generation ties of enchainment. While the accidental/random relocation idea cannot be rejected for all fragments, it is much more probable for the majority of figurine fragments that each fragment was deliberately placed in a different context to provide a material basis for enchainment.

The notion of enchainment has been mentioned several times in this paper and was deployed in a weak sense in the 2000 book. There, it was argued that enchainment was one of the most likely explanations as to why object fragments went missing. But extensive reading has failed to discover a general principle to replace enchained relations to explain the cases of missing fragments in totally excavated sites, or closed entities such as graves, ritual sets, costume sets, burnt houses and hoards. We are now persuaded that a closed context containing part of an object, with another part missing from that same context, is an indication of enchained relations between the context

Figure 13.11. *Distribution of sidedness: A) all phases; B) Phase C; Key: L = left; R = right; N = neutral; C = no information.*

and somewhere else. The hard part is, of course, to find that elusive 'somewhere else'. But there is now accumulating evidence for inter-site as well as intra-site re-fits that cannot be disregarded by the sceptics (Chapman & Gaydarska 2006, ch. 5).

We now turn to the spatial implications of the large number of 'orphan' figurine fragments and, indeed, those re-fitted figurine parts that still miss further parts. Given the almost total excavation of the Final Chalcolithic levels of the tell, we are persuaded that a high proportion of figurine fragments are missing; in other words, the Dolnoslav assemblage is part of a much wider set of figurines, mostly fragments, deposited in other contexts, perhaps many other places — for example, other sites. The Completeness Index for the assemblage shows that the vast majority of anthropomorphic figurines are represented on-site by less than 50 per cent of their body mass. The difficult question for us and for all researchers into fragmentation is whether a complete figurine existed on-site, was broken and parts removed off-site, to another place, or whether complete figurines made in other places (off-site = other sites) were broken somewhere else and only parts of the figurines were brought for deposition

Chapter 13

A DISTRIBUTION OF RIGHT AND LEFT PARTS, MIDDENS

- 4%
- 31% L
- 32% R
- 33% N
- (C)

B DISTRIBUTION OF RIGHT AND LEFT PARTS, OPEN AREAS

- 3%
- 30% L
- 32% R
- 35% N
- (C)

C DISTRIBUTION OF LEFT AND RIGHT PARTS, BUILDINGS

- 4%
- 29% L
- 22% R
- 45% N
- (C)

Figure 13.12. *Distribution of sidedness by context type: A) middens; B) open areas; C) buildings; key as Fig. 13.11.*

to Dolnoslav. One criterion may relate to the number of breaks suffered by the figurine and the extent of its surface wear prior to or subsequent to fragmentation. But we must admit that we find it hard to find criteria to answer this intriguing question that, from a fragmenterist's perspective, is logical but complex.

Right- and left-sidedness and the balance of deposition
We now turn to the third and final question concerning figurine deposition. One of the main principles underlying the deposition of figurines in Dolnoslav proved to be the left/right opposition. Complete figurines form 4 per cent of the assemblage. From the remaining fragments, the percentage of body parts that have no clear indication for sidedness is relatively high (37 per cent). These are fragments that are either entirely neutral to sidedness, such as heads or body parts that have both left and right side — e.g. both legs. However, more than half of the figurines (59 per cent) have some information for either left or right side; their relative distribution proved to be very similar — 30 per cent left parts and 29 per cent right parts, both overall (Fig. 13.11a) and in Phase C (Fig. 13.11b).

All categories — left, right and neutral are present in each context — middens, buildings and open areas. Together, the left and the right parts are dominant in both the middens and in the open areas with relatively equal distributions (Fig. 13.12a & b). A different pattern is observed in the buildings, where the left and the right part hardly exceed 50 per cent, and there is slight dominance of left over right parts (Fig. 13.12c).

The distribution of left, right and neutral parts in each of the middens is proportional to the total number of figurines in D1, D2, D3 and D4. The pattern of deposition shows a prevalence of right parts in D1 and D2, and prevalence of left parts in D3 and D4, which resulted in an overall balanced distribution of left and right parts in the middens (Fig. 13.12a).

The preference for deposition of neutral parts in the built area (Fig. 13.12c) is more obvious in the detailed distribution of body parts in the buildings, where 15 are dominated by neutral parts. The pattern of deposition is very complex. The overall pattern of distribution in the built area suggests that the left/right opposition was not the main depositional principle there. Or, more precisely, it was in conjunction with another depositional principle that finally produced the complex cumulative result.

Apart from the symmetries in the spatial distribution of the different body parts, there is a no less striking symmetry in left and right fragments as types. The similarities are found not only in the deposited left and right types but also in their numbers.

There are many ways in which to interpret the meanings of the right/left complementarity/opposition. Here, we wish to emphasize one main question of *deposition*. How is it that there is such a balance of right- and left-sided figurine fragments in the Dolnoslav deposition? Are we to believe that such balance at several different levels (site level, combined houses, combined middens, combined open areas, types of figurines) could have occurred by chance? If readers continue to believe — against the evidence presented here — that figurine fragments are simply rubbish, thrown away after use or discarded to destroy their remaining ritual power, then the accretion of single acts of discard over years or decades would be the normal (nul) response to the problem of right-/left-sided balance. But if any of our previous arguments have convinced the reader of deliberate fragmentation, then the problem of such a balance becomes more interesting, for the following potential reasons.

The vast majority of Dolnoslav figurines was discarded in two contexts, both of which showed the tendency to associate diverse types of material culture in a massive statement of accumulation — the burnt buildings and the middens. Such accumulations were the equivalent of burials in much of the Late Chalcolithic of Thrace. These contexts of accumulation gained meaning in three ways — by their associations with material remains, by the personal biographies that are attached to the things and by the presencing of associations and physical parts. The inclusion of a left TOLE (torso and leg) of a figurine in one midden whose right parts were placed in a building 30 m away links not only the parts of the figurines but their associated objects and *their* biographies in a complex network of significance — the enchained network that provided at once the structure of social practices in the site and the material means for the practices themselves.

The problem of the right-/left-sided balance can now be re-phrased: Were there many people who were aware not only of the general principle of the balance of sidedness but also of the importance of achieving a numerical balance of right and left parts in the different contexts of deposition and at the site overall? For example, individuals from each household who negotiate the location and type of figurines for deposition with those with the right (not a random use of the term!) to deposit material culture? These household ritual heads would have required meetings to coordinate such strategies and decide upon the nature of the next act of deposition. Or are there individuals (an individual?) who direct(s) such operations at the level of the entire community and maintain(s) counts of how many right-sided fragments have already been placed on such and such a midden? It is worth reflecting upon the existence of simple tallying methods that could readily be used to achieve these varying balances. As the reader may imagine, we find it problematic to pursue this line of reasoning too far but anyone left unsatisfied by the 'random dumping of rubbish' alternative will need to confront these difficult issues.

Conclusion

Our understanding of much recent research is that deliberate fragmentation is a fundamental feature of not only later Balkan prehistory but also of communities living in many other times/places. The evidence for deliberate fragmentation is increasing each year, both at the level of inter-site data and intra-site data, such that the social practice can no longer be ignored by anyone seriously interested in material culture. Through a combination of the *'chaîne opératoire'* approach with that of object biographies, we have used the Dolnoslav figurine assemblage to raise a series of what we hope are stimulating questions about the relationship between social practices and figurine life-histories. The Dolnoslav study supports the premise of deliberate fragmentation in four ways:

1. *Intra-site re-fitting of fragments from different depositional contexts.* The physical re-fitting of two or more fragments together, or even the probability at greater than 50 per cent of such re-fitting, means that there is a *prima facie* case that objects were deliberately broken and their parts deposited in different contexts, with the proviso that it is possible to rule out the movement of objects from their place of initial deposition to another place (e.g. by children, accidental movement or through erosion and re-deposition). Given the social significance of figurines, it is considered unlikely that such post-depositional movement occurred. Moreover, in the case of Dolnoslav, many contexts of deposition were more or less 'sealed' (i.e. burnt houses midden deposits), making such movement of fragments still harder to accept.
2. *Orphan figurine fragments whose related parts must have been deposited off tell or on other sites.* In cases where sites have been totally excavated with high standards of recovery, it is logical to accept that orphan figurine fragments have other parts that were taken off the site or, conversely, that the figurine was broken in another place and the orphan fragment was brought onto the site.
3. *Post-fragmentation decoration, wear and secondary burning over the breaks.* The continued use of figurines after the break can be well supported

when evidence for such activities is found on the breaks.
4. *Depositional practices of fragments leading to left/right balanced deposition in several nested spatial levels of analysis* (the site as a whole; middens as a whole; Open Areas as a whole; and buildings as a whole; also some individual houses, middens and Open Areas). This practice represents another important source of categorization, with interesting symbolic implications, which depends for its creation on deliberate fragmentation.

We hope that this study will provoke researchers into all kinds of images to consider breakage as something more than the inevitable consequence of accidental damage. There is much life left in a figurine 'after the break'.

References

Bailey, D.W., 2005. *Prehistoric Figurines: Representation and Corporeality in the Neolithic*. London & New York (NY): Routledge.

Biehl, P., 2003. *Studien zur Symbolgut des Neolithikums und der Kupferzeit in Südosteuropa*. Bonn: Habelt.

Chapman, J., 1997. Places as timemarks: the social construction of prehistoric landscapes in eastern Hungary, in *Semiotics of Landscape: Archaeology of Mind*, ed. G. Nash. (BAR International Series 661.) Oxford: Archaeopress, 139–64.

Chapman, J., 1999. Where are the missing parts? A study of artefact fragmentation. *Pamatky Archeologicke* 90, 5–22.

Chapman, J., 2000. *Fragmentation in Archaeology: People, Places and Broken Objects in the Prehistory of Southeastern Europe*. London: Routledge.

Chapman, J. & B. Gaydarska, 2006. *Parts and Wholes: Fragmentation in Prehistoric Context*. Oxford: Oxbow Books.

Gaydarska, B., J. Chapman & I. Angelova, 2005. On the tell and off the tell: the fired clay figurines from Omurtag, in *Scripta praehistorica M. Petrescu-Dîmbovița Festschrift* eds. V. Spinei, C.-M. Lazarovici & D. Monah. Piatra Neamț: Centre International de Recherches de la Culture Cucuteni, 341–85.

Gaydarska, B., J. Chapman, A. Raduncheva & B. Koleva, in prep. Images from prehistory: a Late Copper Age figurine assemblage from tell Dolnoslav, Bulgaria.

Geneste, J., 1985. Analyse lithique d'industries moustériennes du Périgord: une approche technologique du comportement des groupes humains au Paléolithique moyen. Unpublished PhD thesis, Université de Bordeaux.

Gheorghiu, D., 2005. The controlled fragmentation of anthropomorphic figurines, in *Cucuteni: 120 ans de recherces, le temps du bilan*, eds. Gh. Dumitroaia, J. Chapman, O. Weller, et al. Piatra Neamț: Centre International de Recherches de la Culture Cucuteni, 137–47.

Koleva, B., 2001. Niakoi nabljudenia vurhu arhitekturata na kusnoeneolitnia kultov obekt pri Dolnoslav, Plovdivsko. *Godishnik na arheologicheskia muzei Plovdiv* X, 5–19.

Koleva, B., 2002. Prostranstven model na inventara ot purvi stroitelen horizont na kusnoeneolitnia obekt pri Dolnoslav. *Godishnik na arheologicheskia muzei Plovdiv* IX(1), 120–30.

Leroi-Gourhan, A., 1964. *Le geste et la parole, I: technique et langue*. Paris: Albin Michel.

Nanoglou, S., 2005. Subjectivity and material culture in Thessaly, Greece: the case of Neolithic anthropomorphic imagery. *Cambridge Archaeological Journal* 15(2), 141–56.

Needham, R. (ed.), 1973. *Right and Left: Essays on Dual Symbolic Classification*. Chicago (IL) & London: The University of Chicago Press.

Raduntcheva, A., 1996. Dolnoslav: a temple centre from the Eneolithic. *Godishnik na Department Arheologiya, Nov Bulgarski Universitet* II/III, 168–81.

Raduntcheva, A., 2002. Eneolithic temple complex near the village of Dolnoslav, district of Plovdiv, and the system of rock sanctuaries with prehistoric cultural strata in Rodopi Mountains and outside its territory. *Godishnik na Arheologicheski Muzei Plovdiv* IX(1), 96–119.

Schiffer, M.B., 1987. *Formation Processes of the Archaeological Record*. Albuquerque(NM): University of New Mexico Press.

Skibo, J.M., M.B. Schiffer & N. Kowalski, 1989. Ceramic style analysis in archaeology and ethnoarchaeology: bridging the analytical gap. *Journal of Anthropological Archaeology* 8, 388–409.

Sullivan, A.P., J.M. Skibo & M. van Buren, 1991. Sherds as tools: the role of vessel fragments in prehistoric succulent plant processing. *North American Archaeologist* 12(3), 243–55.

Todorova, H., 1979. *Eneolit Bolgarii*. Sofia: Sofya Press.

Vajsov, I., 1992. Antropomorfnata plastika na kultura Hamangia. *Dobrudza* 9, 35–70.

Chapter 14

The Emergence of Anthropomorphic Representation in the Japanese Archipelago: a Social Systemic Perspective

Koji Mizoguchi

Theoretical introduction: defining 'spirituality'

How one defines 'spirituality' depends upon how one understands 'sociality'. For a human being to be 'spiritual' — i.e. able to make sense of happenings/contingency in the world by referring to something *other than* the happenings themselves through the mediation of *belief* of some sort — implies a belief system. The existence of others doing the same (or believed to be doing the same) — i.e. making sense of a certain, and *contingent*, happening through the mediation of the same mind-set — is a vital prerequisite for this process.

We have to make sense of happenings in the world in the form of transforming the *contingent* to the *rational/explainable*. That the happenings include the human-made as well as the natural means that the technology of making sense, i.e. converting the contingent/illogical into the explainable/logical, has to be 'socially' shared. In other words, this 'technology of making sense' is the technology of solving problems, which are actually contingent to each individual who experiences them, by making them look *widely shared* and hence, *communicable*. For instance, the members of a small-scale society often make sense of diseases, accidents and natural disasters by attributing their causes to the anger of the spirits of various sorts, i.e. the natural, the ancestral, and so on (e.g. Turner 1967).

The above implies that those artefacts which are recognized as having been involved in 'spiritual' activities *mediated* the act of the making sense of contingent happenings in the form of making them explainable and communicable, i.e. *rationalizing* them. Besides, importantly, communication itself intrinsically involves contingency. According to the German sociologist the late Niklas Luhmann, communication consists of *information, utterance,* and *understanding,* and each of them constitutes a distinct *horizon of choices*: one individual *chooses* what information to utter and how to utter it, and the other *chooses* how to make sense of the utterance (Luhmann 1995, 137–75). Importantly, those who are involved in a given communication cannot confirm *directly* whether the information and the *chosen* understanding coincide, i.e. one cannot directly observe what is going on in the other's mind/*psychic system* (Fig. 14.1) (Luhmann 1995). Instead, they inevitably have to *infer* whether the information and the understanding coincide by observing *whether the communication continues,* i.e. one utterance is articulated to/followed by the next. In other words, *co-presence* enables people to *feel* they are mutually understood.

However, as the scale of a society increases in which certain types of communication have to repeatedly be restarted after periods of recess, specific devices other than the *co-presence* of those who are involved in a previous communication become necessary to ensure the smooth restarting of the communication. I would argue that those artefacts which are recognized to have been involved in 'spiritual' activities helped certain types of communication to be reproduced across such spatio-temporal gaps; if a certain *belief* is connected to a certain material symbol/image, the physical presence of that symbol/image would ensure for those who are involved in the communication that a *proper* mutual (pre-)understanding (i.e. pre-sharing of the framework which is perceived to guarantee the continuation of communication) exists.

A hypothetical assumption upon which the argument of this paper draws is that anthropomorphic clay figurines of the Japanese archipelago, which have widely been recognized as reflecting elements of the spirituality of the people of the Jomon period of the Japanese archipelago (c.12,000–2600/2500 BP), can be understood to have functioned as such, as a *symbolic communication medium*. To reiterate, by a symbolic communication medium I mean an item or set of items, the presence of which initiates/reinitiates a certain communication between individuals in which

Figure 14.1. *Closed self-referential reproduction of psychic systems and communication. 'Spirituality' enables the continuation of communication by helping the generation of 'sociality'.*

they automatically assume that they share a set of mutual expectations and a set of norms for dealing with a certain contingency.

Now, we have to deal with the issue of what leads a certain communication to be described as 'spiritual'. The involvement of a symbolic communication medium is not, in itself, enough: not every symbolic communication medium mediates *spiritual* acts/communications; for instance, money functions as the symbolic communication medium for the economy by providing a norm by which the participants in a financial communication can decide whether to continue that transaction. It can also be deduced that the type/appearance of a medium itself does not necessarily make the acts/communications in which it is involved, 'spiritual'.

If we heuristically replace the category 'spiritual acts' with the category 'ritual acts', we can deduce that it is the way in which a certain type of contingency is rationalized by a communication that makes the communication ritualistic, and hence, spiritual. This recognition leads us to the consideration of how contingency in general is processed through communication. If we recognize communication as a system which reproduces itself in a self-referential manner, it can be said that its reproduction takes the form of *reducing* the complexity generated by contingent occurrences in the world by referring to its memory store, i.e. the memory of how things/images were connected and processed by itself on previous occasions. The *reduction of the complexity* takes the form of *making choices*: choosing one amongst many possible reactions to a given contingent occurrence. 'Ritualistic communication' is commonly recognized as reducing the complexity generated by the types of contingency which are related to the *reproduction of a given community,* e.g. birth, death, and other events which are characterized as rites of passage, the acquisition of food and other resources, and the generation and maintenance of various types of social relations and, inevitably, power. The manner of the reduction in complexity is commonly formalized and standardized (cf. Bloch 1989), and the reduction often takes the form of connecting the characteristic elements (or, at least, those so recognized/differentiated by individuals who are involved in it) of a given contingent occurrence to symbolic referents and then manipulating them, i.e. giving an order to (or rather 'taming') them and/or transforming them to a *rationalizable* form (cf. Needham 1979).

In that sense, symbolic communication media also often function as such referents, and hence are structured and transformed, e.g. a) formalized; b) treated in a structured manner and c) sometimes destroyed (the destruction being an extreme form of transformation).

The above theoretical explication allows us to deduce the following premises and strands of enquiry for the current investigation.
1. The clay anthropomorphic figurine of the Jomon of the Japanese archipelago functioned as a symbolic communication medium as well as a symbolic referent, both defining and being manipulated in ritualistic communication.
2. The communication system which was marked and mobilized by clay anthropomorphic figurines would have reduced the complexity generated by certain types of contingency related to the reproduction of the communities in which the figurines were used.
3. Such contingency is likely to have been related to a) the acquisition of foods and other vital resources and b) the reproduction of individuals, communities and social relations of various types and scales.

These points demand the following enquiries:
A. How were the figurines mobilized to mark the boundary of the ritualistic communication system?
B. What did the figurines symbolize and how were the specimens connected to the types of contingency involved in the reproduction of the Jomon people, communities and social relations?
C. What order(s) were the specimens given, and how were those orders transformed in order to deal with (i.e. reduce and rationalize) the contingency?

The thesis of this paper is:
1. To trace the emergence and the subsequent trajectory of change of the anthropomorphic clay figurines of the Japanese archipelago.

2. To examine whether any archaeologically-reconstructable social system, which was co-transformed with the figurine, can be recognized.
3. To identify what contingency the use of the figurine attempted to rationalize.
4. How that was made possible.

Making sense of the anthropomorphic clay figurines in the Japanese Archipelago: a social systemic framework

Drawing upon the theoretical framework put forward above, the anthropomorphic clay figurines would have mediated the reproduction of a particular type of communication, or a communication *system*. A communication system, according to Luhmann, reproduces itself by reproducing its system–environment boundary, which differentiates what are and what are not its contents, and its reproduction takes the form of *reducing* the *complexity* of its environment by utilizing the boundary (Luhmann 1995, 176–209). To put this in a concrete manner, the world, or the environment of the communication system, i.e. the systemic whole of which the communication system as a sub-system, is *made sense of* in the manner unique to that communication system. By 'making sense' in this case is meant that a certain *sequence of choices* are made *in a self-referential manner* to respond to stimuli coming from the environment of the system.

The clay figurine, in this framework, can be inferred to have: 1) marked the system–environment boundary by its presence, and 2) mediated the 'making sense' of, or the reduction of the complexity of the environment of the system, by those who were involved in the communication of the world, i.e. helped them choose a way among the others to respond to problems which the state of the environment generated. These imply the following:

A. The emergence of the anthropomorphic clay figurine would have marked the emergence/differentiation of the communication system whose system–environment boundary was marked by this specific material category.
B. The emergence, or differentiation/articulation (to be more precise), of this figurine-related ritual communication system was associated with the emergence of a particular state in the social systemic whole in which this communication system was situated (and required), and whose complexity and contingency the figurine-related ritual communication system reduced.
C. The way the clay figurine was used was related to, and constituted by, the way in which the world (i.e. the environment of the system in which the figurine was used), was made sense of in a way unique to that particular system.

These points suggest that if we are to understand the changes which took place to the clay anthropomorphic figurines of the Jomon we shall have to examine the *co-transformation* of the figurine-related ritual communication system and its environment, i.e. the social systemic whole, and interpret how the figurine mediated the making sense/rationalizing of the environment of the system.

In what follows, we will try to make sense of the trajectory of the differentiation, transformation and disappearance of a specific ritual communication system defined by its system–environment boundary and its contents through the use of the clay anthropomorphic figurine, by dividing the more than 10,000 years of the Jomon period (cf. Habu 2004, 26–50) into three phases, each of which witnessed: 1) the initial segmentation of the figurine-related communication system; 2) the development of the figurine-related communication system; and 3) the transformation and disappearance of the figurine-related communication system.[1] A comprehensive outline of the trajectory of the Jomon material evidence is provided in Habu (2004) and Mizoguchi (2002, 75–115).

The emergence

Let us begin with the issues concerning the emergence of clay anthropomorphic figurines in the archipelago.

The beginning of the Jomon period as an archaeological-temporal entity is marked by the emergence of pottery, which dates from *c.* 14,000/15,000 cal. BC (*c.* 12,000 BP), well before the end of the late glacial period (cf. Habu 2004, 26–37), and this *Incipient Jomon* lasts up to *c.* 10,000 BP.[2] Clay figurines or other forms of anthropomorphic expressions, such as stone figurines, are extremely rare during this period, and it was the *Initial Jomon* (*c.* 10,000–7,000 BP) which followed the Incipient Jomon that witnessed the *formalization* in both quantity and appearance of figurines.

Almost all the examples during those periods lack the depiction of facial features, which forms a stark contrast with the clear depiction of the breasts. Many of them do not have arms and legs, and also often lack the depiction of the head, let alone the depiction of facial features (Fig. 14.2). In fact, without the depiction of the breasts they would not be recognized as representing a human figure. It is also important to note that many of the figurines of the period have a hole piercing them through vertically. Importantly, the hole does not appear to be the trace of a wooden stick pierced through, and is inferred to

Figure 14.2. *Earliest figurines from the Kanto region. Not to scale. (Source: Hamano 1990.)*

be the depiction of the internal organs (Hamano 1990, 22–3). It is important to note at this point that despite their highly abstract appearance the figurines of this phase appear to have symbolized *unmediated* human, and particularly female, bodily experiences. We shall come back to this point later.

As mentioned, it is increasingly likely that the emergence of pottery in the Japanese archipelago dates from well before the end of the late glacial period, hence the beginning of the Jomon era as an archaeological temporal category. The mobility pattern of the population appears to have remained almost unchanged from the Upper Palaeolithic for a considerable period of time until well after the emergence of pottery; the pattern being one of so-called *circular mobility* with the locales to be visited, not rigidly fixed spatio-temporally. This can be deduced from the ephemeral nature of the sites, which lack traces of substantial dwelling/huts and other durable features (cf. Mizoguchi 2002, 77–88).

As time passed, though, sites with traces of recursive and intensive seasonal use increased in number, as they began to have clear traces of pit dwellings (Mizoguchi 2002, 80–82), suggesting that the population gradually began to *regularly* visit specific locales to procure specific resource-types such as salmon and nuts in specific seasons of the year. This suggests that the circular mobility pattern transformed during the period from one without rigidly fixed locales to be visited seasonally to one with fairly rigidly fixed locales where the procurement of specific resource types was conducted with certain regularity and intensity (e.g. Mizoguchi 2002, 77–88). In other words, *circularity* in the mobility pattern became one which could be *metaphorically transformed* to *cyclicality*. This condition, apparently, did not exist in the preceding Palaeolithic era.

It can be inferred that this *cyclicality*, fundamentally based upon the cyclic rejuvenation of natural resources, would have constituted the core of the complexity of the world to be reduced/made-sense-of by being metaphorically connected to the working of the female body in reproduction, i.e. the cyclic shift between the period of fertility and that of infertility. The fact that 1) the earliest examples of the clay anthropomorphic figurines in the archipelago, without

The Emergence of Anthropomorphic Representation in Japanese Archipelago

Figure 14.3. *Middle Jomon 'standing' figurines. Left: Tanabatake, Nagano Prefecture (central Japan); Centre: Sakaue, Nagano Prefecture; Right: Nishinomae, Yamagata Prefecture (northeastern Japan). Not to scale. (Source: Kosugi 2002.)*

exception, depicted breasts thus symbolizing the female figure as a whole (see Fig. 14.2); 2) they almost never realistically depicted facial features and limbs and 3) their emergence largely coincided with the emergence of settlement sites with traces of recurrent and intensive seasonal use, all suggest that it was the cyclical rejuvenation of the resources procured at those seasonally visited locales that constituted the basic complexity of the environment which was rationalized, or made sense of, by being metaphorically connected to the female bodily experience, i.e. the cyclical shift between the state of fertility and that of infertility, materialized by the figurines. This thesis can be further supported by the fact that the areas which witnessed the emergence of this figurine form, namely the Kanto region of central Japan and the southern Kyushu region of western Japan, coincide with the areas which also witnessed the emergence of the earliest substantial settlements in the archipelago (Harada 1993).

We have to specifically note *immediacy/unmediatedness* in the materialization of this female bodily experience. The metaphorical connection between the signifier and the signified, i.e. cyclicality in nature and that in the female bodily experience materialized by the figurine, in this case, was not mediated by any *third* abstract/conceptual construct for instance, any decorative trait which might add to the appearance of the figurine, some transcendental elements. This immediacy/un-mediated-ness may be reflected by the depiction of the internal organs in some examples of clay figurines of the period, as mentioned above; the work of the body may have been perceived as the direct reflection of that of nature, and the boundary between the domain of nature and that of culture may not have been marked sharply or may have deliberately been blurred.

The differentiation of specific types of contingency relating to mobility, territoriality (reflected by the emergence of distinct regional styles in the so-called Yori-ito-mon style pottery horizon of the Kanto region: see Harada 1993; Ono *et al*. 1992, 58–60) and subsistence, resulted in the segmentation of a communication system which tamed/processed and rationalized the contingency. Cyclicality, which characterized the mobility pattern of the phase, upon which the territoriality was formed, and the annual rejuvenation of natural resources, were metaphorically connected to the similarly cyclic shift between the state of fertility and that of infertility of the female body, and the materialization of that human experience in the form of the figurines and their use helped the population make sense and tame/rationalize in a symbolic sense the contingency involved in the management of natural resources, vital for the reproduction of the society. The lack of sophistication in the signification of femaleness in the figurines of the period can be understood to reflect the relatively *unmediated* connection between the cyclicality in nature and that in the human experience materially captured by the figurines. This simplicity in the metaphorical transformation, I would argue, derived from the relatively low complexity which the figurine-related communication system had to reduce.

The Middle Jomon climax and the aftermath

The situation did not significantly change during the following Early Jomon period (7000–4500 BP), though the number of the specimens increased steadily.

Figure 14.4. *A typical example of the 'circular settlements': the site of Nishida, Iwate Prefecture (northeastern Japan). Clusters of grave pits (note two rows of pits at the centre), divided into a number of segments, are surrounded by raised floor buildings (probably for food storage). (Source: Taniguchi 2002.)*

Following this the Middle Jomon period (4500–3500 BP) witnessed the emergence of figurines which could stand upright and had the clear, but often not so realistic, depiction of the parts of the body (Fig. 14.3). Some clearly depict the pregnant female form, but many are difficult to sex, though the important work by Yasushi Kosugi has revealed that those specimens which appear transsexual also have traits which, though highly transformed, can be traced back to the original traits, clearly indicating femaleness and pregnancy in their more realistic counterparts (Kosugi 2002). This suggests that the image which previously signified an intimate and immediate human bodily experience became *abstracted* in its appearance, although the original symbolic meaning, i.e. female bodily experiences, appears to have been intact.

The period can also be characterized by 1) the development of 'circular settlements' with a concentric spatial organization further divided into segments (Fig. 14.4) and 2) the establishment of a hierarchical structure in individual regional settlement systems (e.g. Taniguchi 1993).

As mentioned, in comparison to the figurines of the previous phase, i.e. from the Initial to the Early Jomon periods, some of the figurines of this phase had clear and at times exaggerated depictions of the state of pregnancy, and most of the others featured the depiction of breasts. The variables showed highly polythetic combinations in individual specimens, and, although they can be classified into a number of polythetic groupings, they form a continuous cline. This, together with the fact that some specimens also depicted childbirth in the form of the head of the foetus coming out of the vagina, suggests that most of them actually symbolized the child-bearing ability of the female (Kosugi 2005). This suggests that, despite significant changes in appearance, the figurines of this phase continued to materialize the metaphorical connection between cyclicality in the reproduction of natural resources and in human bodily experience. If this is the case, we have to come up with a specific interpretation of the cause and meanings of the changes to the form and appearance of the figurine, and we can assume, by drawing upon the theoretical premises of the current work, that they would have reflected the transformation of the figurine-mediated ritual communication system processing and taming new, different types of contingency from that of the previous periods.

Let us begin by examining the intra- and inter-settlement structure of the phase. The timing of the emergence of circular settlements roughly coincided with that of the regional settlement hierarchy (Taniguchi 1993). Besides, most of the circular settlements constituted core settlements in individual regional settlement systems. These suggest that the characteristic spatial division in these settlements was related to the spatial structuration of human relations not only within them but also in individual local settlement systems.

In order to infer the character of the spatial structuration of the human relations of the phase, let us first look into the mobility pattern of the population. The circular mobility established toward the end of the Initial Jomon and the early part of the Earliest Jomon (particularly in specific districts of the archipelago, the southern Kyushu and Kanto districts, which also witnessed the emergence and the development of figurines, as illustrated above) appears to have been gradually replaced by *radiating mobility* in which populations resided for a considerable proportion of the year in base/core settlements and seasonally visited satellite settlements to procure specific ranges of

resources (Kani 1993). This picture can be supported by the fact that satellites of a local settlement system appear to have been task-specific settlements from the analysis of the lithic assemblages, and usually only the core settlement had burials and substantial storage facilities (e.g. Taniguchi 2002; Sasaki 2002). The rise of sedentism would have necessitated the development of technologies for the maintenance and regulation of inter- as well as intra-regional multi-levelled social relations in addition to those for territorial defence activities which, as argued above, began developing in the previous phase in the regions where the figurines emerged. In other words, this would have been the development of a type of 'tribal' social organization, and not only kin-based but also non-kin-based social relations/corporate groupings would have been developed. Besides, some of those relations would have inevitably been supra-local.

The establishment of this condition would have increased the number of different types of contingency which the ritual communication system had to rationalize. In the previous phase, two types of contingency, i.e. the contingency in the annual cycle of the rejuvenation of natural resources and in territorial defence-related acts had to be processed and tamed. The establishment of a tribal organization would have added contingency in the maintenance and regulation of not only residential but also non-residential/supra-local social relations.

These types of social relations materialized in the form of the complicated spatial segmentation of the circular core settlements (see Fig. 14.4), and it can be inferred from the presence of burials in the central plaza of many of the circular core settlements that the regulation and maintenance of those relations was conducted through the mediation of the dead and the ancestors (e.g. Mizoguchi 2002, 102–11). For instance, at the site of Nishida, two rows of burial pits were located in the middle of the central plaza. These rows of burial pits were encircled by a large number of burials which were segmented into a number of clusters (Fig. 14.4). Those clusters of burials which were laid out to form a circle were further encircled by a number of (probably) raised-floor buildings which some scholars have argued were storage facilities, possibly for storing foodstuff (Sasaki 2002). They also were laid out to form a circle, and can be segmented into a number of clusters, although these did not spatially match the clusters of burials. The concentric rings of burials and possible storage facilities were encircled by pit dwellings. Yasuhiro Taniguchi has shown that in some circular settlements spatial segments similar to those seen at Nishida show different formation processes, different numbers and forms of burials, and different forms of pit dwellings constituting them and so on, and has argued that these strongly support the thesis that these segments were occupied by the dead and living both belonging to *different groupings* such as lineages, sub-clans, and/or the halves of a dual organization (Taniguchi 2002; Mizoguchi 2002, 88–92). If this were the case, it can be further inferred that these groupings were, partially but significantly, maintained and regulated through the act of burying the dead in the manner which materialized the spatial structuration of those groupings.

Of particular importance for the consideration of the character of the figurine-related ritual communication system, likely to have been reproduced predominantly in those circular settlements, is the fact that in that concentric circular spatial organization the dead and the foodstuff might very well have been in contact, physically as well as symbolically, as seen at Nishida where a ring of burials were encircled by a ring of storage facilities. Similar contact between burials and storage facilities can be seen at many other circular settlements (Taniguchi 2002). This leads to the inference that the *contingency involved in death was processed through the handling of foodstuff as the source of life and the contingency involved in the procurement of foodstuff was processed through the handling of the dead.* In other words, they mutually mediated each other's rationalization.

That a majority of the figurines of the phase are from the circular settlements, considered along with the above, suggests that the reproduction of the figurine-related ritual communication system was involved in this mutual mediation and processing between the contingency generated by death and that by the procurement of resources. And considering the fact that most of the figurines of the phase can be inferred to have depicted the pregnant female form and to have signified the metaphorical connection between the cyclic rejuvenation of natural resources and that of the child-bearing capacity of the female sex, this further suggests that the figurine-related ritual communication system was situated on the side of life in the mutually-mediating dichotomy between life and death materialized in the form of the spatial organization of the circular settlements. This inference may be further supported by the fact that some of the figurines were painted with red pigments.

Then, what led to the changes from the previous phase? As argued, the types of contingency which had to be processed and rationalized by the figurine-related ritual communication system in the previous phase were 1) the contingency generated by territorial defence-related acts and 2) that generated by the annual rejuvenation of natural resources. In the Middle

Figure 14.5. *Early Late Jomon figurines. Left: Shibahara A, Fukushima Prefecture (northeastern Japan); Right: Higuchi-Gtanda, Nagano Prefecture (central Japan). Not to scale. (Source: Kosugi 2002.)*

Jomon, in the areas where circular settlements and a settlement hierarchy developed in particular, some new types of contingency generated by the maintenance, negotiation and regulation of multi-scaled social relations, including non-kin-based, supra-local ones, would have been added to 1) and 2) above.

My argument is that the changes to the figurines, including the addition of a number of traits making their appearance rather fantastic and allowing some of them (particularly in the Chubu region) to be able to stand upright, were related to the increasing necessity of processing those new types of contingency. The spatial organization of the circular settlements, as argued, would have connected the above-mentioned domains of contingency and made them mutually mediated. In other words, issues concerning subsistence were connected to that of the reproduction of multi-scaled social relations and made to form a unified domain of contingency/complexity which had to be processed and rationalized, i.e. made sense of, by the figurine-related ritual communication system.

For instance, in order to be seen by a large number of people gathering as a tribe-like regional community for the conducting of rituals, derived from the non-residential, supra-local groupings such as clans, the figurines would have had to *stand* at the centre of communal gaze; their appearance would have had to have been made to signify a range of meanings covering a diversity of issues concerning the reproduction of multi-scaled groupings. In addition, the Tanabatake figurine, one of the most visually striking examples of the standing figurine category, was deposited in a small pit at the centre of the settlement area as if buried as a dead body (Tanabatake-iseki Hakkutsu-chosa-dan 1990). This further suggests that those figurines were gazed at and treated as the node of ancestral images and the notion of fertility, and at times buried in communal ritualistic occasions.

In summary, the changes made to the figurines from the previous phase can be understood as a reaction by the ritual communication system to the change that took place in its environment, predominantly in the form of the increasing number of the domains of contingency differentiated as a consequence of the establishment of a 'tribal' social formation. The figurines were made to fit the ritual communication system with which the people processed and rationalized the newly-risen domains of contingency in the world, i.e. the maintenance of supra-local corporate groupings as well as the necessity of territorial defence and cyclic rejuvenation of nature.

In the Chubu region, the core of the above-illustrated changes in the figurine-related communication system, the production and use of anthropomorphic clay figurines drastically declined at the end of the Middle Jomon, and the timing coincided with the collapse of the above-mentioned settlement hierarchy and regional structure. Many of the pottery-style zones disappeared and were replaced by a small number of extremely large style zones covering large portions of the archipelago. A sharp climatic deterioration is suggested to have been responsible for this, and small-scale population movements appear to have been rife.

It is interesting to note that these phenomena coincided with the expansion of the horizon of the use of clay anthropomorphic figurines to western Japan, previously almost devoid of the use of figurines. The density of settlement distribution in western Japan remained much lower than in eastern Japan throughout the Jomon era, and interestingly, this coincided with the scarcity of the use of figurines. Both the use of figurines and the formation of regional core settlements began almost simultaneously during the late stage of the Late Jomon phase in the central Kyushu region (Miyauchi 1980). It has been pointed out that a majority of the figurines are from the regional core settlements, some of which have also been confirmed to take a circular form (Miyauchi 1980; Tomita 1982). This suggests that the 'technology' of dealing with certain types of contingency, which was developed in the previous Middle Jomon phase, was introduced to western Japan when the same kind of condition which had demanded the development of the technol-

ogy in eastern Japan came into being. Meanwhile, that very condition either ceased to exist or was weakened in its intensity in the Chubu region, the former core area of figurine use. That would explain the sudden and significant decline of the use of figurines in the region.

The transformation and disappearance

Clay anthropomorphic figurines of the Late Jomon (3500–3000 BP) and Final Jomon (3000–2500/2600 BP) periods became increasingly transsexual and unrealistic in appearance (Figs. 14.5 & 14.6). Significantly, in the final Jomon period, some specimens were buried in mortuary contexts; clay figurines had never been in direct contact with the dead within a context before.

Figure 14.6. *Middle Late Jomon figurines. Left: Horinouchi, Chiba Prefecture (central Japan); Right: Inarijinja, Iwate Prefecture (northeast Japan). Not to scale. (Source: Kosugi 2002.)*

The use of figurines continued strongly in the Kanto and Tohoku regions during the Late Jomon phase, though some significant changes occurred to the figurines themselves and the condition surrounding them.

1. Two fairly distinct categories came and went in the figurine population: one, used in the early stage of the Late Jomon, has fairly similar traits to the figurines of the previous phase but the face is often heart-shaped and looks as if it is wearing a mask (Fig. 14.5); the other, which emerged in the middle stage of the Late Jomon, depicts, in a fairly realistic manner, female bodily characteristics with a characteristically triangular-shaped head seen from the front (Fig. 14.6). The figurines, which emerged widely in western Japan during this period, as mentioned above, mostly belong to the latter type, and were also later transformed further to have increasingly fantastic appearances.
2. From the middle stage of the Late Jomon onwards, some settlements began to exhibit new traits such as a separate cluster of burials with the concentration of burial goods and a separate cluster of dwellings with traits distinct from those of the other clusters, and they may suggest an emergent social ranking (Taniguchi 2002).

As repeatedly emphasized above, the final stage of the Middle Jomon and the early stage of the Late Jomon was marked by the collapse of the regional settlement hierarchy, decrease of circular settlements, and a widespread phenomenon of small-scale population movements suggested by the emergence of extremely large pottery style zones. Population decrease appears to have taken place widely, particularly severely in the Chubu region of central Japan, and the maintenance of multi-scaled social relations including both kin-based residential and non-kin-based, non-residential/supralocal ones, would have become difficult. The addition of the heart-shaped, mask-like face to the figurines (Fig. 14.5) can be interpreted as a reaction to this rising difficulty in processing and rationalizing contingency by enhancing the transcendental nature of what was signified and materialized by the figures, which constituted an important medium of the reproduction of the ritual communication system.

It is suggestive that the ritual communication mediated by such physical practices as deliberate and formalized tooth extraction became widely practised from this stage on (e.g. Ono, *et al.* 1992, 102–3). It seems as if the *material signifiers* such as figurines became inadequate at reducing and regulating the increasing complexity/contingency of the world, and instead it might be the case that *signifiers inscribed in the body* became necessary as a medium with which to give orders to the world.

Next, let us examine the situation from the middle stage of the Late Jomon onwards. If what happened to the settlement in this stage reflected a change in the contingency of the world, i.e. the emergence of hierarchical tendencies of some sort, it would be translated into the addition of a new domain of contingency, i.e. contingency in the maintenance and regulation of *hierarchicalized* social relations. Interestingly, the figurines which emerged in the middle stage of the Late Jomon depicted female bodily characteristics in a fairly realistic manner (Fig. 14.6). However, their traits were transformed in various ways to acquire fantastic appearances though retaining, albeit minimally, the signification of femaleness throughout the later stage of the Late and the Final Jomon (Fig. 14.7).

I would argue that this was the process of the detachment of the communication system mediated by the clay figurine from the domain of intimate physi-

Figure 14.7. *Final Jomon figurines. Left: Mushinai I, Akita Prefecture (northeastern Japan); Right: Futago, Iwate Prefecture (northeastern Japan). Not to scale. (Source: Kosugi 2002.)*

cal experiences and its increasing *abstraction*, that we already saw progressing from the Early to the Middle Jomon. Back then, the figurines, it was interpreted, were modified to acquire a fantastic, transcendental appearance in order to allow those who were present at ritualistic occasions polythemic readings of the meaning signified by them in reaction to the increased range of contingency generated by the increasing complexity of society.

After the collapse of that condition, another process began for increasing social complexity and for widening the range of contingency to be rationalized, and this time, the contingency generated by the stratification of social relations was added to it.

We can make sense of the changes occurring to the figurines during this process by examining the situation when the figurines were about to disappear. The end of anthropomorphic clay figurines in the archipelago was marked when some specimens became used as mortuary goods and were deposited with the dead (e.g. Harada 1999). That they still retained the signification of femaleness, and that the trajectory of gradual transformation can be traced in their individual attributes back to the counterparts of the middle stage of the Late Jomon, suggest that they were still mediating the reproduction of the ritual communication system in which the contingency generated by the reproduction of human beings, that of natural resources, and that of social relations were metaphorically connected and mutually mediated. In other words, the figurines would have still signified the cyclic rejuvenation of life, and that they were deposited with the dead suggests they were deposited to metaphorically connect that cyclicality to the dead, possibly in the hope of rejuvenating them. What is fundamentally different in this practice from the use of the figurine in the previous periods is that the contingency involved in the rejuvenation of these domains which constitute the social whole come to be processed on the occasion in which the identity of an individual, rather than a whole community, was ritually confirmed and materialized.

We should not rush to the conclusion that those individuals who were buried with the figurines were 'ritual big-persons', in charge of the conduct of the ritual acts in which the contingency involved in the rejuvenation of these domains constituting the social whole became processed and rationalized. However, it would be possible to infer that they, when living, played a role important enough to be signified by the deposition of the symbolic medium which mediated the reproduction of the ritual communication system that processed and rationalized the increasing range of contingency in the world. I would argue that the increasing complexity in the life-world reached a certain level where the maintenance and regulation of the domains constituting the social whole, each of which generated its own contingency and a range of problems, could not be conducted *communally*, and a certain group of individuals became entrusted to deal with the socially-shared problems. The increasingly fantastic appearance of the figurines would have become necessary in order to rationalize this rising vertical segmentation of community by portraying the domains of contingency which the upper-ranked possessed as being something detached from the life-world of the commoners, and hence, unreachable for them.

Concluding thoughts

The examination of the co-transformation between clay anthropomorphic figurines and domains of social life in the Jomon period of the Japanese archipelago has shown that many of the changes occurred to the figurines themselves and to their distribution. The context in which they were deposited can be understood to have been the consequence of the reaction of the ritual communication system, whose reproduction the figurine mediated, to changes occurring to its systemic environment. By defining the ritual communication system as the subsystem which *processes*, *reduces* and *rationalizes* the *complexity* and *contingency* of its environment — i.e. the state constituted by the other sub-systems constituting the social whole — we could understand the figurine as defining the boundary between the ritual communication system and its

environment, and as mediating the system's processing, reducing and rationalizing of the complexity and contingency of the world.

The clay anthropomorphic figurines of the Jomon of the archipelago emerged when such a communication system became differentiated in reaction to the emergence of a certain level of complexity and a certain range of contingency which needed to be processed socially; figurines were subsequently transformed in their appearance and manner of use as the ritual communication system transformed itself in reaction to changes occurring to the state of its environment, in the form of altered complexity and new ranges/types of contingency.

In conclusion, the clay anthropomorphic figurines of the Jomon of the Japanese archipelago constituted an important *communication medium* whose significance was derived from their potential to metaphorically signify and hence rationalize various human experiences by connecting them to various faculties of the human body, including the female capability for human reproduction.

Notes

1. The scholarship concerning the Jomon clay figurines is immense in its history and depth. The current author tries to offer a new synthetic perspective by focusing on the co-transformation between the figurine use-related communication system and other communication systems constituting the Jomon society. In doing so, the author is particularly indebted to Kosugi's and Taniguchi's innovative works on the figurines and the settlement (Kosugi 2002; 2005; Taniguchi 1993; 2002, amongst many other works by them).
2. For the basic Jomon chronological framework, see (Habu 2004, 37–46).

References

Bloch, M., 1989. *Ritual, History and Power: Selected Papers in Anthropology.* London: Athlone Press.
Habu, J., 2004. *Ancient Jomon of Japan.* Cambridge: Cambridge University Press.
Hamano, M., 1990. Dogu shutsugen no jiki to keitai [The earliest clay figurines of the Jomon period and their traits]. *Kikan Koko-gaku [Archaeology Quarterly]* 30, 21–3.
Harada, M., 1993. Yudo to teijyu [Wandering and the sedentary way of life]. *Kikan Koko-gaku [Archaeology Quarterly]* 44, 82–6.
Harada, M., 1999. Dogu [Jomon clay figurines], in *Saishin Jomon-gaku no Sekai [Latest Outcomes of Jomon Studies]*, ed. T. Kobayashi. Tokyo: Asahi-shinbunsha, 130–43.
Kani, M., 1993. Jomon jidai no setrumento sisutemu [The settlement system of the Jomon period]. *Kikan Koko-gaku [Archaeology Quarterly]* 44, 77–81.
Kosugi, Y., 2002. Shin-zo ga kaiki suru shakai [The society in which transcendental images were recurrently re-created], in *Jomon Shakai-ron [Studies in the Society of the Jomon Period]* 1, ed. M. Anzai. Tokyo: Dosei-sha, 133–80.
Kosugi, Y., 2005. Koumi no zokei hanamagari no zokei [The figurines depicting child-birth and the figurines with vented nose], in *Chi'iki to Bunka no Koko-gaku [Archaeology of Regionality and Culture]* 1, ed. Meiji University Department of Archaeology. Tokyo: Rokuichi-shobo, 589–620.
Luhmann, N., 1995. *Social Systems.* Stanford (CA): Stanford University Press.
Miyauchi, K., 1980. Kyushu Jomon-jidai dogu no kenkyu [A study of the clay anthropomorphic figurine of Jomon period Kyushu]. *Kyushu Kokogaku [Kyushu Archaeology]* 55, 23–35.
Mizoguchi, K., 2002. *An Archaeological History of Japan, 40,000 BC to AD 700.* Philadelphia (PA): University of Pennsylvania Press.
Needham, R., 1979. *Symbolic Classification.* New York (NY): McGraw-Hill.
Ono, A., H. Harunari & S. Oda (eds.), 1992. *Zukai Nihon no Jinrui Iseki [Atlas of Japanese Archaeology].* Tokyo: Tokyo University Press.
Sasaki, F., 2002. Kanjo-resseki to Jomon-shiki kaiso-shakai [Stone circles and the Jomon ranked society], in *Jomon Shakai-ron [Studies in the Society of the Jomon Period]* 2, ed. M. Anzai. Tokyo: Dosei-sha, 3–50.
Tanabatake-iseki Hakkutsu-chosa-dan, 1990. *Tanabatake Iseki [The Tanabatake Site].* Chino: Chino Municipal Board of Education.
Taniguchi, Y., 1993. Jomon-jidai shuraku no ryoiki [The territory of the Jomon settlement]. *Kikan Koko-gaku [Archaeology Quarterly]* 44, 67–71.
Taniguchi, Y., 2002. Kanjo-shuraku to buzoku-shakai [Circular settlements and tribal society.], in *Jomon Shakai-ron [Studies in the Society of the Jomon Period]* 1, ed. M. Anzai. Tokyo: Dosei-sha, 19–65.
Tomita, K., 1982. Kan'nabe iseki shutsudo dogu no kansatsu [A study of clay figurines from the Kan'nabe site], in *Mori Teijiro sensei koki kinen kobunka ronshu [Papers in honour of Dr Teijiro Mori's 70th birthday]* 1, ed. The Editorial Committee. Fukuoka: The Publication Committee, 113–126.
Turner, V., 1967. *The Forest of Symbols: Aspects of Ndembe Ritual.* Ithaca (NY): Cornell University Press.

Section D

Representation, Regions and Power

Chapter 15

Abstract and Figurative Representation and the Politics of Display in Neolithic Southeast Italy

Robin Skeates

This paper explores the social use and significance of 'figurative' and 'abstract' modes of visual representation within the Neolithic communities of southeast Italy. It does so by highlighting some patterns in the spatial distribution of these elements in their art. It is argued that, together, these motifs formed part of a powerful set of cultural symbols, whose display was embedded within political strategies intended to establish and strengthen social identities within early agricultural communities. It is also suggested that the relatively explicit and rare figurative images were regarded as particularly potent and problematic, and therefore carefully controlled by leaders and confined to liminal ritual contexts.

Visual representation involves a conceptual game of make-believe and optical illusion. It refers both to the act of portraying, symbolizing or presenting the likeness of something, and to the use of the resultant image to 're-present', imagine, describe, define, understand, fix, construct, organize, regulate and even transform the world as we perceive it (e.g. Gell 1998; Gombrich 1960). This process involves the subject of representation (either an object or a concept), its substitute image or representation, and the visual experiences and imaginations of the artist and spectator. It is situated within culturally variable systems of representation. These involve learnt rules and conventions about how meanings are visually expressed and interpreted. In particular, artists employ culturally accepted modes of resemblance (such as relevant sizes, shapes, colours or patterns) that convince spectators that the image is sufficiently realistic or life-like for them to suspend disbelief.

'Figurative' (or 'realistic', 'iconic' and 'naturalistic') images are characterized by a relatively high degree of resemblance to the subject of visual representation. As a consequence, they can sometimes be deemed to have captured the power of that which they represent, be perceived to be embodied with human-like social agency and supernatural power, and even be regarded as magically efficacious, particularly when drawn upon in the context of religious worship and ceremonies. Furthermore, as 'realistic' images, their meanings tend to be predisposed towards one particular level of recognition and interpretation. It is not surprising, then, that the display of these powerful images is often carefully controlled. However, within the game of representation, the conceptual status of 'realistic' figurative images is inherently problematic, and their meanings can always be contested by artists and audiences (Goody 2000).

'Abstract' (or 'aniconic') images often appear together with 'figurative' ones, intentionally juxtaposed, in a variety of traditional art-forms (e.g. Boas 1927). Indeed, the differences between them are only a matter of degree. Essentially, an 'abstract image' looks less like its referent, and, in the process of abstraction, realistic representations of objects are distorted and replaced by, or combined with, schematic, stereotypical, conventional symbols (e.g. Gombrich 1979; Hauser 1951, 8–17; Ucko 1977). Many of these are geometric in form, characteristically patterned, formalized and structured, but their forms are sometimes also visually unstable and confusing. The meanings of these images may therefore be clear and overt, but they can equally be malleable and ambiguous. Indeed, they can be intentionally exploited, in order to dazzle, disconcert and confuse audiences, particularly when displayed during the course of social ceremonies or ritual performances (e.g. Gell 1992; Lewis 1980). Furthermore, they can be open to different interpretations, explained at different levels by different groups of people within a community, and may be negotiated in debate. It is no coincidence that they have been used to represent magical superhuman power, and to express mysterious sacred concepts, which are open to social reinterpretation, particularly to people who proceed through different levels of initiation. They have also

been used actively, at various moments in the history of art, to challenge and transform contemporary visual and perceptual conventions, notably those dominated by figurative representation.

Combinations of 'figurative' and 'abstract' images are a characteristic feature of the visual culture of Neolithic southeast Italy (e.g. Graziosi 1973; Giannitrapani 2002; Coppola 1999–2000). This visual culture includes 'portable' (or 'mobile') art objects, such as decorated pottery vessels and pebbles, figurines and body ornaments; as well as 'installation' (or 'static') art, such as painted cave walls (or 'cave-art'), but also circular enclosure ditches (also interpreted as 'landscape-art'), and even the carefully placed bodies of deceased people and animals (also interpreted as 'body-art'). These art-forms and their decoration can be placed along a stylistic scale, ranging from relatively 'figurative' (e.g. whole bodies represented by figurines and painted figures in caves, and human remains in burials), to 'schematic' (e.g. human faces and animal heads represented on pots), to 'abstract' (e.g. geometric motifs, including concentric ditch circuits). However, all of these categories should be regarded as overlapping, particularly since objects have a tendency to move in and out of different states of use and value (Kopytoff 1986). What seems more important, then, is that all of these different art-forms should be regarded as complementary elements of a dynamic visual culture that was broadly shared by people in Neolithic southeast Italy (Skeates 2002; 2005).

The specific region with which this paper is concerned is that of Apulia, which covers most of southeast Italy. It can be divided into three main areas: the north, comprising the off-shore Tremiti Islands, upland Gargano promontory, lowland Tavoliere plain and neighbouring Ofanto river valley; the centre, comprising the Adriatic coastal strip and upland Murge and the south, comprising the Salento peninsula. This region was not isolated in prehistory. Indeed, it seems clear that inspiration for the Neolithic art found here derives ultimately (if indirectly) from across the Adriatic Sea, since virtually all of the new elements of Neolithic visual material in southeast Italy can be paralleled in the slightly earlier and far richer visual culture of the Balkans (e.g. Bray 1966). However, I would also argue that these elements were locally selected, adapted and ascribed different cultural meanings in the west Adriatic, and that they can therefore be studied in their own right.

The Neolithic period covered by this paper, which has traditionally been divided into Early, Middle, Late and Final phases, extended between the sixth, fifth and fourth millennia cal. BC (e.g. Whitehouse 1986, table 1; Skeates 2000, 165–6, table 1). None of the art-works discussed in this paper have been directly dated by absolute methods, and only a few radiocarbon dates are available for material from their associated contexts. However, most of them can, at least, be assigned to one of the traditional phases. This means that although some chronological trends do emerge from this study, the main focus here is on long-term spatial patterns.

Spatial patterns

Turning to the details of the archaeological record for Neolithic southeast Italy, art-works can be assigned to two general spatial contexts, which — for want of better terms — are described here as 'living' and 'liminal'. I must emphasize that I regard these two spatial and behavioural categories as related and overlapping: connected by people, objects and concepts moving between them.

Living contexts
'Living' deposits occur in open sites and in the entrances of selected caves used as convenient and complementary seasonal shelters. Both types of site appear to have served as regular bases for communal activities, such as the manufacture and use of artefacts, the production, procurement, processing and consumption of food, and co-residence.

Abstract geometric motifs predominate in these contexts, notably in the 'portable art' of the decorated pottery, which occurs in large quantities on most sites, but also on a few ceramic stamps (*pintaderas*), with incised and impressed zigzag and spiral patterns (Cornaggia Castiglione 1956) (Figs. 15.1 & 15.2). In addition, occasional examples of relatively abstract anthropomorphic and zoomorphic motifs occur, also on decorated pots, especially in the form of schematic human faces applied to rims and of animal heads applied to handles.

The decorated ceramics, which have received much scholarly attention over the years, are worth considering in some detail. To judge from the results of thin-section analyses, they were generally produced and consumed locally (Skeates 1992). They are distinguished aesthetically, both by the technical excellence of their manufacture, which becomes increasingly skilful throughout the Neolithic, and by their decoration in a variety of geometric styles, which become visually elaborated and regionally differentiated over time (e.g. Stevenson 1947; Trump 1966; Whitehouse 1969; Malone 1985). The proliferation of geometric decorative styles on the densely settled Tavoliere plain in northern Apulia, over both time and space, is particularly striking. Here, for example, three distinctive

Figure 15.1. *Later Neolithic decorated pottery vessels: 1) impressed beaker from Casa San Paolo; 2) graffiti bowl from Sant'Anna; 3) incised, rocker impressed and red painted flask from Lagnano da Piede; 4) trichrome painted jar from Grotta Scaloria Bassa; 5) trichrome painted cup from Grotta Scaloria Alta; 6) Serra d'Alto cup from Masseria Candelaro. (After Cassano & Manfredini 1991; Ingravallo 1997; Mallory 1984–87; Tinè & Isetti 1975–80; Vinson 1974.)*

Figure 15.2. *Ceramic stamps from: 1) open site in front of Grotta Santa Croce; 2) Cave Mastrodonato. (After Caligiuri & Battisti 2002.)*

pottery styles, belonging to the Middle Neolithic of the mid sixth millennium cal. BC, have been named after the sites of Guadone, La Quercia and Lagnano da Piede, which may well have served as regional centres for their production, concentrated in the northwest, central and northeast, and southwest parts of the Tavoliere respectively (Whitehouse 1986, 41–2). The 'Guadone facies' is an 'evolved' dark-burnished impressed and incised ware, characterized not only by finger, point and stick impressions, but also by the relatively frequent use of *Cardium* shell impressions, deep grooves, and zigzagging and hatched incisions and scratches, some of which were filled with white, yellow and red colouring materials. The 'Lagnano' style is a red-painted ware, which appears to mimic the 'Guadone' impressed and incised style, with painted stripes, chevrons and triangles (Fig. 15.1, no. 3). And the 'Masseria La Quercia' style is another red-painted ware, characterized by narrow painted bands, forming geometric motifs such as zigzags and lattices, combined with rocker-pattern shell impressions. The latter style was especially prized, to judge from the frequency of repair holes found on broken vessels (Trump 1980, 53). Some of their geometric motifs may have originated in the patterns formed by woven materials. For example, some of the impressed and incised motifs echo basketry patterns, while some of the painted motifs, including the distinctive 'fringe' motif of the Middle Neolithic Scaloria Bassa style (Tinè & Isetti 1975–80, figs. 9 & 10), may be squeomorphs of textile patterns.

The pottery vessels elaborated with schematic human and animal heads can be divided into two main groups, according to their form and date. The first are rim-sherds with vertical lugs, representing anthropomorphic faces. They comprise a nose pinched out of the clay, a mouth incised below, eyebrows or eyes applied or impressed either side, and sometimes also incised decoration placed to the sides and below (which may represent facial decoration or hair). These features are placed just beneath the rims of pots, including the necks of flasks, and date stylistically to the sixth and fifth millennia cal. BC. The second group are handles elaborated with vague representations of zoomorphic heads, comprising an applied head and sometimes also horns, nostrils and a mouth. Scholars

have tentatively identified these in terms of different animal species, including cattle, sheep, pigs, ducks and frogs (e.g. Childe 1957, 232; Trump 1966, 56). However, their lack of interpretative confidence and agreement emphasizes, above all, the relative degree of abstraction of these zoomorphic images. They appear on sites dating to the later Neolithic of the fifth and fourth millennia cal. BC. Most commonly, they appear on top of horizontal tubular handles attached to Serra d'Alto style painted fineware vessels, including bowls (Fig. 15.1, no. 6). At the site of Cala Tramontana, two examples also take the form of circular lug-handles with impressed holes, representing nostrils and a mouth (Palma di Cesnola 1967, 376–8, figs. 9.1a–b).

Some rare examples of schematic representations of anthropomorphic and zoomorphic bodies on pottery vessels can be added to this group of objects from living contexts. For example, an incised anthropomorphic form, representing a body composed of a head and torso with a pair of arms, legs and feet, appears just below the rim of a vessel from Lama Marangia (Geniola 1979, 60, fig. 123). A small zoomorphic-shaped vessel, comprising a bowl sitting on the back of an animal with a head, four legs and a tail, was found on the surface of the Early Neolithic ditched site of Masseria Candelaro (Cassano *et al.* 1987, tav. VII). A later Neolithic vase from Apulia standing on human feet has also been noted (Childe 1957, 232).

Liminal contexts
The second general spatial arena where art-works appear is the 'liminal' context of 'ritual' deposits found in specific parts of the open and cave sites. By 'liminal', I refer to Victor Turner's anthropological notion of places considered to be the point of contact or transition between the supernatural and quotidian world, characteristically bounded or enclosed, where rituals, and especially rites of transition are performed (Turner 1977, 38; Skeates 1991, 127). And for a definition of 'ritual' I follow Gilbert Lewis, who defines it as a special kind of performance, involving culturally prescribed and highly formalized action, with an alerting quality that affects both the participants and the audience, stimulating, intensifying and focusing their attention and thoughts (Lewis 1980; Skeates 1991, 122).

At the open sites, ritual deposits are characterized by intentional human burials and caches of special artefacts. On Tavoliere sites, these are often found in association with (i.e. in, on or by) the outer ditches which enclose these sites and the smaller C-shaped ditches, which are generally scattered within the enclosures (Jones 1987; Skeates 2000, 173–80).

At the cave sites, the ritual deposits are similar in content, but are more overt and varied, and they are generally found in the interior of the caves. Ruth Whitehouse (1990; 1992) has highlighted the underground situation, hidden location, difficulty of access, restricted space and darkness of these caves, and of their innermost chambers in particular. Their ritual deposits are marked by: networks of stone chambers, corridors and stalactitic formations, some of which were artificially modified; human burials, including cremated remains of children; the deliberate deposition of food remains (plant and animal) and a range of unusual artefacts; the special positioning and intentional fragmentation of fineware vessels; the collection of water, including dripping stilicide water; and the preparation and use of pigments, sometimes for wall paintings (e.g. Tinè 1975; Malone 1985, 135; Whitehouse 1992, 61–72; Skeates 1995). To this category can be added the early example of a rock-cut tomb found at Arnesano near Lecce, which might also be considered as an artificial cave, given its rock construction and oven-shaped form (Whitehouse 1972) (Fig. 15.3). It comprises a spherical chamber with a shaft sealed by a limestone slab, which dates to the Final Neolithic of the fourth millennium cal. BC (Lo Porto 1972).

Geometric motifs also predominate in these liminal spaces, across a variety of art-forms. In 'portable' art, they appear on: decorated ceramics; a stamp from the Grotta dei Cervi (Graziosi 1980, 111); two painted pebbles from Cala Scizzo covered with red ochre painted lines (Geniola & Tunzi 1980, 134–7, fig. 5); an incised pebble of steatite from the Grotta delle Veneri, with a spiral motif on one face and a fish-spine motif on the other (Ventura 1997, 220); as well as on an incised pebble and an incised bone from two other cave sites. Geometric motifs also appear in the 'installation art' of the cave paintings of Porto Badisco, and in the 'landscape-art' of the circular enclosure ditches of north Apulia. Like the ceramics, these enclosures seem to have become visually elaborated and regionally differentiated over time. This is clear, at least, on the Tavoliere plain, where some relatively large sites, delineated by multiple concentric ditches, were constructed, mainly in the northern half of the plain, during the late sixth millennium cal. BC (Brown 1991b). A similar process of visual elaboration may also have taken place in the painted cave of Grotta dei Cervi in the south during the fourth millennium cal. BC, with the addition of some Serra d'Alto style spiral motifs, the replacement of faded images, and the overlapping of geometric motifs in the inner zones of the second and third corridors (Skeates 1995, 205–6).

Schematic anthropomorphic and zoomorphic images are also occasionally present, as in the living contexts, in the form of pottery vessels with human faces applied to rims and animal heads applied to

handles, but also in the form of a unique stone idol. Examples of the anthropomorphic 'face-pots' come from a number of open-site ditches. They also come from cave sites. Examples of zoomorphic tubular handles also come from later Neolithic ritual deposits. The stone 'idol' was found in the rock-cut tomb at Arnesano (Lo Porto 1972) (Fig. 15.3). This tomb contained the crouched body of a young adult, whose arms were oriented towards the idol, suggesting that it had been placed so as to be 'held' in the hands of the dead person (Walter 1988, 153). Three Diana-Bellavista style pottery vessels and a few sherds were also found in the tomb. The idol is 35 cm long, and is made of a piece of limestone, ground into a tapering cylindrical form. A human head is represented at the broadest end by carved eyebrows, a nose and a mouth, together with three deep V-shaped grooves on the neck, which might represent a necklace. This carving echoes the facial features and incised decoration seen on some of the earlier 'face-pots'. The form of the idol has been interpreted as phallic, but given the association between necklaces and women that developed in the art of the Italian Copper Age, this piece has been plausibly reinterpreted as representing a male/female combination (Whitehouse 1992, 166).

More 'figurative' (but not 'naturalistic') representations of anthropomorphic and zoomorphic bodies also appear in the art of these liminal contexts: less frequently, but at least recurrently. These include: the 'portable art' of ceramic figurines; and the 'installation art' of both cave paintings with schematic images of men, women, animals and supernatural figures, and of special deposits containing the carefully placed bodily remains of humans and animals (Figs. 15.4–15.6). Interestingly, these figurative bodies are often 'decorated' by, or closely associated with, specific, culturally significant, geometric symbols.

The clay figurines are technically comparable to contemporary pottery vessels, being generally made from a similar clay fabric, being three-dimensional, and having a similar surface treatment, including the application of polish, slip and paint, as well as impressed or incised marks (Holmes & Whitehouse 1998, 102). More specifically, their faces also exhibit similarities to those of the schematic 'face-pots'. Examples include a pair of figurines from Late Neolithic Passo di Corvo situated on the Tavoliere plain (Tinè 1972, 329–30, fig. 12; 1983, tavs. X–XI & 127–9) (Figs. 15.4, nos. 1 & 2). One is finely made, while the other is more roughly formed. The fine one was found in the fill of a C-ditch, while the rough one was found nearby in the area delimited by that ditch. Both represent the upper half of anthropomorphic bodies, possibly female, comprising a head and face, with

Figure 15.3. *Rock-cut tomb with stone idol at Arnesano. (After Graziosi 1973; Lo Porto 1972.)*

a nose, incised eyes and a mouth, and a torso with breasts and traces of arms along the sides. However, the better-made example is well finished, being carefully shaped, smoothed and decorated with impressed and incised motifs on the head and body. The latter comprise circular incised lines on the top of the head, impressed nostrils, a zigzag line of dots around the neck which resembles a necklace, and zigzagging incised motifs on the front and back. Another figurine from a disturbed deposit, presumed to be Neolithic, at Canne della Battaglia has similar facial features, breasts and incised motifs on its cheeks and body, but its hollow trapeze-shaped body is completely different (Radina 1992) (Fig. 15.4, no. 3). It carries traces of red paint, and measures 8.3 cm in height. Two carefully made clay heads have also been found. One comes from the Late Neolithic Serra d'Alto level of Grotta Pacelli in the Murge (Striccoli 1984, 33–4,

Chapter 15

Figure 15.4. *Ceramic figurines from: 1–2) Passo di Corvo; 3) Canne; 4) Grotta Pacelli. (After Radina 1992; Striccoli 1984; Tinè 1983.)*

the surface. It was also found at the back of this 16 m cave, within an artificial enclosure of stone slabs, and dates to the later Neolithic. Fragments of figurines have also been found at two other sites.

Numerous cave paintings have been identified around Porto Badisco, in the Grotta dei Cervi and in Grotta Cosma (Graziosi 1980; Albert 1982; Guerri 1987–88; Whitehouse 1992, 87–124). They are made of brown bat guano and red ochre (Cipriani & Magaldi 1979). They comprise a combination of geometric motifs (including cruciforms, stelliforms, spirals and zigzags) and schematic figurative motifs (including representations of some 30 men and 12 women, in addition to animals, supernatural figures, bows and arrows, and hand-prints) (Fig. 15.5). Some of these form composite deer-hunting scenes (24 in total), involving one or more male archers, hunting red and roe deer, sometimes accompanied by one or two dogs. The gender of the human figures appears to be marked, for the men by penises and hand-held bows, and for the women by a brown spot of paint in the pubic area and a by 'hand-on-hip' bodily position. The supernatural figures are represented by combinations of human and animal features, including horned heads, beaked heads and forked feet. A degree of spatial patterning can also be seen in the distribution of these motifs. The figurative motifs are generally concentrated towards the entrances of the cave complex, and especially in the relatively spacious Zone III, but they decrease in quantity further into the cave, at the same time as becoming more schematic and abstract. Also, clearly identifiable female figures occur only in Zone III, with possible examples in just two other zones, while male figures occur in almost all of the zones throughout the cave. These paintings were probably produced during the later Neolithic, throughout the fifth and fourth millennia cal. BC.

Examples of 'figurative' human burials with carefully placed bodily remains, sometimes accompanied by pottery vessels and a few other artefacts, also occur (Whitehouse 1984, 1123–6). They appear in two main forms at open sites. Throughout the Neolithic, they occur occasionally as individual tombs, dug within, on top of or close to enclosure and C-ditches. Examples of these have been found at various Tavoliere ditched sites (Fig. 15.6). During the later Neolithic, formal cemeteries were also established at some open sites, containing up to around 20 tombs. Some cave-sites also served as communal cemeteries, which housed the remains of numerous individuals, particularly during the later Neolithic.

142–4, fig. 48) (Fig. 15.4, no. 4). It comprises an oval face, with a nose and eyes in relief, incised nostrils and marks on the cheeks, a neck, and an elaborately carved and incised head-dress. It is broken at the neck. It was found in a hearth made of large stone slabs, placed towards the back of the 16-m-long cave. The other head comes from the Grotta di Cala Scizzo (Geniola & Tunzi 1980, 137–41, fig. 6). It measures 7 cm in length, and comprises a circular face, with applied eyebrows and a nose, and incised eyes and a triangular mouth, placed on a long neck, both of which are framed by long hair represented by incised notches. Traces of red and white colouring remain on

The carefully placed 'figurative' skulls of animals have also been found at some sites. Examples

Figure 15.5. *Painted motifs in the Grotta di Porto Badisco. (After Graziosi 1980.)*

include: deer skulls placed along the walls of an artificial chamber (known as the 'Manfredini hypogeum') that had been dug into the site of an enclosure ditch at the open-site of Santa Barbara near Polignano a Mare; and a dog skull found in the Grotta delle Mura (Whitehouse 1984, 1127).

Social interpretations

The social significance of these patterns in the art of Neolithic southeast Italy can be interpreted using a combination of general analogies with ethnographic studies and theories of art in traditional societies (e.g. Layton 1991; Banks & Morphy 1997), and culturally-specific interpretations derived from the contextual approach of archaeology. According to ethnographic studies of small-scale agricultural societies, such as those of New Guinea (e.g. Strathern & Strathern 1971), art, and especially decoration, is recognized as an active ideological agent, which helps to order patterns of social interaction and political systems. Body decoration, for example, is displayed in a range of social situations, including daily productive activities, courting

Figure 15.6. *Human burial in an enclosure ditch at Masseria Valente. (After Cassano et al. 1987, tav. V.)*

parties, trading visits, ceremonial exchanges, warfare and funerals, where it acts as a signifier of social and ritual positions, although it is interpreted according to a variety of perspectives. Using these ethnographic observations as a starting-point, we can consider further the dynamic visual culture of Neolithic southeast Italy, with reference to the particular contexts (material, behavioural, spatial and historical) within which 'abstract' and 'figurative' motifs were repeatedly produced, displayed and viewed.

Communal bodies
Throughout the Neolithic, the visual culture of the communal 'living' contexts of ditched enclosure sites and cave entrances is dominated by the repeated production and display of a culturally-constrained range of geometric decorative motifs. Here, they appear on stamps, which may have been used to decorate the bodies of more than one person with the same motif. They also appear on pottery vessels, which might equally have been perceived as bodies, as they are in many traditional societies (e.g. Berns 1990; Barley 1994), particularly since some of them were also elaborated by schematic images of human faces and animal heads (Pluciennik 1997, 50), while others may have been 'clothed' in decorative motifs derived from textiles. If this bodily metaphor is appropriate, then both types of decorated body — the human and the ceramic — might be regarded as social bodies, embedded in the quotidian practical and social activities carried out in these communal spaces. As decorated social bodies, they might also have helped, more actively, to frame and highlight visually, peoples' perception of activities such as communal work and food-sharing. In this way, abstract geometric art — and above all its producers and users — could have helped to reinforce an ideal of community identity, both locally and across the region. Such an ideal could, in particular, have been promoted by community leaders, such as a group of elders.

This process can be understood further within the broader context of the Neolithic in southeast Italy, which saw developments in long-distance communication and exchange, and the formation of more settled agricultural communities, over the course of the sixth millennium cal. BC. In the north (and on the Tavoliere in particular), these were possibly established by trans-Adriatic colonists, and in the centre and south by native, but acculturated, complex hunter-gatherers (e.g. Whitehouse 1968a,b; Van Andel & Runnels 1995; Skeates 2000, 170–72). Over time, a process of settlement nucleation can also be seen, particularly on the northern half of the Tavoliere plain at the end of the sixth millennium cal. BC (Delano Smith pers. comm. in Whitehouse 1981, 162; Brown 1991b), together with increasing social interaction, competition and differentiation (Chapman 1988). In this context, the traditional production and display of a regionally- and sometimes locally-specific range of geometric decorative motifs on pottery vessels in communal spaces might be interpreted in terms of the active use of visual culture, functionally and symbolically, to reinforce the social processes of inclusion and differentiation, particularly when displayed on social occasions where food was shared and exchanged (Chapman 1988; Whittle 1996, 309–67; Pluciennik 1997; Skeates 1998). On the one hand, the shared general regional style of these pots might have helped to highlight and overcome a combined sense of social dependency and isolation felt by dispersed groups of colonists, newly settled bands of hunter-gatherers, and even by more established farming communities. And, on the other hand, as some larger and stronger communities emerged, more locally-specific styles and motifs, applied to more aesthetically prized vessels, may also have helped to express their social distinction from neighbouring communities.

The occasional display of schematic images of human faces and animal heads on the lips and handles of some pottery vessels may also have evoked additional meanings. From a practical point-of-view, the lips and handles of serving vessels are the first parts of those vessels their users would have touched with their lips and hands. It may be, then, that the schematic faces and heads highlighted these key points of contact between the two bodies: ceramic and human. More specifically, and with reference to ethnographic analogies, they may also have helped to signal, protect and control the social use of these vessels and their contents, which may have been perceived to contain spiritual forces (Trump 1966, 36; Skeates 1998, 134). Extending from this, the schematic images and their religious meanings could also have provided a subtle reference to the more explicit bodily images displayed in the liminal ritual contexts.

Ritual bodies
The visual material of the liminal contexts, which includes a range of 'portable' and 'installation' art, was, like that of the living contexts, probably embedded in the physical and social activities carried out in those spaces. These appear to have been explicitly ritual in nature, although they were never far-removed from the mainstream of daily life, neither spatially nor conceptually (Skeates 1997). This visual material may also have helped to structure, focus and give meaning to the ritual actions performed in those spaces. Furthermore, it may have been used to express more explicit, cultural and religious, messages and meanings.

This could have been achieved, in particular, by the restricted display of more 'readable' (albeit still 'schematic') figurative representations and combinations of human and animal bodies, including gendered human bodies. These potentially powerful images were confined to the liminal contexts — perhaps not surprisingly, given the inherently problematic conceptual status of 'realistic' figurative images. Here, they were displayed in combination with the more familiar repertoire of geometric decorative motifs and schematic images of human faces and animal heads, seen previously in the living contexts, but now re-contextualized and re-combined to express new messages. Together, all of these images may have continued to be used as a metaphor for social bodies, during the course of ritual performances, particularly given the emphasis of the figurative images and scenes on the relationships between the bodies of humans, animals and combined or supernatural beings. However, slightly different meanings might have been established through their use in open and cave sites.

At the open sites, the highly visible circular and concentric ditches (presumably accompanied by banks), with their ritual deposits of powerful visual material (including 'figurative' human remains, as well as the pair of female figurines at Passo di Corvo), were arguably constructed (and re-constructed) for a combination of purposes, and in particular as strong, practical and symbolic, 'liminal' boundaries (Brown 1991a, 28; Whitehouse 1998, 284; Skeates 2000). On a regional scale, they produced a significant, new and enduring visual impact on the physical and social landscape. Through this, they may have helped to establish a sense of place amongst early agricultural communities engaged in the process of settling down (Whittle 1996, 367), and to provide visual reference points for the ancestral memories and histories of established communities (Robb 1994). Locally, they also helped to structure the social use of space, by controlling access to, and symbolically focusing attention on, boundaries and enclosed areas, people and resources. In doing so, they could have contributed further to the development of a sense of communal identity: practically, through their construction involving communal labour, and culturally, by highlighting distinctions between 'insiders' and 'outsiders'.

In the less accessible natural and artificial caves, situated towards the margins of the Neolithic settled landscape, the marking of chambers by special features, objects, deposits and paintings, may likewise have contributed to the demarcation of cultural and social boundaries. They may have helped to establish those spaces as sacred liminal places, and to demarcate boundaries between 'this world' and the 'other world' (Skeates 1991, 127–9). They were probably also used to shape the meanings of the ritual performances carried out within those spaces, which have been variously interpreted by archaeologists (perhaps too specifically: Grifoni Cremonesi 1994, 190) as rites of passage, including mortuary rites and secret male initiation rites, a cult of the ancestors, fertility rites, and male hunting rituals (Whitehouse 1990; 1992b). In the Grotta dei Cervi, for example, the production and display of increasingly schematic and abstract images in the deepest sections of the cave complex may have been used by leaders to introduce ritual participants to different levels of religious meaning. Visual material could also have been used by ritual leaders in attempts to question and control the identities of the ritual participants, who may have been drawn from restricted groups within communities, based upon their kinship, age and gender. The patterned use of gendered figurative and schematic images is particularly striking, including the painted male hunters and 'hand-on-hip' women in the cave paintings, and the ambiguous ('gender-bending') male/female idol of the artificial cave (Skeates 1995; Whitehouse 2002). A further hint of the social construction and visualization of gender comes from contemporary mortuary deposits, where the bodies of between a quarter and a half of all women appear to have been marked by the intentional removal of front teeth in life (Robb 1997).

These patterned uses of visual material in liminal contexts, which become increasingly evident during the fifth and fourth millennia cal. BC, can be understood further within the broader context of the later Neolithic in southeast Italy. This period saw new technological developments; the diversification of subsistence economies (with an increased contribution from hunting and gathering, and a possible development in the sexual division of labour); a shift in settlement patterns (with an extension of settlement from low-lying areas into inland hilly areas); and an increase in socio-economic interaction, exchange, competition and differentiation between and within communities (e.g. Whitehouse 1968b; 1984; Skeates 1993; Robb 1994). In these circumstances, the production and display of portable and installation art in ritual spaces and performances, including some carefully controlled figurative images, can be interpreted in terms of the active use of a culturally-defined set of ritual symbols and religious beliefs. These may have been manipulated by ritual leaders, in attempts to constrain the meanings of the embodied ritual performances, and to express some more explicit messages. These may have related to their growing efforts to control individuals' identities, including their community- and kin-based affiliation, their age-based status, and above all their gender-roles.

Conclusions

Studies of prehistoric art have been traditionally dominated by an interest in naturalistic images. In this paper, however, I have tried to emphasize that the distinctive visual culture of Neolithic southeast Italy was dominated by the use of abstract motifs, which were open to interpretation across a variety of contexts. I have also argued that the production, display, viewing and meaning of relatively explicit, but also problematic, figurative images was consciously and carefully controlled, and confined to two liminal contexts: settlement enclosure ditches, and ritual caves. I have further suggested that all of these artistic motifs were regarded as powerful, and utilized actively, possibly as part of the socio-political strategies of emergent leaders: first, in the sixth millennium cal. BC, to enhance community identities, and later, in the fifth and fourth millennia, to establish social differences between members of those communities. Other aesthetic properties of the art-works, including their materials, colour, texture, shape, size and symmetry, were probably also used in similar ways, although these fall outside the specific focus of this paper. Finally, I hope to have demonstrated that our chosen analytical categories and terminologies fundamentally affect the way in which we interpret prehistoric art, and that we must continue to select and define them with care, but also a little imagination.

References

Albert, E., 1982. Etude statistique des figurations de la Grotte de Porto Badisco. *Rivista di Scienze Preistoriche* 37, 217–22.

Banks, M. & H. Morphy (eds.), 1997. *Rethinking Visual Anthropology*. New Haven (CT): Yale University Press.

Barley, N., 1994. *Smashing Pots: Feats of Clay from Africa*. London: British Museum Press.

Berns, M.C., 1990. Pots as people: Yungur ancestral portraits. *African Arts* 23(3), 50–60.

Boas, F., 1927. *Primitive Art*. Oslo: H. Aschehoug.

Borzatti von Löwenstern, E., 1965. Il Neolitico della Grotta delle Prazziche (Puglia), in *Atti della X^a Riunione Scientifica, in Memoria di Francesco Zorzi: Verona 21–23 Novembre 1965*, eds. Istituto Italiano di Preistoria e Protostoria. Verona: Istituto Italiano di Preistoria e Protostoria, 129–38.

Bray, W., 1966. Neolithic painted ware in the Adriatic. *Antiquity* 40, 100–106.

Brown, K., 1991a. A passion for excavation: labour requirements and possible functions for the ditches of the 'villaggi trincerati' of the Tavoliere, Apulia. *The Accordia Research Papers* 2, 7–30.

Brown, K., 1991b. Settlement distribution and social organization in the Neolithic of the Tavoliere, Apulia, in *Papers of the Fourth Conference of Italian Archaeology: the Archaeology of Power*, part 1, eds. E. Herring, R. Whitehouse & J. Wilkins. London: Accordia Research Centre, 9–25.

Caligiuri, R. & A. Battisti, 2002. Il nuovo allestimento del Museo Civico Archeologico Francesco Saverio Majellaro di Bisceglie, in *La Preistoria della Puglia: Paesaggi, Uomini e Tradizioni di 8,000 Anni Fa*, ed. F. Radina. Bari: Mario Adda Editore, 93–9.

Cassano, S.M. & A. Manfredini, 1991. Rinvenimento di una sepoltura Serra d'Alto a Masseria Candelaro: scavo 1990, in *Atti del 12° Convegno Nazionale sulla Preistoria-Protostoria-Storia della Daunia*, ed. G. Clemente. San Severo: Archeoclub d'Italia, Sede di San Severo, 21–30.

Cassano, S.M., A. Cazzella, A. Manfredini & M. Moscoloni (eds.), 1987. *Coppa Nevigata e il suo Territorio: Testimonianze Archeologiche dal VII al II Millennio a.C.* Roma: Edizioni Quasar.

Chapman, J.C., 1988. Ceramic production and social differentiation: the Dalmatian Neolithic and the west Mediterranean. *Journal of Mediterranean Archaeology* 1(2), 3–25.

Childe, V.G., 1957. *The Dawn of European Civilization*. 6th edition. London: Routledge & Kegan Paul.

Cipriani, N. & D. Magaldi, 1979. Composizione mineralogica delle pitture della Grotta di Porto Badisco. *Rivista di Scienze Preistoriche* 34, 263–7.

Coppola, D., 1999–2000. Grotta Sant'Angelo (Ostuni, Brindisi), scavi 1984: dalla ceramica graffita al linguaggio simbolico. *Atti della Società per la Preistoria e Protostoria della Regione Friuli-Venezia Giulia* 12, 67–126.

Cornaggia Castiglione, O., 1956. Origini e distribuzione delle pintaderas preistoriche 'euro-asiatiche'. *Rivista di Scienze Preistoriche* 11, 109–88.

Gell, A., 1992. The technology of enchantment and the enchantment of technology, in *Anthropology, Art and Aesthetics*, eds. J. Coote & A. Sheldon. Oxford: Clarendon Press, 40–63.

Gell, A., 1998. *Art and Agency: an Anthropological Theory*. Oxford: Clarendon Press.

Geniola, A., 1979. Il Neolitico nella Puglia Settentrionale e Centrale, in *La Puglia dal Paleolitico al Tardoromano*, ed. D. Adamesteanu. Milano: Electa, 52–93.

Geniola, A. & A.M. Tunzi, 1980. Espressioni cultuali e d'arte nella Grotta di cala Scizzo presso Torre a Mare (Bari). *Rivista di Scienze Preistoriche* 35(1–2), 125–46.

Giannitrapani, M., 2002. *Coroplastica Neolitica Antropomorfa d'Italia: Simboli ed Iconografie dell'Arte Mobiliare Quaternaria Post-Glaciale*. (British Archaeological Reports International Series 1020) Oxford: BAR.

Gombrich, E.H., 1960. *Art and Illusion: a Study in the Psychology of Pictorial Representation*. London: Phaidon Press.

Gombrich, E.H., 1979. *The Sense of Order: a Study in the Psychology of Decorative Art*. London: Phaidon Press.

Goody, J., 2000. Figurative Representations and their Absence: Puritanism on a World. Unpublished paper presented at the Summer Institute in World Art Studies, University of East Anglia, Norwich.

Graziosi, P., 1973. *L'Arte Preistorica in Italia*. Florence: Sansoni.

Graziosi, P., 1980. *Le Pitture Preistoriche della Grotta di Porto Badisco*. Firenze: Istituto Italiano di Preistoria e Protostoria.

Grifoni Cremonesi, R., 1994. Observations on the problems related to certain cult phenomena during the Neolithic in the Italian peninsula. *Journal of European Archaeology* 2(2), 179–97.

Guerri, M., 1987–88. Grotta Cosma: S. Cesarea Terme, Prov. di Lecce. *Rivista di Scienze Preistoriche* 41, 420–21.

Hauser, A., 1951. *The Social History of Art*, vol. I: *from Prehistoric Times to the Middle Ages*. London: Routledge.

Holmes, K. & R. Whitehouse, 1998. Anthropomorphic figurines and the construction of gender in Neolithic and Copper Age Italy, in *Gender and Italian Archaeology: Challenging the Stereotypes*, ed. R.D. Whitehouse. London: Accordia Research Institute, 95–126.

Ingravallo, E., 1997. Sant'Anna (Oria), in *La Passione dell'Origine: Giuliano Cremonesi e la Ricerca Preistorica nel Salento*, ed. E. Ingravallo. Lecce: Conte Editore, 135–56.

Jones, G.D.B., 1987. *Apulia I: Neolithic Settlement in the Tavoliere*. London: Society of Antiquaries.

Kopytoff, I., 1986. The cultural biography of things: commodities as process, in *The Social Life of Things: Commodities in Cultural Perspective*, ed. A. Appadurai. Cambridge: Cambridge University Press, 64–91.

Layton, R., 1991. *The Anthropology of Art*. 2nd edition. Cambridge: Cambridge University Press.

Lewis, G., 1980. *Day of Shining Red: an Essay on Understanding Ritual*. Cambridge: Cambridge University Press.

Lo Porto, F.G., 1972. La tomba neolitica con idolo in pietra di Arnesano (Lecce). *Rivista di Scienze Preistoriche* 27, 357–72.

Mallory, J.P., 1984–87. Lagnano da Piede I: an Early Neolithic village in the Tavoliere. *Origini* 13, 193–290.

Malone, C., 1985. Pots, prestige and ritual in Neolithic southern Italy, in *Papers in Italian Archaeology IV: The Cambridge Conference. Part ii: Prehistory*, eds. C. Malone & S. Stoddart. (British Archaeological Reports International 245) Oxford: BAR, 118–51.

Palma di Cesnola, A., 1967. Il Neolitico medio e superiore di San Domino (Arcipelago delle Tremiti). *Rivista di Scienze Preistoriche* 22, 349–92.

Piccinno, A. & F. Piccinno, 1978. Otranto, Laghi Alimini — stazioni preistoriche. *Ricerche e Studi* 11, 122–32.

Pluciennik, M.Z., 1997. Historical, geographical and anthropological imaginations: early ceramics in southern Italy, in *Not so Much a Pot, More a Way of Life: Current Approaches to Artefact Analysis in Archaeology*, eds. C.G. Cumberpatch & P.W. Blinkhorn. Oxford: Oxbow Books, 37–56.

Radina, F., 1992. Una statuetta neolitica da Canne, in *Atti della XXVIII Riunione Scientifica dell'Istituto Italiano di Preistoria e Protostoria: L'Arte in Italia dal Paleolitico all'Età del Bronzo*, ed. A. Revedin. Firenze: Istituto Italiano di Preistoria e Protostoria, 455–63.

Robb, J., 1994. Burial and social reproduction in the peninsular Italian Neolithic. *Journal of Mediterranean Archaeology* 7(1), 27–71.

Robb, J., 1997. Intentional tooth removal in Neolithic Italian women. *Antiquity* 71, 659–69.

Skeates, R., 1991. Caves, cult and children in Neolithic Abruzzo, central Italy, in *Sacred and Profane: Proceedings of a Conference on Archaeology, Ritual and Religion*, eds. P. Garwood, D. Jennings, R. Skeates & J. Toms. Oxford: Oxford University Committee for Archaeology, 122–34.

Skeates, R., 1992. Thin-section analysis of Italian Neolithic pottery, in *Papers of the Forth Conference of Italian Archaeology*, vol. 3: *New Developments in Italian Archaeology*. Part 1, eds. E. Herring, R. Whitehouse & J. Wilkins. London: Accordia Research Centre, 29–34.

Skeates, R., 1993. Neolithic exchange in central and southern Italy, in *Trade and Exchange in Prehistoric Europe: Proceedings of a Conference Held at the University of Bristol. April 1992*, eds. C. Scarre & F. Healy. Oxford: Oxbow Books, The Prehistoric Society & Société Préhistorique Française, 109–14.

Skeates, R., 1995. Ritual, context and gender in Neolithic southeastern Italy. *Journal of European Archaeology* 2(2), 199–214.

Skeates, R., 1997. The human uses of caves in east-central Italy during the Mesolithic, Neolithic and Copper Age, in *The Human Use of Caves*, eds. C. Bonsall & C. Tolan Smith. (British Archaeological Reports International 667) Oxford: BAR, 79–86.

Skeates, R., 1998. The social life of Italian Neolithic painted pottery, in *The Archaeology of Value: Essays on Prestige and the Processes of Valuation*, ed. D. Bailey. (British Archaeological Reports International 730) Oxford: BAR, 131–41.

Skeates, R., 2000. The social dynamics of enclosure in the Neolithic of the Tavoliere, southeast Italy. *Journal of Mediterranean Studies* 13(2), 155–88.

Skeates, R., 2002. Visual culture in prehistoric southeast Italy. *Proceedings of the Prehistoric Society* 68, 165–83.

Skeates, R., 2005. *Visual Culture and Archaeology: Art and Social Life in Prehistoric Southeast Italy*. London: Duckworth.

Stevenson, R.B.K., 1947. The Neolithic cultures of southeast Italy. *Proceedings of the Prehistoric Society* 13, 85–100.

Strathern, A. & A. Strathern, 1971. *Self-Decoration in Mount Hagen*. London: Duckworth.

Striccoli, R., 1984. Testimonianze cultuali e artistiche nel deposito neolitico di Grotta Pacelli, Castellana Grotte (Bari.) *Miscellanea di Studi Pugliesi* 1, 9–28.

Tinè, S., 1972. Gli scavi del villaggio Neolitico di Passo di Corvo, in *Atti della XIV Riunione Scientifica dell'Istituto Italiano di Preistoria e Protostoria in Puglia, 13–16 Ottobre 1970*, eds. Istituto Italiano di Preistoria e Protostoria. Firenze: Istituto Italiano di Preistoria e Protostoria, 313–31.

Tinè, S., 1975. Culto neolitico delle acque nella Grotta Scaloria, in *Valcamonica Symposium '72: Actes du Symposium International sur les Religions de la Préhistoire, Capo di Ponte*, ed. E. Anati. Capo di Ponte: Centro Camuno di Studi Preistorici, 185–90.

Tinè, S., 1983. *Passo di Corvo e la Civiltà Neolitica del Tavoliere*. Genova: Sagep.

Tinè, S. & E. Isetti, 1975–80. Culto neolitico delle acque e recenti scavi nella Grotta Scaloria. *Bullettino di Paletnologia Italiana* 82, 31–70.

Trump, D.H., 1966. *Central and Southern Italy Before Rome.* London: Thames & Hudson.

Trump, D.H., 1980. *The Prehistory of the Mediterranean.* New Haven (CT): Yale University Press.

Turner, V.W., 1977. Variations of a theme of liminality, in *Secular Ritual*, eds. S.F. Moore & B.G. Myerhoff. Amsterdam: Van Gorcum, 36–52.

Ucko, P.J. (ed.), 1977. *Form in Indigenous Art: Schematization in the Art of Aboriginal Australia and Prehistoric Europe.* London: Duckworth.

Van Andel, T.H. & C.N. Runnels, 1995. The earliest farmers in Europe. *Antiquity* 69, 481–500.

Ventura, V., 1997. Grotta delle Veneri: ceramica, in *La Passione dell'Origine: Giuliano Cremonesi e la Ricerca Preistorica nel Salento*, ed. E. Ingravallo. Lecce: Conte Editore, 198–220.

Walter, P., 1988. Shaft-chambered tombs of the fourth millennium BC in the Mediterranean. *Berytus: Archaeological Studies* 36, 143–67.

Whitehouse, R.D., 1968a. The Early Neolithic of southern Italy. *Antiquity* 42, 188–93.

Whitehouse, R.D., 1968b. Settlement and economy in southern Italy in the Neothermal period. *Proceedings of the Prehistoric Society* 34, 332–66.

Whitehouse, R., 1969. The Neolithic pottery sequence in southern Italy. *Proceedings of the Prehistoric Society* 35, 267–310.

Whitehouse, R., 1972. The rock-cut tombs of the central Mediterranean. *Antiquity* 46, 275–81.

Whitehouse, R.D., 1981. Prehistoric settlement patterns in southeast Italy, in *Archaeology and Italian Society*, eds. G. Barker & R. Hodges. (British Archaeological Reports International 102) Oxford: BAR, 157–65.

Whitehouse, R.D., 1984. Social organization in the Neolithic of southeast Italy, in *The Deya Conference of Prehistory: Early Settlement in the Western Mediterranean Islands and the Peripheral Areas*, eds. W.H. Waldren, R. Chapman, J. Lewthwaite & R.-C. Kennard. (British Archaeological Reports International 229) Oxford: BAR, 1109–37.

Whitehouse, R.D., 1986. Siticulosa Apulia revisited. *Antiquity* 60, 36–44.

Whitehouse, R.D., 1990. Caves and cult in Neolithic southern Italy. *The Accordia Research Papers* 1, 19–37.

Whitehouse, R.D., 1992. *Underground Religion: Cult and Culture in Prehistoric Italy.* London: Accordia Research Centre.

Whitehouse, R.D., 1998. Società ed economia nel Neolitico Italiano: la problematica dei fossati, in *La Preistoria del Basso Belice e della Siclia Meridionale nel Quadro della Preistoria Siciliana e Mediterranea*, ed. S. Tusa. Palermo: Società Siciliana di Storia Patria, 275–85.

Whitehouse, R.D., 2002. Gender in the south Italian Neolithic: a combinatory approach, in *In Pursuit of Gender: Worldwide Archaeological Approaches*, eds. S.M. Nelson & M. Rosen-Ayalon. Walnut Creek (CA): AltaMira Press, 15–42.

Whittle, A., 1996. *Europe in the Neolithic: the Creation of New Worlds.* Cambridge: Cambridge University Press.

Chapter 16

Imagery and Social Relationships: Shifting Identity and Ambiguity in the Neolithic

Ian Kuijt & Meredith S. Chesson

From the perspective of many archaeologists, as well as the general public, one of the most interesting aspects of the ancient Near Eastern Neolithic is the assemblage of exotic anthropomorphic statues, animal and human figurines, and plastered and painted human skulls. Starting at around 11,500 years ago, the Neolithic of the Near East encompassed some of the most profound and fundamental innovations in human lifeways in our species' history, including the establishment of the earliest sedentary villages in the world founded on food-producing communities relying on wild and domesticated plants and animals for subsistence. As part of the tremendous changes in lifeways, with a move from a mobile hunting and gathering lifestyle to one of year-round sedentism and food production of cereals, we witness the shifting use of imagery, both anthropomorphic and zoomorphic, in concert with society's struggle to control and contain new structures of economy, social organization, and symbolism. Over a three-thousand-year period of what is now known as the Pre-Pottery Neolithic (PPN), people and community practices in imagery changed in what they chose to, and chose not to illustrate in their daily lives. This includes shifting interests in and use of human and animal imagery, a focus on the natural and stylized representation of the face and body, and eventually, the almost total disappearance of earlier practices with the emergence of large agricultural villages. Interestingly, the nature and scale of manufacture and use of figural representations of humans, animals, and geometric shapes shift in these communities over time, often changing with documented transitions in economic and social practices. Our attention, then, rests on understanding how we can explore the relationships between social and economic behavioural changes and figurine use in these communities, and more specifically, how the representation of human forms may reflect changing understandings of what it meant for people to live in these communities as individuals and members of collective groups.

In this essay we address a single broad descriptive question: How did the use of imagery change through the Neolithic? In this paper we limit our analysis to published objects from the Pre-Pottery Neolithic of the southern Levant, restricting the geographical and temporal scope in order to focus on the use of figural representation in a defined space and time. Moving beyond research structured by the assumption of a pan-Near Eastern Neolithic, we look at regional patterns of use and focus on three-dimensional representations of humans, animals or geometric shapes in the form of figurines, statues, masks, or human skulls from southern Levantine Pre-Pottery Neolithic sites (Fig. 16.1). In this paper we make several arguments: 1) we believe that arguments for a dominance of female imagery in the Pre-Pottery Neolithic is overstated, not supported by archaeological data, and ignores the presence of male imagery and zoomorphic figurines; 2) we argue that in many cases the focus among researchers for identifying male/female figurines is misplaced and not productive. In many ways the critical issue is not whether a figurine is male or female, rather the relevant question is why did Neolithic groups deliberately choose to not to represent sexually marked identity in imagery? 3) In relation to our second point, we argue that increased attention needs to be directed to documenting and understanding shifting practices in imagery through time, and how these might be related to other social phenomena. We argue that the attention to context forces us to change research questions about figurine function and significance, contextualizing peoples' manufacture, use, and discard of these objects within the social, economic, and political frameworks of their communities.

Chapter 16

Figure 16.1. *Map of Pre-Pottery Neolithic sites of the southern Levant.*

Figurines, bodies and identity

Analysis and interpretation of the social and symbolic context of prehistoric anthropomorphic figurines has produced an extensive series of debates and discussions. Researchers have generated a substantial body of literature which explores questions of why people make figurines and what we can learn about a society from its figurines. This historical context and overview of the practice and theory of figurine studies has been widely discussed in several surveys (Bailey 1996; 2005; Haaland & Haaland 1996; Hamilton 1996; Marcus 1996; Ucko 1996; Knapp & Meskell 1997; Lesure 2002). These authors note that figurines represent a unique form of human representation with a complex array of meanings, simultaneously obvious and nuanced, that may change throughout their life-history as the makers and/or users of the figurines negotiate their own lives and relationships. The figurine may change hands several times over its life-history, be used in many different and differently charged contexts, and embody multiple significances to different people.

Figurines involve the creation of the human image in a three-dimensional, durable, and tangible format that extends beyond gesture, voice, and language in portraying some aspect of humanness (Bailey 1996; 2005). While many figurines may not have been designed to be strictly realistic representations of a human form, nevertheless they do depict recognizably human elements. What is often interesting is the nature of this representation, namely which elements are emphasized and which are de-emphasized or even omitted (Joyce 1993). Joyce argues that details of human images are not random; rather they are deliberate and reflect stereotyping of mental constructs by the makers and users of them. Thus, emphasis and omissions in figurines potentially represent a series of naturalized features that are important elements in how a particular society understands the materiality of human bodies and social identities. Douglas (1982) notes this close and inseparable relationship between peoples' physical bodies and social bodies. In outlining the connections between the personal and social body, Douglas (1982, 63) discusses the interesting implications for how societal structures can be expressed on the body, arguing that, 'The social body constrains the way the physical body is perceived. The physical experience of the body, always modified by the social categories through which it is known, sustains a particular view of society'. We believe that the figural representation of humans potentially intensified this relationship between the personal and social. In representing the human form in a durable material good, people

created an enduring representation of the personal and social body, focusing attention on the key elements of what it meant to be a person and exist in a human body in a particular society.

Many researchers have recognized this connection and interpreted this relationship as a potential venue for expressing concepts of identity, particularly sex and gender, in a society (Martin 1987; Butler 1990; 1993; Lacqueur 1990; Lock 1993), prompting archaeologists to think about identity in the archaeological past (Conkey & Gero 1997, and references therein; Gilchrist 1999; Meskell 1999; Joyce 2000). While the vast majority of archaeological studies of gender successfully de-couple the concept of gender from sex and recognize gender as a social construct, they do not similarly question the notion of sex (Knapp & Meskell 1997). Lacqueur (1990) and Butler (1990; 1993) have demonstrated the constructed nature of sex and gender, that people's understandings of their biological, material bodies are just as socially constructed as understandings of their own gender identities. Therefore there can be multiple ways of understanding the materiality of human bodies that may differ across space and time. How does this affect our study of anthropomorphic figurines? If researchers do not question the binary categories of male and female and conflate categories of sex and gender, then their approach to human figurines by default assumes the presence of only these two categories. They approach the figurine assemblage looking for signs of maleness (penis) and femaleness (breasts, hips, buttocks) that are associated with secondary sexual characteristics. They may also categorize figurines according to other traits, such as costume, hair, or even find context, that may be interpreted as indicating male or female characteristics. If figurines do not display any of these markings then they are often placed in an 'Other' category that may or may not enter researchers' discussions of normative ideas about sex and gender in a society. This constrained approach fails to consider the social construction of sex or gender, or the complexity of figural representation of human bodies.

In this paper we address two major issues:
1. We argue that broad characterizations of the imagery in early Near Eastern Neolithic villages as representing females fails to recognize the co-existence of female and male imagery in the PPNA (Pre-Pottery Neolithic A) and ignores the presence of zoomorphic figurines in the MPPNB (Middle Pre-Pottery Neolithic B). As is often the case, things are more complicated than portrayed by general treatments of Near Eastern imagery.
2. We argue that detailed consideration of shifting patterns of imagery from these periods identifies patterns that are not widely recognized by researchers: a shift from a visual focus on the lower torso and secondary sexual characteristics in the PPNA to one of the face, head and upper torso in the MPPNB. Such shifts do not reflect issues of archaeological recovery, or the scale of field research at sites from different periods. Rather, we argue that this pronounced shift may have been related to differing systems of social organization, views of personhood and identity. Specifically, in the PPNA images appear to have been focused on stylized representation of the human body-representations that were both ambiguous, focused on the lower half of people, and were very simple. In contrast, figurines and imagery in the following MPPNB were focused on personhood, illustrated by naturalistic representations of the face with detailed treatments of the eyes, nose, ears and mouth.

In later sections of this paper we re-examine Neolithic figurine use, meaning, and interpretation. Rather than accepting the traditional view of two naturalized sexes, we instead investigate the spectrum of representation and explicate the nature of marked, unmarked, and ambiguous representations. We argue that for some periods of the Neolithic the traditional search by researchers for two naturalized sexes is misleading and inappropriate, as the vast majority of PPN figurines are unmarked, and thus the emphasis on males and females as key binary features of identity is inaccurate. In this way, we hope to gain a greater understanding of how the PPN people understood what it meant to be human, and how they linked their bodies, and portrayals of human bodies, to the expression of identities.

Levantine Neolithic imagery: shifting practices and patterns

Archaeological field research in the southern Levant provides researchers with our most detailed understanding of the technological background, temporal and spatial distribution of the use and manufacture of zoomorphic and anthropomorphic figurines, as well as clay geometrics, within any single region of the Near East (Kuijt & Chesson 2005; Bar-Yosef 1997) (Fig. 16.2). Research in other geographical areas, specifically at the settlements of Çatalhöyük, Hajji Firuz, and Gritille Höyük (Mellaart 1967; Ucko 1968; Voigt 1983; 1985; 2000; Hamilton 1996), provide important insights into figurine use from surrounding areas. When considering figurine use in the southern Levant, it is clear that changes in both style and frequency of different types of figurines are seen in all of the major phases of the Pre-Pottery Neolithic period, including the first

Chapter 16

Figure 16.2. *Shifting material systems of Neolithic imagery.*

sedentary collector-agricultural villages in the Pre-Pottery Neolithic A (PPNA), the formation of established agricultural villages of the Middle Pre-Pottery Neolithic B (MPPNB) and the eventual emergence of large aggregate villages of the Late Pre-Pottery Neolithic B period/Pre-Pottery Neolithic C (LPPNB/PPNC). Each phase of the PPN involves a specific combination of settlement patterns, socio-economic structures, and community types (Bar-Yosef & Meadows 1995; Kuijt & Goring-Morris 2002; Kuijt & Chesson 2005, table 1).

PPNA
The PPNA period represents the first period of the Neolithic of the Near East. Starting at approximately 11,500 BP, we see the emergence of relatively small forager-collector communities whose architecture is primarily composed of oval-circular stone structures. Figurines of any sort are extremely rare in this period. For example, excavations at Dhra' in an area of 25 by 10 m, and with 100 per cent of sediment screened through 2 mm mesh, has produced a total of two figurines. There are no clearly identified zoomorphic figurines known from the PPNA, but there are eleven anthropomorphic figurines dated to PPNA contexts from several sites and all are carved from limestone or formed of baked clay (Kuijt & Chesson 2005, fig. 8.3, tables 8.2–8.4). One figurine has also been found at el-Khiam and identified as anthropomorphic, but we have characterized it as unknown or unidentifiable due to the lack of any overt human features (Fig. 16.3d). All but the el-Khiam figurine are stylized representations of portions or all of a human body, and each involves a unique combination of marked features or omissions. For example, excavators at Wadi Faynan 16 (WF16), Dhra' and Netiv Hagdud have argued that two figurines represent female bodies, based on their identification of secondary sexual characteristics (breasts, hips), and overall shape of the figures (Figs. 16.3e–g) (Bar-Yosef & Gopher 1997; Kuijt & Finlayson 2002). Similarly, recent excavations at WF16, Zahrat adh-Dhra' 2, and Dhra' have recovered carved phalli (two from WF16, one from Zahrat adh-Dhra' 2 and one from Dhra') (Edwards *et al.* 2004; Finlayson 2005, pers. comm.). It should be noted, however, that four of the eight PPNA anthropomorphic figurines can be interpreted as ambiguous, without any specific markers of sex or gender (Bar-Yosef 1997; Cauvin 2000a). In the three cases where find context was noted, figurines were recovered in trash deposits (Bar-Yosef & Gopher 1997; Kuijt & Finlayson 2002).

Imagery and Social Relationships

Figure 16.3. *Pre-Pottery Neolithic A period figurines.*

Figure 16.4. *Middle Pre-Pottery Neolithic B period anthropomorphic busts and statues.*

PPNB

At the end of the PPNA at *c.* 10,500 BP, we witness a remarkable florescence in the frequency and variety of human images. This includes the appearance of new forms of clay and stone anthropomorphic figurines, and importantly, the widespread use of zoomorphic figurines. The PPNB is commonly divided into three main phases: Early PPNB (EPPNB), Middle PPNB (MPPNB), and Late PPNB/PPNC (LPPNB/PPNC). The collective PPNB assemblage contains at least 708 published zoomorphic, anthropomorphic, and geometric figurines (see Kuijt & Chesson 2005 for detailed accounts of the typology, frequency and typology of PPNB figurines).

EPPNB

The EPPNB is viewed by some as a transitional cultural phase between PPNA and MPPNB (e.g. Goring-Morris & Belfer-Cohen 1998). This transition is poorly understood by researchers, and as discussed elsewhere (Edwards *et al.* 2004; Kuijt 1998; 2003; Kuijt & Goring-Morris 2002), serious questions have been raised about the validity of this cultural-historical phase. Regardless of the problematic acceptance of the EPPNB as a cultural-historical unit, there are no published examples of anthropomorphic or zoomorphic figurines from any of the archaeological sites claimed to date to this period.

MPPNB

The MPPNB period is characterized by the appearance of large agricultural villages characterized by freestanding rectangular residential buildings, domesticated plants and animals, and new developments in lithic technology. Perhaps the most dramatic aspect to representational practice in the MPPNB lies in the appearance of many new forms of anthropomorphic representations. These include large, full-body anthropomorphic statues, large busts with painted faces, face masks made of clay and stone, plastered/painted and cached skulls and masks, and small anthropomorphic figurines made of baked clay or carved in stone (Figs.

215

Chapter 16

Baked clay anthropomorphic figurines

(a) Beidha (after Kirkbride 1968)
(b) 'Ain Ghazal (after Rollefson 1983)
(c) Munhata (after Perrot 1966)

Skulls plastered with clay

(d) Ramad (after de Contenson 1967)
(e) Ramad (after de Contenson 1967)

Figure 16.5. *Middle and Late Pre-Pottery Neolithic B period anthropomorphic figurines and plastered skulls.*

MPPNB baked clay zoomorphic representations

(a) 'Ain Ghazal (after Rollefson 1983)
(b) 'Ain Ghazal (after Rollefson 1983)
(c) 'Ain Ghazal (after Rollefson 1983)
(d) Jericho (after Holland 1982)

Figure 16.6. *Middle Pre-Pottery Neolithic B period zoomorphic figurines and facial representations.*

16.4–16.6). In addition, zoomorphic representations appear in the MPPNB for the first time, including significant numbers of cattle figurines made of baked clay recovered from multiple settlements (Bar-Yosef 1997). In contrast to the limited number of figurines recovered from PPNA sites, there is a remarkable abundance of these objects in the MPPNB (Figs. 16.4–16.6; Kujit & Cheeson 2005, tables 8.1–8.4). These objects have been recovered from a wide variety of contexts, including public caches, trash deposits, fills, and residential spaces.

LPPNB/PPNC

The LPPNB/PPNC period reflects continuity in general architectural and settlement practices from the MPPNB period. Villages are characterized by rectangular architecture with one- and two-storey buildings constructed against each other. While there are some important elements of continuity in the manufacture and use of figurines from MPPNB to LPPNB, there are also some clear differences. Elements of continuity include the use of zoomorphic figurines made of clay (Figs. 16.4 & 16.6; Kujit & Cheeson 2005, tables 8.1–8.4). With the exceptions of one stone human figurine depicting a head and a fragment of a stone mask from Basta, and eight human figurines from 'Ain Ghazal, the LPPNB/PPNC people did not represent humans widely in any medium. Twenty-three figurines from es-Sifiya have been characterized by Mahasneh, Gebel and Bienert as anthropomorphic male (Mahasneh & Bienert 1999; Mahasneh & Gebel 1999). Based on the published examples of the seven classes of human figurines proposed by Mahasneh & Bienert (1999), we disagree with these researchers and categorize these objects as geometric figurines (although we might also entertain their categorization as 'Unknown' or 'Unidentifiable'). There are no clear indications of human features (much less 'male' characteristics), even highly stylized ones, and thus we argue that these figurines are not demonstrably anthropomorphic representations. While we see a remarkable decline of human representations in the LPPNB/PPNC, we witness a marked increase in the number of geometric figurines found at several LPPNB/PPNC sites. Furthermore, while zoomorphic figurines continue to be used in these communities, the number of these is much smaller compared to the MPPNB period.

Meaning and interpretations of Neolithic imagery

Let us now turn to a discussion of how regional patterns of changing imagery provide insight into social practice, identity, and community in the Neolithic. Among the critical unexplored questions are why there was relatively little use of certain types of figurines over others in different periods, and to what extent different images were deliberately selected. Given that images often legitimate authority and power and, as Butler notes, people's understandings of the biological, symbolic and material body are socially constructed, then one of the critical questions is of how representation and social power are interconnected.

Imagery and Social Relationships

	PRE-POTTERY NEOLITHIC A PERIOD (DHRA', NETIV HAGDUD, WF16)	MIDDLE PRE-POTTERY NEOLITHIC B PERIOD ('AIN GHAZAL, JERICHO)
ANTHROPOMORPHIC FIGURINES	***Visual and organizational focus*** Attention on primary and secondary sexual characteristics (breasts, phallus, buttocks). Head and face are not represented. Human images focus on torso, waist and legs. ***Stylized representation*** Interpretation: Masking of gendered identity?	***Visual and organizational focus*** Attention on face: (eyes, mouth, and nose). Limited attention to legs, arms, hands and breasts. No attention to genitalia. ***Naturalistic representation*** Interpretation: new attention to issues of identity, ownership, personhood.
ZOOMORPHIC FIGURINES	No zoomorphic figurines recovered	***Visual and organizational focus*** Clay *Bos* figurines. Generally identified with maleness. Variants: beheaded, tethered, and ritually 'killed' with flint pieces in the head, chest and torso. ***Naturalistic representation*** Interpretation: new attention to wild/domesticated cattle as a social and symbolic focus, ownership and control of resources.

(Central vertical band: *Major transformation in symbolic representations*, 10,500 BP)

Figure 16.7. *Comparison of anthropomorphic and zoomorphic imagery for the PPNA and MPPNB.*

The Pre-Pottery Neolithic A period: imagery of women and men

It is now clear that the production of images in early Near Eastern Neolithic villages included depictions of female and male bodies or portions of bodies in the PPNA, and in the context of the MPPNB, was dominated by the use of zoomorphic figurines (Fig. 16.7). In what is unquestionably the most provocative consideration of Neolithic figurines in the Near East, Cauvin (2000a,b) has written several articles and books exploring the potential links between the origins of agriculture and imagery. His interpretations and reconstruction of the birth of gods in the Neolithic are centred almost entirely upon perceived changes in imagery, and more specifically the purported duality of zoomorphic and anthropomorphic figurines. With the exception of some limited material from the site of Mureybet for the PPNA, Cauvin's interpretation of symbolism and its relation to the origins of agriculture is, unfortunately, based on a poor and outdated understanding of figurine data from the southern Levant, and an unsubstantiated adherence to a homogenizing model of the imagery of the PPNA and PPNB.

Developing arguments for the first phase of his interpretation of the revolution of Neolithic imagery, Cauvin contrasts the PPNA period with the Natufian of the southern Levant, arguing that Natufian art was essentially zoomorphic (Cauvin 2000a, 25). This serves as a highly generalized treatment of these materials, and he fails to recognize that some Natufian art is anthropomorphic, including carved human heads, and in one case, a couple engaged in intimate physical contact, often interpreted as representing sexual intercourse (Perrot 1966; Noy 1991; Weinstein-Evron & Belfer-Cohen 1993; Bar-Yosef 1997). Focusing on the Levantine PPNA, he argues that there was a revolution of imagery that predates the origins of agriculture. Cauvin suggests that it is at this time that we see the emergence of two dominate images: the woman and the bull. He argues, moreover, that female images are representations of a goddess, largely characterized by materials recovered from southern Levantine PPNA examples.[1] To Cauvin, the bull, representative of a male god is indicated by skulls of aurochs buried in houses at Mureybet complete with horns, while the goddess is exemplified by figurines purportedly

Figure 16.8. *Pottery Neolithic figurines* recovered from the southern Levant. He argues that the goddess and the bull form a separate, yet related, symbolic system for the PPNA.

Cauvin's (2000a) interpretation is, however, not consistent with available evidence for imagery in the PPNA. There are, in fact, several major problems with Cauvin's reading of Neolithic data:

1. His assumption of an essentialized duality of males and females, and relating these structures to Neolithic peoples' concepts of nature and culture, finds only tenuous support from the imagery from the Levant. In characterizing the imagery of the PPNA as female, for example, he ignores archaeological evidence for the carving of phallus images in the PPNA. Excavations at WF16 and Dhra' have recovered three examples of phalli.
2. Cauvin's approach to figurine interpretation compresses materials from multiple periods and from a broad geographical area. As such it decontextualizes materials and weakens his interpretive framework.
3. In many ways the intellectual core of his argument centres on the archaeological materials from the Late Neolithic Turkish site of Çatalhöyük, occupied some 2000 years later than the PPNA of the southern Levant. Drawing upon the Çatalhöyük data, Cauvin (2000a, 32) argues that a form of Neolithic female monotheism existed in PPNA and was replaced by religions or ritual systems in the PPNB that focused on males.
4. Perhaps most surprising is the fact that Cauvin does not recognize that imagery and symbolic context in the PPNA may have been very different from the later MPPNB. As with Schmandt-Besserat (1998b), we (Kuijt & Chesson 2005) argue that the stone carvings in the PPNA were sexually ambiguous or even dual-gendered representations that can alternatively be viewed as representations of male genitalia (she argues that these objects appear to be a stylized phallus, from another viewpoint a stylized human female).

Neolithic imagery: symbolic ambiguity in imagery

Over the last 10 years considerable debate has focused on the extent to which imagery and, more specifically, figurines in early agricultural villages represent females or males. In previous research (Kuijt & Chesson 2005) we have explored the alternative perspective that in some cases in the past it was either unimportant to identify the sex of individuals or that these objects were created in a way that deliberately obscured any sexual characteristics. Moreover, we strongly feel that arguments for the dominance of goddess/female cults in the Levantine Neolithic have either misrepresented the number of female images compared to other images, or more likely in the case of the southern Levant, have failed to recognize that in many cases we are unaware of the relative rarity of different types of images, and fail to explore how these patterns reflect past use in communities. Lesure (this volume) makes this point when he argues that social interpretation by archaeologists must deal with recurring patterning, not just a few examples. He states 'Clearly, a mere handful of figurines will not impress. We are not looking for isolated cases, but recurring patterns'. We strongly agree with this point, and argue that in the process of developing broader interpretations of Neolithic figurine use researchers have not addressed how the frequency of these objects might be related to their use. It is critical to consider how few anthropomorphic and zoomorphic figurines have been recovered from the PPNA and address the implications for this paucity *vis-à-vis* current interpretative models.

Regardless of interpretive perspective, researchers agree that at some level there is a linkage between

social interpretation and archaeological data. Our social models and interpretation are based on data and, to an extent, the strength of archaeological patterning. From this perspective there are fundamental data problems with some of the broad claims and generalizations some researchers have made about Neolithic figurines. Cauvin (2000a&b) for example, suggests that the Neolithic reflects the emergence of female figurines and 'femaleness' that lasts for several thousand years. This claim is widely accepted by other researchers, and yet there is remarkably little data to support this pan-Near East Neolithic argument. In the case of the PPNA, many researchers fail to understand how rare figurines are, and that there are a wide range of figurines. Five years of excavations at the PPNA site of Dhra', which is representative of the pattern observed at other PPNA sites, led to the recovery of two figurines below surface. As is outlined elsewhere (Kuijt & Chesson 2005), this rarity of figurines is evidenced at other PPNA sites. There are a number of possible explanations, including the low population density at these PPNA settlements and the social contexts of use. Reconstruction of population levels (site size, number of human burials, total roofed floor area) (Kuijt 2000b) compared to the number of figurines illustrates that figurine frequency is not a function of population growth, and by extension, suggests that the frequency of figurines is probably related to the social context of use. What about for the MPPNB? Given the huge volume of sediment excavated from most PPNB sites, it is surprising that there are not more figurines.

The relative scarcity of figurines in Neolithic villages also highlights another possibility: that PPNA figurines served very different social roles compared to those of the MPPNB. Both their low frequency and, perhaps more importantly, the fact that there is no evidence to suggest that southern Levantine PPNA figurines were cached or buried in ritual or dedicatory contexts, supports the argument that figurines served a very different social role in the PPNA compared to the MPPNB/LPPNB. For example, at the only PPNA settlements with relatively convincing female figurines, Netiv Hagdud and Dhra', these figurines were found in extramural midden deposits. In comparison, the relatively high frequency of MPPNB and LPPNB figurines, the presence of plastered and painted skulls, and several different forms of statues illustrate an important social transition and greater variety of burial contexts. Large anthropomorphic figurines and statues were found in spatially discrete caches while the small zoomorphic figurines were found in midden deposits, inside rooms, and as caches. With the exception of only two cases, 149 zoomorphic figurines were recovered in trash deposits. In some cases, like es-Sifiya, several hundred clay figurines were found in a single context. At other settlements, such as Jericho and 'Ain Ghazal, community members buried large anthropomorphic statues in caches. The depositional context of these figures, the placement of these caches in public contexts, and the frequency of objects buried suggest that they were important material and symbolic expressions of the views and beliefs of members of Neolithic communities.

Thus, it is important to ask why people in the past deliberately marked or obscured the gender and/or sex of human representations when constructing figurines. In light of the frequency of these objects in the MPPNB and their apparent burial in public contexts, it is surprising that most, but not all, of the large anthropomorphic statues have no clearly marked secondary sexual characteristics. The recovery of some large anthropomorphic figurines with breasts and enlarged buttocks illustrates that Neolithic artists often represented morphological differences of humans in clay. Thus, we have to ask why they chose to represent female secondary sexual characteristics on a minority of large anthropomorphic statues while deliberately constructing the majority of these statues as ambiguous with limited, if any, indications of sexed or gendered identities?

Ambiguity and mortuary practices
It is important to note that the patterning of deliberate ambiguity is also seen in mortuary practices in the MPPNB and LPPNB periods, and that similarities in these practices may reflect deliberate attempts to mask or control differences at the individual, household, and community level. As illustrated in several recent syntheses of MPPNB mortuary practices (Goring-Morris 2000; Kuijt 2000a; 2001), burials were organized in such a way that deceased males and females of any age above approximately 12 were usually treated in the same manner: skulls of adults were removed sometime after the primary burial, and no grave goods were placed with the bodies (Bonogofsky 2001). Thus, there were different treatments for, and presumably meanings of, the original burial of individuals and the secondary mortuary practices. We argue (Kuijt & Chesson 2005) that secondary mortuary practices in MPPNB communities reflect two interrelated, yet distinct, social dimensions: 1) the recognition of the individuality of the deceased; 2) the idealization of a collective ancestry. While recognizing that variation is likely to exist within communities and through different regions, we believe that overall the acts of homogeneous grave preparation, burial of individual dead, and absence of mortuary goods can best be

interpreted as reflecting a means of controlling/limiting displays of identity, privilege, or wealth within these communities. The widespread use of secondary mortuary practices in the PPN probably served as community events in which memories of collective and individual ancestries were actively negotiated and defined. We suggest, moreover, that the efficacy and power of these practices physically and symbolically relied on the creation of social memory by ritual practitioners, who employed a shared set of symbols understood by community members.

We believe that this creation of social memories in mortuary practices offers a potential analogue for understanding the use of figurines in the PPN period, particularly in the MPPNB. The homogeneity of mortuary practices appears to emphasize the deconstruction or masking of individual differences and focus on collective identities. Furthermore, the removal of heads of human figurines and the stylized representation of the human features may suggest that the people of 'Ain Ghazal understood the relationship between the physical and the social body very differently than we do.[2] The ambiguity, in choosing not to mark sexual differences in human representations, fits this same pattern, with the vast number of anthropomorphic objects unmarked by secondary sexual characteristics. The deliberate manner in which the majority of large anthropomorphic statues and figurines from 'Ain Ghazal were crafted provides no indication of sex or gender, masking any sense of individuality, with most statues conforming to a stylized set of features (enlarged heads with marked facial features, especially eyes; frequent omission or diminution of legs and arms).

The face, personhood and identity: shifting practices in Early Neolithic imagery
Another interesting aspect to the transition between the PPNA and MPPNB is seen in changing visual orientation in imagery. Consideration of shifting patterns of imagery from these periods highlights a shift from a visual focus of the lower torso and secondary sexual characteristics in the PPNA to one of the face, head and upper torso in the MPPNB. While there is a very small sample compared to the later MPPNB, in the PPNA imagery consists of three general types: 1) phalli carved from stone; 2) carved figurines that are full body in scale but without secondary sexual characteristics; or 3) seated figurines, either carved on stone or made of unfired clay, that are seated. Some of these, such as an example from Netiv Hagdud, have breasts, and no discernable facial features. Other ones, such as recovered at Dhra' and WF16, are focused on the legs, lower torso and, again, with no focus on the face and skull. In each of these cases there is a clear identification and selection of the physical traits that are included, and not included, with the construction of these images. Whatever the specific explanation, this represents a shift in the importance of presenting and reading identity, and the parameters within which people perceived themselves.

We argue that this pronounced shift may have been related to differing systems of social organization, views of personhood and identity. Specifically, in the PPNA images appear to have been focused on stylized representation of the human body — representations that were both ambiguous, focused on the lower half of people, and were very simple. In contrast, figurines and imagery in the following MPPNB were focused on personhood, illustrated by naturalistic representations of the face with detailed treatments of the eyes, nose, ears and mouth.

The Middle Pre-Pottery Neolithic B period: the dominance of zoomorphic images
In contrast to the PPNA, images of the PPNB are focused on zoomorphic clay figurines (cattle), clay and stone figurines of females, and large statuary. It is important to note that numerically anthropomorphic figurines are rare compared to zoomorphic figurines. Schmandt-Bessarat's research provides our most detailed treatment of the manufacture, use and meanings of zoomorphic and anthropomorphic representations of MPPNB and LPPNB communities. The MPPNB people represented humans in several media, including statuary, masks, small figurines, and cached painted, plastered and undecorated human skulls (Bar-Yosef 1997; Cauvin 2000a; Rollefson 2000; 2001a; Kuijt 2001). All of these are relatively rare. In contrast, excavations have recovered a considerable number of clay zoomorphic figurines. The majority of these zoomorphic figurines come from the MPPNB occupation of 'Ain Ghazal. As outlined by Schmandt-Bessarat (1997), zoomorphic objects are remarkably uniform, with the quadrupeds represented as standing, and varying in size from 3–15 cm in length. These animals are portrayed with horns, are recovered from caches, and are widely interpreted as being bovine. Many of the animals were beheaded, and in the case of a few (the exact number remains unreported), apparently stabbed with several small pieces of flint.

For the southern Levantine PPNB period, Cauvin argues that we see a full-fledged emphasis and important shift from female figurines as representations of goddesses to bull figurines, representing a masculine God (Cauvin 2000a, 124). While his 'reading' of the archaeological data is spotty at times, and we believe that there is only limited archaeological support for

his inventive social interpretations, he is correct in identifying the overall patterning. Focusing on the presence and frequency of cattle images, Cauvin sees bull figurines in the PPNB as complementing and even overtaking the authority and power of female figurines. In developing this argument, Cauvin ignores considerable archaeological evidence, and views the plastered MPPNB statues from Jericho and 'Ain Ghazal as males. In the case of the Jericho example (Fig. 16.4a), he accepts Garstang & Garstang's (1940) interpretation that the painted lines on the face represent a bearded rather than a tattooed or painted face. Considering the statues cached at 'Ain Ghazal, he accepts that one of them is female but states (Cauvin 2000a, 111), 'The absence of sexual distinctions could have been intended to make the representations either asexual, or as is more probable, masculine by default'. This last statement is, needless to say, highly problematic, impossible to demonstrate, and in many ways illustrates a concerted effort to fit archaeological data to an interpretive model. It also exemplifies, once again, the remarkable longevity of the binary identification of gender to the exclusion of other equally interesting research topics.

Neolithic imagery: analysis, methods and interpretation

Interpretation: what is all of this telling us about the use of Neolithic imagery?
In considering the general trajectory of representations of human images over the PPNA and PPNB, there is an interesting shift in marking or not marking secondary sexual characteristics on figurines, or representing portions or entire bodies. Recent excavation results are quickly confirming our understanding of the overall pattern, and have some interesting implications for the use of imagery, and the social context under which these patterns emerged. First, there is clearly variation in the frequency and types of figures from the PPNA and different stages of the PPNB, and these are suggestive of some interesting patterns. In contrast to later periods there are no zoomorphic or geometric figurines in the PPNA. During the PPNA, figurines are very rare, and there is a relatively even proportion of marked female figurines (displaying breasts and enlarged hips), unmarked human figurines, and figurines of phalli. In stark contrast to this pattern, in the MPPNB images of the human form are more common, with the vast majority of human figurines or statues are unmarked. A few of the statues from 'Ain Ghazal display breasts, but there are no 'corresponding' representations of male genitalia or phalli. Moreover, the majority of MPPNB figurines are zoomorphic. Finally in the LPPNB/PPNC, the overwhelming majority of figurines are zoomorphic or geometric, but in the human figurines found we see once again the representation of breasts and hips on full-body representations of females or female-gendered figurines and a rare example of a phallus from Basta. From this list of general characteristics several patterns beg to be investigated. For example, representations of female bodies, with hips and breasts, are complemented by the representation of male phalli in only a few rare cases. So why are males not represented in full-bodied form? Why do the proportions of human:zoomorphic:geometric figurines shift through time, with the PPNA and LPPNB/PPNC more similar to each other and markedly different from the MPPNB corpus? The vast majority of MPPNB figurines do not mark secondary sexual characteristics: Why this emphasis on ambiguity?

In many ways the use of imagery expresses the fluidity of identity, sexuality, and statues in multiple worlds. Aside from the representation of secondary sexual characteristics, there are some omissions, emphases and deliberate alterations of human representations that also raise some interesting issues. Research on southeastern European Neolithic figurines by D. Bailey (2005, 32) indicates that some of this may be linked to the process of compression and abstraction. Bailey notes that the process of miniaturism requires compression. Compression requires the abstraction of what is important to the viewer, and the process of concentration and distillation shapes the relationship between the observer and the image. All images and figurines in the Levantine Neolithic are characterized by a significant size reduction. In some cases, such as the statues of 'Ain Ghazal this is *c*. 40 per cent of life size. In the PPNA, and with figurines of the MPPNB, these images and figurines are between 1/20 and 1/50 of actual size. In the MPPNB in particular, the statuary minimizes details of the legs and arms or portrays them in smaller proportion than the torso and head. The heads of these figures are enlarged and emphasized in the depiction of facial features, particularly the eyes. Additionally, the deliberate removal of heads from human figurines at MPPNB 'Ain Ghazal coincides with the practice of skull removal in mortuary practices: What could be the relationship and significance of these symbolically similar behaviours?

Drawing upon the broader social, economic, and political context of PPNA, MPPNB, and LPPNB/PPNC communities, we offer a provisional interpretation of figurine use and meaning during these periods. We believe that the ambiguity in human figurines in different periods, as well as the marking of secondary sexual characteristics in the PPNA and LPPNB may be

related to the socio-economic structures of lifeways in these communities. In the PPNA period many people were moving from a hunting/gathering/foraging to more sedentary food-producing lifeway. People lived in larger, sedentary communities, experimenting with and establishing new food-production systems. With the advent of storage and sedentism, these communities also began to negotiate and develop mechanisms for limiting social differentiation. During the MPPNB people lived in larger, growing communities, building up the scale of established subsistence, residential, and ritual practices. During this period we witness an emphasis on ambiguity and masking of individuality in human images as well as in mortuary practices and the built environment. It is also important to note that the new appearance of numerous zoomorphic figurines co-occurs in time with the appearance of domesticated animals. In the LPPNB/PPNC people were dealing with stresses on their subsistence and social structures. Very large and densely populated communities struggled with stresses of overcrowding, sufficient food production and resource depletion around settlements. Essentially, this period can be viewed as a time in which society struggled greatly with changing residential patterns, stress from living together in sedentary settlements, and subsistence changes. It is during these shifting and stressful times that people represented male and female sexed bodies (or portions of bodies). Perhaps during periods when social, economic, and ritual practices were under contention, aspects of individuality and social differentiation entered into the negotiation of everyday life. Importantly, the built environment and the mortuary practices in LPPNB/PPNC and PPNA show more diversity, underscoring the ways that people worked to live together in sedentary settlements despite the pressures socially, economically, and politically. Alternatively it can be argued that the MPPNB was a period characterized by more gradual developments highlighting elements of cultural continuity.

Final thoughts

When considering Neolithic imagery it is important to recognize how little we understand about the interrelationship between figurine use, ritual and political action, and the social context of figurine manufacture, use and discard. Even in geographical areas where considerable field work has occurred, such as in the Near Eastern Neolithic, it seems like every new field project alters our understanding and interpretation of broader patterning, often raising new questions. In concluding we want to highlight several issues that need further exploration.

1. Archaeological research in the Near East illustrates that there was a remarkable range of symbolic systems employed through different stages of the Neolithic, with local variation in practices, and that attempts to characterize the manufacture and use of imagery and figurines in early villages as being related to female ancestor cults/ritual/ideology is both premature and not supported by available data. Consideration of both the changing frequency of female figurines, the co-existence of these images at different periods with zoomorphic imagery, geometric objects, and phalli, illustrate that monolithic interpretations of Neolithic imagery serve to mask and obscure important data patterning.
2. The significant variation in Neolithic imagery highlights the importance of understanding the life-histories of different image systems within different temporal, geographic and social contexts. It is important, if not critical, for researchers to understand the stages of production, use, modifications, and abandonment of figurines. While solid descriptive research has focused on the physical characteristics of objects, in general researchers have failed to consider the processes of manufacture, use and discard of objects, let alone develop detailed arguments for the life-history of objects.
3. Researchers need to explore changing patterns of figurine use through time, but also consider some of the social, ritual and political reasons why people in the past chose to employ specific symbolic systems, such as zoomorphic figurines, and just as importantly, to address why they chose not to employ other images. For example, why do we see so few figurines and images in the PPNA? While there are no controlled data available for the number of figures *per* volume of sediment, it is our impression that archaeological excavations of PPNB settlements recover 10 to 20 times more figurines than from PPNA sites. This realization challenges the data foundation of some interpretive models of Neolithic figurine use, such as that of Cauvin (2000a&b), and also echoes growing evidence for substantial differences in social organization, economic practices, food storage, and the emergence of property and land ownership (see Kuijt & Goring-Morris 2002 for more detail). In light of the manual skills demonstrated in other artistic activities in the PPNA, why did community members choose to illustrate people in a highly stylized manner with no concern for the head and torso of the body? The relative absence of imagery, either in clay or stone, does not reflect poor manual skills. Rather, from our perspective it provides insight into the changing meanings and use of

imagery between the PPNA and MPPNB. While we have not had time to discuss this in detail, and this important topic needs to be explored through broadened analysis, we are intrigued by the possible links between new imagery in the MPPNB being related to new systems of ownership, greater emphasis on the household as a social and economic unit, and how imagery might reflect shifts in public and private ritual. Along similar lines, future research needs to explore the possible social, economic, and ritual reasons people in LPPNB communities no longer created and employed anthropological imagery in significant quantities, and never again produced naturalistic images that were tightly focused on the face and the person.

4. As Bailey points out (2005, 204), imagery reflects the politics and identity of the body in the past. As such researchers looking at Neolithic figurines need to develop more sophisticated models that move beyond a focus on female/male, to rich considerations of rationales for, and mechanisms of, the balancing of identity and personhood through imagery. For example, why did MPPNB people represent ambiguity in the majority of their human figurines, and alternatively mark or not mark sex or gender attributes on a small percentage of human representations? Why some, but not all? Why was it important in some situations to mark individuals (less than 20 per cent in the case of the large statues), but not all? There are several possible interpretations, including the masking or emphasis of individual or structural differences to help negotiate social and economic changes experienced by these early agricultural communities in which we witness the initial development of storage technologies, surplus economy, and social differentiation. Similarly, these people may not have conceptualized male and female bodily differences as important aspects in their worldviews in understanding what it meant to be a person in a body. These differences may have been crucially important in everyday interactions, and therefore they found it important to mask them in creating idealized social identities and memories. These transitions in the use of imagery, in short, provide insight into the needs of Neolithic people to physically monumentalize the place of the living with imagery, as well as through social activity and ritual practice.

Acknowledgements

Discussions with M. Voigt, R. Joyce, D. Bailey, S. Blum, G. Rollefson, and O. Bar-Yosef have been crucial to the development of this essay. We would also like to thank the editors for their support, clear editorial guidance and good humour with the entire publication process. While not agreeing with some of the concepts and interpretations presented in this essay, the constructive criticism and advice of all of these individuals has immeasurably improved its clarity and organization.

Notes

1. There is an extensive literature, both supportive and critical, centred on the Neolithic Goddess. Readers are referred to Meskell (1995; 1998), Haaland & Haaland (1995), Bailey (1997), and Tringham & Conkey (1998) for critical evaluation.
2. See Bailey 2005, 120 for similar discussions for the eastern European Neolithic.

References

Arensburg, B. & I. Hershkovitz, 1989. Artificial skull 'treatment' in the PPNB period: Nahal Hemar, in *People and Culture in Change: Proceedings of the Second Symposium on Upper Paleolithic, Mesolithic, and Neolithic Populations of Europe and the Mediterranean Basin*, ed. I. Hershkovitz. (British Archaeological Reports, International Series 508). Oxford: British Archaeological Reports, 115–33.

Bailey, D., 1996. The interpretation of figurines: the emergence of illusion and new ways of seeing. *Cambridge Archaeological Journal* 6(2), 291–5.

Bailey, D., 1997. Review of *The Concept of the Goddess*, eds. S. Billington & M. Gren. *Antiquity* 71, 246–8.

Bailey, D., 2005. *Prehistoric Figurines: Representation and Corporeality in the Neolithic*. London: Routledge.

Bar-Yosef, O., 1985. *A Cave in the Desert: Nahal Hemar*. Jerusalem: Israel Museum.

Bar-Yosef, O., 1997. Symbolic expressions in later prehistory of the Levant: why are they so few?, in *Beyond Art: Pleistocene Image and Symbol*, eds. M.W. Conkey, O. Soffer, D. Stratmann & N.G. Jablonski. San Francisco (CA): California Academy of Sciences, 161–87.

Bar-Yosef, O., 2001. PPNB interaction sphere. *Cambridge Archaeological Journal* 11(1), 114–17.

Bar-Yosef, O. & D. Alon, 1988. Nahal Hemar. *'Atiqot* 18, 1–81.

Bar-Yosef, O. & A. Gopher (eds.), 1997. *An Early Neolithic Village in the Jordan Valley*, part I: *the Archaeology of Netiv Hagdud*. Cambridge (MA): American School of Prehistoric Research, Peabody Museum.

Bar-Yosef, O. & R. Meadow, 1995. The origins of agriculture in the Near East, in *Last Hunters — First Farmers: New Perspectives on the Prehistoric Transition to Agriculture*, eds. T.D. Price & A. Gebauer. Santa Fe (NM): School for American Research, 39–94.

Bonogofsky, M., 2002. Reassessing 'dental evulsion' in Neolithic plastered skulls from the levant through the use of computer tomography, direct observation, and photographs. *Journal of Archaeological Science* 29, 959–64.

Butler, J., 1990. *Gender Trouble: Feminism and the Subversion of Identity*. New York (NY): Routledge.

Butler, J., 1993. *Bodies That Matter: On the Discursive Limits of 'Sex'*. New York (NY): Routledge.

Cauvin, J., 1994. *Naissance des Divinités: Naissance de l'Agriculture. La Révolution des Symboles au Néolithique*. Paris: CNRS.

Cauvin, J., 2000a. *The Birth of the Gods and the Origins of Agriculture*. Cambridge: Cambridge University Press.

Cauvin, J., 2000b. The symbolic foundation of the Neolithic revolution in the Near East, in *Life in Neolithic Farming Communities: Social Organization, Identity, and Differentiation*, ed. I. Kuijt. New York (NY): Kluwer Press, 235–51.

de Contenson, H., 1967. Troisiéme campagne á Tell ramad 1966: rapport préliminaire. *Annales Archéologiques de Syria* XVII (1–2), 17–24.

Conkey, M. & J. Gero, 1997. Programe to practice: gender and feminism in archaeology. *Annual Review of Anthropology* 26, 411–37.

van Dijk, J., A. Goetze & M.I. Hussey, 1985. *Early Mesopotamian Incantations and Rituals*. New Haven (CT): Yale University Press.

Douglas, M., 1982. *Natural Symbols: Explorations in Cosmology*. New York (NY): Pantheon Books.

Echegerary, J., 1966. *Excavaciones en la Terrza de El-Khiam (Jordania)*. Madrid: Consejo Superior el Investigaciones Cientificas.

Edwards, P.C., J. Meadows, G. Sayej & M. Westaway, 2004. From the PPNA to the PPNB: new views from the southern Levant after excavation at Zahrat adh-Dhra' 2 in Jordan. *Paléorient* 30(2), 21–60.

Ferembach, D. & M. Lechevallier, 1973. Découverte de deux crânes surmodelés dans une habitation du VIIème millénaire a Beisamoun, Israel. *Paléorient* 1, 223–30.

Foster, B.R., 1993. Before *the Muses*. Bethesda (MD): CDL Press.

Garstang, J. & J.B.E. Garstang, 1940. The *Story of Jericho*. London: Hodder & Stroughton.

Gilchrist, R., 1999. *Gender and Archaeology: Contesting the Past*. London: Routledge.

Gopher, A. & E. Orelle, 1996. An alternative interpretation for the material Imagery of the Yarmukian: a Neolithic culture of the sixth millennium BC in the southern Levant. *Cambridge Archaeological Journal* 6(2), 255–79.

Goren, Y., N. Goring-Morris & I. Segal, 2001. The technology of skull modelling in the Pre-Pottery Neolithic B (PPNB): regional variability, the relation of technology and iconography and their archaeological implications. *Journal of Archaeological Science* 28, 671–90.

Goren, Y., I. Segal & O. Bar-Yosef, 1993. Plaster artefacts and the interpretation of the Nahal Hemar cave. *Journal of the Israel Prehistoric Society* 25, 120–31.

Goring-Morris, N., 2000. The quick and the dead: the social context of Aceramic Neolithic mortuary practices as seen from Kfar Hahoresh, in *Life in Neolithic Farming Communities: Social Organization, Identity, and Differentiation*, ed. I. Kuijt. New York (NY): Kluwer Academic/Plenum Press, 103–36.

Goring-Morris, N. & A. Belfer-Cohen, 1998. The articulation of cultural processes and Late Quaternary environmental changes in Cisjordan. *Paléorient* 23(2), 71–93.

Griffin, P., C. Grissom & G. Rollefson, 1998. Three late eigth-millennium plastered faces from 'Ain Ghazal, Jordan. *Paléorient* 24, 59–70.

Haaland, G. & R. Haaland, 1995. Who speaks the goddess's language? Imagination and method in archaeology research. *Norwegian Archaeology Research* 28(2), 105–21.

Haaland, G. & R. Haaland, 1996. Levels of meaning in symbolic objects. *Cambridge Archaeological Journal* 6(2), 295–300.

Hamilton, N., 1996. The personal is political. *Cambridge Archaeological Journal* 6(2), 281–305.

Hermanson, B.D., 1997. Art and ritual behaviour in Neolithic Basta, in *The Prehistory of Jordan II: Perspectives from 1997*, eds. H.G. Gebel, Z. Kafafi & G. Rollefson. (Studies in Early Near Eastern Production, Subsistence, and Environment 4.) Berlin: Ex oriente, 333–43.

Hertz, R., 1960. *Death and the Right Hand*, trans. R. Needham & C. Needham. Glencoe (IL): Free Press.

Hodder, I., 2001. Symbolism and the origins of agriculture in the Near East. *Cambridge Archaeological Journal* 11(1), 107–12.

Holland, T.A., 1982. Figures and miscellaneous objects, in *Excavations at Jerhicho: IV the Pottery Type and Series and Other Finds*, eds. K.M. Kenyon & D.T.A. Holland. London: British School of Archaeology, 551–63.

Joyce, R., 1993. Women's work: images of production and reproduction in Pre-Hispanic southern central America. *Current Anthropology* 34(3), 255–74.

Joyce, R., 2000. *Gender and Power in Prehispanic Mesoamerica*. Philadelphia (PA): University of Pennsylvania Press.

Kafafi, Z. & G. Rollefson, 1995. Excavations at 'Ayn Ghazal: Preliminary Report. *Annual of the Department of Antiquities of Jordan* 39, 13–29.

Kan, S., 1989. *Symbolic Immortality*. Washington (DC): Smithsonian Press.

Kirkbride, D., 1968. Beidha 1967: an interim report. *Palestine Exploration Quarterly* 100, 90–96.

Knapp, A.B. & L. Meskell, 1997. Bodies of evidence on prehistoric Cyprus. *Cambridge Archaeological Journal* 7(2), 183–204.

Kuijt, I., 1998. Trying to fit round houses into square holes: re-examining the timing of the south-central Levantine Pre-Pottery Neolithic A and Pre-Pottery Neolithic B cultural transition, in *The Prehistory of Jordan II: Perspectives from 1997*, eds. H.G. Gebel, Z. Kafafi & G. Rollefson. (Studies in Early Near Eastern Production, Subsistence, and Environment 4.) Berlin: Ex oriente, 193–202.

Kuijt, I., 2000a. Keeping the peace: ritual, skull caching and community integration in the Levantine Neolithic, in *Life in Neolithic Farming Communities: Social Organization, Identity, and Differentiation*. ed. I. Kuijt. New York (NY): Kluwer Academic/Plenum Press, 137–63.

Kuijt, I., 2000b. People and space in Early Neolithic villages: exploring daily lives, community size and architecture in the Late Pre-Pottery Neolithic. *Journal of Anthropological Archaeology* 19, 75–102.

Kuijt, I., 2001. Meaningful masks: place, death, and the transmission of social memory in early agricultural communities of the Near Eastern Pre-Pottery Neolithic,

in *Social Memory, Identity, and Death: Intradisciplinary Perspectives on Mortuary Rituals*, ed. M.S. Chesson. (American Anthropological Association, Archaeology Division 10.) Washington (DC): American Anthropological Association, 80–99.

Kuijt, I., 2003. Between foraging and farming: critically evaluating the archaeological evidence for the southern Levantine Early Pre-Pottery Neolithic B period. *Turkish Academy of Sciences Journal of Archaeology* 6, 7–25.

Kuijt, I. & M.S. Chesson, 2005. Lumps of clay and pieces of stone: ambiguity, bodies, and identity as portrayed in Neolithic figurines, in *Archaeologies of the Near East: Critical Perspectives*, eds. R. Bernbeck & S. Pollock. London: Basil Blackwell, 152–83.

Kuijt, I. & B. Finlayson, 2002. The 2001 excavation season at the Pre-Pottery Neolithic A period settlement of Dhra', Jordan: preliminary results. *Neo-lithics* 2(1), 12–15.

Kuijt, I. & N. Goring-Morris, 2002. Foraging, farming, and social complexity in the Pre-Pottery Neolithic of the southern Levant: a review and synthesis. *Journal of World Prehistory* 16(4), 361–440.

Lacqueur, R., 1990. *Making Sex: Body and Gender from the Greeks to Freud*. Cambridge (MA): Harvard University Press.

Lesure, R.G., 2002. The goddess defracted: thinking about the figurines of early villages. *Current Anthropology* 43(4), 587–610.

Lock, M., 1993. Cultivating the body: anthropology and epistemologies of bodily practice and knowledge. *Annual Reviews in Anthropology* 22, 133–55.

Mahasneh, H. & H.D. Bienert, 1999. Anthropomorphic figurines from the Early Neolithic site of es-Sifiya, Jordan. *Zeitschrift des Deutschen Palästina-Vereins* 115, 109–26.

Mahasneh, H. & H.G. Gebel, 1999. Geometric objects from LPPNB es-Sifiya, Wadi Mujib, Jordan. *Paléorient* 24, 105–10.

Marcus, J., 1996. The importance of context in interpreting figurines. *Cambridge Archaeological Journal* 6(2), 285–91.

Martin, E., 1987. *The Woman in the Body*. Boston (MA): Beacon Press.

Mellaart, J., 1967. *A Neolithic Town in Anatolia*. New York (NY): McGraw-Hill.

Meskell, L., 1995. Goddesses, Gimbutas and 'New Age' archaeology. *Antiquity* 69, 74–86.

Meskell, L., 1998. Twin peaks: the archaeologies of Çatalhöyük, in *Ancient Goddesses: Myths and Evidence*, eds. L. Goodison & C. Morris. Madison (WI): University of Wisconsin Press, 46–62.

Meskell, L., 1999. *Archaeologies of Social Life: Age, Sex, and Class in Ancient Egypt*. Oxford: Basil Blackwell.

Nissen, H., M. Muhesien & H.G. Gebel, 1991. Report on the excavations at Basta 1988. *Annual of the Department of Antiquities of Jordan* 35, 13–40.

Noy, T., 1991. Art and decoration of the Natufian at Nahal Oren, in *The Natufian Culture in the Levant*, eds. O. Bar-Yosef & F.R. Valla. Ann Arbor (MI): International Monographs in Prehistory, 557–68.

Ortner, S., 1974. Is female to male as nature is to culture?, in *Women, Culture and Society*, eds. M. Rosaldo & L. Lamphere. Palo Alto (CA): Stanford University Press, 67–88.

Perrot, J., 1966. *Le Gisement Natoufien de Mallaha (Eynan) Israel*. Paris: Association Paléorient.

Postgate, J.N., 1994. Text and figurine in ancient Mesopotamia: match and mismatch, in *The Ancient Mind: Elements of Cognitive Archaeology*, eds. C. Renfrew & E.B.W. Zubrow. Cambridge: Cambridge University Press, 176–84.

Rollefson, G., 1983. Ritual and ceremony at Neolithic 'Ain Ghazal (Jordan). *Paléorient* 9(2), 29–38.

Rollefson, G.O., 2000. Ritual and social structure at Neolithic 'Ain Ghazal, in *Life in Neolithic Farming Communities: Social Organization, Identity, and Differentiation*, ed. I. Kuijt. New York (NY): Kluwer Academic/Plenum Press, 165–90.

Rollefson, G.O., 2001a. The Neolithic period, in *The Archaeology of Jordan*, eds. B. MacDonald, R. Adams & P. Bienkowski. Sheffield: Sheffield Academic Press, 67–105.

Rollefson, G.O., 2001b. 2001: an archaeological odyssey. *Cambridge Archaeological Journal* 11(1), 112–14.

Rollefson, G.O. & Z. Kafafi, 1996. The 1995 excavations at 'Ayn Ghazal: preliminary report. *Annual of the Department of Antiquities of Jordan* 40, 11–28.

Rollefson, G.O., D. Schmandt-Besserat & J. Rose, 1999. A decorated skull from MPPNB 'Ain Ghazal. *Paléorient* 24, 99–104.

Rollefson, G.O., A. Simmons, M. Donaldson et al., 1985. Excavations at the Pre-Pottery Neolithic B village of 'Ain Ghazal, Jordan, 1983. *Mitteilungen der Deutschen Orient-Gesellschaft zu Berlin* 117, 69–116.

Schiller, A., 1997. *Small Sacrifices, Religious Change and Cultural Identity among the Ngaju of Indonesia*. Oxford: Oxford University Press.

Schmandt-Besserat, D., 1997. Animal symbols at 'Ain Ghazal. *Expedition* 39(1), 48–58.

Schmandt-Besserat, D., 1998a. 'Ain Ghazal 'monumental' figures. *Bulletin of the American School of Oriental Research* 4, 1–17.

Schmandt-Besserat, D., 1998b. A stone metaphor of creation. *Near Eastern Archaeology* 61(2), 109–17.

Soffer, O., J. Adovasio & D. Hyland, 2000. The 'Venus' figurines: textiles, basketry, gender, and statues in the Upper Paleolithic. *Current Anthropology* 41, 511–37.

Stekelis, M. & T. Yizraeli, 1963. Excavations at Nahal Oren, preliminary report. *Israel Exploration Journal* 131, 1–12.

Strouhal, E., 1973. Five plastered skulls from Pre-Pottery Neolithic B Jericho: anthropological study. *Paléorient* 1, 231–47.

Tringham, R.E. & M. Conkey, 1998. Rethinking figurines: a critical view from archaeology of Gimbutas, the 'Goddess', and popular culture, in *Ancient Goddesses: Myths and Evidence*, eds. L. Goodison & C. Morris. Madison (WI): University of Wisconsin Press, 22–45.

Ucko, P., 1968. *Anthropomorphic Figurines of Predynastic Egypt and Neolithic Crete with Comparative Material from the Prehistoric Near East and Mainland Greece*. (Royal Anthropological Institute Occasional Paper 24.) London: Andrew Szmidla.

Ucko, P., 1996. Mother, are you there? *Cambridge Archaeological Journal* 6(2), 300–304.

Voigt, M., 1983. *Hajji Firuz Tepe, Iran: the Neolithic Settlement.* (Hasanlu Excavation Reports, vol. I. University Museum Monograph 50.) Philadelphia (PA): University of Pennsylvania Museum of Archaeology and Anthropology.

Voigt, M., 1985. Village on the Euphrates: excavations at Neolithic Gritille, Turkey. *Expedition* 27, 10–24.

Voigt, M., 2000. Çatal Höyük in context: ritual at Early Neolithic Sties in central and eastern Turkey, in *Life in Neolithic Farming Communities: Social Organization, Identity, and Differentiation*, ed. I. Kuijt. New York (NY): Kluwer Academic/Plenum Press, 253–94.

Wienstein-Evron, M. & A. Belfer-Cohen, 1993. Natufian figurines from the new excavations of the el-Wad cave, Mt Carmel, Israel. *Rock Art Research* 10(2), 102–6.

Yakar, R. & I. Hershkovitz, 1990. Nahal Hemar cave: the modelled skulls. *Atiqot* 18, 59–63.

Chapter 17

Bodies of Evidence: the Case Against the 'Harappan' Mother Goddess

Sharri R. Clark

In this paper, the corpus of terracotta figurines from Harappa, a major urban centre of the Indus civilization, is used to explore Indus concepts of religion, particularly the idea that it was focused on a Mother Goddess, based in part upon representations of the Indus body. One of the most enduring interpretations in archaeology is that early anthropomorphic figuration must have been associated with religion and ritual, and thus, that female figures from around the world represent a universal female deity associated with the earth, nature, fertility, reproduction, and maternity, typically called the 'Mother Goddess'. Despite persuasive critiques (e.g. Tringham & Conkey 1998; Ucko 1968), the terracotta figurines from the Indus civilization (c. 2600–1900 BC), the earliest urban civilization of south Asia, have long been identified — often without question — as representations of a Mother Goddess, based largely upon implicit assumptions and analogies with modern Hinduism. The interpretation is so insidious in south Asian archaeology that some publications refer to terracotta female figurines as 'mother goddesses' rather than as figurines. This is partly a legacy of interpretations in the earliest publications on the Indus civilization by Sir John Marshall (1931) and Ernest Mackay (1938), based primarily upon their excavations at Mohenjo-daro and excavations at Harappa (Vats 1940). I reexamine these earlier interpretations and evaluate the general criteria used to identify modern representations of the Mother Goddess in south Asia against the terracotta figurines and other archaeological evidence from Harappa to show that this interpretation is largely unsupported. By evaluating the specific case for an Indus Mother Goddess at Harappa, I hope to encourage more critical interpretation and reassessment of the still widespread goddess interpretation for early female figuration elsewhere as well.[1]

The Indus female figurines as the source of the south Asian Mother Goddess tradition

The Indus (or Harappan) civilization was a vast third-millennium BC phenomenon with large well-planned cities, a writing system that still awaits decipherment, a distinctive, technologically sophisticated material culture, an abundance of terracotta figurines at many sites, and a conspicuous absence of monumental art (Kenoyer 1998; Possehl 1998) that extended over much of what is now Pakistan and northwestern India. As one of the most ancient civilizations in south Asia, the Indus civilization has often been considered a potential source of modern traditions, including the Mother Goddess tradition.

The allure of the Indus civilization as a source of later Hindu traditions is explained by Wendy O'Flaherty (1980, 244–5) as follows:

> The Indus Valley civilization has, for Indologists, the supreme virtue of being largely unknown, since we have not succeeded in deciphering its script; anything, therefore, that is not found in the Vedas but appears in later Hinduism is blamed on the Indus Valley, a most convenient catchall and a dignified academic way of saying 'I don't know'. Non-Vedic religious and social phenomena are said to 'come from the Indus Valley', much as werewolves or visitors from outer space appear from Hungary or Mexico in English and American films, respectively.

Tracing the goddess tradition to a non-Aryan indigenous tradition that was later incorporated into Hinduism (originally suggested by Marshall 1931[2]) might also help explain the drastic change in emphasis from an early Vedic tradition dominated by male deities to a later Hindu tradition with dominant goddesses (Kinsley 1986, 216).

However, connecting ancient and modern traditions can be problematic. Unbroken cultural continuity

Figure 17.1. *Two outdoor shrines in Gujarat, India, with aniconic representations and terracotta figurine offerings: a) a tree shrine at Goli Gadh Tekro, Gujarat, where stones represent the Mother Goddess 'Goli Gadh Matu' and other deities; and b) a shrine outside a village in Gujarat with decorated wooden pillars representing village deities. (Photo: S. Clark.)*

from Harappan times until the present in south Asia is unlikely, although some cultural continuities have been demonstrated (e.g. Kenoyer 1989). Some modern traditions are not indigenous to south Asia, and criteria for representing particular deities are not always explicit or absolute, especially over such a long span of time. For example, local or village deities, which are typically goddesses, are not usually represented by anthropomorphic images (Kinsley 1986, 198) but by a variety of aniconic objects such as stones or carved wooden pillars (see Fig. 17.1), while major deities are often represented as iconic anthropomorphic images. Both aniconic and iconic images and attributes are used to see (and to be seen by) the divine (*darśan*), a major part of the Hindu worship experience (Eck 1996).

Seeking interpretive keys for the Indus civilization from subsequent Indian traditions is equally problematic unless overwhelming parallels can be demonstrated (Kinsley 1986, 212). The fact that the Indus script remains undeciphered, leaving us with no texts to inform us of Indus religion(s), makes it equally tempting to interpret the Indus figurines using later Hindu traditions. However, historians of Hindu religion have been particularly skeptical of the interpretation of ancient figurines as prototypes of the Hindu goddesses, noting only superficial similarities between the ancient and later figurines (e.g. Kinsley 1986, 213–17) and questioning how they were utilized ritually (Eck 1996, 32).

Still, almost all research on south Asian art and archaeology continues to suggest that at least some of the Indus female terracotta figurines are representations of the Mother Goddess (e.g. Banerjee 1995; Craven 1997; Kenoyer 1998), with only a few exceptions (e.g. Mookerjee 1966). Literature on south Asian goddesses typically references the Indus female figurines as early evidence of Mother Goddess worship as well (e.g. Bhattacharyya 1999; Dhawan 1997; Larson *et al.* 1980).

Scholars are actually, and often unwittingly, repeating the earliest interpretations published by Marshall (1931), which have come to be regarded as fact. For example, Marshall's (1931, 49–52; 339 ff.) emphasis on Indus female terracotta figurines as 'Mother Goddesses' was echoed in other early excavation reports (e.g. Mackay 1938, 259; Vats 1940, 292), and it has been repeated in many subsequent publications on the Indus civilization. Marshall (1931, 339) based his conclusion that the female figurines were 'no doubt' sacred images on his observations that they were 'extremely common' throughout the site, that they closely resembled one another, and that they were 'considerably better made' than other figurines. This early emphasis on the female figurines[3] encouraged the identification of many Indus figurine fragments as female that do not have clearly female attributes and the uncritical use of the Mother Goddess interpretation, neglecting the rest of the corpora.

Of course, there have been critics who have found no convincing evidence of attributes that presumably distinguish the Mother Goddess in the Indus figurine corpus. D.H. Gordon & M.E. Gordon (1940, 3) showed that the one female figurine from Mohenjodaro specifically identified by Mackay (1938, 267, pl. LXXVI, 5) as a possible representation of the Mother Goddess owing to an unusual headdress with bird-like projections is actually a misshapen example of a headdress with upright projections (see Mackay 1938, 261, pl. LXXV, 15–16). Thus, 'any linking of doves and the mother goddess would in this particular instance be quite unwarranted by the facts' (Gordon & Gordon 1940, 3). N. Chaudhari (1950; 1951) also noted that none of the Indus female figurines seem to have typical 'marks of divinity' such as associated animals. Finally, Sir Mortimer Wheeler (1968, 91) later concluded in his well-known work on the Indus civilization that

Figure 17.2. *Some examples of the many types of female figurines from Harappa (top to bottom, left to right; maximum height: 8.4 cm.): a) female (presumably) lower torso (H98-4220/8440-157); b) seated female with painted features and ornamentation with bent lower legs/skirt missing (H98-3456/8404-161); c) female with a bun headdress nursing an infant (H99-4222/8749-16); d) unadorned female torso and arm (H2000/2222-1); e) female with a fan-shaped headdress with remnants of a nursing infant on the left side (H98-3708/8400-2); f) female with a double volute headdress (H88-882/531-1); g) female with a broken fan-shaped headdress with panniers (H99-4981/9900-44); and h) female head and upper torso (H2000-4997/9811-2). (Photo: S. Clark; courtesy of the Harappa Archaeological Research Project [HARP] and the Harappa Museum, Department of Archaeology and Museums, Government of Pakistan [DAMGP].)*

'there has been perhaps an exaggerated tendency to regard these (female figurines) as a manifestation of the great Mother Goddess familiar in the religions of western Asia and parts of Europe'.

Despite critics and critiques, the Indus Mother Goddess interpretation persists. Its entrenchment in south Asian archaeology appears to result from ethnographic analogy with the Goddess of south Asia and modern Hinduism. S.P. Gupta (pers. comm. 2001) summarized the attributes that distinguish many ethnographic representations of the Mother Goddess in south Asia, criteria that are presumably also found in Indus female figurines and not in depictions of ordinary women, as: 1) elaborate ornamentation (headdresses, earpieces, necklaces, bangles, and belts); 2) emphasis on the lower torso (full hips or ornamentation that emphasizes the child-bearing aspect of the body); and 3) association with lamps.

With these attributes as explicit criteria, I evaluate the interpretation of Indus figurines as representations of the south Asian Mother Goddess against attribute and contextual data from my own research on the terracotta figurines from Harappa. An assemblage of terracotta figurines from Trench 39 on Mound AB at Harappa provides a full corpus of recovered figurine fragments from a complete stratigraphic sequence in this area of the site, although not all types of figurines may be represented in this particular sample. Deposits in this area of the site include buildings, hearths, drains, pits, and wash deposits, dating from the earliest known occupation (the Ravi Phase, *c.* 3300–2800 BC[4]) to the latest (the Late Harappan Phase, *c.* 1700–1300

Chapter 17

Figure 17.3. *Some examples of the different types of male and other figurines from Harappa (left to right, maximum height: 13.2 cm.): a) seated figurine with either male or no sex characteristics with arms around the bent knees (H96-3063/7237-20); b) seated figurine with no sex characteristics with joined hands raised in front (H94-2301/5073-2); c) standing male with a necklace and male genitalia (H99-4973/8765-6); d) standing male with nipples and male genitalia (H98-3495/8173-43) and e) standing male with a necklace, nipples, male genitalia, and a fan-shaped headdress typical of females (H87-388/13-44). (Photo: S. Clark; courtesy of HARP and the Harappa Museum, DAMGP)*

[?] BC). The larger corpus of figurines excavated from Harappa is also evaluated for comparison.

Two important issues, the fragmentation and identification of the terracotta figurines from Harappa, are carefully considered. Both Mackay (1938, 258, 263) and Marshall (1931, 340) noted that the figurines found at Mohenjo-daro are usually broken. As illustrated in Figure 17.2, the terracotta figurines from Harappa are almost always broken as well. They, like figurines from many ancient Near Eastern archaeological sites, are recovered from trash deposits throughout the site, along with fragments of other small terracotta objects such as animal figurines, carts, and game pieces, as well as seals, tablets, pottery sherds, and bone fragments, perhaps discarded following their primary use (Mackay 1938, 259). Despite suggestions that even garbage deposits may be the result of intentional social acts that give a particular 'meaning' to each deposit (see Tringham & Conkey 1998, 33–5), the figurines are not necessarily associated with other artefacts in these deposits beyond proximity at deposition. No figurines have been found in potentially meaningful mortuary contexts at Harappa (*contra* Vats 1940, 292), as the 'post-cremation urns' that sometimes contained figurine fragments were actually sump pots (Kenoyer 1991, 34). Because of the fragmentary nature of the corpus, all percentages presented here are based upon figurine fragments with relevant body parts represented (e.g. only figurines with lower torsos are considered in the percentages for belts).

At Harappa, female figurines are most reliably identified by the presence of certain physiological attributes such as appliquéd conical breasts (see Fig. 17.2[d–f & h] for examples). Since the upper torso is not always represented due to breakage, the certain identification of female figurines is relatively low at Harappa, approximately 16 per cent in Trench 39 and less than 25 per cent in the larger site sample. Based upon probability and the attribute patterns of the more complete figurine fragments, secondary attributes such as particular headdresses and belts typical of female figurines at Harappa may also be useful in identification (see Fig. 17.2 & 17.4).

At Harappa, male figurines are identified by primary sex characteristics such as genitalia or flattened appliquéd 'nipples' or by secondary sex characteristics such as beards (see Fig. 17.3 for examples). Fewer figurine fragments can be identified as male at Harappa — only approximately 2 per cent of those from Trench 39 and 9 per cent of the larger site sample. Other attributes such as posture can also be useful in identifying male figurines at Harappa, since those in certain postures always have male attributes when sex characteristics are represented (see Fig. 17.3[a]). A few figurines have no primary or secondary sex characteristics (see Fig. 17.3[b]) or have both male and female characteristics.

Thus, contrary to the expectations established by many publications (e.g. Marshall 1931), a large percentage of figurine fragments from Indus sites cannot be identified as male or female, or even as having both male and female sex characteristics. Even with secondary, non-physiological attributes considered, only approximately 45 per cent of the figurine fragments from Harappa could be identified by this author as female, and fewer than 16 per cent as male. Less than 1 per cent of the figurines have both female and male attributes. Thus, almost 40 per cent of the recovered anthropomorphic figurine fragments from Harappa could not be identified as male, female, or both male and female.

Evaluating the Harappan female figurines against ethnographic criteria for representations of the Mother Goddess

The *first ethnographic criterion* to be evaluated is elaborate ornamentation. Typical ornamentation of Indus figurines includes headdresses, earpieces, necklaces, belts, and bangles (see Fig. 17.4), and occasionally painted designs (see Fig. 17.2[b]). All forms of ornamentation are more commonly found on female figurines than on male figurines. However, most of the female figurines from Harappa are not heavily ornamented, despite M.S. Vats's (1940, 293) statements that most of the figurines from Harappa wear 'an abundance' of jewellery (based on examples such as Fig. 17.6[a]), just as most female figurines from Mohenjo-daro are not heavily ornamented (see Gordon & Gordon 1940), despite similar statements that most are 'loaded' with jewellery (Marshall 1931, 339) and that some are 'overloaded' with necklaces (Mackay 1938, 265). At Harappa, almost all of the female figurines have headdresses, up to 95 per cent of the female figurines have earpieces (see Figs. 17.2, 17.4–17.6 & 17.8), and almost half of the female figurines have at least one necklace. However, no more than 5 per cent

Figure 17.4. *A figurine from Harappa with body shape and attributes typical of Indus female figurines (HP 1603; height: 13.2 cm). (Photo: J.M. Kenoyer; courtesy of HARP and the National Museum of Pakistan, DAMGP.)*

from Trench 39 and no more than 14 per cent from the larger site sample have more than one necklace. Less than 15 per cent of the female figurines from Harappa have bangles on the arms, and less than 1 per cent have bangles on the legs. Even if additional (perishable) ornamentation had been added, it would not necessarily have identified the figurines as mother goddesses. For example, the amount of ornamentation on figurines sometimes reflects the owner's status or devotion in the modern tradition (S.P. Gupta pers. comm. 2001).

The *second ethnographic criterion* is an emphasis on the lower torso and reproductive properties. At Harappa, most of the female figurines' hips (and breasts) are proportional to a small waist and the abdomens are typically flat, like the figurine body in Figure 17.4, giving the appearance of a youthful, curvaceous figure with no features overemphasized.

Figure 17.5. *Some globular figurines and figurines with children from Harappa (left to right; maximum height: 8.0 cm.): a) female figurine reclining on a* charpoi *(bed) and nursing an infant with another young child behind her (HP 14292; NMI 229); b) globular female figurine nursing an infant (HP 213; NMI 230); and c) globular male figurine (H 595; HM 2460). (Photo: S. Clark; courtesy of the National Museum of India and the Harappa Museum, DAMGP.)*

Figure 17.6. *Some examples of figurines with panniers from Harappa (maximum height: 13.8 cm.): a) unusually large and elaborately ornamented female figurine head and torso with black pigment inside the broken panniers (H87-189/1-13); b) head with large, deep panniers (H99-4981/9900-44); and c) head with small, shallow panniers (H99/9790-10). (Photo: S. Clark; courtesy of HARP and the Harappa Museum, DAMGP.)*

And while almost 85 per cent of the female figurines from Trench 39 at Harappa do have some lower torso ornamentation (appliquéd belts or painted decoration), no more than 16 per cent have elaborate belts with multiple strands and appliquéd ornaments. In fact, the typically simple belts on Indus female figurines may reflect codes of modesty (Marshall 1931, 338) and an attempt to *de-emphasize* rather than emphasize the lower body, although obfuscation can also focus attention (cf. Bailey this volume).

Statements about the perception that Indus female figurines' bodies have exaggerated features related to fertility are inconsistent in the earliest excavation reports. For example, figurines were described in some places as having prominent breasts, attenuated or narrow waists, and broad hips, while in other places the hips and buttocks were described as not unduly pronounced or exaggerated (e.g. Mackay 1938, 269, 277; Marshall 1931, 246, fn. 1). Some early scholars noted that the breasts are not unusually large and that there is no emphasis on the pubic area (Gordon & Gordon 1940) or on the 'generative organs' of the Indus female figurines, as one would expect in Mother Goddess cults (Wheeler 1968, 91). However, other scholars such as George Dales described the Indus female figurines as having 'large and graphically represented' breasts (sometimes nursing an infant) with elaborate ornamentation almost certainly representing fertility and reproduction (Dales 1991, 140; Dales *et al.* 1991, 227). Perhaps these differing interpretations of the figurines actually say more about the archaeologists' ideas than those of the Indus artisans or the figurines themselves. In any case, many archaeologists and historians of religion reject the idea that the Indus figurines exaggerate the female body or represent fertility (e.g. Ardeleanu-Jansen 1993; Kinsley 1986, 218).

One might expect to find abundant depictions of pregnancy and children (Figs. 17.2c & 17.5[a–b]) if the figurines were intended to emphasize reproduction. The usually hollow 'globular' (so-called by Wheeler 1947, 128) type of figurine (see Fig. 17.5[b]), sometimes depicted nursing an infant, is often considered a depiction of pregnancy (originally suggested by Marshall 1931, 33 ff. and echoed by others e.g. Mackay 1938, 269, 272; Vats 1940, 29 ff.). These figurines have also been interpreted as caricatures (e.g. During Caspers 1979, 352–3), as representations of dwarves (Marshall 1931, 344), or as representations of opulence, symbolizing wealth and prosperity (e.g. Mackay 1938, 279). A non-fertility interpretation is even more plausible with the

discovery of a 'globular' male figurine with a beard and nipples (Fig. 17.5[c]) from Harappa. While Marshall (1931, 33, 49) interpreted both the globular figurines and other '*genre* subjects' such as female figurines depicted with infants as '*ex voto*' offerings, perhaps for magical or apotropaic purposes, and *not* as representations of the Mother Goddess, this distinction was not maintained by other scholars (e.g. Mackay 1938, 269, 272; Vats 1940, 29 ff.).

In any case, the occurrence of both the globular type of figurine and figurines depicted with children is very low at Harappa. No globular figurines have been recovered from Trench 39, and fewer than 3 per cent of the figurine fragments in the larger site sample are of this type. Female figurines with children (including infants that were formerly attached to the torso of an adult figurine) comprise only 2 per cent of the figurine fragments from Trench 39 and less than 4 per cent of the larger site sample. None of the male figurines from Harappa are depicted with infants or children (*contra* Vats 1940, 295).

The *third ethnographic criterion* is an association with lamps. The cup-like panniers on the heads of some of the Indus figurines (see examples in Fig. 17.6; also Figs. 17.2[g] & 17.4) were originally interpreted as representations of distended ears or exaggerated parts of actual headdresses (Mackay 1938, 261; Marshall 1931, 338–9), as well as receptacles for oil or incense based on traces of a black substance (possible residue from burning) found inside some of the panniers (Mackay 1938, 260–61). Mackay's (1938, 260) interpretation of the panniers led to the idea that the female figurines functioned as anthropomorphic votive lamps, which might mirror the association of the Hindu goddess Lakshmi with lamps in a unique form. Although this interpretation has been repeated in numerous publications (e.g. Vats 1940, 293; Wheeler 1947, 126), it has never before been empirically tested. In fact, there are several problems with it.

First, contrary to the impression created by early excavation reports (e.g. Marshall 1931, 49, 338; Vats 1940, 292–3), not many of the female figurines from Mohenjo-daro and Harappa have panniers. None of the figurines from Trench 39 and less than 30 per cent of the larger site sample of figurines from Harappa have panniers, and only 27 per cent of this 30 per cent that have panniers have any traces of a black substance preserved inside the panniers. Second, panniers vary

Figure 17.7. *A male figurine from Harappa with panniers (H95/4973-19; height: 4.2 cm.): a) front view; and b) top view. (Photo: S. Clark; courtesy of HARP.)*

Figure 17.8. *One of the female figurines from Harappa with black residue in the panniers analysed by both FT-IR and GC/MS (H96-3148/6353-1; height: 8.1 cm.). (Photo: HARP (R.H. Meadow); courtesy of HARP and the Harappa Museum, DAMGP.)*

considerably in size, depth, and form (compare those in Fig. 17.6), as Mackay (1938, 260) also noted. The panniers are often shallow (see Fig. 17.6[c]) or not attached well enough to the sides of the head to hold burning liquids such as oil or incense, as in Figure

Figure 17.9. *One side of a moulded terracotta tablet from Harappa with a central female figure holding two felines shown below a* chakra *(wheel) sign and above an elephant (H95-2486/4651-1; height: 1.6 cm.). (Photo: HARP (R.H. Meadow); courtesy of HARP and the Harappa Museum, DAMGP.)*

Figure 17.10. *A group of terracotta artefacts from Harappa with a male figurine on a model cart behind zebu and water buffalo figurines. (Photo: S. Clark & L. Miller; courtesy of HARP and the Harappa Museum, DAMGP.)*

17.6[c]. Some scholars had already noted that traces of the black substance found inside the panniers are often found on the outsides of the panniers as well (Wheeler 1947, 126) and that it might have been soot used as pigment to decorate the headdresses (Kenoyer 1998, 135). In any case, the fact that panniers are also found on male figurines (Fig. 17.7), as well as on composite zoomorphic/anthropomorphic figurines (Fig. 17.11[b]), challenges the assumption that female figurines with panniers represent the Mother Goddess.

For the first time, I also empirically tested Mackay's interpretations of the panniers and the figurines as anthropomorphic votive lamps. 11 black pigment samples from various terracotta figurines from Harappa were analysed at the Strauss Laboratory of the Fogg Art Museum at Harvard University using Fourier transform infrared microscopy (FT-IR) analysis and electron beam microprobe elemental chemical analysis. This analysis showed that the black pigments inside the panniers, those on figurine headdresses without panniers and those on animal figurines are essentially the same — bone black, which is a mixture of carbon black, calcium phosphate, some small amounts of calcite (calcium carbonate), and other trace amounts of inorganic material created by burning bone. Once the black substance inside the panniers was identified as bone black pigment rather than soot, gas chromatography mass spectroscopy (GC/MS) was used to determine whether the bone black inside the panniers contained residues from burning oils. Samples from inside the panniers of two figurines, including the one in Figure 17.8, and a control sample from a headdress without panniers showed no substantial difference in fatty acids; all had remnant organic materials from the burning of the bone to create the pigment rather than from incense or oils. Thus, there is no evidence that incense or oils were burned in the panniers of the female figurines (see chapter 3 in Clark 2007 for more discussion).

Additional archaeological evidence from Harappa

The fact that no Indus architecture or other archaeological features can be clearly identified as religious in nature (see Marshall 1931, vi; Possehl 1998, 276–7), and the lack of deciphered Indus texts, renders any

interpretation of Indus religion(s) and a religious context for the figurines hypothetical, as scholars have long noted (e.g. Sullivan 1964, 116). This uncertainty enhances the importance of other evidence from the same archaeological contexts as the figurines, and none of that evidence seems to support the Mother Goddess interpretation for the female figurines either.

For example, as several scholars have suggested (e.g. Atre 1985–86, 8; 1987, 17, 179), if the figurines represent an Indus Mother Goddess one might expect to find similar representations in the iconography of the inscribed objects from Harappa. However, only one fragmentary (Period 3) seal with an anthropomorphic figure, a head with a 'double bun' (typically a male attribute) and a schematic upper body, has been recovered from Trench 39 (see Meadow *et al.* 1998, fig. 23, 5). Similarly, only one scene (see Fig.17.9[a]) on all of the seals and tablets recovered from Harappa, made with a mould and thus repeated on multiple tablets, includes what appears to be a female figure with breasts (see Kenoyer 1998; Meadow & Kenoyer 2000). Unlike the female figurines, the female figure in this scene is apparently nude and without ornamentation, shown holding two felines, and it fulfills none of the ethnographic criteria for representing the Mother Goddess. Even the most frequently cited representation of an Indus 'Earth or Mother Goddess' (presumably giving birth), a nude figure on a tablet from Mohenjo-daro shown upside down with a small circular object between its bent legs (see Marshall 1931, 52, pl. XII, 12), has no physical attributes to indicate sex — and there is no indication whether the circular object is vegetation or 'issuing from her womb' (Marshall 1931, 52). It is also unclear why the Mother Goddess would have been depicted upside down giving birth (Sastri 1957, 50–1). In fact, none of the scenes on the Indus seals and tablets seem to conform to later Hindu myths that feature goddesses (Kinsley 1986, 217).

The fact that Indus female figurines are not similar to the female figures in the iconographic repertory

Figure 17.11. *Some terracotta artefacts that suggest Indus belief in myth and magic (left to right; maximum height: 7.0 cm.): a) unicorn figurine (B 836; ASI 62.3/284); b) seated composite figure with an anthropomorphic head and a zoomorphic body (HM 2082); and c) mask or amulet combining bovid, feline, and possibly anthropomorphic features (H93-2093/4093-1). (Photo: HARP (R.H. Meadow) and by S. Clark; courtesy of the Archaeological Survey of India, the Harappa Museum, and HARP, DAMGP.)*

Figure 17.12. *Some male figurines from Harappa with animal attributes (maximum height: 8.0 cm.): (left) a bearded male figurine with animal horns/ears, possibly a headdress (H96-3075/7266-2); and (right) two bearded male figurines with horned headdresses with a central projection (HM-2295 and HM-2187). (Photo: HARP (R.H. Meadow) and by S. Clark; courtesy of HARP and the Harappa Museum, DAMGP.)*

of the Indus seals and tablets has been cited as an argument both *for* (e.g. Wheeler 1968, 109) and *against* (e.g. During Caspers 1985) the interpretation of the female figurines as representations of deities or Mother Goddesses. Although many of the anthropomorphic terracotta figurines were interpreted as toys or votive offerings initially (Marshall 1931, 33, 49–50; Vats 1940, 292), Mackay (1938, 258–9) suggested that only the coarser terracotta figurines had votive functions and that the well-made female figurines and some of the male figurines were cult images instead. The

interpretation of the female figurines as representations of deities or Mother Goddesses used temporarily in a separate domestic cult in household shrines or niches (originally suggested by Marshall (1931, 50) and Mackay (1938, 259) is based on: 1) analogies with traditional south Asian practices (e.g. Marshall 1931, 50, fn. 5) incorporating terracotta figurines into religious rituals and sympathetic magic (e.g. Shah 1985); 2) the fact that usually broken figurines are most often found discarded in trash and street deposits, which may suggest temporary function (e.g. Jarrige 1991, 92; Kenoyer 1998, 111); and 3) the absence of counterparts in seals or other extant sculptural forms (Wheeler 1968, 91). Of course, other figurines and other types of artefacts are usually found broken in the same contexts as the female figurines, and iconography often differs across media. Although Shubhangana Atre (1985–86, 8; 1987, 17–18) has criticized Marshall's (1931) assumption that equally important male and female deities might have been represented in different media (male deities on seals/tablets and female deities in figurines), studies of other ancient civilizations (e.g. Brumfiel 1996) have shown that differences in the iconography of artefact classes may reflect differences in the intended messages and functions of artefacts such as seals, tablets, and figurines.

The predominance of cattle figurines and female figurines (see Fig. 17.10) and female figurines at Harappa (Dales et al. 1991, 227) and at other Indus sites (Ardeleanu-Jansen 1993; Jarrige 1991) mirror an ancient Near Eastern pattern dating as far back as the Neolithic, and the common interpretation of these as deities associated with fertility extends to the association of cattle with the goddess Lakshmi in modern Hinduism (e.g. Lodrick 1981, 4 ff.). Marshall (1931, 101, 347) interpreted the cattle figurines as 'bulls' representing an Indus male god and associated these figurines and the Indus female figurines with the cult of the Mother Goddess of western Asia (which sometimes included a male consort). He based this, at least in part, on his suggestion that most of the Indus cattle figurines 'appear to be bulls' and that the cow is conspicuously absent, apparently because most have horns (Marshall 1931, 347, fn. 1, 355). However, less than 1 per cent of the cattle figurines from Harappa have genitalia or udders depicted, and horns are not reliable indicators of sex. In addition, although cattle and female figurines are often discarded and found together with other artefacts in trash deposits, there is no evidence that they were associated when they were originally used. Neither is there any evidence for a connection between females and cattle in the iconography of other Indus artefacts, such as seals and tablets. Still, not only has this interpretation been echoed repeatedly (e.g. Atre 1987, 195; 2002, 198), it has even been used to explain the emphasis on the sanctity of cattle and the Mother Goddess in later Vedic literature and Hinduism (see Lodrick 1981, 48–55). Even if some of the Indus female figurines do represent an Indus Goddess, possibly connected with the later south Asian Goddess, the cosmogonic Magna Mater from which most western notions are derived is remarkably different from the great goddess of south Asia today (Larson et al. 1980, 13).

Cattle do dominate the faunal record at Harappa (e.g. Meadow 1991), but Indus cattle were being used for both food and traction (Miller 2003; also see the model cart in Fig. 17.10). This would seem to deny them the status of deities that they enjoy in some other societies, such as in Hindu societies where (although individual practices may vary) cattle are not usually eaten or disturbed in any way (e.g. Fuller 1992; Lodrick 1981).

Yet another argument against the Mother Goddess interpretation is the diversity of the Indus terracotta figurine corpus itself, which includes a number of male and other-gendered anthropomorphic figurines, zoomorphic figurines, and figurines representing composite and fantastic creatures (see Figs. 17.3, 17.11 & 17.12). Some of the anthropomorphic figurines with mixed gender attributes, which are typically male representations with genitalia, nipples, and/or beards in what is usually female costume (for example, Fig. 17.3[e] has a typically female headdress), may also suggest magical transformation and ritual. Another type of figurine from Harappa with no sex or gender attributes is seated with raised hands pressed together in front (Fig. 17.3[b]) in what is an almost universal gesture of respect and supplication (Fuller 1992, 3), possibly representing ritual or worship. Other examples of the potentially mythical or magical in the figurine corpus include the 'unicorn' found on many seals and occasionally represented in figurines (Fig. 17.11[a]), composite animals, animals with multiple heads, and composite creatures with anthropomorphic heads and zoomorphic bodies with tails (Fig. 17.11[b]). A few figurines with male anthropomorphic bodies and animal ears or horns (Fig. 17.12) may represent either men in costumes (e.g. headdresses) with animal attributes or actual transformation. These combinations of anthropomorphic and zoomorphic attributes may provide evidence of magical rituals or even shamanism (During Caspers 1993). Other artefacts such as composite anthropomorphic/zoomorphic terracotta masks or amulets (Fig. 17.11[c]) and large terracotta buffalo horns with holes for attachment may have been used as paraphernalia for such rituals. All of

these figurines and other artefacts offer tantalizing glimpses into a rich ideology that appears to have been steeped in mythology, magic, and/or ritual transformation — not an ideology focused solely on a Mother Goddess.

Conclusion

Interpreting all female imagery as one goddess is tantamount to interpreting plastic figures of the Virgin Mary and Barbie as having the same ideological significance (Meskell 1995), and interpreting *every* Indus female figurine as a Mother Goddess is equally illogical. While the evidence presented here does not necessarily refute the Mother Goddess interpretation for at least some of the Indus terracotta figurines, it does challenge this pervasive interpretation for most of the female figurines from Harappa. I have shown that past research has overemphasized and over-identified the female figurines. In addition, the general criteria used to identify modern representations of the Mother Goddess in south Asia and implicitly applied to the Indus figurines are rarely met in the attributes of these figurines, including the idea that the panniers were used as lamps or incense burners, which has now been tested for the first time. Other archaeological evidence from Harappa does not seem to support an Indus religion focused on a Mother Goddess either.

The fact that the female figurines vary in style and distribution across the Indus realm also seems contrary to what one would expect of a uniform Mother Goddess phenomenon (Ardeleanu-Jansen 1993; 2002) unless, like the Goddess in historical Hinduism, a single deity with varying aspects was represented by different forms and attributes specific to different geographic locations (Fuller 1992, 41; Kramrisch 1975). Explanations for the fact that there is no evidence of a Mother Goddess tradition in the earliest Vedic texts, the earliest south Asian records following the Indus civilization (Michael Witzel pers. comm. 2001; also see Bhattacharyya 1999, 26, 94–8) have been offered, but even if it was an indigenous tradition later incorporated into Hinduism this does not mean that it had to originate in the Indus civilization.

In fact the uncritical and pervasive use of the Mother Goddess interpretation is in part a legacy of early anthropology's more androcentric and evolutionary concept of lower matriarchal 'primitive' ancient societies (Hamilton 1996). However, as far as we know matriarchy, a form of political organization in which women hold absolute decision-making power, has not existed in any ethnographic, historic, or prehistoric society (Townsend 1990, 183). Ironically, even some leading feminists (e.g. Irigaray 2002) seem to accept the mythical 'pseudo-history' of matriarchy (e.g. 'pre-Aryan feminine' versus 'Aryan patriarchal') nurtured by the modern 'goddess movement' (see Townsend 1990, 197). Uncritically labelling figurines as religious or cultic objects helps perpetuate the 'goddess' myth, and it also discourages scholars from seeking potentially more challenging interpretations regarding ancient societies (Tringham & Conkey 1998, 42; Ucko 1968, 426). Instead, interpretations should be sought after re-contextualizing the figurines and considering the entire corpus, along with associated archaeological material including faunal remains, seals, and tablets.

If the Indus female figurines are not early representations of the south Asian Mother Goddess, what are they? In an initial attempt to look for meaningful patterns, I analysed the spatial distributions of female figurines with different headdress styles from Harappa and found that figurines with different headdress styles seem to be distributed (or at least discarded) fairly evenly across all excavated areas of the site, including mounds that were separated by walls in antiquity. Based on this cursory analysis, it appears that headdress styles were not specific to particular areas of the site, as one might expect of deities or other figures belonging to separate kin or other groups. This pattern could still indicate a domestic cultic or ritual use for these figurines across the site, although it is not clear what they would then represent. Non-cultic interpretations for the figurines also deserve consideration. For example, the figurines may have represented ordinary or elite people and codes of dress and ornamentation, perhaps as indicators of rank, status, and ethnicity in Indus society. Ethnographic studies (e.g. Shah 1985) suggest that even if they were originally made for cultic or ritual purposes, they may have been used as toys as well before they were discarded.

Old paradigms that demand that Indus religion(s) strictly conform to Hindu or other religious traditions that are now associated with south Asia are no longer appropriate. While threads of Indus and other indigenous traditions may have become incorporated into later traditions, Indus religion(s) may have been unlike any extant religious system — perhaps a mosaic of regional and varied traditions beneath the veneer of a larger civilization. Even if the Mother Goddess was an Indus tradition embodied in some of the figurines, it is certain that this third-millennium BC goddess is not the *same* Goddess of modern Hinduism. The richness of the figurine corpus itself suggests that Indus religion(s) included myth, magic, and ritual, and was not focused solely on a single female deity.

Acknowledgements

This paper would not have been possible without the support and encouragement of my advisors at Harvard University, C.C. Lamberg-Karlovsky and Richard Meadow. It has been greatly improved by comments from Richard Meadow, Colin Renfrew, Lynn Meskell, Rosemary Joyce, and Mary Voigt. The research was made possible through the generous cooperation of many institutions and individuals in Pakistan and in India, especially the Department of Archaeology of the Government of Pakistan, the Harappa Archaeological Research Project, the Archaeological Survey of India, and the National Museum of India, and through the financial support of the American School of Prehistoric Research, the Harappa Archaeological Research Project, and the George F. Dales Foundation.

Notes

1. For additional discussion of this topic, see Clark 2005.
2. Marshall (1931, 57–63) first argued that the Mother Goddess was an indigenous pre-Hindu or tribal tradition, possibly from the Indus civilization, that was eventually incorporated into Hinduism. Stella Kramrisch (1968) also posited a possible relationship between the pre-Aryan tribal people of India and the people of the Indus civilization based upon terracotta figurines.
3. For example, Marshall (1931, 339) stated that the female figurines were so numerous that there must have been a female figurine in every household. However, only 475 female figurine fragments were identified in the fieldnotes of the Mohenjo-daro excavations (Ardeleanu-Jansen 1993, 87–102).
4. All BC dates are based on calibrated radiocarbon dates from Harappa.

References

Ardeleanu-Jansen, A., 1993. *Die Terrakotten in Mohenjo-daro: eine Untersuchung zur keramischen Kleinplastik in Mohenjo-Daro, Pakistan (c. 2300–1900 v. Chr.)*. Aachen: Aachen University Mission.

Ardeleanu-Jansen, A., 2002. The terracotta figurines from Mohenjo Daro: considerations on tradition, craft and ideology in the Harappan civilization (c. 2400–1800 BC), in *Indian Archaeology in Retrospect*, vol. II, *Protohistory: Archaeology of the Harappan Civilization*, eds. S. Settar & R. Korisettar. New Delhi: Manohar, 205–22.

Atre, S., 1985–86. Lady of beasts: the Harappan goddess. *Puratattva* 16, 7–14.

Atre, S., 1987. *The Archetypal Mother: a Systemic Approach to Harappan Religion*. Pune: Ravish Publishers.

Atre, S., 2002. Harappan religion: myth and polemics, in *Indian Archaeology in Retrospect*, vol. II, *Protohistory: Archaeology of the Harappan Civilization*, eds. S. Settar & R. Korisettar. New Delhi: Manohar, 185–204.

Banerjee, R., 1995. Harappan terracotta art, in *Researches in Indian Archaeology, Art, Architecture, Culture and Religion*, vol. I, ed. P. Mishra. Delhi: Sundeep Prakashan, 207–16.

Bhattacharyya, N.N., 1999. *The Indian Mother Goddess*. 3rd edition. New Delhi: Manohar.

Brumfiel, E.M., 1996. Figurines and the Aztec state: testing the effectiveness of ideological domination, in *Gender and Archaeology*, ed. R.P. Wright. Philadelphia (PA): University of Pennsylvania Press, 143–66.

Chaudhari, N.M., 1950. The worship of the Great Mother in the Indus religion. *Calcutta Review* 117(3), 151–67.

Chaudhari, N.M., 1951. The worship of the Great Mother in the Indus religion. *Calcutta Review* 118(1), 1–17.

Clark, S.R., 2005. In search of the elusive 'Mother Goddess': a critical approach to the interpretation of Indus terracotta figurines with a focus on Harappa, in *South Asian Archaeology 2001*, eds. C. Jarrige & V. Lefevre. Paris: Editions Recherche sur les Civilisations-ADPF, 61–77.

Clark, S.R., 2007. The Social Lives of Figurines: Recontextualizing the Third Millennium BC Terracotta Figurines from Harappa (Pakistan). Unpublished phd dissertation, Harvard University.

Craven, R.C., 1997. *Indian Art: A Concise History*. Rev. edition. London: Thames & Hudson.

Dales, G.F., 1991. The phenomenon of the Indus civilization, in *Forgotten Cities on the Indus: Early Civilization in Pakistan from the 8th to the 2nd Millennium BC*, eds. M. Jansen, M. Mulloy & G. Urban. Mainz: Verlag Philipp von Zabern, 129–44.

Dales, G.F., J.M. Kenoyer & the Staff of the Harappa Project, 1991. Summaries of five seasons of research at Harappa (District Sahiwal, Punjab, Pakistan) 1986–1990, in *Harappa Excavations 1986–1990: a Multidisciplinary Approach to Third Millennium Urbanism*, ed. R.H. Meadow. (Monographs in World Archaeology 3.) Madison (WI): Prehistory Press, 185–262.

Dhawan, S., 1997. *Mother Goddesses in Early Indian Religion*. Jaipur: National Publishing House.

During Caspers, E.C.L., 1979. Caricatures, grotesques and glamour in Indus Valley art, in *South Asian Archaeology 1977*, ed. M. Taddei. Naples: Istituto Universitario Orientale, 345–74.

During Caspers, E.C.L., 1985. Sundry technical aspects of the manufacture of Indus Valley terracotta art, in *Miscellanea of Studies in Memory of Guiseppe Tucci*, ed. G. Gnoli. Rome: Istituto Italiano per il Medio ed Estremo Oriente, 267–85.

During Caspers, E.C.L., 1993. Another face of the Indus Valley magico-religious system, in *South Asian Archaeology 1991*, eds. A.J. Gail & G.J.R. Mevissen. Stuttgart: Franz Steiner Verlag, 65–86.

Eck, D., 1996. *Darśan: Seeing the Divine Image in India*. 2nd edition. New York (NY): Columbia University Press.

Fuller, C.J., 1992. *The Camphor Flame: Popular Hinduism and Society in India*. Princeton (NJ): Princeton University Press.

Gordon, D.H. & M.E. Gordon, 1940. Mohenjo-daro: some observations on Indian prehistory. *Iraq* 7, 1–12.

Hamilton, N., 1996. The personal is political. *Cambridge Archaeological Journal* 6(2), 282–5.

Irigaray, L., 2002. *Between East and West: from Singularity to Community*, trans. S. Pluháček. New York (NY): Columbia University Press.

Jarrige, C., 1991. The terracotta figurines from Mehrgarh, in *Forgotten Cities on the Indus: Early Civilization in Pakistan from the 8th to the 2nd Millennium BC*, eds. M. Jansen, M. Mulloy & G. Urban. Mainz: Verlag Philipp von Zabern, 87–93.

Kenoyer, J.M., 1989. Socio-economic structures of the Indus Civilization as reflected in specialized crafts and the question of ritual segregation, in *Old Problems and New Perspectives in the Archaeology of South Asia*, ed. J.M. Kenoyer. (Wisconsin Archaeological Reports 2.) Madison (WI): F & H Printing Company, 183–92.

Kenoyer, J.M., 1991. Urban process in the Indus tradition: a preliminary model from Harappa, in *Harappa Excavations 1986–1990: a Multidisciplinary Approach to Third Millennium Urbanism*, ed. R.H. Meadow. (Monographs in World Archaeology 3.) Madison (WI): Prehistory Press, 29–60.

Kenoyer, J.M., 1998. *Ancient Cities of the Indus Civilization*. Karachi: Oxford University Press.

Kinsley, D.R., 1986. *Hindu Goddesses: Visions of the Divine Feminine in the Hindu Religious Tradition*. Berkeley (CA): University of California Press.

Kramrisch, S., 1968. *Unknown India: Ritual Art in Tribe and Village*. Philadelphia (PA): Philadelphia Museum of Art.

Kramrisch, S., 1975. The Indian great goddess. *History of Religions* 14(4), 235–65.

Larson, G.J., P. Pal, & R.P. Gowen, 1980. *In Her Image: the Great Goddess in Indian Asia and the Madonna in Christian Culture*. Santa Barbara (CA): UCSB Art Museum, University of California.

Lodrick, D.O., 1981. *Sacred Cows, Sacred Places: Origins and Survivals of Animal Homes in India*. Berkeley (CA): University of California Press.

Mackay, E.J.H., 1938. *Further Excavations at Mohenjo-Daro: Being an Official Account of Archaeological Excavations at Mohenjo-Daro Carried Out by the Government of India between the Years 1927 and 1931*, vols. I–II. New Delhi: Government of India.

Marshall, S.J., ed., 1931. *Mohenjo-daro and the Indus Civilization*, vols. I–III. London: A. Probsthain.

Meadow, R.H., 1991. Faunal remains and urbanism at Harappa, in *Harappa Excavations 1986–1990: a Multidisciplinary Approach to Third Millennium Urbanism*, ed. R.H. Meadow. (Monographs in World Archaeology 3.) Madison (WI): Prehistory Press, 89–106.

Meadow, R.H. & J.M. Kenoyer, 2000. The 'tiny steatite seals' (incised steatite tablets) of Harappa: some observations on their context and dating, in *South Asian Archaeology 1997*, eds. M. Taddei & G. de Marco. Istituto Italiano per l'Africa e l'Oriente, Rome, 321–40.

Meadow, R.H., J.M. Kenoyer & R.P. Wright, 1998. Harappa Archaeological Research Project: 1998 Excavations. Submitted to the Department of Archaeology and Museums, Government of Pakistan.

Meskell, L.M., 1995. Goddesses, gimbutas and 'new age' archaeology. *Antiquity* 69, 74–86.

Miller, L.J., 2003. Secondary products and urbanism in south Asia: the evidence for traction at Harappa, in *Indus Ethnobiology: New Perspectives from the Field*, eds. S.A. Weber & W.R. Belcher. Lanham (MD): Lexington Books, 251–326.

Mookerjee, A., 1966. *The Arts of India: from Prehistoric to Modern Times*. Rev. edition. Calcutta: Oxford & IBH.

O'Flaherty, W.D., 1980. *Women, Androgynes, and Other Mythical Beasts*. Chicago (IL): University of Chicago Press.

Possehl, G.L., 1998. Sociocultural complexity without the state: the Indus civilization, in *Archaic States*, eds. G.M. Feinman & J. Marcus. Santa Fe (NM): School of American Research Press, 261–91.

Sastri, K.N., 1957. *New Light on the Indus Civilization*. Delhi: Atma Ram & Sons.

Shah, H., 1985. *Votive Terracottas of Gujarat*. New York (NY): Mapin International.

Sullivan, H.P., 1964. A re-examination of the religion of the Indus civilization. *History of Religion* 4(1), 15–25.

Townsend, J.B., 1990. The goddess: fact, fallacy and revitalisation movement, in *Goddesses in Religions and Modern Debate*, ed. L.W. Hurtado. Atlanta (GA): Scholars Press, 179–203.

Tringham, R. & M. Conkey, 1998. Rethinking figurines: a critical view from archaeology of Gimbutas, the 'Goddess' and popular culture, in *Ancient Goddesses: the Myths and the Evidence*, eds. L. Goodison & C. Morris. London: British Museum Press, 22–45.

Ucko, P.J., 1968. *Anthropomorphic Figurines of Predynastic Egypt and Neolithic Crete with Comparative Material from the Prehistoric Near East and Mainland Greece*. (Royal Anthropological Institute Occasional Paper 24.) London: Andrew Szmidla.

Vats, M.S., 1940. *Excavations at Harappa*, vols. I–II. New Delhi: Government of India.

Wheeler, R.E.M., 1947. Harappa 1946: the defenses and cemetery R37. *Ancient India* 3, 59–130.

Wheeler, R.E.M., 1968. *The Indus Civilization*. (Supplementary volume to the *Cambridge Ancient History of India*.) 3rd edition. Cambridge: Cambridge University Press.

Chapter 18

The Emergence of Figuration in Prehistoric Peru

Richard L. Burger

The purpose of this paper is to review the evidence for the appearance and early development of figuration in prehistoric Peru. The larger goal is to explore whether generalizations can be made about the trajectory of figuration in the central Andes which may resemble or contrast with those known elsewhere in the world. Archaeology in the central Andes is best known in relation to the Inca empire, a late prehistoric expansionist state that in a century grew to a scale and sophistication comparable to anything known in the pre-industrial Old World. This empire, known as Tawantinsuyu, was built and administered without the presence of wheeled vehicles, standardized money or writing, following patterns dissimilar in some ways from those in the Old World. Archaeological research over the last century has demonstrated that early social and cultural development in the central Andes was both distinctive and independent of outside influences. Tawantinsuyu was simply the last expression of this indigenous trajectory prior to the invasion of Spanish troops in 1532.

The role or roles of early figuration in the central Andes has attracted little attention from archaeologists and other scholars. The Inca culture was strongly hierarchical and its world-view was steeped in notions of inequality, but these relationships were largely expressed without recourse to figuration. As in many of the world cultures, the Incas seem to have preferred the use of non-figurative conventionalized geometric designs and they employed these to represent both status and ethnicity. Ancestors played a crucial role in cosmology but they were more often represented by natural rock formations than by attempts to naturalistically represent their forms in two or three dimensions. Architectural features, such as double- and triple-jamb niches and doorways, and differences in topographical elevation were all widely understood signals of hierarchy and status without involving figuration, and Inca palaces and administrative centres are generally image-free. In this regard, the Inca culture contrasts with many but by no means all of the cultures that preceded it in the larger central Andean world. These introductory remarks suggest the potentially complex relationship between figuration, power and status within the Pre-hispanic Andean world.

The trajectory of figuration within ancient Peru holds special interest because of its autochthonous character but there are other factors that further enhance the desirability for its consideration in cross-cultural discussions. Archaeology in Peru has been making incremental progress since the first expedition of Reiss and Stubel to the Peruvian coast in 1874 and 1875, and after over a century of research our understanding of Peruvian prehistory, although limited, is still much fuller and more reliable than most other regions of South America. Another factor that makes the consideration of figuration in Peru worthwhile is the unusually good preservation encountered along its desert coast. The intense aridity that has characterized this zone for over 5000 years enables the recovery of organic materials such as textiles and wooden objects, as well as normally perishable non-organic remains such as unbaked clay murals. These items are frequently the carriers of figuration. While sampling bias due to differential preservation is always a problem, an unusually complete archaeological record exists for many coastal Peruvian sites and, as will be seen, this has implications for tracing the development of figuration in the area.

The chronological framework that will be employed in this discussion consists of a series of chronological periods originally defined on the basis of stylistic and other cultural criteria and subsequently linked by calibrated radiocarbon measurements. The crucial periods for our purposes are the Late Preceramic (3000–2000 BC), the Initial Period (2000–1000 BC), and the Early Horizon (1000–50 BC), although reference will be made to the Early Preceramic (10,000–5000 BC) and the Middle Preceramic (5000–3000 BC).

The beginning of figuration in prehistoric Peru

As Paul Bahn summarized in his contribution to this volume, early examples of petroglyphs and rock painting were widespread outside of western Europe and

Figure 18.1. *Cave painting from Toquepala, Peru. (Courtesy of James B. Richardson III.)*

there are numerous examples known from throughout South America, although the examples discussed by him are from Brazil and Argentina. While these features present difficulties for dating, at least some examples go back 10,000 to 12,000 years and claims of greater age for some examples continue to be debated. It is likely that, as in the Old World, these rock paintings constitute the earliest examples of figuration in the New World.

Studies of analogous features from Peruvian caves, rock-shelters and other stone outcrops have a long history. Rogger Ravines (cf. Nuñez Jimenez 1986), produced a preliminary inventory registering 97 sites with rock paintings and 137 sites with petroglyphs distributed through all of Peru's departments and macro-geographical regions. Other scholars have produced more focused inventories of *arte rupestre* from specific regions or sites (e.g. Ampudia 1978; Linares Malaga 1973; Neira 1968; Pimentel 1986). These publications document a time when hunters and gatherers in Peru painted or carved representations of wild animals and in some cases of their hunters as well. They also produced non-figurative motifs such as lines of dots and circles. The motivation for creating these images remain as controversial as their dating. The tradition of *arte rupestre* probably runs throughout Peruvian prehistory and may even continue after the Spanish conquest. Some of the best-known examples of these scenes such as the Toquepala paintings have traditionally been dated to the Early Preceramic period (Bonavia 1991), although a more recent review by French archaeologist Jean Guffroy (1999, 23–46) has argued that most probably date to the mid-Holocene between 6000–3000 BC.

The best known of these early rock paintings are from the highlands of central and southern Peru at sites such as Lauricocha in the Department of Pasco, Jaywamachay in the Department of Junin, Macusani and Pizacoma in the Department of Puno, Sumbay in the Department of Arequipa, Azana in the Department of Moquegua and Caru and Toquepala in the Department of Tacna (Fig. 18.1). These paintings are frequently linked to lengthy Preceramic occupations, hence the difficulty of providing a definitive date for their production. There is, however, considerable similarity between many of the paintings both in subject matter and style. They most often portray zoomorphic animals, identified as camelids (most likely guanacos or vicunas) and anthropomorphic figures carrying weapons. The arrangement of the figures and the occasional representation of possible dead animals suggest that hunting scenes are being shown, although the occasional representation of masked figures points to a ceremonial component as well. Guffroy's argument for dating most of these scenes between 6000–3000 BC receives support from the creations of similar paintings during this same time period in the neighbouring areas of Chile and Bolivia (Guffroy 1999). In any case, whether one accepts Guffroy's conservative estimates or the older estimates made by other investigators, these rock paintings would still qualify as the earliest examples of figuration from the Peruvian area.

On the other hand, habitation or special purpose activity areas dating to the Early Preceramic and the Middle Preceramic, whether on the coast or in the highlands, have not yielded objects adorned with representations of the natural world. By the Middle Preceramic, sedentary or semi-sedentary settlements became common and evidence of early cultigens appear along with collected wild plants. Some of these sites on the central coast of Peru, such as Chilca 1 or La Paloma, are small villages in which twined textiles and other perishable materials are well preserved. During the 1950s, 1960s and 1970s, Engel's archaeological team from CIZA (Centro de Investigaciones de Zonas Aridas) excavated at dozens of Middle Preceramic sites along the coast, most of which had outstanding preservation. While he never published most of these sites in detail, he did present the most

noteworthy finds at these sites (Engel 1988) and the absence of portable objects, including textiles and bone objects with evidence of figuration is conspicuous. The work at La Paloma by Jeffrey Quilter (1989) and Benfer (2000) was particularly intensive and built upon the extensive excavations by Frederic Engel (cf. Donnan 1964). At Paloma alone over a dozen houses were uncovered and over a hundred intact burials were documented. The paucity of figuration there or at contemporary sites offers a stark contrast with most later Peruvian cultures and it does not appear to be the consequence of sampling bias. While preservation is poorer in the highlands and fewer sites have been intensively studied, no examples of figuration have been reported from the numerous cave and open site deposits that have been investigated (Lavallée *et al.* 1982; Lynch 1980; Rick 1980).

Figure 18.2. *Unbaked clay figurines from Aspero, Supe Valley. (Courtesy of Robert Feldman.)*

The general absence of any type of figuration on constructions or artefacts prior to the Late Preceramic, with the exception of rock art, suggests that the potent forces inherent in figuration were not to be treated in a cavalier manner nor were they thought to be appropriate for most contexts, regardless of the ability of the indigenous population to create such images. Thus in prehistoric Peru for at least seven millennia, figuration appears to be absent on all but caves, rock-shelters and possibly boulders.

The emergence of figuration during the Late Preceramic period

The appearance of naturalistic images outside of caves and rock-shelters occurs for the first time during the Late Preceramic period (3000–2000 BC) in the form of figurines, building decoration and textile designs. The Late Preceramic period in Peru has attracted attention in part because of the association of large-scale monumental architecture with societies that still did not rely on intensive agriculture for their subsistence. Both in the highlands and on the coast, the collection of wild plants was complemented by the cultivation of cultigens, although the precise makeup and balance of the diet remains a subject of debate. Similarly, protein sources came mainly from sources other than domesticates — hunting in the highlands and fishing and shellfish collection with some hunting on the coast. Monumental architecture was erected along the central and northern coast and also in the northern highlands beginning around 3000 cal. BC. The contrast between the impressive evidence for corporate constructions represented by immense plazas, high-stepped pyramids and elaborate temples and the mixed diet of domesticated and wild resources has led to heated debates, as has the apparent contradiction between the frequent assumption of hierarchy for such public centres and the paucity of evidence for strong stratification and craft specialization.

Recent attention has focused on the monumental architecture of Caral, previously known as Chupacigarro, in the Supe Valley on the north-central coast of Peru. It was in this same valley that Gordon Willey in 1941 excavated the first example of a Late Preceramic temple with its terraced sides, central access and flat-topped summit. The constructions at the 10 hectare site of Aspero were so impressive that Willey dated it to much later times, despite the absence of pottery (Moseley & Willey 1973). Three decades later Michael Moseley and Robert Feldman returned to Aspero for more intensive research that proved that the flat-topped pyramids at Aspero, Huaca de los Idolos and Huaca de los Sacrificios, had been erected around 3000 BC. Particularly relevant, for our purposes, Feldman's investigations at the 10 m high Huaca de los Idolos encountered a cache of unfired clay anthropomorphic figurines (Fig. 18.2). These constitute some of the earliest examples of figuration known from Pre-Hispanic Peru. Huaca de los Idolos, like most early temples in the central Andes, was characterized by repeated rebuilding marked by the placement of solid fills covering earlier structures. The rebuilding was not moti-

vated by the need to repair or to change the function of the architecture, but to respond to cosmological or ceremonial demands. The cache of figurines had been placed between two floors in a small summit room. The room was dated by a radiocarbon measurement of 4360±175 BP (GX–3860) which when calibrated is 3055 BC. Based on other dates from above the cache, Feldman concluded that the cache had to be deposited before 2500 cal. BC. Feldman rejected a much earlier date from the cache itself because it was inconsistent with other measurements. In the space between Floors one and two of Room 2, where the figurines were recovered, there were also mats, baskets, fur, wooden sticks, cane, sedge, food remains and lumps of clay similar to that used to produce the figurines.

None of the 13 figurines were complete, and given the good preservation and careful excavation, this breakage appears to be meaningful. All of the figurines were made in a similar manner and they share many features. The torso and head was made of a single oval cylinder of clay with the addition of separate pieces of clay to represent arms, legs, and in some cases, breasts and costume elements. Feldman estimates that when complete the figurines would have been between 5 and 14 cm tall. Little attention was paid to the faces; they usually consist of eyes represented by narrow slits, a nose formed by a triangular ridge, sometimes with two holes to represent nostrils, and small grooved tabs for ears. In contrast to the crude treatment of the face, considerable care was taken to show a turban-like hat and what appears to be shoulder-length hair. On two figurine fragments a necklace and a bracelet made of rectangular beads are carefully represented. Based on the representation of breasts, Feldman identified 12 of the 14 figurines as female; one or two of the remaining figurines was tentatively identified as male. A large male figurine was found alone outside of the room where the cache was recovered, but its placement was contemporary with the others. Based on the context and comparisons with later Andean practices, Feldman concluded that the figurines had been left as a dedicatory or honorific cache and that it was placed in Room 2 and the adjacent corridor on the occasion of the rebuilding of the Huaca de los Idolos (Feldman 1980; 1991).

These well-documented and carefully described unbaked clay anthropomorphic figurines found in 1973 by Feldman are part of a larger phenomenon now documented for the Supe Valley, and for other valleys on the north-central and central coast of Peru. It has parallels with discoveries for the Huallaga Valley in the central highlands of Peru. In the Supe Valley 25 km inland from Aspero, the excavations at Caral directed by Ruth Shady yielded a cache of unbaked clay figurines in the rooms on the Pirámide de la Cantera, a 15.4 m high terraced pyramid on the northwest end of the site. These figurines have yet to be published in detail, but photographs of two nearly complete figurines reveal that they are made in the same manner as the Aspero figurines and have simple faces made by mainly by incised slits for the eyes and mouth and perforations for the nose. They likewise have small appliqués apparently representing breasts, while arms and hands are made in the most cursory fashion. According to Shady, she found the offerings of unbaked clay statues in ceremonial contexts and she believes that they generally represent women related to rituals of propitiation or fertility (Shady 2003, 27). In another set of excavations in Residential Sector A, in the centre of Caral, Shady unearthed a kind of box that was created and filled with offerings as part of final entombment of this building complex. Among a wide range of organic and inorganic offerings were a pair of unbaked clay figurines (Shady & Lopez 2000, 197, fig. 8). These were smaller than those described above, no more than 7 cm in height. Little attention was given to the hair of these figurines and no evidence of the gender was provided; arms, hands and feet were lacking and the presence of legs was suggested only by vertical incisions. Faces received the same schematic treatment as on other unbaked clay figurines. Based on the facial characteristics (and perhaps on the slight difference in size and clay composition), Shady interprets the pair of figurines as a male and a female, although she acknowledges that no sexual attributes can be observed (Shady & Lopez 2000, 208). The context and makeup of the 'box of offerings' suggests a ceremonial act at the time of building closure.

The case of Caral is particularly interesting; the extensive excavation of seven major pyramids, one smaller temple and several residential complexes has been ongoing since 1994. In all, some one hundred examples of unbaked clay figurines have been recovered but most are broken and missing body parts. Shady believes that they were used in rituals associated with the renovation of buildings and fertility rites (Shady 2005, 44–5). Given the scale of the excavations, the unbaked clay figurines just mentioned are very rare at Caral and are among the very few examples of figuration that have come to light at this major Late Preceramic centre. The specific dating of the two groups of figurines has not been discussed in detail, but it should fall within the range of 2800–2400 cal. BC for the Late Preceramic occupation of Caral which has been established by 18 radiocarbon measurements (Shady et al. 2001). At Caral, the only other significant evidence of figuration was a set of 32 incised tubes made of pelican and condor bone which will be

discussed subsequently. These artefacts, interpreted as flutes, were found buried in a small sand-filled pit in the southwest corner of the plaza of the Pirámide del Amfiteatro (Shady 2003, 20).

The Aspero and Caral finds of unbaked clay anthropomorphic figurines resemble an unbaked clay figurine recovered at Bandurria, a Late Preceramic located at the mouth of the Huaura Valley, one drainage to the south of Supe. Salvage archaeology at the site by the University of San Marcos recovered over one hundred burials none of which produced figurines or other examples of figuration (Lucy Salazar pers. comm.). However, at the base of the Preceramic deposits, perhaps as an offering associated with the construction of the site's pyramid-mound, Rosa Fung encountered a complete 16 cm tall figurine placed inside a basket and associated with the uncalibrated radiocarbon measurement of 4530±80 BP (V-3279) (Fung 1988, fig. 3.2, 95). The treatment of the arms, legs, and face share much with the Supe figurines. The hair, highlighted by incisions, differs in being pulled forward and in being long enough to extend beyond the shoulders onto the figure's chest. Although a photograph of the piece has been published, no detailed description of it or of its context has yet appeared.

Additional fragments of unbaked clay anthropomorphic figurines were also recovered in the Chillon Valley near Lima at the site of El Paraiso during Frederic Engel's excavation of the ceremonial structure known as Unit 1 (Fig. 18.3). As in the case of Bandurria, only the general context is known along with photographs of the fragments. Given the distance of El Paraiso from finds on the north-central coast, over 100 km away, and radiocarbon dates that suggest a terminal Late Preceramic date several hundred years after the Aspero and Caral finds (Quilter 1985), it is not surprising that the appearance of these figurines differ significantly from their northern counterparts. Despite this they are similar in construction and they too are characterized by only the most casual rendering of the face through incision and punctation (Engel 1967).

During the Late Preceramic, the production of clay figurines with human and other figurative attributes was not limited to the Peruvian coast. In the Huallaga Valley, some 400 km to the east of El Paraiso, the site of Kotosh yielded early evidence of unbaked clay figurines during the University of Tokyo excavations in 1963. Kotosh, like the Late Preceramic sites on the coast, is dominated by high eroded mounds that enclose multi-phase stepped pyramids with flat summits upon which ceremonial architecture was constructed. On one of the two major mounds, known as KT, a three-phase sequence was revealed, the oldest of which includes the Templo Blanco, a

Figure 18.3. *El Paraiso unbaked clay figurine head. (Courtesy of Jeffrey Quilter.)*

niched rectangular building in which burnt offerings were made. In one of the niches on the north wall, an anthropomorphic figurine of unbaked clay was encountered along with three other small unbaked clay items, including what appear to be representations a plant and a bowl. Punctation is used to represent eyes, noses and mouths and some indication of hair appears on the edge and back of the heads. Although limbs are missing, fragments that may have served this purpose were found nearby. Sexual attributes are not shown and the figurines are relatively small (7.5 cm & 8.2 cm). A similar anthropomorphic figurine was recovered from the floor of the same building and it may have been painted with red and white pigment. In addition to the unbaked clay figurines found in the Templo Blanco (ER-27), two other figurine fragments made of clay baked at a low temperature were found in the slightly later Templo de las Manos Cruzadas. Facial features are clearly shown but the body is just a flat lump of solid clay in the form of a stick (Izumi 1971, 63–4; Izumi & Terada 1972, 210–11, pls. 51a–b & 131, nos. 11–16). The dating of Kotosh remains poorly understood although most scholars would accept that the Templo de los Manos Cruzadas was erected by 2000 BC and the Templo Blanco must be earlier.

The material summarized above suggests a number of generalizations. First of all, it appears that some of the earliest expression of figuration in Pre-Hispanic Peru was the production of crude figurines with human features. While some of these show specific elements of dress and hair style, as well as sexual attributes, others show only the general body form and basic elements such as eyes, nose and mouth. These figurines were generally made from a material that was not in general use — modelling clay

Chapter 18

The best-known cases of this occurred at the site of Kotosh. As already mentioned, Kotosh is dominated by two high-terraced pyramid mounds which, upon excavation, proved to contain a series of small rectangular flat-roofed temple structures with central hearths for the burning of offerings. These buildings were often buried while still in excellent condition following a pattern known as temple entombment, so that the light-coloured clay plaster covering their interior and exterior walls remained intact. The oldest of the Kotosh temples to be excavated was a dual structure know as the Templo Blanco. The outer walls of temple building were left undecorated but on the inside of the south wall, facing the entryway, the upper half of a small anthropomorphic figure was painted in white pigment on the yellow-brown plastered wall face. Shown in profile with his/her arms raised, this 12 cm high figure occupies the centre of wall along the ceremonial access of the building. No details of the face or other elements are shown (Izumi & Terada 1972). The small size and light colour of these images would have diminished their visual impact.

The Templo de los Manos Cruzadas was built above the Templo Blanco after it had been ceremonially interred. On the wall facing the entrance were five niches, the largest of which was located in the centre. Beneath each of the two flanking niches was a low-relief clay frieze of crossed arms (Fig. 18.4). The friezes were situated symmetrically in relation to the building's central axis, but the set to the right of the axis was larger than the one to the left, and the position of the arms on the two friezes likewise contrasted with each other. The excavator, Seiichi Izumi, plausibly interpreted them as the hands of a man and a woman (Izumi 1971), while I have argued elsewhere that the broader principle being expressed in these friezes is one of duality in which the unity of fundamentally opposing forces is symbolized (Burger 1992). This latter interpretation is likewise reflected in the pattern of twin-temple constructions at the site. Another painting in white pigment, this time of a stylized snake, was found on the stairway leading to the Temple of the Manos Cruzadas.

The appearance of figuration in public constructions at Kotosh is important, particularly given the crucial location of the friezes and painting within the ritual chambers. However, it was not common. At Kotosh, 11 Late Preceramic ritual chambers were excavated, but only two showed evidence at figuration. Other highland sites with similar Late Preceramic public architecture for the ceremonies of the Kotosh Religious Tradition were excavated subsequently, but none showed evidence of wall painting or friezes. This was true for other sites related to Kotosh in the

Figure 18.4. *Clay sculpture of crossed hands from the Templo de los Manos Cruzados, Kotosh.*

— and the discovery of these figurines is rare, even at archaeological sites where years of extensive research has been conducted. At Kotosh, two of these figurines show evidence of baking at a low temperature, which suggests experimentation with the potential of the modelling clay and perhaps the first tentative steps towards pottery making. When Late Preceramic anthropomorphic figurines are encountered, whether on the coast or highlands, it is almost always as some sort of offering made in the context of public architecture where ceremonial activities were carried out. Thus far, these objects have not been encountered by investigators focusing on refuse or burial contexts, and it seems reasonable to suggest that in both the coast and highlands anthropomorphic figurines were produced to be used in a narrow range of Late Preceramic rituals at public centres.

Figuration during the Late Preceramic is not limited to the crude anthropomorphic figurines discussed thus far. There are also rare cases in which humans and animals appear on the walls of pubic constructions that have been interpreted as temples.

Huallaga drainage, as well as for the smaller and more rustic centres at Piruru in the drainage of the Rio Tantamayo or Huaricoto in the Callejon de Huaylas. The absence of public examples of figuration on the walls of La Galgada, a particularly large and well preserved centre in the Tablachaca drainage (a tributary of the Santa) is particularly conspicuous given the large number of well-preserved ceremonial chambers that were unearthed by Terence Grieder and Albert Bueno (Burger 1992, 45–53).

Similarly, numerous large ceremonial constructions on the coast have been heavily excavated including the Huaca de los Idolos and the Huaca de los Sacrificios at Aspero, seven pyramids and two temples at Caral, several terraced platforms at the site of Salinas in Chao, the platform at Huaynuná in Casma and Unit 1 at El Paraiso, to mention just the best-known cases. While none of the published coastal centres have revealed evidence of figuration, ongoing excavations at the mid-valley site of Buena Vista in Chillon have unearthed clay friezes of a giant round face and a profile animal decorating the interior of the ritual chamber (Fig. 18.5). Radiocarbon dates place these friezes in the third millennium BC, based on two radiocarbon measurements indicating its contemporaneity with other Late Preceramic centres; the sample from the lower level associated with the frieze is 3790±80 BP (GX-32177), which has a calibrated 1 sigma range between 2390–2049 BC (Robert Benfer pers. comm.). It is significant that the large sculpted image appears in a building that Benfer believes has an orientation of astronomical significance, such as to the equinox and the solstices. The unambiguous Late Preceramic date of the Buena Vista sculpture on the Central Coast suggests that Peter Fuchs and Henning Bischoff may be correct in their current belief that the painted feline and the incised human, fish (Fig. 18.6) and other figures shown on the walls of the early buildings at Cerro Sechin in the Casma Valley may

Figure 18.5. *Clay sculpture from Buena Vista, Chillon Valley. (Courtesy of Robert Benfer.)*

Figure 18.6. *Incised clay frieze of a mythical fish from Cerro Sechin, Casma Valley. (Courtesy of Lorenzo Samaniego.)*

date to the Late Preceramic (Fuchs 1997), rather than the Initial Period as often assumed (Burger 1992).

A third source of evidence for figuration in the Late Preceramic comes from the realm of cotton textiles. First documented in 1946 and 1947 at Huaca

Figure 18.7. *Cotton textile with the bird and serpent image from Huaca Prieta, Chicama Valley. (Courtesy of Junius Bird.)*

Prieta, a site on the shores of Chicama Valley with exceptional preservation, a total of 6368 pieces of fabric were recovered along with other elements of yarn, cordage and fibre. Its excavator, Junius Bird, was particularly interested in textile analysis and for the next thirty years, he and his team studied the Huaca Prieta collection at the AMNH (American Museum of Natural History). He identified 257 fabrics that were produced using a technique known as twining transposed-warp construction; this allowed the production of designs prior to the introduction of weaving with a heddle loom, although these motifs are no longer visible owing to the loss of colour in the cotton fibre. Nevertheless Bird and his collaborators meticulously plotted the structure of these rare textile fragments and determined that they depicted both geometric and figurative representations (Fig. 18.7). According to Bird *et al.* (1985, 146–90), the figurative depictions include human figures, a spread-winged male condor, condors in profile, condors with raised spread wings, parrots, rock crabs, joined birds, joined faces, interlocked condors, double-headed snake-like creatures, snakes in bands, cats, rock crabs with snakes, and humans. The number of fabrics with figurative representations was tiny, making up less than a half of one per cent. Many represent animals that were locally prominent in this maritime environment but the images are often far from naturalistic. Crabs are combined with snakes, snakes and birds are shown with two heads and even the condor with raised spread wings is shown in an almost X-ray fashion with a snake inside its body. Found scattered amidst the refuse of the mound, the original context in which they were used remains unknown.

Subsequent excavations at Late Preceramic sites with good preservation have confirmed both the existence of figurative motifs on Late Preceramic fibre arts as well as their extreme rarity. Engel documented a few additional cases at the site of Asia on the central coast south of Lima, but the largest sample of such representations outside of Huaca Prieta has come from the excavations at La Galgada (Grieder *et al.* 1988, 166–81). Textiles and other fibre artefacts were more frequently decorated there than at Huaca Prieta, but they were made by looping rather than transposed warps. Several looped bag fragments depict a frontal anthropomorphic figure with ear ornaments, a headdress and with serpents substituting for arms. Serpents, double-headed serpents, double-headed birds, frontal birds, and frontal anthropomorphic figures were depicted in red, black, brown and yellow on weft-twined cloth, looped bags and were placed with the dead in tomb contexts within the temple structures. Although the ceremonial architecture and the textile techniques contrast with those used at Huaca Prieta and the surrounding littoral, the style and content of the motifs on these items is similar in many respects.

A number of conclusions can be drawn from this brief overview of the evidence from the Preceramic in Peru. First of all, figuration first made its appearance by about 6000 cal. BC on rock formations in conjunction with a hunting and gathering economy. The images on these stone outcrops suggest an intimate relation between the creation of the images, and hunting activities and the lives of the wild animals represented. Outside of the use of figuration in rock art, figuration in Peru first occurs in the Late Preceramic by 3000 cal. BC usually in the context of monumental public constructions. The intimate link between the emergence of figuration and the building of ceremonial centres is intriguing. Other related changes in both the coast and the highlands include the increasing importance of agriculture as a critical component of the subsistence system, and the resulting increase in sedentism and population size. The three classes of figuration encountered at the large centres is contrastive: one consists of crude images placed as some sort of votive offerings, perhaps designed to placate the supernatural elements and ensure fertility of the crops or human populations. The second class of figuration consists of wall friezes and paintings probably representing cosmological elements underpinning the rituals carried out in and around these buildings on behalf of the community. While the wall decorations were visible for large periods of time and reflect relatively sophisticated artistic conventions, the figurines were intentionally crude and were often broken, buried and placed out of sight following their ceremonial use. The third class of figuration occurs on textiles and the images represented in this medium are perhaps the most sophisticated of all, despite the technological challenges in creating them. The original context in which these decorated fibre arts were

originally used remains poorly understood, and some specialists such as William Conklin have argued that their purpose was not utilitarian. This Late Preceramic pattern lasted from 3000–2000 cal. BC and quite surprisingly, is equally true for both the coast and highlands. The rarity of these occurrences prior to 2000 cal. BC is, in some respects, as noteworthy as the cases of figuration themselves.

The flourishing of figuration during the Initial Period and Early Horizon

Around 2000 cal. BC, it became commonplace to fire pottery and this technological innovation has been used by archaeologists in the Andes to mark the beginning of what is called the Initial Period. During the following millennium agriculture increased in importance while wild plants diminished in their contributions to the diet, both in the highlands and coast. Maritime resources along the coast and hunting inland remained crucial for obtaining protein and domesticated animals remained rare or of secondary importance. It was in this context that figuration became widespread. Large- and small-scale ceremonial architecture became common on the coast, and was not unusual for a single coastal valley to have six to twelve public centres built during this time. Archaeologists have disagreed on how this unusual pattern of public construction should be interpreted, some arguing that the centres served as the civic focus of small independent polities that interacted with each other socially and economically but remained independent from a political perspective (Burger 1992). Others have viewed these centres as being part of small states with multi-tiered administrative hierarchies (Pozorski & Pozorski 2005). While the former interpret the absence of specialization and a lack of sharp status differentiation in burials as reflecting the unstratified socioeconomic system of pre-state societies, the latter argue that the large scale of the architecture and long-standing adherence to the same site design make the pre-state interpretation implausible. This is not the place to resolve or detail these ongoing debates although they are clearly relevant to an understanding of the spread of figuration.

During the early Initial Period the creation of wall paintings and wall friezes becomes increasingly common on the coast. By the end of the Initial Period, they appear to become the rule rather than the exception, and their presence graces both the large and the small centres. This may also be true for the early Initial Period but the problem of reaching early Initial Period constructions should not be underestimated. As a consequence, the sample of early Initial Period public architecture remains relatively small. Nonetheless, the pattern that emerges is compelling. In the Nepeña Valley, for example, the site of Punkuri is generally dated to the early Initial Period and its walls were covered with a complex bas-relief made by incision and painting, as were two columns. In the centre of the of the staircase of the ceremonial platform was a modelled feline head with interlocking fangs and clawed paws originally painted white, black, red and yellow. The wall decorations were more stylized and complex, incorporating elements identified by Antuñez de Mayolo as representing monkeys, a stylized condor, a fish with a stylized head and other stylized figures (Bonavia 1985, 27).

The richness and pervasiveness of this imagery in Nepeña is paralleled in the neighbouring valley of Casma, where the well-preserved early Initial Period site of Moxeke-Pampa de las Llamas has yielded a remarkable abundance and diversity of images. The main mound at the site measures 160 × 170 m at the base and it has a total height of 30 m. Most of it has not been excavated, but when the outer face of the third terrace was cleared, the front wall was found to have a series of large niches with enormous painted high-relief sculptures originally reaching over 3 m in height (Tello 1956). These massive sculptures were located 10 m above the open plazas below and would have been visible to those attending the ceremonies below. The sculptures show anthropomorphic figures elaborately dressed in tunic, short skirt and loose mantle. In one sculpture the figure holds bicephallic snakes with forked tongues. The naturalistic modelling of the clothing and hands is striking as is the use of contrasting colours (pink vs black) to increase the impact of these unbaked clay sculptures. The niches along the northwest side of the building were smaller but they were filled with massive painted anthropomorphic heads. Across a huge area of open plazas is another platform mound whose summit was filled with repetitive square rooms that may have served as storage chambers. Known as Huaca A, this complex was covered with a now badly damaged large-scale incised and painted image; while only the lower section of this remains, the excavators believe that it represents a stylized feline. Inside Huaca A, a rectangular stone sculpture was encountered showing a naturalistic human hand on one face and a double bodied snake on another (Pozorksi & Pozorski 1986). A long series of radiocarbon measurements from the site suggest that it was established by 2000 cal. BC and abandoned by 1400 cal. BC.

Two other sites with early Initial Period occupations have been intensively studied: one is the well-known site of Cerro Sechin. Originally investigated

Sechin carvings are remarkable in the knowledge they show of human anatomy and the ability to depict it to reinforce the theme of violence, blood-letting and death. At the same time, this theme appears to have been part of a more complex message that involved fish and felines, animals with powerful symbolic associations in the early Andes (Burger 1992).

The largest site in Casma, Sechin Alto, has only been intensively studied over the last decade and its monumental scale has presented great and unusual obstacles. Nonetheless, a recent summary by the Pozorskis (2005) dates the lower two-thirds of the complex to the early Initial Period and mentions the discovery of badly damaged large-scale colourful clay sculptures that decorated the exterior of the main platform mound during both early phases — Moxeke A (2150–1500 cal. BC) and Moxeke B (1500–1400 cal. BC).

There is little reason to believe that the situation in Casma and Nepena is anomalous. Further north along the coast in the Jequetepeque Valley, the German excavations in mid-valley at Montegrande unearthed representational clay sculpture adorning the walls (Tellenbach 1986). In the upper section of that same valley at the highland site of Kuntur Wasi, at the highland site of Kuntur Wasi, a painted clay sculpture of an anthropomorphic supernatural was recovered from the open plaza of the site's earliest Initial Period complex (Fig. 18.8) (Onuki 1995). Still deeper in the highlands, representative sculptures similar to those at Cerro Sechin are known from the massive platform complex at Chupacoto in the Callejon de Huaylas (Burger 1992, 123). At Pacopampa, an even larger highland centre to the northeast, investigators have documented a large lintel-like block with a pair of footprints carved in one face and a composite double-bodied snake with avian and feline elements on the other (Burger 1992, figs. 92 & 93). This carving resembles the carving from Huaca A at Moxeke-Pampa de las Llamas.

Judging from the evidence available, it would seem that at least in northern Peru, representative imagery became a pervasive and important feature of public centres during the early Initial Period. At the same time, the practice of creating solid anthropomorphic figurines likewise expanded and figurine fragments are reported from almost all coastal and highland sites of this time period. This practice can be seen as linked to the Late Preceramic pattern, given the continued crudeness in the modelling, the stance the figures and the emphasis on representing females. However, the Initial Period figurines are well fired rather than being left unbaked and, more importantly, the context in which they are found has shifted from ceremonial contexts in pubic architecture to domestic refuse and household areas. While the anthropomor-

Figure 18.8. *Painted clay figure from Kuntur Wasi, Idolo Phase, Jequetepeque Valley. (Courtesy of Yoshio Onuki.)*

prior to the development of radiocarbon dating, this site has been re-excavated and redated to the beginning of the Initial Period (Samaniego *et al.* 1985), and some suggest the possibility that its earliest phase could actually be Late Preceramic in age (Fuchs 1997). The Cerro Sechin mound, like virtually all of the complexes of this time, consists of a series of superimposed temple constructions. Each of the four constructions had its exterior walls decorated with representations, the first using a wall painting technique, the second and the third using a combination of incision and painting, and the final and best-known complex substituting stone sculpture for the painted clay images. The themes represented in the stone frieze show a procession of victorious anthropomorphic warriors dressed with maces and standards alternating with their bleeding and dismembered victims, all of whom have been stripped of their clothing. Elements of this theme also occurs in the clay representations in conjunction with other images, including an enormous fish. From the perspective of figuration, the Cerro

phic figurines were probably still produced for ritual purposes, this shift would suggest a fundamental change in who was using these figurines and how they were being employed. Little is known about the textile arts of the early Initial Period, but it is significant that figuration plays little role in most of the earliest ceramic traditions that were developed at this time. With the conspicuous exception of the Wairajirca style in the Huallaga drainage (Kano 1979), most pottery receptacles feature geometric or textured decoration on simple forms reminiscent of gourd vessels. There is an apparent increase in representational decoration on amulets and bone items but these remained scarce.

The spread of figuration during the Initial Period followed patterns already set in motion during the Late Preceramic, but one apparently new context in which representative imagery appears is on portable ceremonial paraphernalia, most notably the mortars used to grind hallucinogenic snuffs and other ritual plants, and the receptacles used to consume these and other ritually charged substances. The early Initial Period features the decoration of mortars on the north coast, including one found in an offering at Punkuri, and the production of stone ritual vessels, including a remarkable set of steatite plates and tumblers from Limoncarro in the Jequetepeque Valley. The mortars are made from basalt and other hard volcanic stone and are distinguished by their sophisticated style that combines anthropomorphic and geometric elements to create highly schematic motifs (e.g. Burger 1992, 89, fig. 71). The Limoncarro steatite vessels stand out because of their depiction of a complex mythical narrative involving an anthropomorphic spider supernatural that decapitates human victims and collects their heads as trophies (Salazar & Burger 1983).

During the late Initial Period (1200–1000 cal. BC), figuration not only becomes pervasive on public architecture and ritual equipment, and continues in the form of anthropomorphic figurines, but it also becomes widespread in many of the pottery styles of central and northern Peru. The images on late Initial Period pottery often parallel the religious imagery on the public architecture. By the end of the late Initial Period, the shock of seeing the elements of the world represented by modelling, painting or carving would have disappeared. Nonetheless, the increasing abundance of figuration remains directed toward the representation of creatures or monstrous composites that were not seen in everyday life. The Manchay culture centre of Garagay in the Rimac Valley represented an anthropomorphic supernatural in vivid colours and in the neighbouring Lurin Valley we have found examples of figuration at three public U-shaped Initial Period centres investigated thus far: Cardal, Manchay Bajo

Figure 18.9. *Drawing of giant clay frieze of a fanged mouth decorating the Middle Atrium at Cardal, Lurin Valley.*

and Mina Perdida. Both Cardal and Manchay Bajo had painted clay images on their exterior or interior walls, the former of a large mouth band of interlocking teeth and fangs (Fig. 18.9), the latter of anthropomorphic faces with feline elements. The wall friezes at Mina Perdida had been destroyed by looting, but we unearthed a large puppet-like religious image of perishable materials that combined anthropomorphic elements with the crest of a male condor, eye markings of a hawk and a large canines of a wild carnivore (Fig. 18.10) (Burger & Salazar 1991; 1998).

During the first millennium cal. BC, known by specialists as the Early Horizon, the great public centre at Chavín de Huántar and other highland and coastal centres within its sphere of interaction created increasingly sophisticated images drawing upon the styles and themes of the preceding millennium. The technological innovations associated with the Chavin culture led to the depiction of the imagery in new ways and on new materials (Fig. 18.11). Supernaturals and monstrous animals were depicted on cut, hammered and shaped precious metal objects, textiles that were painted or used dyed camelid wool for embroidery, and stone sculptures carved in the round. The density of the figuration in Chavin art was viewed by Alfred Kroeber as the apex of Native American artistry and it has stimulated a large interpretive literature that agrees on few things other than the fundamentally religious and supernatural focus of the figuration (Burger 1992). Perhaps these technological breakthroughs helped retain some of the sense of awe that had originally been associated the very production of representative imagery (Burger 1988), but which may have been lessened by its increasing ubiquity.

Discussion

From its inception, the early history of figuration in the ancient Andes was linked to religious practice and belief. During the Early and Middle Preceramic

Chapter 18

Figure 18.10. *Supernatural effigy of perishable materials recovered from the summit of Mina Perdida, Lurin Valley.*

Figure 18.11. *The sculpted stone cult object from the Old Temple of Chavín de Huántar, Mosna Valley.*

it was initially confined to a small number of natural settings with imagery related to the rituals of early hunters and gatherers. While the ability to produce recognizable images of the natural world seems to have existed from early times, perhaps from the first settlement of the Andes, people were slow in applying such images to the buildings and portable objects that they used on a daily basis. Whether the absence of figuration in these early times reflects fear of the potency of such images or whether they were simply seen as unnecessary and irrelevant to everyday life remains to be seen. It is only with the emergence of ceremonial centres as the focus of small-scale agricultural societies on the coast and in the highlands that figuration begins to appear on public buildings, as if by representing elements of the cosmology the efficacy of these temples and their leaders is enhanced. At the same time, some rituals at the temples apparently required analogues of humans and unbaked or poorly baked clay figurines were produced to meet this need. Both of these classes of very early figuration are only found in ceremonial contexts and there can be little doubt of their general purpose. The figuration found on Late Preceramic textiles are somewhat more ambiguous in their function although their themes, featuring two-headed or double-bodied animals and anomalous anthropomorphic figures, have led Terence Grieder and others to suggest that these too represent the cosmology of these early agriculturists.

The increasing size and complexity of agricultural societies in the central Andes following the intensification of cultivation and the introduction of pottery led to the proliferation of ceremonial centres within a vast quilt of cultures organized into small

independent polities. While figuration had been the rare exception during the Late Preceramic, it became widespread during the Initial Period without losing its close association with religious architecture and ritual paraphernalia. Elaborate artistic conventions attempting to represent cosmology, supernaturals and mythological narratives diversified throughout the coast and highlands as ceremonial centres sought to represent their special beliefs and social identity in a manner that transcended quotidian reality. At the same time, the tradition of producing crude anthropomorphic figurines continued, albeit incorporating the advances in ceramic technology (i.e. firing and slip painting) and shifting the use of these ritual items into domestic settings. The images that dominate the Initial Period are of exotic animals or, more frequently, images that represent beings that do not exist in the natural world but are generated by combining traits taken from multiple sources, such as anthropomorphic figures with feline traits. The Early Horizon marks the culmination of early traditions of figuration with the images still focusing on mythical and religious themes, but utilizing new techniques and new media to increase their power and diversity. Moreover, the individuals associated with the temples were buried with costume elements representing these supernatural themes. This pattern suggests that figuration had become a tool that could be used to enhance the power of specific religious leaders through making explicit their special link to the supernatural world, often using technologies not available or known by the larger population.

As we briefly review the early history of figuration in Peru it is noteworthy to consider what does not appear. There seems to be a conspicuous absence of the portrayal of leaders and there is an equally conspicuous absence of historical events. Early figuration in Peru was not designed to commemorate or glorify particular rulers or their polities. There is, likewise, little attempt to chronicle the natural world or represent the objects or activities that constituted daily life. Most figuration was segregated in places where public activities were carried out. When figuration ultimately penetrated the domestic world it did so in the form of figurines used in domestic rituals or in the form of pottery bearing elements of the culture's religious cosmology. The recognizable features of the landscape likewise were not represented and the images of supernaturals and other creatures appear as if they existed outside the normal framework of space and time.

It is only with the radical reorganization of cultures during the very end of the Early Horizon and the beginning of the Early Intermediate Period (200 cal. BC–cal. AD 300) that representative imagery breaks these traditional constraints. Suddenly ancient artists and artisans begin to represent aspects of the secular world that served as the basis of their wealth and power and, in some cases, figuration becomes a blatant tool of state expansion and dynastic ambition.

References

Ampudia, T., 1978. El arte rupestre en Huánuco como legado prehistórico. *III Congreso Peruano: el Hombre y la Cultura Andina* 2, 594–603.

Benfer, R., 2000. Proyecto de excavaciones en Paloma, Valle de Chilca. *Boletín de Arqueología PUCP* 3, 213–237.

Bird, J., J. Hyslop & M. Dimitrijevic Skinner, 1985. *The Preceramic Excavations at the Huaca Prieta Chicama Valley, Peru*. (Anthropological Papers of the American Museum of Natural History 62[1]). New York (NY): American Museum of Natural History.

Bonavia, D., 1985. *Mural Painting in Ancient Peru*, trans. P.J. Lyon. Bloomington (IN): Indiana University Press.

Bonavia, D., 1991. *Peru Hombre e Historia De los Orígenes al Siglo* XV(I). Lima: EDUBANCO.

Burger, R.L., 1988. Unity and heterogeneity within the Chavin horizon, in *Peruvian Prehistory*, ed. R. Keatinge. Cambridge: Cambridge University Press, 99–144.

Burger, R.L., 1992. *Chavin and the Origins of Andean Civilization*. London: Thames & Hudson.

Burger, R.L. & L. Salazar, 1991. The second season of investigations at the Initial Period centre of Cardal, Peru. *Journal of Field Archaeology* 18(3), 275–96.

Burger, R.L. & L. Salazar, 1998. A sacred effigy from Mina Perdida and the unseen ceremonies of the Peruvian formative. *Res: Anthropology and Asthetics* 33, 28–53.

Donnan, C., 1964. An early house from Chilca, Peru. *American Antiquity* 30(3), 137–44.

Engel, F., 1967. Le complexe preceramique d'El Paraiso (Perou). *Journal de la Societe des Americanistes* 55, 43–96.

Engel, F., 1988. *Ecología Prehistórica Andina*, vol. 1. Lima: CIZA.

Feldman, R.A., 1980. Aspero, Peru: Architecture, Subsistence Economy, and other Artefacts of a Preceramic Maritime Chiefdom. Unpublished PhD dissertation, Department of Anthropology, Harvard University, Cambridge (MA).

Feldman, R.A., 1991. Preceramic unbaked clay figurines from Aspero, Peru, in *The New World Figurine Project* vol. 1, ed. T. Stocker. Provo: Research Press, 5–19.

Fuchs, P., 1997. Nuevos datos arqueométricos para la historia de ocupación de Cerro Sechín — Período Lítico al Formativo, in *Archaeologica Peruana 2: Arquitectura y Civilización en los Andes Prehispánicos*, eds. E. Bonnier & H. Bischof. Mannnheim: Reiss-Museum, 145–61.

Fung, R., 1988. The Preceramic and Initial Period, in *Peruvian Prehistory*, ed. R. Keatinge. Cambridge: Cambridge University Press, 67–96.

Grieder, T., A. Bueno, C. Earle Smith & R. Malina, 1988. *La Galgada, Peru: a Preceramic Culture in Transition*. Austin (TX): University of Texas Press.

Guffroy, J., 1999. *El Arte Rupestre del Antiguo Perú*. Lima: IFEA/IRD.

Izumi, S., 1971. The development of the formative culture in the Ceja de Montaña, in *Dumbarton Oaks Conference on Chavin*, ed. E. Benson. Washington (DC): Dumbarton Oaks, 49–72.

Izumi, S. & K. Terada, 1972. *Andes 2: Excavations at Kotosh, Peru, 1960*. Tokyo: Kadokawa Press.

Kano, C., 1979. *The Origins of the Chavín Culture*. (Studies in Pre-Colmbian Art and Archaeology 22.) Washington (DC): Dumbarton Oaks.

Lavallée, D., M. Julien, J. Wheeler & C. Karlin, 1985. *Telarmachay: chasseurs et pasteurs préhistoriques des Andes*. Paris: Editions Recherches sur les Civilisations.

Linares Malaga, E., 1973. Anotaciones sobre cuatro modalidades de arte rupestre en Arequipa. *Anales Científicos de la Universidad del Cenatro del Peru* 2, 133–267.

Lynch, T., 1980. *Guitarrero Cave*. New York (NY): Academic Press.

Moseley, M. & G. Willey, 1973. Aspero, Peru: a reexamination of the site and its implications. *American Antiquity* 38(4), 452–68.

Neira, M., 1968. Un nuevo complejo lítico y pinturas rupestres en la Gruta Su-3 de Sumbay. *Revista de la Facultad de Letras, Universidad Nacional de San Agustin* 5, 47–75.

Nuñez Jimenez, A., 1986. *Petroglifos del Perú*, vol. 1. La Habana: Ministerio de Cultura, Cuba.

Onuki, Y., 1995. *Kuntur Wasi and Cerro Blanco: Dos Sitios Formativos en el Norte del Perú*. Tokyo: Hokusen-sha.

Pimentel, V., 1986. *Petroglifos en el Valle Medio y Bajo del Jequetepeque, Norte del Perú*. (Materialien zur Allgemeinen und Vergleichenden Archaeologie, Band 31.) München: Verlag C.H. Beck.

Pozorski, S. & T. Pozorski, 1986. Recent excavations at Pampa de las Lllamas-Moxeke: a complex Initial Period site in Peru. *Journal of Field Archaeology* 13, 381–401.

Pozorski, T. & S. Pozorski, 2005. Architecture and chronology at the site of Sechín Alto, Casma Valley, Peru. *Journal of Field Archaeology* 20, 143–61.

Quilter, J., 1985. Architecture and chronology at El Paraiso, Peru. *Journal of Field Archaeology* 12, 279–97.

Quilter, J., 1989. *Life and Death at Paloma: Society and Mortuary Practices in a Preceramic Peruvian Village*. Iowa (IA): University of Iowa.

Ravines, R., 1986. *Arte Rupestre del Perú. Inventario General (Primera Aproximación)*. Lima: Instituto Nacional de Cultura.

Rick, J., 1980. *Prehistoric Hunters of the High Andes*. New York (NY): Academic Press.

Salazar, L. & R. Burger, 1983. La araña en la iconografía del horizonte temprano en la costa norte del Perú. *Beitrage zur Allgemeinen und Vergleichenden Archaologie* 4, 213–53.

Samaniego, L., E. Vergara & H. Bischof, 1985. New evidence on Cerro Sechin, Casma Valley, Peru, in *Early Ceremonial Architecture in the Andes*, ed. C. Donnan. Washington (DC): Dumbarton Oaks, 165–90.

Shady, R., 2003. *Caral, Supe: La Civilización Mas Antigua de América*. Lima: INC.

Shady, R., 2005. *The Caral-Supe Civilization: 5000 Years of Cultural Identity in Peru*. Lima: INC.

Shady, R. & S. Lopez, 2000. Ritual de Enterramiento de un Recinto en el Sector Residencial A en Caral-Supe. *Boletín de Arqueología PUCP* 3, 187–212.

Shady, R., J. Haas & W. Creamer, 2001. Dating Caral: a Preceramic urban centre in the Supe Valley on the central coast of Peru. *Science* 292, 723–6.

Tellenbach, M., 1986. *Die Ausgrabungen en der Formativzeitlichen Siedlung Montegrande, Jequetepeque-Tal, Nord-Peru*. (Materialen zur Allgemeinen und Vergleichenden Archaologie 38.) Munich: Verlag C.H. Beck.

Tello, J.C., 1956. *Arqueología del Valle de Casma*. Lima: UNMSM.

Chapter 19

Early Figuration in Northwest Argentina: Materiality, Iconography, and the Uses of Imagery

Elizabeth DeMarrais

Figuration, as defined for the purposes of this volume, is 'the representation, in two or three dimensions, of aspects of the visible world'. In this paper, I discuss the origins and changing uses of figurative images from the Formative societies of northwest Argentina, considering materiality and iconography to understand aspects of ritual and cult activity and their relationship to socio-political organization.

One of the striking features of early figuration in northwest Argentina is the diversity of media used. Through time, objects — ranging from pipes, snuff trays, containers and metal plaques — in addition to anthropomorphic clay figurines, carried figurative representations. Figuration is found on the full range of media, from stone, wood and pottery to metals and textiles, in two- or three-dimensional forms according to the material properties of the distinct media used. Functional objects such as ground-stone mortars, used to process plants with hallucinogenic properties, were also elaborately adorned with zoomorphic and anthropomorphic features, particularly during the Early Period.

For over a century, Argentine archaeologists have worked to understand chronology and settlement patterns, as well as to interpret the complex iconography of pre-Hispanic groups who occupied this Andean region in the northwest of the country. Although some archaeological materials excavated early in the century lack detailed contextual information, ongoing excavations are regularly contributing new insights. Current evidence suggests that small-scale polities with incipient social differentiation had appeared by the Middle Period and probably earlier. Cult activities associated with ritual specialists (probably shamans) emphasized worship of the sun (or a 'solar being') and ancestors, as well as the use of hallucinogens (Pérez Gollán 2000, 236). Crafted goods — with the exception of bronze plaques and fine pottery — were produced less for use as sumptuary items and more for their symbolic — as well as functional — roles in ritual. Following this proliferation of figurative material culture during the Early and Middle Periods, the ritual complex declined; Late Period iconography retains figurative elements but is less intricate and complex.

Because the archaeology of northwest Argentina is not widely published in English, one aim of this chapter is to present a survey of the figurative material culture and iconography. For this purpose, I have drawn upon the publications of Pérez Gollán (2000), González & Pérez (1990) and particularly a recent synthesis of Aguada by A. Rex González (1998). This chapter also addresses questions of materiality and iconography with the aim of understanding the uses of figurative material culture. I begin by assuming that material culture is active, used by people to forge, to maintain — and sometimes to transform — social and political relationships (Hodder 1982; DeMarrais *et al.* 2004). To some extent, art and iconography may be said to have agency (Gell 1998), although this point continues to provoke debate (Robb 2004).

Given the importance of cult activity in the pre-Hispanic south Andes, I also consider the relationship between ritual and socio-political integration in small-scale societies. In the absence of coercive forms of leadership and prestige goods systems, figurative material culture may be integral to ritual practice and instrumental in its creation and elaboration (Clark 2004; Renfrew 2001; 2004; Mithen 1998). In small-scale societies, where spheres of ritual activity and those of everyday life overlap (Bradley 2004), symbolic objects are likely to have had varied contexts of use, ownership, and display. Those who control ritual knowledge or the skill to acquire or to create the paraphernalia used in ritual (Brandt 1977; Helms 1993) may occupy positions of authority or hold political power.

Furthermore, although it can be helpful to distinguish 'utilitarian' from 'prestige' goods (or valuables), such a distinction may not always further

Chapter 19

Figure 19.1. *Map of southern South America, showing places mentioned in the text. The map of the provinces of Argentina is redrawn and modified from Rossi (2003, 44.)*

Northwest Argentina and its pre-Hispanic inhabitants

The area considered in this study encompasses the northwest provinces of modern Argentina. It is a region of narrow, longitudinal valleys set in the eastern slopes of the Andes (Fig. 19.1) that act as routes of communication between the altiplano to the north and west and the more humid forests located to the south and east. Elevations range from 800 to 3000 m above sea level; while extremes of topography limit rainfall in some valleys, there is substantial variation and the easternmost valleys are more humid. Subsistence during the pre-Hispanic era relied upon cultivation of maize, supplemented by collection of wild plants and the herding and hunting of camelids.

The chronology of northwest Argentina is summarized in Figure 19.2. The periods of greatest interest for early figuration are the Early and Middle Periods (which together comprise the Formative). Time periods considered here include the period of mobile forager/hunters or Archaic Period (c. 6000–200 BC), the Early Period (c. 200 BC–AD 650) marked by more sedentary lifestyles, agriculture, and the emergence of a feline cult; the Middle Period (AD 650–950) marked by the elaborate art and ritual of Aguada peoples; and finally the Late Period (AD 950–1460), when socio-political complexity and population sizes increased but iconography was simplified. Trends in figuration during each period are discussed briefly in the following sections.

Archaic Period

Rock art can be difficult to date, but petroglyphs throughout the region were created by mobile foraging/hunting groups from at least 6000 BC. Many involve simple figurative designs pecked into boulders and outcrops; during a survey of the northern Calchaquí Valley, such images were encountered regularly. Common themes include elements of the natural world, including camelids and the columnar cactuses that are ubiquitous in the landscape (Fig. 19.3). It seems reasonable to assume that these images reflected the concerns of early hunters.

While scholars generally agree that a substantial proportion of these petroglyphs date to the Archaic Period, other parietal art — such as that found in the Cueva de la Salamanca in Catamarca — is more recent (Boschín & Llamazares 1996; Hedges *et al.* 1998; Boschín *et al.* 1999). Cave murals (such as the 'Dance of the Suris' panel discussed below) have been absolutely dated to the Middle Period, confirming an association (derived from stylistic analysis) with the Aguada culture (Boschín *et al.* 1999).

our understanding of the uses of figurative objects in small-scale societies. As Spielmann (2002, 198) has argued, assigning non-subsistence goods to discrete categories may lead archaeologists to miss the wide range of uses to which these goods are put. She argues that 'socially valued' objects (e.g. pottery, stone containers, figurines, metals, or textiles), may be displayed or used in ritual settings and then ' ... move into the realm of more individualized social-ceremonial events, from bride-price payments to homicide reparations'. Finally, while many archaeologists view economic and political interests as underlying causes of craft specialization, Spielmann suggests that the demands of ritual — and social reproduction more generally — may also create strong incentives for increased production of 'extraordinary' material culture.

Early Period

Early villages, based upon an agro-pastoral economy, appeared late in northwest Argentina in comparison to other areas of the world. During the last few centuries BC (perhaps as early as 450 BC (Tartusi & Núñez-Regueiro 2002, 128) dispersed households and villages appeared along the edges of river terraces, where maize could easily be cultivated. The cultures of the Early Period include Condorhuasi (200 BC–AD 500), La Ciénaga (200 BC–AD 600), and Tafí (100 BC–AD 900), among others (Fig. 19.2). Villages, consisting of clustered residential enclosures, contain evidence for sculpted pipes executed in polished stone or fired clay, often modelled to resemble animals. Tafí polished stone is more highly elaborate than pottery; masks (Fig. 19.4) and upright stones, or menhirs (Fig. 19.5) were among the figurative forms executed in stone.

The menhirs stood in residential patios. Examples include animals with human characteristics (a viper with a human head) and a naturalistic depiction of a feline. Some of the menhirs have grooves, perhaps used to attach cords with feathers or other offerings. These early figurative representations, in their use of zoomorphic forms, and particularly their frequent depiction of felines, hint at cult activities that will become much more elaborate during the Middle Period (González & Pérez 1990, 41). Tafí peoples cooperated in the construction of agricultural terraces, as well as in the efforts required to procure and erect the menhirs within their villages.

Other cultures, including La Ciénaga and Condorhuasi are roughly contemporaneous with Tafí. Artisans of La Ciénaga culture (located primarily in the Hualfín Valley but extending north into the Calchaquí Valley), produced elaborate pottery (Rossi 2003, 51) and pipes similar to the example shown in Figure 19.6. Urns were used for infant burials, a practice that continued into the Middle and Late Periods. Some adult burials of Ciénaga contain as many as 50 objects, made from clay, metal, and bone (González & Pérez 1990, 48), suggesting social differentiation and probably some degree of craft specialization.

Ciénaga sites also contain pipes, used for smoking tobacco and perhaps hallucinogens; González & Pérez (1990, 46) characterize some as 'incensarios' with anthropomorphic faces '… with fantastic aspect', again suggesting cult activity in the Early Period. Ciénaga

PERIOD	DATE	PUNA North	PUNA South	VALLEYS & QUEBRADAS Quebrada Humahuaca	VALLEYS & QUEBRADAS Calchaquí & Santa María	Tafí	Hualfín	EASTERN FORESTS
Colonial	1640 1536	Colonial	Colonial	Colonial	Colonial Hisp.–Ind.	Colonial	Colonial Hisp.–Ind.	Belén & Santa María influences
Inka	1480	Inka	Inka	Inka	Inka	Inka	Inka	
Regional Developments	1350 1200	Puna	Complex	Humahuaca	Santa María II Santa María I	Santa María	Belén II Belén I	
Formative	1000 700 500 250	Pozuelos ? ?	Tebenquiche Ciénaga	Alfarcito Isla Otumpa ?	San José? Aguada Condorhuasi Ciénaga	Tafí	Aguada Condorhuasi Ciénaga	Candelaria San Francisco
Pre-Ceramic	AD 1 BC 6000	Saladillo		Ayampitín Ampajango		? ?		?

Figure 19.2. *Chronology chart for northwest Argentina (based upon information in González & Pérez 1990, 37.)*

Figure 19.3. *Petroglyph from the northern Calchaquí Valley showing a columnar cactus and a camelid. (Photo: E. DeMarrais.)*

material culture includes bronze axes or celts, as well as bone and wood implements, used for weaving and other tasks, also decorated with figurative designs. Many archaeologists see La Ciénaga as a stylistic precursor to Aguada, nevertheless characterizing the style as 'balanced and decorative' in contrast to that of Aguada which is richer in symbolic content (González & Pérez 1990).

Condorhuasi was a culture contemporaneous with La Ciénaga; indeed some suggest the sharing of styles among members of these two groups. Centred in the Hualfín Valley in Catamarca, the remarkable pottery of Condorhuasi was exchanged widely, as far as the oasis of San Pedro de Atacama in Chile. Demand for these ceramics has led to widespread looting of

Chapter 19

Figure 19.4. *A stone mask from the Tafí culture (Museo Chileno de Arte Precolombino, Santiago), height = 21.5 cm.*

Figure 19.5. *Menhir displayed in the Museo Arqueológico de Cachi. (Photo: E. DeMarrais.)*

sites. The economy of Condorhuasi was similar to that of Ciénaga but perhaps with greater emphasis on pastoralism, as reflected in burials of animals, probably sacrifices. Because residential sites are little studied, however, daily life is poorly understood.

Condorhuasi polychrome pottery (Fig. 19.7), often with reddish surfaces and geometric decorations in white or black, is modelled to depict human figures seated or crawling on all fours. The pieces, probably intended for mortuary ritual, have to date only been found in tombs and would have had few practical uses. The vessel showing the individual on all fours may be a reference to a feline's mode of locomotion, possibly, again, reflecting the early stages of a feline cult. The faces are often decorated elaborately, while their bulbous forms create an unusual sense of volume.

Stone pipes were created for use in ceremonies; large and heavy, they are impractical for everyday use (González & Pérez 1990, 51). Condorhuasi artisans made extensive use of stone for sculpture; mortars were modelled with anthropomorphic and zoomorphic features (Fig. 19.8), and the 'supplicant' sculptures (Fig. 19.9) are justly recognized for the skill of their sculptors. The technical and artistic skill of sculptors and potters of the Early Period are striking, as is the prevalence of figurative representations. Evidence of wider contacts (with inhabitants of San Pedro de Atacama in northern Chile or the Lake Titicaca region of Bolivia) are visible in the use of metal and stone, as well as in an emphasis on pastoralism. More specifically, iconographic similarities with stone sculptures of the Chiripa culture in the Bolivian altiplano are suggestive, although direct evidence of contact remains elusive (Tartusi & Núñez-Regueiro 2002).

Middle Period
Continuity from Condorhuasi and La Ciénaga to Aguada is visible in art and iconography. In the Valley of Ambato (a place of origin for Aguada), alluvial deposits along the river served as settings for small villages. These grew in size during the Middle Period, when the first ceremonial centres appeared. Further changes involved diversification of iconographic themes and elaboration of the feline cult; a 'solar' cult or 'solar being' also appeared, probably associated with fertility rituals. The paraphernalia for the cult expressed its concerns through a vivid and intricate iconography. Contact, albeit usually indirect, with the expansionist Tiwanaku state (AD 500–1150) of the Lake

Figure 19.6. *Zoomorphic pipe fragment, San Francisco culture. (Museo Arqueológico R.P. Gustavo Le Paige.)*

Figure 19.8. *Zoomorphic stone mortar (height = 25.4 cm). (Museo de la Plata, Argentina.)*

Figure 19.7. *Condorhuasi vessel depicting a crawling (part-feline?) figure.*

Figure 19.9. *'Supplicant' sculpture in stone from the Alamito culture (height = 30 cm). (Museo de la Plata, Argentina.)*

Titicaca basin was a further influence on the development of Aguada iconography (González 1998, 180).

Between AD 650 and 950, Aguada artisans expanded the range of portable objects with figurative elements; most were intended for use in rituals. Stone and clay continued to be used to fashion pipes for smoking hallucinogens and containers respectively; snuff trays were also produced from stone. Argentine scholars generally agree that Aguada style is the expression of a cult whose symbols and ritual practices varied locally but nevertheless exhibited a surprising stability and uniformity of iconographic conventions

Figure 19.10a. *Figure with Two Sceptres (red and black on cream) on an Aguada vessel. (Redrawn from González 1998, 170.)*

Figure 19.10b. *The Sacrificer, image from an incised vessel (Hualfín Grey Incised). (Redrawn from González 1998, 173.)*

across the region. The iconography emphasizes felines, anthropomorphic and zoomorphic forms, and fantastic beings (most part-human and part-animal). The images are complex and varied, appearing on a wide range of media and reflecting the skill of their artisans.

Aguada ceremonial centres were laid out in a U-shaped plan, with platform mounds facing onto public plazas. The best known of these centres, La Rinconada, found in the Valle de Ambato, has a platform mound standing 3 m tall (23 × 13 m in length and width) situated in front of a large plaza that opens to the west, measuring 75 m on a side. Ramps allowed access to the top of the mound, suggesting that rituals were performed in front of an audience gathered in the plaza. The recovery of fragmented human remains from these areas further suggests that sacrifice rituals depicted in the iconography took place at the site (González 1998, 40).

Aguada iconography indicates that ritual practices revolved around an elaborate feline-solar cult, involving ceremonies (including sacrifice) conducted by shamans or priests. The images on the pottery and other material culture depict distinct supernatural beings, who often hold or display axes or knives (Figs. 19.10a&b, 19.11, 19.12 & 19.13). A key debate centres on questions of the degree to which the violence depicted in iconography (warfare and sacrifice) was real or mythical.

Bronze plaques (Figs. 19.12 & 19.13), among the most elaborate of Aguada artefacts, are few in number but have been found throughout northwest Argentina, Bolivia, and Chile (González 1992). Plaques have holes for suspension by a cord and may have been worn as pectoral ornaments by officiants at rituals (Pérez Gollán 2000). The plaques also provide evidence that tunics with elaborate designs were worn by individuals, presumably those who played important roles in ritual practices. Unlike most other Aguada figurative objects, the plaques may have been widely traded as sumptuary goods.

Finally, anthropomorphic clay figurines are common in Aguada sites (Figs. 19.14a–c). Most are surface finds lacking good provenance information, and like the pottery, figurines vary widely in design from one valley to another.

Late Period
During the Late (or Regional Developments) Period, with population growth, larger regional polities emerged; these show clearer evidence of social ranking and leadership. The art and iconography of the Late Period was simpler and sparer than that of its Aguada predecessors, although continuity can be seen in some elements, as bronze plaques continued to be produced. Figurative representations can be seen in Figures 19.15 & 19.16 below, an urn and a plaque from the Calchaquí and Santa María Valleys, respectively.

The iconography of plaques was simplified; instead of supernatural beings, a single (severed?) head is often depicted, along with serpents or other animals.

Figure 19.11. *Severed head vessel, Ambato Black Incised. The face and head are covered with tattoos or painting.*

Along with the plaques, the societies of the Late Period are known for their infant burial urns. Many are figurative, painted or modelled with anthropomorphic features, while others are decorated with geometric and zoomorphic designs. Serpents and birds commonly appear on the painted urns, and decorative geometric elements usually fill all of the available space on the vessel. These urns, as well as plain-ware cooking pots containing infant or child remains, were buried under house floors, as revealed in recent excavations in the northern Calchaquí Valley (DeMarrais 2004) and in cemeteries. In many ways, daily life is better understood for the Santamariana and Belén cultures of the Late Period (AD 950 until the Inka conquest, c. 1460) than for the earlier periods.

While the double-headed serpents recall aspects of the fantastic, so prevalent in Aguada iconography (see Fig. 19.16), the easily recognizable personages of Aguada art are absent. Archaeologists, including Raffino (Raffino *et al.* 1979–82, 26), have noted continuity from Aguada to Santamariana and Belén iconography. At the same time, pipes, snuff trays, and other ritual paraphernalia are less common in archaeological sites, suggesting a decline in cult activity. At the same time, serving and 'libation' bowls appear more frequently, probably reflecting a shift to increased public feasting in place of cult activity.

Materiality and the uses of images

Most of the figurative material culture presented in this survey is portable, rather than fixed or monumental. Exceptions include the Tafí menhirs (Fig.

Figure 19.12. *Aguada bronze plaque showing a central personage flanked by two animals. There are holes for suspension in the headdress of the central figure. An axe hangs from the figure's arm, and his costume is decorated with geometric designs. This plaque was received as a donation (c. 1892) by the Museum of Archaeology & Anthropology in Cambridge (Z-2540); unfortunately its provenance is not known. It measures 12.3 × 10.9 cm. (Photo: G. Owen, copyright Cambridge University Museum of Archaeology and Anthropology, used with permission.)*

19.5) and large rock-art compositions. The frequent use of durable materials — stone, fired clay, and metal — further suggests that figurative objects were created to last (although perishable materials — especially textiles and wood — are likely to have displayed figurative designs). Stone was sculpted to create menhirs, pipes, and containers in the Early Period, frequently modelled in anthropomorphic or zoomorphic forms. Pottery is often equally elaborate (especially that of Condorhuasi). The use of stone declined in the Middle Period. Perhaps the shift from polished stone toward a wider reliance on fired clay and metal for symbolic objects during the Middle Period was a response to the demands of cult activity for complex and intricate iconography. Aguada artisans exploited both the plasticity of clay (for sculpting three-dimensional forms such as the severed head shown in Fig. 19.11) and its potential use as a canvas (Brody *et al.* 1983), whether painted (Fig. 19.10a) or incised (Fig. 19.10b). Anthropomorphic figurines fashioned from clay also became more common during the Middle Period.

Figure 19.13. *Aguada bronze plaque showing three figures wearing elaborate tunics. Two figures had heads protruding above the main plaque, now missing. The central figure is shown upside down. This plaque was donated (c. 1895) to the Museum of Archaeology & Anthropology in Cambridge (Z-2541); it may have been found with the plaque shown in Figure 19.12. The plaque measures 10.5 × 9.0 cm. (Photo: G. Owen, copyright Cambridge University Museum of Archaeology and Anthropology, used with permission.)*

The figurines in particular, are abundant; although their uses remain poorly understood, they provide information about clothing, hairstyles, adornments, and face-painting. Some show evidence of cranial deformation and lip or ear adornments. Figurines may be solid or hollow, clothed or naked. Some are shown standing, some sitting; others are kneeling. Males and females are represented, without overemphasis of sexual characteristics. Eyes and nose are modelled; arms are stumps or complete. Figures 19.14a–c show examples of Aguada figurines, which represent people, rather than fantastic beings or creatures.

The quotidian qualities of the figurines set them apart from much of the paraphernalia produced for ritual use. Solid figurines from Aguada sites, when identifiable as to gender, are more commonly female. One reasonable interpretation of the uses of the figurines has been advanced by González (1998), following Reichel-Dolmatoff (1964). Drawing upon ethnographic studies in Colombia, Reichel-Dolmatoff argued that figurines (depicting young and old, male and female, pregnant and not pregnant women, etc.) were used in healing ceremonies. The wide range of variation in the Aguada figurines, seen in hair styles, the presence of both males and females, as well as idiosyncrasies in other attributes, makes this a plausible interpretation, although difficult ultimately to prove.

Figurative images executed in perishable materials — especially textiles and wood — are probably under-represented in the archaeological record because they preserve poorly. Four fragments of cloth, recovered from tombs in the Atacama desert, depict Aguada figures carrying weapons or wearing feline headdresses (González 1998, 116–17). It is intriguing to consider whether textiles were used for decorative purposes or worn as costumes, perhaps by the officiants of rituals. If the depictions in the murals and iconography are taken at face value, then costumes as well as masks were common elements in rituals. Wooden objects, such as figurines, are also likely to be missing from the assemblage.

Most Aguada objects were not fashioned using exotic or imported raw materials; instead their value or visual interest derives primarily from the skill of the artisan and/or the fantastic character of the iconography. The use of hallucinogens as part of cult activity is apparent from the functions of many objects (pipes, tablets, tubes, snuff trays, and mortars). Although archaeological evidence from ritual settings or sites is limited, figurative cult paraphernalia has often been recovered from exceptional tombs. Drawing upon ethnographic parallels, it is possible to suggest that individuals buried with these objects were officiants at the rituals. Two additional lines of evidence point, albeit more indirectly, to ritual use of hallucinogens. The first is the diversity and number of hallucinogenic plants in the New World generally (Furst 1976; Reichel-Dolmatoff 1975; Schultes 1987; Ripinsky-Naxon 1989). The second is the suggestion that the imagination (or visions) that produced such fantastic beings must have been induced by use of hallucinogens (González 1998, 181).

Among the most elaborate of Aguada objects, the bronze plaques reveal an early local development of arsenic bronze technology (Lechtman 2003, 408). The plaques, found throughout northwest Argentina, Chile, and Bolivia, were possibly exchanged along with metal ores and seeds of cebil, a tree whose toasted seeds have psychoactive properties. This tree (*Anadenanthera colubrina*) grows in the eastern forests found close to Aguada territory. Angelo and Flores (ms.) argue that demand for hallucinogens intensified economic interaction, fostering social networks across areas of southern Bolivia and northern Argentina and Chile. Pérez Gollan (2000, 252) argues further that hallucinogens, as well as bronze, were strategic goods that could be controlled. Pastoralists, engaging in long-distance exchange, travelled with llama caravans from the puna (high-altitude pasture) areas

Figure 19.14. *a) Aguada figurine (height 19.5 cm) (Museo Adán Quiroga); b) Aguada figurine (Museo Adán Quiroga); c) Aguada figurine with face painting (Museo Nacional, Buenos Aires.)*

of northwest Argentina, Chile, and Bolivia to lower elevations. The caravans, carrying salt, textiles, metal objects, and cebil, crossed zones rich in ore sources (Nuñez 1987; Lechtman 2003). Albeck (2002), citing evidence of Aguada and Tiwanaku materials in the oasis of San Pedro de Atacama in northern Chile, suggests that Tiwanaku influence on Aguada was indirect, channelled through long-distance contacts. Most puna regions of northwest Argentina lack direct evidence of Tiwanaku influence. Nevertheless, it seems reasonable to suggest that while these long-distance contacts involved primarily the exchange of material goods, they also created the conditions for an increased flow of ideas, iconographic styles, and even aspects of ritual practice.

Iconography

Early Period iconography provides hints of the feline cult, with its emphasis on zoomorphic images, and the skill of some artisans is remarkable. Nevertheless, Argentine scholars associate the Middle Period (AD 650–900) with a jump in the complexity, diversity, and elaborateness of iconography. Recurring figures in Aguada iconography include the Sacrificer (Fig. 19.10b) and the figure with Two Sceptres (Fig. 19.10a) (both usually found on incised or painted pottery) and the figure with the Empty Hands, who appears on plaques (Fig. 19.12). The Sacrificer carries an axe or a knife and sometimes a severed head or an infant to be sacrificed. The Sacrificer image is shown on pottery, metal plaques, and in rock art; the 'El Diablo' petroglyph (Fig. 19.17) from the northern Calchaquí Valley (discussed below), depicts an individual wearing a feline mask and skin, carrying an infant for sacrifice. This large and dramatic scene is unusual, as it occurs in a region in which Aguada material culture is not widespread.

The figure with Two Sceptres resembles the Tiwanaku front-facing deity; further Tiwanaku influence is inferred from depictions of severed heads and of figures wearing feline masks. Human figures are usually depicted standing and frontal with an emphasis on the vertical; in contrast, felines are shown in profile, usually in action, with an emphasis on the horizontal axis (Kusch *et al.* 1994).

Another figure, the 'personage with the prominent nose' has a long history in south Andean iconography. Appearing in both Ciénaga and Condorhuasi, this individual re-appears in Aguada imagery, as well as on textiles from Tiwanaku. Particularly common in stone sculpture (vessels and pipes), some variants resemble a bird's beak more than a prominent nose. González (1998) interprets the exaggerated nose as a reference to its role in the inhalation of hallucinogenic substances. While cebil could be taken in various ways, ethnographic and archaeological evidence suggests that inhalation (using tubes or tablets) or smoking in pipes were common methods (Pérez Gollan 2000, 240–41).

Figure 19.15. *Infant funerary urn from the Calchaquí Valley. (Photo: G. Russell.)*

Figure 19.16. *Bronze plaque from Santa María Valley. (Museo Nacional de Bellas Artes, Buenos Aires.)*

More generally, the proliferation of fantastic forms in Aguada iconography accords with Dissanayake's (1995, 46) proposition that art and ritual are '... deliberately non-ordinary'. Iconography associated with religious ideology or cult activity may not be intended to be comprehended straightforwardly, because the emotional impact depends upon esoteric elements and mystery. As Sperber argues,

> the most evocative representations are those which, on the one hand, are closely related to the subject's other mental representations, and, on the other hand, can never be given a final interpretation. It is these relevant mysteries, as they could be described, which are culturally successful ... (Sperber 1985, 85).

In an analysis of the complex and intricate Chavín iconography of the north and central Andes, Burger (1992, 148) has argued that the art may not be meant to communicate equally to all members of an audience. Esoteric designs, understood only by those initiated into the cult, may allow those who direct ritual or have access to knowledge to maintain positions of power or authority over others. Certainly the Aguada representations lend themselves to interpretations that emphasize control, display, or manipulation through mysterious or esoteric knowledge.

With the decline of Aguada, the Late Period cultures (e.g. Santamariana and Belén) emerged, marked by larger, more hierarchical polities and a decline in paraphernalia for the use of hallucinogens. The Late Period is seen by some (Tarragó 1989) as a time of 'impoverishment' both in iconography and also in the production and consumption of wealth. There is limited evidence, for example, for centrally-administered exchange in goods such as obsidian throughout northwest Argentina (Yacobaccio *et al.* 2002, 174); instead, most exchange was organized around personal relationships. The collapse of Tiwanaku at the end of the mid-twelfth century AD may also have contributed to a decline in long-distance exchange and related cult activity.

Violence in Aguada iconography
Warfare, weapons, and suggestions of sacrifice feature prominently in Aguada iconography. In the past, figures with weapons were seen as warriors, although more recently they have been interpreted as 'deities' (González 1998, 138; Pérez Gollan 2002). The extent of conflict (actual or ritualized) amongst Aguada groups (or between Aguada groups and their neighbours) is unclear. If the Sacrificer, shown immolating human victims (both adults and children) was an officiant at sacrifice rituals, then it might be the case that ritual and civic power resided in a single individual, with that individual leading the group in ritual as well as during times of conflict. Yet if the Sacrificer were a

supernatural or mythical being and the violence largely symbolic, idealized, or rare in its occurrence, a different view of Aguada society emerges.

Effigy vessels, such as the one shown in Figure 19.11, are interpreted as severed heads, their faces decorated with tattoos or other face painting. Elsewhere in the Andes, the curation of severed heads has links to warfare but also to ancestor worship. Both Nasca (c. AD 1–700) on Peru's south coast and Tiwanaku peoples curated 'trophy heads' and depicted these practices in their iconographies. Archaeologists debate whether the heads were trophies taken in warfare or the curated remains of ancestors. DeLeonardis & Lau (2004), in a recent comparative study, argue that while head-taking rituals were linked to ideology and competition for power, they also '... served to promote social cohesion and kinship ties' (2004, 77). They argue that the '... portability and accessibility of ancestors guaranteed that they could be revisited, handled, and revered well past the time of physical death' (2004, 79). Nasca mummification of trophy heads may well have emphasized ancestor veneration rather than (or in addition to) warfare (Silverman 1993, 221). The heads are 'profusely illustrated' in the visual imagery of Nasca, alongside human figures holding weapons and San Pedro cactus (a psychotropic agent).

While Nasca lies some distance from the Aguada region, the influence of Tiwanaku on Aguada iconography is well-accepted. González (1998) believes that the feline cult arrived from the altiplano (from routes through San Pedro de Atacama), brought by local or foreign shamans. Tiwanaku iconography exhibits stylized trophy heads, thought to reflect heads taken in warfare for ritual display of vanquished foes, as well as ancestor worship. Janusek (2003, 78–9) alludes to a:

> ... generalized emphasis on heads — whether human, ancestral, or divine — as the embodiment of religious power and identity. Both ceramic iconography and human remains ... indicated that heads and faces (or masks) were considered important loci of religious power and social identity.

While Tiwanaku and Aguada differ in their scale and socio-political organization, the thematic similarities in the respective iconographies are nevertheless apparent.

Figure 19.17. *The 'El Diablo' petroglyph. The panel is large, covering several square metres of a rock outcrop. (Photograph (by the author) of a drawing in the Museo Arqueológico de Cachi, made by P. P. Díaz, R. Moya, and D. Salvatierra.)*

To return to the question of violence in Aguada iconography, it is notable that only rare images depict warriors engaged in combat (González 1998, 194), although the Sacrificer appears frequently. González (1998, 180) argues that the Sacrificer's weapons are not the sort that would be useful in warfare, noting further that fortifications are not present at Aguada sites. At the same time, finds of fragmented human remains in public spaces within ceremonial sites (e.g. La Rinconada), as well as the layouts of public sectors, have led González and others to conclude that some sacrifice (perhaps of infants) did occur. Nuñez-Regueiro (1993), again citing evidence of human remains, suggests that sacrifice occurred in Condorhuasi sites and that the practice continued into Aguada times. Some individuals were buried with decorated metal axes, suggestive but inconclusive evidence that they were Sacrificers in life.

Some researchers also cite the frequency of severed heads in the iconography as evidence that Aguada sacrifice rituals took place regularly. As outlined above, however, this argument is inconclusive. Severed heads depicted in the iconography may instead be references to trophies taken in warfare, or perhaps to ancestors. The resolution of these questions awaits the recovery of more detailed contextual evidence.

Chapter 19

Figure 19.18. *Cave-painting 'Dance of the Suris'. The original is crudely executed in white pigment on a dark background. (Redrawn from an image in González 1998, 179; see also Gudemos 1992–94, fig. 11.)*

Gender

Proportions of female and male representations changed from the Early Period to the Middle Period. González (1998, 161), examining modelled figurines and pottery appearing in tombs, observes a decline in the prevalence of female images from Condorhuasi to Aguada. The prominence of males as central figures has been noted, although rare examples of paired panels suggest dual male and female personages, possibly reflecting the conceptions of gender complementarity that characterize many Andean societies.

Males were privileged in Aguada iconography, as in other figurative traditions in the Andes (DeLeonardis & Lau 2004, 86). Individual males are usually shown accompanied by ancillary figures; the central figure is distinguished by central location and size, often wearing an elaborate costume and carrying accoutrements including weapons. Perhaps (and again tentatively) the iconography depicts officiants or shamans; the ritual arena may have been controlled by males. While depictions of multiple individuals are rare, one example, the 'Dance of the Suris' cave painting (discussed below) clearly shows that participants are male. The violence in Aguada art may further suggest an association of ritual with (male) warriors.

Because the iconography on the plaques is distinct from that found on the pottery, González (1998) considers whether these contrasting media reflect the differential involvement of male (metallurgy) versus female (pottery) artisans and their different concerns and access to ritual knowledge. As suggested earlier, bronze objects may have been sumptuary goods, produced by males, traded widely, and controlled by ritual specialists. While these are intriguing possibilities, they await confirmation through further excavation.

Narrative scenes versus isolated figures

Aguada iconography usually emphasizes individuals, sometimes accompanied by ancillary figures. Occasionally paired figures appear, while scenes with multiple figures are rarer. Some rock-art murals depict collective activities, possibly dances or rituals. One example, a cave painting entitled 'Dance of the Suris (Ostriches),' is located in the Cueva de la Salamanca, Catamarca (Gudemos 1992–94). This image (Fig. 19.18), fairly crudely executed in white pigment, is dated stylistically by reference to the representation of a feline with a collar ending in a circle (and absolutely dated by Boschín *et al*. 1999). The feline occupies the central upper portion of the image. A grotesque severed animal head lies at the bottom of the image. In the centre is a line of 14 dancers, all males with erect penises; their curved postures and bent knees suggesting movement. Some dancers hold objects. A figure on the left side plays a drum; below lies an animal body and a figure carrying a curved object. Below the dancers stands a large figure holding a

walking stick; this figure also holds a curved object. To the right are eleven little ostriches accompanied by a larger ostrich, presumably the mother. To the right of the flock is another human being, seated and holding both a stick and a curved object, perhaps helping to control the birds.

The scene is unusual in showing people (and animals) engaged in ritual. The ostrich was an important food source for Aguada people, so perhaps the image refers to a fertility or hunting ritual. González (1998) also suggests that use of hallucinogens with an aphrodisiac action is suggested by the line of males with erect penises. Ethnographic studies by Reichel-Dolmatoff (1978) indicate that some hallucinogens have aphrodisiac effects.

Other images in the same cave include several depictions of the Sacrificer. Another scene that represents multiple individuals is the 'El Diablo' petroglyph in the northern Calchaquí Valley (Fig. 19.17) mentioned earlier, interpreted as an individual in a feline mask carrying an infant, possibly for sacrifice.

Conclusions

The high quality of Condorhuasi pottery and Ciénaga stonework suggests the presence of specialized artisans and incipient forms of social differentiation. Hints of a feline cult appear in the Early Period and are elaborated in Aguada times. The richness of Aguada iconography, including the personages who appear on pottery and plaques, as well as rarer scenes depicting ritual, raise intriguing questions for understanding the uses of figurative images. Did cave paintings and petroglyphs, such as Dance of the Suris and El Diablo, depict actual ritual practices, or did they represent imagined, idealized, or mythical activities? If the fantastic beings (part-human and part-feline) were mythical, then was the Sacrificer (and his activities) also an idealized or a mythical being?

The available archaeological evidence suggests that ritual was widespread, that some individuals acted as officiants in rituals, and, more tentatively, that sacrifices took place. At the same time, the proliferation of paraphernalia for cult activities in Aguada times, richly decorated with figurative images, suggests frequent use of hallucinogens as part of ritual practices. Yet both iconography and pottery styles vary in their local expressions, to the extent that the relative stability and uniformity of the Aguada tradition (e.g. the Sacrificer and the figure with Two Sceptres) across the region is surprising.

In some areas of northwest Argentina (the northern Calchaquí Valley and parts of the Santa María Valley), Aguada material culture and iconography are scarce. If archaeologists look to long-distance interaction with Tiwanaku and other altiplano cultures to explain the stability and longevity of the Aguada symbolic and ritual tradition, we should also acknowledge that these influences (as ideas, iconographic conventions, ritual practices, or material culture) were rarely uniform. The evidence from northwest Argentina clearly indicates that some local groups were more interested than others in acquiring cult objects or adopting new forms of ritual practice. Those groups who adopted elements of Tiwanaku iconography or material culture also adapted it to their local circumstances and traditions, creating the wide variation observed in Aguada pottery styles across the region. Despite such differential influence, the broader Aguada figurative tradition nevertheless achieved a widespread distribution throughout northwest Argentina.

More generally, the character of figurative representation changed in its emphases over the long-term. González (1998, 218) characterizes the transition from Ciénaga to Aguada as a shift from a 'profane' to a 'sacred' art; the shift from a 'decorative' style in the Early Period to one richer in symbolic content during Aguada times was noted earlier. From their earliest stages, stone sculpture and pottery emphasized anthropomorphic and zoomorphic figuration. A key difference between Early Period cultures and Middle Period Aguada is the greater regional coherence and consistency of Aguada symbolism, visible in the recurring use of identifiable personages and other motifs (González 1974, 124; 1998, 155). Aguada artisans introduced depictions of violence, fantastic beings, and individuals in showy dress, while elaborating the cult of the feline in association with the 'solar being'.

The elaboration of figuration in northwest Argentina was arguably a crucial aspect of shamanic activity. Objects with figurative elements (mortars, pipes, snuff trays) were used — not simply displayed — in rituals. A key element of this figurative tradition was intertwined more with practices — involving engagement with portable and functional objects — than with passive viewing of static displays. Elaborate figurative decoration may have served to heighten interest among viewers or participants in cult activities, while at the same time expressing themes relevant to the shaman's transformation or experiences. While archaeologists often remark on the ways that the scale of an image influences its impact on an audience, virtuosity or skill such as that displayed by Early and Middle Period artisans can similarly enhance the visual and affective experience of viewers.

The materiality of different objects similarly influenced their potential for expressing aspects of

ritual or shamanic experience. The widespread preference for stone in the Early Period suggests that objects were being made to last. The shift in emphasis toward use of pottery, both modelled and painted, during Aguada times, suggests a demand for greater flexibility and intricacy in figuration practices. The violence of Aguada iconography is notable, but sadly we are not yet in a position to comment on the degree to which these vivid images reflected actions in real life.

In the absence of more concrete data, it is tempting to attribute the decline in the complexity of figuration during the Late Period to the disappearance of the Tiwanaku state from the Bolivian altiplano. At the same time, such reasoning ignores factors internal to northwest Argentina, such as the introduction of new, more productive strains of maize and subsequent population growth, or the possibility that increased conflict fostered opportunities for leadership during the Late Period. It is possible that the authority of ritual leaders or shamans gradually gave way to that of political leaders, as the need for defence provided incentives for nucleation into larger settlements under more hierarchical forms of leadership. Whatever the causes of political changes, a marked decline can be observed in the complexity of figurative material culture during the Late Period.

Finally, the long-term trend, first toward elaboration and then the subsequent simplification of visual material culture in northwest Argentina, helps to challenge assumptions about the link between increasingly hierarchical socio-political organization and the elaboration of iconography and craft production. In this region, the elaboration of figurative material culture was probably more a response to the demands of ritual than it was a direct consequence of increasing political competition.

Acknowledgements

I wish to thank the members of the organizing committee for the invitation to participate in this symposium. I thank Iain Morley for his editorial efforts, and Christine Hastorf for a helpful discussion about south Andean exchange networks. Kevin Lane kindly commented upon an earlier draft. William Spring produced the drawings.

Notes

1. Some early expeditions, such as those of Muñiz Barreto (1922–1930), were conducted systematically and carefully, often excavating extensively in cemeteries. Unfortunately, much of this work remains unpublished.
2. The appropriateness of the term 'shaman' for interpretation in archaeology is currently debated (Klein *et al.* 2002). In the absence of detailed archaeological evidence, I use the term shaman in its general sense (following Van Pool 2002, 40) to designate 'a religious practitioner who serves as an intermediary between the natural and supernatural worlds. The shaman, usually male, commonly experiences three phases in his spiritual journey. First, he prepares to leave this world by entering a trance, often through the use of psychoactive plants, self-mutilation, sleep deprivation, ritual dancing, or fasting. In this state, he travels to the supernatural realm. During his flight, the shaman is protected by animal spirits from the dangers inherent in interacting with the spirit world, and often metamorphoses into the totem animal he represents. Once in the spirit world, he communes with supernatural beings, bringing gifts and prayers from his people, and gaining knowledge or assistance in healing, divination, successful hunts, or weather management'.
3. Condorhuasi is also referred to as Condorhuasi-Alamito.
4. Hallucinogens included cebil (vilca), tobacco, and San Pedro (Trichocereus pachanoi) among others (Pérez Gollán 2000, 249; Angelo & Flores ms.).
5. Population estimates for these regional polities range from the low thousands to several tens of thousands.
6. Some argue that vessels such as the one shown in Figure 19.10b were containers for burying sacrificed victims, although as far as I know this interpretation has not yet been substantiated through evidence from excavation.
7. 'Cut and polished skulls have been found in excavations at Tiwanaku, leaving little doubt that the practice of taking heads in battle was a central symbolic element of warfare and ritual sacrifice. The testimony of state-art indicates that the elite of Tiwanaku were obsessed with decapitation and the ritual display of severed heads' (Kolata & Sangines 1992, 331–2).

References

Albeck, M., 2002. La puna Argentina en los períodos medio y tardío, in *Historia Argentina Prehispánica*, eds. E. Berberían & A. Nielsen. Buenos Aires: Editorial Brujas, 347–88.

Boschín, M., R. Hedges & A.-M. Llamazares, 1999. Dataciones absolutas de arte rupestre de la Argentina. *Ciencia Hoy* 9(50), 54–65.

Boschín, M. & A.-M. Llamazares, 1996. La datacion absoluta del arte rupestre. *Ciencia Hoy* 6(34), 14–20.

Bradley, R., 2004. Domestication, sedentism, property, and time: materiality and the beginnings of agriculture in northern Europe, in *Rethinking Materiality*, eds. E. DeMarrais, C. Gosden & C. Renfrew. (McDonald Istitute Monographs.) Cambridge: McDonald Institute for Archaeological Research, 107–16.

Brandt, E., 1977. The role of secrecy in a Pueblo society, in *Flowers of the Wind: Papers on Ritual, Myth and Symbolism in California and the Southwest*, ed. T. Blackburn. (Anthropological Paper 8.) Socorro (TX): Ballena Press, 11–28.

Brody, J., C. Scott & S. LeBlanc, 1983. *Mimbres Pottery*. New York (NY): Hudson Hills Press.

Burger, R., 1992. *Chavín and the Origins of Andean Civilization*. London: Thames & Hudson.

Clark, J., 2004. The birth of Mesoamerican metaphysics: sedentism, engagement and moral superiority, in *Rethinking Materiality*, eds. E. DeMarrais, C. Gosden & C. Renfrew. (McDonald Institute Monographs.) Cambridge: McDonald Institute for Archaeological Research, 205–24.

DeLeonardis, L. & G. Lau, 2004. Life, death, and ancestors, in *Andean Archaeology*, ed. H. Silverman. Oxford: Blackwell, 77–115.

DeMarrais, E., 2004. The materialization of culture, in *Rethinking Materiality*, eds. E. DeMarrais, C. Gosden & C. Renfrew. (McDonald Institue Monographs.) Cambridge: McDonald Institute for Archaeological Research, 11–22.

DeMarrais, E., C. Gosden & C. Renfrew (eds.), 2004. *Rethinking Materiality*. (McDonald Institute Monographs.) Cambridge: McDonald Institute for Archaeological Research.

Dissanayake, E., 1995. *Homo Aestheticus*. Seattle (WA): University of Washington Press.

Furst, P., 1976. *Hallucinogens and Culture*. San Francisco (CA): Chandler & Sharp.

Gell, A., 1998. *Art and Agency*. Oxford: Oxford University Press.

González, A.R., 1974. *Arte, Estructura y Arqueología: Análisis de Figura Duales y Anatrópicas del N.O. Argentino*. Buenos Aires: Nueva Visión, Colección Fichas.

González, A.R., 1992. *Las placas metálicas de los Andes del Sur: AVA-Materialien 46*. (Comisión fur Allgemeine und Vergleichende Archaologie des Deutschen Archaologicshen Instituts.) Mainz am Rhein: Verlag Phillipp von Zabern.

González, A.R., 1998. *Cultura La Aguada: Arqueología y diseños*. Buenos Aires: Filmediciones Valero.

González, A.R. & J. Pérez, 1990. *Historia Argentina: Argentina Indígena, Vísperas de la Conquista*. Buenos Aires: Paídos.

Gudemos, M., 1992–94. *Consideraciones Sobre Música Ritual en la Cultural la Aguada*. (Publicaciones de Arqueología 47.) Cordoba: CIFFyH, Universidad Nacional de Cordoba.

Hedges, R.E.M., C.B. Ramsey, G.J van Klinken, *et al.*, 1998. Methodological issues in the 14c dating of rock paintings. *Radiocarbon* 40(1), 35–44.

Helms, M., 1993. *Craft and the Kingly Ideal*. Austin (TX): University of Texas Press.

Hodder, I., 1982. *Symbols in Action*. Cambridge: Cambridge University Press.

Janusek, J., 2003. Vessels, time, and society: toward a ceramic chronology in the Tiwanaku heartland, in *Tiwanaku and its Hinterland*, vol. II, ed. A. Kolata. Washington (DC): Smithsonian Press, 30–94.

Klein, C., E. Guzman, E. Mandell & M. Stanfield-Mazzi, 2002. The role of shamanism in Mesoamerican art: a reassessment. *Current Anthropology* 43(3), 383–420.

Kolata, A. & C. Ponce Sanginés, 1992. Tiwanaku: the city at the center, in *The Ancient Americas: Art from Sacred Landscapes*, ed. R. Townsend. Chicago (IL): Art Institute of Chicago, 317–34.

Kolata, A. (ed.), 2003. *Tiwanaku and its Hinterland*, vol. II. Washington (DC): Smithsonian Press.

Kusch, M.F., 1994. *Investigaciones Arqueológicas en la Localidad de Bañados del Pantano, La Rioja*. (Resumenes expandidos del XI Congreso Nacional de Arqueología Argentina, 2da.) San Rafael, Mendoza: Parte.

Lechtman, H., 2003. Tiwanaku period (Middle Horizon) bronze metallurgy in the Lake Titicaca Basin: a preliminary assessment, in *Tiwanaku and its Hinterland*, vol. II, ed. A. Kolata. Washington (DC): Smithsonian Press, 404–34.

Mithen, S. (ed.), 1998. *Creativity in Human Evolution and Prehistory*. London: Routledge.

Museo Chileno de Arte Precolombino, 1994. *La Cordillera de los Andes: Ruta de Encuentros*. Santiago: Banco O'Higgins.

Nuñez, L., 1987. Tráfico de metales en el area centro-sur Andina: factos y expectativas. *Cuadernos del Instituto Nacional de Antropología, Chile* 12, 73–105.

Nuñez-Regueiro, V., 1993. Análisis del tránsito del Formativo Inferior al Medio. Unpublished doctoral dissertation, Universidad Nacional de Rosario, Argentina.

Olivera, D.E., 2002. Sociedades agro-pastoriles tempranas: el formativo inferior del noroeste argentino, in *Historia Argentina Prehispánica*, eds. E. Berberían & A. Nielsen. Buenos Aires: Editorial Brujas, 83–125.

Pérez Gollán, J.A., 2000. El jaguar en llamas (la religión en el antiguo noroeste Argentino), in *Nueva historia Argentina, tomo 1: Los pueblos originarios y la conquista*, ed. M.N. Tarragó. Buenos Aires: Editorial Sudamericana, 229–56.

Raffino, R., G. Raviña, L. Baldini & A. Iacona, 1979–82. La expansión septentrional de la Cultura La Aguada en el N.O.A. *Actas del C.I.N.A.* 9 (Buenos Aires), 179–82.

Reichel-Dolmatoff, G., 1964. Anthropomorphic figurines from Colombia: their art and magic, in *Essays in Precolombian Art and Archaeology*, ed. S. Lothrop. Cambridge (MA): Harvard University Press.

Reichel-Dolmatoff, G., 1975. *The Shaman and the Jaguar: a Study of Narcotic Drugs among the Indians of Colombia*. Philadelphia (PA): Temple University Press.

Reichel-Dolmatoff, G., 1978. *Beyond the Milky Way: Hallucinatory Imagery of the Tukano Indians*. (UCLA Latin American Center Publication No. 42.) Los Angeles (CA): UCLA Latin American Center.

Renfrew, C., 1994. The archaeology of religion, in *The Ancient Mind: Elements of Cognitive Archaeology*, eds. C. Renfrew & E. Zubrow. Cambridge: Cambridge University Press, 47–54.

Renfrew, C., 2001. Symbol before concept: material engagement and the early development of society, in *Archaeological Theory Today*, ed. I. Hodder. Cambridge: Polity Press, 98–121.

Renfrew, C., 2004. Towards a theory of material engagement, in *Rethinking Materiality*, eds. E. DeMarrais, C. Gosden & C. Renfrew. (McDonald Institute Monographs.) Cambridge: McDonald Institute for Archaeological Research, 23–32.

Ripinsky-Naxon, M., 1989. Hallucinogens, shamanism, and the cultural process: symbolic archaeology and dialectics. *Anthropos* 84, 219–24.

Robb, J., 2004. The extended artefact and the monumental economy: a methodology for material agency, in *Rethinking Materiality*, eds. E. DeMarrais, C. Gosden & C. Renfrew. (McDonald Institute Monographs.) Cambridge: McDonald Institute for Archaeological Research, 131–40.

Rossi, J.J., 2003. *Diseños nativos de la Argentina*. 2nd edition. Buenos Aires: Galerna-Búsqueda de Ayllu.

Schultes, R., 1987. Antiquity of use of New World hallucinogens. *Archaeomaterials* 2(1), 59–72.

Silverman, H., 1993. *Cahuachi in the Ancient Nasca world*. Iowa City (IA): University of Iowa Press.

Sperber, D., 1985. Anthropology and psychology: towards an epidemiology of representations. *Man (N.S.)* 20, 73–89.

Spielmann, K., 2002. Feasting, craft specialization, and the ritual mode of production in small-scale societies. *American Anthropologist* 104(1), 195–207.

Tartusi, M. & V. Núñez-Regueiro, 2002. Fenómenos culticos tempranos en la subregion valliserrana, in *Historia Argentina Prehispánica*, eds. E. Berberían & A. Nielsen. Buenos Aires: Editorial Brujas, 127–70.

Tarragó, M., 1989. Contribución al Conocimiento Arqueológico de las Poblaciones de los Oasis de San Pedro de Atacama en Relación con los otros Pueblos Puneños, en especial, el Secor Septentironal del Valle Calchaquí. Unpublished doctoral thesis, Universidad Nacional de Rosario, Argentina.

Van Pool, C., 2002. Flight of the shaman: exquisite painted pots from the Casas Grandes region depict journeys to the spirit world. *Archaeology* 55(1), 40–43.

Yacobaccio, H., P. Escola, M. Lazzari & F Pereyra, 2002. Long distance obsidian traffic in northwestern Argentina, in *Geochemical Evidence for Long Distance Exchange*, ed. M. Glascock. Westport (CT): Greenwood Press, 167–203.

Chapter 20

Early Figurations in China: Ideological, Social and Ecological Implications

Li Liu

The earliest figurations in China appeared almost simultaneously in the northeast and central areas of the country during the sixth millennium BC, when both regions experienced early sedentism and incipient agriculture (mainly millet). In south China figurations occurred around the fifth millennium BC when rice domestication was already well established. The early finds, dated to before the third millennium BC, tend to concentrate in three regions: the Liao River, the lower Yangtze River, and the middle and upper Yellow River (Komoto & Imamura 1998; Yang 1988; 2000).

In order to understand symbolic expression of ancient people, we need to take into account both social organization and the natural environment which form the material matrix of ideology (cf. Bar-Yosef 1997). In this paper I will investigate early human and animal figurations; the examples used include three-dimensional figurines and two-dimensional images on artefacts dated to c. 6000–3000 BC in these three regions (Fig. 20.1). In some cases material from the third millennium BC will also be mentioned in order to describe the continuity of cultural elements.

The Liao River region

The Liao River valley is an area situated between the traditional agricultural regions of the south and the pastoral steppes of the north. Most figurations from this region date to three successive archaeological cultures: Xinglongwa (c. 6200–5200 BC), Zhaobaogou (c. 5200–4500 BC), and Hongshan (c. 4500–3000 BC).

When the earliest figurations appeared in the Xinglongwa culture it was the beginning of the Holocene climatic optimum. Incipient millet domestication was likely underway, at least at some settlements, although faunal remains and tools indicate that hunting and gathering played dominant roles. Settlements up to 2 ha in size with well-arranged and closely spaced houses also indicate increases in population density and family size. During the Zhaobaogou culture agriculture together with hunting and gathering continued to dominate subsistence economy. The Hongshan culture witnessed the first episode of agricultural intensification in the region, characterized by domestication of pig, sheep/goat, and millet. Settlements increase dramatically in number and size, and societies were clearly stratified (Li 2003; Linduff et al. 2002–2004).

Figurations
Two Xinglongwa culture sites, Xinglonggou in Chifeng (c. 6000–5500 BC) and Baiyinchanghan in Xilin (c. 5200–5000 BC), both in Inner Mongolia, reveal the earliest figurations, including both humans and animals (Inner Mongolia Institute 2004; Liu 2002; Liu et al. 2003). A clay figurine (5.2 cm in height), unearthed from an ash pit at Xinglonggou, depicts three squatting human figures hugging each other, which were identified as females based on their obese body shape (Fig. 20.2, no. 1). A stone human figurine (35.5 cm in height) was discovered *in situ* having been inserted into a house floor near the hearth at Baiyinchanghan. It is interpreted as a female adult, primarily based on its convex abdomen (Fig. 20.2, no. 2). Facemasks, made of shell, stone and human skullcap, have been found in houses at both sites (Fig. 20.2, nos. 3–5). Several burials at Baiyinchanghan have yielded stone and jade ornaments, including a jade cicada and stone bear head. These are the earliest jade/stone figurations so far discovered in China.

During the Zhaobaogou period figurations increased in number. The most interesting finds are from Houtaizi in Luanping county, Hebei province. Seven stone sculptures, unearthed from a residential site, include six adult females, as indicated by either primary or secondary female characteristics (breasts, protruding abdomen, and female genitalia), and one infant (Chengde District 1994). This group of figurines appears to depict the process of pregnancy and childbirth. Different stages of pregnancy are indicated by various sizes of abdomen, and the process of giving

Figure 20.1. *Location of archaeological cultures and major sites discussed in the text: I) Xinglongwa, Zhaobaogou, and Hongshan cultures; II) Peiligang culture; III) Yangshao culture; IV) Majiayao culture; V) Hemudu culture; VI) Majiabang and Liangzhu cultures; VII) Lingjiatan.*

birth is shown by the adult figurines with concave abdomens and enlarged genital areas, as well as by the infant figurine (Fig. 20.2, nos. 6–9) (Wang 1997). Small clay human facemasks were found at Zhaobaogou (Institute of Archaeology 1997, 95), a continuation of a tradition from the Xinglongwa period. Animal figurations also occurred in this period. *Zun* vessels from several sites bear complex zoomorphic motifs, including deer, boar and bird, all depicted with wings (Fig. 20.2, no. 10) (Li 2003, 111–18).

The Hongshan culture witnessed the flourish of figurations in this region. The most important discoveries of human and animal figurines are from Niuheliang in Lingyuan and Dongshanzui in Kezuo, both in Liaoning province and dated to the late Hongshan period (*c.* 3500–3000 BC). Niuheliang refers to a cluster of sixteen major ritual sites, each composed of cairns, altars, or other monumental architecture, spread over a mountainous area of 50 sq. km, and forming a spectacular ritual landscape. Within this area no residential site has been located. The best-known site is the Goddess Temple, which is situated on a mountaintop at the central location of the Nuheliang area. It is composed of two semi-subterranean structures, one large (18.4 m long and 6.9 m wide) and one small. These two structures yielded a number of human and animal clay sculptures. The fragments — of hand, ear, shoulder, arm, breast, and other parts of the human body — belong to seven individuals; only female characteristics (such as breasts) can be identified, leading to the appellation 'Goddess Temple'. However, it is unclear if all seven human sculptures there were representations of females. The human sculptures were made in various scales as suggested by the three sizes of ears found, which range from life-size to three-times life-size. A life-sized human facemask, whose eye sockets were inserted with green jade balls, is an unprecedented find (Fig. 20.2, no. 11). Animal figures include bird claws and fragments of pig-dragon, including a jaw and a head connected to part of its body. Small clay human figurines (Fig. 20.2, no. 12) have been found in burials and pits near the ritual structures (Liaoning Institute 1986; 1997)

The cairns were built in round and square shapes, many containing elite burials. These burials have yielded a large number of jade objects, including human and animal figurines. A jade human figurine (18.5 cm in height) has been found near the pelvic area of the human skeleton in the largest burial at Locality XVI. It is portrayed in a standing position with arms folded in toward the chest, but its gender is unidentifiable (National Bureau 2003) (Fig. 20.2, no. 13). Jade animals are much greater in number and form than the previous periods, including turtle, bird (mainly owl), dragon, and pig-dragon (Fig. 20.2, nos. 14–17).

Implications

From a temporal perspective, the figurations in their early stage were small in size and only associated with domestic features; but they later increased in size dramatically, and became important components of public ritual structures. Female figurations and facemasks are a unique cultural/ritual tradition of this region. The decline of the Hongshan culture marked the end of this complex of figurations associated with ritual landscapes, a tradition which was never paralleled by any other Neolithic cultures in China.

These changes in figuration were closely related to the ecological and social transformations in the region. At the beginning of the Neolithic period, the Xinglongwa people must have experienced significant

Early Figurations in China

Figure 20.2. *Figurations from the Liao River region: 1–5) Xinglongwa culture; 6–10) Zhaobaogou culture; 11–17) Hongshan culture (not to scale except 6–9). (Modified from Chengde District 1994; Inner Mongolia Institute 2004; Liaoning Institute 1986; 1997; Li 2003; Liu 2002; Liu et al. 2003; National Bureau 2003.)*

social, political and economic changes. These may have included territorial control, competition for resources, and inter- and intra-community relationships. In these early villages households seem to have been the central focus of ritual, as suggested by indoor burials and figurations placed inside houses. The anthropomorphic figurations and ornaments, found inside or near residential structures, probably were used as paraphernalia in household rituals (Li 2003). It is unclear whether these figurations represent deities, ancestors, or both, but such ritual activities centred on the household may have been a social response to scalar and economic stresses at the time.

The group of figurines unearthed from Houtaizi, demonstrating the event of pregnancy and childbirth, may have been related to fertility rites. Given that the figurines were made of stone rather than clay, certain amount of craft skill and labour were invested in making these artefacts. These objects were thus likely used for recurrent ritual performances, which may have been held by ritual practitioners. Ritual activities associated with female figurines reached a peak during the Hongshan period, exemplified by those large sculptures and small figurines unearthed from major ritual sites at Niuheliang.

Female sculptures and figurines from the Liao River region have received much attention from archaeologists, and most scholars believe that these small figurines generally reflect a belief in female power associated with reproduction of humans and the land, while the large sculptures in the Goddess Temple may have related to the worship of female ancestors or deities (e.g. Chen 1990). It may be sometimes difficult to separate these two functions, which ultimately reveal people's world-view concerning the sources of fertility derived from the interactions between the human, natural, and supernatural domains.

These artistic and ritual expressions focusing on female fertility were accompanied by other social developments. These included the rise of elite groups, production of prestige items such as jade, and construction of large public monuments associated with collective ritual activities, particularly in the Hongshan culture. It is notable that the skeletons found in elite burials at Niuheliang include both male and female, although the occupant in the most elaborate tomb belongs to a male (National Bureau 2003). It seems that female iconography was not necessarily related to matriarchy as some archaeologists previously assumed (see discussion by Nelson 1991). However, given that some female burials were well furnished, some women's social and ritual statuses may have been relatively equal to those of men in the Hongshan culture.

When animal iconographies first occurred in the Xinglongwa and Zhaobaogou cultures, they depicted hunted wild animals, mainly wild pig, deer, bear, and bird. Among these animals, wild pig and deer constituted a significant proportion of people's diet based on the faunal remains from Baiyinchanghan (Inner Mongolia Institute 2004, 546–75) and Zhaobaogou (Institute of Archaeology 1997, 180–93). However, the winged pig and deer images on the *zun* vessels are not realistic portraits but fantastic forms, probably suggesting a belief that some animals had power to travel to the supernatural world. This theme of animal power was later elaborated in shamanistic art (see below).

The earliest iconographies in the Liao River region were associated with ritual power derived from female human fertility and animals which were important to the subsistence economy. Jade artefacts for the first time occurred in burials, also initiating a tradition for the mortuary use of jade. Some of these indigenous characteristics continued and became elaborated in the Hongshan culture, as exemplified by the female statues and figurines and abundant jade objects associated with elite tombs. However, when Hongshan jades flourished, they did not portray the traditional themes. The jade human figurine from Niuheliang is sexless, and jade zoomorphic items (bird, turtle, and dragon) do not reflect the diet of the Hongshan people revealed in faunal remains, which are predominantly pig, sheep, bovine, and deer (Guo 1995; 1997). Rather, these Hongshan jade figurations may have portrayed important elements in ancient cosmological knowledge (Li 2003, 170–81).

In this ancient belief system, the turtle symbolized a natural model of the universe, with its convex dorsal shell imitating a dome-shaped heaven, its flat ventral shell symbolizing the earth, and its four feet representing the pillars supporting the heaven (Allan 1991, 103–11). Sacred birds were important for the regular operation of the universe, especially associated with the movement of the sun (Wu 1985), and many of the bird figurines and motifs in the Hongshan culture appear to be realistic or abstract depictions of owls (Li 2003, 177). The pig probably symbolizes the Northern Dipper (Feng 2001, 106–26; Li 2003, 173), while the dragon probably assisted religious practitioners in their communication with the supernatural world (Chang 1988).

Some of these interpretations may be debatable since they are based on later textual records; nonetheless, these jade figurations were ritual paraphernalia symbolizing the power of the elite who had much to do with creating and controlling cosmological knowledge and communicating with the supernatural worlds (Li 2003, 173–81). Small chert tools likely for manufactur-

Figure 20.3. *Figurations from the Lower Yangtze River region: 1) Hemudu culture; 2–3, 8–10) Lingjiatan; 4–7, 11–12) Liangzhu culture (not to scale). (Modified from Anhui Institute 1989; 1999; 2000; Fanshan Archaeology Team 1988; Zhaolingshan Archaeology Team 1996; Zhejiang Institute 2003.)*

ing jade objects, such as drills and scrapers, have been found in the cairns (National Bureau 2003, 21) and pits near the ritual structure in Niuheliang (Liaoning Institute 1986, 14–15), suggesting that the elite may have been involved in making these jade artefacts.

The accelerated ritual activities involving the use of human and animal figurations during the late Hongshan period coincide with an episode of increasingly arid conditions (Jing 2004; Zhang *et al.* 2000), as the summer monsoon front retreated southward after 6000 cal. BP (An *et al.* 2000). The archaeological record shows that the Hongshan culture experienced the intensification of dry-farming agriculture and a marked increase in population density during the fourth millennium BC (Li 2003). It is not difficult to imagine the social stress placed on Hongshan societies in this marginal agricultural area if there was a long period of climatic fluctuation coupled with reduced precipitation. The ritual activities may have thus been a part of leadership strategies adopted by the elite in response to the pressures from ecological and social systems that were affected by climatic change. The Hongshan culture finally collapsed around 3000 BC and art works declined afterwards when the Liao River region experienced a prolonged climatic deterioration.

The lower Yangtze River region

The lower Yangtze River region witnessed the transition to sedentism around 10,000 cal. BP, but clearly identifiable figurations did not appear until 5000 BC. These figurations belong to four Neolithic cultures: Hemudu (*c.* 5000–3300 BC), Majiabang (*c.* 5000–3200 BC), Lingjiatan (*c.* 3500–3300 BC), and Liangzhu (*c.* 3200–2000 BC) (Fig. 20.1).

Figurations
The earliest human and animal figurations appear in several dwelling sites of the Hemudu and Majiabang cultures, particularly at Hemudu in Yuyao (Zhejiang Institute 2003) and Luojiajiao in Tongxiang (Luojiajiao Archaeology Team 1981). These include clay figurines of humans (human faces and a male figurine) and animals, and zoomorphic images incised on pottery, bone, and ivory objects. The animal forms include bird, pig, dog, buffalo, fish, sheep and deer. Most clay figurines are schematic with little similarity in style, but two bird images carved on a bone object and an ivory object are rather elaborate (Fig. 20.3, no. 1). Both depict a flaming circle from which two birds emerge on opposite sides, often interpreted as sun-bird motif (Wu 1985).

A large number of jade objects, some made in human and animal forms, were unearthed from elite burials at Lingjiatan in Hanshan, Anhui province. Six jade human figurines (7.7–9.9 cm high) are depicted in either standing or sitting positions with their arms folded upwards on the chest, and wearing a flat cap, a belt at the waist, and bracelets on the arms (indicated by multiple carved lines) (Fig. 20.3, no. 2). A jade bird, with an octagonal star (probably representing the sun) carved on its chest, is portrayed with open wings (8.4 cm wide), from the tips of which emerge the heads of pigs (Fig. 20.3, no.3). A jade dragon is shown with a circular-shaped body, the head connecting to the tail and the mane running along the entire back of the body (4.4 × 3.9 cm in diameter and 0.2 cm in thickness) (Fig. 20.3, no. 10). A turtle, made of two pieces of jade (9.4 cm long), had a jade plaque (11 cm long) placed between its shells (Fig. 20.3, nos. 8–9). The plaque, convex in shape, was incised with a complex geometrical design showing an octagonal star in the centre. Animal forms on other jade items include bird, cicada, rabbit, pig, and tiger; most are depicted in schematic styles (Anhui Institute 1989; 1999; 2000).

The Liangzhu culture, centred in the Lake Tai region, is well known for its jade objects from elite burials. Most jade artefacts are geometrical in form, but some were carved in anthropomorphic and zoomorphic shapes. A typical motif, referred to as the human–beast motif (Fig. 20.3, no. 12), is a recurrent image incised on different types of jade objects, but more often on *cong* tubes which are square outside and round inside (Fig. 20.3, no. 11) (Fanshan Archaeology Team 1988). Such a motif depicts a creature with a half-human and half-animal body; the upper part is human-like, wearing a large feathered headdress and showing human arms and hands, while the lower part is animal-like, with large round eyes and sharp claws. A jade figurine from Zhaolingshan in Kunshan shows a human figure with its left arm raised and holding an animal; it also wears a tall headdress with a bird on the top (5.5 cm long, 0.3–0.4 cm thick) (Fig. 20.3, no. 4) (Zhaolingshan Archaeology Team 1996).

Animal forms include fish, turtle, cicada, and bird. Bird images continued in importance in this region. A motif incised on a number of jade objects is composed of a bird standing on an altar; the altars are decorated with symbols, two of which can be identified as the sun and moon (Fig. 20.3, no. 5–7). This theme seems to echo the sun-bird motif first seen at Hemudu (Wu 1985).

Implications
The lower Yangtze River region was environmentally unstable in prehistory as it was affected by sea-level changes. This region experienced a punctuated cultural development, which is, at least partially, attributable

to marine transgressions that periodically inundated large parts of the coastal regions and affected human settlements (Stanley & Chen 1996). Scholars have also argued that the disappearance of the Liangzhu culture was caused by marine transgression (Stanley *et al.* 1999). Moreover, the southward retreat of the summer monsoon during the mid Holocene affected north and south China in different ways: while the north suffered from drought due to reduced precipitation, the south experienced floods caused by increased rainfall (Wu & Liu 2004). Flooding is likely to have occurred more often than marine transgressions and caused more immediate and frequent threats to human societies.

Similar to the Zhaobaogou culture in the Liao River, all of the animals represented in the figurines from Hemudu and Luojiajiao can be found in the faunal assemblages unearthed at the same sites (Wei *et al.* 1990; Zhang 1981). However, the bird was depicted with special attention, exemplified by the sun-bird motifs from Hemudu. Bird iconography was prevalent in east China, and has been interpreted as evidence of a bird cult, a part of a belief system shared by many Neolithic cultures along the east coast areas (Wu 1985); the Hemudu culture may have been the origin of this cult.

Jade figurations dominated the iconographic inventory in the lower Yangtze River region when elite groups emerged, a phenomenon similar to the Hongshan culture in the Liao River region. Jade objects, which functioned as tangible expressions of ritual power, formed the central focus of the elite life. Some elite individuals appear to have been involved in manufacturing jades, as suggested by tools and debitage revealed in the elite burials at Lingjiatan and at several Liangzhu sites (Liu 2003).

There are marked differences between the early clay figurations and later jade iconographies. Most animals important in the subsistence economy, which were previously portrayed as clay figurines, are absent in jade forms. Unlike the roughly made clay human figurines, jade anthropomorphic forms were depicted in rather standardized fashion, exemplified by the six jade human figurines from Lingjiatan and human–beast motifs from several Liangzhu sites. The human figurines from Lingjiatan all show a similar sitting/standing and arm-folding pose, and wear similar outfits, ornamentations, and headgear. In the Liangzhu culture, the complex human–beast motifs occur in various forms of jade objects from different sites, and all share the same essential elements and structure. Their rarity suggests their exclusive nature as prestige items, and their standardized forms indicate well-established belief systems supported by certain iconographies.

The human-beast motif on the jade *cong* tubes has been interpreted as a shamanistic alter-ego image, and the *cong* tubes, which have a square outer shape and circular inner shape, as a symbolic expression of a shamanistic heaven–earth communication (Chang 1989).

The sacred bird appears to have been the traditional theme in figurations throughout the Neolithic period in this region. It is also notable that birds were often depicted in combination with other subjects, including animal, human, and natural forms, as exemplified by the examples from Lingjiatan, Zhaolingshan, and the Liangzhu 'bird emblems' (Fig. 20.3, nos. 5–7). The bird theme, which persisted for several thousand years from Hemudu to Liangzhu in the lower Yangtze River valley, may have contributed to its sacred function in an ancient cosmology later shared by other regions.

The turtle was also a recurrent animal form in Lingjiatan and Liangzhu figurations, but was absent in the previous Hemudu and Majiabang cultures. The jade turtle from Lingjiatan was used together with the jade plaque as ritual paraphernalia; the convex-shaped plaque probably symbolized the domed heaven, and the design on the plaque, including an octagonal star (symbolizing the sun or polestar), may represent a diagram of the universe for Neolithic people (Li 2003, 171–3).

As bird and turtle played significant roles in ancient world-views, the growing sophistication in these figurations perhaps implies increased complexity in the belief system concerning the form of the universe, the movement of celestial bodies, as well as associated ritual practice. All of these matters might determine a good or bad harvest in the minds of ancient agricultural people, who were often under threat of natural disasters, such as drought and flood.

Several features in figurations were shared by the cultures in the lower Yangtze and Liao river valleys: the posture of the standing Lingjiatan human figurines are remarkably similar to that of the Niuheliang counterpart (standing with arms folded on the chest); jade birds (many are owls) and turtles are common to both regions; and a cosmological concept, round heaven and square earth, was expressed in the stone cairns and altars in the Hongshan ritual sites, the jade turtle and plaque from Lingjiatan, and the *cong* tubes from Liangzhu burials. These phenomena suggest that some cultural contacts, direct or indirect, between these two regions occurred during the late fourth millennium BC. These contacts and their material manifestations served as vehicles for the diffusion of cosmological knowledge as well as certain elite behaviour in prehistoric China.

The iconographic representations in the lower Yangtze River region may be described as two

Figure 20.4. *Figurations from the middle and upper Yellow River valley: 1–4) Peiligang culture; 5) stone and clay phalluses (c. 5000–2000 BC); 6) Banpo Phase facemasks; 7) jar from Liuwan; 8) jar from Shizhaocun; 9) clay figurines from Anban; 10) face relief from Jiangxicun; 11) facemask from Liujiahe; 12–13) human burial and shell mosaics from Xishuipo; 14) lizard/alligator relief from Qianmao; 15) turtle and birds painted on burial urn from Hongshanmiao (not to scale except 1–5). (Modified from Institute of Archaeology 1999; Komoto & Imamura 1998; Northwest University 2000; Puyang Cultural Relics 1988; Puyang Xishuipo 1989; Wei & Yang 1991; Wei River Team 1959.)*

systems. The first system is an indigenous tradition, developed in the fifth millennium BC, and primarily of clay figurations depicting a bird cult and animal forms closely related to people's daily life. The second system, represented by jade items, emerged in the fourth millennium BC. It continued and elaborated the traditional images of the bird cult, but also developed a new symbolic assemblage, such as a shamanistic concept of an alter-ego, and shapes of the universe symbolized by the form of the turtle and *cong* tubes. All of these are closely related to cosmological concepts. This pattern to some extent parallels that of the Liao River region.

The middle and upper Yellow River region

In the Yellow River region sedentism and domestication of plants and animals (mainly millet, pig, and dog) developed during the Peiligang period (*c.* 7000–5000 BC), coinciding with the arrival of the mid-Holocene climatic optimum. This region is covered with fertile loess and alluvial soil, which made dry farming relatively easy. However, it is an area affected by the monsoon systems, and drought and river flooding were constant threats during the prehistoric period.

Figurations
Figurations first appeared in a limited culture area in central Henan during the late Peiligang culture (*c.* 6000–5000 BC), including a human head, pig heads, and phalluses (Fig. 20.4, nos. 1–4).

Figurations increased dramatically in number and form in the successive Yangshao culture (*c.* 5000–3000 BC) and Majiayao culture (*c.* 3100–2000 BC). The Yangshao culture was distributed over a broad region in the middle Yellow River valley, and is divided into several phases based on spatial and temporal variations:
1. Banpo (*c.* 5000–4000 BC);
2. Miaodigou (*c.* 4000–3500 BC);
3. Late Yangshao (*c.* 3500–3000 BC);
The Majiayao culture, distributed in the upper Yellow River valley, is also divided into three phases:
1. Majiayao (*c.* 3100–2700 BC);
2. Banshan (*c.* 2600–2300 BC);
3. Machang (2300–2000 BC);
Most figurations show great variability and scattered distribution, while certain representational

Figure 20.5. *Distribution of phalluses and female figurines in Neolithic China.*

themes tend to cluster in limited areas. For example, painted ceramics sometimes depict combined anthropomorphic and zoomorphic motifs, which show human heads wearing pointed headgear decorated with feather-like objects, with fish or fish-like objects emerging from their faces (Fig. 20.4, no. 6). This type of image has been interpreted as shamanistic representation (Chang 1983, 114–15). They date to the Banpo phase at several sites, stretching about 200 km east–west along the Wei River valley and north–south across the Qingling Mountains.

Shamanist representation has also been found in the upper Yellow River areas. Pottery jars with the upper portions sculpted into a human head/face are widely distributed in the Majiayao culture (for references see Komoto & Imamura 1998). The one from Liuwan portrays not only the face but also the body, illustrating both breasts and male genitalia (Fig. 20.4, no. 7), which has been interpreted as representing shamanistic transformation (Chang 1994).

Shamanistic art was reflected on X-ray style images. A painted dancing scene was discovered on a house floor at Dadiwan in Qin'an, Gansu, dating to the late Yangshao culture. It depicts two dancing human figures; next to them are two creatures whose bodies are depicted in X-ray style (Gansu Cultural Relics 1986). The X-ray type of human representations has also been found on a pottery basin from Banshan in Guanghe (Chang 1994) and a jar from Shizhaocun in Tianshu

(Institute of Archaeology 1999) (Fig. 20.4, no. 8), both in Gansu province, and date to the Banshan phase.

Clay human figurines have been found at several Yangshao culture sites. They vary greatly in style and craftsmanship. However, a number of finds from central and southern Shaanxi seem to share some common characteristics. At Anban in Fufeng ten small baked clay figurines (2.7–6.8 cm high) were unearthed, mostly broken, with eight of them from pits near a public architectural foundation (Northwest University 2000). One of the figurines is a headless, pregnant woman. Several figurines manifest long and straight or hooked noses, including one with a full beard. In addition, most of them have either pointed or flat-topped headgear (Fig. 20.4, no. 9). An anthropomorphic relief attached to a Yangshao basin, discovered at Jiangxicun in Fufeng, shows a human face with a long, hooked nose, thin lips and a narrow face (Fig. 20.4, no. 10) (Wei River Team 1959). A clay human mask (10 cm in height) was found at Liujiahe in Ankang, southern Shaanxi, and dates to the Miaodigou phase. This realistically rendered sculpture has a long and large nose, deep eyes, and a narrow face (Fig. 20.4, no. 11) (Wei & Yang 1991). These figurines, although rather different in style, manifest several physical and cultural characteristics, which were non-local in origin, including long, large noses, full beards, and tall headgear. These features can be identified in archaeological remains in ancient cultures of central Asia (Liu 2004, 88–93).

In contrast to most figurations, which have limited spatial and temporal distribution, clay or stone phalluses (Fig. 20.4, no. 5) were prevalent across the middle Yellow River region throughout the Neolithic period. Their distribution appears to have expanded to the surrounding areas during the late Neolithic before reducing in overall number and in geographical distribution during the Bronze Age (Fig. 20.5).

Wild and domestic animal images and figurines are common in Yangshao sites; archaeological reports identified them as pig, dog, deer, frog, sheep, turtle, bird, owl, snake, and lizard (Fig. 20.4, nos. 14–15). Most animal figurines show little similarity in style, and are scattered over a large region (for references see Komoto & Imamura 1998).

Some unprecedented finds of figurations have been made at Xishuipo in Puyang, Henan province (c. 4600–4000 BC). These are three groups of images made of mollusc shell mosaics. The first group is associated with burial M45, whose occupant was an unusually tall male (1.84 m in height) and who was oriented toward the south. Two animal forms made of shells accompanied him: a dragon on his right and a tiger on his left (Fig. 20.4, no. 12). Two human leg bones with a cluster of shells were placed to the north of the skeleton. The second group of shell mosaics was located some 20 m south of M45, composed of a dragon, a tiger, a deer and a spider. Twenty-five metres further south is the third group, including a person riding a dragon, a tiger, a bird, and some unidentified objects (Fig. 20.4, no. 13) (Puyang Cultural Relics 1988; Puyang Xishuipo 1989).

Implications

Similar to the Liao River region, the earliest figurations occurred when early agricultural villages thrived, but the discard patterns of figurations between these two regions are different. Most Neolithic human and animal figurines in the Yellow River valley were found in ash pits and middens, and were roughly rendered with little uniformity in style. These suggest that individuals occasionally made them for various purposes and discarded them afterward, and that these activities were likely held at a household level.

The only example in which human figurines were associated with public architecture are the clay figurines from pits near a large building at Anban in Fufeng, some of which show central Asian physical and cultural characteristics. It is possible that some figurines are self-portraits of diviners who travelled around to perform divinations (Liu 2004, 88–93). These figurines, either from small houses or large buildings, however, do not show involvement in exclusive elite activities.

The figurations similar in style tend to distribute in clusters, dating to roughly the same periods. This pattern perhaps reflects particular ideologies and ritual practices that were shared by closely related communities.

The phallus was the type of figuration with the greatest spatial and temporal distribution in this region. It was among the earliest figurines in the Peiligang culture, and continued throughout the Neolithic period with an increased spatial distribution. This pattern sharply contrasts with that of the female figurines, which occurred in isolation at two sites in the Wei River valley (Fig. 20.5). Most phalluses have been found in ash pits and middens. Unlike female figurines and sculptures from the Liao River region, phalluses apparently were not permanent cult symbols installed in architecture. Rather, they were probably used occasionally in ritual performances, and discarded afterwards. Stone or clay phalluses found in Neolithic sites have long been interpreted as a symbol of the veneration of male fertility, and hence, as manifestations of male ancestor worship (for related references see Liu 2000); however, the discard pattern of these artefacts does not conform to the non-random pattern of remains that reflect rituals relating to ancestor cults observed in Neolithic

China (Keightley 1998; Liu 2000) and in other regions (cf. Marcus & Flannery 1994, 56; McAnany 1994). The Chinese Neolithic mortuary data show that deified ancestral status was granted to both male and female deceased individuals, although males often received the most elaborate mortuary treatment (Liu 1996). Taken as a whole, although the occurrence of phalluses may only imply a belief in male fertility power, this ideology does appear complementary to other ritual behaviours under a broader religious system, including veneration of male ancestors. The male fertility cult, therefore, seems to have been an important component in the indigenous belief system in this region.

Most animal figurations in the Yellow River valley depict fauna important to the subsistence economy, such as pig, dog, wild sheep/goats, fish, and bird. However, there are three exceptions. The first case is the owl and lizard images of the Miaodigou phase distributed in the western Henan and eastern Shaanxi (Fig. 20.4, no. 14). These two animals, with limited value for human diet, may have assumed some symbolic significance in the ancient conception of the universe, as it was also common in the Hongshan and Liangzhu jades. There appears no special place for the lizard in ancient Chinese cosmology, but I would argue that these animal figures may be better identified as alligator rather than lizard. Both animals are reptiles and similar in shape disregarding their sizes. It is notable that the dragon images from Xishuipo resemble alligator in form (Gao & Shao 2000). In *Shuowen Jiezi*, the oldest dictionary in China (AD 100), 'dragon' was defined as,

> the chief of animals with scales, with ability to change forms between dark and bright, large and small, and long and short; it ascends to the heaven in the Spring Equinox, and descends to the deep water in the Autumnal Equinox.

The dragon was apparently described as a form of reptile, similar to lizard and alligator, and its presence and absence in different seasons seem to resemble reptile's hibernation. Therefore, the so-called lizard reliefs on Miaodigou pottery might actually be depictions of dragons.

The second exception is the turtle images on Yangshao burial urns from Hongshanmiao in Ruzhou (Fig. 20.4, no. 15). Turtle shells used as ritual objects first occurred in the Peiligang culture and continued to appear in Neolithic burials over a broad area (Chen & Lee 2004). An image of turtle and birds together from Hongshanmiao may be the earliest figuration that echoes the sacred functions of these two animals in ancient cosmology. It is possible that the belief in turtles' supernatural nature along with the associated cosmological knowledge was first developed in the Yellow River valley, and later spread to other areas.

The third exception is the Yangshao shell mosaics of dragons, tigers, deer, bird, human riding dragon, and the Great Dipper at Xishuipo in Puyang. Many scholars have attempted to interpret the meanings of these complex images. Some argue for shamanistic implications in that the human world and the supernatural world were bridged by religious practitioners and their animal helpers (Chang 1988; 1993; 1994). Others believe that these were images of an astronomical system, and symbolized solar terms, such as summer solstice and winter solstice, which were significant for agricultural activities (Feng 1990; Lu & Li 2000, 1–15). The animal pattern at the Xishuipo M45 is remarkably similar to the image painted on a lacquer box from the tomb of Marques Yi of the Zeng state in the Eastern Zhou dynasty (the fifth century BC), which shows the Northern Dipper and the names for the twenty-eight lunar mansions in the centre flanked by a dragon and a tiger (Feng 1990). These two interpretations are complementary, and the Puyang mosaics provide the best tangible information of the power and function of religious practitioners in the Yangshao culture.

The Neolithic animal figurations identified as dragons by archaeologists seem to show various forms in different regions. It has a pig head and a snake body in the Hongshan culture, but has a long mane covering its entire body in Lingjiatan. At Xishuipo it was depicted with legs, similar to the lizard/alligator relief on some ceramic vessels. We cannot be sure whether these dragon images, which occurred in different regions a few hundred kilometres apart from each other, represent the same animal identity and had the same ritual function to the people of these different cultures. But if they indeed expressed the same concept for a fantastic serpent-like creature, these 'dragons' may have derived from different animals or different combinations of local animals. Most importantly, images reflecting a 'dragon-like' fantastic creature seem to have coexisted in different regions, suggesting interregional interactions and diffusion of ideologies between distant cultures. The dragon also continued to exist in many parts of China, and later became the symbol of high social status throughout Chinese history. The fifth and fourth millennia BC probably witnessed the formation and recreation of the concept and image of the dragon across north and south China.

As a whole, while many figurations in the Yellow River valley show rather localized patterns, in a few cases influences from other regions were present, although some of these foreign elements were isolated and short-lived, such as figurines with non-local features. The depictions of the alligator-shaped dragon

most resemble the description of this mythical animal in later textual sources, indicating an early development of such a concept in the Yellow River region. Animal figurations reflecting certain cosmological conceptions show similarities with other regions, suggesting inter-regional contacts. However, unlike the other two regions, these ideologies were expressed in non-prestige materials, such as pottery and shell mosaic, rather than in jade.

Conclusions

The first figurations in China were material expressions of a human response to a dramatically altered natural and social environment resulting from sedentism and incipient agriculture. Each region developed its own iconographic system, which had deep roots in the local cultural traditions. Nevertheless, several iconographic and ritual features, related to cosmological knowledge, are shared by the cultures in all three regions. The origins of these features can be traced back to different areas, but during the fourth millennium BC they became shared cultural elements of the three regions, exemplified by some recurrent animal and human forms.

Coinciding with the development of complex societies, the figurations of certain animal and geometrical forms, which express cosmological and astronomical elements, also became increasingly elaborate and similar in style, particularly the jade objects from the Liao and lower Yangtze Rivers which are more than 1000 km apart. Since elite individuals were likely involved, at least partially, in manufacturing the jades which carried ritual power, the similarities in jade forms from these regions suggest interactions between distant elite groups (Liu 2003). The close relationship between ritual objects and cosmological conceptions helps us to understand the function of the elite, who were believed to have power in connecting the human world with supernatural domains, foreseeing and controlling weather, and ensuring a good harvest. The populace supported their legitimacy and wealth as long as the elite was able to deliver the promise. Increased quantities of ritual items, including figurations, during a decline in climatic conditions, may be seen as indicators of the elite's attempts to respond to natural challenges and demonstrate their supernatural power. The disappearance of the jade-rich Hongshan and Liangzhu cultures may reflect the collapse of the elite groups and their ritual activities that resulted from a loss of public support during worsening climatic conditions.

The middle and upper Yellow River valley appears to have been different from other regions in terms of figuration styles and context, especially apparent with the lack of jade figurations and elaborate elite burials. But this by no means suggests that Neolithic people there did not encounter any environmental challenges, or that there was no jade source available for the elite. Depictions of dragon, owl and turtle from the Yellow River valley certainly demonstrate a similar cosmology shared by the Yangshao people and those in other regions, and the Yangshao elite participated in the inter-regional interaction relating to the formation of cosmological systems. The Yangshao elite groups, however, may have adopted different leadership strategies in creating and maintaining power, rather than using jade figurations as a means to express their authority.

Analysis of early figurations from three regions in China reveals processes through which ideologies and relevant symbolic systems were created, amalgamated, and changed. Since human cognitive systems are not independent of social contexts and the natural environment that affect human decisions, a socio-ecological approach to the understanding of ancient ideology proves to be fruitful.

Acknowledgements

I would like to thank Xingcan Chen for his helpful comments and information. I am also grateful to Thomas Bartlett and Elisabeth Bacus who edited early versions of this paper.

References

Allan, S., 1991. *The Shape of the Turtle: Myth, Art and Cosmos in Early China*. Albany (NY): State University of New York.
An, Z., S.C. Porter, J.E. Kutzbach *et al.*, 2000. Asynchronous Holocene optimum of the east Asian monsoon. *Quaternary Science Reviews* 19, 743–62.
Anhui Institute of Cultural Relics, 1989. Anhui Hanshan Lingjiatan xinshiqi shidai mudi fajue jianbao. *Wenwu* 4, 1–9.
Anhui Institute of Cultural Relics, 1999. Anhui Hanshanxian Lingjiatan yizhi disanci fajue jianbao. *Kaogu* 11, 1–12.
Anhui Institute of Cultural Relics, 2000. *Lingjiatan Yuqi*. Beijing: Wenwu Press.
Bar-Yosef, O., 1997. Symbolic expressions in later prehistory of the Levant: why are they so few? in *Beyond Art: Pleistocene Image and Symbol*, eds. M. Conkey, O. Soffer, D. Stratmann & N.G. Jablonshki. San Francisco (CA): Memoirs of the California Academy of Sciences, 161–87.
Chang, K.-C., 1983. *Art, Myth, and Ritual*. Cambridge (MA): Harvard University Press.
Chang, K.-C., 1988. Puyang sanqiao yu Zhongguo gudai meishu shang de ren shou muti. *Wenwu* 11, 36–9.
Chang, K.-C., 1989. An essay on cong. *Orientations* 20, 37–43.

Chang, K.-C., 1993. Shamanism in human history: a preliminary definition. *The Bulletin of the Department of Archaeology and Anthropology* 49, 1–6.
Chang, K.-C., 1994. Ritual and power, in *China: Ancient Culture, Modern Land*, ed. R. Murowchick. Norman (OK): University of Oklahoma Press, 61–9.
Chen, X., 1990. Fengchan wushu yu zuxian chongbai: Hongshan wenhua chutu nuxing suxiang shitan. *Huaxia Kaogu* 3, 92–8.
Chen, X. & Y.K. Lee, 2004. Shelun zhongguo shiqian de guijia xiangqi, in *Taoli Chengxi Ji: Qingzhu An Zhimin Xiansheng Bashi Shouchen*, eds. C. Tang & X. Chen. Hong Kong: Hong Kong Chinese University Press, 72–97.
Chengde District Cultural Relics Department, 1994. Hebei Luanpingxian Houtaizi yizhi fajue jianbao. *Wenwu* 3, 53–74.
Fanshan Archaeology Team, 1988. Zhejiang Yuhang Fanshan Liangzhu mudi fajue jianbao. *Wenwu* 1, 1–31.
Feng, S., 1990. Henan Puyang Xishuipo 45 hao mu de tianwenxue yanjiu. *Wenwu* 3, 52–60.
Feng, S., 2001. *Zhongguo Tianwen Kaoguxue*. Beijing: Shehui Kexue Wenxian Press.
Gansu Cultural Relics Working Team, 1986. Dadiwan yizhi Yangshao wanqi dihua de faxian. *Wenwu* 2, 13–15.
Gao, G. & W. Shao, 2000. 'Puyanglong' chansheng de huanjing tiaojian he shehui beijing, in *Haidaiqu Xianqin Kaogu Lunji*, ed. G. Gao. Beijing: Kexue Press, 334–9.
Guo, D., 1995. Hongshan and related cultures, in *The Archaeology of Northeast China: Beyond the Great Wall*, ed. S. Nelson. London & New York (NY): Routledge, 21–64.
Guo, D., 1997. Zhonghua wu qian nian wenming de xiangzheng, in *Niuheliang Hongshan Wenhua Yizhi yu Yuqi Jingcui*, ed. Liaoning Institute of Archaeology. Beijing: Wenwu Press, 1–48.
Inner Mongolia Institute of Archaeology (ed.), 2004. *Baiyinchanghan*. Beijing: Kexue Press.
Institute of Archaeology, CASS (ed.), 1997. *Aohan Zhaobaogou*. Beijing: Zhongguo Dabaikequanshu Press.
Institute of Archaeology, CASS, 1999. *Shizhaocun yu Xishanping*. Beijing: Zhongguo Dabaikequanshu Press.
Jing, G., 2004. Yanshan nanbei changcheng didai zhong quanxinshi qihou huanjing de yanhua ji yingxiang. *Kaogu Xuebao* 4, 485–505.
Keightley, D., 1998. Shamanism, death, and the ancestors: religious mediation in Neolithic and Shang China (*c.* 5000–1000 BC). *Asiatisch Studien Etudes Asiatiques* 52, 763–831.
Komoto, M. & Y. Imamura, 1998. Corpus of the stone and earthern figurines in prehistoric east Asia, in *The Prehistoric Cultures of the Circum East China Sea Area*, ed. Masayuki Komoto. Kumamoto: University of Kumamoto, 114–228.
Li, X., 2003. Development of Social Complexity in the Liaoxi Area, Northeast China. Unpublished PhD dissertation, Melbourne, La Trobe University.
Liaoning Institute of Archaeology, 1986. Liaoning Niuheliang Hongshan wenhua 'nushenmiao' yu jishizhongqun fajue jianbao. *Wenwu* 8, 1–17.
Liaoning Institute of Archaeology, 1997. *Niuheliang Hongshan Wenhua Yizhi yu Yuqi Jingsui*. Beijing: Wenwu Press.
Linduff, K., R. Drennan & G. Shelack, 2002–2004. Early complex societies in northeast China: the Chifeng international collaborative archaeological research project. *Journal of Field Archaeology* 29, 45–73.
Liu, G., 2002. Xinglonggou juluo yizhi. *Wenwu Tiandi* 1, 1.
Liu, G., X. Jia & M. Zhao, 2003. Xinglonggou juluo 2002. *Wenwu Tiandi* 1, 36–9.
Liu, L., 1996. Mortuary ritual and social hierarchy in the Longshan culture. *Early China* 21, 1–46.
Liu, L., 2000. Ancestor worship: an archaeological investigation of ritual activities in Neolithic north China. *Journal of East Asian Archaeology* 2, 129–64.
Liu, L., 2003. 'The products of minds as well as of hands': production of prestige goods in the Neolithic and early state periods of China. *Asian Perspectives* 42, 1–40.
Liu, L., 2004. *The Chinese Neolithic: Trajectories to Early States*. Cambridge: Cambridge University Press.
Lu, S. & D. Li, 2000. *Tianwen Kaogu Tonglun*. Beijing: Zijincheng Press.
Luojiajiao Archaeology Team, 1981. Tongxiangxian Luojiajiao yizhi fajue baogao. *Zhejiangsheng Wenwu Kaogusuo Xuekan*, 1–42.
Marcus, J. & K.V. Flannery, 1994. Ancient Zapotec ritual and religion: an application of the direct historical approach, in *The Ancient Mind*, eds. C. Renfrew & E. Zubrow. Cambridge: Cambridge University Press, 55–74.
McAnany, P.A., 1994. *Living with the Ancestors: Kinship and Kingship in Ancient Maya Society*. Austin (TX): University of Taxas Press.
National Bureau of Cultural Relics, 2003. Niuheliang Hongshan wenhua yizhiquan, in *2003 Zhongguo Zhongyao Kaogu Faxian*, ed. National Bureau of Cultural Relics. Beijing: Wenwu Press, 17–22.
Nelson, S., 1991. The 'Goddess Temple' and the status of women at Niuheliang, China, in *The Archaeology of Gender: Proceedings of the Twenty-Second Annual Conference of the Archaeologifcal Association of The University of Calgary*, eds. D. Walde & N.D. Wilows. Calgary: The University of Calgary, 302–8.
Northwest University, 2000. *Fufeng Anban Yizhi Fajue Baogao*. Beijing: Keixue Press.
Puyang Cultural Relics Management Council, 1988. Henan Puyang Xishuipo yizhi fajue jianbao. *Wenwu* 3, 1–6.
Puyang Xishuipo Archaeology Team, 1989. 1988 nian Henan Puyang Xishuipo yizhi fajue jianbao. *Kaogu* 12, 1057–66.
Stanley, D.J. & Z.Y. Chen, 1996. Neolithic settlement distributions as a function of sea level-controlled topography in the Yangtze delta, China. *Geology* 24, 1083–6.
Stanley, D.J., Z. Chen & J. Song, 1999. Inundation, sea-level rise and transition from Neolithic to Bronze Age cultures, Yangtze delta, China. *Geoarchaeology* 14, 15–26.
Wang, Y., 1997. Lun Houtaizi yuanshi nuxing fenwan xilie shidiao. *Wenwu Jikan* 1, 57–61.
Wei, F., W. Wu, M. Zhang & D. Han, 1990. *Zhejiang Yuyao Hemudu Xinshiqi Shidai Yizhi Dongwuqun*. Beijing: Haiyang Press.

Wei, J. & Y. Yang, 1991. Jinnianlai Shaanxi xinchutu de Yangshao wenhua yuanshi yishupin. *Kaogu yu Wenwu* 5, 54–61.
Wei River Team, Institute of Archaeology CASS, 1959. Shaanxi Weishui liuyu diaocha baogao. *Kaogu* 11, 588–91.
Wu, H., 1985. Bird motif in eastern Yi art. *Orientations* 16, 30–41.
Wu, W. & T. Liu, 2004. Possible role of the 'Holocene Event 3' on the collapse of Neolithic cultures around the central plain of China. *Quaternary International* 117, 153–66.
Yang, X., 1988. *Sculpture of Prehistoric China*. Hong Kong: Tai Dao Publishing.
Yang, X., 2000. *Reflections of Early China: Decor, Pictographs, and Pictorial Inscriptions*. Seattle (WA) & London: The Nelson-Atkins Museum of Art.
Zhang, H.C., Y.Z. Ma, B. Wunnemann & H.J. Pachur, 2000. A Holocene climatic record from arid northwestern China. *Palaeogeography, Palaeoclimatology, Palaeoecology* 162, 389–401.
Zhang, M., 1981. Luojiajiao dongwuqun, in *Zhejiangsheng Wenwu Kaogusuo Xuekan*, ed. Zhejiang Institute of Archaeology. Beijing: Wenwu Press, 43–53.
Zhaolingshan Archaeology Team, 1996. Jiangsu Kunshan Zhaolingshan yizhi di yi, er ci fajue jianbao, in *Dongfang Wenming Zhiguang*, ed. H. Su. Hainan: Hainan Guoji Xinwen Press, 18–37.
Zhejiang Institute of Archaeology, 2003. *Hemudu*. Beijing: Wenwu Press.

Section E

Refiguring Perceptions of Perception

Chapter 21

Before and Beyond Representation: Towards an Enactive Conception of the Palaeolithic Image

Lambros Malafouris

A famous philosopher wrote in his *Philosophical Investigations* that the reason '[w]e find certain things about seeing puzzling' is 'because we do not find the whole business of seeing puzzling enough' (Wittgenstein 1953/1958, 212). I do not think that we need any striking experimental demonstration in order to accept the validity of the above claim. A simple example suffices to illustrate what lies at the heart of the matter: look at the two drawings (Fig. 21.1) taken from the so-called 'Panel of the Horses' from Chauvet cave (Vallon-Pont-d'Arc, France). If we ask ourselves what we see when we look at this image the majority of us will immediately and without any particular effort recognize a pair of rhinoceroses facing each other. The ease by which we are able, as modern human perceivers, to make such identifications belies the complexity of the cognitive processes behind them and, I suggest, renders invisible some phenomena of special interest in the study of the Palaeolithic image. Trying to draw out those hidden processes lets us attempt to go deeper into the phenomenology of our perception by asking the following: How exactly do we see, and what exactly do we see when we look at this image printed on paper? What does our experience of seeing really consist of? One might think that these are questions not for archaeology but for neuroscience or psychology of perception to answer. But an additional point that I want to argue in this paper is that as long as we treat cognition and material culture as separate and distinct epistemic domains of human experience our chances of understanding the nature of either are very limited. In considering the case of early imagery in particular, the underlying assumption of this paper is the following: image and perception are continuous; in changing the one you affect the other and thus you cannot understand the one in isolation from the other. The image, I will propose, is not simply the object of human perception; it is itself a historically situated component of human perceptual and cognitive architecture.

So let us return to our question: How exactly do we see, and what exactly do we see when we look at the image below? If we turn to the neuroscience of vision for an answer this will be, more or less, of the following general form: what we really see when we look at this image, what our experience of seeing really consists of, is essentially an internal representation of the retinal image of this image that is automatically constructed and processed in the so-called primary visual cortex (V1) at the back of our heads. More simply, what we 'really see' is a representation of a representation of a representation. Uncontestable as this claim might be, at least on the neurophysiological side, I think most of us would agree that our personal intuition and experience of seeing tells us a different story. For indeed very simply, looking at these two drawings we do not feel anything like seeing them inside our heads, we see them right where they are, printed on the paper in front of us. O'Regan & Noë (2001, 955) provide another, less-complicated, example that hopefully will convince even the

Figure 21.1. *Rhinoceroses, the panel of the horses, Chauvet Cave, France. (Re-drawn after Fritz & Tosello 2007, fig. 11.)*

sceptic that there is more to 'seeing' than meets the eye. (Fig. 21.2) Look at the sign below.

Figure 21.2. *Ceci n'est pas: the illusion of 'seeing'. (After O'Regan & Noë 2001, 955, fig. 4.)*

It may take you a while to realize that the sign does not say: The illusion of 'seeing'.

There are many, and often conflicting accounts, about why most of us, in spite of looking directly at the above sign, fail to notice the existence of the second 'of' or, to give another example, why 'words whose inner letters have been re-arranged can be read with quite anazimg esae'! (Grainer & Whitney 2004, 58), and any attempt to discuss them would have to exceed the scope of this paper. But why should someone choose such a peculiar way to introduce a paper on the images of the Palaeolithic?

I believe that every image one encounters in the world, past or present, embodies a perceptual trick analogous to the one we experienced in the above figure (Fig. 21.2). The cognitive efficacy and affective power of this perceptual trick primarily emanates from the creative conflation of appearance with reality that every image is capable of bringing forth. Paradoxically however, we are rarely ever being aware of this fact. This crucial property of every image usually escapes our conscious attention. The reason for this is not so difficult to imagine. Perception is not simply about directly perceiving the world (Gibson 1966; 1979), it is also, if not primarily, about *learning how to see the world* and *formulating hypotheses* about this world (Gregory 2005; 1990; 1980). Thus, immersed in a predominantly visual culture, and well trained from the early years of our childhood to create and make sense of visual phenomena of the above figurative type, they often appear so familiar to us as 'a sense datum' that we rarely find it necessary to stop and think either about how this recognition is made or about the existence of the image as an entity. We don't ask 'What is this thing?' or 'What does this thing do?', we rather immediately assume that we are dealing with some sort of visual representation and proceed with questions about its visual content and symbolic meaning. I believe that it is this familiarity that enables us to identify and talk about the image as a representational entity, that also blind us and constrains how precisely this image should be understood. The following quote from the work of Anthony Forge in New Guinea may help to illustrate this point:

> But when [the Abelam are] shown photographs of themselves in action, or of any pose other than face or full figure looking directly at the camera, they cease to be able to 'see' the photograph at all. Even people from other villages who came specially because they knew I had taken a photograph of a relative who had subsequently died, and were often pathetically keen to see his features, were initially unable to see him at all, turning the photograph in all directions. Even when the figure dominated (to my eyes) the photograph I sometimes had to draw a thick line round it before it could be identified, and in some cases I had the impression that they willed themselves to see it rather than actually saw it in the way we do (1970, 287).

This is then the problem with the study of images and more specifically with the cognitive archaeology of images that I will attempt to tackle in this paper. Whenever as archaeologists we turn our gaze upon the image of the past we may find ourselves wondering about a whole series of questions but most likely none of us will ever be puzzled about the most basic fact of all, namely, that the moment we look at the image we have already identified it as an image. It is already an image *of* something, that is, a *representation of* something. From a certain viewpoint this may not seem to be much of a problem. After all it is precisely our perceptual familiarity with the image as a representational phenomenon that transforms, for example, Palaeolithic cave art to an open window on the mind of the past. However although representation might offer the most familiar path to follow if one wishes to approach and understand the coming-into-being of an image, it can also lead to a series of problems. These problems, which will be the focus of this paper, become even more acute when we examine the role of the image in human cognitive evolution. The reason is fairly obvious. In such a context the question of image and representation takes altogether a different significance. It is no longer simply a question about the coming-into-being of the image itself (parietal or mobiliary), it now becomes a question about the coming-into-being of modern human cognition. Palaeolithic imagery is of course only one among the many archaeological traits that are usually brought to

bear upon the question concerning the emergence of behavioural modernity. Personal ornaments and tools, pigments, burials, engraved bones and stones, musical instruments and systems of notation are some of the usual candidates that comprise the archaeological list (d'Errico 2003; 1998; 1995; Mellars 1989; 1996a,b; Bar-Yosef 2002; Noble & Davidson 1996). Nevertheless, the image is undoubtedly the trait that, in spite of probably coming last chronologically, puzzles and fascinates us the most. Perhaps more importantly, it is the trait that very often defines the cognitive standards upon which all other manifestations of modern human intelligence are measured up and interpreted. As Gregory observes 'together with language, making pictures is uniquely human' (2005, 1237). This may also explain why this unique and rather isolated phenomenon of the development of Franco-Cantabrian cave art has been associated, wrongly in my opinion, with some sort of general creative or even cognitive revolution.

The crucial question facing us then, is how those images should be understood and upon which aspects or properties of those images we should focus. As mentioned earlier, for most archaeologists the meaning of the image appears to be grounded upon, if not synonymous with, the notion of representation and symbolism. In what follows I want to challenge this assumption. And in this respect it might be useful first to discuss more precisely when something is a representation and why representation is so important as a concept.

Image and representation

Generally speaking representation can be understood in a double sense: as an object which stands for, refers to or denotes something, but also as the relation between a thing and that which stands for or denotes it. We may distinguish between two major types of representations, namely, 'internal' and 'external'. 'External' representations are those material signs or sign systems that are publicly available in the world, whereas mental or 'internal' representations can be understood as what philosophers call the representational content of a certain intention or belief *about* the world. Now what precisely a representation is and what are the neural correlates of such a phenomenon is far from clear. However, according at least to the dominant computational theory of mind, representations are considered to be the very stuff that our mental engines are made of. More precisely, representation is generally recognized as the principal mechanism by which we feed our brains with information *from* the world and by which we externalize our mental contents *into* the world. It is only natural then that for most archaeologists it is this representational function, the 'symbolic function' or 'symbolling', which defines more than anything else what it means to be a modern human cognizer. Language (Deacon 1997), 'What if?' reasoning (Foley 1995), theory of mind (ToM) capacity (Mithen 1998c; 2000; Leslie 1987), imagination (Harris 2000), all those concepts seem to revolve around and are often understood through the representational idiom. And although we may not have reached as yet any particular consensus about exactly *when, why or how* this precious human cognitive capacity first appeared (e.g. d'Errico 2003; d'Errico & Nowell 2000; McBrearty & Brooks 2000; Noble & Davidson 1991; 1996; Deacon 1997; Klein 2000; Mithen 1996; Donald 1991; 1998; Mellars 1989), there seems to be a broad agreement that the early image offers our best evidence for the existence of this representational mechanism that we often construe as the key feature of modern human intelligence. Many researchers, for example, may dispute to what extent the shape of a so-called Acheulean handaxe should be accepted as the first true example of conscious imposition of form rather than the unintended side effect of a reduction sequence (Wynn 2002; Noble & Davidson 1991; 1996; Ingold 1993; McPherron 2000), or to what extent the engraved ochre pieces from the Blombos cave constitute an irrefutable evidence for symbolic behaviour as d'Errico proposes (2003). But when it comes to the images of the Upper Palaeolithic few people will question that human creativity and symbolic capacity have left an incontestable mark in the archaeological record.

So given all that, is it not then, the representational status of the image and its role in the evolutionary trajectory of human cognition that we need, above anything else, to understand? Admittedly placed against the background of the above considerations my suggestion in this paper of approaching the image *before* and *beyond* representation may sound confusing. So before we proceed further I would like to underline some basic points which may help clarify the reasons for proposing this shift and possibly the reception of the arguments to follow:

The thing I should probably underline first is that, despite my anti-representational disposition in this paper, I do not all together deny the representational character of the image. There is no doubt that the image as a material sign can be seen very often to operate as a form of external representation or as a part of a larger representational structure. What I object to in this paper is the exclusive focus on representation that preoccupies the archaeological interpretation of the prehistoric image.

My overall argument in this paper is that approaching imagery, and more specifically imagery

from the Upper Palaeolithic, solely from a representational perspective is not simply to leave several important questions unaddressed but also to be led, very often, to ask the wrong questions about it. This, I argue, is for two main reasons.

1. The first reason has an ontological dimension and relates to my general contention that, what we call representation is not what really matters in the study of the human mind. As I will discuss below, I doubt that the representational path holds the key to unlock the mysteries of human cognitive evolution. Even if I am wrong and representation does hold such a key, I believe it would be the question of meta-representations that we should be focusing upon. In other words, the crucial question in cognitive evolution is not when people started to represent one thing with another, but rather when they become aware of doing so. More specifically in the case of early imagery, it is one thing to say that the people of the Upper Palaeolithic were creating representations — they certainly appear as representations to the modern observer — it is another to say that the Palaeolithic people were aware or knew they were making representations in some arbitrary symbolic sense.

2. The second reason is a methodological one and can be roughly sketched as follows. Whilst it probably makes perfect sense to see the Palaeolithic image as a representation *of* something — from our contemporary habits of seeing and perceiving — to assume uncritically that this was also the way the image was experienced in its original context is to take as our starting point what should have been the end of our analysis. The above can seriously distort our understanding of how the image might have operated as part of a new trajectory of *material engagement* which, we should bear in mind, unfolds in a world that was to a large extent uninitiated to the psychological power of the image. I am not saying that the light projected from such an image in the past would have followed a different path than that of the physiology of our present visual system would allow. What I am saying is that if we could compare our *perceptual experience* of this image, in the present, with that of our Palaeolithic ancestors, in the past, I doubt that we would find much in common. Of course simply to claim that, is not to say much. The question rather is, on the one hand, what might be the feature that distinguishes those different types of perceptual experience, and on the other, how it might be possible to identify such a feature archaeologically?

Working towards an answer to that, I am looking beyond representation because I intend to pursue the cognitive life of images without the usual presumptions about what this cognitive life might have been and through which mechanisms it became enacted. Two major questions then immediately follow: a) What can an image be if not a representation?; and b) What is the human mind if not the familiar 'internal' representational engine? I start with the latter.

Image, material engagement and extended cognition

Elsewhere I have provided a more detailed exposition of my scepticism about the representational or computational thesis that sees on the one hand the relationship between mind and the brain as that between software and hardware, and on the other, understands the essence of human cognition as that of an 'inner' representational engine (Malafouris 2004; 2005; in press; forthcoming; Malafouris & Renfrew forthcoming). Focusing for our present purposes more specifically on the issue of human cognitive evolution my principal concerns amount to the following: I consider representationalism to be inherently misleading in a double sense: 1) it implies that in human cognitive evolution the hardware (biology) drives the software (culture), leading as such to an inherently dualistic conception of the complex co-evolutionary brain-culture spiral that characterizes hominin evolution; 2) it reiterates the myth of the isolated or unaided mind which invites us to think that the cognitive life and efficacy of *things* is that of a disembodied digit of information written somehow on the neural tissue by way of representation.

I believe that things do much more for the mind than what a strictly representational mental engine would allow them — and we should keep in mind that as the psychologist A. As Costall observes '[p]ictures are admittedly unusual kinds of things, but they are nonetheless things like everything else' (1997, 57). Although the human mind may well possess the capacity to represent the world, the cognitive efficacy of material culture lies primarily in the fact that it makes it possible for the mind to operate without having to do so, that is, to think through things in action without the need of mental representation (Malafouris 2005, 58; see also Brooks 1991; van Gelder 1995). What this hypothesis of the constitutive intertwining of cognition with material culture (cf. also the hypothesis of extended cognition: Clark & Chalmers 1998) implies, among many other things, is that as embodied beings we engage with the world and our cognitive capabilities emerge out of this interaction. As such if internal representations do exist they should be understood as dynamic and action-specific emergent structures rather than as 'passive recapitulations of external

reality' (Clark 1997, 51; 2003). Cognition, perception and action arise together, dialectically forming each other. Placed against an evolutionary background the hypothesis of extended mind raises the following possibility: that the intelligent use of material culture precedes intelligent thinking, or more precisely for our purposes in this paper, that symbolic usage of material culture precedes symbolic thinking. Put it in simple terms, the tool is often smarter than the toolmaker and can be sown in time to posses a mind of its own. Or as the philosopher Daniel Dennet suggests in his *Kinds of Minds*

> tool use is a two-way sign of intelligence: not only does it *require* intelligence to recognize and maintain a tool (let only fabricate one) but a tool *confers* intelligence on those lucky enough to be given one (1996, 99–100).

But let us now unfold the significance of the above premises in relation to the first of our previously stated questions: What can an image possibly be if not representation?

Generally speaking, following the usual semiotic avenue, the image can be understood in two major respects; on the one hand we have the obvious Peircian (1955) sense of an *icon*, namely, a 'motivated' sign that operates through some sort of visual resemblance. On the other, we have the 'arbitrary' sense of a *symbol*, that is, a signifier that operates via convention. In this latter case the image is taken to embody a sort of visual code or language and thus invites reading. Indeed according to Mithen (1996, 181) there are at least three mental attributes involved in creating and reading the images of the Upper Palaeolithic: 1) planning and execution of a preconceived mental template; 2) intentional communication; and 3) the attribution of arbitrary meaning. To give another example of the above general line of thinking according to Lewis-Williams a 'pre-existing symbolic vocabulary' must have been certainly in place at the time when Upper Palaeolithic people made those images: 'There must ... have been a socially accepted set of zoomorphic mental images *before* people began to make representational images of them' (2003, 266).

Indeed, confronting the striking naturalism of the cave images of Franco-Cantabrian art one is prompted to infer that the mind of the image-maker must certainly have possessed the capacity for retaining in his working memory an image of the creature he was going to depict on the walls of the cave. This capacity for seeing in 'the mind's eye', or what we generally refer to as imagination, must certainly have been in place. But does this imply — to use Lewis-Williams's term (2003, 266; 2002) — an 'already-existing mental symbology'?

I believe that this question should be answered in the negative, in spite the existence of a general consensus in archaeology that supports the opposite opinion. However, let me clarify that it is not the *iconicity* of those images that I am disputing here. No doubt the two rhinoceroses from the Panel of the Horses from Chauvet (Fig. 21.1) 'look like' the animals we know, as is also the case with the majority of animal drawings from this cave. I simply believe that to say that a painting from Chauvet 'resembles', or 'looks like', a rhinoceros, a horse or a bull, does not necessarily imply that these paintings also 'represent' those animals in a concept-mediated referential manner. Iconicity does not in itself imply the existence of consciously manipulable content-bearing tokens, though it certainly sets up, as I will argue bellow, a visually stimulating channel of influence for their creation. I am not questioning the existence of some sort of 'basic level' perceptual categories about those animals. What I am questioning is the prevalent tendency to regard Palaeolithic drawings as the equivalent of 'linguistic signs' and thus as parts of a larger symbolic system in use among the Palaeolithic people which we can decode by looking at the formal, spatial or thematic relationships between the images. No doubt, to depict a living creature on the walls of a cave in such an executive naturalistic manner is an extremely difficult task. However, there is no symbolic or linguistic prerequisite criterion for the accomplishment of this task, no need for a modern 'fully equipped' representational mental engine. What is needed instead is acute perceptual training and sensorimotor co-ordination of an unprecedented type. One needs the ability to attend and retain in one's memory the exact physical characteristics of the features one is portraying. One needs to control the succession of strokes that will generate form and contour. One needs to understand metric proportions, the modulations of colour, and the surrogate function of lines that create the appearance of form. These are the truly significant puzzles concerning the cognitive and perceptual foundation of the Palaeolithic image that we need to solve, and not their symbolic function.

To this end, instructive lessons can be derived from at least three different directions:

1. We have developmental studies with young children which clearly indicate that having identified the pictorial content of an image does not necessary mean that you have also identified the relation of this image with the world (Costall 1997, 56; 1989; 1990). For example when nine-month-old-infants are presented with books containing highly realistic pictures of individual objects and toys they do not simply look at them but engage in all sorts

of exploratory behaviours with them (e.g. manual exploration like feeling, rubbing or striking the picture surface, or even at times grasping the pictures as if trying to pick up the depicted objects). The infants' appreciation of symbolic relations — that is, of a signified as representing something other than itself — emerges gradually in child development. It is only around 18 months of age, and after extensive engagement with pictures, that children are able to point and talk about pictured objects as 'other than itself', that is treat pictures symbolically, as objects primarily of communication rather than action. Infants have to learn through experience that for example 'a depicted toy cannot be picked up and milk cannot be obtained from a photograph of a cup' (DeLoache 2004, 68; DeLoache *et al.* 1998). In fact, the more a depicted object looks like a real object, the more infants explore it.
2. Then, we have the semiology of neuropathologies — especially Autism Spectrum Disorders (ASD) — such as the famous case study of a four-year-old autistic savant, Nadia — a severely retarded girl who had virtually no language and no ability to think conceptually. The case of Nadia's drawings, as discussed by Nicholas Humphrey in 'Cave art, autism and the evolution of the human mind' (Humphrey 1998), reveal that graphic skills like those we see in cave art do not necessarily imply a representational mind endowed with the sophisticated capacities of symbolization, language and communication as it is often assumed (Humphrey 1998). The surprising fact, as noted by Humphrey, is that drawings of this quality are never produced by untrained artists today unless they are autistic, which may point to, among other things, the possibility that the ice-age artists themselves may have been operating at a pre-linguistic non-conceptual level.
3. As both the history and the anthropology of the image have often pointed out: even in those well-testified cases where a representational or symbolic relationship can safely account both for the question 'What is this an image *of*?' and for the question 'What is this an image *for*?' this remains a relationship that cannot fully encompass the cognitive biography and dynamic of the image as a material sign and thus it should not lead us, or be used as a basis for, further unwarranted abstractions and generalizations about its meaning (e.g. Steiner 1998). Images do not simply possess semiological qualities to be interpreted, but an agency potential to be abducted (Gell 1998).

The question thus emerges: If the conventional signifier/signified relationship, that defines an image as an object and 'imaging' as a process, is not one of representation, then how else can it be construed? A good starting point for answering this question can be found in the following suggestion from the anthropologist Tim Ingold: those activities, the products of which a modern Western observer may unproblematically identify as representational art, in a non-modern context may well be 'understood as ways, not of representing the world of immediate experience on a higher, more "symbolic" plane, but of probing more deeply into it and of discovering the significance that lies therein' (1998, 183). But to what precisely does this 'probing' or 'discovering' amount to in the case of Palaeolithic imagery?

The enactive logic of imaging

As discussed previously, the hypothesis of extended cognition material culture as a *tool for thinking* is not simply an expression of intelligent behaviour but very often the necessary condition for the emergence of such behaviour. To describe the semiotic dimensions of this operation, I have introduced elsewhere the notion of 'enactive signification'. This 'enactive conception' derives primarily from the work of Maturana and Varela (Maturana & Varela 1980; Varela *et al.* 1991) where it denotes their conception of mind as action structurally coupled in a network of ongoing interactions. My own use of enactive signification refers to a process of embodied 'conceptual integration' (Fauconnier & Turner 1998; 2002) responsible for the co-substantial symbiosis and simultaneous emergence of the signifier and the signified that *brings forth* the world (Malafouris 2005, ch. 3).

To illustrate what this means a good example to consider is the relationship between counting, fingers and clay tokens (Malafouris forthcoming). From a representational perspective counting is essentially an innate biological capacity of the human brain. Counting with the fingers or with clay tokens is an expression of this capacity in material form. However from an enactive perspective things appear rather different. What in the representational account is understood as an externalization of mental content, that is, numerical concepts are represented in material form, from an enactive view is more of a dense structural coupling between the supposedly 'internal' and 'external' domains of the human conceptual map. More specifically, counting with the fingers or with clay tokens is an integrative projection between mental — the basic biological approximate 'number sense' (Dehaene 1997) — and physical — e.g. fingers or clay tokens — domains of experience. It is the resulting structural coupling or blend that brings about

the possibility of the meaningful cognitive operation we know as counting and not some innate biological capacity of the human brain. What essentially happens according to the enactive scenario, put in very simple terms, is that the vague structure of a very difficult and inherently meaningless conceptual problem, i.e. counting, by being integrated via projection with the stable material structure of fingers and clay tokens, is transformed into an easier perceptual problem. However, perceptual problems embody a spatial logic and as such can be directly manipulated and resolved in real time and space. Thus the problem (i.e. counting) becomes meaningful, and I want to suggest that when a problem becomes meaningful a material sign has already emerged. The fingers do not 'stand-for' numbers, as it may seem, the fingers *bring forth* the concept of numbers by making visible and tangible the manipulation of their properties.

My suggestion is that it is precisely such an enactive 'bringing forth' that characterizes above anything else the cognitive life of the Palaeolithic image. In other words, I propose that images like the ones we see, already 30,000 years before present, at the caves of Chauvet and Lascaux *before* and *beyond* representing the world they first *bring forth* a new process of acting within this world and at the same time of thinking about it. This thinking however, should not be understood — at least not in the first instance — as that of the 'higher level' abstract or symbolic type. This thinking should be understood in the more basic 'lower level' sense, namely, as a new form of active sensorimotor engagement (O'Regan 1992; O'Regan & Noë 2001; Noë 2005; Hurley 1998). It should be understood as a new form of perceptual learning on a par with the 'bringing forth' or 'bringing out' of a figure by embellishing the natural formation of the rock. Or, alternatively, a practice-induced change in the human ability to perform certain 'unnatural' perceptual tasks.

By taking such a stance on the issue of the Palaeolithic image, it does not mean of course that we can now answer all the difficult questions related to the visual experience and constitution of early imagery. However, what I want to suggest is that such an approach does offer us is an escape route from having to postulate 'magical mechanisms' and internally driven biological mutations to account for the emergence of the image. This sensorimotor account has two major implications. The first is that it enables us to understand seeing and perceiving as a form of 'skillful interactive engagement', as a form of acting in the world rather than as a form of representing the world:

> under the present theory, visual experience does not arise because an internal representation of the world is activated in some brain area. On the contrary, visual experience is a mode of activity involving practical knowledge about currently possible behaviors and associated sensory consequences. Visual experience rests on know-how, the possessions of skills. Indeed, there is no 're' — presentation of the world inside the brain: the only pictorial or 3D version required is the real outside version. What *is* required, however, are methods for probing the outside world — and visual perception constitutes one mode via which it can be probed (O'Regan & Noë 2001, 946).

Turning now to the second and correlated implication, this is that once we recognize visual perception as a mode of probing the outside world rather than representing it, then we may well also conceive the role of the Palaeolithic image as a continuous prosthetic part of this probing mechanism and thus a cultural extension of the visual brain. What this means is that the image instead of being the product of some 'hard-wired' cognitive ability that, for example, the Neanderthal brain was lacking, it should now be seen as the extended part of a new cognitive strategy. We should approach 'imaging', in other words, as the sort of activity that Kirsh & Maglio (1994) term 'epistemic actions': namely, actions whose purpose is not to alter the world so as to advance physically toward some goal but rather to alter the world so as to help make available information required as part of a problem-solving operation. Elsewhere I discuss how such a problem-solving operation can be understood in the context of early religious thinking (Malafouris in press). For our present purposes I want to explore more specifically the possible effect of the image at the level of perceptual experience. My main argument consists of two major premises. The first is that the cognitive and neurophysiological requirements for the perception and creation of these images does not differ from that of ordinary object recognition (see also Halverson 1992a, 402) and as a result no additional hard-wired cognitive requirement is needed to account for their origin. The second is that although no symbolic cognitive requirement is needed, the emergence of the image made possible a new special kind of perception of the world not previously available. The implication of the latter is that the question to ask about Palaeolithic imagery is not 'What kind of mind was needed to made those images?' but instead 'What kinds of minds are constructed by perceiving those images?'.

To better understand the above we need to understand the Palaeolithic image as a perceptual device and the key question to ask to this end is the following: Why does a Palaeolithic image look the way it does? How do lines of pigment depict anything? Answering this basic question will not help us understand

Chapter 21

Figure 21.3. *Major perceptual features of Palaeolithic imagery. The panel of the horses, Chauvet Cave, France. (Re-drawn after Fritz & Tosello 2007, fig. 20.)*

what those images mean, but it will certainly help us understand *how* they mean. So let us review some of the most salient perceptual features. In the following sections, I shall be drawing primarily on the work of Halverson (1992a&b).

Pictorial outline
It is generally agreed that cave art is overwhelmingly animal art (with only a few human or human-like images depicted in a different schematic form, and some geometric motifs), and there is a wealth of studies attempting to discern the possible patterns and messages behind the observed groupings and frequencies of animal species depicted. However, one element of vital significance that is often taken for granted is the fact 'above all, Palaeolithic art is an art of outline' (Halverson 1992a, 390) (Fig. 21.3). Although exceptions do occur, as in the famous polychrome figures of Altamira and Lascaux, most of the images, engravings in particular, are of simple outline.

The majority of animal figures are portrayed in profile, often 'strict' profile (only two legs showing) and, as I will discuss below, from a 'canonical' perspective. This is very important because, especially in the absence of background, as is the case with cave art, the silhouette outline of an animal displays the animal's distinguishing characteristics of form and thus it is 'as recognizable as the fully illuminated creature — in some circumstances even more so'. As Halverson comments:

> The pictorial outline abstracts from the silhouette its only signifying feature, its occluding edge ... Thus, although an unnatural artefact, the pictorial outline successfully exploits a fundamental component of natural object perception (1992, 391).

'Occlusive overlap' is also very frequent (especially in the depiction of the legs of a single animal). And the same applies to 'superpositioning', where one figure is drawn over another without any regard to visual occlusion, and also to 'partial' or 'abbreviated' depiction (e.g. heads without bodies, a few lines depicting the outline of head and back or a part of the legs).

Canonical perspective and diagnostic features
Given that different perspective views present different information about any individual object, the view containing the most information should be maximally recognizable. This 'best' or 'most' typical perspective view of an object is called the 'canonical perspective'. Canonical perspectives should be the ones that are most easily identified and categorized as perceptual instances of the object depicted. This implies that there must be also an angle view which depicts any given object in an orientation which contains the

Figure 21.4. *Canonical perspective. (Adapted and re-drawn from Palmer et al. 1981, fig. 2 and Fritz & Tosello 2007, fig. 21.)*

most canonical and diagnostic features necessary for the recognition of this object. This is a premise that resonates well both with what Merleau-Ponty in his phenomenology of perception defines as the 'maximum grip' (1962) as well as with the Gibsonian notion of affordances (1979). Characteristic in this respect is the study of Palmer *et al.* (1981) which set out to investigate the hypothesis that our knowledge of an object and as such our ability to identify and classify that object is maximally accessible from a privileged or 'canonical' perspective. In their experiment a series of photographs of common objects were shown to various subjects, who were asked, in the first stage, to rate them for *typicality* or 'goodness rating' (that is, how perceptually familiar and accessible they might seem), and in the second stage to identify the object as rapidly as possible. Not surprisingly, the reaction times correlated with the rated *typicality* of the object. Of important note for our present purposes in this paper is the example of a horse figure presented in twelve different perspectives. At the top left corner of Figure 21.4 one can see two of the most rapidly identified views of the horse image, with BC representing the 'best canonic' perspective, that is, the one most rapidly identified. While in the top right corner of Figure 21.4 one can see a selection of images among the less canonical views which took the subjects much longer to identify. Various explanations can be brought to bear to account for this phenomenon but what is important to emphasize in the context of our present discussion is that non-canonical depictions not only are totally absent from Palaeolithic depiction, but importantly, that most depictions present a consistent preference towards best canonical profile views (Fig. 21.4). Indeed, the two highest-rated views in the above experiment, i.e. slightly angled and full profile, closely correspond to the prevalent tendency in Palaeolithic depiction. This indicates that the persons which produced those images strongly favoured canonical perspective for its ability to embody the maximum perceptual information content (Halverson 1992a, 402). In other words, the immediate concern seems to be with maximizing perceptual identification rather than the reading of some more elaborate cultural message. A far more elementary intention of permitting easy recognition of the subjects depicted seems to be at work here, and the extensive use of, simplification and accentuation of 'salient' or 'diagnostic' features, such as animal horns or the use of 'twisted perspective' (i.e. when for example the horns of an animal are shown from the front in a profiled figure), further testify to that.

Gestalt principles

The psychology of perception tells us that a great deal of our ordinary ability to identify patterns and objects in the world can be accounted for by way of some basic principles of perceptual organization. These principles are also known as perceptual Gestalts such as those of proximity, similarity, good continuation, closure, figure/ground etc. (Wertheimer 1938; Koffka 1935; Ellis 1938; Kanizsa 1979) (Fig. 21.6). These are 'basic level' properties of the visual system through which sensations acquire order and meaning and which figure prominently both in the so-called 'direct' and the 'indirect' schools of human perception (Gibson 1966; 1979; Gregory 1990; Marr 1982). What is important to note for our present purposes, however, is the following: although ordinarily we experience the world without having any awareness about the influence that these basic properties exert on our visual apparatus, it is possible, that these implicit properties, if properly materialized can become themselves the object of human perception and thus revealed to us in a conscious way. Consider for example the principle of proximity. Proximity is perhaps the most fundamental of the Gestalt grouping laws, one to which, as many studies suggest (Kubovy & Holcombe 1998), the human visual system is extremely sensitive. What this principle states, in brief, is that visual features of an image that are close together tend to be associated. At the neurological level the processes responsible for this reaction are ones that occur automatically somewhere between the image and the primary visual cortex — their precise location varies according to which school of perception ('direct' or 'indirect') you follow. Nevertheless, although we are not aware of the underlying processes we are certainly aware of their results, and what those results are telling us is how to segment our visual field. If however, we attempt to illustrate this proximity principle on paper using a series of parallel dots, like the ones presented in Figure 21.5, we almost immediately acquire a genuine conscious understanding about what the operation of this principle might be. It is almost as if something of the workings of our own mind is magically revealed in front of our eyes. In some sense, we gain a new perceptual awareness about the hidden operations of our own vision.

Final discussion

Perhaps, by way of conclusion, a useful analogy can be drawn: where the toolmaker brings forth the possibility of a new form of tactile thinking, the image-maker brings forth the possibility of a new form of visual thinking. As the liberation of the prehensile

Figure 21.5. *The principle of proximity is responsible for seeing in (a) a series of horizontal parallel lines of dots; and in (b) a series of vertical parallel lines of dots.*

hand from the requirements of locomotion allowed it to become a privileged interface between the organism and its physical environment, so it seems to me that the liberation of sight from its ordinary experiential requirements, in the case of the Palaeolithic image, allowed the eye to gradually become the privileged interface of human perceiving. To appreciate this point better one should bear in mind that as the psychologist Gibson observed, our visual system has arms and legs, it has evolved so as to visually engage the world, not pictures (Costall 1997, 50). Pictures, objectively considered, are 'thoroughly unnatural, especially outline depictions' (Halverson 1992, 390). In other words, the effected 'liberation of sight' emanates from the unique ability of the image to disrupt or question the ways the world is experienced under normal conditions. By that I do not mean that the image impinges upon the retina of the visual system in a different way from that in which the rest of the world does. What I suggest is, that the image makes it possible for the visual apparatus to interrogate itself and thus acquire a sense of perceptual awareness not previously available. The image, as Gibson observed, 'freezes' some of the structure available in the 'optic array' (for a detailed discussion see Costall 1990). This mediating perceptual role that every image embodies is precisely the feature that the image shares, according to Gibson, with indirect perception. Thus the key question that confronts us in the case of the Palaeolithic image is not whether it signifies the sudden cognitive origin of such a mediating or symbolic mechanism. The crucial question, I want to suggest is rather, to what extent this symbolic mediating mechanisms of indirect perception could have emerged or developed in the absence of the image itself. It is the latter that constitutes my working hypothesis in this paper. In particular I propose that the principal role of early imagery in the

Figure 21.6. *Major perceptual Gestalts. The panel of the horses, Chauvet Cave, France. (Re-drawn after Fritz & Tosello 2007, fig. 20.)*

context of human cognitive evolution was to provide a scaffolding device that enabled human perception gradually to become aware of itself. The previously discussed major perceptual characteristics of the Palaeolithic image, such as the outline style and the extensive use of basic gestalts, occluding contours, and canonical perspectives (e.g. Clottes 1996; Deregowski 1995; Halverson 1992a,b; Kennedy & Silver 1974) (Fig. 21.6), testify to this process of creative engagement and of sensory learning.

Those features offer us some of the earliest examples of those key moments in the engagement of mind with the world in which structures of mind meet and identify with structures imposed on materiality. Such a meeting must have had some very important cognitive consequences because it is in cases like these that early humans most probably began to expand and explore their own minds as perceptual systems. Through the process of 'imaging' the underlying mechanisms of human perception are being transformed to an object *for* perception and contemplation. Those invisible mechanisms become now perceivable visual patterns arrayed and combined in real time and space. In this sense, the image offers a new mode of epistemic access to the world of visual experience.

In this regard it can be argued that, in constructing images, the Palaeolithic person was not simply externalizing the contents of their mind but was exercising once more what they could do better than any other species: the ability to construct external patterns for sensorimotor engagement and let the resulting dense and reciprocal mind/world interaction 'bring forth' their perceptual and experiential content. In other words, the role of the image in the drama of human cognitive evolution was not to provide the static scenery for a 'Cartesian theatre' (Dennett 1995). The role of the image was that of an active material agent. The image was an active part of the world it often represented. The boundary between the 'internal' concept seen in 'the mind's eye' and its external representation on the wall of the cave should be questioned. The cave wall was not simply a 'context' for the 'mind inside the head', it was the outward membrane of the 'mind inside the cave'.

The Palaeolithic image-maker constructs an external scaffold that affords the world to be seen and experienced in ways that the physiology of the

naked eye by itself does not allow. This scaffolding also enables a new direct understanding of the human perceptual system and thus offers to the Palaeolithic individual the opportunity to become in some sense, maybe for the first time, the engineer of his or her own perception. The image, as it is also the case with language, enabled humans *to think about thinking*. Once that happens than this basic scaffolding role of the image withdraws and higher (representational) functions for the image can now be introduced.

References

Bar-Yosef, O., 2002. The Upper Paleolithic revolution. *Annual Review of Anthropology* 31, 363–93.

Brooks, R.A., 1991. Intelligence without representation. *Artificial Intelligence* 47, 39–59.

Clark, A., 1997. *Being There: Putting Brain, Body and World Together Again*. Cambridge (MA): MIT Press.

Clark, A., 2003. *Natural-Born Cyborgs: Minds, Technologies and the Future of Human Intelligence*. New York (NY): Oxford University Press.

Clark, A. & D. Chalmers, 1998. The extended mind. *Analysis* 58(1), 10–23.

Clottes, J., 1996. Thematic changes in Upper Palaeolithic art: a view from the Grotte Chauvet. *Antiquity* 70, 276–88.

Clottes, J. (ed.), 2001. *La Grotte Chauvet*. Paris: L'art Des Origines, Editions du Seuil.

Clottes, J. & J.D. Lewis-Williams, 1998. *The Shamans of Prehistory: Trance and Magic in the Painted Caves*. New York (NY): Harry Abrams.

Costall, A., 1989. A closer look at 'direct perception', in *Cognition and Social Worldseds*, eds. A. Gellatly, D. Rogers & J.A. Svoboda. Oxford: Clarendon Press, 10–21.

Costall, A., 1990. Picture perception as 'indirect' perception, in *Ecological Perception Research, Visual Communication and Aesthetics*, ed. K. Landwehr. New York (NY): Springer-Verlag, 15–22.

Costall, A., 1997. Things and things like them, in *The Cultural Life of Images*, ed. B.L. Molyneaux. London & New York (NY): Routledge, 49–59.

Davidson I. & W. Noble, 1989. The archaeology of perception. *Current Anthropology* 30(2), 125–55.

Deacon, T.W., 1997. *The Symbolic Species: the Co-evolution of Language and the Brain*. New York (NY): Norton.

Dehaene, S., 1997. *The Number Sense*. New York (NY): Oxford University Press.

DeLoache, J., 2004. Becoming symbol-minded. *Trends in Cognitive Sciences* 8(2), 66–70.

DeLoache, J., S.L. Pierroutsakos, D.H. Uttal, K.S. Rosengren & A. Gottlieb, 1998. Grasping the nature of pictures. *Psychological Science* 9, 205–10.

Dennett, D., 1995. *Darwin's Dangerous Idea*. New York (NY): Simon & Schuster.

Dennett, D., 1996. *Kinds of Minds*. New York (NY): Basic Books.

Deregowski, J.B., 1995. Perception-depiction-perception, and communication. *Rock Art Research* 12, 3–22.

Donald, M., 1991. *Origins of the Modern Mind: Three Stages in the Evolution of Culture and Cognition*. Cambridge (MA): Harvard University Press.

Donald, M., 1998. Material culture and cognition: concluding thoughts, in *Cognition and Material Culture: the Archaeology of Symbolic Storage*, eds. C. Renfrew & C. Scarre. (McDonald Institute Monographs.) Cambridge: McDonald Institute for Archaeological Research, 181–7.

Ellis, W.H., 1938. *Sourcebook of Gestalt Psychology*. London: Routledge & Kegan Paul.

d' Errico, F., 1995. New model and its implications for the origin of writing: La Marche antler revisited. *Cambridge Archaeological Journal* 5(1), 3–46.

d' Errico, F., 1998. Paleolithic origins of artificial memory systems, in *Cognition and Material Culture: the Archaeology of Symbolic Storage*, eds. C. Renfrew & C. Scarre. (McDonald Institute Monographs.) Cambridge: McDonald Institute for Archaeological Research, 19–50.

d'Errico, F., 2003. The invisible frontier: a multiple species model for the origin of behavioral modernity. *Evolutionary Anthropology* 12, 188–202.

d'Errico, F. & A. Nowell, 2000. A new look at the Berekhat Ram figurine: implications for the origins of symbolism. *Cambridge Archaeological Journal* 10(1), 123–67.

Dehaene, S., 1997. *The Number Sense*. New York (NY): Oxford University Press.

Fauconnier, G. & M. Turner, 1998. Conceptual integration networks. *Cognitive Science* 22(2), 133–87.

Fauconnier, G. & M. Turner, 2002. *The Way We Think: Conceptual Blending and the Mind's Hidden Complexities*. New York (NY): Basic Books.

Foley, R.A., 1995. *Humans Before Humanity: an Evolutionary Perspective*. Oxford: Blackwell Publishers.

Forge, A., 1970. Learning to see in New Guinea, in *Socialization: the Approach from Social Anthropology* ed. P. Mayer. New York (NY): Tavistock, 269–99.

Fritz C. & G. Tosello, 2007. The hidden meaning of forms: methods of recording Paleolithic parietal Art. *Journal of Archaeological Method and Theory* 14(1), 48–80.

van Gelder, T., 1995. What might cognition be, if not computation? *Journal of Philosophy* XCII(7), 345–81.

Gell, A., 1998. *Art and Agency: an Anthropological Theory*. Oxford: Oxford University Press.

Gibson, J.J., 1966. *The Senses Considered as Perceptual Systems*. Boston (MA): Houghton Mifflin.

Gibson, J.J., 1979. *The Ecological Approach to Visual Perception*. Boston (MA): Houghton Mifflin.

Grainer, J. & C. Whitney, 2004. Does the Huamn mind raed words as a wlohe? *Trends in Cognitive Sciences* 8(2), 58–9.

Gregory, R.L., 1980. Perceptions as hypotheses. *Philosophical Transactions of the Royal Society B* 290, 181–97.

Gregory, R.L., 1990. *Eye and Brain: the Psychology of Seeing*. Oxford: Oxford University Press.

Gregory, R.L., 2005. Knowledge for vision: vision for knowledge. *Philosophical Transactions of the Royal Society B* 360, 1231–51.

Halverson, J., 1992a. The first pictures: perceptual foundations of Palaeolithic art. *Perception* 21, 389–404.

Halverson, J., 1992b. Paleolithic art and cognition. *The Journal of Psychology* 126(3), 221–36.

Harris, P., 2000. *Work of the Imagination*. Oxford: Blackwell Publishers.
Hoffman, D.D., 1998. *Visual Intelligence: How We Create What We See*. New York (NY): Norton.
Humphrey, N., 1998. Cave art, autism, and the evolution of the human mind. *Cambridge Archaeological Journal* 8(2), 165–91.
Hurley, S.L., 1998. *Consciousness in Action*. Cambridge (MA): Harvard University Press.
Hutchins, E., 2005. Material anchors for conceptual blends. *Journal of Pragmatics* 37, 1555–77.
Ingold, T., 1993. Introduction: tools, techniques and technology, in *Tools, Language and Cognition in Human Evolution*, eds. K. Gibson & T. Ingold. Cambridge: Cambridge University Press, 337–45.
Ingold, T., 1998. Totemism, animism, and the depiction of animals, in *Animal, Anima, Animus*, eds. M. Seppala, J.P. Vanhala & L. Weintraub. Pori: Frame/Pori Art Museum, 181–207.
Kanizsa, G., 1979. *Organisation of Vision: Essays on Gestalt Perception*. New York (NY): Praegervon.
Kennedy, J.M. & J. Silver, 1974. The surrogate functions of lines in visual perception: evidence from antipodal rock and cave artwork sources. *Perception* 3, 313–22.
Kirsh, D. & P. Maglio, 1994. On distinguishing epistemic from pragmatic action. *Cognitive Science* 18, 513–49.
Klein, R., 2000. Archeology and the evolution of human behavior. *Evolutionary Anthropology* 9, 17–36.
Koffka, K., 1935. *Principles of Gestalt Psychology*. New York (NY): Harcourt, Brace, & World.
Kubovy, M. & A.O. Holcombe, 1998. On the lawfulness of grouping by proximity. *Cognitive Psychology* 35, 71–98.
Leslie, A., 1987. Pretense and representation: the origins of 'theory of mind'. *Psychological Review* 94, 412–26.
Lewis-Williams, D., 2002. *The Mind in the Cave: Consciousness and the Origins of Art*. London: Thames & Hudson.
Lewis-Williams, D., 2003. Overview (in review feature): 'The Mind in the Cave: Consciousness and the Origins of Art'. *Cambridge Archaeological Journal* 13(2), 263–79.
Malafouris, L., 2004. The cognitive basis of material engagement: where brain, body and culture conflate, in *Rethinking Materiality: the Engagement of Mind with the Material World*, eds. E. DeMarrais, C. Gosden & C. Renfrew. (McDonald Institute Monographs.) Cambridge: McDonald Institute for Archaeological Research, 53–62.
Malafouris, L., 2005. Projections in Matter: Material Engagement and the Mycenaean Becoming. Unpublished PhD dissertation, Cambridge University.
Malafouris, L., in press. The sacred engagement: outline of a hypothesis about the origin of human 'religious intelligence', in *Cult in Context* eds. D. Barrowclough, C. Malone & S. Stoddart. Oxford: Oxbow Books.
Malafouris, L., forthcoming. Grasping the concept of number: how did the sapient mind move beyond approximation?, in *Measuring the World and Beyond: the Archaeology of Early Quantification and Cosmology*, eds. C. Renfrew & I. Morley. (McDonald Institute Monographs.) Cambridge: McDonald Institute for Archaeological Research.
Malafouris, L. & C. Renfrew (eds.), forthcoming. *The Cognitive Life of Things: Recasting the Boundaries of the Mind*. (McDonald Institute Monographs.) Cambridge: McDonald Institute for Archaeological Research
Marr, D., 1982. *Vision*. New York (NY): W.H. Freeman & Sons.
Marshack, A., 1990. Early hominid symbol and evolution of the human capacity, in *The Emergence of Modern Humans*, ed. P. Mellars. Edinburgh: Edinburgh University Press, 457–98.
Maturana, H.R. & F.J. Varela, 1980. *Autopoiesis and Cognition: the Realization of the Living*. Dordrecht: Reidel.
McBrearty, S. & A. Brooks, 2000. The revolution that wasn't: a new interpretation of the origin of modern human behavior. *Journal of Human Evolution* 39(5), 453–563.
McPherron, S.P., 2000. Handaxes as a measure of the mental capabilities of early hominids *Journal of Archaeological Science* 27, 655–63.
Mellars, P., 1989. Major issues in the emergence of modern humans. *Current Anthropology* 30, 349–85.
Mellars, P., 1991. Cognitive changes and the emergence of modern humans in Europe. *Cambridge Archaeological Journal* 1(1), 63–76.
Mellars, P., 1996a. *The Neandertal Legacy: an Archaeological Perspective from Western Europe*. New Jersey (NJ): Princeton University Press.
Mellars, P., 1996b. Symbolism, language, and the Neanderthal mind, in *Modelling the Early Human Mind*, eds. P. Mellars & K. Gibson. (McDonald Institute Monographs.) Cambridge: McDonald Institute for Archaeological Research, 15–32.
Merleau-Ponty, M., 1962. *Phenomenology of Perception*. London: Routledge & Kegan Paul.
Mithen, S., 1996. *The Prehistory of Mind*. London: Thames & Hudson.
Mithen, S., 1998a. Introduction, in *Creativity in Human Evolution and Prehistory*, ed. S. Mithen. London & New York (NY): Routledge, 1–15.
Mithen, S., 1998b. Introduction, in *Creativity in Human Evolution and Prehistory*, ed. S. Mithen. London & New York (NY): Routledge, 1–15.
Mithen, S. 1998c. A creative explosion? Theory of mind, language and the disembodied mind of the Upper Palaeolithic, in *Creativity in Human Evolution and Prehistory*, ed. S. Mithen. London & New York (NY): Routledge, 165–91.
Mithen, S., 2000. Palaeoanthropological perspectives on the theory of mind, in *Understanding Other Minds: Perspectives from Autism and Cognitive Neuroscience*, eds. S. Baron-Cohen, H.T. Flusberg & D. Cohen. Oxford: Oxford University Press, 488–502.
Noble, W. & I. Davidson, 1991. The evolutionary emergence of modern human behaviour: language and its archaeology. *Man* 26, 223–53.
Noble, W. & I. Davidson, 1996. *Human Evolution, Language and Mind: a Psychological and Archaeological Inquiry*. Cambridge: Cambridge University Press.
Noë, A., 2005. *Action in Perception*. Cambridge (MA): MIT Press.
O'Regan, J.K., 1992. Solving the 'real' mysteries of visual

perception: the world as an outside memory. *Canadian Journal of Psychology* 46(3), 461–88.

O'Regan, J.K. & A. Noë, 2001. A sensorimotor appraoch to vision and visual perception. *Behavioral and Brain Sciences* 24(5), 939–73.

Palmer, S.E., E. Rosch & P. Chase, 1981. Canonical perspective and the perception of objects, in *Attention and Performance* IX, eds. J. Long & A. Baddeley. Hillsdale (NJ): Erlbaum, 135–51.

Peirce, C.S., 1955. *Philosophical Writings of Peirce*, ed. B. Justus. New York (NY): Dover Publications.

Renfrew, C., 2001a. Symbol before concept, material engagement and the early development of society, in *Archaeological Theory Today,* ed. I. Hodder. Cambridge: Polity Press, 122–40.

Renfrew, C., 2001b. Commodification and institution in group-oriented and individualizing societies. *Proceedings of the British Academy* 110, 93–117.

Renfrew, C., 2004. Towards a theory of material engagement, in *Rethinking Materiality: the Engagement of Mind with the Material World,* eds. E. DeMarrais, C. Gosden & C. Renfrew. (McDonald Institute Monographs.) Cambridge: McDonald Institute for Archaeological Research, 23–31.

Solso, L.R., 1994. *Cognition and the Visual Arts*. Cambridge (MA) & London: MIT Press.

Steiner, D.T., 1998. *Images in the Mind: Statues in Archaic and Classical Greek Literature and Thought*. Princeton (NJ) & Oxford: Princeton University Press.

Varela, F.J., E. Thompson & E. Rosch, 1991. *The Embodied Mind: Cognitive Science and Human Experience*. Cambridge (MA): MIT Press.

Wertheimer, M., 1938. Laws of organization in perceptual forms, in *A Sourcebook of Gestalt Psychology*, ed. W.D. Ellis. London: Routledge & Kegan Paul, 71–88. [First published 1923, in *Psychol. Forschung* 4, 301–50.]

Wittgenstein, L., 1953/1958. *Philosophical Investigations*. 3rd edition. Oxford: Blackwell.

Wynn, T., 2002. Archaeology and cognitive evolution. *Behavioral and Brain Sciences* 25, 389–403.

Chapter 22

A Note on Representations and Archaeology: Evolution and Interpretation

Evangelos Kyriakidis

It is the aim of this paper to make a small contribution to the greatly debated topic of representations and their role in archaeology. It explores how neither the creation nor the perception of representation necessarily involves high-level 'thinking', with two interesting repercussions for the study of representations in archaeology. Firstly, the representational capacity *per se* is not the result of a major stage in human evolution. Secondly, this illuminates how it comes to pass that a great number of (archaeological) interpretations — though not necessarily wrong — may not have been intended by the authors of the respective representations.

Semiotic representations

As we shall be talking of representation we must make clear that we are talking of semiotic representations, which are quite similar to the use of the word in some philosophical traditions, though not all. The use of the phrase 'semiotic representation' that we shall be making in this paper, can, be *iconic, indexical or symbolic* (Sebeok 1994; see also Morley this volume; Joyce this volume). In fact every representation can function in all these ways depending on the agent (if there is one), the thing represented, the thing representing, the receiver (or audience — if there is one) and the context (time, space, history). For example a picture of a bearded head with a pipe can be an icon[1] (or one-to-one representation) of a bearded head with a pipe, an index (partial representation) of a smoking man and may be a symbol (having nothing or very little in common with its denotatum) of a men's lavatory. This picture may simultaneously have all these 'meanings' if I am allowed to use the term in this way. It is common when talking about representations not to distinguish between these different ways in which an item may represent or be represented. But this is potentially misleading due to the differing relation between a representation and the thing represented, icons and to some extent indices tend to vary less than symbols do. Anyone used to pictures of things may recognize the iconic and indexical 'meanings'. Fewer however, will initially think of a men's lavatory first when in an irrelevant context (e.g. in a tobacco shop). People who are not familiar with separate sex lavatories will certainly not think of this; indeed, different people with different backgrounds and histories are likely to think of different things. And this is because representation, as mentioned above, is a five-party relation between the agent (if there is one), the thing represented, the thing representing, the receiver (or audience — if there is one) and the context (time, place, history).

Our attempts to reinterpret past representations are likely to be relatively successful as regards iconic and indexical values, but difficult, warped and even futile when it comes to symbolic meanings. Difficult, because there are very few ways to link a symbol with its denotatum if they are both things of the past or of a different culture and language; warped, since it is the creative imagination of the missing agent(s) which is largely responsible for the symbolic link, and perhaps even futile, because it is impossible to be sure that a certain symbolic link, even if we can identify it, was widely held in the given society. Arguably, the only way a symbolic link can be traced is when in a situation[2] or in a configuration of signs, one of the constituent signs can be replaced for another one with little physical resemblance. 'The identical employment of objects that have nothing obvious in common may be interpreted as a result of their symbolic link' (Kyriakidis 2005, 47).

As I want to stress below, representation, though fascinating, is not something extraordinary. Indeed, from the moment we learn to use our eyes, ears and other sensory organs we use icons (one-to-one representations) and indices (partial representations) constantly. In fact the senses are largely an iconic phenomenon, as they give accurate translations of

301

things, so accurate that they can collaborate with one another. For example, when roast lamb is placed in front of me in the appropriate conditions (e.g. with the presence of light) it makes photons bounce in a unique way that excites my optical nerves. My receptors then transform these photons into configurations of electricity that fairly accurately translate the way photons fall on them; this electricity is then further translated by my brain into an image of a roast lamb in its context through a staggering number of processes of perception and cognition.

Understanding and creating representations: no big deal

Notwithstanding arguments put forward elsewhere in this volume, our brains and sensory organs not only represent but actively interpret the world that surrounds us. I do not mean to argue that the brain cannot be studied as part of the material world, that it should be seen as in a vat, or that there is a mind/world duality. However, there is a host of indications that we (if we artificially and for analytical purposes only divide ourselves from the rest of the world) interpret this world (see Malafouris this volume, for a different and often complementary view). A most interesting example is the research by Moutoussis & Zeki (1997, 393–9) that shows how colour information and direction of movement information are perceived independently, with a time difference of 70–80 milliseconds (the colour information being perceived first). This means that a change in colour that takes place 70–80 milliseconds after a change in the direction of movement is perceived as contemporary to the latter, and thus interpreted mistakenly by the brain as contemporary (Moutoussis & Zeki 1997, 393, 397). The phenomena of split image, inverted and reversed vision are all examples of how the brain interprets the stimuli in the world around it. The gestalt arguments also point to the same direction of interpretation of stimuli by the brain, no matter how extended one wishes to make brain as a category.

A less straightforward situation than the iconic processing of stimuli is illustrated by my almost mechanic acknowledgement that my good friend Lambros is behind the fence when I see his head with his brown pony-tail appearing above that fence. In this case a common reaction will be to recall my category of human, and that of 'Lambros' and 'fill in the gaps' in my mind. This process involves me taking his head as an index of the entire Lambros. If smoke is coming out of his mouth, I might guess he is smoking a cigarette, because my category 'Lambros' does smoke, because smoke recalls my category 'smoking' and so on. This again, is indexical referencing. It must be made clear, however, that I do not intend to argue that I am right when I take Lambros's head as an indication that the rest of him is behind the fence. It may have been a very good effigy of Lambros's head with a stick underneath for all I know, or it may be Harry, Lambros's spitting image. Right or wrong about Lambros, I think I am right that the common process which leads to the attribution of the rest of Lambros's body to the head I saw above the fence, is indexical in nature.

But both functions, I am sure, are no exclusive privilege of us humans. Many animals would be able to see roast lamb (my dog would do if I had one) or even recognize Lambros if only his head were visible (certainly his dog would if he had one). In other words, we, like many animals, interpret iconic and indexical representations, and this therefore is not a very impressive trick performed only by humans.

Symbolism is a phenomenon that results from the association of two remotely related or unrelated things, whereby one can stand for the other with, of course, some room for expansion of the reference set. For example, not only can small candles be taken to refer to a birthday cake when they are lit, they can also be associated with fire and light. Symbolism is largely governed by the context (temporal, spatial and historical); if you have seen candles used in certain ways it is normal to associate them with the respective uses; candles and birthday cakes or even birthdays can easily be associated together and refer to each other. The agency in the creation of any type of sign, including symbols, although often extrapolated by the beholder, is sometimes missing or irrelevant, as for instance with symbols that can be seen in nature. This type of association is in some ways related to a Humean notion of causality ('constant conjunction')[3], where two contiguous events fit into our own predetermined cause and effect categories. The famous early experimental psychology Pavlovian experiment shows how the stimulus and the reinforcer work for dogs. An intense sound is always followed by food in such a predictable manner that seeing the former will instantly bring the latter to mind (even though the latter might not appear: see McLaren *et al.* 1989). This reinforcement had such profound psychosomatic effects on the dogs that they would salivate once the sound went off. Although there is nothing to directly causally connect the sound and the food their contiguity was so predictable that in that situation humans would look for a causal link, if not between the two, then certainly between the two and something else. Actually, the same is the case with our own everyday causal explanations. We *learn* that by turning the switch the light will turn on, without

really knowing how it works. If we were asked how the light was turned on, we might volunteer that the light went on because the switch was pushed. We may have never seen cables in our lives and we would still hold this to be true. We would also claim that warmth and light of a specific colour can both be caused by the sun. So we will know the morning has come if light and warmth are felt through our sensory system. I argue that it is in a very similar way that we make symbolic associations between things. An association may be empirical, even when not metaphysical. If this mnemonic connection is responsible for symbolism as it may be for causality (*sensu* Hume) then we may see causality as a particular type or a subset of symbolism. We may connect the clouds with rain and think of the two together but we may not see that there is a causal link between the two. In that case, symbolic connections are an integral part of life and must be widely understood not only by us but also a great part of the animal kingdom. So again, I would never entertain any argument that understanding symbolism is something that discerns us from other animals.

Nor is the creation of signs something exclusively human. Bees signal (von Frisch 1967) with a dance that uses both icons and indices, pointing to the direction in which nectar can be found. Aphids (e.g. Norin 2001, 609) communicate with a chemically based language, using symbols. Even plants have been observed to communicate symbolically (Baldwin & Schultz 1983, 277–9). The fact that the understanding and creative use of representation are not exclusively human attributes does not of course mean that they are not complex phenomena, but it does mean that as far as human evolution is concerned, neither demonstrate a keystone in human development. If there was a keystone involving representation, it would be in the creative use of a complicated series of representations to hide and evoke meanings. This implies that in the evolution of human cognition a quantitative rather than a qualitative change is involved in the way we use and understand representation. In other words, it should not be the appearance of representational capacities *per se* that should be taken as a sign of human evolution but rather their higher frequency and complexity.

Going one step further, I would like to argue that representation (both using and understanding representations) does not even have to involve thinking, if one distinguishes thinking from simpler cognitive processes. I will argue that although thinking is often involved in representation it is not a prerequisite. This idea has potentially far-reaching consequences for our understanding of representation and its study in archaeology.

Thinking and representations

Thinking always involves a reference to the objective notion of truth, according to the so-called new 'Cogito' put forward by Donald Davidson (1995, 203–20; 2004, 1–15). Davidson's argument starts with the Cartesian axiom that the existence of thought cannot be doubted, since, as Davidson proposes, doubt is a type of thought. He ascribes to thought a propositional content,[4] and this is by most accounts tantamount to the existence of conditions of truth or falsity. By doing so, he distinguishes thought from other simpler cognitive processes with no propositional content. Davidson argues that we can survive just as well without any propositional content (i.e. without any beliefs, desires for something to happen, fears of something, and hopes that something is the case, to mention only a few types of propositional attitudes). Belief however, the most basic form of thought, does indeed need a propositional content. Holding a belief or a concept should be reserved for cases where 'it makes clear sense to speak of a mistake' (Davidson 2004, 8), 'otherwise if concepts are a mere distinction or recognition of properties earthworms and tomato plants may have concepts such as dry and wet or night and day'. According to Davidson all thought, beliefs, hopes and fears have propositional content and thus conditions of truth (Davidson 2004, 3).

> To apply a concept is to make a judgment, to classify or characterize an object or event or situation in a certain way, and this requires application of the concept of *truth*, since it is always possible to classify or characterize something wrongly. To have a concept, in the sense I am giving this word, is, then, to be able to entertain propositional contents (Davidson 2004, 9).

Davidson uses this argument to go further and to defy the skeptic argument, something that is beyond our interests here. It is important to note, however, that Davidson's critics (e.g. Nagel 2002, 175–86), although they attempt to maintain some room for the skeptic, do not refute or even doubt the distinction between thought and other lower cognitive activity.

And this is the point that I want to make; neither do the cognitive processes of understanding or creating a representation necessarily involve thought, as we define it here, since they do not always refer to any conditions of truth. Not only is representation not exclusive to humans, but it can exist without the most valuable attribute of humanity, thinking.

The above assertion has interesting repercussions. A message from a representation may be (and is usually) received before the beholder is able to engage with its interpretation and may even create reactions

Figure 22.1. *The 'Anatomically Correct Oscar'. (© 2002, Guerrilla Girls, Inc; courtesy of www.guerrillagirls.com.)*

before the beholder starts thinking. For instance a scary representation may scare you, before you believe *that you are scared of it*. This means that representations can be the means to evoke non-propositional attitudes such as feelings or moods.

Stating vs asserting

Davidson's argument is similar to the one made by Strawson (1950, 320–44, *contra* Russell 1913) which will further clarify our own argument here. Strawson held that in a given sentence like 'The King of Greece is valiant' we should distinguish between:
'A1. a sentence;
A2. a use of a sentence;
A3. an utterance of the sentence' (Strawson 1950, 325).
Although, as Strawson points out, the uttering of the very same sentence in various periods of Greek history is a possibility (A1), the use of the sentence (A2) will vary as in the 1810s there was no Greece, in the 1830s there was a Greece and a king and in the 1980s there was a Greece but no king. Also if the same sentence was uttered during the reign of two different kings it is fair to say that they would be referring to different persons. According to Strawson's argument, if the same sentence is uttered in the 1830s and in the 1980s it is used in two different ways.[5]

> We cannot talk of *the sentence* being true or false, but only of its being used to make a true or false assertion, or (if this is preferred) to express a true or false proposition. And equally obviously we cannot talk of *the sentence* being *about* a particular person, for the same sentence may be used at different times to talk about quite different particular persons, but only of a *use* of the sentence to talk about a particular person (1950, 326).

The 'utterance' of a sentence (A3) obviously refers to the same sentence being pronounced by two different people at the same time, or by the same person at two different instances etc.

To take the argument on the use of a sentence (A2), further

> the sentence: 'the table is covered with books', is significant and every one knows what it means. But if I ask, 'What object is that sentence about?' I am asking an absurd question — a question which cannot be asked about the sentence but only about some use of the sentence (Strawson 1950, 328).

The same can be true of other representational forms. A painting of a bull on a cave wall is primarily a painting of a bull, beyond its particular use as a painting of a particular bull. To refer to a bull, is not necessarily to assert that there *is* a bull, that bulls *exist* or that bulls *are scary creatures*, as 'referring to or mentioning a particular thing cannot be dissolved into any kind of assertion. To refer is not to assert, though you refer in order to go on to assert' (1950, 333). And to recapitulate the previous argument about propositional attitudes and representations, to represent (refer to) a scary large bull does not necessarily mean that you assert that this bull is scary or large. And conversely you may be scared when you see a representation of a bull, without necessarily being scared *of the* bull.

Intended meanings and interpretation

The above means moreover, that, since intentions (using the word with its everyday meaning, (e.g. 'I intend to wash the clothes') are propositional, there is a difference between non-propositional attitudes on the part of the beholder and intentions on the part of the author. The original intentions of those who painted the horned creature in the Lascaux cave (Ruspol 1987) may have been to depict a hunt, a horned-shaped god, to tell a story. They could be making a statement that the creature is large and scary, without ever asserting that it is a bull or a buffalo, that this is a specific animal, or that this animal is scary. And this is a common theme in modern art, whereby the beholder receives messages that may have never been intended by the author. So the 'Anatomically Correct Oscar' by the Guerrilla Girls does not assert that there is an Oscar prize that looks like that, though it is possible that some might think so (Fig. 22.1).

Like in modern art, when we are not familiar with the history of the artist and the piece or the culture in which they are imbued (Danto 1998; Renfrew 2003), our interpretations of images of past or other

cultures are mainly predicated on these non-asserted pieces of information which may or may not be true. For instance a hunting scene in Lascaux implies (but does not assert) that there are people and animals in this scene and that hunting is taking place. All these are interesting pieces of information which are however, in all probability, not *asserted* by the makers of these images. Though in most cases they may be 'implied' as Russell might argue or 'assumed' by the makers as Strawson might point out, it is not always possible to prove that there was such an intention.

One other significant aspect of the non-propositional messages of representations is the evoking of mood and feelings. These are particularly important for our understanding of the function and influence of representations, as they also are important for the understanding of ritual or any other activity that involves such evocation. Little work has been done in this area as far as the understanding of representations in archaeology is concerned. In cases like the awe inspiring horned animal in Lascaux (Ruspol 1987) or the otherworldly whale in Tsodillo rock paintings in Botswana (Stewart *et al.* 1991, 11–17), the iconic material starkly contrasts with everything else depicted. These images are particularly evocative representations with powerful non-propositional meanings that have a largely unexplored and potentially strong mood evoking aspect. The problem of course with exploring the capacity of representations for mood evoking is that it is not tangible and easily quantifiable. Archaeological phenomenology, the main field that aims to capture feelings and moods of the past, does not have a strict or rational methodology on this matter.

As mentioned above, most, if not all, of the non-propositional aspects of representation may be perceived in different ways to what was intended. The makers of the Tsodillo hills rock paintings may have never intended to assert that there is an animal with the traits of a whale, and may have wished to make a different statement (let's say, they were referring to a legend where a whale ate a man). Those who look at these paintings, however, may take the painting of the whale as an assertion with propositional attitudes (truth values), i.e. that there is such an animal. Likewise, the artists of the Lascaux horned animal may not have asserted that the animal is awesome, whereas the viewers of such an animal may think that it *is* awesome or scary, or that when they see it they feel scared in a non-directed way. Thus a sizable proportion of archaeological interpretations — whether 'true' or not — may have never been intended by those who created the representations. This does not imply that interpretations which do not correspond to the intentions of the authors are wrong. As we said above, a mere association is sufficient for the symbolic relation; intention or agency is not required. On the other hand such associations are difficult to demonstrate.

And this is the beauty of a careful and cautious study of representation, as it can alert us to the possibility of such different points of view of authors and beholders in different circumstances. After all, the study of representation by its nature looks at this five part equation between the agent (if there is one), the thing represented, the thing representing, the receiver (or audience — if there is one) and the context (time, space, history).

To sum up, the study of representation can be a valuable analytical tool for understanding human cognition, today (Hutchins 1995) or in the past. We should keep in mind that the ability to represent is not extraordinary in itself, and was there before our earliest evolutionary stages as humans. The step that led to the explosion of representational art may have been the development of increased capacity rather than a new ability. After all elephants and apes can also paint and represent (Altwood Laurence 1995, 75). Although we must be aware that iconicity and indexicality are much easier to trace and interpret than symbolism, we must not delude ourselves that the reconstructed values of representations were necessarily intended by their authors. This does not put archaeologists at any special disadvantage. Even contemporary viewers, with their own special cultural knowledge would still have taken a great number of statements in representational art as assertions, much as we would be inclined to do in archaeology. And they would feel things, or would get into moods that were never intended to be evoked. The study of representation may often provoke more questions than it provides answers, but in doing so can enrich our understanding of how we interact with the world, and of how our ancestors may have done so.

Acknowledgements

Many thanks to Kathy Kollwitz and the Guerilla Girls for letting me publish the 'Anatomically Correct Oscar' Figure 22.1. I also thank Jon Williamson and Laurence Goldstein of the philosophy department at Kent for much provoking discussions and their corrections. The mistakes remain all mine. This article is dedicated to Lloyd Cotsen, a great friend and mentor, who taught me the virtue of allowing others to be generous if it makes them happy.

Notes

1. In order to avoid the conflicting views that various semiotics experts have on the definitions of icons, indices and symbols, a short definition is given in the brackets after each term.

2. According to Langer (1951, 73) situations are 'things in combination'.
3. Humean causality has been largely abandoned by mainstream analytical philosophy which mainly concentrates on how things are causally connected in the real world, rather than how causal links are perceived. In fact, some thinkers such as Davidson (problems in the explanation of action) want to rid philosophical debates of causality altogether; see also Russell (1913, 1–26).
4. The existence of a propositional content of something (a phrase, or an action) means that this phrase or action is about something. There is a distinction between different types of propositional content in that it may be referring to a relation or an attribute, e.g. the sentences 'I fear', 'I have a hunger of Gargantuan proportions', 'I feel miserably sad', refer to some things such as the word 'I' and some mental state or attribute; these can be seen as a separate category from sentences like 'I am afraid that the prices in the stock-market will fall', 'I am sad that you are leaving us', 'I believe that Bertrand Russell is dead' the propositional content being 'the prices in the stock-market will fall', 'you are leaving us', 'Bertrand Russell is dead' which relate to the world in another way. Certain attitudes such as beliefs or intentions ('I want to break this pimple of mine') always have a propositional content. Propositional content usually has conditions of truth and falsity, i.e. conditions that will decide whether what I believe is false, what I want cannot be attained, what I fear will not happen and so on. For more on propositional contents and attitudes (see Searle 1983).
5. ...to make two different statements, if it succeeds to make a statement at all.

References

Altwood Lawrence, E., 1995. Cultural perceptions of differences between people and animals: a key to understanding human–animal relationships. *Journal of American Culture* 18, 75–82

Baldwin, J. & J. Schultz, 1983. Rapid changes in tree leaf chemistry induced by damage: evidence for communication between plants. *Science* 221, 277–9.

Danto, A., 1998. *Beyond the Brillo Box: the Visual Arts in Post-historical Perspective*. Berkeley (CA): University of California Press.

Davidson, D., 2004. The problem of objectivity, in *Problems of Rationality*, ed. D. Davidson. (Tijdschrift voor Filosofie 57.) Oxford: Oxford University Press, 1–15. [First published in *Tijdschrift voor Filosofie* 57, 1995, Leuven, 203–20.]

von Frisch, K., 1967. *The Dance Language and Orientation of Bees*. Cambridge (MA): Belknap Press.

Hutchins, E., 1995. *Cognition in the Wild*. Cambridge (MA): MIT Press.

Kyriakidis, E., 2005. *Ritual in the Aegean, the Minoan Peak Sanctuaries*. London: Duckworth.

Langer, S., 1951. *Philosophy in a New Key*. New York (NY): Mentor.

McLaren, I., H. Kaye & N. Mackintosh, 1989. An associative theory of the representation of stimuli: applications to perceptual learning and latent inhibition, in *Parallel Distributed Processing — Implications for Psychology and Neurobiology*, ed. R. Morris. Oxford: Oxford University Press, 102–30.

Moutoussis, K. & S. Zeki, 1997. A direct demonstration of perceptual asynchrony in vision. *Proceedings of the Royal Society of London* B 264, 393–9.

Nagel, T., 2002. Davidson's new Cogito, in *Concealment and Exposure*, by T. Nagel. Oxford: Oxford University Press 175–86. [First published in *The Philosophy of Donald Davidson*, ed. Lewis Hahn 1999. Chicago (IL): Open Court, 195–206.]

Norin, T., 2001. Pheromones and kairomones for control of pest insects: some current results from a Swedish research program. *Pure Applied Chemistry* 73, 607–12.

Renfrew, C., 2003. *Figuring it Out*. London: Thames & Hudson.

Ruspol, M., 1987. *The Cave of Lascaux: the Final Photographs*. New York (NY): Abrams.

Russell, B., 1913. On the notion of cause. *Proceedings of the Aristotelian Society* 13, 1–26.

Searle, J., 1983. *Intentionality: an Essay in the Philosophy of Mind*. Cambridge: Cambridge University Press.

Sebeok, T., 1994. *Signs: an Introduction to Semiotics*. Toronto: University of Toronto Press.

Stewart, K., N. Stevens & L. Robins, 1991. Botswana, fish and reptiles from the Tsodilo hills white paintings rock-shelter. *Nyame akuma* 35, 11–17.

Strawson, P., 1950. On referring. *Mind*, 320–44.

Towne, W. & J. Gould, 1998. The spatial communication of the honey bees' dance communication. *Journal of Insect Behaviour* 1(2), 129–55.

Chapter 23

Neuroarchaeology and the Origins of Representation in the Grotte de Chauvet

John Onians

In the Bible, representation begins with the Creation, when God makes man in his own image, and most modern accounts of the origins of representation are tinged with Creationism in their use of terms like Pfeiffer's 'Creative Explosion' (Pfeiffer 1982)[1] or Mithen's 'Big Bang' (Mithen 1996). Almost all recent accounts of human history look for, and find, in the appearance of representation in the Upper Palaeolithic, decisive evidence of the emergence of human beings fundamentally distinguished from animals by their use of speech and symbolization to construct a social culture. This paper is more cautious. Like Lewis-Williams (2002) and McBrearty & Brooks (2000) it sees the story as more episodic and gradual. Instead of looking optimistically for a fully-fledged modern-type human, adept at most of the behaviours that would later assure the species's dominance, it seeks to understand how such behaviours might have emerged more slowly out of a series of contingencies. It does so by relating new knowledge of Palaeolithic art to new knowledge about the brain. It will discuss representation, not as the attribute of a suddenly manifested and almost divine humanity, but as one of several behaviours that developed when a distinctive neurobiology reacted to a new environment.

This new 'neural' approach to archaeology has features in common with an established tradition, one that leads from Breuil and Lucquet to Lorblanchet and Lewis-Williams, but it is much more radical. Neuroarchaeology, the term I use for the approach adopted here, like neuroanthropology (Onians 2003a) and neuroarthistory (Onians 2003b), acknowledges that humans are different in crucial ways from other animals, but sees that difference as primarily due to the unique ways our distinctive neural apparatus leads us to relate to the material and social environment. It agrees with those like Damasio who criticize thinkers such as Plato and Descartes for seeking to separate the mind from the body, and seeks to reintegrate the neural and the physical. To do so it bypasses terms like 'mind', 'cognition' and 'consciousness', which are tainted by their association with the same tradition, and which prove slippery tools. Instead it treats the operation of the human brain as concretely as possible, in terms of the firing of neurons, the formation and breakdown of neural networks, the operation of neurotransmitters and the distribution of hormones, and it relates this activity to the moods, emotions and thoughts which make up our inner life, and the actions and behaviours to which they give rise.

Representation without intention

The value of this neurological approach as a way to open up debate becomes apparent as soon as we apply it to a reappraisal of the phenomenon of representation, whose frequency in the Upper Palaeolithic is often taken, uncritically, as clear proof of the currency of conscious symbolic behaviour within a language-based culture. We tend to think that someone who represents something does so because he or she is aware that such a representation has some socially recognized function, but there is no necessity for this to be the case. What we call representation can come about for many reasons. Indeed, in order to distance ourselves from the concept of intention it is safer to think only of one thing visually *resembling* something else. There are many examples in the natural world of one thing resembling another, from the extreme cases of the chrysalis of the blue butterfly, *Spalgis epius*, that resembles the face of a monkey and the Brazilian bug, *Fulgora lucifera*, that resembles an alligator, to the orchid whose flowers resemble bees or the butterfly whose wing markings resemble eyes. There is, of course, no intention behind such resemblances. What does lie behind them is a long process during which one creature's neurally directed proclivities interacted with the other's form and configuration. The reason why these life-forms have acquired these visual attributes is because when seen by another creature,

Figure 23.1. *Man and dolphin. (From Byrne 1995, 74, ill. 6.4.)*

and carried from its eye to its brain, they cause that life-form to either seek out or avoid them. Because possession of the genetic coding for these resemblances increases the likelihood that the creature or plant will survive it has become part of that creature's or plant's genome. Resemblances are thus frequent in nature and they are the product of neurological activity, but not necessarily of the lofty mental activity we associate with a Leonardo. In most cases they are the passive consequence of genetic selection.

In other cases a resemblance can be the result of an individual animal's autonomous, but unconscious, action. Take for example an event recorded three decades ago. An ethologist was watching dolphins in a tank (Taylor & Saayman 1973). He was smoking, and on one occasion he noticed that when he blew a cloud of smoke into the air, a young female dolphin swam off to its mother, took a suck of milk and coming back to him blew it into the water, so making a cloud just like his (Fig. 23.1). In artistic terms what the dolphin did was to copy the image she had seen made using a different medium on a different support, milk instead of smoke on water instead of air. Seeing the effect the man had produced and remembering that she had seen a similar effect when milk leaked from her mouth, she collected some more milk and copied him. There was no training or external inducement involved. Rather, the image was again the product of the impact of natural selection, only in this case the selection was for a complex neural apparatus that would ensure that a young mammal would imitate its elders and so acquire the skills necessary to survive. The reward system that provoked the behaviour was purely biological. An important aspect of the behaviour is that it goes beyond the simple reflexive imitation of an action. What captures the young dolphin's attention is a particular object with a particular shape, that is the cloud that the man makes, and what her neural apparatus encourages her to do is replicate that shape, in Peircean terms, making an *icon*, that is a representation, of it. Like the art school student copying an object, she can only do this because she remembers how such shapes can be made. The principal difference between her and the art school student is that while the student has been trained in such copying and makes the copy because he or she is responding to a reward system that is external and social, for example the expectation of the approval of teacher and fellow students, for the dolphin the reward is internal and neurochemical. Evidently the act of representation can take place without any of the conscious mental activity, training or social formation with which it has now routinely become associated. Until we have investigated the possibility of the earliest representation in the Palaeolithic arising from similar causes, we are unwise to assume a more conscious origin.

Two other case studies involving our primate relatives bring us closer to identifying such causes. Over 60 years ago, T.H. Huxley observed the young gorilla Meng, apparently tracing his shadow on the white wall of his cage and suggested that such an activity might have been at the origin of painting (Huxley 1942). Whether or not he was right, he certainly presents evidence for the existence of an inclination among primates to trace their own shadow, an inclination which must be rooted not in social formation but in the neural linkages between the eye and the hand. A further insight into those linkages surfaced ten years ago, when I visited Sue Savage-Rumbaugh in Atlanta to discuss her work with the Bonobo chimpanzee, Kanzi (Savage-Rumbaugh & Lewin 1994). In pursuit of my interest in Palaeolithic vulvas, I asked her about Kanzi's interests in female genitalia. In response, she told me that the toy he most enjoyed playing with was a red rubber ball, a preference she explained in terms of an inborn tendency to reach out for things having the visual and tactile properties of female bonobo genitals. Such a tendency must be triggered by the sight of a particular object causing the release of brain hormones, which in turn stimulates manual activity, which probably leads to further hormonal activity. What gives the actions of these two primates their relevance to our enquiry is that Kanzi's might be considered to be proto-sculptural, that of Meng proto-pictorial. Both raise issues of representation and both are the products of unconscious neural activity.

Some neuroscience: neuroplasticity and mirror neurons

To pursue our enquiry we clearly need to have some knowledge of our neurobiology and neuropsychology and we are lucky that this is now increasingly available to us thanks to improvements in the technology used to investigate the brain. Research has in many areas shed light on artistic activity, as has been demonstrated by the neuroscientists Ramachandran (Ramachandran & Hirstein 1999) and Zeki (1999a & b), but the present paper will concentrate on two discoveries, each of them of great significance for an understanding of our humanity. One is the recognition of the importance of neural plasticity for the formation of the individual's brain. The other is the importance of mirror neurons for the shaping of the individual's behaviour.

Neural plasticity is the key to understanding why we differ from each other at another level than the genetic. The basic principle of neuroplasticity is that our brain changes its configuration in response to changes in the individual's experience and actions. We are all born with 100 billion neurons, each capable of having up to 100,000 connections to other neurons. What makes us different from each other is the way those connections form and fall away in response to our experiences. Thus, if we repeat an experience, such as an action or a sensory exposure, the particular neurons involved in the motor or sensory cortex develop more connections, so improving our success in those actions or perceptions. Hubel and Wiesel showed forty years ago how this happens in the case of the neurons that respond to lines of different orientations (Hubel 1963; Hubel & Weisel 1963; 1973) and Tanaka showed ten years ago how this operates in the case of the perception of a single object (Tanaka 1993; Tanaka & Matsumoto 2004). In terms of vision, the more often we look at something the more connections will form between the neurons involved, so strengthening our preference for looking at that thing.

Such neural plasticity is clearly adaptive, as it means that if, for example, when we are young we see our elders eating a fruit with a particular shape and texture we will acquire a preference for giving that fruit visual attention. The more often we see that fruit the better we will become at detecting it when we are food-gathering ourselves. The same is true of things we learned to avoid. If we see our elders looking at something dangerous, such as a poisonous mushroom or a dangerous animal, the effect will be similar. The more often we look at the poisonous mushroom or dangerous animal the more our neural networks will become adapted to perceiving it and the stronger will be our preference for giving it visual attention, with obvious benefit to us. Neural plasticity in the visual cortex helps us both to find things and to avoid things. This is why such neural plasticity has been selected for. It has helped our ancestors survive, especially when they changed habitat and needed to learn to give new things visual attention.

But this is not why it is important for us. What makes neural plasticity so important for someone studying the history of art is that it holds a critical clue to the understanding of the formation of visual preferences generally. The core principle is that the more someone looks at any configuration the better he or she will get at finding and identifying it, and this means that the more we know what a particular individual or the members of a particular group have been looking at the more we will know about what they will have been inclined to look at and *see*, whether in their environment as a whole or in a particular surface. The predictability of this principle is an extraordinary resource for anyone seeking to understand the history of artistic activity, because it implies that if you know what somebody has been looking at with attention you will know what they will have been inclined to see in the materials around them, with obvious consequences for the character of their art. Of course, in some communities people give more visual attention to things in their environment that have been around for a long time, and if that includes existing art that will encourage the maintenance of tradition, while in others people may look at new things, and that will encouraging innovation. In each case we need to ask ourselves afresh: What are the members of this particular community, or what is this particular individual likely to have been looking at?

While the principle of neuroplasticity sheds light above all on our differences, 'mirror neurons' tell us more about our similarities. Not only are they a type of neuron that we all share, their particular property is that they help us to imitate each other. They were first identified by Rizzolatti and his team at Parma University, who noted that when a monkey observes another primate doing something with its hand, such as reaching out for a peanut, some neurons in the premotor cortex of the observing monkey, that is those which would normally fire before it performed the same action, also fire (Rizzolatti *et al* 1996; Rizzolatti & Craighero 2004). Although no signal is transmitted to the motor cortex and no movement results, the observer monkey learns how to perform the action. Many experiments later it has become clear that this means that the observer monkey understands not only what the other monkey is doing, but why he is doing it, as is shown by the way the same mirror neurons fire at the simple sound of a peanut being cracked, presumably because the

observer monkey knows from its own experience that peanuts are obtained by hand movements. Important conclusions can be drawn from these observations. In particular it is now recognized that the existence of many such neurons in the primate brain gives us and our relatives an unconscious understanding of what our fellow primates are doing, an understanding that is akin to empathy. Watching the motor actions of others is enough to give us an understanding of what they are doing and why, and gives us that understanding automatically. The neural connections throughout the brain that sustain such empathy are exceedingly complex, but the core of mirroring is manifest in the way the sight of another's hand prepares us to activate our own. The potential importance of mirror neurons is widely recognized, as by the neuroscientist V.S. Ramachandran, who has predicted that:

> mirror neurons will do for psychology what DNA did for biology: they will provide a unifying framework and help to explain a host of mental abilities that have hitherto remained mysterious and inaccessible to experiments (Ramachandran 2000, 1).

These two fragments of an emerging neuroscience are of immense importance because they allow us to move away from a notion of the brain as a stable organ. Until now archaeologists have typically talked of differences in the brain in terms of genetically determined features, size, complexity etc., that is, the features that distinguish the different species of the genus *Homo*. What the new neuroscience allows us to do is something much more fine-grained, to talk of differences between individuals. To the extent that an individual has been exposed to a different environment he or she will have a differentiated neural apparatus. Depending on what plants or animals they have looked at, what bodily movements etc. they have witnessed, what emotions they have shared and what attention they have given them, their neural apparatus will be different, and to the extent that those differences affect vision and movement their visual and motor preferences will be different. To the extent that all individuals in a group have had a similar exposure they are liable to share those preferences. This allows us to potentially explain any aspect of an individual's or a group's behaviour, from art-making or tool-making to ways of thinking and feeling, in relation to such exposure. The better we can reconstruct that exposure, the more accurate our explanation is likely to be.

The earliest representational art

It is particularly appropriate to apply knowledge of the modern human brain to the study of the earliest art, since there is good evidence for its emergence being connected with the arrival of modern-type humans in western Europe between 40,000 and 35,000 years ago. There have been claims made for early art elsewhere, but it is generally less impressive and less well dated (see Bahn this volume). In Europe, on the other hand, as the studies by Bahn, Bosinski, Lorblanchet, White and others have demonstrated, in the period 35,000 to 25,000 BP there are many candidates for early examples of representation, from Russia, across eastern Europe and southern Germany to southern and western France, and in each case the art is associated with the arrival of the new slender-boned, large-brained anatomically modern humans, also known as modern-type humans, who ultimately displaced the heavier-boned Neanderthals. Since improvements in both neural plasticity and mirroring/empathy are critical determinants of adaptability it is virtually certain that improvements in these areas of our neurophysiology were a key to the newcomer's success. These improvements would have been particularly critical for the visual and motor areas that support the activities that are our concern here. In a cold environment at the limits of human survivability, where there were few sources of vegetable food, success in hunting large herbivores and in avoiding or killing large and dangerous rivals was vital and such success would have required unprecedented skills in the fields of both visual attentiveness and the manipulation of tools. The connection between the severity of the environment and the development of new skills is already apparent in the Neanderthal populations who previously occupied the region. They certainly had exceptionally large brains and particularly effective tools, when compared to all other contemporary populations except the modern-type humans who were to emerge from Africa and replace them. However, the rapidity with which they were displaced suggests that there were fundamental constraints associated with their genetic make-up, constraints which were much reduced in the new species. Certainly neural plasticity in the visual cortex and success in mirroring would have been at a particular premium and, given that the relevant areas of the brain would have been under constant stress, any genetically driven enhancement of these attributes in the newcomers would have given them an enormous advantage.

In considering how the new humans' engagement with the new environment might have affected those behaviours we call artistic, we could consider any of the early assemblages, but the most rewarding context for their application is the collection of representations from the Chauvet Cave in the Ardeche valley. Not only is the dating evidence remarkably clear and consistent, suggesting that most of the art

was made about 32,000 BP, but the whole site is in an excellent state of preservation. The latest publication documents 420 images, of which 65 are rhinoceroses, 71 felines, 66 mammoths, 40 horses, 31 bovids, 20 ibex, 25 cervids, 15 bear, 2 musk ox and 1 an owl, not to mention a whole group that are unidentified, as well as 4 or 5 female genitalia and many silhouettes and stencils of hands (Clottes 2003). A few images are engraved, but most are painted in charcoal and/or ochre.

Any discussion of the art of Chauvet needs to take account of both the variety of its subject matter and the range of techniques used. It also, above all, needs to acknowledge the astonishingly life-like property of many of the images. Some of the rhinoceroses seem nervously about to charge, menacingly presenting their horns (Fig. 23.2). Lions lower their shoulders, as they would when hunting, and the positioning of the eyes and ears well conveys an appropriate sensory alertness (Fig. 23.3). Four horses' heads are painted next to each other, but each captures a different equine behaviour. On many heads shading suggests the underlying bone structure, and on bodies the mobility and texture of flesh covered by fur. Often there is an extraordinary sense of a moment of viewing recaptured, as in a photograph. One figure may conceal another from the viewer, as would happen in a real encounter, and some animals, such as bears, are shown from on top, in slightly three-quarters view (Fig. 23.4). It is not going too far to say that often the spectator's experience is like that of someone watching a modern wild-life film. The art of no other cave is so natural or vivid. Publications of the cave under the direction of Jean Clottes (e.g. Clottes 2003) scrupulously document these remarkable attributes, but they do not explain them. Indeed, the fact that the publication limits itself almost entirely to description, with the addition of a few unsystematic interpretations based on anthropological analogies which don't seem to convince even their authors, leaves the reader with the impression that those who have studied the cave so far can make little sense of it. There is certainly no suggestion that a solution is near using any available cultural approach.

Neuroscience and representational art

A neural approach offers more possibilities and its desirability has long been recognized. The psychologist, G.H. Lucquet, observed in 1926 that many prehistoric representations, and especially engraved representations, are superimposed on the marks made by bear claws and Chauvet contains several examples of this, such as the engraved mammoths in the panel of the

Figure 23.2. *Rhinoceros, Grotte de Chauvet. (From Clottes 2003, 134, ill. 130.)*

Figure 23.3. *Lion, Grotte de Chauvet. (From Clottes 2003, 131, ill. 126.)*

Figure 23.4. *Bear, Grotte de Chauvet. (From Clottes 2003, 70, ill. 63.)*

Figure 23.5. *Reconstruction of bear activity, Grotte de Chauvet. (From Clottes 2003, 117, ill. 2.)*

Figure 23.6. *Reconstruction of superimposed human and bear activity, Grotte de Chauvet. (From Clottes 2003, 117, ill. 3.)*

engraved horse in the Hilaire Chamber (Figs. 23.5 & 23.6). Lucquet suggested that the activity of the bears was the starting point for that of humans and Michel Lorblanchet has recently repeated the claim, pointing out that hand prints are superimposed directly on claw marks on a panel dated to around 25,000 BP in the Galérie de Combel in the cavern at Pech-Merle (Fig. 23.7) (Lorblanchet 1999, 11, 15). Lorblanchet is adamant that the origin of this phenomenon and others such as the popularity of hand silhouettes, which are known throughout time and throughout the world, lies in *le cerveau humain*, 'the human brain', and it is now possible to suggest more precisely what that origin might be (Lorblanchet 1999, 218). If the sight of another hand, or even the sound of a peanut, can activate the mirror neurons in the premotor cortex of a primate it is easy to see how the sight of the marks made by a bear's claw could have activated the premotor cortex of the individuals entering Chauvet and that in some cases this would have led to the firing of the relevant neurons in the motor cortex, leading to the making of a similar mark. The likelihood of this happening would have been greatly increased because the chance touch of a hand on the wall must often have left some sort of mark, whether a groove in the white cheese-like substance known as 'moonmilk', a prototype engraving, or a black mark from a soot-covered palm, a prototype painting. Such actions can only have been encouraged by the natural empathy that human beings would have felt with bears, who, like them, also spent much time in caves, were omnivorous, frequently stood erect on two legs, and whose claws were enviable equivalents to human tools. Given such empathy, the same neural apparatus that led a young dolphin to imitate the art-like action of a human, might have led a human to imitate that of a bear.

If the principles governing the operation of mirror neurons help us to understand why humans made marks on the walls of the cave, and why those marks are of two kinds, one engraved and the other coloured, the principles of neural plasticity help us to understand why the making of coloured marks led to the replication of images of the hand with which the marks were made. Such hand images are of two types, the one, dark, being made by pressing a hand covered with paint against the cave wall, and the other, light, and made by spitting dark paint around it (Fig. 23.8). Visitors to the cave who brought their hands close to the cave wall would have seen the shape of the hand successively in two tonal modes, first as a black shadow cast by the torch, and then, as the hand came between the torch and the wall, as a bright illuminated form. They would have seen this again and again and this would have caused the formation of neural networks that would have strengthened their preference for looking at such configurations, so increasing the pleasure in making them. Huxley's observation of a young gorilla tracing his shadow on the white wall of his cage shows how shadows may elicit manual

activity in a primate, and the notion of a human using blown paint to reproduce a light effect is not far from the young female dolphin's untaught blowing of milk to imitate an effect created by a human blowing smoke. As with the young dolphin, all that was necessary was for the individual involved to remember how a particular chance effect had been produced before. Such a chance effect could have been created either by a random spitting of paint during the sort of play activity indulged in by other great apes in the wild or by a cough or sneeze which might easily have left some silhouette of the hand. Either way the effect could have been striking and surprising enough for the memory of how it was produced to stay in the brain, where it was ready to be called upon when the networks of the pre-motor cortex that stimulate imitation, stimulated the human's hand to find a way of rivalling the imprint of the bear's hand. The making of both positive and negative hand images can be seen as another example of the innovations in both general behaviour and detailed technology that result from *Homo sapiens'* possession of a distinctively powerful and generalized inborn inclination to imitate creatures whose habits or equipment gave them advantages that they particularly desired to share.

If one of the distinguishing features of Chauvet was its popularity with cave bears, another was its inherent visual interest. The limestone caves of southern France come in many forms and Chauvet is among the most splendid, its vast voids filled with all sorts of crystalline concretions and its surfaces stained with many different minerals (Fig. 23.9). It was already filled with forms and colours of great visual appeal long before our ancestors added their paintings and engravings. Those who entered such an environment, their visual neural networks formed by exposure to those things at which they would have looked with most attention, above all the large and powerful animals from whom they were in danger, and to a lesser extent the vulnerable species on which they preyed, would have tended to see those creatures that they either feared or desired in the colours and shapes revealed by the shifting lamp light. In many places at Chauvet, as often in other caves, we can see how a projection or recession, a line or a stain, was the starting point for a representation. We cannot reconstruct the precise sequence of neural events that led

Figure 23.7. *Human marking superimposed on bear claw marks, Galerie du Combel, Grotte de Peche-Merle. (From Lorblanchet 1999, 15.)*

Figure 23.8. *Hand stencilled with blown paint, Grotte de Chauvet. (From Clottes 2003, 84, ill. 77.)*

to an individual completing the image, often in lifelike detail, but we can imagine that the sight of claw marks will have aroused memories of how similar marks had been made by the visitor's own fingernails or tools, while the sight of brilliant washes of colour created by the seepage of ochre down the cave walls will have reminded visitors of effects they may have already achieved in the application of pigment to their own bodies. The memory of what the hand could

Figure. 23.9. *Chamber of the bear hollows, Grotte de Chauvet. (From Clottes 2003, 80, ill. 73.)*

Figure 23.10. *Rock arch near Grotte de Chauvet. (From Clottes 2003, 6–7, ill. 2.)*

do is likely then to have primed the motor networks involved, and this in itself could have encouraged people to return to the cave later with their familiar tools, stones and sticks, ochre and charcoal, the neural networks controlling their hands primed to extend or complete an imagined shape.

Once they had begun to add their own marks and colours, their pleasure in the imagined shape would have been increased, prompting further enhancement.

In each case the continued activity is likely to have been fuelled by the brain's chemistry, with each enhancement of the correspondence causing the release in the brain of one of the neurotransmitters that drive all the actions that are vital for our survival. The chemicals involved in such different activities as competing with a rival, searching for food or pursuing a sexual object are different, but with each the release is apt to increase until a goal is fulfilled. Sometimes, as when dealing with animals that are either dangerous or are potential food, the release may be an acquired response, while in others, such as the sight of female genitalia, it is inborn, as Kanzi's fondness for a red rubber ball illustrates. In all cases, however, the release would have prompted the repetition of the activity, so eliciting a further release and this process of continuous positive chemical feedback from the manual interaction would have been liable to continue as long as the constant increase in the resemblance intensified the chemical reaction. The process might thus only stop when the chemical reaction could not be strengthened further. In each case the point where the process would stop might be different, but when the engagement established by the artist's neural networks was particularly intense the point might be some notional one of maximum correspondence to the object represented. An unconscious feedback process could thus lead to the production of a highly naturalistic representation or artwork, without any teaching, guiding or other social stimulation. A naturalistic image might be produced completely spontaneously, due to nothing more than the normal operation of the human neural make-up.

But why should all this happen in this particular cave? As we have seen, the improved neural apparatus of the new light-boned big-brained human type would have made all members of the new species who lived in the novel environment more likely to manifest art-making behaviour than their predecessors, while at Chauvet the combination of cave-bear activity and a visually

stimulating environment would have further enhanced this likelihood; but this combination was found in several environments in southwest France. Was there anything special about Chauvet that would account for the unique response it elicited? Neuroscience would lead us to look for a reason why individuals in the area might have spent more time looking at animals than their contemporaries elsewhere, and one unique feature of the cave's environs is likely to have had precisely that effect. The natural rock arch, after which the present town of Vallon Pont d'Arc is named, is one of only a few in the world that bridges a fast flowing river and its situation close to the point where the Ardeche river enters the Rhone would have made it a tempting crossing point for the animals forced to migrate north or south in search of food in the then severe climate (Fig. 23.10). The bridge's presence would not only have made the site particularly suitable for human habitation, it would also twice a year have presented those in the vicinity with the sight of an exceptional procession of animals. Those who witnessed that sight would indeed have had neural networks exceptionally attuned to seeing large mammals.

This explanation for the emergence of representational activity in the cave also sheds light on some of its most remarkable features. One of these is the way animals are in two cases grouped in tripartite panels around arches, one around the Alcove of the Lions in the Horse Sector and the other around a niche containing a horse in the End Chamber (Fig. 23.11). The latter, which is the richest collection of animals in the cave, is striking not only for its composition around the arch-like niche, but for the way the mammoths and bison at the right and the rhinoceros at the left seem to be climbing up, as if negotiating a mountainous landscape, while another mammoth stands at the top (Fig. 23.12). The suggestion that the scene recalls one of migration is reinforced by the way it is framed on both sides by a dense and dynamic procession of animals without parallel in prehistoric art. Yet another feature of both panoramas is the way animals are often shown superimposed on each other, but moving in opposed directions. This happens, for example, both in the case of the rhinoceroses to the left of the horse niche and the reindeer to the right of the Alcove of the Lions (Fig. 23.13). Seeing an animal moving in one direction might have brought back the memory of a similar movement in the other. All these features, which are without parallel in other caves, are easily understood if those who made the images did so because of the way their neural networks had been configured by repeated exposure to a varied procession of animals migrating over the arch. They are difficult to explain in any other way. Perhaps the

Figure 23.11. *Animals painted around rock niche in End Chamber, Grotte de Chauvet. (From Clottes 2003, 130–31, ill. 126.)*

Figure 23.12. *Mammoth climbing beside rock niche, Grotte de Chauvet. (From Clottes 2003, 130–31, ill. 126.)*

most decisive contingency at Chauvet leading to the occurrence of representation there was the distinctiveness of the surrounding landscape.

Figure 23.13. *Reindeer moving in opposite directions, Grotte de Chauvet. (From Clottes 2003, 108, ill. 104.)*

Some conclusions: on art

If the argument presented here is accepted, it leads to some conclusions that many will find surprising. One is that Chauvet is not only an early example of cave painting, it may even be the earliest, the product of a unique set of contingencies. The members of the new species, having settled into an inhospitable environment far more challenging than those they had occupied before, with their visual networks dramatically reshaped by the sight of animals migrating over the rock arch and their mirror neurons activated by the sight of the marks of bear claws, were provoked into adding to the extraordinary visual richness of the cave by their memory of how similar linear and colouristic effects had been achieved by their own hands. This argument explains why Chauvet may be the earliest painted cave, but it doesn't require it to be, since a similar conjunction might have had the same consequences anywhere. Indeed, it follows from this argument that, since other powerful, though different, conjunctions may have happened at any time, with similar consequences for art production, artistic activity is likely to have emerged in any number of places at different periods, wherever *Homo sapiens* lived, which is exactly what seems to have happened, with representational art being found in Australia, South America and Africa at different times in the Upper Palaeolithic, without any evidence that the habits involved were transmitted by diffusion. However, the likelihood of other sites producing evidence that controverts the present argument is not great. The situation with Chauvet is very different from that with Altamira and Lascaux. In their case it would have been rash for anybody to claim that they constituted the earliest art, since it has long been known that the human type that made them had lived in the area for over 15,000 years. The art at Chauvet, on the other hand, was made so soon after the new species' arrival that the chance of comparable early art being discovered is drastically reduced.

Indeed, it is interesting that the body of small statuettes from the Swabian Jura, of which the material from the Vogelherd cave is the most significant, appears to represent a precise parallel to Chauvet. Conard now dates this art to about 33,000 BP, that is shortly before the French cave, and sees it as an early product of the new groups of modern-type humans, as they entered the area from the east, before some moved on to the west. Since the limestone outcrops and caves of the Swabian Alps have much in common with those of the Ardeche and the Dordogne, it is easy to see both outbursts of creativity being the result of a similar conjunction of neural resources and environment. Though it is important to recognize that the Swabian caves are much smaller and less colourful than those in France and would certainly have been less likely to provoke the act of painting, which could well explain why the art with which they are associated is almost exclusively sculptural.

Another conclusion that emerges from the study of Chauvet is that, applying the same neurobiological principles, we would expect later representations to be less naturalistic. This last point, that the later art is in many ways less effective in capturing the vitality of its subjects, will puzzle those who are used to the history of art as a story of progressive improvement as a result of social criticism and conscious effort. To someone writing a history of art based on the principles of neuroscience it is not just comprehensible, it is predictable. If it was a particularly intense visual exposure to real animals that created the neural networks that guided the hands of the first artists at Chauvet, then the progressive increase in the number of painted images that followed would have resulted in the formation of neural networks shaped by very different experiences. The networks of later artists would have been shaped less by the sight of fur over skin over muscle and bone, and more by that of outlines filled in with ochre and carbon and engraved silhouettes. We would expect a hand guided by such networks to produce less naturalistic and more schematic results, and we can see this happening already at Chauvet. Those who made the paintings frequently repeat themselves, making one image after another in a similar way, and, as a consequence, we often find particular representational devices, such as the way a rhinoceros' horn or a lion's

brow is drawn, recurring again and again (Fig. 23.14). Often traits become exaggerated, as in the lengthening of the rhinoceros horn, as might be expected from the operation of the neurally based 'peak shift' phenomenon discussed by Ramachandran & Hirstein (1999). Obviously those who painted the first images and who necessarily spent some time looking at them would have been the first to have had their networks reconfigured by the exposure. For those who came after them the process can only have accelerated, although there must always have been a range of neural networks involved, with some artists having looked more at real animals and some more at painted representations. The more time someone had spent looking at art and the less at live animals, the more their work would have become stilted and formulaic, the more they looked at animals, the more it would have been naturalistic. Often individuals with the two types of networks might contribute images to the same cave, as already seems to happen at Chauvet, which is why both here and in later caves there is a great variety in the way representations are made. The stylistic variety of Palaeolithic art and the absence within it of a simple stylistic progression, which have become increasingly clear over the years, have puzzled, even annoyed, scholars, though not Lorblanchet who has a more open-minded approach than many. To the scholar who follows the principles of neuroscience, both properties of the art are no more than one would expect.

Some conclusions: on language

The argument advanced here proposes that the first phase of representation, including the time and place of its emergence and the character of its development, is congruent with the principles of the neuroscience of the human visual and motor systems. We have not needed to invoke the role of language, but we should at least reflect on its possible influence. After all, as David Lewis-Williams says: 'There is no doubt in any researcher's mind that Upper Palaeolithic people had fully modern language ... ' (Lewis-Williams 2002, 88) and if that view is correct we should need to at least consider what role it might have played in our account. In evaluating this common view we can begin by disposing of one of the main assumptions on which it is based, that it is unthinkable that representation

Figure 23.14. *Repeated lions and rhinoceros, Grotte de Chauvet. (From Clottes 2003, 130–31, ill. 126.)*

should emerge without it. As we have seen there is good evidence that, far from being unthinkable, it is predictable.

A more reliable approach is to look for evidence of its role in the content of the representations. What do they suggest? After all a visual representation has something in common with a verbal description; so we should be able to learn something about Palaeolithic verbal descriptions from visual representations from the same period. If we ask ourselves what language we would need in order to produce a verbal equivalent of Palaeolithic art, an immediate answer would be, we would need nouns, e.g. 'bison'; adjectives, e.g. 'big'; and intransitive verbs, e.g. 'runs'. What is missing, not just in the earliest art, but in all the tens of thousands of specimens of all types of Palaeolithic art, is any clear example of a representation that would require a transitive verb, that is, a verb that takes an object, for its description. There is not a single indubitable representation of a noun–verb–object relation, such as a human or an animal doing something to another human or animal. There are no scenes of something attacking, killing or eating something else or a woman giving birth to a baby. Nor is there any scene which suggests that because this happened that happened, for example, because this animal or human appeared this other animal or human ran away. There is no scene of cause and effect, none in which one thing has 'power' over another, none even of basic narrative, e.g. this happened after that. One of the few possible exceptions to this rule is the scene in the shaft at Lascaux showing what might be a disembowelled bison in threatening proximity to a recumbent man, but, although this may suggest that something has

been done to a man or an animal, it certainly doesn't represent that action. In other words the art provides lots of evidence for description, none, or virtually none, for narrative.

Of course, it would be possible to argue that this doesn't prove that narrative did not exist. Visual art and verbal language could be two separate domains, and a single image could act as a cue for a narrative. However, we should remember that since the common argument is that the clearest proof of the importance of language is the wealth of representational art, we should expect there to be some correspondence between these two media. More particularly, since the common view is that the representational art demonstrates the existence of such phenomena as shamanism, religion, and cosmology, we would expect to see in the art some evidence of the type of linguistic formulations on which such systems always rely. Now, all currently known versions of those systems rely precisely on narrative, on stories of causation, on tales of differentials of power. They all depend on what we call myth. Again, it could be argued that perhaps we are not adept at reading the imagery. Perhaps when animals are shown running one behind the other or standing beside each other a narrative or tale of power differential is alluded to but not represented. This certainly happens in later art, that produced after 10,000 BP, and would have been possible in the Palaeolithic.

It is, however, most improbable. What makes it improbable is precisely the character of that later art. One of the principal new features of that art is its frequent representation of scenes of men and animals doing things to each other, that is narrative scenes, scenes that would have required a subject–transitive verb–object sentence for their description. It also represents differentials of power, with large and small figures contrasted and organs such as eyes, mouths and hands enlarged, in expression of the basis of such power differentials. At European sites such as Çatalhöyük in Turkey, Addaura in Sicily or Morella la Vieja, Spain, and at many sites in Africa and Australia, such representations of narrative and of power differentials become commonplace in the millennia associated with the Neolithic and other later cultures. Of course, there were also many other images which were not either narrative or expressive of power differentials, as there are today. That is what one would expect. Many phenomena that are important to humans are independent of narrative and power differentials. The point is that, while narrative is increasingly omnipresent after 10,000 BP, and especially after 5000 BP, before that it is totally absent. Palaeolithic art has been assumed to be the evidence that such narratives existed, but it suggests the reverse. It would surely be quite extraordinary if Palaeolithic art, with its tens of thousands of images, depended on myth but never illustrated it directly.

What Palaeolithic art suggests is that not only was there no narrative but that the role of speech was very reduced, and independent support for such a claim comes from recent psychological research. Nicholas Humphrey (1999) used the similarity between the art of Chauvet and that of the autistic and virtually languageless Nadia to argue that the inhabitants of Chauvet might also have been deficient in speech use, and some of his observations apply to Palaeolithic art in general.

Some conclusions: on new material and social technologies

Besides the presence of art, the other features that are seen as inconceivable without the elaborate use of language are the rapid advances in tool technology and the social exploitation of the environment. A neural archaeology has to explain the emergence of these features, just as it has to explain the emergence of art, and such an explanation is available. The explanation of the emergence of artistic activity proposed earlier saw it as the product of the interaction of the complex and flexible neural networks of *Homo sapiens* and a particularly rich, but particularly stressful, environment, and it is possible to extend that explanation to deal with the new problem. One of the most important discoveries of neuroscience is that the operation of mirror neurons is correlative with complex empathy, that is, the stimulation of the pre-motor cortex in the viewer of a movement is associated with an understanding of what it means to the other, its purpose and value (Rizzolatti & Craighero 2004), and this finding is a particular help to us as we try to understand the emergence of new material and social technologies.

Once arrived in northern and western Europe, faced with the need to maximize their exploitation of food resources and to protect themselves from the cold, the members of the new species would have looked with a new attention at the life-forms with which they were surrounded. As they observed how mammoth used their tusks, rhinoceros their horns, lions and bears their claws and teeth, bison their horns and reindeer their antlers, they would have empathized intensely with their value as instruments for piercing, tearing and scraping. With their pre-motor cortices activated in this way they would have been more inclined to adapt the stones and sticks which they had long used as tools to better mimic the different functions they observed in the animal world, creating complex instruments, such as harpoons and

spear throwers. Similarly, seeing how spiders spun webs to trap their food and birds wove fibres into nests to protect their young they would have found their hands doing what birds did with their beaks or arachnids with abdominal extruders; in other words they would have been liable to spontaneously develop textiles, baskets, traps and nets. Seeing how other mammals were protected by warm coats they would have wanted their own, which they often took from the creatures they envied. Humans had, of course, always been surrounded by such phenomena, and the Neanderthals, whose neural resources were only proportionately rather than absolutely less rich than those of modern-type humans, had already been affected by them, which is why they were as adept as they were in the use of tools and the making of clothes. Of course, too, the new lighter larger-brained species had also already been exposed to these and analogous phenomena. That exposure had begun tens of thousands of years earlier in Africa and southwest Asia and helps to explain many of the technological advances they achieved in those regions. It had continued during their expansion into Europe and westwards across that continent, but at the beginning of that migration the conditions would not have been harsh enough to force them to look with such envy on other species and later on their journey up the Danube the environment probably became so ecologically poor that there was much less to observe. It was only when they arrived in the west where the climate was severe, but the proximity of the ocean and the Mediterranean assured a richer flora and fauna, that they were drawn to look at the rest of nature so intently. Finding themselves in an environment where they could not opportunistically vary their diets, but were forced to maximize their consumption of their fellow mammals, and where fire alone could not keep them warm, their visual attention was inevitably drawn more than before to the many rival life-forms and their different resources for dealing with similar problems. Material technologies that we think of as the product of reflection and analysis, need only have been the fruit of an unconscious process by which intense observation led to imitation.

The same would have been true of social technologies. As they observed the behaviours on which other species depended for survival, whether they were prey animals or predators, whether their expertise was in defence or aggression, they would have heightened their own already strong sense of the advantages of co-operation, team work, the division of labour and leadership. They would have empathized with their mental as well as their physical resources and begun the process that would eventually lead to notions of spirit transfer and the appearance of shamanism and totemism. All this would have happened simply as a consequence of the neural networks of the new species being confronted with a new environment. There would have been no need for language-based reflection, or analysis or instruction.

Final conclusion: the 'big bang', the eye and the brain

In his article on mirror neurons Ramachandran has envisaged that

> the so-called 'big bang' only occurred because environmental triggers acted on a brain that had already become big for some other reason and was therefore pre-adapted for those cultural innovations that make us human (Ramachandran 2000, 4).

He does not speculate about what those triggers may have been, but the scenario presented here is consistent with his hypothesis. Implicit in his celebration of the role of mirror neurons is a recognition of the importance of the act of looking that most typically activated them. In this sense it was not language but looking that led to the dramatic changes in behaviours that characterize the Upper Palaeolithic. It was a new intense looking that lay behind the appearance of new physical and mental resources. It also lay behind the appearance of representational art. Indeed, the two types of looking were intimately connected. It was empathy that led our ancestors to look at the life-forms with which they were surrounded with such intensity that their neural apparatus was transformed and it was this transformation of the neural apparatus that led to them seeing and representing animals on the walls of caves and in pieces of ivory and bone. This is why it is not surprising that the range of the fauna represented at Chauvet — or for that matter at Vogelherd — precisely matches that of the animals with which their empathy would have been greatest.

Many were the attributes of their fellow creatures with which they empathized, but perhaps one attribute engaged them above all, the animals' own capacity for visual attention. They looked intently at animals that were themselves looking intently. They may have desired their horns and claws, their thick skins and warm furs, but most of all they will have found themselves valuing their visual alertness and hunting intelligence, as particularly exemplified in the highly focused lions and bears (Figs. 23.3 & 23.4). The tools they envied most in the animals they lived with were the neural linkages between their eyes and their brains. It was watching the animals that activated their mirror neurons, so teaching them too to look intently, and it was this intense looking that affected the plasticity of their neural networks in such ways that they projected life-like images on the cave walls.

Neuroarchaeology thus suggests an explanation for most of the remarkable properties of these remarkable images. It helps us to understand why these subjects were painted in this way at this time and at this place, and nowhere else on the planet. It may thus provide us with the key to the origins of representation. As a theoretical framework it may also help to solve many other problems that archaeologists have found intractable using existing methods.

Neuroarchaeology makes no claim to replace those methods. Traditional cultural approaches have been and always will be the principal framework for the study of archaeological material. Indeed, they will surely eventually yield alternative and better explanations for some aspects of Chauvet. For the time being, though, it seems that there are no coherent cultural explanations for this extraordinary art to match the neural explanations offered here.

References

Byrne, R., 1995. *The Thinking Ape: Evolutionary Origins of Intelligence*. Oxford: Oxford University Press.

Clottes, J. (ed.), 2003. *Return to Chauvet Cave: Excavating the Birthplace of Art: the First Full Report*, trans. by P.G. Bahn. London: Thames & Hudson.

Hubel, D.H., 1963. The visual cortex of the brain. *Scientific American* 209, 54–62.

Hubel, D.H. & T.N. Weisel, 1963. Receptive fields of cells in striate cortex of very young visually inexperienced kittens. *Journal of Neuropsychology* 26, 994–1002.

Hubel, D.H. & T.N. Weisel, 1973. A re-examination of stereoscopic mechanisms in area 17 of the cat. *Journal of Physiology* 232, 29–30.

Humphrey, N., 1999. Cave art, autism, and the evolution of the human mind. *Journal of Consciousness Studies* 6, 116–43.

Huxley, T.H., 1942. Origins of human graphic art. *Nature* 3788, 367.

Lewis-Williams, D., 2002. *The Mind in the Cave*. London: Thames & Hudson.

Lorblanchet, M., 1999. *La naissance de l'art: genèse de l'art préhistorique*. Paris: Errance.

McBrearty, S. & A.S. Brooks, 2000. The revolution that wasn't: a new interpretation of the origin of modern human behaviour. *Journal of Human Evolution* 39, 453–63.

Mithen, S., 1996. *The Prehistory of the Mind*. London: Thames & Hudson.

Onians, J., 2003a. A natural anthropology of art. *International Journal of Anthropology* 18, 259–64.

Onians, J., 2003b. Inside the brain: looking for the foundations of the history of art, in *Subjectivity and the Methodology of Art History*, ed. M.R. Rossholm Lagerlof, Stockholm: Konstvetenskapliga Institutionen, Stockholm Universitet.

Pfeiffer, J., 1982. *The Creative Explosion*, New York (NY): Harper and Row.

Ramachandran, V.S., 2000. Mirror neurons and imitation learning as the driving force behind 'the great leap forward' in human evolution. *Edge 69*. http://www.edge.org/documents/archive/edge69.html.

Ramachandran, V.S. & W. Hirstein, 1999. The science of art: a neurological theory of aesthetic experience *Journal of Consciousness Studies* 6, 15–51.

Rizzolatti, G. & L. Craighero, 2004. The mirror neuron system. *Annual Review of Neuroscience* 27, 169–92.

Rizzolatti, G., L. Fadiga, L. Fogassi & V. Gallese, 1996. Premotor cortex and the recognition of motor actions. *Cognitive Brain Research* 3, 131–41.

Savage-Rumbaugh, E.S. & R. Lewin, 1994. *Kanzi: the Ape at the Brink of the Human Mind*. New York (NY): Wiley

Tanaka, K., 1993. Neuronal mechanisms of object recognition. *Science* 262, 685–8.

Tanaka, K. & K. Matsumoto, 2004. The role of the medial prefrontal cortex in achieving goals. *Current Opinion in Neurobiology* 14, 178–85.

Taylor, C.K. & G.S. Saayman, 1973. Imitative behaviour in Indian ocean bottle nose dolphins (*Tursiops aduncus*) in captivity. *Behaviour* 44, 286–98.

Zeki, S., 1999a. *Inner Vision: an Exploration of Art and the Brain*. Oxford: Oxford University Press.

Zeki, S., 1999b. Art and the brain. *Journal of Consciousness Studies* 6, 76–96.

Section F

Relating Representation and Religion

Chapter 24

The Worship and Destruction of Images

Robert A. Hinde

Why do people worship images, investing them with magical powers that can seem absurd to the modern mind? And why, from time to time, are people violently against the worship of images, and find it necessary to destroy them? Discussion of these questions in the context of archaeological evidence inevitably depends on speculations based on knowledge of present societies; this contribution uses studies of current or relatively recent religious practices in the hope that they are of use in the interpretation of archaeological data. It is concerned primarily with the possible *religious* significance of figurines, while recognizing that, in most cultures, the religious and secular are virtually inseparable, and with no implication that the artefacts necessarily had religious or magical significance.

Most religions involve, though to varying extents, six components: 1) structural beliefs, that are outside time; 2) narratives, that expand the beliefs; 3) ritual; 4) a moral code; 5) social aspects; and 6) religious experience. These components are inter-related and form a system with mutual influences. The term 'spirituality' is often equated with acceptance of a religious system, but is more usefully limited to susceptibility to religious experience. *Religious* experience is often taken as implying a reality outside the subject (e.g. 'the numinous', 'awe'), but must in practice be at least in part a construction by the subject, and need have no intangible referent. The words used in descriptions of religious experience resemble those used for aesthetic experience, but are at least in part constructions in that they are influenced by the subject's religious beliefs (e.g. Christians seldom have visions of Buddha). Thus religious (spiritual) experience is unlikely without religious belief, but not vice versa (Hinde 1999). First, a brief summary of answers to the preliminary question of 'How do people come to believe in gods?'

Why do people believe in gods?

To an extent differing between cultures and between individuals within cultures, belief in deities can satisfy one or more pancultural human needs (Hinde 1999; Hood *et al.* 1996):

1. *Attribution*: all humans need to explain perceived events in the world. Usually this is possible on the basis of current concepts, knowledge or conjecture: thus, 'he is running away because he is frightened'. Apparently inexplicable events are often attributed to pseudo-human causes, such as 'Lady Luck' or to a deity: 'The volcano erupts because Zeus is angry'. Ascribing an inexplicable event to a deity can bring satisfaction, especially if others believe likewise.
2. *Control, self-efficacy*: we need to believe in our ability to control events. We may do this by consulting a fortune teller, by superstitious practice (e.g. touching wood), by prayer to a benevolent god or an intermediary, or by placating or exorcising a malevolent being.
3. *Coping with adversity*: closely related to the need for self-efficacy, humans must cope with suffering and danger. Deities enable the individual to accept the adversity as 'God's will', or provide a means to deal with it through prayer.
4. *Mortality*: belief in an after-life enables many individuals to cope with death.
5. *Relationship factors*: individuals need to share their experiences with others. A deity can be seen as a listener who always understands.
6. *Social factors*: belief in an unverifiable deity provides a feeling of affinity for others who share the belief, and thus provides a sense of community.
7. *A meaning for life*: belief in a deity can provide a meaning for life.

In ascribing a religious significance to a figurine, it would be advisable to ask which of these might apply. In addition, belief in non-material deities is made possible by pan-cultural psychological propensities (Boyer 1994; Hinde 1999):
1. *Agency*: from an early age, humans distinguish between animate and inanimate objects by the abilities of the former for self-propelled motion and to act as agents (Gelman *et al.* 1995). Therefore most religions conceive the deity in anthropomorphic,

or at least in zoomorphic, terms. Only an animate being can influence events in the material world.
2. *Responsiveness to faces*: humans are especially sensitive to stimuli resembling a human face: we readily 'see' faces in ambiguous pictures or in cloud formations (Guthrie 1993). Thus, assigning anthropomorphic characteristics to deities accords with pan-cultural cognitive predispositions.
3. *Special characteristics of deities*: deities almost invariably combine everyday and improbable characteristics: the former make them comprehensible, the latter make them interesting and memorable and usually include mystical powers (Boyer 1994; 2002). The Judaeo-Christian god, like a human being, can get angry if not obeyed but, unlike any human, can be everywhere and attend to everything at once. Could this explain figurines with animal and human features or incomplete figurines?
4. *Symbolic processing*: a special cognitive process, 'symbolic processing', may allow counter-intuitive concepts to be taken-on even though not readily assimilable to existing representations (Atran 1993).
5. *The religious system*: belief in an image's power is part of the religious system.

Thus the acquisition of beliefs at variance with the everyday world is now facilitated by universal characteristics of human nature. At least 1–3, above, were probably present when the first figurines were made.

Psychological processes in attributing power to a religious image

In the great majority of religions worship is focused on a location and/or an image. Sometimes mystical powers are seen to reside in the material image, and sometimes the image is seen as providing access to the powers of the deity. The image has some, but usually not all, the characteristics of the deity: for instance, whereas the Christian God is everywhere, images are not, and one must get close to them if they are to hear an appeal. Images of deities are usually representational, though sometimes they are symbolic, as with the use of the phallus for Shiva as god of fertility. Even twentieth-century Western minds can accept these significances of images; recently images of Padre Pio, a monk to whom were attributed miraculous powers and whose canonization was somewhat controversial, were selling in Rome for up to £3300. But how can a material image be seen to have some of the supposed properties of an immaterial being?
1. *Belief institutionalized*: belief in the power of an image is usually acquired as part of a world-view in a culture in which any distinction between sacred and secular is muted or absent, and religious beliefs are assimilated along with everyday aspects of the culture. 'Religious' beliefs and imagery both reflect and influence the culture of the time.
2. *Social influence*: almost all religious beliefs are acquired in a social context, where the believer is surrounded by others who also appear to believe in the icon's efficacy. Our everyday judgements are easily swayed by what we believe others to believe (Asch 1959). Furthermore, we are especially prone to acquire the beliefs of those of whom we are fond or admire: reciprocally, belief enhances attraction to individuals with similar beliefs, and thus augments group integrity — we are prone to become fond of those whose beliefs we share. This effect is particularly strong in the case of beliefs that are otherwise unverifiable, such as religious beliefs (Byrne *et al*. 1966; Tajfel & Turner 1986).
3. *Secular myths:* in every modern culture children are exposed to myths involving magical happenings. Even if parents explain that the magical events belong to a 'let's pretend' world, that world may be accepted as half-believed in. Just as deities are appealing in part because they are improbable, so may children find the world of magic exciting just because anything may happen. But while parents usually imply that magic is make-believe, in a religious situation it is an authority figure, and one who makes no distinction between truth statements about the everyday world and those about deities — or images (Wooley 1997).
4. *Purveying the good news*: just because miraculous events are rare, they make a good story. So an individual who believes, or pretends to believe, that he has witnessed an image's miraculous powers will not only retain the belief in the face of contradictory evidence, but will gain kudos by telling others about it. And the story is likely to be embellished in the re-telling, especially if the individual who had the original experience is not available for cross-examination (Christian 1996).

In spite of the social support that belief in images received, contradictory evidence must have been encountered frequently. However a number of intra-individual psychological processes contribute resistance to contradictions.
1. *Need satisfaction*: religious images are believed to have provided a route to the powers of deities. They are therefore believed to be able to satisfy a variety of human needs (see above).
2. *Correlation and attribution*: if praying to an image is correlated with a good harvest in any one year, then the farmer may attribute the crop to the suc-

cess of his prayer and will pray to the image before every harvest. A special experience in the presence of an icon is likely to induce a feeling that the icon was responsible and has special powers.

3. *Lack of disconfirmation*: once an individual believes in the effectiveness of an icon, the belief may be very stable. For example, that a St Christopher medal will ensure that you have a safe journey will be reconfirmed by subsequent safe journeys, accidents being relatively uncommon. And if the icon is believed to have human properties, belief may survive much contrary evidence because the icon can then be seen to have the power to choose amongst requests it receives. Furthermore, occasions when the belief was confirmed are more salient, and more likely to be remembered, than those on which it was not. Experimental evidence shows that responses that are reinforced only intermittently are resistant to extinction (Skinner 1959). And, as mentioned again below, it is always hard to relinquish a belief, especially if it involves admitting to oneself that one was wrong: the resulting cognitive dissonance leads to arousal that causes one either to reassert or to discard the original belief, and often the former wins out (Backman 1988).

4. *Maintenance of the self-system*: beliefs are especially stable when they concern one's self. Individuals see their religious beliefs as part of the sort of person they see themselves to be — the 'self-concept' (Baumeister 1999; Hinde 2002). The self-concept is defended against apparently contradictory evidence, for instance, one who considers herself to be honest will reject accusations of dishonesty as unreliable, or strive to prove her honesty. Similarly one who considers herself to be religious will reject accusations of faithlessness, questioning the reliability of the evidence or the integrity of the accuser. In a similar way, adherents to religious systems often treat evidence that an outsider would see as contradicting their beliefs to be irrelevant, or as belonging to a different realm of discourse — knowledge of specific gravity is seen as irrelevant to belief that Jesus walked on water.

5. *Social exchange*: many aspects of human relationships can be understood in terms of exchange. Individuals perform services for each other on the supposition that they will be reciprocated. Indeed some form of 'do-as-you-would-be-done-by' seems to be common to all moral codes and based on a pan-cultural predisposition. In like-manner, the assistance of images was usually a matter of exchange made in return for services rendered. This might involve pilgrimage to a shrine, or payment for a miracle, or merely good behaviour and repentance for past misdeeds (Aston 1997; Park 2002; Webster 1998). It is thus natural to expect that a service to a deity (or an image) will bring its reward, though belief that a deity will intervene if asked does not prevent practical action to bring about the desired goal. Destruction of an image that failed to answer prayer is known in modern times, but in general should not destruction of images be taken as evidence that they were unlikely to have a religious function, at least for the destroyers?

6. *The improbability factor*: as noted above, most deities themselves have a mixture of improbable and everyday anthropomorphic characteristics. A similar ambiguity plays an important part in the acceptance of belief in the potency of an image.

7. *Role of religious specialists*: most religious beliefs are purveyed by religious specialists whose reputation and livelihood depend on the acceptance of their pronouncements by others. Various devices are employed to this end, including the stick and carrot of hell and heaven. Believers may have been taught that they are 'lacking in faith' if they are perturbed by apparent contradictions with evidence from the everyday world. Their imperturbability brings them a certain peace of mind.

The makers of religious images and religious specialists use many devices to support the laity's perception of images as lifelike and as having special power. While some images are symbolic, in others trouble has been taken to give them lifelike characteristics, often including glass eyes and jointed limbs (Stanbury 2002; Stoichita 1995). The effectiveness of verisimilitude rests on a pancultural psychological characteristic: we tend to see things that have a superficial resemblance also to have a deep relation. This makes good biological sense; it is better to treat something that looks like a tiger as though it were a tiger (Rozin & Nemeroff 1990). In addition, medieval images were often gilded, dressed in splendid robes and embellished with precious stones. Some religious images have certain salient features exaggerated, such as the eyes (Black & Green 1992). This could account for the large breasts, bellies or buttocks of some figurines, and imply a special function for the image.

Special rituals may be used to imbue statues of a deities with the divine presence or special powers. (Rozin & Nemeroff 1990). In Christian cultures this often involves sprinkling with holy water. This also rests on an everyday psychological propensity — to believe that an object that has once been in contact with another retains some of the latter's essence. Again, this makes biological sense, for instance in the case of food on which flies have landed. The use of holy water involves several transfers of essence — from the bishop

to the priest at ordination, from the priest to the holy water, from the holy water to the image, and from the image to the worshipper who touches it.

A final issue here is that the images were kept in places regarded as holy, such as churches and, if taken out, they were returned there. In some other cultures the image is kept in a special and forbidden place, and a cult of secrecy enhances its perceived potency.

In view of all these issues, it is not surprising that the use of images is widespread across the world's religions and that belief in the powers of an image is resistant to contradictory evidence. However there are some exceptions. Where the god is conceived as formless, a material image is not possible (e.g. Lienhardt 1961), but the deity may be held to reside in specified holy places or objects, which provide foci for worship; and images may be made of lesser gods or prophets. In many religions representations of the deity are forbidden, but images of minor deities and other religious figures are permitted or even encouraged. In parts of Islam and Judaism the ban includes images of all anthropomorphic or even all living beings (Goody 1997), though in Judaism the Torah later took the place of an icon. Existing world religions in which images do not play a prominent part were established in opposition to, and were surrounded by, religions in which images were used. Devaluation of images as part of the religious system could then have had the consequence of maintaining religious, and thus tribal, distinctiveness.

Where images play an important part in belief and worship, strong opposition to their use is likely to arise from time to time (Goody 1997). The causes of this opposition vary from case to case, and what follows refers primarily to the English Reformation. The relevance of iconoclasm in the Reformation to that in other systems is discussed later.

Pre-Reformation religion

Officially the early Christians had allowed no images. However, some converts found them valuable. Their use was eventually condoned at the Second Council of Nicaea in 787 AD, provided they were venerated but not worshipped. This was too fine a distinction for many. And as Christianity spread, its leaders, rather than confronting paganism, assimilated some of its elements (Russell 1994) and the syncretism necessarily involved toleration of, and belief in, the powers of images. Division between parts of the Byzantine Empire into regions in which images were used and regions where they were not was associated with 100 years of conflict and sometimes with war. Today, some tension still persists in Christian churches between those who use images and those who think they know better.

Before the Reformation, the use of images had become an essential part of worship, especially amongst the laity. Most parishes had their own saint, who was seen as a powerful intercessor and whose presence was incorporated in an image. Pilgrimages were usually directed to the locus of an image or relic, supposed to have power to heal, to protect or to have other beneficial properties. Pilgrims might take away replicas as souvenirs, and even these images of images were often thought to carry some of the miraculous properties of the original, especially if the two had been in physical contact. Healing properties were associated with a belief in the divinity of the image, and in the image's ability to answer prayer or to convey messages to a higher authority. Often images were treated as personages being approached with personal supplications (Belting 1994).

Thus the Church was caught in a dilemma. In theory, the use of images was condemned, but in practice it was widespread. Pragmatically, the Church encouraged it. Images were seen as a Bible for the illiterate, providing instruction and reminders of the Christian narrative (Duffy 1992; Webster 1998). Images were also justified as foci for visionary experience or meditation, perhaps especially in the monasteries.

There was, perhaps, even more diversity in pre-Reformation Christianity than there is in Christianity today. Religion in the Church, monasteries, and universities involved a fairly rigid body of doctrine. While some controversy persisted — for instance over the precise interpretation of the Mass, the Assumption of the Virgin, original sin and so on, marked departures from the accepted doctrines were seen as not only heretical, but also as seditious. While the ritual may have provided emotional and visionary experience for some, it is not clear how important this was for the majority.

Religion in the parishes, by contrast, though based in the same beliefs and liturgy, involved a whole range of emotion-arousing practices. These included frequent festivals, feast days, carnivals and miracle plays, and a cult of saints involving the veneration of images. As we have seen, the use of images was often encouraged or condoned by the Church which, while not claiming the power to work miracles, was willing to credit the images of saints with miraculous efficacy (Duffy 1992).

The festivals and feasts were closely interwoven with the structure of secular life. The Sunday services strengthened corporate identity, and absence was often regarded as more than heretical. Some rituals emphasized the integrity of the Parish: the Rogantide processions reaffirmed the Parish boundaries as well

as driving out evil spirits. Aspects of the social hierarchy were reflected in the order in which people went in processions and in other details of the rituals.

For some individuals fairly intense emotional experiences may have been involved in religious practice. For instance, Easter Day was associated with dances and games, carols were often convivial, and miracle plays could be profoundly exhilarating or disturbing. On the other hand, Good Friday was a day of deep solemnity and mourning, and a degree of fasting was obligatory for nearly 70 days in each year. Veneration of the Virgin Mary was based largely in belief in her role as an intercessor who could ameliorate the anxieties of the everyday world. While these practices were mostly based in, or made compatible with, Christian doctrine, this may not have been important for the laity. For many, they were not clearly distinguished from what we might call 'superstitions'. Many of these 'superstitious' beliefs persisted in country districts into the twentieth century.

Of course, the distinction between the religion of the elite and that of the laity was by no means absolute, and members of both differed greatly in literacy. The important issue here is that the Reformation took place in a complex and hierarchically ordered society, ranging widely in sophistication and literacy, and with a Church that had already experienced a good deal of dissent. Furthermore the Church and the State, though often in conflict, were closely interwoven.

Motivation for iconoclasm: social and doctrinal issues

Secular images have often been destroyed by those in power in order that they could be replaced by the symbol of their own religion or regime. For instance, the Communists in the Soviet Union removed the symbols of the old Czarist regime, only to have their own symbols removed in due course in the post-Communist era. In 844 AD (Tang dynasty) the Chinese Emperor Wu-tsung caused images of Buddha to be destroyed and Buddhist scriptures burned, in their place he set up images of Lao-tzu and other Taoist images (Ch'en 1964).

Destruction of images, especially of secular ones, may have another explanation. Natural selection sometimes results in the development of appendages, like the peacock's tail, that handicap the owner in one way but demonstrate to mates or rivals his/her general ability to function effectively in spite of the handicap (Zahavi 1975; Cronin 1992). A similar principle operates through cultural selection in potlatch, and also in the extravagant expenditure of some western media personalities. Could it apply also to some cases of the destruction of figurines ('Look, it is easy for me to make these things: I will break this one and make another')?

The iconoclasm that took place in several periods in Christian churches differed from the above cases in that it involved not the destruction of one image to replace it by another, but the *destruction of images per se*.

Iconomachy and iconoclasm spanned much of three centuries of English history, and there was little continuity between its early (Lollard) phases and the Reformation itself (Aston 1997). Throughout that period there were divergent opinions as to whether images should be worshipped or destroyed; controversy was continuous.

In the English Reformation ecclesiastical and secular issues were inextricably interwoven, for the seeds had been sown many years earlier. An extreme Protestant (Coulton 1931) pointed to four categories of issue. On moral grounds, he argued that the papacy and many of the clergy exploited their positions and were personally immoral, that the priests gave inadequate succour during the Black Death, and that the burden imposed by the system of tithes and by the appropriation of parishes by the monasteries was excessive. On doctrinal grounds, there was the lurid doctrine of heaven and hell and the availability of the Bible only in Latin. Economically, lands were enclosed and taken away from the poor by landlords, amongst whom were many Abbots. And while the king's desire to marry Anne Boleyn was a trigger, this was by no means the first disagreement with the Pope.

No doubt Catholics would disagree on many of Coulton's points, and some doubt is cast on their general validity by the manner in which the reforms were sometimes resisted by traditionalist clergy and local communities, who were outraged by the break with the old ways. During the more than one hundred years of the Reformation, there were always some who objected. But the validity of the Protestant case is not the present issue. The point is that it was sufficient to endow the Protestant reformers with a sense of injustices that should be put right. After the Dissolution of the monasteries in Britain, as reform became more of an official policy, the Reformation brought a sense of liberation to many.

But on the surface, at least, doctrinal arguments were primary. In Luther's view indoctrination should involve faith alone, so that images were superfluous: the Word, not the image, was a sign of the Covenant. The attack was on many facets of Catholic practice — pilgrimages, worshipping of saints, purgatory, and so on, not just images (MacCulloch 1999). The Protestants argued that the Catholic Church had

allowed ritual works, the offering of candles, decking of images, pilgrimages and other practices to divert people's motivation to do good.

The use of images, and anything that was deemed to have properties beyond its physical substance, provided a ready focus for the Reformers. Given that images had long been in some degree problematic throughout the history of the Christian Church, the destruction of images was a symbol of opposition to many aspects of religious orthodoxy, a focus for the elimination of a religious system. A literal reading of the Old Testament gave plenty of precedents for forbidding the use of idols. There was always the possibility that they would be identified too closely with that which they represent, especially if they were worshipped. In addition, it was argued that just because images could be identified closely both with everyday reality and with the deity, their worship involved a contradiction between the sacred and the secular. To confuse the two was seen as blasphemous. Again, images are made by man and cannot equal the beauty of anything made by God, let alone God himself — a principal reason why images are forbidden in Islam. Any attempt to emulate that creator must necessarily be abortive, and thus deceitful. It must surely be sinful to try to encapsulate the unknowable in an image. Furthermore, there was always a tension between the image as a material object and the view that it has special powers and even animate properties. And some objected to images simply because the sumptuousness of their decoration was deemed to involve an inappropriate display of wealth, or the misuse of resources that would have been valued by the poor, as well as the danger of idolatry. Consecration or other ceremonies could partially circumvent this.

Finally, iconoclastic orders could be justified to the people on the grounds that the worship of idols would make God angry and bring vengeance from above. At the time of the Reformation it was still customary to ascribe community disasters to community sins, so that the destruction of images became a matter of community protection (MacCulloch pers. comm.).

Motivation for iconoclasm: individual issues

In the early days of the Reformation in Britain, before reform was given any legitimacy, the motivation of the iconoclasts must have been genuine religious horror at Catholic practices. At that time, to break or deface a crucifix or an image of a saint was a most serious offence: the early iconoclasts mostly operated at night, and at least some of those who were caught were hanged.

As time went on and official attitudes changed, no doubt many iconoclasts acted out of conviction but many, perhaps the majority, did so because they were told to. The telling argument throughout the Reformation was 'it is the Royal will'. Orders from above were resented by many, and there was sometimes open revolt — with disastrous consequences for the rebels. Recalcitrance could bring severe penalties. Bishops and clergy were sometimes deprived of their offices, and even executed. Active traditionalists were arrested, placed in the stocks or otherwise severely punished.

For much of the time destruction was limited to images that were worshipped rather than those which were merely venerated. Determining which were worshipped was a problem, but the lighting of candles before a statue was often taken as significant. In addition, for many the mere removal of images was insufficient; if idolatry were to be defeated, the images must be destroyed. Thomas Cromwell, Cranmer and, it was believed, the King Henry himself, encouraged their supporters to dismember and burn images publicly, to convince the population of their ineffectiveness. This led at times to gleeful destructiveness and the incitement of public ridicule against the traditional style of devotion.

Perhaps the iconoclasts' desire to destroy the images arose because they really believed that the images somehow usurped the presence of God from human consciousness. Or perhaps, as some have argued, they believed that the images were meaningless, and stood for and concealed nothing. Thus the image masked the absence of a basic reality, or perhaps it bore no relation to any reality whatever. On this view it could be argued that the iconoclasts, 'often accused of despising and denying images, were in fact the ones who accorded them their actual worth' (Baudrillard 1988). Baudrillard suggests that this capacity of images to murder that for which they stand has always been opposed to the dialectical capacity of representations as a visible and intelligible representation of the real.

Or did some iconoclasts have some suspicion that the images did indeed have some special power, some feeling that the images were something more than the wood or stone of which they were made? As we have seen, belief in the power of images was based in pan-cultural predispositions and had long been quite general. The Reformists' doctrinal approach had considerable resistance to overcome. Just because the cultural climate in which they had been living was so highly conducive to belief in the power of images, it must have been difficult for anyone to become totally free of its influence. Indeed the Reformers were attacking not only the use of images but the whole system of festivals, feasts and carnivals which was closely interwoven with the seasons and with the everyday lives of the laity. Reservations about abandoning be-

liefs and practices that had long been incorporated into their self-systems must have induced some ambivalence. Indeed, even today many who would now call themselves agnostics or atheists hesitate to enter the chancel, to sit on the altar, or to behave in an unruly way in church, and that in the absence of anyone who could be offended. Belief is not solely rational, and nearly always has some emotional underpinning. The fervour that the iconoclasts sometimes displayed could suggest not single-mindedness but ambivalence of some sort.

So one may ask, where images were burned or totally destroyed, was this really to convince the people that the image was nothing more than the material of which it was made, or because the iconoclasts themselves half believed that they might have some special power, even if they did not admit this to themselves? Boldrick (2002) writes ' ... references to statues of the Virgin and St. John that were "burned with great wonder" and "fires of joy" support the perspective that iconoclasm can be another form of idolatry, with its own distinctive sense of wonder'. So was the fervour of the iconoclasts merely rage at the violation of purity (Douglas 1970), or fear of the images' power (Douglas 1970). Or perhaps not a fear of the power of the image itself, but fear arising from a voodoo-like belief that damaging the image would damage the prototype, and rebound on their own heads? Such beliefs were in the air in an era when fear of divine punishment was endemic and witches were still being persecuted (Thomas 1971).

This raises many questions which perhaps can never be answered. For instance, why did the iconoclasts often content themselves with merely mutilating the hands, face and/or eyes? After all, they had been ordered to destroy them completely. Was it simply because disfigurement was the easiest course? Face and hands stick out and are easily mutilated. That this was sometimes the issue is suggested by the description of an attempt to destroy the Cross at Cheapside in 1581. Apparently attempts to pull down the Cross failed, so the iconoclasts defaced the Virgin and the images by striking off their arms. Or was it because such amputations left the image powerless and open to derision, recognizably there but powerless and therefore looking silly? Could that in itself not imply a feeling that the image might itself have some anthropomorphic properties, and thus power? Or, when total destruction was avoided, was it because some power was held to reside in the image?

Why did many of those ordered to remove and destroy images (and other religious paraphernalia) delay doing so for as long as they could? In many cases, especially in Edward VI's reign, the sacred objects were merely hidden or ostensibly sold, to be restored to the churches when the climate was reversed by Mary's accession (Duffy 1992; 2001). Sometimes the material from which the images were made was subsequently recovered and reverenced. Often the images were soon replaced by paintings of Biblical scenes. Could this mean not only a desire for the traditional religion to remain, but also that portrayals of Christ or the Saints were still seen as sacred, and thus as having special properties, and perhaps powers? Or was restraint necessitated by a need to avoid infuriating the more conservative believers?

That the iconoclasts often had at least a suspicion that the icon did have special powers is suggested by a number of reports. For instance it was said that iconoclasts would 'prick (the images) with their bodkins to say if they will bleed or not'. Again, two fourteenth-century Lollards who destroyed a statue of St Catherine at Leicester chopped the head off first, ' ... for if her head should bleed when we strike it, then we shall worship her as a saint. On the other hand, if no blood flows, she will make fire to cook our stew' (Stanbury 2002, cited in Park 2002). Of course it could be that such remarks were merely ironic.

We shall never know exactly what went on in the minds of the iconoclasts. No doubt individuals differed, and most probably had mixed motives. What is clear, however, is that both the arguments for the Reformation, and those against it, were diverse. The Reformers encountered the force of pan-cultural dispositions reinforced by deeply engrained beliefs and social customs. They were only partially successful, and the royal succession could bring a reversal to the changes. The Church of England that eventually emerged can be seen as far from purely doctrinal, and relatively few splinter groups were fully successful in shedding all vestiges of the practices they wished to forbid.

Conclusion

As a take-away message, three points should perhaps be emphasized in relation to the figurines discussed in this volume:
1. The worship of deities, and the acceptance of images as substitutes, however strange to modern minds, depend on pan-cultural human propensities that were probably acquired, by natural or cultural selection, because of their values in non-religious contexts. However humans live in diachronic dialectical relations with their social and physical environment, relations that imply change in all three (Hinde 1999; 2002). Thus human nature, as seen today, is no certain guide to human nature 60,000 years ago. Nevertheless commonalities are to be expected, and

it is hoped that the preceding discussion at least raises questions for archaeologists.

2. Every instance of iconoclasm is complex, likely to have multiple interacting causes, so that simple explanations are to be distrusted. The causes in the case of the Reformation are more accessible than instances further back in time, but enormous caution is necessary in generalizing to other cultures and to pre-history. Destruction of images in the Reformation involved *destruction per se*, whereas many cases of iconoclasm involve destruction of one image to replace it by another. This could be seen as a difference between religious and secular images, but this distinction must not be taken too far; religious images have often been used in secular contexts (e.g. the Virgin of Guadaloupe carried into battle), and secular symbols can have an almost religious significance (e.g. the blessing of regimental colours and willingness to die for them). In addition, loss of belief in the power of a religious image does not necessarily lead to its destruction. Firth has recorded how, when the Tikopia were converted to Christianity, they put away their traditional gods, apologizing to them (Firth 1967). Another major difference is that doctrinal disputes among the more sophisticated individuals would probably be absent or less tortuous in pre-literate societies.

3. Any religious system with any degree of elaboration is likely to involve religious specialists. Destruction of religious images is most likely to be initiated by individuals who possessed authority by virtue of their position or their charisma, and could thereby command obedience, building on discontent and disconfirmation of the perceived powers of the icon, and inspired by hopes that their needs would be better fulfilled by new beliefs. Once a few individuals were converted, affinity with other converts would facilitate integration in the break-away group.

Destruction of secular images may also have a variety of causes, including changes in power relations. But operation of the Handicap Principle (see above) is at least a possibility.

Acknowledgements

I am grateful to Margaret Aston, Peter Linehan, Jessica Rawson and Harvey Whitehouse for critical and helpful comments on earlier versions of the manuscript, and to Michael Brick and Duncan Dormor for references.

References

Asch, S.E., 1959. A perspective on social psychology, in *Psychology: a Study of a Science*, vol. 3, ed. S. Koch. New York (NY): McGraw Hill, 363–83.

Aston, M., 1997. Iconoclasm in England: official and clandestine, in *The Impact of the English Reformation 1500–1640*, ed. P. Marshall. London: Arnold, 167–91.

Atran, S., 1993. Whither ethnoscience?, in *Cognitive Aspects of Religious Symbolism*, ed. P. Boyer. Cambridge: Cambridge University Press, 48–70.

Backman, C.W., 1988. The self: a dialectical approach. *Advances in Experimental Social Behavior* 21, 229–60.

Baudrillard, J., 1988. Simulacra and simulations, in *Selected Writings*, ed. M. Poster, Cambridge: Polity Press, 166–84.

Baumeister, R.F., 1999. *The Self in Social Psychology*. Philadelphia (PA): Psychology Press.

Belting, H., 1994. *Likeness and Presence*. Chicago (CL): Chicago University Press.

Black, J. & A. Green, 1992. *Gods, Demons and Symbols of Ancient Mesopotamia*. London: British Museum.

Boldrick, S., 2002. Introduction, in *Wonder*, ed S. Boldrick, D. Park & P. Williamson. Leeds: Henry Moore Institute, 12–29.

Boyer, P., 1994. *The Naturalness of Religious Ideas*. Berkeley (CA): University of California.

Boyer, P., 2002. *Religion Explained*. London: Vintage.

Byrne, D., D. Nelson & K. Reeves, 1966. Effects of consensual validation and invalidation on attraction as a function of verifiability. *Journal of Experimental Social Psychology* 2, 98–107.

Ch'en, 1964. *Buddhism in China*. Princeton (NJ): Princeton University Press.

Christian, W.A., 1996. *Visionaries*. Berkeley (CA): University of California Press.

Coulton, G.G., 1931. *In Defence of the Reformation*. London: Simpkin Marshall.

Cronin, H., 1992. *The Ant and the Peacock*. Cambridge: Cambridge University Press.

Douglas, M., 1970. *Purity and Danger*. Harmondsworth: Penguin.

Duffy, E., 1992. *The Stripping of the Altars*. New Haven (CT) & London: Yale University Press.

Duffy, E., 2001. *The Voices of Morebath*. New Haven (CT): Yale University Press.

Firth, R., 1967. *Tikopia Ritual and Belief*. London: Allen & Unwin.

Gelman, R., F. Durgin & L. Kaufman, 1995. Distinguishing between animates and inanimates: not by motion alone, in *Causal Cognition*, eds. D. Sperber, D. Premack & A.J. Premack. Oxford: Clarendon, 150–84.

Goody, J., 1997. *Representations and Contradictions*. Oxford: Blackwells.

Guthrie, S., 1993. *Faces in the Clouds*. New York (NY): Oxford University Press.

Hinde, R.A., 1999. *Why Gods Persist*. London: Routledge.
Hinde, R.A., 2002. *Why Good is Good*. London: Routledge.
Hood, R.W., B. Spilka, B. Hunsberger & R. Gorsuch, 1996. *The Psychology of Religion*. New York (NY): Guilford.
Lienhardt, G., 1961. *Divinity and Experience: the Religion of the Dinka*. Oxford: Clarendon Press.
MacCulloch, D., 1999. *Tudor Church Militant*. London: Allen Lane, Penguin.
Park, D., 2002. The polychromy of English medieval sculpture, in *Wonder*, ed. S. Boldrick, D. Park & P. Williamson. Leeds: Henry Moore Institute, 30–56.
Rozin, P. & C. Nemeroff, 1990. The laws of sympathetic magic, in *Cultural Psychology*, eds. J.W. Stigler, R.A. Shwerdt & G. Herdt. Cambridge: Cambridge University Press, 205–32.
Russell, J.C., 1994. *The Germanization of Early Medieval Christianity*. New York (NY): Oxford University Press.
Skinner, B.F., 1959. *Cumulative Record*. New York (NY): Appleton-Century-Croft.
Stanbury, S., 2002. The vivacity of images, in *Idolatry and Iconoclasm in Late Mediaeval England*, eds. J. Dimmick, J. Simpson & N. Zeeman. Oxford: Oxford University Press.
Stoichita, V.I., 1995. *Visionary Experience in the Golden Age of Spanish Art*. London: Reaktion Books.
Tajfel, H. & J. Turner, 1986. The social identity theory of intergroup behaviour, in *Psychology of Intergroup Relations*, eds. S. Worschel & W.G. Austin. Chicago (IL): Nelson, 7–24.
Thomas, K., 1971. *Religion and the Decline of Magic*. London: Weidenfeld & Nicolson.
Webster, S.V., 1998. *Art and Ritual in Golden Age Spain*. Princeton (NJ): Princeton University Press.
Wooley, J.D., 1997. Thinking about fantasy. *Child Development* 68, 991–1011.
Zahavi, A., 1975. Mate selection — a selection for a handicap. *Journal of Theoretical Biology* 53, 205–14.

Chapter 25

Images and the Biological Origins of Religion

Donald M. Broom

The first theme of this paper is that, biologically, helping others and not harming others are effective strategies, especially for animals such as humans who live in long-lasting social groups. This is why 'the Good Samaritan' is much emphasized in Christian teaching and why there are parallels in the teachings and codes of conduct of other religions. The second theme is that religious images and symbols are easier to understand if the biological basis of morality and religions is understood.

Concepts and attitudes

Something is moral if it pertains to right rather than wrong. Every person has ideas about what is right and hence takes account of morality in their actions. Most people discuss moral issues with others. *Ethics is the study of moral issues.* Unless otherwise attributed, definitions and ideas presented in this paper come from Broom (2003).

Some ideas which biologists would take as axiomatic are not necessarily accepted by other people. One example of such a biologically-based statement is that humans are animals. Another is that humans and other animals take all decisions using their brains and that the heart is not directly involved in decision making. These and many other biological facts are relevant to the discussions about the biological basis of morality, religions and images that are presented here.

Morality is a topic which some people would not accept as suitable for discussion from a biological or other perspective, because it is thought of as sacred or God-given. The influential philosopher G.E. Moore (1903) went so far as to state that: 'It is illegitimate to argue from the facts of nature to human values'. Even a biologist might regard morality as in some way outside biology. In the midst of a strong argument about the importance of evolution by natural selection in social life, Dawkins (1976) said: 'We, alone on earth, can rebel against the tyranny of the selfish replicators'. Somewhat similar views are stated by Alexander (1979) and Williams (1988). Dawkins's term 'the selfish gene', proposed in an illuminating and influential book, is misleading. *Selfish describes an individual acting in a way that increases its fitness at the expense of the fitness of one or more other individuals whilst being aware of the likely affects on itself and on the harmed individual or individuals* (Broom 2003). The word selfish is thus limited to individuals and it could not describe a gene. If there is no awareness, it is not selfishness.

A word which is widely used with one set of connotations cannot be transferred to another set without causing the reader or hearer to misunderstand either the breadth of its implications or the concept itself (Midgley 1994). One consequence of Dawkins's usage of 'selfish gene' is that people will argue firstly, that we are not responsible for the effects of our genes and secondly, because genes are often selfish there is nothing wrong with being selfish. It would be better to produce another term to refer to genes that promote the fitness of the bearer, i.e. the actions benefit the subject, at the expense of others that are harmed by the action. The terms 'harmful subject-benefit' (Broom 2003), or 'subject-benefit at the expense of others', are more accurate if more cumbersome.

The desirability of considering the biological basis for morality has been expounded by many authors, (e.g. Kropotkin 1902; Kummer 1978; Midgley 1978; de Waal 1996 and Ridley 1996). In order to explain the basis for morality we often refer to altruism. *An altruistic act by an individual is one which involves some cost to that individual in terms of reduced fitness but increases the fitness of one or more other individuals.* Trivers (1985) said: 'There can hardly be any doubt that reciprocal altruism has been an important force in human evolution'. *Reciprocal altruism occurs when an altruistic act by A directed towards B is followed by some equivalent act by B directed towards A or by an act directed towards A whose occurrence is made more likely by the presence or behaviour of B.*

A major confusion exists in the usage of the term morality to refer especially to aspects of sexual activity. There are some actions which might be criticized

by some or many in human society but which are to do with sexual or other customs rather than with true morality. However, many sexual taboos serve a mate-guarding function for certain males rather than being in the general interest of the members of a social group. A straightforward example is the view that it is morally wrong for women to derive pleasure from the act of copulation. The practice of clitorectomy is a consequence of this view. I consider that some actions are always wrong, so they cannot be justified by cost–benefit analysis of consequences. However, I consider that sexual acts are not in themselves wrong. The consequentialist argument is useful here in that moral judgements about sexual activity should concern whether or not there are harms to individuals as a consequence of the acts (Broom 2003; 2006). Hence, whilst rape would always be immoral because it would always have harmful effects, most sexual acts would not be immoral. It is necessary to consider the context of the act, including the individual to which it is addressed, and its consequences in order to determine whether or not there are harms as a result of the act. Indeed, some sexual acts result in the production of much desired offspring, help to cement bonds between partners, or calm individuals and reduce the risk of anti-social behaviour.

Codes and rules of conduct, which include issues of great importance, are widespread in human society. Some of these codes are specified as laws, for example those to prevent murder, theft, rape and fraud. Other selfish acts are the subject of sanctions which, although social rather than legal, are important nonetheless. Indeed Ridley (1996) refers to a taboo against selfishness. Codes of conduct have been written down in many societies, for example the ten commandments of the Jews and Christians, in the Bible (Exodus 20, 3–17 and Deuteronomy 5, 7–21) and the Greek rules of conduct. The Qu'ran makes it clear that it is the morality of the individual's actions which determine reward and punishment (Sura XLIV, 40).

Those who injure another deliberately, those who cause injury by careless contact with another such as a push which leads to a head injury, and those who are negligent with the consequence that an injury is caused to another, are condemned by society, albeit to different degrees. For example, a person who leaves a large hole in the ground uncovered in the dark, or who gives a child a dangerous weapon is severely criticized in almost all human societies. There are also rules relating to the use of important resources. If plentiful quantities of food are occasionally obtained by individuals in a social group, there is likely to be an expectation within the group that these will be shared. Many of these rules seem to exist in other social species.

Morality and its evolution

Humans and other animals that live in social groups cooperate in many ways which benefit the cooperating individuals more than would occur if they just competed with one another. In addition to the more obvious kinds of cooperation, the most common kind of altruistic behaviour in social groups, which is often reciprocated, is to avoid injuring other individuals. Great care is usually taken by individuals to avoid collisions, which would benefit the avoider as well as the avoided, but also not to step on others, or injure them with horns or teeth, or push others out of trees, or over cliffs, or into places of danger from predators. The avoidance of harming others is advantageous in order to minimize disruption of group stability (Broom 2003; 2006). It may also reduce the likelihoods of kin being harmed or of potentially dangerous retaliation occurring.

If any accidental and perhaps avoidable harm to another does occur, this can be followed by changed behaviour on the part of the harmed individual and on the part of the one who has harmed. Harm may be followed by some form of retribution but either accidental or deliberate harm may also be followed by reconciliation, at least in primates (de Waal 1996).

The key points of the arguments presented here about morality and its evolution and elaborated by Broom (2003) are as follows:

1. True morality does not include customs, or attitudes to sexual behaviour stemming from mate guarding etc. except indirectly by effect.
2. Some laws indicate what is morally right but others may protect the persons and property of the powerful or perpetuate tribal or other customs. Although more likely to do so in a democracy, laws will not always indicate what is right.
3. There is widespread occurrence of cooperative and altruistic behaviour in social animals.
4. Awareness, feelings and cognitive ability are clearly demonstrated in mammals, birds and other animals to a lesser extent.
5. There is great overlap in the gene complement of humans and other animals.
6. The likely success of strategies which involve moral action is demonstrated by modelling and the actual success is apparent from behavioural and other observation.
7. Reciprocal altruism is important in the evolution of morality but is not all of the biological basis.

The moral core of religion

A religion is a system of beliefs and rules which individuals revere and respond to in their lives and which are seen as emanating directly or indirectly from some intangible power (Broom 2003). All religions which have adherents numbering millions have a moral code that is central to their functioning. The differences among religions are in peripheral aspects, including tribal components. Holy books are a source of information about what is moral but they also include much history. Religions have a guide to behaviour and a system for discouraging cheats or those who harm others. The moral code in each religion is very similar and includes a variety of commandments used by those who adhere to the religion.

Images in relation to biologically based preferences

Images of humans and of other animals have been viewed as a source of protection and sometimes revered. What are the characteristics of these images and why have they been made or selected? There will be many answers to these questions and the ideas presented in this paper present the biological basis as a guide to some of the answers.

Many images are symbols of collaboration, cooperation and altruism. Some of the individuals, human or non-human, portrayed in the images are of those who help the people involved. A person who guides or provides other resources, or an animal which in some way shares its capabilities or body with the people is often respected for those reasons. People have long appreciated the sentience of various domestic and other animals and have often thought of them as an example to follow or a friend who would help, rather than just as a resource object. *A sentient being is one that has some ability: to evaluate the actions of others in relation to itself and third parties, to remember some of its own actions and their consequences, to assess risk, to have some feelings and to have some degree of awareness* (Broom 2006). Both humans and sentient non-humans were thought of by many people in European societies during the last three hundred years (Podberscek *et al.* 2000; Serpell 2002) as having the capability to be good or bad. These attitudes were based on observations of behaviour and of the consequences of behaviour. They may have been exaggerated by anthropomorphism but they were not just anthropomorphic.

When humans or other animals showed maternal care, defence of others, careful avoidance of causing harm to others, or direct assistance to others, they were respected for doing so. Both humans and non-humans sometimes act in selfish ways but this does not mean that all actions are selfish. Indeed, societies can only persist if the net effect of the actions of their members is to promote stability of the social group so it is logical that selfless actions should engender respect. The fact that non-human animals often showed behaviour that was a good example to people may well have been an important reason why some animals were revered to some extent, thought to be holy, or worshipped. Such reverence could lead to the production of images of the animal to possess or even idolize.

Some of the images which reflect these biological principles are listed here:
1. a mother, sometimes with her offspring;
2. individuals whose conduct is explained and well known and who are revered for their conduct and teaching;
3. an animal which is valuable and considered blameless;
4. an animal which is thought or known to be altruistic;
5. an individual, human or non-human, whose image or reputation indicates an ability to see or understand what others are doing and to be in a position to punish cheats;
6. an individual reputed to be perfect and hence not selfish, for example, the Buddah, Jesus or other deities.

Some individuals perceived or reported to be perfect are, as a consequence, not allowed to be represented as an image.

In contrast to the above, the source of retribution or terrible vengeance is sometimes the subject of an image. Such images are less common and less long-lasting in the history of a religion, than images of the good, the altruistic, or the useful, or of those believed to be perfect or aware of transgressions.

The question of the level of reverence given to images found in human communities may not be answerable with certainty so reference to images in this paper does not imply that these are likely to have been worshipped. Human mothers have often been the subject of images, for example in India (Gordon & Gordon 1940) and China (Wang 1997). Cattle may also be used as images (Atre 2002) and, since both males and females normally have horns, many of these may have been females who were mothers. As Meskell (1995) emphasizes, a female figure may be a mother, perhaps exaggerating maternal physical attributes, but may not be a mother and many different individuals with different qualities could have been used as models for image production. Whilst not all female figures were portraying morally desirable qualities, there may well be more of such figures than would be expected by chance.

A question which is worth asking, whenever an image is found, is whether or not that image might be of an individual whose moral status is exemplary to those who see the image. The creator of the image may have fashioned it for this reason but may sometimes have been unaware of why that particular image was fashioned. When morally exemplary images were fashioned, in some cases they would have been seen by very many of the people in the community. In order for this to occur, they would usually have been impressive because of their size or because of their exceptional quality. Some morally exemplary images would have been produced for individual usage but there are many other reasons why individually available images might have been produced. Hence there might not necessarily have been large numbers of morally exemplary images but those that did exist would have been widely seen. Both human and non-human exemplary images could have had useful effects in human societies if a sufficient number of people responded to them by some reduction in behaviour that destabilized the structure of the society, or by an increase in behaviour that promoted societal stability. In many cases, images with such value would have been linked to the religion of that society.

General conclusion

The central characteristic of religions is a structure which supports a moral code, essentially the same one in all religions. This is derived from moral structures that have evolved in complex animal societies. Natural selection acts on individuals to promote behaviours that minimize harms to those perceived to be group members and encourage collaboration. Many images, especially those with spiritual significance, are of humans or non-humans perceived to have important moral qualities. Preference for these has some biological basis. Whenever an image is found, it is worthwhile to consider whether or not that image might be of an individual whose moral status is exemplary to those who see the image. If so, the larger and otherwise most impressive morally exemplary images may have been readily seen by many people, so evidence concerning the likelihood of this should be sought.

References

Alexander, R.D., 1979. *Darwinism and Human Affairs*. Pullman (WA): University of Washington Press.

Atre, S., 2002 Harappan religion: myth and polemics in Indian Archaeology, in *Retrospect vol. II. — Protohistory: Archaeology of the Harappan Civilization*, eds. S. Settar & R. Korisettar. New Delhi: Manohar, 185–204.

Broom, D.M., 2003. *The Evolution of Morality and Religion*. Cambridge: Cambridge University Press.

Broom, D.M., 2006. The evolution of morality. *Applied Animal Behaviour Science* 100, 20–28.

Dawkins, R., 1976. *The Selfish Gene*. Oxford: Oxford University Press.

Gordon, D.H. & M.E. Gordon, 1940. Mohenjo-daro: some observations on Indian prehistory. *Iraq* 7(1), 12.

Kropotkin, R., 1902. *Mutual Aid: a Factor in Evolution*. London: Allen Lane.

Kummer, H., 1978. Analogs of morality among non-human primates, in *Morality as a Biological Phenomenon*, ed. G.S. Stent. Berkeley & Los Angeles (CA): University of California Press, 31–47.

Meskell, L.M., 1995. Goddesses, gimbutas and 'New Age' archaeology. *Antiquity* 69, 74–86.

Midgley, M., 1978. *Beast and Man: the Roots of Human Nature*. Hassocks, Sussex: Harvester Press.

Midgley, M., 1994. *The Ethical Primate*. London: Routledge.

Moore, G.E., 1903. *Principia Ethica*. Cambridge: Cambridge University Press.

Podberscek, A.L., E.S. Paul & J.A. Serpell, 2000. *Companion Animals and Us: Exploring the Relationships Between People and Pets*. Cambridge: Cambridge University Press.

Ridley, M., 1996. *The Origins of Virtue*. London: Viking.

Serpell, J.A., 2002. *In the Company of Animals*. Cambridge: Cambridge University Press.

Trivers, R., 1985. *Social Evolution*. Menlo Park (CA): Benjamin Cummings.

de Waal, F., 1996. *Good Natured*. Cambridge (MA): Harvard University Press.

Wang, Y., 1997. Lun Houtaizi yuanshi nuxing fenwan xilie shidiao [On the Houtaizi stone sculptures as depicting a birth-giving process]. *Wenwu Jikan* 1, 57–61.

Williams, G.C., 1988. Reply to comments on 'Huxley's evolution and ethics in sociobiological perspective'. *Zygon* 23, 437–8.

Chapter 26

Incorporating Figuration and Spirituality

F. LeRon Shults

It was a great pleasure for me as a philosopher and theologian to listen in on a conversation among archaeologists and anthropologists about the material role of images and figuration in early human cultures. My task as discussant was to point toward possibilities for 'incorporating' figuration and spirituality. Can we bring these disciplines together into the same 'corpus' or 'body' of knowledge? In what follows I explore ways in which we might 'refigure the corpus' (to borrow a phrase from Lynn Meskell, this volume) of the interdisciplinary dialogue between archaeologists and theologians. Participants in both of these disciplines are interested in the origin, condition and goal of the human passion for figuration. While anthropologists are interested in the con-figuration of spiritual practices, theologians are interested in re-figuring the practice of conceptualizing spirituality. I believe we can learn from each other.

The phenomenon of figuration, insofar as it is related to the religious dimensions of a culture, is an expression of the human attempt to configure the transcendent, to 'figure out' that which is experienced as a force that cannot be controlled. From a theological point of view, religious figuration is interesting for the way in which it involves the desire to comprehend the ultimate Other, to render that which is beyond our limits (the infinite) in finite images. In this brief space, I will not explore this in detail; my goal is simply to make some observations about the dialogue and some suggestions for the way forward. Three aspects of the discussion seemed particularly helpful to me as we move toward this interdisciplinary incorporation: 1) contextuality; 2) relationality; and 3) interdisciplinarity. Each of these is part of a broader development within the dialogue among philosophers of science, which impacts both of our disciplines; this seems an appropriate place to start.

The appeal to contextuality

My first observation has to do with the frequency with which presenters appealed to the importance of contextuality (e.g. DeMarrais, Malafouris, Svoboda). The role of subjectivity, which has to do with the way in which context shapes knowledge, was also emphasized in several papers (e.g. Bailey, Morley). This attention to context is part of a philosophical turn in the broader academy. The Enlightenment idealization of the neutral 'man of reason' and universal, totalizing theories of rationality has for the most part been weeded out of scholarly discourse, and philosophers of science have increasingly argued that all intellectual searching emerges out of and operates within particular contexts shaped by particular commitments. Far from inhibiting scientific research, this 'personal coefficient' (Polanyi) of inquiry is essential, for commitment and intellectual passion are an impetus for the pursuit of knowledge. Whether we call this web of beliefs that guides inquiry a 'paradigm' (Kuhn) or a 'research programme' (Lakatos), the point is that such constructs shape and are shaped by our contexts. Alongside this general aversion to generality, however, I commonly heard expressions that presupposed generic features of our species — most notably that we could be called *Homo symbolicus* or *Homo figurans*. How are we to hold together both our commitment to contextuality and our intuitions about generality?

My first suggestion is that we aim for a *both/and* rather than an *either/or* solution. In post-positivist philosophy of science, several models of rationality have been offered that reject the dichotomy and find a middle way between the Scylla of absolutism and the Charybdis of relativism. The bifurcations between subject and object, value and fact, relativism and absolutism, are themselves modernist constructions. We may agree that there are no neutral 'universals' but still search for 'transversal' connections; reaching from within and across contexts, humbly identifying patterns that illuminate our experience. Elsewhere I have explored the emergence of a *post*-foundationalist model of rationality (Shults 1999), which attempts to move beyond the *either/or* impasse by articulating the possibility of a *both/and* relationality. We are not forced to give up on the ideal of trans-contextual discourse,

even though we may need to acknowledge that this ideal is a *focus imaginarius* that guides and orientates our search for knowledge.

Archaeologists seem to start with the particular (with concrete materiality), and then ask about general features. Philosophical theologians would be more predisposed to start with the general (with concepts like culture, religion, spirituality), and then see how these work on particulars. However, both are inextricably tied together in both disciplines. I suggest that we admit we 'start' already within the dialectic between our attention to a particular context *and* our interest in general conceptual connections. We need both; the danger is staying too focused on one or the other. We can accept the limitation that all inquiry begins with our participation within our own particular contexts (where else could it begin?), but as we critically distance ourselves from our individual contexts we may also face our own fallibility, exploring the inter-subjective and trans-communal critiques and insights of other persons in other disciplines and traditions.

The appeal of relationality

A second observation has to do with the way in which so many of the papers emphasized the importance of *relationality*. For example, the relation of maker to figurine, the relation of persons to communities, the relation of figurines to that which they symbolize, etc. were all lifted up as central to the interpretive process (cf. Burger, Chapman, Kuijt, Lesure, Mizoguchi). This appeal by so many presenters to the value of relational categories is evidence of another broader shift in the philosophy of science, which I have called the 'turn to relationality' (Shults 2003). The easiest way to illustrate this shift is by comparison to Aristotle and Kant. In Aristotle's philosophy of science, the category of 'substance' was privileged over the category of 'relation'. True knowledge of a thing involved defining its substance, marking off its genus and differentiae. The way in which the thing was related to other things was 'accidental' — not essential for understanding or explaining the reality of the thing itself (e.g. *Categories* II, VII; *Metaphysics* XIV.1). Over the centuries, however, the difficulties with a theory of knowledge (and predication) that failed to attend sufficiently to the relations between things became increasingly evident. By the end of the eighteenth century Kant found it necessary to reverse Aristotle's preference for substance. In his own list of categories in the *Critique of Pure Reason* Kant made 'of relation' a broader category than 'substance and accidents' (1965, 113). Several presenters also utilized C.S. Peirce's philosophical analysis of semiotics in their analyses (e.g. Joyce). Peirce himself developed a new approach to categories that led him to propose three 'classes of relations', which he called monadic, dyadic, triadic — or Firstness, Secondness, and Thirdness (Peirce 1998).

My suggestion here is that archaeologists consider pressing this interest in relationality even further, challenging the modernist emphasis on substance dualisms of various kinds; e.g. body vs. soul, secular vs. sacred, natural vs. supernatural, and even materiality vs. spirituality. Professor Meskell illustrated such a move in her paper by questioning the projection of a strong dichotomy between the everyday and the ritual into our interpretation of early cultures. As the inheritors of Cartesian anthropology increasingly recognized, it is difficult to make sense of any real connection between the body and the soul if we conceptualize them as substances. Similarly, we make the process of incorporating figuration and spirituality more difficult than it needs to be if we begin with a bifurcation between material substance and spiritual substance. The late modern turn to relationality opens up new conceptual space for overcoming this bifurcation, without collapsing or conflating the intuitions behind the distinction.

This has 'material' ramifications for the way in which we understand the concept of 'spirit'. A first step toward re-figuring our understanding of spirituality is to note that the very idea of spirit may be described otherwise than as the negation of the material, i.e. as in-corporeal or im-material substance. Elsewhere I have outlined ways in which the category of relationality can help us to make sense theologically of the idea of 'spirituality' as a qualification of matter (energy) at complex forms of organization, as in the case of *Homo sapiens* in cultural relation (Shults 2005; Shults & Sandage 2006). We may think of the human 'spirit' as describing a real and causally efficacious property, embedded within embodied human life but emerging superveniently at sufficiently complex levels of criticality, giving rise to the capacity of a finite organism to engage in dynamic self-reflection on its limits (the in-finite). This allows us to define 'spirituality' as a way of tending to this relationality (finite/infinite) in all its embodied complexity, thematizing and ritually mediating its relation to the ultimately unmanipulable and unsymbolizable Other, which leads to both anxiety and hope. As Colin Renfrew observed in our discussion, this sounds like self-consciousness. Indeed. Human spirituality is inherently linked to our natural longing to make meaning of our lives in relation to the other (and the Other), that which we cannot control. It is characterized by the intensification of our natural openness to

that which is beyond us. In our ordinary use of the term, 'spirit' refers to the energetic organization of a complex self-related (conscious) organism, describing the complexity of its relation to self and other (e.g. she is 'high-spirited'). The human spirit naturally longs to figure out the ultimate meaning of its becoming, and figuration is one expression of this desire.

The appeal for interdisciplinarity

My final observation has to do with the eagerness for interdisciplinary dialogue expressed by so many of the participants. Several presenters were (rightly) critical of biologist Richard Dawkins for reducing explanations of human behaviour to the categories of his own discipline (the concept of the 'selfish' gene). One of the values of transdisciplinary discussion is that we can hold each other accountable as we fight against the temptation toward reductionism. It is important to acknowledge an asymmetric organization of levels of inquiry. On the one hand, sciences like physics (carbon dating) and chemistry (material analysis) have something to say to archaeology but the conceptual apparatus of these fields cannot makes sense of or explain all of the data that interests archaeologists. On the other hand, the cultural insights of palaeoanthropology may lead to interesting new research programmes or developmental technologies in these other disciplines. I would argue that the same kind of asymmetric relation holds between anthropology and theology. The latter cannot (and ought not) tell anthropologists how to do their jobs, but it may provide new conceptual space for imagining and figuring out the role of spirituality and religion in the life of early human cultures.

One way in which this overlap between the disciplines could be explored is by attending to a common set of questions that interests both theologians and anthropologists: what is the origin, condition and goal of particular forms of figuration? The proximate origins of figuration clearly have biological dimensions (Broom), the conditions of figuration include the adaptation of the brain for language (Layton), and the goals of figurines may vary from the provision of comfort (Hinde) to expressions of political strategies for controlling the identities of ritual participants (Skeates). But this leaves open the philosophical and theological questions about the *ultimate* origin, condition and goal of the aesthetic longing that is expressed through figuration. It was encouraging to see how archaeologists are fascinated with the Other — my final suggestion is that this delight in alterity might be extended even more through dialogue with the strangely other discipline of theology, and of course vice versa. A little alterity of disciplinary perspective might mutually enhance all of our endeavours.

I conclude by mentioning what was the most striking aspect of the discussion for me: the ease with which the figuration of the penis and the vulva, and other sexual differentiae, could be illustrated and discussed without the slightest blushing. I must admit I experienced a bit of 'parlance envy'. Yet whenever the terms 'spirituality' or 'religion' suddenly invaded the discourse, I noticed a certain nervous shifting in seats and faces turned slightly red. I recognize that spirituality can be even scarier than sex for in many ways it penetrates to the depths of our sense of identity. Talking about them both more freely and openly might lead to new insights for both disciplines. Speaking of sex, one often hears that if theology marries a particular, popular science, it will inevitably face an unhappy divorce when that science is no longer in vogue. If archaeology ties the knot with a particular religious or philosophical construct, it faces a similar danger. But is marriage the best metaphor for interdisciplinary dialogue? In our late modern culture theology — once considered the 'queen' of the sciences — often can't even get a date. Surely we might learn more about ourselves as well as each other if we allow ourselves a little flirting? We might even accept the marriage metaphor, but not a marriage in which one of the spouses never changes or explores new ideas, but one in which the partners search for meaning together and learn from one another, appreciating the complementary perspectives provided by their always newly significant other.

References

Kant, I., 1965. *The Critique of Pure Reason*, trans. N. Kemp Smith. New York (NY): St Martin's Press.
Peirce, C.S., 1998. *The Essential Peirce: Selected Philosophical Writings,* vol. 2, ed. the Peirce Edition Project. Bloomington (IN): Indiana University Press.
Shults, F., 1999. *The Postfoundationalist Task of Theology*. Grand Rapids (MI): Eerdmans.
Shults, F., 2003. *Reforming Theological Anthropology: After the Philosophical Turn to Relationality*. Grand Rapids (MI): Eerdmans.
Shults, F. & S.J. Sandage, 2006. *Transforming Spirituality: Integrating Theology and Psychology*. Grand Rapids (MI): Baker Academic.

Topographical Index

Note: A page number in italic type indicates a figure, table or caption. Site names beginning with a definite article are filed under the second element, and names beginning with 'Caverna', 'Cueva', 'Grotta' or 'Grotte' are filed under the first significant element.

A

Achilleion (Greece), *36*
Addaura, Sicily (Italy), 318
Afalou-Bou Rhummel (Algeria), 7
Afghanistan, earliest imagery, 8
 Aq Kupruk, 8
Ahu Akivi (Easter Island), *130*, 131
'Ain Ghazal (Jordan), 124, *125*, *212*, 215–17, 216, 219, 220, 221
Alberndorf (Austria), 62
Alexandrovac (Kosovo), 122, *122*
Algeria
 earliest imagery, 7
 see also Afalou-Bou Rhummel; Oued Djebbana; Tamar Hat Cave
Altamira (Spain), 3, *74*, 294, 316
Amazonia, animality and humanity in Amazonian ethnography, 84, 86, 88–9, 90–91
Ambato Valley (Argentina), 258, 259
 see also La Rinconada
Amomoloc (Mexico), *37*, *40*
Amorgos (Greece), 122, 123, *123–4*
Anban (China), *37*, *278*, 280
Ankara (Turkey), 147
Apollo 11 Cave (Namibia), 7
Aq Kupruk (Afghanistan), 8
Arcy-sur-Cure (France), 3
 Grande Grotte, *74*, 75
Argentina
 earliest imagery, 5
 early figuration, 255–70, *256–7*, *264*, *266*
 see also Ambato Valley; Calchaquí Valley; Catamarca; El Ceibo; Epullán Grande Cave; Hualfín Valley; Inca Cueva 4; La Rinconada; Santa María Valley; Los Toldos
Arizona (USA), 4
Arnesano (Italy), 202, 203, *203*
Aspero (Peru), 243–4, *243*, 245, 247
Aswad II (Syria), *36*
Atacama desert (Chile), 262
 see also San Pedro de Atacama
Aucilla River, Florida (USA), 4
Australia
 earliest imagery, 10–12, *10–11*
 rock art, 50, 52
 see also Ballawinne Cave; Carpenter's Gap rock-shelter; Devil's Lair Cave; Early Man shelter; Gum Tree Valley; Jinmium; Keep River region; Koonalda Cave; Lake Mungo; Laurie Creek rock-shelters; Malakunanja II shelter; Mandu Mandu Creek rock-shelter; Nauwalabila I shelter; Panaramitee North; Pilbara; Puritjarra rock-shelter; Sandy Creek; Snowy River Cave; Spring Creek; Sturts Meadow; TASI 3614 Cave; Walkunder Arch Cave; Wharton Hill; Yingalarri
Austria
 anthropomorph images, 59
 Bandkeramik figurines, 18, 19
 earliest imagery, 3
 see also Alberndorf; Krems-Galgenberg; Willendorf

Avdeevo (Russia), 58, 59, 60, 62
Avebury (England), 132
Azana (Peru), 242

B

Badari (Egypt), *36*
Baiyinchanghan (China), 271, *273*, 274
Ballawinne Cave, Tasmania (Australia), 10
Bandurria (Peru), 245
Banshan (China), 279
Basta (Jordan), *212*, 216, 221
La Baume-Latrone (France), 72
Bayol (France), 72
Beidha (Jordan), *212*, *216*
Berekhat Ram (Israel), 8, 12, 62
Bernifal (France), *74*
Beycesultan (Turkey), 151
Bhimbetka (India), 8
Bilzingsleben (Germany), 3
Bison, Grotte du (France), *74*
Blombos Cave (South Africa), 7, 8, 289
Bolivia *see* Titicaca, Lake; Tiwanaku
Border Cave, Kwazulu (South Africa), 7
Borneo, earliest imagery, 10
Botswana *see* Tsodillo
Boyne Valley passage graves (Ireland), 25
Brassempouy (France), 58, 62
Brazil
 earliest imagery, 5, 6
 see also Amazonia; Pedra Furada, Boqueirão da; Pedra Pintada, Caverna da; Perna
Britain
 English Reformation, 327–9
 human representations from Mesolithic and Neolithic contexts, 25–6, *25*
 see also Avebury; Creswell Crags Caves; Dagenham; Folkton Wold; Grimes Graves; 'Long Meg and her Daughters'; Ring of Brodgar; Rothley Lodge Farm; Somerset Levels
Brno 2 (Czech Republic), 59, 62
Buang Merabak, New Ireland (Papua New Guinea), 12
Buena Vista (Peru), 247, *247*
Bulgaria
 incomplete figurines, 111
 from Durankulak, 111–19, *112*
 see also Dolnoslav; Kodzhaderman-Gumelniţa-Karanovo VI; Omurtag; Samovodyane; Varna
Buret' (Russia), 9, 59, 60

C

Cala Scizzo, Grotta da (Italy), 202, 204
Cala Tramontana (Italy), 202
Calchaquí Valley (Argentina), 256, *256–7*, *257*, 260, 261, 263, *264*, 267
Cambous (France), 24
Canada *see* Stein River valley
Canne della Battaglia (Italy), 203, *204*
Caral (Peru), 243, 244–5, 247
Cardal (Peru), 251, *251*
Carpenter's Gap rock-shelter, Kimberley (Australia), 11
Caru (Peru), 242

Casa San Paolo (Italy), *201*
El Castillo (Spain), *74*
Çatalhöyük (Turkey)
 evidence for female monotheism, 218
 figurines, 137–49, *138–40, 143–7*
 fertility theme, 35
 male and female, 151, 167, 168
 therianthropic images, 95–7, *95–7*
 use of, 213
 houses, 85
 representational art, 318
 wall paintings, 166
Catamarca (Argentina), 257
 Cueva de la Salamanca, 256, 266–7, *266*
Çayönü (Turkey), *36*
El Ceibo (Argentina), 5, *5*, 6
Cernavoda (Romania), 118
Cerro Sechin (Peru), 247, 249–50
Cervi, Grotta dei (Italy), 202, 204, 207
Chalcatzingo (Mexico), *37*, 38, 108
Château-Blanc (France), 24
Chauvet, Grotte de (France), 3, 69
 hand prints and stencils, 72–3, *72–4*, 312–13, *313*
 neurology and origins of representation, 307–320, *311–17*
 'Panel of the Horses', 287, *287*, 291, 293, *294*, 297
Chavín de Huántar (Peru), 251, *252*
Chichen Itza (Mexico), Chacmool figures, 130, *131*, 132
Chilca 1 (Peru), 242
Chile *see* Atacama desert; San Pedro de Atacama
China
 agriculture, pottery and gynecomorphs, Yellow and Yangtze rivers, 37, 39
 destruction of Buddhist images, 327
 earliest imagery, 9
 early figurations, 271–84, *273, 275, 278*
 life-sized figures, 121, *128–9*, 129, 132
 see also Anban; Baiyinchanghan; Banshan; Dadiwan; Dongshanzui; Hemudu; Hongshanmiao; Houtaizi; Jiangxicun; Lingjiatan; Liujiahe; Liuwan; Longgu Cave; Luojiajiao; Niuheliang; Qianmao; Sanxingdui; Shijiahe; Shiyu; Shizhaocun; Xian; Xinglonggou; Xishuipo; Zhaobaogou; Zhaolingshan; Zhoukoudian
Chojt-Cencherijn-aguj Cave (Cave of the Blue River) (Mongolia), 10
Chupacigarro (Peru) *see* Caral
Chupacoto (Peru), 250
Clermont-Ferrand (France), 21
Les Combarelles (France), *74*
Coptos (Egypt), 126, *128*, 131–2
Cosma, Grotta (Italy), 204
Coso Range, California (USA), 4
Cosquer Cave (France), 69, 73–4, *74–5*, 75, 76, 77, 78, 79
Creswell Crags Caves (England), 69
Cyclades (Greece), life-sized figures, 121, 122–4, *123–4*, 132
Czech Republic
 anthropomorph images, 59
 see also Brno 2; Dolní Věstonice; Pavlov; Petřkovice; Předmostí; Spytihněv

D

Dadiwan (China), 279
Dagenham (England), 25–6
Daima (Nigeria), 34
Daraki-Chattan, Indragarh, Chambal Valley (India), 8
Devil's Lair Cave (Australia), 11
Dhra' (Jordan), *212*, 214, *215*, *217*, 218, 219, 220
Diepkloof Cave (South Africa), 7

Djoser, pyramid of, Saqqara (Egypt), 125, *127*
Dolní Věstonice (Czech Republic), 58, 59, 60–61, 62, 63, *63*
 Black Venus, 62, 63, 65
Dolnoslav (Bulgaria), 171–84, *172, 174–5, 177–9, 181–2*
Dongshanzui (China), 272
Dumeşti (Romania), *113*
Durankulak (Bulgaria), 111–19, *112*

E

Early Man shelter (Australia), 10, *10*
Easter Island, life-sized figures, 122, 130, 131
 Ahu Akivi, *130*, 131
 Ranu Raraku, *130*
Ecuador *see* Valdivia
Eghazer (Niger), 34
Egypt
 life-sized figures, 121, 122, 125–6, *127–8*, 131–2
 see also Badari; Coptos; Giza; Luxor; Saqqara
Eilsleben (Germany), 20
Eliseevichi (Russia), *58*, 59, 60
Enkapuna Ya Muto (Kenya), 7
Epullán Grande Cave (Argentina), 5
Erberua (France), *74*
Erfurt (Germany), *19*, 20
es-Sifiya (Jordan), *212*, 216, 219
Espaly-Saint-Marcel (France), 21
Espiritu Santo, Cueva del (El Salvador), 102

F

Les Fieux (France), *74*
Folkton Wold (England), Folkton drums, 25, *26*
Font-de-Gaume (France), *74*
Fort-Harrouard (France), 20, 21, 26
France
 earliest imagery, 3
 hand print and stencil anthropomorphic representation, 72–9, *72–6*
 Paris basin, Bandkeramik figurines, 18, 19, 20–22, *20–21*
 statue-menhirs, 22–5, *22*, *27*
 see also Arcy-sur-Cure; La Baume-Latrone; Bayol; Bernifal; Bison, Grotte du; Brassempouy; Cambous; Château-Blanc; Chauvet, Grotte de; Clermont-Ferrand; Les Combarelles; Cosquer Cave; Erberua; Espaly-Saint-Marcel; Les Fieux; Font-de-Gaume; Fort-Harrouard; Gargas; Jonquières; Labattut shelter; Lascaux; La Madeleine; Maizy; Mas-d'Azil; Mont Bégo; Montaïon; Moulin-de-Laguenay; Noyen-sur-Seine; Pech-Merle, Grotte de; Points, Grotte aux; Le Poisson shelter; Roc-de-Vézac; Rocamadour; La Roche-Cotard; Roucadour; Saint-Sernin-sur-Rance; Table des Marchand passage grave; Tibiran; Trets basin; Les Trois-Frères
La Fuente del Salín (Spain), 73, *74*
La Fuente del Trucho (Spain), 73, *74*
Futago (Japan), *194*

G

Gagarino (Russia), 58, 59, 60, 62, *64*
La Galgada (Peru), 247, 248
Garagay (Peru), 251
Gargas (France), 73, *74*, 75–6, *76*, 77–8, 79
Gasja (Russia), 9
Geissenklösterle (Germany), 3
Georgia *see* Khramis Didi Gora
Germany
 Bandkeramik figurines, *19*, 20

earliest imagery, 3
 see also Bilzingsleben; Eilsleben; Erfurt; Geissenklösterle; Hohle Fels; Hohlenstein-Stadel; Vogelherd
El Gigante rock-shelter (Honduras), 102
Gilgal I (Palestine), 212, 215
Giza (Egypt), pyramid of Kephren, 125, 127
Göbekli Tepe (Turkey), 148, 151
Greece
 incomplete figurines, 111
 life-sized figures, 121, 122–4, 123–4, 132
 see also Achilleion; Amorgos; Keros; Nea Nikomedia; Olympia; Pellas
El Greifa (Libya), 6
Grimaldi Caves (Italy), 58
Grimes Graves (England), 25
Gritille Höyük (Turkey), 213
Guadone (Italy), 201
Gujarat (India), 228
Gum Tree Valley, Burrup Peninsula (Australia), 12

H

Hacılar (Turkey), 151–69, 155–65
Hagar Qim (Malta), 128
Hajji Firuz Tepe (Iran), 154–5, 213
Harappa (Pakistan), 227–39, 229–35
Hayonim Cave (Israel), 8
Hemudu (China), 276, 277
Higuchi-Gtanda (Japan), 192
Hódmezövásárhely-Kökénydomb (Hungary), 19, 20
Hohle Fels (Germany), 3
Hohlenstein-Stadel (Germany), 3, 52
Hohokam (USA), 39
Honduras
 figurines, 101–110, 104–5
 see also El Gigante rock-shelter; Mesoamerica; Playa de los Muertos; Puerto Escondido
Hongshanmiao (China), 278, 281
Horinouchi (Japan), 193
Houtaizi (China), 271–2, 273, 274
Höyücek (Turkey), 152, 153, 157
Huaca Prieta (Peru), 247–8, 248
Hualfín Valley (Argentina), 256–7, 257
Huaricoto (Peru), 247
Huaynuná (Peru), 247
Hungary
 Bandkeramik figurines, 18, 19, 20
 Hódmezövásárhely-Kökénydomb, 18, 19, 19, 20
 Szentgyörgyvölgy-Pityerdomb, 20
 incomplete figurines, 111
Hunsgi (India), 8

I

Inarijinja (Japan), 193
Inca Cueva 4 (Argentina), 4, 5
India
 earliest imagery, 8
 life-sized figures, 129
 see also Bhimbetka; Daraki-Chattan; Gujarat; Hunsgi; Patne
Ingaladdi (Australia) see Yingalarri
Iran see Hajji Firuz Tepe; Sarab
Iraq see Jarmo; Mesopotamia; Tell es-Sawwan; Uruk
Ireland, Boyne Valley passage graves, 25
Israel
 earliest imagery, 7–8
 see also Berekhat Ram; Gilgal I; Hayonim Cave; Jericho; Mount Carmel; Munhata; Nahal Hemar; Nahal Oren; Netiv Hagdud; Qafzeh Cave; Quneitra; Salibiya IX; Skhul; Urkan e-Rub; El-Wad Cave
Istanbul (Turkey), 147
Italy
 abstract and figurative representation, southeast Italy, 199–210, 201, 203–5
 see also Addaura; Arnesano; Cala Scizzo, Grotta da; Cala Tramontana; Canne della Battaglia; Casa San Paolo; Cervi, Grotta dei; Cosma, Grotta; Grimaldi Caves; Guadone; Lagnano da Piede; Lama Marangia; Masseria Candelaro; Masseria Valente; Mastrodonato Cave; Mura, Grotta delle; Pacelli, Grotta; Passo di Corvo; Porto Badisco, Grotta di; La Quercia; Santa Barbara; Santa Croce, Grotta; Sant'Anna; Scaloria Alta, Grotta; Scaloria Bassa, Grotta; Su Anzu; Valcamonica; Veneri, Grotta delle

J

Jacob's Cave, Missouri (USA), 4
Japan
 agriculture, pottery and gynecomorphs, 34–5, 39
 earliest imagery, 9
 emergence of anthropomorphic representation, 185–95, 188–90, 192–4
 see also Futago; Higuchi-Gtanda; Horinouchi; Inarijinja; Kamikuroiwa; Kanto region; Mushinai I; Nishida; Nishinomae; Odai Yamamoto; Sakaue; Shibahara; Tanabatake
Jarmo (Iraq), 36
Jaywamachay (Peru), 242
Jericho (Palestine), 124, 125, 132, 212, 215–17, 219, 221
Jiangxicun (China), 278, 280
Jinmium (Australia), 12
Jonquières (France), 21–2
Jordan see 'Ain Ghazal; Basta; Beidha; Dhra'; es-Sifiya; el-Khiam; Wadi Faynan 16; Zahrat adh-Dhra' 2
Judds Cavern (Australia) see Wargata Mina

K

Kamikuroiwa (Japan), 9
Kanto region (Japan), 188, 189, 190, 193
Kara'in Cave (Turkey), 7
Kazakhstan see Pazyryk
Keep River region (Australia), 50
Kenya, earliest imagery, 7
 Enkapuna Ya Muto, 7
Kephren, pyramid of, Giza (Egypt), 125, 127
Keros (Greece), 122, 124
el-Khiam (Jordan), 214, 215
Khoist-Tsenker-Agui Cave (Cave of the Blue River) (Mongolia), 10
Khotylevo II (Russia), 60
Khramis Didi Gora (Georgia), 36
Khummi (Russia), 9
Kiev-Kirillevskaya (Ukraine), 59
Klasies River Mouth Caves (South Africa), 7
Kodzhaderman-Gumelniţa-Karanovo VI (Bulgaria), 119
Koonalda Cave (Australia), 10, 12
Korea, earliest imagery, 8–9
Kosovo see Alexandrovac
Kostenki (Russia), 57, 58, 59, 60, 61, 62, 64–5
Kotosh (Peru), 245, 246, 246
Krems-Galgenberg (Austria), 3
Ksar-Akil (Lebanon), 7
Kuntur Wasi (Peru), 250, 250

L

Labattut shelter (France), 74
Lagnano da Piede (Italy), 201, *201*
Lake Mungo (Australia), 52
Lama Marangia (Italy), 202
Lascaux (France), *88*, 293, 294, 304, 305, 316, 317–18
 Georges Bataille on, 86–9
Lauricocha (Peru), 242
Laurie Creek rock-shelters (Australia), 11
Lebanon *see* Ksar-Akil
Lepenski Vir (Serbia), 92–5, *93–5*
Libya, earliest imagery, 6
 El Greifa, 6
Limoncarro (Peru), 251
Lingjiatan (China), 275, 276, 277, 281
Liujiahe (China), *278*, 280
Liuwan (China), *278*, 279
Loiyangalani valley (Tanzania), 7
Loltun Cave, Yucatan (Mexico), 102
'Long Meg and her Daughters' (England), 132
Longgu Cave (China), 9
Luojiajiao (China), 276, 277
Luxor (Egypt), Colossi of Memnon, 126

M

Macedonia, incomplete figurines, 111
Macusani (Peru), 242
La Madeleine (France), *89*
Maina (Russia), *58*
Maininskaja (Russia), 60
Maizy (France), *20*, 26
Malakunanja II shelter, Arnhem Land (Australia), 11
Malta
 life-sized figures, 121, 126–9, *128*, 132
 see also Hagar Qim; Skorba; Tarxien
Mal'ta (Russia), 9, 58, 59, 60, *65*
Maltravieso (Spain), 74, 75, 76, 77, 78
Manchay Bajo (Peru), 251
Mandu Mandu Creek rock-shelter (Australia), 11–12, *11*
Mas-d'Azil (France), *92*
Masseria Candelaro (Italy), *201*, 202
Masseria Valente (Italy), *205*
Mastrodonato Cave (Italy), 201
Matupi Cave (Zaire), 7
Mehrgarh (Pakistan), 36
Mesoamerica
 agriculture, pottery and gynecomorphs, 37–9, 41
 figurines, 101–110, *104–5*
 life-sized figures, 121, 130, 131, *131*, 132
 see also Honduras; Mexico
Mesopotamia, life-sized figures, 121, 124–5, *126–7*, 132
Mexico
 earliest imagery, 4
 see also Amomoloc; Chalcatzingo; Chichen Itza; Loltun Cave; Mesoamerica; Mexico City; Oaxaca, Valley of; Paso de la Amada; San José Mogote; San Lorenzo Tenochtitlan; Santa Marta Ocozocoautla rock-shelter; Tequixquiac; Tula; Zohapilco
Mexico City (Mexico), Templo Major, 130
Mezhirich (Ukraine), *58*, 59
Mezin (Ukraine), 58, 59, 61, 62
Milagro (USA), 37
Mina Perdida (Peru), 251, *252*
Mohenjo-daro (Pakistan), 227, 228, 230, 231, 233, 235, 238
Moldova, incomplete figurines, 111
Molodova (Ukraine), *58*, 59

Mongolia
 earliest imagery, 10
 Khoist-Tsenker-Agui (Chojt-Cencherijn-aguj) Cave (Cave of the Blue River), 10
Mont Bégo (France), 24–5
Montaïon (France), 24
Montegrande (Peru), 250
Moravany (Slovakia), 58, 59, *64*
Morella la Vieja (Spain), 318
Morocco, earliest imagery, 6–7
 Taforalt, Grotte des Pigeons, 7
 Tan-Tan, 6–7
Moulin-de-Laguenay (France), *74*
Mount Carmel (Israel), 8
Moxeke-Pampa de las Llamas (Peru), 249, 250
Munhata (Israel), *212*, 216
Mura, Grotta delle (Italy), 205
Mureybet (Syria), 217
Mushinai I (Japan), *194*

N

Nahal Hemar (Israel), *212*, 215
Nahal Oren (Israel), *212*, 215
Namibia, earliest imagery, 7
 Apollo 11 Cave, 7
Nauwalabila I shelter, Arnhem Land (Australia), 11
Nea Nikomedia (Greece), 122
Nemrut Dag (Turkey), 133
Netiv Hagdud (Palestine), *36*, *212*, 214, *215*, *217*, 219, 220
Nevali Çori (Turkey), 148, 151
Niger *see* Eghazer; Oroub
Nigeria *see* Daima
Nishida (Japan), *190*, 191
Nishinomae (Japan), *189*
Niuheliang (China), 272, *273*, 274, 276, 277
Nooitgedacht (South Africa), 6
Noyen-sur-Seine (France), 21, *21*, 22, 26, 27
Nswatugi Cave (Zimbabwe), 6

O

Oaxaca, Valley of (Mexico), 32
Odai Yamamoto (Japan), 9
Oklahoma (USA), 4
Olympia (Greece), Temple of Zeus, *84*
Omurtag (Bulgaria), 172
Oroub (Niger), 34
Oued Djebbana (Algeria), 7

P

Pacelli, Grotta (Italy), 203–4, *204*
Pacopampa (Peru), 250
Pakistan
 life-sized figures, 129
 see also Harappa; Mehrgarh; Mohenjo-daro
La Paloma (Peru), 242, 243
Panaramitee North (Australia), 12
Papua New Guinea *see* Buang Merabak
El Paraiso (Peru), 245, *245*, 247
Paso de la Amada (Mexico), *37*, *38*, 106, 107, 108
Passo di Corvo (Italy), 203, *204*, 207
Patne (India), 8
Pavlov (Czech Republic), 59, 60–61, *60–62*, 62
 see also Dolní Věstonice
Pazyryk (Kazakhstan), 132

Index

Pech-Merle, Grotte de (France), *74, 78,* 312, *313*
Pedra Furada, Boqueirão da (Brazil), *5,* 6
Pedra Pintada, Caverna da, Monte Alegre (Brazil), 6
Pellas (Greece), *84*
Perna (Brazil), Toca do Baixão do Perna I (Brazil), 6
Peru
 emergence of figuration, 241–54, *242–3, 245–8, 250–52*
 see also Aspero; Azana; Bandurria; Buena Vista; Caral; Cardal; Caru; Cerro Sechin; Chavín de Huántar; Chilca 1; Chupacoto; La Galgada; Garagay; Huaca Prieta; Huaricoto; Huaynuná; Jaywamachay; Kotosh; Kuntur Wasi; Lauricocha; Limoncarro; Macusani; Manchay Bajo; Mina Perdida; Montegrande; Moxeke-Pampa de las Llamas; Pacopampa; La Paloma; El Paraiso; Piruru; Pizacoma; Punkuri; Salinas; Sechin Alto; Sumbay; Toquepala
Petit-Chasseur, Sion (Switzerland), *23,* 24, 25
Petřkovice (Czech Republic), 59, *60*
Pigeons, Grotte des, Taforalt (Morocco), 7
Pilbara (Australia), 12
Pinarbaşı (Turkey), 142
Piruru (Peru), 247
Pizacoma (Peru), 242
Playa de los Muertos (Honduras), *37,* 38, 103–8, *104–5*
Points, Grotte aux (France), 72
Le Poisson shelter (France), *74*
Pomongwe Cave (Zimbabwe), 6
Porto Badisco, Grotta di (Italy), 202, 204, *205*
Předmostí (Czech Republic), 59, *62*
Puerto Escondido (Honduras), 103, 106
Punkuri (Peru), 249, *251*
Puritjarra rock-shelter, Cleland hills (Australia), 10

Q

Qafzeh Cave (Israel), 7, 8
Qianmao (China), *278*
La Quercia (Italy), 201
Quneitra (Israel), 8

R

Ramad (Syria) *see* Tell Ramad
Ranu Raraku (Easter Island), *130*
La Rinconada (Argentina), 260, 265
Ring of Brodgar (Orkney, Scotland), 132
Roc-de-Vézac (France), *74*
Rocamadour (France), Les Merveilles, *74*
La Roche-Cotard (France), 3
Romania
 incomplete figurines, 111, *113*
 see also Cernavoda; Dumeşti
Rothley Lodge Farm (England), 26
Roucadour (France), *74*
Rouergat group of statue-menhirs (France), 17, 23–4, 27
Russia
 anthropomorph images, 59–60, 63, *64–5*
 earliest imagery, 9–10
 see also Avdeevo; Buret'; Eliseevichi; Gagarino; Gasja; Khotylevo II; Khummi; Kostenki; Maina; Maininskaja; Mal'ta; Shishkino; Siberia; Sungir; Tolbaga; Yakutia

S

Sahara
 agriculture, pottery and gynecomorphs, southern Sahara, 34, 39
 earliest rock engravings, 6
Saint-Sernin-sur-Rance (France), *22,* 23–4

Sakaue (Japan), *189*
Salibiya IX (Palestine), *212, 215*
Salinas (Peru), 247
El Salvador *see* Espiritu Santo, Cueva del
Samovodyane (Bulgaria), 36
San José Mogote (Mexico), *37,* 38
San Lorenzo Tenochtitlan (Mexico), *131*
San Pedro de Atacama (Chile), *256,* 257, 258, 263, 265
Sandy Creek (Australia), 11
Santa Barbara (Italy), 205
Santa Croce, Grotta (Italy), *201*
Santa María Valley (Argentina), *256–7,* 260, *264,* 267
Santa Marta Ocozocoautla rock-shelter, Chiapas (Mexico), 102
Sant'Anna (Italy), *201*
Sanxingdui (China), 129, *129,* 132
Saqqara (Egypt), pyramid of Djoser, 125, *127*
Sarab (Iran), 36
Scaloria Alta, Grotta (Italy), *201*
Scaloria Bassa, Grotta (Italy), 201, *201*
Sechin Alto (Peru), 250
Sedlare (Serbia), 172
Serbia
 incomplete figurines, 111
 see also Lepenski Vir; Sedlare; Vlasac
Shibahara (Japan), *192*
Shijiahe (China), 37
Shishkino (Russia), 9
Shiyu (China), 9
Shizhaocun (China), *278,* 279–80
Siberia (Russia)
 earliest imagery, 9
 see also Russia
Sibudu Cave, KwaZulu-Natal (South Africa), 7
Skhul (Israel), 7
Skorba (Malta), 36
Slovakia, anthropomorph images, 59
 Moravany, 58, 59, *64*
Snowy River Cave (Australia), 10
Somerset Levels (England), Somerset God-Dolly, 25, 26
South Africa
 earliest imagery, 7
 see also Blombos Cave; Border Cave; Diepkloof Cave; Klasies River Mouth Caves; Nooitgedacht; Sibudu Cave
Spain
 hand print and stencil anthropomorphic representation, 73, 74
 see also Altamira; El Castillo; La Fuente del Salín; La Fuente del Trucho; Maltravieso; Morella la Vieja
Spring Creek (Australia), 11
Spytihněv (Czech Republic), 59, 62
Stein River valley, British Columbia (Canada), 50–51, *52–3*
Sturts Meadow (Australia), 12
Su Anzu, Sardinia (Italy), *36*
Sumbay (Peru), 242
Sungir (Russia), 61
Switzerland, statue menhirs, 24–5
 Petit-Chasseur, Sion, 23, 24–5
Syria *see* Aswad II; Mureybet; Tell Ramad
Szentgyörgyvölgy-Pityerdomb (Hungary), 20

T

Table des Marchand passage grave (France), 18
Taforalt (Morocco), Grotte des Pigeons, 7
Tamar Hat Cave (Algeria), 7
Tan-Tan (Morocco), 6–7
Tanabatake (Japan), *189,* 192
Tanzania, earliest imagery, 6, 7

345

Loiyangalani valley, 7
Tarxien (Malta), *128*, 129, 132
TASI 3614 Cave, Tasmania (Australia), 11
Tell es-Sawwan (Iraq), 151
Tell Ramad (Syria), *212*, *216*, *218*
Tequixquiac (Mexico), 3–4
Tibiran (France), 73, *74*
Titicaca, Lake (Bolivia), *256*, 258–9
Tiwanaku (Bolivia), *256*, 258–9, 263, 264, 265, 267, 268
Tlapacoya-Zohapilco (Mexico) see Zohapilco
Tolbaga (Russia), 9
Los Toldos (Argentina), 5, *5*
Toquepala (Peru), 242, *242*
Trets basin (France), stelae from, 24
Les Trois-Frères (France), *74*, *92*
Tsodillo (Botswana), 305
Tula (Mexico), 130, *131*, 132
Turkey
 earliest imagery, 7
 see also Ankara; Beycesultan; Çatalhöyük; Çayönü; Göbekli Tepe; Gritille Höyük; Hacılar; Höyücek; Istanbul; Kara'in Cave; Nemrut Dag; Nevali Çori; Pinarbaşı; Üçağizli Cave
Turkmenistan see Yalangach-depe
Twin Rivers (Zambia), 6

U

Üçağizli Cave (Turkey), 7
Ukraine
 anthropomorph images, *58*, 59
 incomplete figurines, 111
 see also Kiev-Kirillevskaya; Mezhirich; Mezin; Molodova
United States of America
 earliest imagery, 4–5, *4*
 see also Arizona; Aucilla River; Coso Range; Hohokam; Jacob's Cave; Milagro; Oklahoma; Wyoming
Urkan e-Rub (Israel), 7–8
Uruk (Iraq), Warka head, 124, *126*

V

Valcamonica (Italy), 24
Valdivia, Real Alto (Ecuador), 37, *37*, 38, 39, 41, *41*

Varna (Bulgaria), 119
Veneri, Grotta delle (Italy), 202
Věstonice (Czech Republic) see Dolní Věstonice
Vlasac (Serbia), 93, *93*
Vogelherd (Germany), 3, 316, 319

W

El-Wad Cave (Israel), 8
Wadi Faynan 16 (WF16) (Jordan), *212*, 214, *217*, *218*, 220
Walkunder Arch Cave (Australia), 11
Wargata Mina (Judds Cavern), Tasmania (Australia), 10
WF16 (Jordan) see Wadi Faynan 16
Wharton Hill (Australia), 12
Willendorf (Austria), 58, 59, 62
Wyoming (USA), 4, *4*

X

Xian (China), *128*, 129
Xinglonggou (China), 271, *273*
Xishuipo (China), *278*, 280, 281

Y

Yakutia (Russia), 9
Yalangach-depe (Turkmenistan), *36*
Yingalarri (Ingaladdi) (Australia), 50

Z

Zahrat adh-Dhra' 2 (Jordan), 214
Zaire, earliest imagery, 7
 Matupi Cave, 7
Zambia, earliest imagery, 6
 Twin Rivers, 6
Zhaobaogou (China), 272, *273*, 274
Zhaolingshan (China), *275*, 276, 277
Zhoukoudian (China), 9
Zimbabwe, earliest imagery, 6
 Nswatugi Cave, 6
 Pomongwe Cave, 6
Zohapilco (Mexico), 37, *37*, 102